Graphic Design Solutions

3rd Edition

Robin Landa talks about all the fundamentals in a clear and concise language—if you are clueless about design, read her Graphic Design Solutions *and you will have a clue.*

— Stefan Sagmeister

Graphic Design Solutions

3rd Edition

By Robin Landa

THOMSON
DELMAR LEARNING

Australia Canada Mexico Singapore Spain United Kingdom United States

THOMSON

™

DELMAR LEARNING

Graphic Design Solutions, 3rd Edition
Robin Landa

Vice President, Technology and Trades SBU:
Alar Elken

Editorial Director:
Sandy Clark

Senior Acquisitions Editor:
James Gish

Development Editor:
Jaimie Wetzel

Editorial Assistant:
Niamh Matthews

Marketing Director:
Dave Garza

Channel Manager:
William Lawrensen

Marketing Coordinator:
Mark Pierro

Production Director:
Mary Ellen Black

Senior Production Manager:
Larry Main

Production Editor:
Thomas Stover

Art & Design Specialist:
Mary Beth Vought

Full Production Services:
Liz Kingslien,
Lizart Digital Design

Cover Design:
Denise M. Anderson,
Design Management
Associates, Inc.

Cover Art:
Jennifer Morla,
Morla Design
www.morladesign.com
Photography: Gerry Bybee
Poster: *The Radical Response*

Luba Lukova,
Luba Lukova Studio
Poster: *Virgil*

John Muller,
Muller + Company
Poster: Mission Mall

Thomas Ema,
Ema Design Inc.
Poster: *Fritz Gottschalk*

Alexander Isley,
Alexander Isley Inc.
Poster: *New Music America*

John Gall,
Vintage/Anchor
Book cover: *South of the Border*
by Haruki Murakami

Shira Shecter,
Shira Shecter Studio
Promotional postcard booklet:
Tamooz

Library of Congress
Cataloging-in-Publication Data
Landa, Robin.
 Graphic design solutions / Robin Landa.--
3rd ed.
 p. cm.
 Includes bibliographical references and index.
 ISBN 1-4018-8154-8
 1. Commercial art. 2. Graphic arts. I. Title.
NC997.L32 2005
 741.6--dc22 2005004047

NOTICE TO THE READER

Table of Contents

Foreword

Luba Lukova

I must confess a sin from back in my student years: whenever I had an art book in my hands, I ignored the text and looked only at the pictures. So I know there are aspiring designers who will probably do the same thing when they open this book. Why did I do this? Well, I thought that the text in this kind of publication was just fluffy filler and the images were all that really mattered. But a recent event made me realize how wrong my student convictions were.

When I was in school in Bulgaria, one of the toughest teachers at the Art Academy was the typography professor. A strange man in his late sixties who was strongly influenced by the German type tradition, he imposed an almost military discipline in class. He was the author of two books on type, and in addition to teaching, he was researching the ancient roots of the Cyrillic alphabet for another volume. Everyone knew that he was as devoted as a monk to his upcoming book; he had even traveled to remote historic sites to gather typographic examples that were engraved on the ruins.

I studied type for five years, meeting with him every week. The assignments were difficult and everything had to be done by hand, very often using a magnifying glass for the finest details. It was not easy to please him, and even when he liked something, he was very stingy with his compliments. Many of my classmates were angry with him because, even though we worked hard, it was next to impossible to earn his praise. As a result of this treatment, none of us wanted to read his books. We saw him every week, so why bother?

Years went by. I immigrated to the United States and established my studio in New York City. Then not long ago, my parents visited from Bulgaria and came to see my new workplace. To my surprise, my mother brought with her two of my typography professor's books. She said that

Luba Lukova is an internationally recognized artist and designer working in New York. Originally from Bulgaria, she has lived in the United States since 1991. Her distinctive graphic art has been published in The New York Times, The Washington Post, The Wall Street Journal *and* Le Monde, *among many others. Her posters are widely exhibited in the United States, Europe, and Asia and are in the permanent collections of The Museum of Modern Art, New York; The Library of Congress, Washington, D.C.; Museum für Gestaltung, Zurich; and the Bibliothèque Nationale de France. Her awards include the Grand Prix Savignac/ World's Most Memorable Poster, International Poster Salon, Paris; the Golden Pencil Award, One Club, New York; and the Honor Laureate, Colorado International Poster Exhibition, Fort Collins, Colorado.*

they looked good to her, and she thought that they could be more useful with me than lying on the shelf in Bulgaria.

Fifteen years ago, I wouldn't have imagined that one day I would be in my New York office, holding a book about Cyrillic type written by my former professor. I flipped through the pages; the images were beautiful, but this time I wanted to read the text. It was a discovery—so interesting and vivid! Toward the end of the text, I found the most fascinating part: he had written an

appendix to the book wherein he presented his theory about the origins of beauty. There were many intricate graphics that showed the cells of the human eye and their connection to the brain. He claimed that the cells in the eye were structured by the golden mean ratio, so that when they detected an object of the same "golden" proportions, it produced a pleasing sensation in the brain. His conclusion was that beauty was not a product of trend or fashion, but something divine. That is why the typefaces of the ancient times still look so magnificent to us.

When I read this, I felt silly about my stubbornness as a student. What a pity I hadn't read it earlier; I could have asked him so many questions. I grabbed the phone and called a Bulgarian friend, hoping to find the whereabouts of my professor. I was told he had passed away several years ago.

Graphic Design Solutions is a book worth reading; don't just look at the pictures. Robin Landa speaks with clarity and love for her subject. In accessible language, she addresses the complexity of graphic design problem solving in a way that only a true practitioner can. Theory is immediately related to real-world solutions; this stands in contrast to the numerous esoteric design publications available today. Her deceptively simple writing reveals Landa's extensive experience as a pedagogue. You will be immediately engaged and enlightened by her discussion of visual communication, as though she were present in your classroom.

Recognizing that design is an active process, Landa has included exercises and assignments in every section of this book. The reader becomes an active participant and can use the completed projects as high-level portfolio pieces.

The images in the book are a collection of the world's most outstanding graphic designs, created by master and contemporary artists. They are examples of imagination, intelligence, and harmony produced by designers, illustrators, photographers, and art directors.

When she analyzes the visuals, Landa grasps the essence of each piece and clarifies its message. She links it with the graphic design practice by discussing the methods used to achieve the desired effect. It becomes obvious that good design cannot be created by merely following a simplistic formula; it is always a challenge that requires much skill and tenacity.

The main objective of this book is not only to provide students with a comprehensive foundation in design and communication, but also to encourage experimentation and critical thinking. Landa is convinced that the ability to assess problems is an important part of the educational process. She strongly believes that when you question what you have learned—not just accept it—you will learn even more.

It is easy for a student to get lost in the contemporary art and design scene. *Graphic Design Solutions* is a book that can be used as a point of departure by beginning designers. As Landa says: "Movements come and go and are everywhere—in politics, pop culture, music, theatre, and literature." Rules are created and are being broken. But it seems to me that what my old professor stated in his study might be true: the rules of beauty are given to us. And what else is design but an eternal search for beauty and meaning? It is almost impossible to succeed in this quest by intuition alone; we need the right tools. *Graphic Design Solutions* is such a tool.

Preface

Intended Audience

Graphic Design Solutions is the most informative how-to book on graphic design and advertising available and was created in response to the many needs of a student's design education.

This book serves several purposes for students in visual communication programs who are graphic design and advertising majors, and for aspiring designers. *Graphic Design Solutions* is:

• A thorough guide to key graphic design and advertising applications from concept to execution

• An overview of the visual communication profession

• A historical framework that puts the theories in this book into a broader context

• An introduction to a design process for solving visual communication problems

• A presentation of design elements and principles as the foundation to any design

• An informative guide to cause and effect visual communication

• A teaching tool with exercises and projects at the end of each chapter

Throughout the life of this book, students have found it a rewarding educational experience.

Emerging Trends

There are always emerging trends and, more importantly, design movements and theories. Those that seem most vital to the most people are discussed here.

On Strategy. More often, designers, art directors, and creative directors are being called upon to formulate strategy. Some collaborate with clients; some formulate strategy as members of conventional creative teams; and some are members of brand teams combining professionals from both the studio/agency side and the client side. Emphasizing strategy in this book encourages

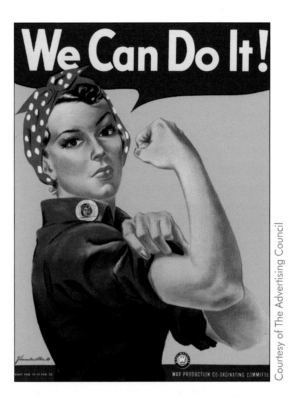

Courtesy of The Advertising Council

students to begin understanding the importance of strategy to the creative process, of using design or creative briefs to formulate a plan. Designers and art directors solve visual and verbal communication problems. Although a portion of the work created is aesthetically compelling, thought provoking, and expressive, designers are not creating art as a pure matter of self-expression. Clients want their visual communication problems solved, and they want creative professionals who understand the true nature of the discipline. Using a design brief keeps everyone on course.

On Collaboration. Clients want to be heard, to have a creative professional who can actively listen and respond. Sure, some clients want you to "design" their ideas and that is not desirable. But most clients want a designer or art director who will work in partnership, forming strategy to best solve the problem.

On Ethics. In 1964, twenty-two visual communication professionals signed the original *First Things First* manifesto—a call to use designers' problem-solving skills in pursuit of projects that would better society, for example, creative social cause campaigns and information design. Existentialism is not new, either—asking people to take responsibility for their actions isn't an emerging trend. Therefore, what I am about to say is not new and may even seem a contradiction, given my interest in branding. My main interest is to have students realize that they have a social responsibility to communicate truthfully and to respect their audience's human dignity. Of course, advertising communicates in broad stokes; however, it is possible to communicate and still avoid ethnic, racial, religious and gender stereotyping, negative portrayals of cultures and communities, veiled negative messages, and scare tactics, among other critical ethical issues. In the spirit of ensuring that we all practice ethically, we can remember Margaret Mead's wisdom: "Never doubt that a small group of thoughtful, committed citizens can change the world. Indeed, it is the only thing that ever has."

On Branding. There is an ever-growing convergence of specialized areas of visual communication. Advertising agencies are creating branding programs. Design studios are creating advertising. Certainly, interactive agencies, packaging design firms, and environmental design studios also are involved. And a client should expect a common thread throughout all work. It is important for a student to realize that no application is isolated—it is part of a larger plan.

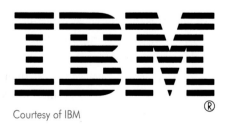

Courtesy of IBM

On Creativity. Paula Scher, Pentagram design partner, took part in a panel discussion on the nature of creativity—"Compelled to Create?"—at Rockefeller University, along with other acclaimed people, including Nobel prize-winning scientists. Scher stated that recently she had been taking on different types of design projects (moving away from flat graphic design to working with architects), ones that were quite different in nature from those she had been solving for years (such as posters and visual identities).* Solving problems that did not draw on her usual problem-solving skills was refreshing her creative energies.

Scher is able to take on new challenges not so much because she is a prodigious designer—which she is—but because she is a great thinker. For any student or novice it is imperative, first and foremost, to develop sophisticated problem-solving skills, to be grounded in liberal arts, to have excellent communication skills, and to be a good "information-gatherer" and a careful listener. That will serve you best for the long career. This book fully addresses developing problem-solving skills.

Background of This Text

Without fail, every semester I want to hand over, in a bundle, all the information and insights into graphic design and advertising that I possess, so that my students can immediately start creating solutions with impact. I remind myself that it will take many weeks for students to get the notion that information must be gathered, strategy and ideas must be formed, that an idea propels a solution, and finally, that together design and text visually communicate the idea.

I have written the third edition of *Graphic Design Solutions* to serve as a guide for my own teaching, and hopefully students and other educators will find it helpful, as well.

* For the full discussion, see *www.rockefeller.edu/events/creativity/2003/program.php* .

If you teach or if you are studying graphic design or advertising, then you're most likely as fascinated by visual communication as I am. Absolutely, I believe that graphic design and advertising matters. From public service advertising to publication design, creative solutions become important contemporary visual communication vehicles. The fascination with a discipline that demands creativity and critical thinking from its creators is what led me to the field.

Teaching graphic design and advertising is very challenging. Strategy, ideation, design, writing, and social responsibility are taught simultaneously. Students must become critical and creative thinkers very quickly, learning to visually and verbally express and represent their creative ideas.

In a fast-paced marketplace, in order to thrive, any visual communication professional must stay current with technology, design theory and movements, economic trends, and culture. Knowing and respecting one's audiences and clients is crucial. Today, collaboration is becoming more and more a necessity. A designer collaborates with clients, IT professionals, and many other creative professionals in order to best solve communication problems.

My research into visual communication is ongoing. Like any conscientious physician, I must stay abreast of all current research, work, theories, trials, discourse, and papers.

By interviewing hundreds of the world's most esteemed graphic design and advertising practitioners, I am completely familiar with many viewpoints and solutions. By being privy to their individual design briefs and creative strategies, I possess a remarkable umbrella view of how studios and agencies formulate strategy to design effective, creative solutions.

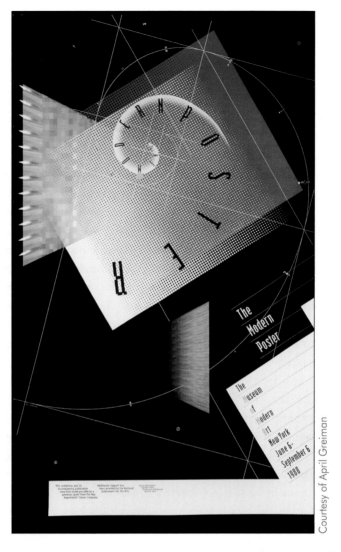

Courtesy of April Greiman

In fact, by reviewing work to include in this book (and for my other nine books), I am in a unique position to have a comprehensive overview of international solutions and points of view. As a practitioner, I understand what clients need. As an educator, I know how to break down enormous amounts of complex information into digestible bits.

To best utilize this text, a reader should have studied a basic course in visual basics and/or drawing for designers. This book includes a chapter on design fundamentals and that chapter should be read first, if the reader has not had a course in two-dimensional design or visual basics. Certainly, a basic knowledge of the necessary tools, materials, and techniques (hand skills and tools, as well as computer skills) would facilitate learning.

Textbook Organization

The major portion of this book covers the basics of essential graphic design applications. A historical perspective is included, at the beginning of this book, in order to view contemporary thinking in perspective. To set the stage for discussion of specific applications, an introduction to the subject and overview comprise the first two chapters. For some readers, these chapters may be the only introduction to visual communication they receive; thus, I tried to make it as full of vital information as possible. The third chapter on fundamentals provides a refresher in two-dimensional design elements and principles as they relate to visual communication. Chapter Four: Typography, and Chapter Five: Layout, are best read before any of the chapters on specific applications since typography and layout are utilized across all applications.

Chapters six through fourteen cover major graphic design and advertising applications; they are easily used in any order that is appropriate for the reader or best suits the educator. As some educators have mentioned to me, there is far too much in this book to be covered in one semester.

What I have done is allow for at least three scenarios:
• Instructors may pick and choose what to teach, whether it is applications or the number of projects.
• Instructors may choose to use this book in several courses, in order to make the investment in a textbook worthwhile.
• Students and designers alike will be able to use this book as a resource for a very long time due to the abundance of information, great examples by venerated designers, and large number of projects.

Each chapter provides substantial background information about how the application is used and how to create an application, including appropriate exercises and projects. Also included are sidebars with suggestions, tips, and important design considerations. Some chapters are much longer than others due to the role they play in most curricula.

The last chapter, which describes putting together a portfolio and the job search, offers very helpful advice to students and aspiring designers and art directors. Included are student projects, which are intended as examples of range and types of applications. And at the end of the book are the glossary to help with terminology, a selected bibliography to encourage further reading, and two extensive indexes—one regarding all subject matter and another referencing all the agencies, clients, creative professionals, and studios mentioned in this book.

Throughout this book are several informative articles by well-respected visual communication professionals, intended to add different voices and greater wisdom to the reader's education.

Looking at the Illustrations

Anyone can learn an enormous amount by analyzing graphic design solutions. Whether you dissect the work of peers, examine the examples of work in this text, closely observe an instructor's demonstrations, or analyze professional work, you will enhance your learning by asking *how* and *why* others did what they did. The examples provided in this text are just that—examples. There are innumerable solutions to any exercise or project. The examples are here to give you an idea of what is possible and what is in the ballpark; neither are they meant to be imitated, nor are they by any means the only "correct" solutions. Creativity in any visual communication discipline is not measured in terms of right and wrong, but rather by the degree of success demonstrated in problem solving, communicating, applying visual skills, and expressing appropriate personal interpretations.

Every illustration in this book is excellent and was chosen with great thought to providing the best possible examples of effective and creative work. The work and information in this book represents the best of what is being produced today. When you look at the examples of the greats—the highly respected professionals in the various design fields—do not look at them and think, "Oh, I could never do that." Instead, think, "This is great stimulation. I could learn a lot from these people." We can and should learn from the creativity of others. Creativity can be enhanced by study. It is simply a matter of deciding that you can be creative and having someone guide the way.

Features

The following list provides some of the salient features of the text:
- Examples of work from the most esteemed designers and art directors in the world
- State-of-the-profession overview of both graphic design and advertising
- Clear explanation of the major graphic design applications
- "How-to" explanations of the applications, with numerous bulleted lists and sidebars to assist in student comprehension
- An extensive, cutting-edge chapter on Web design
- A comprehensive, edgy chapter on advertising
- Articles by professionals
- A timeline with numerous historical images
- "A good read"

New to This Edition

- Foreword by renowned designer/illustrator Luba Lukova
- How-to explanations, exercises, and projects covering a range of applications, including logos, pictograms, symbols, visual identity, branding, book jackets, magazine covers, packaging, posters, annual reports, Web design, and advertising
- An article on design history by Steven Brower, former creative director of *Print* magazine, and a historical, visually oriented timeline showcasing images from various periods to convey the evolutionary progression of graphic design
- Essays by highly regarded design and advertising professionals providing insight into developing creative ideas, working successfully with the printer, selecting color palettes, the grid, the advertising creative team, and interactive design
- A new chapter on unconventional advertising
- New student design solutions
- Additional information on Web design
- Historical information on poster design
- More on the grid, including diagrams
- New illustrations from top international and American designers, art directors, and interactive designers, which make this book an outstanding addition to any design professional's bookshelf
- Supplemental package providing instructors with key tools

E.Resource

This guide on CD was developed to assist instructors in planning and implementing their instructional programs. It includes sample syllabi for using this book in both an 11-week and a 15-week semester. It also provides chapter review questions and answers, exercises, PowerPoint slides highlighting the main topics, and additional instructor resources.

ISBN: 1-4018-8156-4

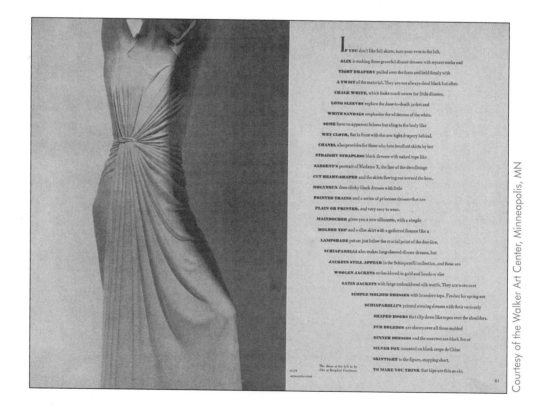

Courtesy of the Walker Art Center, Minneapolis, MN

About the Author

Robin Landa is the author of ten published books about art and design, including *Advertising by Design*™ (John Wiley & Sons), *Thinking Creatively* (North Light Books), and *Visual Workout Creativity Workbook* (Thomson Delmar Learning) co-authored with Rose Gonnella, and *Creative Jolt* and *Creative Jolt Inspirations* (North Light Books) co-authored with Rose Gonnella and Denise M. Anderson, and the upcoming *Designing Brand Experiences* (Thomson Delmar Learning). Robin Landa's article on ethics in design, "No Exit for Designers," was featured in *Print* magazine's European Design Annual/Cold Eye column. Her articles have been featured in *HOW* magazine and *Icograda*. Landa's upcoming articles include a feature on the work of Steven Brower and another article on ethics in design and advertising.

Landa has won many awards for writing and design, including the New Jersey Authors Award, The National League of Pen Women, National Society of Arts and Letters, Art Directors Club of New Jersey, The Presidential Excellence Award in Scholarship from Kean University, Rowan University Award for Contribution to Design Education, Graphic Design USA cover design award, Creativity 26, and Creativity 34.

Landa is a professor in the Department of Design at Kean University of New Jersey. She is included among the teachers that the Carnegie Foundation for the Advancement of Teaching calls the "great teachers of our time." Also highly interested in the issues of social responsibility, Landa worked on an Alcohol Awareness Grant received by Kean University, to create a print and Web advertising campaign to promote awareness among university students about alcohol abuse. Annually, Landa directs a student project to create an unconventional public service advertising campaign to solicit donations for various charities and raise awareness for social causes.

Mike Tesi Photography

Landa has lectured across the country, including very positively reviewed lectures at the *HOW* International Design Conferences, and has been interviewed on radio, television, in print, and the World Wide Web on the subjects of design, creativity, and art. In 2002, Landa was the keynote speaker at the Graphic Artists Guild conference in Philadelphia, and in 2003, she participated on a panel about graphic design education at the College Art Association conference in New York City. In 2004, Robin Landa gave a lecture at the Art Directors Club of New Jersey about the creative side of advertising. At the One Club 2004 Summit for Educators in Advertising and Design, Landa participated in a panel discussion on textbooks and defining the needs of college and university curricula.

In addition, Landa is a Branding and Creativity Strategist with Design Management Associates (DMA), Jersey City, New Jersey. Robin Landa's freelance work includes graphic design, copywriting, and working with corporations as a creativity and branding consultant. She also is a member of The One Club, AIGA, Art Directors Club of New Jersey, and Art Directors Club of New York. Robin resides in New York City with her husband and their daughter.

Acknowledgments

Without the brilliantly creative graphic design and advertising solutions that inhabit these pages, my book would be an entirely different study. Humbly and gratefully, I thank all the creative professionals who granted permission to include their work in this new edition of *Graphic Design Solutions*. Some of these designers' and art directors' works have graced the previous editions of *Graphic Design Solutions*; some are newly seen here. Thank you. Thank you.

Great thanks to the clients and corporations who also granted permission, and to all the generous people whose help was so valuable. Thank you to Emma Banks, Strawberryfrog; Katie Dishman, Corporate Archivist, General Mills; Sabine Gilhuijs, KesselsKramer; and Lara Haarhoft, R/GA; and the gracious experts at Sandy Alexander, Inc. of Clifton, NJ, for their invaluable help.

Luba Lukova's brilliant work has graced this book in previous editions; and now, her foreword provides insight for readers. New to this edition are wonderfully informative articles by Steven Brower, Rose Gonnella, Michele Kalthoff, Nick Law, Dave Mason, Dawnmarie McDermid, Christopher Navetta, and David J. Nehamkin. Very respectfully, I thank you all.

And where would I be without my esteemed colleagues at Kean University's Department of Design who have provided continued, generous support of this book? I am indeed fortunate to work alongside such consummate educators and experts (and the kindest of friends): Denise M. Anderson, Steven Brower, Rose Gonnella, Martin Holloway, Laura F. Menza, Richard Palatini, Alan Robbins, and Michael Sickinger. To Lou Acierno, Tricia Boffice, Frank Holahan, Michael O'Keefe, and Andrea Pedolsky, thank you for your expertise and support.

Rewriting a book, such as this one, is a huge undertaking. Without such exceptional professionals as Jim Gish, senior acquisitions editor, and Jaimie Wetzel, development editor, at the helm of this project, and every other skilled, talented, dedicated professional on the Delmar team to support this endeavor, I'd still be writing and gathering images. Great, grateful thanks to the following people at Delmar whose hard work and intelligence made this book happen: Larry Main, production manager; Tom Stover, production editor; Mary Beth Vought, art and design specialist; Niamh Matthews, editorial assistant; Laura Molmud, permissions editor; Mardelle Kunz, copyeditor; and Liz Kingslien, designer. Not only is the Delmar team a stellar group, they are genuinely kind. Thank you one and all.

Warm thanks to former students, now responsible, highly creative professionals, who have made me proud, and great thanks to my current students. Thanks for allowing me to bask in your cumulative creative glow and glory. A special thanks to Sanghee Jeon, Christopher J. Navetta, and Adam C. Rogers for allowing me to showcase your outstanding work.

Loving thanks to my friends and family. And finally to my handsome husband/tango partner/ personal physician, Dr. Harry Gruenspan, and to our darling daughter, Hayley, thank you, my two loves, for putting up with me.

Thomson Delmar Learning and the author would also like to thank the following reviewers for their valuable suggestions and expertise:

Frank Abnet
Graphic Communication Department
Baker College of Owosso
Owosso, Michigan

David Andrus
Art/Graphic Design Department
John Brown University
Siloam Springs, Arkansas

David Carroll
Visual Arts Department
North Greenville College

Tigerville, South Carolina
Cynthia Clabough
Graphic Design Program Coordinator
SUNY Oswego
Oswego, New York

Anna Couch
Visual Art Department
Irvine Valley College
Irvine, California

Leslie Denhard
Graphic Design Department
Southwest Florida College
Fort Myers, Florida

Natham Gams
Academy of Design Department
McIntosh College
Dover, New Hampshire

Barbara Goodman
Graphic Design Department
Art Institute of California, Orange County
Santa Ana, California

Eric Joseph
Multimedia/Graphic Design Department
Pittsburgh Technical Institute
Oakdale, Pennsylvania

Genny Kotun
Graphic Design Department
Hagerstown Business College
Hagerstown, Maryland

Therese LeMelle
Visual Communications Department
Katharine Gibbs School
New York, New York

Andres Moreno
Advertising Art
The Art Center Design College

Tucson, Arizona
Marjaneh Talebi
Art/Graphic Design Department
Harrisburg Area Community College
Harrisburg, Pennsylvania

Jim Watson
Design Department
University of Central Oklahoma
Edmond, Oklahoma

Questions and Feedback

Thomson Delmar Learning and the author welcome your questions and feedback. If you have suggestions that you think others would benefit from, please let us know and we will try to include them in the next edition.

To send us your questions and/or feedback, you can contact the publisher at:

Thomson Delmar Learning
Executive Woods
5 Maxwell Drive
Clifton Park, NY 12065
Attn: Graphic Communications Team
800-998-7498

Or the author at:
RLANDA@KEAN.EDU
Robin@designmanagementassociates.com

Dedication

To the memory of my dear parents:
my beautiful mother, Betty Landa,
and my talented father, Hy Landa.

Robin Landa
2005

Graphic Design Timeline

The history of design, like any history, is completely malleable. With no hard start date, we have to make choices. Should we begin with the cave paintings of Lascaux, Chinese moveable type, the Trajan column, or Gutenberg? Our history is the history of human communication, so where to begin?

Steven Brower

Now in his own design studio, most recently Steven Brower was the creative director for Print *magazine. He has been an art director for* The New York Times, The Nation *magazine, and* Citadel Press. *He is the recipient of numerous national and international awards, and his work is in the permanent collection of Cooper-Hewitt National Design Museum, Smithsonian Institute. He is on the faculty of the School of Visual Arts, New York and Marywood University's Masters with the Masters program in Scranton, Pennsylvania and Kean University of New Jersey. He resides in New Jersey with his wife and daughter and their six cats.*

For our purposes, we begin in the modern era, in the late 19th century. The advent of improved travel to Asia brought sailors onto the streets of Paris and London, weighted down with Japanese prints in their knapsacks. The influence of these Japanese artists on their European counterparts was profound. An organic sense of form based on nature, refined ornamental borders, and elegant composition became the rage. Combined with refined printing processes, Art Nouveau was indeed the new art.

This style spread quickly. The Arts & Crafts movement in England, Jugendstil (Youth Style) in Germany, and Glasgow Style with versions in Belgium and the United States, the basic elements were reinvented by each culture, which added their own twist. In Austria it was taken a step further with the Vienna Succession, a group dedicated to creating a new visual language.

In the early 1900s, the shot heard round the world would be in Germany. Lucian Bernhardt was fifteen years old when he visited the Munich Flaspalast Exhibition of Interior Design. So moved by the forms and colors he had witnessed, he returned to his parents' house while his father was away on a business trip, and painted every wall and piece of furniture in these bold new colors. When his father returned, he was so outraged that Lucian left home, permanently.

Lucian Bernhardt was fifteen years old when he visited the Munich Flaspalast Exhibition of Interior Design. So moved by the forms and colors he had witnessed, he returned to his parents' house while his father was away on a business trip, and painted every wall and piece of furniture in these bold new colors.

Stranded in Berlin, he entered a contest sponsored by Priester Match to create a poster advertising their wares. He painted a composition that included matches on a tablecloth, along with an ashtray containing a lit cigar, and dancing girls in the background. Dissatisfied, he painted out the dancing girls. Feeling it was still not working, he deleted the ashtray. The tablecloth was next to go. There remained the singular word "Priester" and two matches, on a brown background, along with a discrete signature. The birth of the object poster was born, prefiguring the Ludwig Mies van der Rohe "less is more" philosophy.

Soon the Russian Revolution was under way, resulting in an extraordinary (albeit

short-lived) amount of creative freedom for artists such as El Lissitsky, Rodchenko, and Malevich. The Futurists' typographic experimentation with typography in Italy resulted in an influence that would outlast their

In 1954, a group of Cooper Union graduates banded together to form Push Pin Studios. Well-versed in design and illustration history, they drew upon existing forms, such as Art Nouveau and Art Deco, to create new ones.

movement, halted by World War I. After the war, De Stijl in the Netherlands and The Bauhaus in Germany would further refine the clean modernist esthetic. Artists such as A. M. Cassandre in France would synthesize entire art movements such as Cubism, Surrealism, and Art Deco.

With the advent of War World II, many of these artists would be forced to emigrate to the United States. Their influence was profound. Just as Japan had influenced the Europeans fifty years earlier, thus America was impacted by Europe. Lester Beall was one of the first American designers whose work showed strong evidence of this inspiration. Paul Rand and Alvin Lustig's designs, in part, explored the amorphous forms of European painters Paul Klee and Juan Miro.

In 1954, a group of Cooper Union graduates banded together to form Push Pin Studios. Well-versed in design and illustration history, they drew upon existing forms, such as Art Nouveau and Art Deco, to create new ones. By combining illustration and design seamlessly, they ushered in a new era, in contrast to the stark Modernist movement that had gone before. Their reexamination of the Art Nouveau style moved west in the late 1960s, combined with the cultural and musical changes at the time, and reappeared in the form of Psychedelic posters by the likes of Rick Griffin and Victor Moscoso.

In the mid 1970s and early 1980s, the retro approach reached its zenith. The European type styling of Louis Fili, Jennifer Morla and Carin Goldberg, and Constructivist type design of Neville Brody revisited and reinvigorated existing forms.

In 1984, Apple Computers released the first Macintosh, and the relationship between technology and design moved forward yet another step. Designers such as April Greiman and later David Carson took up the call. A myriad of new typefaces were displayed in *Emigre* magazine. Design, type setting, and production were fused for the first time. In reaction, hand-lettered typography was suddenly manifest.

Today, we are still reeling from the effects of the personal computer. Designers, perhaps more than ever before, can be the complete masters of their domain, responsible for every aspect of what winds up on the page or digital display. The timeline continues. Where are we headed? Only the future will tell.

Historical Image Timeline (1893–present)

THIS BRIEF HISTORICAL OVERVIEW of visual communication in the twentieth century is in no way meant to be a substitute for a full study; my offering does not include, as any full history would, the influences of current events, social climate and issues, inventions, politics, music, and art on the topic of visual communication. For example, the social and political climate of World War II had a profound influence on European and American artists' and designers' lives and work.

A full study of graphic design history would be advantageous to any reader, as is Philip B. Meggs's important volume *A History of Graphic Design*. As history is not the subject of this book, the goal of this brief visual timeline is to put the theories and methodologies in this book into a broader context.

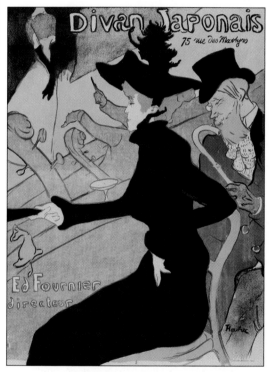

Poster: Henri de Toulouse-Lautrec (1864–1901), *Divan Japonais (Japanese Settee)*, 1893.
Lithograph, printed in color, composition: 31 5/8" x 23 7/8". Abby Aldrich Rockefeller Fund (97.1949).
Collection: The Museum of Modern Art, New York, NY, U.S.A.
Digital Image © The Museum of Modern Art/Licensed by SCALA/Art Resource, NY

Although primarily a painter (and printmaker), French artist Toulouse-Lautrec's embrace of the poster would drive the medium into popularity; he created a total of thirty-two posters.

"The Japanese influence is applied to Parisian nightlife."

—Steven Brower

1890s

THE PROPONENTS of the Arts & Crafts movement continued to disseminate information about design. Moving toward the twentieth century, European art was deeply affected by an influx of Japanese prints. In turn, American artists and designers were influenced by European trends and movements. The Art Nouveau movement, with its flowing organic-like forms, was felt in all the visual arts, from design through architecture. In both Europe and America, there were advances in printing technology by the late nineteenth century; in France, color lithography significantly advanced by Jules Cheret allowed for great color and nuance in poster reproduction. Advances in lithography helped give rise to the poster as a visual communication vehicle. Toulouse-Lautrec embraced the poster. Companies hired Art Nouveau artists, such as Alphonse Mucha, to create posters to advertise their products.

In 1898, an American advertising agency, N. W. Ayer & Son, opened a design department to "design" their own ads. An American woman, Ethel Reed, became a noted graphic designer and illustrator. William H. Bradley, an important American designer influenced by the British Arts & Crafts movement and Art Nouveau, designed a series of covers for *The Chap Book*, which became an important disseminator of style.

1870s through the **1890s**—Arts & Crafts movement

1890—Art Nouveau movement begins

1891—*La Goulue* Toulouse-Lautrec's first poster

1893—Coca-Cola is registered as a trademark

1897—Vienna Secession is formed

1898—Advertising agency N. W. Ayer created the slogan, "Lest you forget, we say it yet, Uneeda Biscuit," to launch the first prepackaged biscuit, Uneeda, produced by the National Biscuit Co. (today, a company called Nabisco).

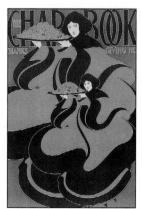

Literary periodical: William H. Bradley (1868–1962), published by Stone & Kimball (Chicago), *The Chap Book* (Thanksgiving), 1895.
Color Lithograph, 528 x 352 mm.
The Baltimore Museum of Art: Gift of Alfred and Dana Himmelrich, Baltimore (BMA 1993.89).

Bradley, influenced by the Art Nouveau style, introduced an American audience to a new vocabulary of forms.

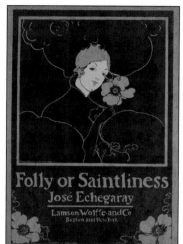

Poster: Ethel Reed (1876–ca.1910), *Folly or Saintliness*, 1895.
Heliotype on paper, 20 1/4" x 14 7/8".
Collection: Smithsonian American Art Museum, Washington, D.C., U.S.A.
Photo credit: Smithsonian American Art Museum, Washington, D.C./ Art Resource, NY

Working in the 1890s, Ethel Reed was one of few women illustrators and designers who gained recognition in her lifetime. Reed designed and illustrated posters, illustrated books, and designed covers and endpapers.

1900s

AT THE BEGINNING of the twentieth century, milestones in graphic design history occurred. Principles of grid composition were taught in Germany, and we saw the birth of pictorial modernism.

In graphic design, the watershed work of architect/designer Peter Behrens exemplifies the relationship between design and industry. Behrens sought a 'modern' visual language to express the age of mass production. In 1907, Peter Behrens designed what might be thought of as the first corporate identity for A.E.G., a German electrical manufacturing corporation.

Very importantly, in 1919, Walter Gropius founded the Weimar Bauhaus in Germany. This highly influential design school, whose philosophy laid the foundation for much of modern thinking about architecture and design, attempted to bridge art and industry with an emphasis on rationality.

In fine art, this time period was enormously creative. Two groups of German painters formed art philosophies: *Die Brücke* (The Bridge) with Ernst Ludwig Kirchner as a leading proponent, and *Der Blaue Reiter* (The Blue Rider) with Russian artist Wassily Kandinsky as a leading member. Kandinsky is credited with the first nonobjective painting and was a great influence on modern art. In France, major artists Henri Matisse and Pablo Picasso (born in Spain) created rippling, everlasting effects in all the visual arts.

A very noteworthy influence (still to this day) on typography was the Italian Futurists' challenge to grammatical and typographic conventions; they saw typography as a way to "redouble the force of expressive words." Similarly, Dadaists used type and image as expressive visual elements. Concerned with neither legibility nor function, but only with expressive form, artists such as Kurt Schwitters in his *Merz* magazine used the idea of "randomness" as a guiding principle.

1901–1905—Picasso's "Blue" period

1905—Lucien Bernhard designs the Priester Match poster

1905—Salon d'Automne, Paris, is an important French art exhibit

1907—Peter Behrens's corporate identity for A.E.G.

1909–1914—Pablo Picasso and George Braque and the period of "Analytical Cubism"

1909—Futurist Manifesto proclaims enthusiasm for speed, war, and the machine age

1910–1914—*Die Brücke* (The Bridge) flourishes in Berlin

1910—Kandinsky and *Der Blaue Reiter* (The Blue Rider)

1910—Analytical Cubism

1913—Synthetic Cubism

1916—The Dada movement is founded

1919–1933—Bauhaus; founded in Weimar in 1919, under the direction of architect Walter Gropius. Staff included Paul Klee, Johannes Itten, Wassily Kandinsky, Laszlo Moholy-Nagy.

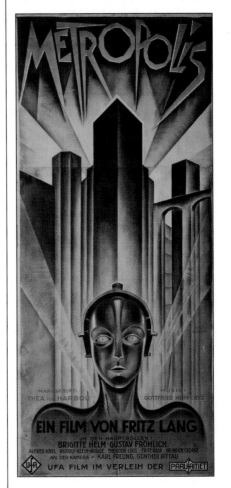

Film poster: Heinz Schulz-Neudamm (20th CE), *Metropolis*, 1926. Lithograph, printed in color, 83" X 36 1/2" Gift of Universum-Film Aktiengesellschaft (80.1961) The Museum of Modern Art, New York, NY, U.S.A. Digital Image © The Museum of Modern Art, Licensed by SCALA/Art Resource, NY

"Art Deco meets Cubism and the sci-fi film poster is invented."

—Steven Brower

1920s

FINE ART MOVEMENTS—Cubism, Futurism, De Stijl, Constructivism, Dada, Surrealism—greatly affected design and advertising. Picasso's work continued to have a powerful effect on the visual arts. The popular geometric style of the 1920s was Art Deco and was significantly manifested in all the visual arts.

Many graphic designers absorbed these artistic movements, creating a popular visual aesthetic. For example, A. M. Cassandre, who was a renowned poster designer, created a visual language clearly influenced by Cubism, and brought it to the greater public via poster design. His success in both typeface design and poster design established him as a purveyor of style.

In 1921, a group of Russian artists led by Constructivists Vladimir Tatlin and Alexander Rodchenko rejected "art for art's sake," to pursue the duty of artist as citizen. They viewed visual communication, industrial design, and the applied arts as mediums that could best serve their ideals and ideas for society.

Also greatly influenced by the Cubism, Futurism, and Art Deco movements, American graphic designer E. McKnight Kauffer created a body of work, including 141 posters for the London Underground, as well as others for major corporations, that would carry fine art forms to the general viewing public. American advertising reflected designers' great interest in Modernism and European art ideas, as well; for example, the work of Charles Coiner for the N. W. Ayer agency reflected an avant-garde influence. In an attempt to visually express their dynamic modern age, both artists and designers are highly concerned with the relationship between form and function.

1922—Aleksei Gan's *Konstruktivizm*, brochure on Constructivist ideology

1922—E. McKnight Kauffer's poster for the London Underground

1922—Piet Mondrian's "Tableau 2"

1923—Herbert Bayer's cover design for Bauhaus catalog

1924—El Lissitzy's poster for the Pelikan Corporation

1924—Andre Breton's *Manifesto of Surrealism*

1924—Charles Coiner joins N. W. Ayer's art department

1926—Fritz Lang's film *Metropolis*

1927—Paul Renner designs Futura typeface

1927—A. M. Cassandre's railway poster

1928—Dr. Mehemed Fehmy Agha is made art director at *Vogue* magazine

1928—Jan Tschichold advocates new ideas about typography in his book *Die Neue Typographie*

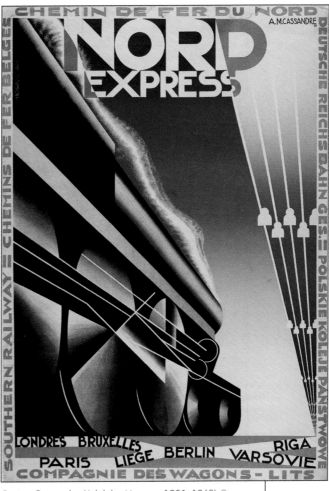

Poster: Cassandre (Adolphe Mouron, 1901–1968) © Copyright. *Nord Express*, 1927
Poster: The Museum of Modern Art, New York, NY
Gift of French National Railways
The Museum of Modern Art, New York, NY, U.S.A.
Digital Image © The Museum of Modern Art/Licensed by SCALA/Art Resource, NY

Cassandre was a founding partner of a Parisian advertising agency, the Alliance Graphique. The work produced by Cassandre and the Alliance Graphique established a French urbane modern visual vocabulary, utilizing Cassandre's typeface design.

"The romanticism of travel was about the journey, not the arrival."

—Steven Brower

1930s

AT THE END OF THE 1920S, the modern movement hit America. By the 1930s, designers such as Lester Beall, William Goldin, Alvin Lustig, Paul Rand, Bradbury Thompson, and émigrés Mehemed Fehmy Agha (Russian-born, immigrated to the U.S. in 1928), Alexey Brodovitch (Russian-born, immigrated in 1930), Will Burtin (German-born, immigrated in 1938), Leo Lionni (Dutch-born, immigrated in 1939), Herbert Matter (Swiss-born, moved to New York in 1936), and Sutnar Ladislav (Czech-born, traveled to U.S. in 1939 and stayed) were pioneering visual ideas in the United States. Boldly testing the limits of contemporary editorial design, experimental page layout, shape relationships, color, and photographic reproduction, these designers created visual masterpieces.

The 1930s was a tragic and turbulent time for artists and designers in Europe. Many fled the Nazis and immigrated to America, including esteemed Bauhaus members Mies van der Rohe, Josef Albers, Laszlo Moholy-Nagy, and Walter Gropius. Their subsequent presence in America would have a profound influence on design, architecture, and art. Many American-born designers also became important design pioneers, including Lester Beall. Lester Beall's convincing posters for America's Rural Electrification Administration have his distinctive imprint, and yet are influenced by European modernism.

A seminal American designer, Paul Rand, started his distinguished career in 1935 as the art director of *Esquire* and *Apparel Arts* magazines; he also designed covers for *Direction*, a cultural journal, from 1938 until 1945. Rand's influence holds to this day. What should be noted is that although Rand was greatly influenced by the European avant-garde thinkers and designers, he established his own indelible point of view and visual vocabulary.

1934—Herbert Matter designs Swiss travel posters

1934—Alexey Brodovitch is art director at *Harper's Bazaar*

1935—WPA hires designers to work for the project

1937—Lester Beall designs *Rural Electrification Administration* poster

1937—Picasso's *Guernica* painting about the devastation of the Spanish Civil War

1939—Bradbury Thompson designs first Westvaco *Inspirations for Printers*

1939—Leo Lionni becomes art director at N. W. Ayer

Poster: Jan Tschichold, *Konstruktivisten* (Constructivists), 1937
Poster: The Museum of Modern Art, New York, NY Abby Aldrich Rockefeller Fund, Jan Tschichold Collection, The Museum of Modern Art, New York, NY Digital Image © The Museum of Modern Art/ Licensed by SCALA/Art Resource, NY

"The Constructivist influence is apparent."

—Steven Brower

Magazine spread: *Harper's Bazaar*, March 15, 1938
Art director: Alexey Brodovitch
Photographer: Hoyingen-Huene, Courtesy of *Harper's Bazaar*, New York, NY
Photograph courtesy of the Walker Art Center, Minneapolis, MN

"Form follows form."

—Steven Brower

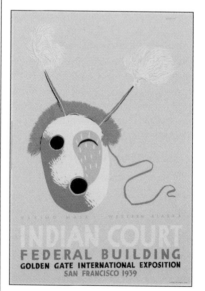

Poster: Siegriest, Louis (1899–1990), *Eskimo Mask, Western Alaska*. 1939
Serigraph on paper, 36 1/8" x 25 1/4". Gift of Ralph H. Hines.
Collection: Smithsonian American Art Museum, Washington, D.C.
Photo credit: Smithsonian American Art Museum, Washington, D.C., Art Resource, NY

This poster is part of the eight-piece series "Indian Court" by Siegriest, part of the Works Projects Administration (WPA) posters for the Golden Gate International Exposition held in San Francisco in 1939. Using materials provided by the Bureau of Indian Affairs, Siegriest chose visuals to represent various tribal nations.

1940s

IN 1939, World War II began. Many artists and designers were called into active duty; others, including Ben Shahn, E. McKnight Kauffer, Joseph Binder, and Abram Games, used their great talents to create posters to disseminate public information, support the war effort, pump up morale, and create anti-Nazi vehicles. In England, The British Ministry of Information recruited available preeminent designers to this cause.

At this time, many designers were embracing Surrealism and making it their own visual language, using photomontage and bold typography to create stirring war posters. One such designer was German graphic artist John Heartfield, whose strong antiwar work satirized the Nazi party.

What would eventually become The Advertising Council, a public service advertising organization, began in 1942 as the War Advertising Council; it was organized to help prepare voluntary advertising campaigns for wartime efforts.

In Italy, the Olivetti Corporation hired Giovanni Pintori, who contributed enormously to Italian design. Pintori's vision, drawing on Futurist visual forms, manifested itself in corporate identity design and advertising.

In the United States during the 1940s and 1950s, Abstract Expressionism was the primary artistic movement (overshadowing any representational artists), with leading artists such as Jackson Pollack, Willem de Kooning, Franz Kline, and Mark Rothko. In the post–World War II years, New York City became the art capital of the world.

1940s—Paul Rand designs *Directions* covers

1946—Lou Dorfsman joins CBS

1947—Armin Hofmann begins teaching graphic design at the Basel School of Design

1947—Giovanni Pintori is hired by Olivetti

1949—Doyle Dane Bernbach opens

1949—Cipe Pineles's cover for *Seventeen*

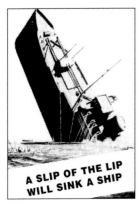

Advertisement: Security of War Information, *Loose Lips Sink Ships* (1942–1945)
Sponsors: The Office of War Information, U.S. Army, U.S. Navy, and the Federal Bureau of Investigation

"The campaign encouraged Americans to be discreet in their communication to prevent information from being leaked to the enemy during World War II."

—The Advertising Council

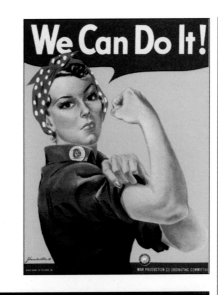

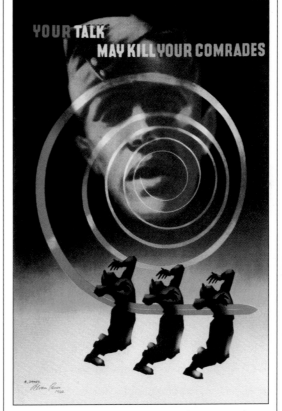

Poster: Abram Games, *Your Talk May Kill Your Comrades*, 1942 © Estate of Abram Games
Poster: Abram Games, *Salute the Soldier (Save More, Lend More)* 1944 © Estate of Abram Games

Abram Games, known for his powerful wartime posters, used the potential of the poster-as-vehicle to visually communicate public information fully and quickly in a boldly poetic way. Games's personal conceptual design viewpoint was "maximum meaning, minimum means."

Advertisement: Women in War Jobs—*Rosie the Riveter* (1942–1945)
Sponsors: Office of War Information, War Manpower Commission
Volunteer Agency: J. Walter Thompson

"The most successful advertising recruitment campaign in American history, this powerful symbol recruited two million women into the workforce to support the war economy. The underlying theme was that the social change required to bring women into the workforce was a patriotic responsibility for women and employers. Those ads made a tremendous change in the relationship between women and the workplace. Employment outside of the home became socially acceptable and even desirable."

—The Advertising Council

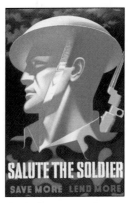

"Design goes to war."

—Steven Brower

1950s

THE INTERNATIONAL TYPOGRAPHIC STYLE, or Swiss design, played a pivotal role in design with an emphasis on clear communication and grid construction, with Max Bill and Ernst Keller as major proponents. In 1959, the movement became a unified international one, disseminating ideas in a journal, *New Graphic Design;* the editors included Josef Muller-Brockmann, Richard P. Lohse, Carlo L. Vivarelli, and Hans Neuburg.

In America, seminal designers such as Paul Rand, William Goldin, Lou Dorfsman, Saul Bass, Bradbury Thompson, George Tscherny, Ivan Chermayeff, Tom Geismar, Cipe Pineless, Otto Storch, and Henry Wolf created watershed work. Saul Bass's movie titles and film promotions set new standards for motion graphics and promotional design.

Doyle Dane Bernbach (DDB) rocked the advertising world with their Volkswagen campaign and began a creative revolution in advertising, with art directors such as Bob Gage, Bill Taupin, and Helmut Krone. Bernbach teamed art directors and copywriters to generate creative ideas to drive their advertising. DDB didn't use a hard sell—it set a new standard that winked at the consumer with greater respect.

Visual identity became gospel at corporations with in-house designers such as William Goldin and Lou Dorfsman at CBS, and Giovanni Pintori at Olivetti. Corporations began to rely on designers to create visual identities that would differentiate them within a competitive marketplace. Designers such as Paul Rand created visual identities for IBM, Westinghouse, and ABC.

Magazine spread:
Westvaco *Inspirations 192,*
1953
Designer: Bradbury Thompson, Copyright by Westvaco Corporation, New York, NY

"Seldom is there logic in using two different styles of typesetting in a design. But here, to provide symmetrical relationships to symmetrical graphics, the type is set in centered style on the left page, while on the right page the text type is set flush right and ragged left to accompany asymmetrical graphics."

—Karen M. Elder, manager, Public Relations, Westvaco Corporation

Bradbury Thompson is one of the great pioneers of American design who fully integrated European ideas of abstraction and modernity into American design, establishing his own voice while communicating effectively with resonance.

1949—Hermann Zapf designs Palatino typeface

1950—Jackson Pollack's *Autumn Rhythm*

1950—William Goldin designs the CBS symbol

1951—Roy Kuhlman designs Grove Press paperback covers

1952—Rudy deHarak opens his New York studio

1953—James K. Fogleman defines "corporate identity"

1954—Adrian Frutiger creates a family of twenty-one sans-serif fonts named Univers

1954—Push Pin Studios is formed

1955—Saul Bass designs *Man with the Golden Arm* film graphics

1950s—Henryk Tomaszewski creates *Cryk*

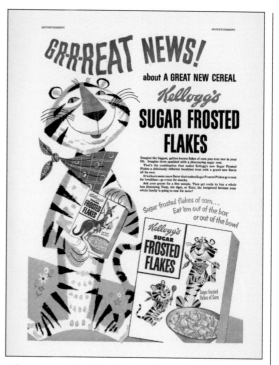

Advertisement: In 1952, Tony the Tiger™ was introduced as the spokestiger for Kellogg's Sugar Frosted Flakes®! cereal. As one of four original animated animals (the others being Katy the Kangaroo, Newt the Gnu, and Elmo the Elephant) created for the advertising campaign to introduce Kellogg's new cereal, Sugar Frosted Flakes, Tony became the sole icon for the brand. *Advertising Age* considers Tony the Tiger™ to be one of the top ten icons of the twentieth century. Originally illustrated by Martin Provinsen, a children's book illustrator, Tony the Tiger™ has gone through many changes over the decades. According to *Advertising Age:* "One thing that remained constant for much of Tony's life was his voice. Thurl Ravenscroft provided the sole voiceover for Tony and his trademark growl: 'They're Gr-r-reat®!'"

TONY THE TIGER™ is a trademark of Kellogg Company. All rights reserved. Used with permission.

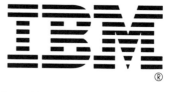

Logo: IBM, 1956
Designer: Paul Rand
Client: IBM Corporation

Paul Rand was among the first wave of American modernists who created iconic visual identities among many other famous solutions—from posters to children's books.

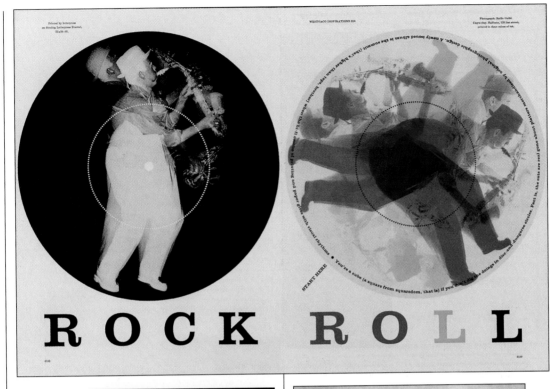

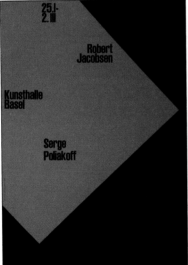

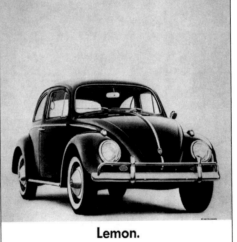

Interior spread: Westvaco *Inspirations 210,* 1958
Designer: Bradbury Thompson
Copyright by Westvaco Corporation, New York, NY

"This graphic design puts forth the illusion of color in motion as the saxophonist comes alive on the whirling record. Process printing plates were not employed, as just one halftone plate was printed in three process inks and on three different angles to avoid a moire pattern."

—Karen M. Elder, manager, Public Relations, Westvaco Corporation

Exhibition poster: Armin Hofmann, *Robert Jacobsen & Serge Poliakoff,* 1958
Collection: The Museum of Modern Art, New York, NY, Gift of the designer. Digital Image © The Museum of Modern Art, Licensed by SCALA/Art Resource, NY

Hofmann's modernist viewpoint and aesthetic was infused with a profound understanding of form and elements. Hofmann's book *Graphic Design Manual,* which explained his graphic design aesthetic and philosophy, was first published in 1965.

Advertisement: "Lemon," 1959
Agency: Doyle Dane Bernbach, New York, NY
Client: Volkswagen

This gutsy ad winks at its audience, as did most of DDB's advertising. Doyle Dane Bernbach and its legendary founder Bill Bernbach are credited with the creative revolution in advertising.

1960s

CORPORATE IDENTITY DESIGN grows in importance with work by Lester Beall for International Paper Company, and design firms such as Chermayeff & Geismar creating programs for Mobil and the Chase Manhattan Bank; Saul Bass for AT&T, Continental Airlines, and the Girl Scouts; and Massimo Vignelli and the Unimark office for Knoll.

In advertising, Doyle Dane Bernbach (DDB) continued to be the force behind creative advertising. Employed at DDB were some of the most brilliantly creative art directors and writers of the twentieth century, such as Bob Gage, Helmut Krone, George Lois, Mary Wells Lawrence, Phyllis K. Robinson, and Julian Koenig. Some of these creatives, such as George Lois, Julian Koenig and Mary Wells Lawrence, left DDB to open their own creative agencies.

American graphic designers, including the Push Pin Studios, Saul Bass, and Herb Lubalin, redefined American graphic design—especially typography and the relationship of type with image—thereby influencing generations.

The poster was an extremely popular application in the 1960s, with great work from Gunter Rambow in Germany, Wes Wilson in California, and Victor Moscoso in California. George Lois's covers for *Esquire* magazine raised the bar of cover design, provoking and jarring readers to stop and think.

Representational art made a comeback with the Pop Art movement—a movement drawing upon imagery from popular culture—with leading artists Andy Warhol, Roy Lichtenstein, and Robert Indiana. The Pop movement (influenced by commercial art), ironically, was clearly felt in graphic design and challenged the conventions of Modernist thinking. Push Pin Studios in New York and the Haight Ashbury music scene designers in San Francisco rocked Modernism's structural boat. Wolfgang Weingart was at the forefront of those slowly challenging Modernism's core.

1960—John Berg becomes art director at CBS records

1960—Lester Beall designs International Paper logo

1961—Edouard Hoffman and Max Miedinger design Helvetica typeface

1962—Herb Lubalin designs *Eros* magazine

1962—Carl Ally opens Ally & Gargano

1963—"The Pepsi Generation" ad

1964—*First Things First* manifesto signed by twenty-two signatories

1965—Andy Warhol's *Campbell's Soup*

1967—Jay Chiat opens Chiat/Day

1968—Herb Lubalin designs *Avante Garde* magazine

1969—George Lois's composited *Esquire* cover of Andy Warhol drowning in an oversized can of Campbell's soup

Poster: Muller-Brockman, Josef (b. 1914). *Weniger Lärm (Less Noise)*, 1960 Offset Lithograph, Printed in color, 50 1/4" x 35 1/2". Acquired by exchange (513.1983).
The Museum of Modern Art, New York, NY
The Museum of Modern Art, New York, NY, U.S.A.
Digital Image © The Museum of Modern Art/Licensed by SCALA/Art Resource, NY

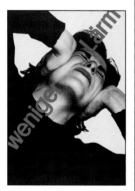

Muller-Brockman, in Zurich, was a leading designer in the International Typographic Style. He sought to communicate to the audience without the interference of the designer's subjectivity.

This solution reminds us to never underestimate the power of a great visual mime to communicate a message.

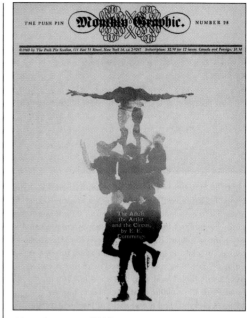

Magazine cover: 1960
Credit: Milton Glaser, Push Pin Studios

Push Pin Studios, co-founded by Milton Glaser, Seymour Chwast, Reynold Ruffins, and Edward Sorel, ushered in a new era. The studio's influence radiated. Any lines of distinction among design, illustration, and art became blurred—these designers and illustrators were auteurs.

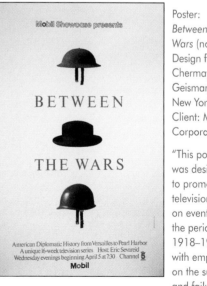

Poster: *Between the Wars* (no date) Design firm: Chermayeff & Geismar, Inc., New York, NY Client: Mobil Corporation

"This poster was designed to promote a television series on events during the period 1918–1940, with emphasis on the successes and failures of diplomacy. The hats symbolize the two wars, and the diplomacy between them."

—Tom Geismar, Chermayeff & Geismar Inc.

"A complex theme is communicated effortlessly through headgear."

—Steven Brower

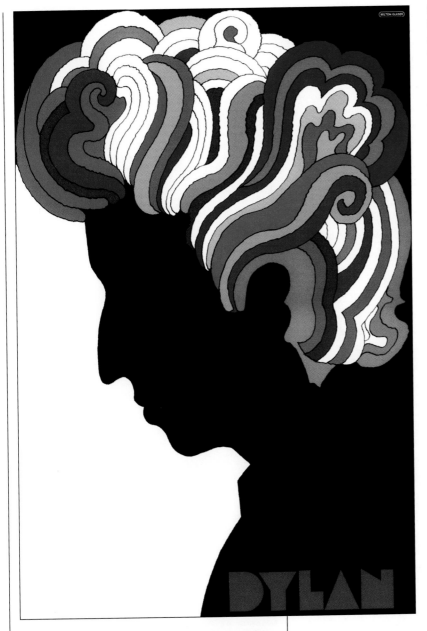

Poster (enclosed in a Bob
Dylan record album):
Dylan, Milton Glaser, 1967
Credit: Milton Glaser

"Islamic art meets Marcel
Duchamp at the dawn of
the psychedelic era."

—Steven Brower

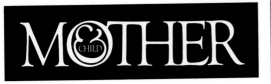

Logo: "Mother & Child," 1967
Designer: Herb Lubalin, The Design Collection at the Herb
Lubalin Study Center, The Cooper Union, New York, NY
Courtesy of the Lubalin Family

In the 1960s, Lubalin's unique ability to creatively combine
type and image influenced a wide audience, from the
United States to Western and Eastern Europe. This is a
quintessential example of Lubalin's thinking: finding the
solution inside the problem.

1970s

SOME CRITICS SEE THE 1970S as the end of Modernism and the beginning of Postmodernism thinking, especially with the typographic directions taken by designers such as Wolfgang Weingart, April Greiman, Willi Kunz, and Dan Friedman leading the way.

In the 1970s, it became perfectly clear to clients and corporations that it was design and advertising that was going to distinguish their goods and services in a highly competitive international marketplace.

Some designers saw the Modernist style as corporate and reacted with alternative creative thinking. The subversive posters emanating from the French design collective Grapus created an independent design point of view. In California, April Greiman was experimenting with type, hybrid imagery, and mixing media to create a whole new visual vocabulary.

Clearly, there was a growing response to the perceived "objectivity" of Modernism, with highly individual, personal aesthetics growing around the world.

1970—Grapus Studio, a French design collective, is formed by Pierre Bernard, Francois Miehe, and Gerard Paris-Clavel

1970—Raymond Loewy designs the U.S. Mail eagle symbol

1970—Shigeo Fukuda designs graphics for Expo 70

1971—Saul Bass designs the United Way logo

1974—Paula Scher designs covers for CBS records

1975—Milton Glaser designs the "I LOVE NY" symbol

1978—Louise Fili becomes art director of Pantheon Books

1978—Pentagram opens their New York office

1979—M&Co founded by Tibor Kalman with Carol Boku-niewicz and Liz Trovato

Symbol signs: AIGA, 1973
A complete set of fifty passenger/pedestrian symbols developed by AIGA.
AIGA Signs and Symbols Committee members:
Thomas Geismar, Seymour Chwast, Rudolph de Harak, John Lees, and Massimo Vignelli
Production designers:
Roger Cook and Don Shanosky;
Page, Arbitrio and Resen, Ltd.
Project coordinators:
Don Moyer, Karen Moyer, Mark Ackley, and Juanita Dugdale

In 1973, the United States Department of Transportation (DOT) commissioned the American Institute of Graphic Arts (AIGA), which formed a committee of five outstanding designers, to create a set of passenger and pedestrian symbol/signs for use in DOT public spaces.

These symbol signs represent a consistent use of visual language that defies language barriers. The final set of symbol/signs was designed and created by Cook and Shanosky.

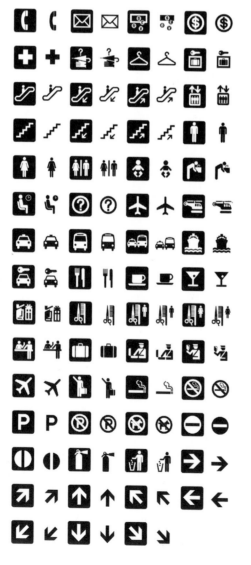

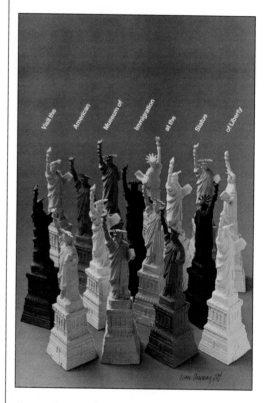

Poster: Chermayeff, Ivan (1932)
Visit the American Museum of Immigration at the Statue of Liberty, 1974
Offset Lithograph on paper, 42 1/8" X 28".
Smithsonian American Art Museum, Washington, D.C., U.S.A.
Photo credit: Smithsonian American Art Museum, Washington, D.C./Art Resource, NY

Ivan Chermayeff (Chermayeff and Geismar) multiplies the Statue of Liberty to creatively express the idea of immigration. Chermayeff and Geismar set a standard for corporate communications.

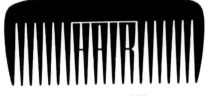

Logo: Mr. and Mrs. Aubrey Hair, 1975
Designer: Woody Pirtle

Pirtle originally worked for The Richards Group in Dallas and took his Texan sensibility and conceptual sharpness to the New York office of Pentagram.

Wit, in this case a pun, combines with an American Postmodern sensibility in Pirtle's trademark for Aubrey Hair.

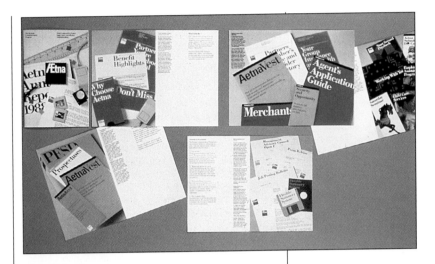

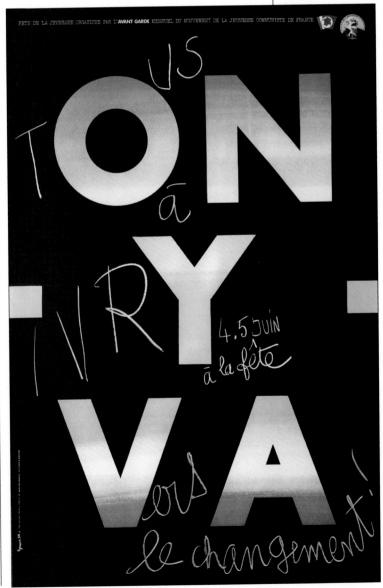

Corporate Identity (no date)
Design firm: Vignelli Associates, New York, NY
Designers: Massimo Vignelli and Michael Bierut
Client: Aetna Life and Casualty, Hartford, CT

In 1971, Massimo and Lella Vignelli founded Vignelli Associates in New York and had a profound voice in corporate communications with an emphasis on rationality and clear communication.

Poster: Grapus, On Y Va
(Let's Go), 1977
The Museum of Modern Art, New York, NY
Gift of the designer.
The Museum of Modern Art, New York, NY, U.S.A.
Digital Image © The Museum of Modern Art/Licensed by SCALA/Art Resource, NY

The French design collective Grapus and their distinctive combinations of type and image—part of the European New Wave—made a significant and lasting contribution to modern design.

1980s

IN 1984, APPLE COMPUTER introduced the Macintosh computer, which provided graphic designers with the most significant tool since the pencil.

The digital revolution enabled designers to have more creative control. Visual communicators could design and lay out their own type (thus becoming their own compositors), more easily manipulate imagery (as opposed to using hand-crafted photomontage), imitate visual effects such as airbrushing, very easily make changes to layout and color, generate type without a typesetter, and substitute hand-lettered comps with digitally produced "finished-looking" comps, among other things.

Termed the Postmodern (or Late Modernist) period, the 1980s and 1990s was an eclectic and diverse time as designers experimented with new technology, trying to capture an ever-growing audience with break-through concepts and graphics. The political and social climate of the 1980s provided a fertile environment for provocatively creative designers and thinkers such as Tibor Kalman, founder of M&Co.

In California, Rudy VanderLans (trained in the Netherlands) and Zuzana Licko (born in Czecho-slovakia) collaborated to create experimental typography in *Emigre*, a progressive periodical that contributed to disrupting typographic conventions. David Carson designed *Beach Culture* magazine, and his typographic methodology would eventually divide designers into "camp" divisions about typographic design philosophy. Similarly, in England, Neville Brody was challenging both editorial design and conventional typographic design with his own typeface designs and in his capacity as art director of *Face* magazine.

Also in England, advertising agency Bartle Bogle Hegarty (BBH) created sexy campaigns for Levi's® and Häagen-Dazs™ using erotic imagery. In New York, George Lois's ad campaign concept "I want my MTV" transformed entertainment. Chiat/Day created one of the great moments in TV advertising with its "1984" spot for Apple's Macintosh. Advertising agencies outside of the usual ad hubs made indelible marks, making cities such as Minneapolis and Dallas the homes of creative advertising.

1981—MTV logo (art director: Fred Seibert; designers: Frank Olinsky, Pat Gorman, and Patti Rogof, Manhattan Design)

1982—George Lois's "I want my MTV"

1983—R/Greenberg Associates film title sequence for *The Dead Zone*

1984—Apple's Macintosh TV spot "1984" by Chiat/Day Agency; directed by Ridley Scott

1984—*Rolling Stone* "Perception/Reality" campaign by Fallon McElligott and Rice, Minneapolis, MN

1985—Bartle Bogle Hegarty (BBH), London, revitalizes the Levi's® brand

1986—Neville Brody designs Typeface Six for *Face* magazine

1988—Motel 6 "We'll Leave a Light on for You," The Richards Group, Dallas

1988—David Carson designs *Beach Culture* magazine

1989—Jonathan Hoefler and Tobias Frere-Jones create The Hoefler Type Foundry

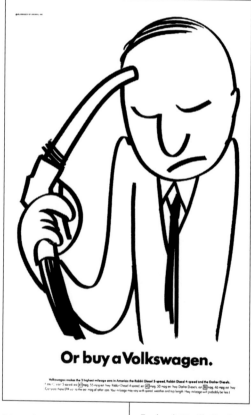

Print advertisement: *Or buy a Volkswagen*, 1980
Agency: Doyle Dane Bernbach, New York, NY
Art director/Artist: Charles Piccirillo
Writer: Robert Levenson
Client: Volkswagen

Doyle Dane Bernbach continued to set standards for creative advertising well after the 1960s.

Poster: Seitaro Kuroda, *Seibu*, 1981.
Poster for an exhibition at a department store.
The Museum of Modern Art, New York, NY, U.S.A.
Gift of the designer.
Digital Image © The Museum of Modern Art/Licensed by SCALA/Art Resource, NY

An influential Japanese graphic designer and illustrator, Kuroda's posters are held in museum collections. Kuroda's distinctive sensibility has influenced generations of Japanese, European, and American designers.

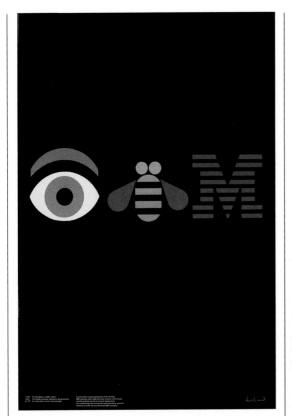

Poster: Paul Rand, *IBM*, 1982
The Museum of Modern Art, New York, NY
Gift of the designer
The Museum of Modern Art, New York, NY, U.S.A.
Digital Image © The Museum of Modern Art/Licensed by
SCALA/Art Resource, NY

Utilizing his own logo design for IBM, Rand made the famous logo even more elastic, using visual replacements for two of IBM's initials for this poster design. As it states on the poster, "An eye for perception, insight, vision; a bee for industriousness, dedication, perseverance; and an 'M' for motivation, merit, moral strength," represent the spirit of the corporation.

Exhibition poster: *The Modern Poster*, 1988
Designer: April Greiman, Los Angeles, CA
Client: The Museum of Modern Art, New York, NY

"This was an invited competition to design the poster for an exhibition on 'The Modern Poster.' We won!

The poster is a true 'hybrid image.' It utilizes state-of-the-art technology and is a composition of still video, live video, Macintosh computer art, traditional hand skills, typography, and airbrush.

The rectangular gradation represents time and evolution as graphic media have evolved from photomechanical means to the dynamic moving poster of TV (the video rectangles that are seen in perspective)."

—April Greiman

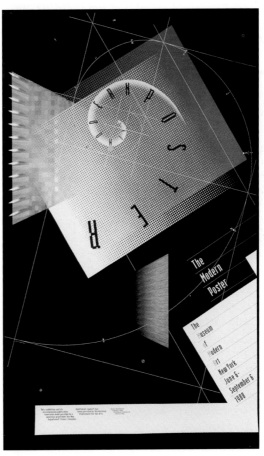

A west coast American designer, Greiman (who studied in Basel) was one of the first designers to use the Macintosh computer and Apple software to her distinct advantage, creating hybrid imagery. Her unique way of utilizing technology, handling type, creating the illusion of space, and playing with it makes her work watershed.

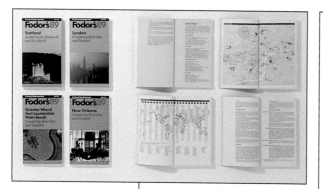

Books: Travel Guides, 1989
Design firm: Vignelli Associates,
New York, NY
Designer: Massimo Vignelli
Client: Fodor's Travel Guides

Vignelli Associates became
synonymous with classical typefaces,
the grid, and articulate design.

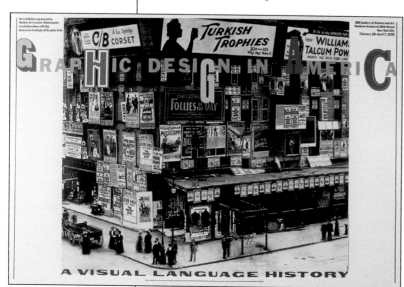

Exhibition poster: *Graphic Design In America*, (no date)
Designer: Seymour Chwast
Design firm: The Push Pin Studios, New York, NY
Client: IBM Gallery, New York, NY

"This poster, for an exhibit of all aspects of American
graphic design, had to be developed without my
expressing any specific design idiom. The image also had
to be neutral. My design has a little bit of everything and
no style in particular."

—Seymour Chwast, The Push Pin Studios

Chwast, co-founder of Push Pin Studios, is a
designer/illustrator/sculptor/artist who is able to imprint
his visual communication solutions with a personal
vision. His style, always identifiable, enhances each
solution's communication.

Magazine spread: *Emigre No.19*,
"Starting From Zero," 1991
Designer/Publisher: Rudy VanderLans
Typeface designer: Barry Deck

"Ever since I started conducting my own interviews,
I have been intrigued with the idea of how to re-create
the actual atmosphere or mood of a conversation. Usually,
as a graphic designer, you receive a generic-looking,
typewritten transcript, written by someone else, that you
lay out and give shape to. Before I start the layout of an
interview, I have spent hours transcribing the tape, listening
to the nuances of the conversation, the excitement in
someone's voice, etc. Much of the expressive/illustrative
type solutions that I use in *Emigre* are a direct result of
trying to somehow visualize the experience of having a
conversation with someone. Although this approach is not
always successful (some readers are put off by the often
'complex-looking' texts), when it does work, and the
reader gets engaged in deciphering and decoding the
typographic nuances, the interview inevitably becomes
more memorable."

—Rudy VanderLans, *Emigre*

VanderLans and Zuzana Licko launched *Emigre*, their
graphic magazine, in 1982. In *Emigre*, they established an
experimental approach to combining new technology with
typographic design that rocked the design world.

1990s

AS THE CENTURY CAME TO A CLOSE, the technological boom continued to deeply affect all the visual arts. In 1990, Adobe released its *Photoshop* digital imaging software, providing a tool that enabled individual designers to manipulate imagery effectively, inexpensively, and rapidly. The Web became a home to every brand worldwide, as well as set new design challenges. Designers were forced to work closely with IT professionals to launch their visual designs. Design and technology were at aesthetic crossroads that were reconciled in various ways with interesting effects on popular visual culture.

Not only did technology become a star, design itself now received new respect in museums and in media coverage. Hot debates on consumerism, typographic design form/function questions, and "green issues" were arguments that became known even outside the design community. Besides creating design to earn a living, some designers were tackling social and political issues with their independently conceived, created, and produced posters.

Irony became king in advertising and in much of graphic design—a truly pervasive postmodern approach to all visual communication. Unusual combinations of form and color juxtapositions marked the work of many. Historical stylistic references allowed visual communicators to hold fast to the end of the century.

Corporations continued to count on branding and visual communication to distinguish their brands across borders. No longer belonging to the marginalized artist, Postmodernism was co-opted by major brands seeking to align themselves with hipsters and to be perceived as trendsetters.

1990—Fabien Baron redesigns *Interview* magazine

1991—Paula Scher joins Pentagram, New York

1993—David Carson designs *Ray Gun* magazine

1993—Sagmeister Inc. is founded by Stefan Sagmeister in New York

1994—"Got Milk?" ad campaign by Goodby, Silverstein & Partners, San Francisco, for the California Fluid Milk Processor Advisory Board

1995—Razorfish web design studio is founded

1996—"Mixing Messages: Graphic Design in Contemporary Culture" at the Cooper-Hewitt National Design Museum

2000—Steven Brower redesigns *Print* magazine

2000—*Emigre* magazine (and other magazines) publishes *First Things First* manifesto

Visual identity: Public Theater, 1994–96
Designer: Paula Scher
Design firm: Pentagram, New York, NY

Starting out by designing album covers at CBS records, Scher moved onward and upward to become a highly esteemed designer and partner at Pentagram, whose work is revered and often imitated. In her recent book, *Make It Bigger*, Scher describes her brilliant career, and talks about working with clients and her design philosophy.

"The energy of the city is reflected in the graphics for the theatre."

—Steven Brower

Book jacket: *Sylvia* by Howard Fast, 1992
Designer: Steven Brower

"The themes of hidden identity and censorship are combined in a single image, conveying not only the content of the book, but its history as well: the author, blacklisted during the McCarthy era, was forced to publish under a pseudonym. Here it appears under his name for the first time. The painting style is based on Mexican posters."

—Steven Brower

Now in his own design studio, most recently Steven Brower was the creative director for *Print* magazine. He has been an art director for *The New York Times*, *The Nation* magazine, and *Citadel Press*. Brower is able to give visual life to a creative idea and his work's spirit exemplifies American wit, reminiscent of writers such as Mark Twain.

Chantry, Art (1954). *Kustom Kulture*, 1994
Serigraph on paper, 33 1/2" X 22 3/8"
Photo credit: Smithsonian American Art Museum, Washington, D.C./ Art Resource, NY

Art Chantry, a seminal designer in the American Postmodernist movement, continues to create work that disarms and provokes. The power of Chantry's early punk flyers and work for *The Rocket* music magazine emanated from his immersion in the Seattle culture scene, his low-tech method of creating design, and his attitude about the nature of design. Working on low budgets, and utilizing and integrating found imagery and type, Chantry's two-dimensional graphic designs conjure the feeling of real time and full-sensory experiences.

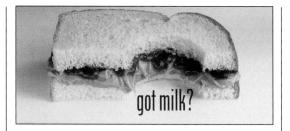

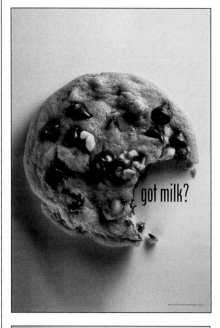

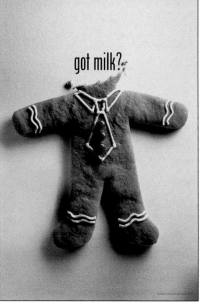

Advertising campaign: "Got Milk?" 1990s
Agency: Goodby, Silverstein & Partners, San Francisco, CA
Client: California Fluid Milk Processor Advisory Board

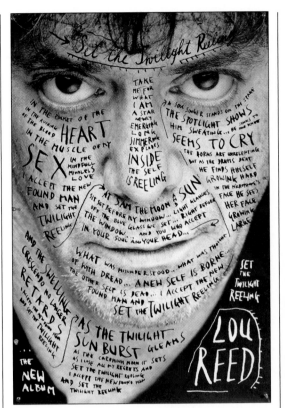

Poster: *Lou Reed*, 1996
Design studio: Sagmeister Inc., New York, NY
Art director/Designer: Stefan Sagmeister
Photography: Timothy Greenfield Sanders
Client: Warner Bros. Records, Inc.

"I went to a show in Soho given by Middle Eastern artist Shirin Neshat. She used Arabic type written on her hands and feet. It was very personal.

When I came back, I read Lou's lyrics for 'Trade In,' a very special song about his need to change."

—Stefan Sagmeister

Sagmeister emigrated from Austria, first working with Tibor Kalman, and then going on to become a highly respected member of the New York and international design world.

Poster: *The Radical Response*
Design firm: Morla Design, San Francisco, CA
Art director: Jennifer Morla
Designers: Jennifer Morla and Sharrie Brooks
Client: The Museum of Modern Art, San Francisco, CA

"The Radical Response was the focus of a lecture series given at the San Francisco Museum of Modern Art Design. The series investigated the qualities that make design radical, featuring four individuals whose approaches to design have transformed the context of the ordinary into the realm of the extraordinary. We created an image for the Design Lecture Series that aggressively portrays the title of the series."

—Morla Design

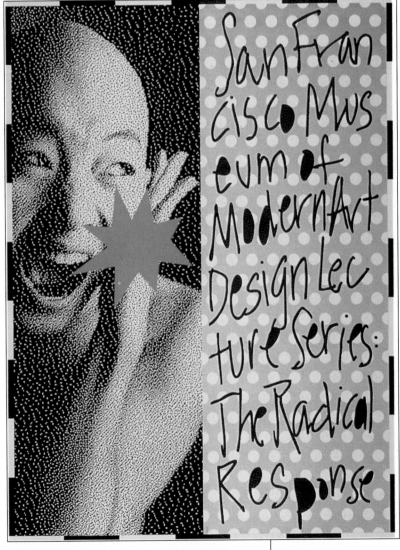

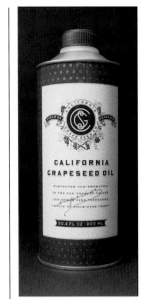

Packaging: California Grapeseed Oil
Design firm: Louise Fili Ltd., New York, NY
Art director/Designer: Louise Fili
Client: California Grapeseed Co.

Early in her career, Fili worked for Lubalin, and then was art director at Pantheon Books before she opened Louise Fili Ltd. Greatly influenced by French and Italian graphics and typography, Fili's work is unique and her sensibility her own.

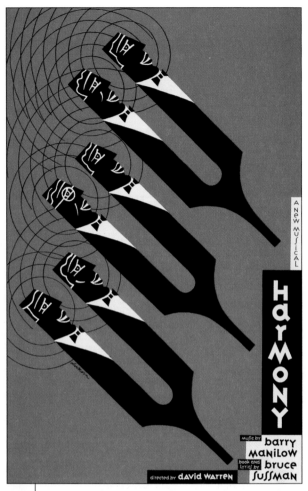

Portfolio of works: Jennifer Sterling Design
Design firm: Jennifer Sterling Design, San Francisco, CA
Art director/Designer: Jennifer Sterling

Poster: Broadway premiere of Barry Manilow's musical at the Harmony Theater
Design studio: Luba Lukova Studio, New York, NY
Designer/Illustrator: Luba Lukova

Born in Bulgaria, Lukova immigrated to the United States, and gave the visual communication world a fresh style with her seamless combination of design, illustration, and lettering. Lukova's consistently luminous design solutions are a testimony to design as art.

2000–Present

THE CONVERGENCE OF TECHNOLOGY in the visual arts industry has helped redefine what graphic design is, but not *what it is not*. Visual communication is an ever-evolving discipline that can solve innumerable communication problems. Highly entertaining and engaging unconventional advertising formats and solutions are redefining advertising and promotional design, with agencies such as Crispin Porter + Bogusky, Diabolical Liberties, KesselsKramer, and Strawberryfrog leading the way.

In a post-9/11 world, visual communicators are finding more and more often that design does matter. Whether it is to disseminate information to the public, enhance understanding of editorial content through editorial design, design better election ballots or posters to "get out and vote," or create public service campaigns to raise awareness, there are creative professionals who are constantly challenging us to think and reevaluate.

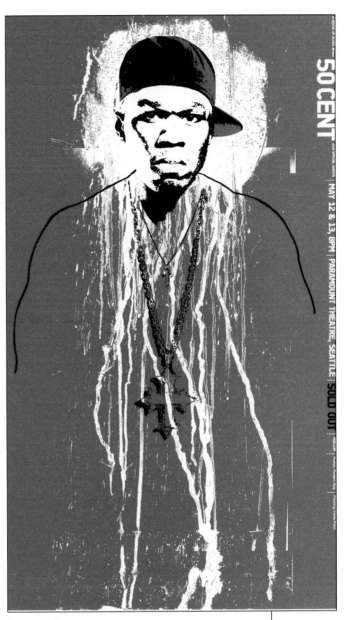

Poster: *50 Cent*
Design studio: © Modern Dog Design Co., Seattle, WA

Robynne Raye and Michael Strassburger co-founded Modern Dog in 1987, and together have created an identifiable and provocative visual vocabulary.

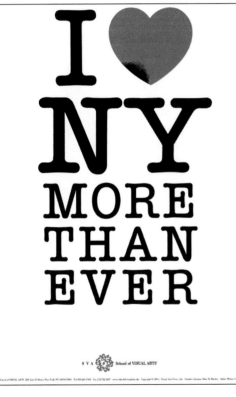

Poster: *I Love NY More Than Ever*
Credit: Milton Glaser
Client: School of Visual Arts (SVA)

A poignant post-9/11 commentary, with Glaser utilizing his own original logo for New York State.

Unconventional advertising: The column "MISS WORLD 2002"
Agency: KesselsKramer, Amsterdam

Using wit and irony, Erik Kessels and Johan Kramer produce highly creative advertising among other visual arts contributions. They set a standard for ethical advertising.

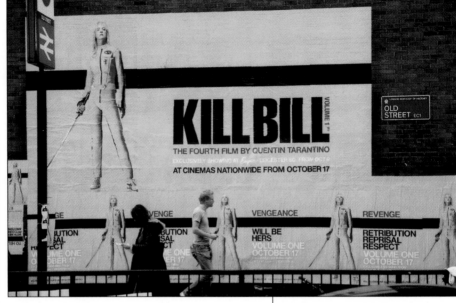

Advertising: *Kill Bill*
Agency: Diabolical Liberties, England
Credit: Images reproduced from *Your Space or Mine*, published in the U.K. by ambient media agency Diabolical Liberties, 2003

"Diabolical Liberties masterminds the creation and implementation of unconventional media campaigns for some of the world's leading brands. We translate innovative concepts into street-level marketing and headline-grabbing PR activity. Because we are the best out on the streets, and operate where popular culture is at its most fluid and edgy, we excel in being flexible, reactive and intrepid."

—Diabolical Liberties

Diabolical Liberties's unconventional solutions to marketing problems have expanded and stretched the profession's definition of creative advertising. They combine advertising, branding, and graphic design by incorporating the feel of happenings and media events into their solutions.

Logos: Q101 Halloween Slime Ball, MTV campus invasion tour
Designer: Carlos Segura
Agency: Segura Inc., Chicago, IL

Segura, born in Cuba, originally moved to Miami in 1965 and then to Chicago. First, he worked in advertising and then founded Segura Inc. in Chicago in 1991, and one year later founded T26 Digital Type Foundry. In 2001, Segura launched 5inch.com. Forever experimenting and pushing the limits, Segura's work resonates.

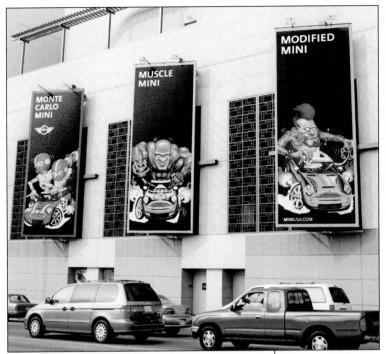

Photo courtesy of MINI division of BMW of North America, LLC.

Outdoor advertising: MINI "Mavericks"
Agency: Crispin Porter + Bogusky, Miami, FL
Executive creative director: Alex Bogusky
Creative director: Andrew Keller
Art director: Kat Morris
Copywriter: Ronny Northrop

Crispin Porter + Bogusky's MINI campaign set a new standard for unconventional advertising that gets to the consumer in unexpected ways.

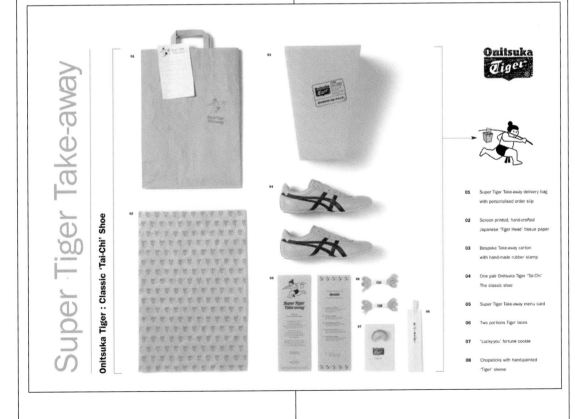

Campaign: "Super Tiger Take-away"
Agency: Strawberryfrog

Amsterdam—a creative hotbed for visual communication in the early twenty-first century—is home to the creatives of Strawberryfrog, whose work is so innovative, people collect it.

Print magazine: Henna cover, 2000
Art director/Designer: Steven Brower
Photographer: Barnaby Hall
Henna artist: Makiko Yoshimura

"Many people mistake this for a Photoshop effort, but the type I created was actually transferred to a model's back, by henna artist Makiko Yoshimura."

—Steven Brower

Brower's redesign of *Print* magazine in January 2000 ushered in a new editorial era, and each of his covers stands as an example of problem-solving manifested as creative thinking. Brower infuses all his work—from editorial to poster design—with monumentality.

Book cover: *Pragmatism: A Reader* by Louis Menand
Art director/Designer: John Gall
Photographer: Katherine McGlynn
Publisher: Vintage Books

John Gall is the art director at Vintage Books. In addition to Vintage, Gall is the art director of another august imprint, Anchor Books. Steven Brower writes about Gall: "Gall's stylish sensibility, simple but elegant use of typography, and quiet rebellious spirit infuse these literate works with an added dimension. Subtle and compelling, his covers play with the perceptions of the viewer in unexpected ways, and to satisfying effect."

Part I:
Fundamentals

Defining Graphic Design

The Nature and Impact
of Visual Communication

◀ Ad
Brand: Green Giant®
(Courtesy of General Mills Archives.)

Objectives

Define graphic design

Understand the place graphic design has in our world

Become familiar with the major categories and specializations in graphic design and advertising professions

Become acquainted with the nature and impact of visual communication

Be aware of the employment opportunities for visual communication professionals

Understand the nature of collaboration

Appreciate why design matters

Value ethical practice in visual communication

Realize the education necessary for visual communication professionals

We don't have to go to a museum or gallery to see graphic design—it comes to us. Everything from a web site to the label on a ketchup bottle is designed by a visual communication professional. Graphic design and advertising are integral parts of contemporary popular culture.

Since visual communication plays a key role in the appearance of almost all print, film, and digital media, graphic designers and advertising art directors are the primary source of the visual artifacts of our environment and popular culture. Imagine a world with no provocative posters and no thought-provoking visual design on compact disc covers. Imagine packaging that all looks the same, with no graphics (Figure 1-1); and imagine the chaos of a newspaper that wasn't designed by a professional graphic designer. That would be a world without graphic design.

Defining Graphic Design

Graphic design refers to the application of the design process—which determines the look and structure of human-made objects—to visual communication. "It is therefore one of the ways in which creativity takes on a visual reality," says Professor Alan Robbins. **Graphic design** can be thought of as a visual language that is used to convey a message to an audience, and is a visual representation of an idea that relies on the creation, selection, and organization of visual elements to create an effective communication. A powerful graphic design can imbue a message with greater meaning through a compelling solution.

A **graphic design solution** can persuade, inform, identify, motivate, enhance, organize, brand, rouse, locate, engage, and carry or convey many levels of meaning. A design solution can be so effective that it influences behavior: you may choose a particular brand because you are attracted to the design of its package, or you may donate blood after viewing a public service advertisement.

The Graphic Design Profession

The **graphic design profession** is an expert creative discipline that focuses on visual and verbal communication and meaning. It is also a business practice through which ideas are given visual form using type, image, and composition. Some graphic design and advertising serves commerce and drives the economy; other graphic design and advertising serves society and social causes. Still other uses are as educational tools, to motivate on behalf of charitable organizations, and to communicate vital information and editorial content to the public.

Figure 1-1
Ski graphics
Design firm: Hornall Anderson Design Works Inc., Seattle, WA
Art director: Jack Anderson
Designers: Jack Anderson, David Bates, and Sonja Max
Client: K2

"Because graphics are a main factor in the successful marketing of skis, we work closely with K2 to develop each season's look, while consistently representing K2 and leveraging the equity in its now well-established identity.

Early on, most ski manufacturers implemented a similar appearance for their skis, using color palettes consisting of a white base ski and black, blue, or red accent colors.

As new energy and younger skiers began making up a larger part of the market, and fashion trends in Europe began influencing what people wore on the ski slopes, K2 was one of the first companies to change its graphics to fit the times.

In order to capture a greater market share, the graphics are targeted specifically to the audience that would be using the skis.

Each season begins with a study of which colors are 'hot' for that year. Different color combinations, and in some cases different graphics, are produced for the American, Japanese, and European markets. Because colors and graphics look different on the snow than they do in a retail environment, the skis are designed to show well in both settings.

Other design considerations include different pricing points and ski construction/features. Each year, several lines of skis are developed for the different markets of skiers—competition, high-end performance, recreational, and beginner skis, as well as special niche skis."

—Hornall Anderson Design Works

There are many specialized areas within the graphic design profession; however, all graphic designers solve problems and generate ideas that take visual form. Graphic design areas of specialization can be broken into a number of major categories.

Information Design

"**Information design** is a highly specialized area of design that involves making large amounts of complex information clear and accessible to audiences of one to several hundred thousand" is the definition given by the American Institute of Graphic Arts (AIGA). Whether the application is a chart, web site, pictogram, or instruction booklet, the graphic designer's task is to clearly communicate, make information easily accessible, and clarify and enhance any type of information (from data to listings) for the user's understanding (Figures 1-2 and 6-43).

Identity Design

Identity design involves the creation of a systematic visual and verbal program intended to establish a consistent visual appearance—a coordinated overarching identity—and spirit or image for a brand or group. Identity design is also called corporate identity, brand identity, and corporate design (Figures 1-3 through 1-5).

Promotional Design

Promotional design is design intended to introduce, sell or promote brands (products and services), ideas or events and to introduce or

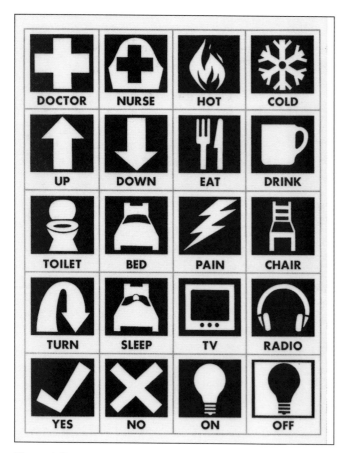

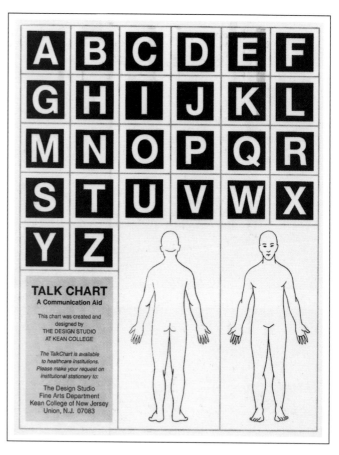

Figure I-2

Chart: The Talk Chart

Description of work: A communication device utilizing icons

Creative director: Alan Robbins, The Design Studio, Kean University of New Jersey

Designers: Various dedicated students

Client: Self-initiated

The Talk Chart is a communication device for patients in hospitals and nursing homes. Using the 8½" x 11" laminated chart, patients with aphasia, throat tubes, or other impairments to their speech can now make their needs known to family and staff by pointing to the graphic symbols or letters of the alphabet that appear on the chart. The graphic symbols represent fifteen basic patient needs and figures of the human body for pinpointing problems.

The Talk Chart was created and designed by college students in The Design Studio at Kean University under the direction of Professor Alan Robbins, and is donated to local hospitals. Thanks to a generous grant from Sappi Paper, the Talk Chart is currently being used in 2,000 hospitals throughout the United States.

Figure I-3

Logo: Lizart Digital Design

Design firm: Lizart Digital Design, Chicago, IL

Art director: Liz Kingslien

Designer/Illustrator: Liz Kingslien

Figure I-4

Logo

Design firm: Rizco Design, Manasquan, NJ

Creative director/Art director: Keith Rizzi

Designer/Illustrator: Dawnmarie McDermid

Client: Anxiety Disorders Association of America/GCI Group

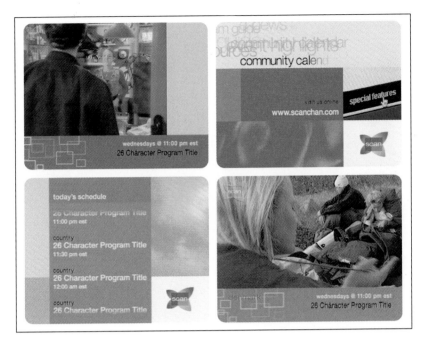

Figure 1-5

Brand identity interstitials: Scandinavian Channel
Design studio: SamataMason, West Dundee, IL
Art director: Greg Samata
Designers: Greg Samata and Lynne Nagel
Client: Scandinavian Channel

The Scandinavian Channel was a 24-hour cable channel that featured programming exclusively from Sweden, Finland, Denmark, Iceland, and Norway. Cultural programming ranged from film and entertainment to news and current affairs.

Figure 1-6

Web site: Copyhouse Chava Doron
Design studio: Shira Shecter Studio; Fresh Graphic Design, Israel
Client: Copyhouse

"Copyhouse Chava Doron specializes in strategy, branding, and copywriting solutions. Here we aimed to provide corporate identity solutions through the design by merging the company's various services such as branding, positioning, strategy development, copywriting, writing workshops, etc. The design was composed of warm colors mixed with plays on punctuation marks and typography. The home page contains Flash animation with expressive use of various slogans and tag lines as messages for generating dynamic flow on-screen."

—Shira Shecter

Figure I-7
Watch: "Fuel Gauge"
Design firm: Drenttel Doyle
Partners, New York, NY

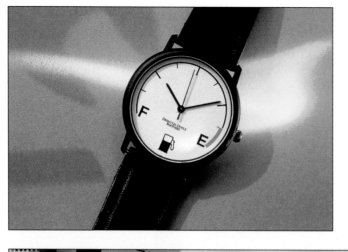

Figure I-8
Portfolio of works:
Jennifer Sterling Design
Design firm: Jennifer
Sterling Design,
San Francisco, CA
Art director/Designer:
Jennifer Sterling

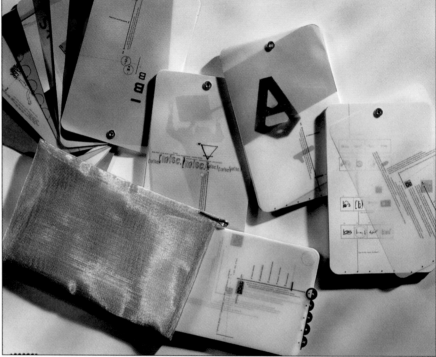

promote groups and social causes. Promotional design and advertising, at times, overlap in definition and purpose. For example, one could consider a web site banner either promotional design or advertising (Figures 1-6 through 1-8).

Branding
Branding is the entire development process of creating a brand, brand name, or brand identity (Figure 1-9).

Brand Experience
Brand experience entails developing an entire brand experience—a comprehensive, strategic, unified, integrated, creative program for a brand, including every graphic design and advertising application for that brand, with an eye and mind toward how consumers and individuals experience the brand or group as each interacts with it.

Publication Design
Publication design involves the design of editorial content; it is also called **editorial design**. The publication designer makes content accessible, interprets the content's intention in order to clearly communicate it, enhances the reader's experience, and establishes a voice, character/spirit, and format for the publication (Figure 1-10).

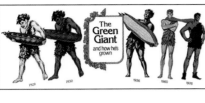

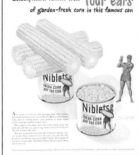

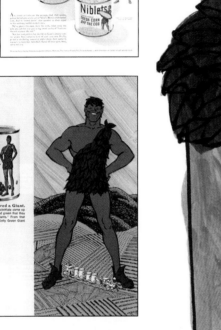

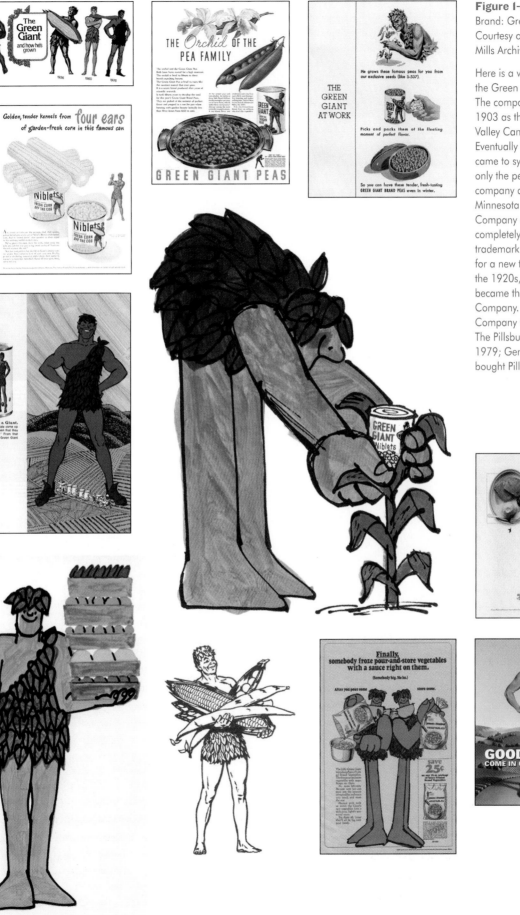

Figure 1-9
Brand: Green Giant®
Courtesy of General
Mills Archives

Here is a visual timeline of the Green Giant® brand. The company started in 1903 as the Minnesota Valley Canning Company. Eventually the Green Giant came to symbolize not only the pea, but the company as well. In 1950, Minnesota Valley Canning Company disappeared completely behind the trademark it had created for a new type of pea in the 1920s, and officially became the Green Giant Company. The Green Giant Company was bought by The Pillsbury Company in 1979; General Mills bought Pillsbury in 2001.

Figure I-10

Magazine spread: "Beat,"
Oxymoron, Vol. 2, 1998
Art directors: Steven Brower
and Seymour Chwast
Designer: Steven Brower

"I used the entire
publication as a vehicle to
explore legibility, since the
theme was 'the fringe.' The
text is to be read, of course,
and not merely decoration.
Therefore, it was quite
labor intensive to achieve
this. And it works."

—Steven Brower

Figure I-11

Ad: Absolute Sterling
Design firm: Jennifer
Sterling Design, San
Francisco, CA
Art director/Designer:
Jennifer Sterling

Advertising

Advertising involves generating and creating specific visual and verbal messages constructed to inform, persuade, promote, provoke, or motivate people on behalf of a brand or group; here, "group" represents both commercial industry and social cause (nonprofit) organizations (Figures 1-11 through 1-13).

Environmental Design

Environmental design solves problems about information or identity communication in constructed or natural environments, defining and marking interior and exterior commercial, cultural, residential, and natural environments (Figures 1-14 through 1-16).

Type Design and Lettering

Type design and lettering is a highly specialized area of graphic design focusing on the creation and design of fonts, type treatments, and the drawing of letterforms by hand (as opposed to type generated on a computer). Many type designers own digital type foundries, which are firms that design, license, publish, and dispense fonts (Figures 1-17 and 4-2).

Within these categories are subspecialties and specific applications. Some applications cross over; for example, posters can be promotional, informational, or advertising. Some primary applications within each design specialization include:

- *Information design:* charts, graphs, signs, pictograms, symbol signs, icons, web sites, sign systems
- *Identity design:* logos, visual identity, corporate identity, branding
- *Promotional design:* CD covers, book covers and jackets, posters, packaging, web sites, web banners, motion graphics (film title design, TV graphics design, openers, promotional motion presentations), multimedia promotions, giveaways, merchandise catalogs, direct mail, invitations, announcements

Figure 1-12
Television commercial:
"Faster, Faster"
Agency: Grey Advertising,
New York, NY
Client: New York Lottery

Figure 1-13
Outdoor board campaign:
ABC Television Network

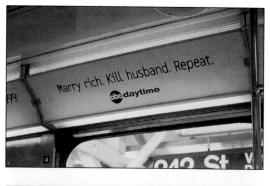

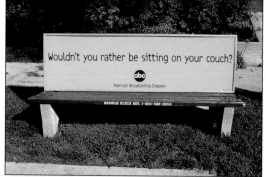

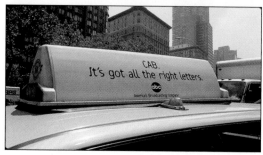

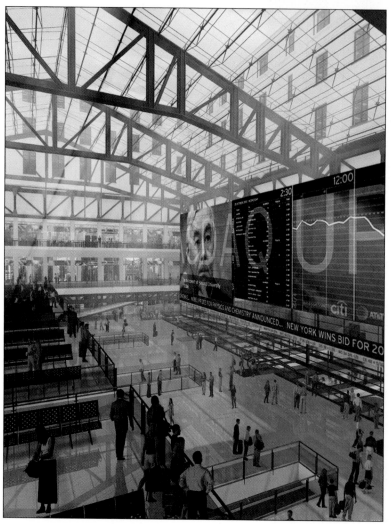

Figure 1-14
Interior graphics: Penn
Station, New York, NY
Design studio: Pentagram
Design Ltd.

"Part of a comprehensive
interior graphics program,
this 200-foot-long
prototype media wall will
inhabit the main concourse
at New York's busiest train
station. The architectural
redevelopment was led
by project architects at
Skidmore Owings
Merrill LLP."

—Pentagram

Figure 1-15
Signs: Maggiano's Bakery,
Blade Sign, Banners,
Corner Bakery Sign
Design firm: Ema Design
Inc., Denver, CO
Art director:
Thomas C. Ema
Designers: Thomas C. Ema
and Prisca Kolkowski
Client: Maggiano's Bakery

Figure I-16
Signs
Design firm: Richardson or
Richardson, Phoenix, AZ
Designers/Writers: Forrest
Richardson and Valerie
Richardson
Client: Sunrise Preschools

"The client had an
immediate need for
a sign to identify new
construction sites. Rather
than supporting the usual,
noncreative approach or
projecting an architectural
image of the building,
the design team looked
inward to the preschool's
marketing program for
a related icon. An existing
program by Richardson
or Richardson used
a simplified shape of a
shovel, a saw, and a key—
all die-cut cardboard about
24 inches long—as a door
hanger direct-delivery
program to the immediate
neighborhood where new
schools were being built.

Taking the shape of the
saw, the designers simply
turned the shape on its
side and communicated
the simple message. More
than six hundred calls were
placed as a result of the
coordinated sign and
delivery program as both
marketing and signage tied
together to support a single
image and identity."

—Richardson or Richardson

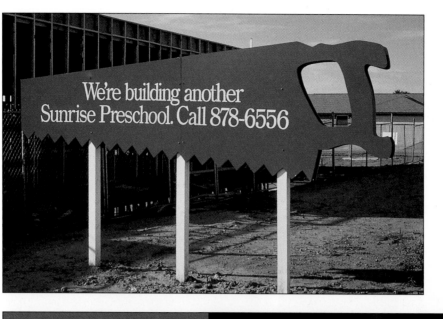

Figure I-17
Logo: Chili Eleven
Design studio: Red Flannel, Freehold, NJ
Creative director/Art director: Jim Redzinak
Designer/Illustrator: Jim Redzinak
Client: Jim Redzinak

About this custom typography, designer Michele Kalthoff
comments: "I just love the balance of the typography, the
colors, the character. It makes me want a bowl of super
spicy chili."

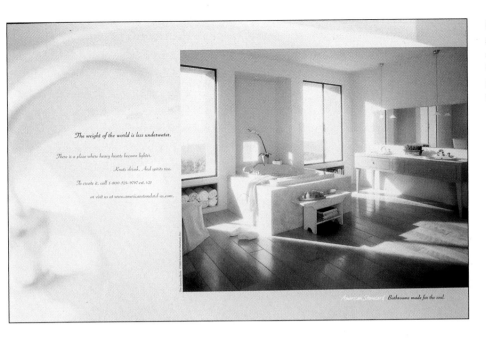

Figure 1-18
Ad: Savona Suite
Advertising agency:
Carmichael Lynch,
Minneapolis, MN
Client: American Standard

• *Branding:* brand naming, brand conception, brand identity, brand revitalization, brand launch, brand relaunch, brand environments, global branding, corporate branding, social cause branding, brand strategy
• *Publication design:* book design, magazine design, newspaper design, newsletters, booklets
• *Environmental design:* architectural interiors, interplan exhibit environmental graphics, exhibits, environmental wayfinding (system of integrated signs)
• *Type design and lettering:* custom and proprietary font design for digital type foundries, hand lettering, custom typography
• *Advertising:* print ads, television commercials, unconventional formats, banner ads, web sites, "**webisodes**" (a short audio or video presentation on the Web, used to promote a brand or group, preview music, or present any type of information), web films, product placement, **viral marketing**, direct mail, branded entertainment, product placement

Media Uses

For many of these categories, different media can be employed, such as print, digital, unconventional, or film. For example, one sees advertising in various media: television commercials, commercial spots run in movie theaters, print advertisements in magazines and newspapers, unconventional formats such as chalk writing on a

Figure 1-19
Logo: Dr. Patty's
Skincare Products
Design firm: LFM Design,
Hillside, NJ
Art director: Laura F. Menza
Client: Dr. Patty's
Skincare Products

sidewalk, motion-activated graphics projected on pavement, and online ads in the form of web sites, viral marketing, web film banners, and webisodes (web commercials). One can read a magazine in the conventional print format or as an online magazine, and the formats may look entirely different. Most branding integrates various media.

The Nature and Impact of Visual Communication

Graphic design is created for a specific audience; a message is intentionally designed, transmitted, and then received by viewers. Whenever you read an advertisement or see a logo, you are on the receiving end of communication through design (Figures 1-18 and 1-19). Is the viewer's interpretation of graphic design and advertising paramount? Is graphic design an art that allows self-expression? Is it a discipline that can be tested, quantified, and scientifically evaluated?[1]

Certainly, it is reasonable that all of these viewpoints should be considered and incorporated into one's view of the nature of graphic design. We can look at the works of many designers and see personal expression. The readability and legibility of typography can be scientifically studied and measured. Advertisements are targeted at specific groups in consideration of the viewer's identity; ads are also tested in focus groups of viewers.

Most graphic design and advertising is ephemeral by nature—people don't keep it. However, there are some applications, such as posters, book covers (Figure 1-20), album covers, CD covers, advertisements, and labels that people want to keep, savor, and contemplate.

Figure I-20
Cover: *The Theatre of the Absurd* by Martin Esslin
Art director/Designer:
John Gall
Publisher: Vintage Books

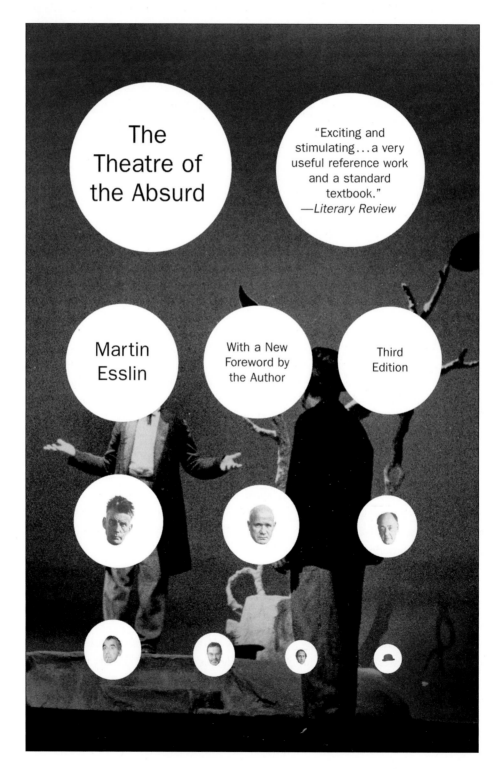

The Field of Visual Communication

The main places of employment for a visual communication professional are design studios, branding firms, publishers, interactive agencies, unconventional marketing firms, advertising agencies, integrated communication firms, and companies, corporations and organizations with in-house design departments, as well as self-employment and freelance work.

Many designers are self-employed. It is advisable to work for someone else to gain design experience and learn all the aspects of running a small business and working with printers before going out on your own. It is highly beneficial to secure an internship, a cooperative educational experience, or part-time work in the design field while still in school. Attend the meetings of local art directors' clubs and professional design organizations, such as the AIGA (The American Institute of Graphic Arts) in the U.S. and the D&AD in England. Find an organization in your community. The purpose of these institutions is to educate, help set professional standards, and promote excellence. Attend as many professional conferences and lectures as possible.

You may begin to notice that you enjoy some styles or some areas of graphic design and advertising more than others. Which work attracts your interest? Which designers' work do you admire? Make a list of ten designers and art directors whose work you find admirable. Noticing which you like may help you decide on the direction of your graphic design career.

Collaboration

Most often, graphic designers work closely with their clients. From developing a strategy to negotiating a fee to choosing a printer, the client and graphic designer need to collaborate. Whether the client is a local business owner, a large corporation, or a nonprofit organization, the graphic designer's role is to provide solutions to visual communication problems.

Sometimes a designer needs to help direct a client in determining the best type of design applications to solve the problem. Design solutions must be relevant to stated objectives and clear in the communication of messages. The visual message usually fits into a larger marketing, promotion, or communication plan to achieve the goal.

In addition to collaborating with a client, a graphic designer works with many other visual communication professionals, such as creative directors, design directors, associate creative directors, production experts, photographers, illustrators, copywriters, art directors and specialists (interactive and type and hand-lettering specialists, architects, film directors, producers, casting directors, talent (actors, musicians, and models), music houses, IT professionals, psychologists, social anthropologists, and market researchers), and with printers' sales representatives and printers. At times, the collaboration begins at the ground level when different firms work together to solve a visual communication problem. For example, from the start of a large project, a branding firm and an advertising agency might work together. Or a design studio might collaborate with an interactive studio. At other times, the lead design firm or agency may hire freelancers.

When a design concept is selected, graphic designers and advertising art directors select illustrators and photographers, or buy stock illustration and photography. When working on television commercials, advertising art directors and creative directors work with directors, location scouts, and postproduction experts, and may also be involved in casting actors and suggesting locations, as well as choosing music. It is important for graphic designers and art directors to recognize successful illustration and photography and to be aware of styles.

Why Design Matters

As designer Paula Scher wisely said, "Design matters."

Most people know that graphic designers have commercial clients—creating solutions for brands and corporations. The visual communication profession helps to drive the economy, provide information to the public, and promote research and development of goods and services. There is another side of graphic design that is

less well-known and vital to society: designers use their expertise to inform people about important issues and promote good causes, for example, this logo for a nonprofit AIDS awareness organization (Figure 1-21). Graphic designers create symbol signs and icons that transcend language barriers and impairments (AIGA Symbol Signs in the Timeline (page TL-12) and the Disability Access Symbols Project, Figure 6-43). Graphic designers and advertising art directors are capable of remarkable contributions, such as the Talk Chart, designed by Professor Alan Robbins and his students in The Design Studio of Kean University of New Jersey. The Talk Chart is a communication device, which uses icons, designed for patients with aphasia, throat tubes, or other impairments to their speech (Figure 1-2). Patients can make their needs known by pointing to the graphic icons, symbols, or letters of the alphabet that appear on the chart. The graphic symbols represent fifteen patient needs and figures of the human body for pinpointing problems.

Ethics in Visual Communication

Each designer is responsible to discover ethical ways to practice. Any design problem can be solved in a great number of ways, and each solution has different economic and social benefits and consequences.

Social responsibility for a designer means maintaining respect for others, and not comprising one's own ethics in order to satisfy client demands. Each design solution bears consequences. Social concerns are a designer's concerns.

Many in the global design community are actively voicing the need for entirely ethical practice and for limiting consumer work. The important manifesto "First Things First" is the subject of an ongoing heated debate. It was originally written in 1964 and updated by Adbusters and six design magazines in 2000. The "First Things First" manifesto is a call to designers to use problem-solving skills in pursuit of projects that would better society. There are urgent concerns worldwide that would greatly benefit from the expert skills of designers, what the twenty-two original undersigned members of the manifesto would consider "cultural interventions," such as educational tools, health tools, information design, public service advertising campaigns—any design project that moves away from consumerism and toward a socially useful benefit. Any student or novice, whether you agree or not, should be familiar with this manifesto.

Advertising matters, too. It drives the economy in a free market system and provides information and choices to the public. Ethical advertising is critical to competitive enterprise and to bringing better products and services to people.

Globally, public service advertising campaigns have helped an enormous number of people. For example, the Ad Council's "Friends Don't Let Friends Drive Drunk" campaign (sponsored by the U.S. Department of Transportation/NHTSA) significantly affected people's behavior. "A recent poll revealed that 68 percent of Americans have acted to stop someone from driving drunk after being exposed to the advertising. I think that shows the impact of the strategy and the creative ability to motivate change in attitudes and behavior," says Peggy Conlon, Ad Council president, about this campaign.[2]

In the early days of advertising, there were no government regulations or watchdog groups. Concerned citizens united and governmental agencies formed to protect consumers from unethical manufacturers and fraudulent adver-

tising claims. With or without watchdog groups or governmental regulations, every art director, copywriter, creative director, and creative professional involved in the creation of advertising must assume responsibility for ethical practice.

There will always be clients who make questionable demands. In this author's opinion, it is the responsibility of the creative professional to direct a client away from negative messages. Every ad sends a message; every image tells a story.

Due to its ubiquity and long modern life, people have absorbed advertising so deeply that many may no longer recognize the countless ways in which effective advertising persuades and motivates. Visual communication professionals are the leading architects of popular culture and mass communication; they create images that help delineate, reflect, and describe contemporary reality. The representation of appearances and the artificial constructions of reality in print ads, television commercials, online marketing, and unconventional formats not only communicate direct messages—when well constructed, these messages become meaningful. That meaning can have positive or negative social consequences. We all need to mine visual communication for negative connotative messages.

It is important to understand that ads should reflect diversity. Ads should respectfully reflect the range of cultures and ethnicities of viewers. Since advertising is mass communication, even when directed toward a segment of a population, it is drawn in broad strokes. Those broad strokes, for many, translate to mean generalizing and stereotyping of cultures, groups, and genders. All of us—clients, account managers, executives, and creative professionals—need to be more vigilant, to interrogate all connotative cultural messages in the visual communications they commission and create.

Since the creative revolution of the 1960s, creative advertising has made great strides to distance itself from hucksterism. More than ever before, the self-conscious tone of much celebrated advertising winks at the viewer. To keep moving forward, all advertising professionals, not just a small number, need to find responsible voices.

Each art director is also a world citizen and has a responsibility to discover ethical ways to practice.

Almost every country regulates advertising to some extent, especially advertising to children. (It should be noted that I am entirely against consumer advertising aimed at children.) Some advocacy and watchdog groups are Adbusters, Action for Children's Television, mediawatch-uk, Commercial Alert, the Advertising Standards Authority, Media Task Force of the National Organization for Women, and Guerrilla Girls, as well as individual critics such as Jean Kilbourne, and collectives such as Men Organized Against Sexism and Institutionalized Stereotypes (OASIS). Professional groups also aid the profession, such as AIGA, AWNY (Advertising Women of New York), International Association of Business Communicators (IABC), D&AD in England, and the One Club and the Art Directors Club in New York.

The following excerpts from professional organizations are very helpful in creating a foundation for ethical practice. For more information, please visit their respective web sites.

Preface to the Code of Ethics for Professional Communicators

The following is the International Association of Business Communicators' (IABC) ethics statement, which they have posted on their web site at *www.iabc.com.*

"Because hundreds of thousands of business communicators worldwide engage in activities that affect the lives of millions of people, and because this power carries with it significant social responsibilities, the International Association of Business Communicators developed the Code of Ethics for Professional Communicators.

The Code is based on three different yet interrelated principles of professional communication that apply throughout the world.

These principles assume that just societies are governed by a profound respect for human rights and the rule of law; that ethics, the criteria for determining what is right and wrong, can be agreed upon by members of an organization; and, that understanding matters of taste requires sensitivity to cultural norms.

These principles are essential:
- *Professional communication is legal.*
- *Professional communication is ethical.*
- *Professional communication is in good taste.*

Recognizing these principles, members of IABC will:
- *Engage in communication that is not only legal, but also ethical and sensitive to cultural values and beliefs;*
- *Engage in truthful, accurate, and fair communication that facilitates respect and mutual understanding; and,*
- *Adhere to the articles of the IABC Code of Ethics for Professional Communicators.*

Because conditions in the world are constantly changing, members of IABC will work to improve their individual competence and to increase the body of knowledge in the field with research and education."

AIGA

AIGA has released a series of brochures outlining the critical ethical and professional issues encountered by designers and their clients. The series, entitled "Design Business and Ethics," examines the key concerns a designer faces in maintaining a successful practice and speaks directly to the protection of individual rights. Here is an excerpt:

Ethical Standards

- *A professional designer does not work on assignments that create potential conflicts of interest without a client's prior consent.*
- *A professional designer treats all work and knowledge of a client's business as confidential.*
- *A professional designer provides realistic design and production schedules for all projects and will notify the client when unforeseen circumstances may alter those schedules.*
- *A professional designer will clearly outline all intellectual property ownership and usage rights in a project proposal or estimate.*

Clients can expect AIGA members to live up to these business and ethical standards for professional designers. Through consistently professional work, AIGA members have documented substantial bottom-line contributions to corporations and organizations. For more information and case studies about how professional designers have produced excellent business results, visit *www.aiga.org.*

Visual Communication Professionals' Knowledge and Education

Graphic designers need to fully understand the fundamental elements and principles of design. These elements include line, shape, volume, texture, color, and format; these principles include balance, emphasis, rhythm, unity, positive-negative space, and the illusion of three-dimensional space. The fundamental elements and principles of design are the foundation of a design education—like understanding the basic parts of speech and the principles of composition before writing a novel. Ideally, these basics are studied before attempting practical applications and should always be employed.

A graphic designer or advertising art director needs a liberal arts education as well. The visual communication profession demands a high level of critical thinking skills, and an understanding of technology, psychological perception, how society functions, and cultural movements and ideas. As stated earlier, graphic designers and art directors collaborate not only with other creative professionals, but also with other professionals, from marketing directors to social psychologists to IT professionals. A liberal arts education prepares a designer to think critically, to collaborate effectively, and to understand ethics. A visual communication education prepares a designer to think critically, as well, and to think creatively, to problem-solve, to effectively communicate visually and verbally, and to impart the necessary subject matter—both theory and skills—to practice as a visual communication professional.

The visual communication field—graphic design and advertising—is very exciting. Each and every day, visual communication professionals have the opportunity to be creative. How many professions can boast that?

Summary

Graphic design and advertising both play a key role in the appearance of almost all print, film, and digital media forming society's popular visual landscape. Graphic designers and advertising art directors are the creative professionals who, through ethical practice, use a visual language to convey messages to an audience. Visual communication can persuade, inform, identify, motivate, enhance, organize, brand, rouse, locate, engage, and carry or convey many levels of meaning.

Visual communication professionals work in a variety of settings—design studios, branding firms, companies, corporations and organizations with in-house design departments, publishers, interactive agencies, unconventional marketing firms, advertising agencies, and integrated communication firms—as well as in their own studios as freelancers. They collaborate with a good number of other creative professionals, as well as with their clients.

Design matters—visual communication helps society in a great number of ways, from driving the economy to informing the public. Visual communication professionals need to be well educated with a strong liberal arts background and excellent training in design and writing, and also be conversant in ethics.

Notes

[1] Steven Heller, ed., *The Education of a Graphic Designer* (New York: Allworth Press, 1998), p. 10.

[2] Peggy Conlon interview in *Advertising by Design*™, Robin Landa (Hoboken, NJ: John Wiley & Sons, Inc., 2004).

Dave Mason
SamataMason

After twelve years of specializing in corporate communication design, Dave Mason and co-founders Greg and Pat Samata formed SamataMason Inc. in 1995. Dave Mason's work has been honored in numerous national and international competitions and publications including: The Mead Annual Report Show, The AR100 Annual Report Show, The American Center for Design 100 Show, Communication Arts, Graphis Annual Reports, and Print *and* How *magazines.*

From Start to Finish

I've been asked to write a brief article about the process designers use to move an idea from thought to execution. Since design is the result of both left and right brain activity in varying proportions, it's subject to the individual nuances of individual brains—it's highly unlikely that any two designers would solve the same problems in exactly the same way. So while there are probably universal checkpoints in the design process, the only designer I can actually speak for is me. A lot of this may be just common sense and a lot happens between and around these points, but here's my attempt to systemize an incredibly complex, nonlinear process.

1. Have a problem. There is no more difficult design project than one which does not involve solving a problem. All of the work I consider my most successful has been built around a problem (or two). Want something to just look good? Big problem!

2. Have an audience. If I don't know who my client wants to be talking to, how can I determine which language to use?

3. Get the information. Design is about solving someone else's problem with someone else's money, so it has to start with someone else's information. I'm an "expert" in very few areas, but I get asked to help communicate for people who do incredibly diverse things, and they usually know their stuff. So I sell my ignorance. I ask as many dumb/smart questions as necessary to try to get to the essence of any problem.

4. Read between the lines. I pay attention to what I'm hearing, but also to what I'm *not* hearing. Sometimes there are incredible ideas hiding in there.

5. Get the words right. A picture may paint a thousand words, but a few of the right words can help me visualize a design solution. I think in words. I design around words. There are usually lots of good ones flying around in the meetings I have with my clients. And clients say the darnedest things!

6. Bring yourself to the problem. Design is the product of human interpretation. I believe if a client has hired me to help solve their problem, I have to approach it in a way that makes sense to me. If I try to solve a problem the way I think someone else would, what value have I added?

7. Recognize the solution when you see it. Buckminster Fuller summed it up perfectly: "When I am working on a problem, I never think about beauty. I only think about how to solve the problem. But when I have finished, if the solution is not beautiful, I know it is wrong."

8. Don't sell design. When I present a design recommendation, I'm not selling "design"—I'm selling a solution to my client's problems. Colors, images, typefaces, technologies, papers—whatever. No one cares but you and your peers. Your client just wants to: *insert client problem here.*

9. Make sure your clients can see themselves in the solution. If I've done my home-

work and my interpretation is correct, my clients should recognize themselves—either as they are or as they want to be—in what I design. If they don't, I missed the mark. If you don't believe in listening to your clients, try putting your money where your mouth is: give your hair stylist $500 and let him do whatever he wants to your head.

10. Make sure you can build what you've designed. Everyone has a budget, and everyone needs/wants more for that budget than they can get. Never present anything unless you know it delivers on that. The best solution isn't a solution at all if your client can't afford it.

11. Keep the ball in your client's court. Once a project is into development and production, never get into a situation where you are the one holding things up. Move it or lose it.

12. See it through. How a design project is printed/programmed/fabricated/finished is critical, and attention to detail makes all the difference. I remember seeing a sign in an aircraft factory: "Build it as if you are going to fly it." When the finished design project is in your client's hands, your reputation is too.

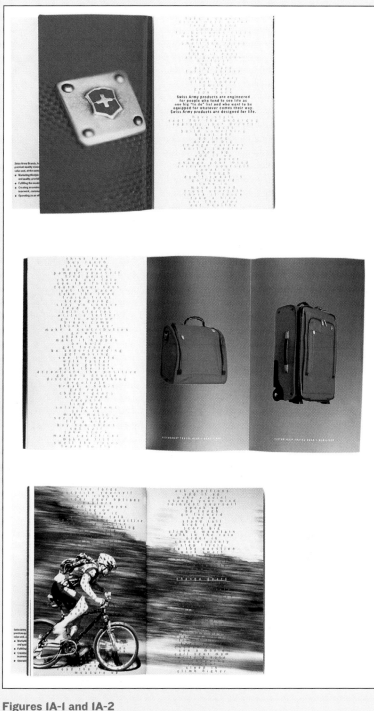

Figures IA-I and IA-2

Annual report: Swiss Army Brands
Design studio: SamataMason, West Dundee, IL
Art director: Dave Mason
Designers: Dave Mason and Pamela Lee
Copywriter: Swiss Army Brands personnel and Dave Mason
Photography: Victor John Penner and James LaBounty
Client: Swiss Army Brands

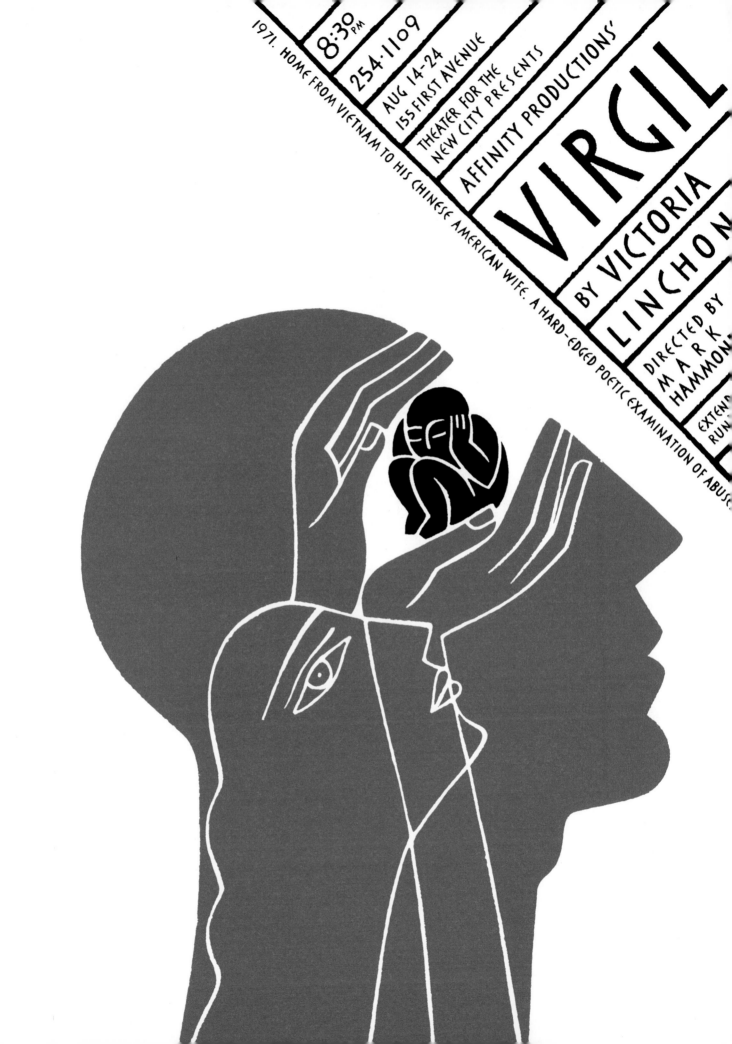

VIRGIL

BY VICTORIA LINCHON

AFFINITY PRODUCTIONS'

THEATER FOR THE NEW CITY PRESENTS

155 FIRST AVENUE

AUG 14-24

254·1109

8:30 PM

1971. HOME FROM VIETNAM TO HIS CHINESE AMERICAN WIFE. A HARD-EDGED POETIC EXAMINATION OF ABUSE

DIRECTED BY MARK HAMMON

EXTEND RUN

Graphic Design Solution
Components

Critique Guidelines

◀ Poster: *Virgil*
Design studio: Luba Lukova Studio, New York, NY
Designer/Illustrator: Luba Lukova
Client: Theater for the New City

Objectives

Learn the components of a graphic design solution

Gain knowledge of setting strategy and determining objectives

Learn to write and work with a design brief

Recognize the critical nature and role of concept generation

Become skilled at methods for concept generation

Grasp designing as the integration of concept and visual elements

Examine the basic visual elements of any design solution

Become familiar with the process and phases of designing

Comprehend the need to learn about paper, printing, and production

Learn to critique work

Consider keeping an idea and source book

Graphic Design Solution Components

A successful graphic design solution is, as the old saying goes, the result of perspiration and inspiration, which requires problem-solving, focused creative energy, ideation, designing, and an effective outcome.

Regardless of the media, every design solution requires the following essential components:

- Strategy
- Concept
- Design
- Production
- Execution

Strategy

Advertising agency professionals utilize creative briefs to determine the strategy for each assignment (Figure 2-1). Many graphic designers are finding that a design brief (also called a design plan, creative brief, or creative work plan) can help establish a strategic platform that they can utilize for ideation, as well as for being on the "same page" as the client. A **design brief** is a written plan delineating strategy, objectives, expectations, audience, brand or group perception, and may include budget and media. It defines the scope of the work (or problem) and can be revisited during the life of the project to make sure everyone is meeting objectives. In respect to ethical practice, the AIGA offers this comment about the design brief from their web site at *www.aiga.org*: "…As the client, you are spelling out your objectives and expectations and defining a scope of work when you issue one. You're also committing to a concrete expression that can be revisited as a project moves forward. It's an honest way to keep everyone honest. If the brief raises questions, all the better. Questions early are better than questions late."

The **strategy** is the master plan, a starting point to determine several key factors, such as the problem to solve, the objectives, the audience, and brand positioning.

A typical design brief answers the questions:

- What is the message?
- To whom are we speaking?
- How do we want to be perceived?
- What are the executional guidelines or budget constraints?

Design solutions must be relevant to stated objectives and clearly communicate to a targeted audience. Usually, each solution fits into a larger branding or communication plan. Any number of individuals can be involved in determining strategy and devising a design brief; for

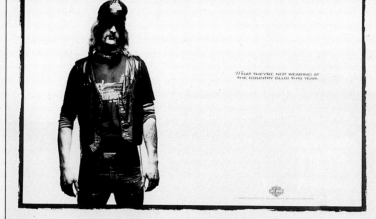

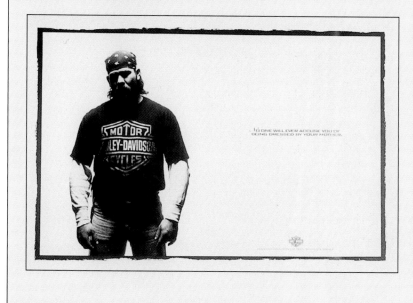

Warning: People don't like ads. People don't trust ads. People don't remember ads. How do we make sure this one will be different?

Why are we advertising?
To announce the introduction of a clothing line to the Harley-Davidson store in Dallas.

Who are we talking to?
Weekend rebels. Middle-class men who are not hard-core bikers (they may not even own motorcycles), but want a piece of the mystique.

What do they currently think?
Harley-Davidson has a badass image that appeals to me.

What would we like them to think?
Harley-Davidson now makes clothing that reflects that wild, rebellious image.

What is the single most persuasive idea we can convey?
Harley-Davidson clothing reflects the rebellious personality of the Harley-Davidson biker.

Why should they believe it?
Harley-Davidson bikers shop for their clothes at Harley-Davidson.

Are there any creative guidelines?
Real and honest. Should be viewed favorably by hard-core Harley-Davidson bikers.

—The Richards Group

Figure 2-1
Ads: Harley-Davidson of Dallas
Agency: The Richards Group, Dallas, TX
Creative director/Writer: Todd Tilford
Art director: Bryan Burlison
Photographer: Richard Reens
Client: Harley-Davidson of Dallas

example, a designer and a client may collaborate, or other marketing and/or creative professionals may be involved.

Sometimes a designer needs to help direct a client in determining the best type of design applications to solve the problem.

Determining Objectives

For each graphic design or advertising problem, write a clear, succinct statement of objectives. This statement should summarize the key message. When your design is roughed out, you can assess how well it expresses this **objectives statement.**

The following set of questions will help you determine design objectives:

What is the purpose of the design?

Is the design meant to inform, persuade, promote, mark, or identify? Determine how it will function.

Who is the audience?

Any individual or group who is on the receiving end of a graphic design solution is the **audience.** The **target audience** is a specific targeted group of people. An audience's scope can be global, international, national (Figure 2-2), regional, or local. In a diverse society, designers can choose to target groups of people, whether the groups are defined by age, interest, or ethnicity. Some design studios, branding firms, and advertising agencies specialize in creating graphic design or advertising for particular ethnic markets.

What message needs to be communicated?

Make certain that the intended message is clear and that your design is effective. Designs have at least two levels of meaning. The first is the primary meaning, which is the direct message of a word, sign, or image. What is conveyed or suggested by the overall design is the secondary meaning. Keep both of these in mind while you work. (Philip B. Meggs, design historian, refers to these two levels of meaning as denotation and connotation.) As demonstrated in the selection and arrangement of visual elements in the design of the book for Levi's Jeans (Figure 2-3), authenticity is suggested, which is intrinsic to the secondary meaning of the message.

Figure 2-2
Ad
Agency: Leo Burnett
Client: Fiat Auto China,
Shanghai

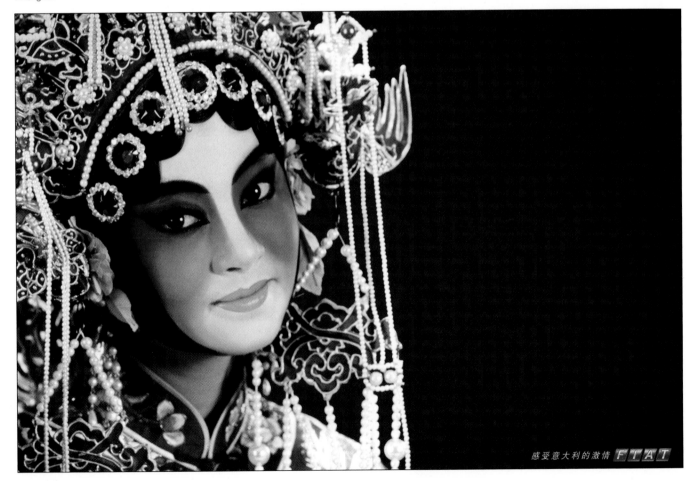

感受意大利的激情 **FIAT**

What is the competition and marketplace?

Know a brand's or group's position in the marketplace. Know the competition and how they have solved similar problems (to avoid solving it the same way). You want your design solution to differentiate the brand or group, and you do not want it to be confused with the competition.

What is the context?

Find out where (environment, circumstance), how, and when a design will be seen. For example, there are innumerable books on bookstore shelves and on display. John Gall's beguiling combination of imagery and colors for this cover design (Figure 2-4) would stand out.

In what voice?

Each graphic design solution communicates a personality or has an expressive voice, which should be consistent with the overarching strategy.

Make a list of descriptive words that you would use to describe the brand or group. These words may help you establish a personality or voice for a new brand or group, or be consistent with the determined voice for an established brand or group.

What kind of response is desired from your audience?

If you can get the audience to react, to feel, to think, then you have made a connection with them—you have communicated.

Concept

A concept lays the foundation for any design solution. The **design concept** is the creative solution to the design problem, the underlying thought or reasoning for how you design a piece—the primary idea behind the piece. Essentially, it

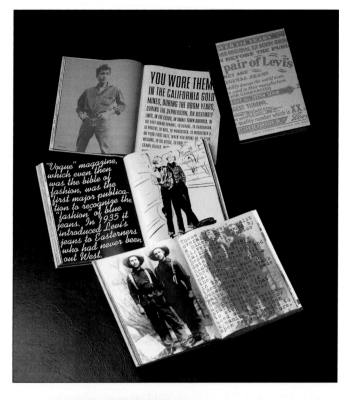

Figure 2-3
Book: Levi's Jeans
Design firm: Morla Design, San Francisco, CA
Art director: Jennifer Morla
Designers: Jennifer Morla and Craig Bailey
Client: Levi Strauss & Co.

"This is a pair of Levi's jeans... is the definitive history of the Levi's 501 Brand. The book lavishly illustrates the past 140 years of Levi's 501 jeans with the people, places, movements, and marketing that turned one brand into an American icon.

Eclectic typography, historic letters, western imagery, and pull-out spreads add to its visual interest. What began as a small project turned into a 300-page book of which Morla Design handled all aspects of production, from concept inception to delivery of 40,000 books."

—Morla Design

Figure 2-4
Book cover: *Love in the Time of Cholera* by Gabriel García Márquez
Art director/Designer: John Gall
Publisher: Vintage Books

Suggestions for Ideation

Formulating a design concept is part of the designer's problem-solving task. It is something you are trained for in school and become proficient at through practice. You will learn to rely on your intuition, intellect, training, and experience.

Brainstorm. Make a list of anything and everything related to your subject. If you do not want to do it alone, get someone to talk it out with you. Brainstorming may conjure up some ideas or visuals that can lead to other ideas.

Gather even more information. Knowing your subject inside and out will inevitably trigger ideas.

Play with visuals. Find some visuals related to your subject. Don't design them—play with them. Try **cropping** them. Cut them up and reassemble them differently. Change the colors. Add textures. Combine images. Use paper that you would not ordinarily consider. Be adventurous. (This suggestion may foster ideation; it is not a conceptual platform.)

Get some visual stimulation. Go to the movies. Look at old or antique labels, woodcuts, etchings, typefaces, and drawings. Go to a museum or gallery. Look at award-winning designs in visual communication magazines or annuals.

Think of the wrong answer. You are probably so worried about the right answer that you cannot find it, so try to find the wrong one. At least you will know what not to do.

Let it be. Get away from it. Take your mind off the work itself. Take off a few days before returning to ideation and sketching. Sometimes concepts come to people when they are relaxed or doing something unrelated to their assignment.

Change directions. If you have been exploring one avenue of thought and nothing is happening, drop that direction and explore a new one. Try not to get stuck in a line of reasoning or in anything if it is not working for you. Go in a totally different direction to find a concept.

Creative approaches can yield exciting results during idea generation. They are not suitable for every concept, brand, or group, even though they are very elastic. The following creative approaches are taken from Chapter 11, where they will be repeated with visual examples (Figures 11-35 through 11-43):

• *Reverse things and statements.* Look at something in a mirror. Turn a mouth upside down. Reverse a popular phrase.

• *Merge things.* Bring two different things, images, or objects together to make a new one. Merge a tennis ball and a croissant. Merge a fish and a carrot.

• *Use a strange point of view or angle.* View something from an unusual or unexpected angle.

• *Compare things.* This could be pastimes or unlike objects, such as socks and cacti.

• *Devise a visual surprise.* Create a visual that will make viewers do a double-take.

• *Personify things.* Give inanimate objects human qualities.

means you have a reason for what you are doing, for the imagery, the colors you select, for cropping something, or for using a particular font. The design concept is the framework for all your design decisions. (Absolutely, this explanation does not exclude the value of any designer's intuitive choices.) A concept is expressed through the selection, creation, combination and arrangement of visual and verbal (typographic) elements. Successful concepts are fresh, relevant, and effective. (Designers tend to use the word "concept" and advertising creatives tend to use the word "idea" to mean the same thing.)

A graphic designer formulates a creative idea—a design concept—and gives it visual form. How do you come up with a concept?

It can happen in a variety of ways. Sometimes you immediately visualize a solution in your

mind; at other times, you may struggle until the last minute. There is no one way to find or formulate a design concept; it is a very individual process. There are, however, steps that designers take to work it out. It all begins with knowing what needs to be accomplished by defining your strategy. Most designers start sketching in order to develop ideas. Some make lists or just write.

Design

Designing demands conceptualization and visualization, and, very importantly, the *integration of the concept and visual elements*. You need to create and/or select visual elements that will comprise your design, and that will express and effectively communicate your design concept.

Visual Elements

Every graphic design project exists in some type of media or carrier. And every design solution involves visual elements; they are type and visuals.

Graphic designers and advertising art directors design with type. Almost always, type is computer generated. A designer can render type or create hand lettering, as well. Type communicates both literal messages and connotative messages to a viewer. Designing with type seems to be the most challenging part of graphic design for most beginners. (See Chapter 4 on Typography.)

A graphic design solution expresses an idea in visual form. In combination, visuals and type are integrated to communicate messages and meaning to an audience. There are basically four types of visual elements available to designers:
• Type: computer generated, custom, or hand lettering
• Photographs: custom or stock
• Illustrations: custom or stock
• Graphics: custom or stock (includes visual elements such as borders, arrows, bullets, graphic illustrations, charts, and graphs)

One can create original visuals, select visuals from stock photography and stock illustration, or hire illustrators and photographers to create custom images. Some graphic designers create their own graphics, illustrations, lettering, and photographs. A designer also can hire a type

designer for custom typographic treatments and/or hand lettering. At times, photographs or illustrations are supplied by the client.

Students usually do not have the resources to buy visuals or hire professionals, so many students take their own photographs and create their own graphics or illustrations. It is perfectly acceptable to use found visuals and select stock photography; professionals looking at your portfolio understand the constraints of a student's budget and resources. It can be just as effective to demonstrate your ability to select appropriate stock photography or illustration.

It also is advisable to have some solutions that demonstrate your ability to create visuals. Visuals can be combined or modified to create unusual or hybrid imagery. Deciding which type and style of visuals to use, and whether to create new or locate stock ones is usually determined by objectives, skills, concept, resources, and appropriateness to the design concept.

The way elements are combined visually and conceptually not only communicates a message, it can also convey greater meaning.

Many students ask about developing a personal design style. "A style is like a language, with an internal order and expressiveness, admitting a varied intensity or delicacy of statement," stated Meyer Shapiro in his quintessential article entitled "Style." Luba Lukova, designer and illustrator, has an immediately recognizable and unique style; her particular way of rendering form, drawing with lines inside solid forms, and her corresponding

Figure 2-5

Poster: *Virgil*

Design studio:
Luba Lukova Studio,
New York, NY

Designer/Illustrator:
Luba Lukova

Client: Theater for
the New City

Notice how the linear
elements used to
delineate the details
of this illustration
brilliantly correspond
in quality to the type
in this theater poster
for a play by Victoria
Linchon presented by
the Theater for the
New City.

typography/lettering and compositional ideas all contribute to her style (Figures 2-5 and 2-6). **Style** is a designer's individuality expressed through interpretation of the concept and the graphic elements; it is the quality that makes something distinctive. The best way to learn about style is to study the history of graphic design, fine art, and the lives and careers of other designers. There are excellent texts available on the history and development of style in graphic design; refer to the bibliography in this book.

Solving a Design Problem: Process and Phases

When you solve a graphic design problem in a routine way, you are merely getting the job done. When you go beyond a perfunctory solution, you can be expressive. It is possible to present a personally expressive point of view while meeting your design objectives and solving your design problem.

For an aspiring designer, it's difficult to know how to begin solving a design problem. How do you get an idea? Do you first create a visual? Do you start with font selections? Most successful designers take a design problem through phases of development. The following general guide will help you become familiar with the design process and the phases of design development.

Step 1: Understand the problem.

Fully understand the assignment and the goal. Ask as many questions as you need to be on track. Some possible questions you can ask are:

• Who is the audience?

• What is the competition?

• When and where will the project be seen?

• What message needs to be communicated?

• Which media would be best suited to communicate the message?

• What image should this piece project? (For example, an image might be bold, high-tech, corporate, or funky.)

• What particular types of positive responses are desired from the audience?

Once these and other basic questions are answered, create a list of objectives that are simple and clear. Write the goal or problem on an index card and keep it in front of you so you can easily evaluate your solution for relevance to the project or assignment.

Step 2: Gather information.

Information gathering is essential. Conduct research at the library or Internet, and cross-reference what you find. Obtain information, photographs, and materials at this stage of the process. Information gathering is crucial, and most students mistakenly think they can do a good job without it. Researching your topic will provide many points of departure that might not immediately have occurred to you. Finding photographs and visuals that relate to your assignment is extremely useful. A professional assignment would involve obtaining as much information from the client as possible. Often, information obtained from the client is supplemented by a designer's or firm's own research.

Step 3: Think by sketching (and writing).

Most of the time, sitting and thinking is not enough. For many designers, ideation happens when they are sketching. Finding fresh design concepts is very difficult. The process of

sketching will allow your research and strategy to take visual form. Or write a descriptive paragraph; words can lead to visuals.

One visual leads to another. The initial quality of your first sketches doesn't matter—just start sketching. **Thumbnail sketches** are preliminary, small, quick, unrefined drawings of your ideas, in black and white or color. Create many. Judging your sketches at this stage may inhibit your creative energy—just keep sketching.

Thumbnail sketches allow you to think visually. Coming up with many thumbnail sketches may be frustrating at first, but the process will become more natural. (Unfortunately, many beginners are happy with their first and, often, only sketches.) The point of this phase is to generate as many different ideas as possible. Jose Molla, creative director of La Comunidad in Miami, advises: "The difference between bad and good creatives is that they both come up with the same pedestrian solutions, but the bad creative stops there and the good creative keeps working toward a more unique and interesting solution."

You can create thumbnail sketches by hand, usually with a fine-point marker on paper, or you can go straight to the computer. If you do work on the computer, at this point make sure that you sketch rather than create a finished piece. Print out your sketches so that you can look at them in a different environment.

Step 4: Choose your best thumbnail sketches and turn them into roughs.

Roughs enable you to visualize your ideas more fully. **Roughs** are sketches that are larger and more refined than thumbnails and better represent how all the basic elements will work in a design. They should be done to scale and in the right proportion. Roughs allow you to test ideas, methods, techniques, tools, and colors. (Although some designers go directly from thumbnails to comps, it is better for students to work out their ideas more fully before going to a comp.)

Here, type is rendered or generated so that specific decisions about the appropriate font, spacing, and sizes can be made. Colors are clearly indicated. Imagery is clearly conceived or

Figure 2-6
Poster: Avila/Weeks Dance
Design studio: Luba Lukova Studio, New York, NY
Designer/Illustrator: Luba Lukova
Client: Pace Downtown Theater

chosen. Everything is specific enough to make a decision about which concept, composition, type, and visuals work. Most people create their roughs on the computer and because of this, a rough tends to look like a finished piece. Even though a rough may look slick, it is not finished at this point. The purpose of this stage is to flesh out a few of your best ideas—to work on each concept and how it is executed using type, visuals, and layout.

The client does not see this phase. Roughs are only for use by the designer and/or design director. A client is shown a more refined final comp.

Work your concept out in thumbnail sketches and roughs. If a concept does not work as a sketch, it certainly will not work as a comp.

If the thumbnails you have chosen to turn into roughs do not work, go back over your other thumbnails and turn some of them into roughs. Here's a tip: It is a good idea to wait a day or so between creating roughs and creating comps. The time in between will give you a fresh perspective on your work.

Step 5: Choose your best roughs and turn them into comps.

A **comp** or **comprehensive** is a detailed representation of a design; comps usually look like a printed or finished piece. (Keep in mind, color comps generated on an office or home ink-jet printer will vary a good deal from color printed by a professional printer using printing inks). Type, illustrations, photographs, paper stock, and layout are rendered closely enough to the finished product to convey an accurate impression of the printed piece. Every line of type should be adjusted, all the letterspacing considered.

The term **mock-up** or **dummy** is used to describe a facsimile of a printed three-dimensional design piece.

A comp is important; it represents your solution to the design problem before it goes public, before it is printed or viewed digitally or in any other media. Your presentation must hold up to professional industry standards. It must be extremely clean and accurate. Remember, a presentation represents you and your work. You want people to notice your idea, not your fingerprints or uneven cut marks. A comp is first presented to your design director or creative director and, if approved, it is shown to the client. Very often the comp is used as a guide or "blueprint" for the printer.

Production

If you are working on a paid job for a client, the next step is to produce your design solution. This is called **production**, which is usually preparing the electronic file, collecting all needed photographs and/or illustrations and having them scanned, and then proofreading (with or without the client) and working with the printer. The designer must create meticulous digital files and give explicit instructions to the printer, check laser proofs and other prepress proofs, and deliver the job to the client.

A design solution must be prepared in the form of digital files. All visual elements—photography, illustration, and fonts—must be prepared properly in order to ensure successful printing or digital loading.

A comp is important; it represents your solution to the design problem before it goes public, before it is printed or viewed digitally or in any other media.

The technical skills one needs for creating a comp are somewhat different from the ones needed to prepare a file for the printer. Many students and designers work in imaging or drawing software to create comps. For the printer, almost all files should be prepared in layout programs. (For a fee, most printers can prepare your files, if you cannot.) Also, one must learn to properly prepare font and label folders. This book does not attempt to cover the intricacies of print or web production; those are different areas of study. However, advice on working with a printer and information about paper are included.

The following are steps for preparing an electronic file:

1. Produce the overall design in a page layout program such as QuarkXPress or InDesign. This file will serve as your mechanical for printing.

2. If there is text (even a few paragraphs), you may want to produce that in a word processing program like Word, and bring it into the layout program. Plus, for larger jobs, the Word files can be coded and formatted for easier transition into QuarkXPress or InDesign.

3. Create all necessary art in Adobe Illustrator or Photoshop, but make sure that your layout program will read the kinds of files that these applications produce. Also make sure that the files use the same colors as your layout program.

4. Most printed work is either black-and-white, flat or spot color (Pantone selection), or full color (CMYK selection). On-screen color is handled differently in each case, so again, check with your printer to make sure you are placing color in images and type using the correct method. Most print color work is broken down into CMYK (as opposed to RGB on computer screens), while Pantone is better for two colors or spot color. Also, color management tools in QuarkXPress, InDesign, Photoshop, and Illustrator can help the process. Again, checking with your printer for specifications is important when color is critical.

5. You may also scan photos or other artwork for use in the layout. Issues here relate to the resolution of the image, the size of the image, and the type of image file created. The rule of thumb is 300 dpi at 100 percent. Usually, Adobe Illustrator EPS (Encapsulated PostScript) files,

with all colors converted to CMYK and all fonts converted to outlines, or Photoshop TIFF (Tagged Image File Format) files are preferred. *Check with the printer* to make sure you are handling all this in the most effective way!

If your document is to be printed in four-color process, save the file as CMYK (either TIFF or EPS). If your document is to be printed in Pantone colors, save the image as a grayscale TIFF and apply the Pantone color to the image in QuarkXPress or InDesign. Place or import all illustrations at close to 100 percent size.

Please note that images can be scanned as low-resolution files and sized for position only (FPO) in the page layout program. At an additional cost, the printer can rescan and replace the images as high-resolution files prior to printing.

It is now very common for designers to provide high-resolution PDF (Portable Document Format) files to the printer. Using this method, designers don't need to send fonts and linked images—these files are automatically embedded in the high-resolution PDF file. The book you are now holding was produced in this way.

6. Proof your job with ink-jet printouts or, if possible, color laser printouts, which give a higher-quality product. These can be shown to a client for approval. Also, contact the printer to see what kind of proof you can get to check the job before it is actually printed.

For some jobs, designers require high-resolution proofs that they can review and approve. Those proofs, if approved, are then given to the printer's pressman so that he or she can match the quality.

7. When you submit the job to the printer, make sure you have all the necessary parts and pieces. This normally includes a layout, image files, and all font files used in the document. There are two formats for type files: TrueType and PostScript. If your type is in the PostScript format, make sure you have both the bitmap file and the printer file for each typeface that you use. Some printers do not accept TrueType fonts, as these fonts may cause on-press problems. Follow these guidelines to ensure that the printer will have everything he or she needs to reproduce the image correctly.

8. Put all the digital material together and burn it onto a CD or upload it to the printer's web site. If you upload it, use a compression program, such as StuffIt or ZipIt, to compress the files into one smaller file. Stuffit and ZipIt are good for avoiding the corruption of files sent via FTP, as well.

9. Submit this along with the best-quality, full-color printout that you can get, to show the printer exactly the way you want the final job to look.

Also submit a page of information that includes the name of the job, the date of submission, your contact information, a description of the job (size and format), what is on the disk (file names), the quantity you would like printed, the date you need the printed job by, and any other special instructions.

Communication with the printer is critical to the success of any print production.[1]

When you submit the job to the printer, make sure you have all the necessary parts and pieces. This normally includes a layout, image files, and all font files used in the document.

Suggestions

Practice ethically. Graphic design communicates messages on several levels. Have a social conscience. Do not employ negative stereotypes. Be truthful. Try to be ecologically aware about paper and waste.

Be willing to modify your original concept or even to hunt for another concept. In the process of working on a design problem, you may need to make changes. This may mean extra work, but if it yields an original or appropriate solution, then it is worth it.

Save your thumbnail sketches. You may need to go back to them if your concept does not work out or if the client or your instructor is not satisfied. If you are working with computer software, print out your sketches, and look at them on paper. It is also a good idea to include your working sketches in a separate binder in your portfolio to further illustrate your abilities.

Execution

Execution is the fulfillment of the concept through physical processes that include the selection and manipulation of materials and/or software.

Craftsmanship refers to the level of skill, proficiency, adeptness, and/or dexterity of the execution. It includes the use of papers, inks, varnishes, cutting and pasting, and software programs. Well-crafted work is always a plus. You might put your whole portfolio on disk or online, but most potential employers will prefer to see hard copies; clients like to see comprehensives or mock-ups (detailed representation of a visual solution that has not been printed or published online). Many people respond to the visceral impact of work. Design solutions should be neat, clean, accurate, functional, and ecologically mindful.

You should familiarize yourself with as many materials, tools, and processes as possible: papers, boards, inks, adhesives, cutting tools, drawing tools (markers, pens, pencils, chalks, brushes, crayons), software programs, and graphic aids. Learn about materials by visiting art supply stores and printing shops, and attend paper shows where you can examine paper samples. Ask questions of sales representatives and printers. Learn about the different types of inks, finishes, and printing techniques. Learning about paper is crucial. When you obtain paper samples, notice how each paper takes ink. (Many designers are seduced by the tactile aspect of a paper and forget to check how it will take ink.) Visit a printer and see how things are done. In addition to the basic materials listed, there is a wealth of presentation materials available. Access to a computer and knowledge of several software programs is essential; you won't get a job without being well versed in every popular program. Learning to cut, glue, mount, and mat are essential hand skills for a design student.

The materials you use, whether for a comprehensive or a printed graphic design solution, are critical to the execution of the design and contribute to effective communication, expres-

Paper tips:
- Consider recycled paper or tree-free papers.
- Consider all paper attributes: finish, weight, and color.
- Understand which paper weights are best suited for various applications.

Tips from Sandy Alexander, Inc. of Clifton, New Jersey:
- Ask "How will this paper hold up for binding, laminating, foil stamping, spot varnish, die cut, or embossing?"
- For a small quantity, the cost is insignificant for a higher-grade paper.
- When choosing paper, look at printed pieces, not just swatches.
- Go to paper shows and get paper promotionals. It will allow you to see how paper takes ink and special printing techniques. Also, there is often an explanation of how it was printed on the back of the promo.

- Paper choice usually represents fifty percent of the cost of the entire printing job.
- Never skimp on paper! Stock will determine how the paper handles the finishing process.
- Coated and uncoated papers take color very differently.
- Think of paper choice and color results together.
- Your choice of paper will affect how the color is reproduced.
- Each paper type has its own limitations.

Paper knowledge supplied by Fox River Paper Co. LLC:
- Whenever possible, buy premium paper. Using lighter-weight papers affects printing results; they may have inadequate opacity to handle solid printed areas, resulting in show-through.
- The quality of the paper dictates the quality of the printing.

sion, and impact. The skill with which you craft your solution and present it can enhance or detract from it.

Presentation—the manner in which comps are presented to a client or the way work is presented in your portfolio—is important. The method of presentation should be determined by the type of work being presented and by whom it will be seen. Do not underestimate the importance of presentation; it is as important as the work being presented. A good presentation can make ordinary work look great, and a poor presentation can make great work look ordinary. Until you prepare your portfolio, the rule is: simple and inexpensive but professional. You will need to spend more money and time to produce the work that goes into your final portfolio.

Suggestions

- Make it accurate. Try to closely capture the colors, textures, type, etc. of the concept you are presenting.
- Make it neat. You want people to notice your design, not how poorly something is cut or pasted.
- Present it professionally. A good and thoughtful presentation can enhance your design solution, and a poor presentation can only detract from it.

Critique Guidelines

A **critique** is an assessment, an evaluation of your solution. Assessing your solution maximizes your learning; it forces you to reexamine the problem, to evaluate the way you went about solving the problem, to determine how well you used the design medium, and to see if you fulfilled your objectives. Most design instructors hold a critique or critical analysis after students create solutions to a design project. Holding your own critique before you present your work to an instructor or a client allows you to check your thinking and gain insight.

Once you finish your graphic design solution, or even while you are creating roughs, you can use these critique guidelines to make sure you are on the right path.

The Project

- Refer to your design brief or written objectives. Does your solution communicate the intended message or information to your audience? Survey people to ascertain the message they are receiving. Did you fulfill the goal or did you miss the point of the original problem? At times, you may come up with an approach to a problem that does not directly answer the problem, but you like it and pursue it regardless. Be aware that sometimes it pays to let go of an approach that is not on target, even if you love it.
- How well does your solution fulfill stated objectives?
- Did you create a hierarchy of information? Can information be easily gleaned?
- Did you successfully integrate the concept with the visual elements?
- Is it appropriate for the brand or group? Often, it can be difficult for beginners to determine when a design or a design element is appropriate. Think of how your solution communicates the brand or group essence, or how it communicates information. For example, if you design a business card for a banker, you certainly would not want to create a design that conveys a whimsical or unstable spirit.
- Is your solution appropriately executed? Is your choice of color, paper, media, size, and style right for the purpose or goal of the problem?
- Is the audience enriched by their experience with your solution?

Assessing Your Process

Did you gather enough information?

How many thumbnail sketches and roughs did you do before creating the comp? How much time did you spend thinking about the problem?

Did you lock yourself into your own area of strength rather than experimenting with less familiar tools, techniques, or methods? For example, if you always use software to create your design, were you willing to create it by hand? Did you make any assumptions about what you could or could not do? Experimentation is very

important; it can lead to exciting discoveries. Even mistakes can yield interesting results.

Did you really become involved with the problem? Did you use your intuition? Was your solution personal or removed? Not everyone finds the same subject matter or project exciting. Remember, it is not whether the subject or the project is exciting or dull, it is how you solve it.

Did you give yourself a chance to be creative? Were you patient with the project and with yourself? Try to be as supportive of your own work as you would be of a friend's work.

Did you take chances? Were your solutions fresh or pedestrian? Is the design in your own style or have you tried to emulate someone else's? You've heard it before, but it is worth noting: zig when everyone else zags. When the critique is held in class, one way to test whether your solution is original is to notice how many others came up with similar solutions.

Did you make good use of materials? Is your comp well crafted? Presented professionally?

Professor Barbara Goodman of the Graphic Design Department at the Art Institute of California–Orange County, Santa Ana, California, recommends creating a list of the formal elements and principles of design as a checklist to make sure that each one has been addressed as fully as necessary to create a cohesive solution.

This critique guide is placed in this chapter so you can use it for all the projects in this book. It will make a great deal more sense once you actually apply it to your solutions. Make a photocopy of this critique guide so that is always handy. The process of assessing other people's work and your own will become more natural with practice. You can learn an enormous amount about graphic design by assessing how others have successfully solved the same problem. Did they approach the problem the same way you did? What did they do differently?

Another way to improve your analytical skills is to assess the professional work you see, from logos to web sites. The best way to learn design is to learn to think like a designer. You need to question and experiment. Ask: "Why did the designer arrange the elements on the page like that? Why did the designer choose that color palette? Why that font or combination of fonts? Does the design solution work? Does it communicate?" Learn to constantly dissect the designs you see.

One of the advantages of studying graphic design is that you are surrounded by examples, both good and bad. Turn on the television and you see commercials; try to discern the pedestrian from the effective. Open a newspaper and look for thoughtful editorial layout (Figure 2-7). Take a drive, and you see outdoor boards. Go to paper shows and pick up paper promotionals designed by outstanding designer firms (Figure 2-8). Look for experimental design solutions (Figure 2-9). Become a critical observer—you can always learn something through observation.

Suggestions

There are many schools of thought and movements in graphic design. Movements and collectives in music, politics, popular culture, literature, and fine art, and influences from different cultures, countries, and technology all affect graphic design and designers. Some famous designers have rules about design; some say there are no rules and if there are any, they should be broken. Novices and students, however, need a point of departure. Here are some useful suggestions:

• Stay in touch with contemporary culture. It is important to be aware of what is going on in the world in terms of style and content.

• Be eclectic. Look to many time periods and to world culture for inspiration. Stay current with movements and research in typography.

• Stay current with technology and tools. If you reject technology, it should be by stylistic choice, not by default.

• Learn the history of art and graphic design to understand style and movements. Know what is possible, what has happened, and why it happened that way.

Figure 2-7
Newspaper layout:
"Circuits" section of
The New York Times
Design firm: Steven Brower
Design, New York, NY
Art director/Designer:
Steven Brower
Illustrator:
Kati Beddow Brower
Photographer:
Naum Kazhdan
Client: *The New
York Times*

Figure 2-8
Promotion book: "Fluff"
Mohawk Paper
Design firm: The Planet
Design Company,
Madison, WI

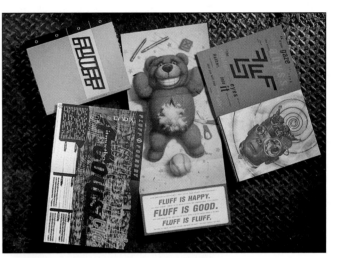

Figure 2-9
Book spread:
French Fries
Designer/Co-author:
Warren Lehrer
Co-author:
Dennis Bernstein
Client: Visual Studies
Workshop

"This double-page spread
from *French Fries* shows
how each character is
typecast into a distinct
color and typeface."

—Warren Lehrer,
Designer/Co-author

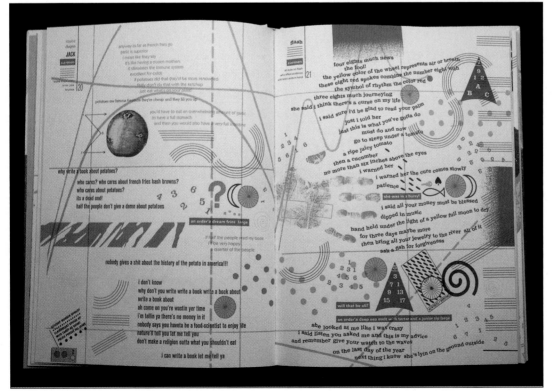

Keep a Source Book

It's a good practice to keep an idea and source book, which is a collection of art reproductions, illustrations, photographs, advertisements, graphics, graphic design solutions, printed paper samples—any imagery you find stimulating and exciting. You can use this collection of materials as a source book if you need references in order to create your design or if you need stimulation. Denise M. Anderson, president/creativity and design strategist of Design Management Associates (DMA), keeps a filing cabinet filled with clippings she calls her "inspiration files." These folders comprise fifteen years' worth of colors, type, textures, images, and formats. Anderson says, "Because of my clip files, I never feel like I am starting a project from scratch." Remember, an idea book is not for the purpose of plagiarism—it is for inspiration and reference. The inspirational imagery you keep in your source book should be varied, and it does not have to be graphic design. In fact, a wide range of visuals—photographs of anything from Venetian chimneys to ephemera, old machines, Chinese Tang dynasty earthenware, and Peruvian ancient textiles—anything of interest can activate ideation or help you solve a design problem.

Regardless of the specific task, the graphic designer has two interconnected goals: to communicate a message to an audience, and to create a compelling design that will enhance the message. That hasn't changed over time, whether you look at historical work (Figure 2-10) or work by contemporary designers (Figures 2-11 and 2-12). Like other communicators, the graphic designer works to make the message clear and, like any other artist, the graphic designer is concerned with visual expression. Whether these goals are achieved depends on how well the designer understands the design medium and the design problem.

And to be a successful visual message maker, you must learn by doing.

Summary

Each graphic design solution requires problem-solving, ideation, designing, and an effective outcome, requiring five basic components: strategy, concept, design, production, and execution.

To set strategy, visual communication professionals work with a design brief, which is a master strategic plan. The design brief helps form the platform for concept generation. A design concept lays the foundation for any design solution; it is the underlying thought or reasoning for how you design a piece. Essentially, a concept means you have a reason for what you are doing, for the imagery, the colors you select, for cropping something, or for using a particular font. Idea generation is crucial to the design process and, in this chapter, methods were presented that are practiced by many professionals.

Figure 2-10
Poster: "Concerts," Ballet for London Transport, unpublished
Date: 1936–37
Designer: Abram Games
© Estate of Abram Games

Designing demands conceptualization and visualization, and the *integration of concept and visual elements*. You need to create and/or select visual elements that will comprise your design, express your design concept, and effectively communicate it. This chapter demystifies the design process and phases of design development.

Although students sometimes can't afford to buy visuals, they do have several options for creating effective comprehensive solutions. Execution is the fulfillment of the concept through physical processes that includes selection and manipulation of materials and/or software. Craftsmanship refers to the level of skill, proficiency, adeptness, and/or dexterity of the execution. Familiarize yourself with as many materials, tools, and processes as possible. Visit paper shows; talk with printers. Ask questions of paper company and printing representatives. Even though student work doesn't need to be printed, a student must learn about production, which is preparing the electronic file, collecting all needed photographs and/or illustrations and having them scanned, and working with the printer.

Learn to critique your work to ensure effectiveness. Also, it's a good practice to keep an idea and source book, which is a collection of any visuals you find stimulating.

Notes

[1]Information is based on the collected expert advice of Liz Kingslien, Lizart Digital Design; Larry Main, production manager, Thomson Delmar Learning; Laura F. Menza, art director, LFM Design; Alan Robbins, creative director, Design Studio at Kean University of New Jersey; Thomas Stover, production editor, Thomson Delmar Learning; and the author.

FREECOUNTRY

Figure 2-11
Book cover: *Up in the Air* by Walter Kirn
Art director/Designer: John Gall
Photographer: Stephen Swinteck, Getty Images
Publisher: Anchor Books

The flight attendant's missing head cleverly alludes to the main character's job, as well as his sense of dislocation. Our perspective is the main character's perspective—from an airline seat. The main character's goal is to accumulate a million travel miles.

Figure 2-12
Logo
Design firm: Rizco Design, Manasquan, NJ
Creative director/Art director/Designer: Keith Rizzi
Illustrator: Keith Rizzi
Client: Freecountry Apparel

Christopher J. Navetta

Christopher J. Navetta, an alumnus of Kean University of New Jersey, is a freelance graphic designer who works in print as well as new media (digital video and 3-D rendering). His short but remarkable career has included published book covers, album covers, press kits, interior book design, and comic books, as well as stopping bad guys in Gotham City.

Designing for Print

As conscientious designers, it is our job to see a project through to the end, ensuring the best possible product for both our clients and our portfolios. Accomplishing this means following a multistep cooperative process which involves you, your client, and the service provider—more commonly known as the printer.

When choosing a printer, it's a foregone conclusion that you should know your project's needs. A small neighborhood business might be fine for popping out some business cards, but bigger jobs require bigger service providers. What kind of equipment does the printer use, and how does that affect output? Get samples of the printer's work to see where their strengths (and potential weaknesses) lie.

Printers build reputations like any other business. Ask around and get opinions from other designers and production people. If at all possible, tour the facility and meet the people you're going to be working with. Get to know the people in prepress and make sure that you're all comfortable with system and software variables. Once you've found your printer, the most important step then awaits you.

Building a relationship with your output provider can be the most crucial step in realizing any design or project. Effective communication is key. No technical issues can be handled, no design questions can be answered, and no progress can be made unless you build a positive working interaction with the printer. There was even a relationship that needed to be built for the writing of this article, and I am indebted to the staff at Sandy Alexander, Inc. of Clifton, New Jersey—one of the country's most respected printers, that works with most of the leading design agencies—for providing a wealth of invaluable information.

This communication process absolutely must begin before you get deep into a project. You are designing for output—which means that cost, quantity, quality, and time will all affect what and how you design. Howard Swerdloff, vice president of Production and Prepress Services, stresses that you should communicate "early and often about everything: your budget, expectations, and end-use." This dialogue must be an open one, not only with the customer service representative at your printer, but also with anyone who will be working on the mechanical end of your job. Your customer service rep should act as a bridge between you and the technical people.

Vice president of Corporate Communications Printing Lawrence Westlake puts it very simply: "The more information given to the printer up front, the better the project will turn out. The printer should be asking you the questions about the design." They will work with you and offer options that might enhance the look or quality of a piece, or maybe even save you money on a job. Knowing their business will enable them to help you in ways that we, as designers, wouldn't normally think of. Simple tweaks or alterations might seem like nothing to us, but "1/8 of an inch might not matter in your

Building a relationship with your output provider can be the most crucial step in realizing any design or project that you create.

design, but may save you $20,000 in the end!" asserts Wendy Pavlicek, director of Supplier Management. Think to ask about cost considerations when using bleeds, varnishes, and special inks, as well as the potential for ganging various jobs to see some significant changes in cost.

Know your software and how to prepare all files for the printer to use. It is not always as simple as having a working knowledge of Photoshop, Illustrator, and Quark. Relatively newer programs, such as Adobe's InDesign, are gathering popularity with printers. InDesign, for example, offers more options than the previous mainstay of Quark does, such as better integration with Photoshop files. What platform you work on is often a consideration as well. Designers traditionally use Macs, but many printers will accept both Mac and PC (Windows) files. With that said, one of the most important factors is font selection and use. Windows and the Mac OS both have TrueType fonts that work within their individual environments, but they do not function as cross-platform items. Moreover, many printers choose to avoid using TrueType fonts altogether, in favor of high-quality PostScript fonts that generally hold together when the file is going through the RIP process. The higher the quality of a font, the better it will set up and reproduce. Different printers have varying preferences, and to clearly understand all these, ask for a spec sheet. This will delineate all the technical specifications you should follow before you begin a job.

With those primary "digital" issues addressed, we then move on to more instantly tangible concerns. What kind of paper will a particular piece be printed on? Different inks take to different papers in all sorts of ways. (Ask what the printer's "house stock" is. It should be top-quality—that can speak volumes about the printer's standards.)

Coated and uncoated papers have different saturations. While you may be attached to a certain texture or finish of a particular paper, it might not always be the best choice to produce images or text in the way you want. And remember that what you do at home or in your office won't be the same as when produced by a large printer. Understand the color gamut of the output device, and always view comps under a consistent source. In fact, the light you view a piece under can seriously change the way colors appear. Always remember, "Lighting, lighting, lighting. Use industry standardized lighting to view your comp," urges manager of Electronic Systems Greg Hill. You can even calibrate your monitor (as closely as possible) to simulate the colors that will reproduce in print. A good relationship with the color manager can help with this.

A final paper consideration may be its weight and feel. Always be realistic about what use your piece is intended for—a thin sheet that might work well for flyers or pages in a book or annual report would not be appropriate for a postcard or mailer or large poster. And what if the paper will need to be folded in any way? Will it bend well, or will it crack or wrinkle and flake off the ink? Can the paper take foil stamping or a spot varnish? Will it hold up when being sent through the mail? Prepress general manager James Gellentienn maintains that, "Each paper has its unique characteristics. Understand the major impact paper has on color." Paper can often make up more than half the cost of a job, and finding out that you've made the wrong decision only after it's gone to press can be costly.

So, learn all you can to prepare yourself for the printing process, and it will undoubtedly progress much more smoothly. Printers should be creative collaborators. And they can be. Knowing how to work with them will help them work with us . . . and that can make all the difference in your designs.

"The more information given to the printer up front, the better the project will turn out. The printer should be asking you the questions about the design."

Lawrence Westlake,
Vice-president,
Corporate
Communications Printing,
Sandy Alexander, Inc. of
Clifton, New Jersey

Formal Elements of Design

Principles of Design

Manipulation of Graphic Space

◀ Poster: *The Tale of the Allergist's Wife*
Design studio: SpotCo, New York, NY
Illustrator: Roz Chast
Designer: Mark Burdett

Objectives

Learn to design with the formal elements of design

Understand the nature of color

See how to employ the principles of design

Realize how to manipulate graphic space

A graphic designer must have a good foundation in two-dimensional design and color. The **formal elements** used as building blocks of two-dimensional design are:

- Line
- Shape
- Value
- Color
- Texture
- Format

Line

When you look at an exquisite linear illustration—for example, the illustration by James Grashow on the package design by Louise Fili (Figure 3-1)—you realize the potential of line as a graphic element.

Let's start with a definition. A **line** is a mark made by a tool as it is drawn across a surface. The tool can be almost anything—a pencil, a pointed brush, a computer and mouse, even a cotton swab. Also, a line is defined as a moving dot or point, and can be called an open path.

There are different types of lines, and all lines have direction and quality. The **line type** or **attributes** refers to the way it moves from its beginning to its end. Lines may be straight, curving, or angular.

The second category is **line direction**. The direction of a line describes a line's relationship to the page. Horizontal lines move across the page, east to west or west to east. Vertical lines move up and down

Figure 3-1
Package design: Margarita Mix
Design firm: Louise Fili Ltd.,
New York, NY
Art director/Designer: Louise Fili
Illustration: James Grashow
Client: El Paso Chile Co.

on the page, north to south and south to north. Diagonal lines look slanted in comparison to the edges of a page.

Line quality refers to how a line is drawn. A line may be delicate or bold, smooth or broken, thick or thin, regular or changing, and so on.

Shape

The general outline of something is a **shape**, also defined as a closed form or closed path. There are many ways to depict shapes on a two-dimensional surface. One common way is with lines.

Lines can be used to describe a flat shape, like a pyramid or a cube. A shape can be open or filled with color, tone, or texture. How a shape is drawn gives it a quality; a shape may be curving or angular, regular or changing, flat or volumetric, and so on.

This method of describing shapes is termed **linear**. We apply this term to art when there is a predominant use of lines to describe shapes or when lines are used as a way to unify a design, as in the poster in Figure 3-2. In Figure 3-3, the illustration for the moving announcement for Authors & Artists Group is linear; lines are used to describe the objects and map and to unify the illustrations.

There are ways other than using lines to create shapes on the two-dimensional surface. An area of color (or an area of gray created by black and white) that is not surrounded by a line, yet is clear and distinct, is considered to have a hard edge and can define a shape, as in the graphic identity by Harp and Company (Figure 3-4).

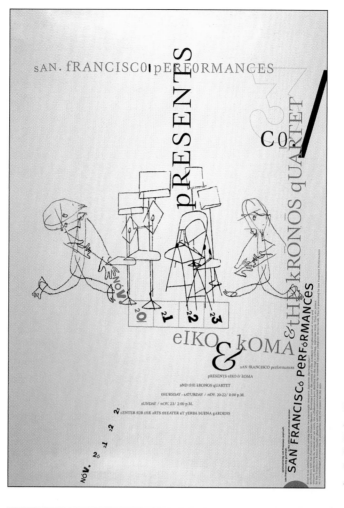

Figure 3-2
Poster: *San Francisco Performances*
Design firm: Jennifer Sterling Design, San Francisco, CA
Art director/Designer/Illustrator: Jennifer Sterling
Copywriter: Corey Weinstein
Client: San Francisco Performances

Figure 3-3
Announcement
Design firm: The Valentine Group, Inc., New York, NY
Client: Authors & Artists Group

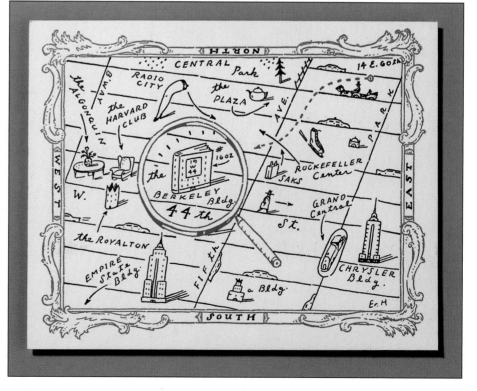

Figure 3-4
Graphic identity
Design firm: Harp and
Company, Hanover, NH
Designer: Douglas G. Harp
Client: Coyote Loco
Restaurant and Cantina

"The coyote is a worn-out
cliché, it seems, for all
things—food, clothing,
etc.—to do with the
Southwest. But its
immediate association with
this region is undeniable;
our challenge, therefore,
was to use this familiar
icon, but to somehow give
it a different spin. Here,
the moon that the coyote
is howling at is, in fact,
a hot pepper."

—Douglas G. Harp,
president, Harp and
Company

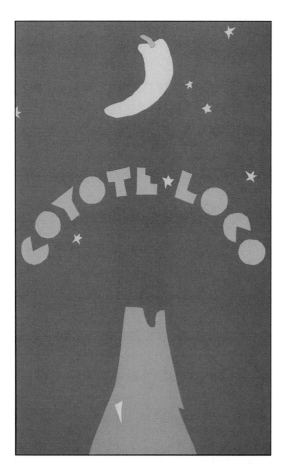

Figure 3-5
Posters: *Couch
Flambeau/P'elvis*
Design firm: Planet Design
Company, Madison, WI
Art director: Kevin Wade
Designers: Michael
Byzewski and Kevin Wade

A set of posters designed
and hand silkscreened by
Planet Design to promote
co-principal Kevin Wade's
band P'elvis.

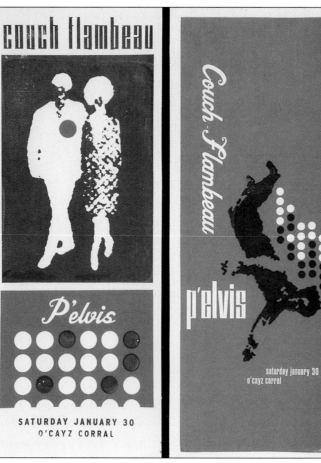

Value

Value describes the lightness or darkness of a visual element.

The relationship of one element (part or detail) to another in respect to lightness and darkness is called **value contrast**. This allows us to discern an image and perceive detail. We need value contrast in order to read words on a page. If the words on a page were close in value to the color of the page, then it would be difficult, if not impossible, to read them. Most text type is black and the page white—it gives the most contrast.

Different value relationships produce different effects, both visual and emotional. When a narrow range of values, which is called **low contrast**, is used in a design, it evokes a different emotional response from the viewer than a design with a wide range of values, or **high contrast**. The high contrast in these posters by Planet Design Company easily captures one's attention (Figure 3-5).

Color

Understanding and utilizing color effectively comes more easily to some than to others; however, one thing is certain—the study of color deserves your attention. It is a powerful and highly provocative design element. Color is difficult to control when creating an original work, and even more so when a work is reproduced in print or viewed on a computer screen.

We can discuss color more specifically if we divide the element of color into three categories: hue, value, and saturation. **Hue** is the name of a color, that is, red or green, blue or orange. Value is the range of lightness or darkness, that is, a light red or a dark red, a light yellow or a dark yellow. Shade, tone, and tint are different

aspects of value. **Saturation** is the brightness or dullness of a color, that is, bright red or dull red, bright blue or dull blue. Chroma and intensity are synonyms for saturation.

To further define color, it helps to understand the role of basic colors called primary colors.

When working with light, the three primaries are red, green, and blue (RGB). For example, color on a computer monitor is produced by mixing light, using the RGB model. Mix red and green and you get yellow. Mix red and blue and you get magenta. Mix green and blue and you get cyan. These primaries are also called the **additive primaries** because when added together, in equal amounts, red, green and blue create white light (Figure 3-6). When working with a computer's color palette, you can mix millions of colors. However, it is very difficult, if not impossible, for the human eye to distinguish the millions of tones and values created by the additive primaries on a computer.

Subtractive color is seen as a reflection from a surface, such as ink on paper, or another type of pigment on a substrate, such as paint on a canvas. We call this system the subtractive color system because a surface subtracts all light waves except those containing the color that the viewer sees (Figure 3-7). In paint or pigment such as watercolors, oils, or colored pencils, the subtractive primary colors are red, yellow, and blue. They are called primary colors because they cannot be mixed, yet other colors can be mixed from them. Mix red and yellow and you get orange. Mix yellow and blue and you get green. Mix red and blue and you get violet. Orange, green, and violet are the secondary colors. You can mix these colors and get numerous variations.

In offset printing, the subtractive primary colors are cyan, magenta, and yellow, and black (CMYK), as seen in Figure 3-8; most often, black is added to increase contrast. Using all four process colors—cyan, magenta, yellow, and black—to print a document is called four-color process. Four-color process is used to reproduce color photographs, art, and illustrations. The viewer perceives full color that is created by dot patterns of cyan, magenta, yellow, and/or black.

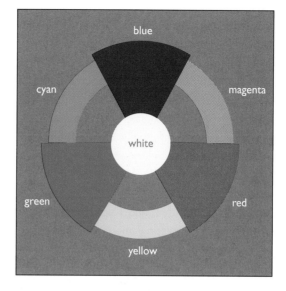

Figure 3-6
Diagram: Additive Color System

The color system of white light is called the additive color system.

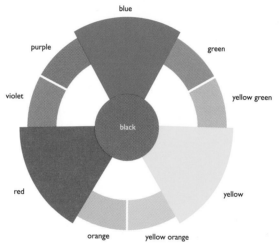

Figure 3-7
Diagram: Subtractive Color System

There are books available that illustrate the various mixtures resulting from mixing two, three, or four process colors.

In offset printing, another way to produce color is by using spot color—a color that is printed with its own ink, as opposed to creating the specific color from process color. Most often, spot color is used when three or fewer colors are indicated in a design. Using more than three spot colors is very expensive. For indicating and creating spot color, a popular color matching system called the Pantone® Matching System (PMS) is used (Figure 3-9). A color matching system is a standard reference used by designers to communicate about color with clients and printers. Using the Pantone® Matching System, a designer specifies colors by indicating the Pantone® name or number. Using a color matching system ensures that the color printed

	C 0 M 100 Y 100 K 5
	C 0 M 10 Y 100 K 0
	C 100 M 10 Y 0 K 0

Figure 3-8
Diagram: Subtractive Primary Hues with CMYK Percentages

In offset printing, magenta, yellow, and cyan are the colors of the process inks used for process color reproduction A fourth color, black, is added to increase contrast.

Figure 3-9
Swatch: Pantone®
Matching System

Pantone® *match color* can be specified by the designer for filling a color area, using the PMS color number. The printer then matches the color by following the ink formula provided on the swatch. Also, "C" indicates coated paper and "U" indicates uncoated paper.

from the digital file is the color intended, though it may look different when viewed on a color monitor. It is always advisable to work closely with a printer to ensure color correctness. Also, it's advisable to investigate the different printing inks available; for instance, nontoxic, nonflammable, and nonpolluting inks are available.

There have been many scientific studies of color, as well as many unscientific theories. (You may want to read the color theories of Josef Albers, Johannes Itten, and Faber Birren.) Most of what you need to know about color and its use in graphic design will come from experimentation, experience with print production, asking printers questions, getting color advice before going to print, and observation. In graphic design, color depends on the use of printing inks, so color choices can be dictated by budget constraints and paper selection, as well as a project's needs.

Allow your design solution to guide your color choices; some colors are more appropriate than others for certain problems and brands or groups. For example, if you were to design a one-color logo for an American insurance company, you probably would not choose pink. In American popular culture, pink may be

thought of as a frivolous color and therefore would not be appropriate.

If you make keen observation a habit when looking at existing packages, posters, web sites, or any other design, it will become an integral part of your design education. You may have noticed that gold, for example, is often used in the package design of cosmetics; it is associated with luxury and quality. Try not to lock yourself into using your favorite colors in all your design solutions. Experimentation, experience, and keen observation will help you develop the ability to use and control color.

Texture
The tactile quality of a surface or the representation of such a surface quality is a **texture**. In the visual arts, there are two categories of texture: tactile and visual. **Tactile textures** are real; we can actually feel their surfaces with our fingers. **Visual textures** are illusionary; they simply give the impression of real textures.

Compare the rough visual textures of the type and visual in the poster in Figure 3-10 to the many intricate visual textures in the package design shown in Figure 3-11.

Suggestions
• Choose colors appropriate for your design concept.
• Select colors that will communicate a brand's or group's spirit.
• Make sure the colors will enhance the readability of the type.
• Establish sufficient contrast to create visual impact.
• Create many color sketches (at least twenty).
• Try to design the same piece with one color, two colors (a limited palette and budget), and then with full color.
• Analyze the use of color in successful contemporary and master design solutions.
• When designing with color on a computer, remember you are looking at a digital

page, and the color will look different when printed on the reflective surface of paper.
• Study the use of color in the history of graphic design.
• Study color symbolism in different cultures. In a global marketplace, it is essential to be familiar with color symbolism across cultures. Color symbolism is not universal— red may mean one thing in one culture and something else to another.
• Don't imitate trendy color palettes. Your work will look like many other design solutions.
• Visit a printer. Go to paper shows. Talk to printers, paper sales representatives, and professional designers about color and paper stock, special effects, special colors, and varnishes.

Figure 3-10
Poster: 50-Mile Fun
Bicycle Ride
Design firm: Studio
Bustamante, San Diego, CA
Designer/Illustrator:
Gerald Bustamante
Client: Bicycling West, Inc.

"The client wanted to add another date to an already established ride, but did not wish to produce a separate poster. In order to convey all that information as simply as possible, I took the graffiti wall approach, painted a tandem bicycle, and surrounded the image with all the pertinent information, as condensed as possible. It is not unlike a wall one might find in Ensenada, Baja California, Mexico."

—Gerald Bustamante,
Studio Bustamante

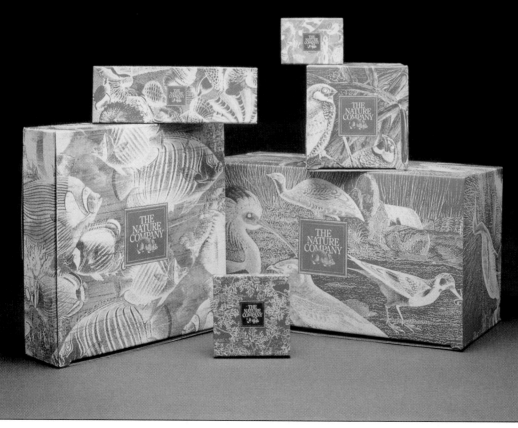

Figure 3-11
Gift box packaging:
The Nature Company
Design firm: Gerald Reis &
Company, San Anselmo, CA
Art director: Gerald Reis
Designers: Gerald Reis
and David Asari
Client: The Nature
Company

Pattern can be defined as a repetitive arrangement of elements, like a wrapping paper design or a plaid shirt. The unique and creative pattern in Luba Lukova's poster is an integral part of the visual message (Figure 3-12).

Format

The **format** is the substrate or support for the graphic design. There are many types of formats and, of course, there are variations within each format. For example, there are a variety of brochures in different sizes and shapes, and each may open up differently. Sometimes a format is predetermined, and the designer has to work within those constraints.

There also may be contextual constraints concerning where and how the design will be seen; for example, magazines are seen up close and intimately, and outdoor boards are seen while driving or walking by and at a distance. Budgetary constraints are always a factor to consider at the outset. One thing you can do is ask the printer if you can save money by selecting a different size paper.

There are standard sizes for some formats. CD covers, for example, are all the same size. Posters have standard sizes; however, you can print a poster in almost any size, too. Any size format is available to the designer at varying costs. Shape, paper, size, and special printing techniques can greatly affect cost. Paper is roughly half the cost of any printing job. Size is determined by the needs of the project, function and purpose, appropriateness for the solution, and cost.

Principles of Design

Moving on to the principles of design entails utilizing the formal elements as a basic vocabulary. You will now be building on that vocabulary. In combination, your working knowledge of the formal elements and principles of design will be applied to each and every design or advertising application.

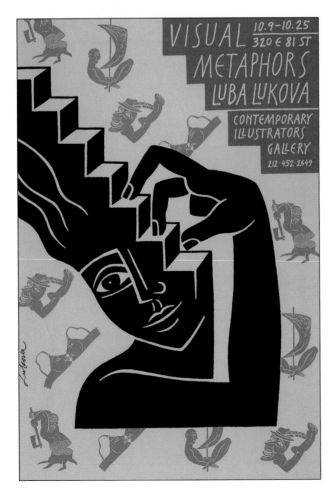

Figure 3-12
Poster: *Visual Metaphors*
Design firm: Luba Lukova Studio, Long Island City, NY
Designer/Illustrator: Luba Lukova
Client: Contemporary Illustrators Gallery

Balance

Very simply, **balance** is an equal distribution of weight. When a design is balanced, it seems to hold together, look unified, and feel harmonious. When a design is imbalanced, it can make us feel uncomfortable. Understanding balance involves the study of several interrelated visual factors: weight, position, and arrangement.

When you make a mark on a page, that mark has a visual weight—it can appear to be light or heavy. **Visual weight** can be defined as creating the illusion of physical weight on a two-dimensional surface. The size, value, color, shape, and texture of a mark all contribute to its visual weight. Where you position the mark on the page also affects its visual weight. The same mark positioned at different points on a page—bottom right, bottom left, center, top right, or top left—will appear to change in visual weight because of its position. In visual per-

ception, different areas of the page seem to carry more or less visual weight.

Symmetric vs. Asymmetric Balance

There are basically two approaches to the arrangement of elements on a two-dimensional format in print or digital media. You can arrange all identical or similar visual elements so that they are evenly distributed on either side of an imaginary vertical axis, like a mirror image. This is called **symmetry**; it is always balanced.

The design of the poster *The Tale of the Allergist's Wife* in Figure 3-13 is symmetrical. Imagine a vertical axis dividing the poster in half; you can see an equal distribution of weight on either side of it.

When you arrange dissimilar or unequal elements of equal weight on the page, it is called **asymmetry** (Figure 3-2). To achieve asymmetrical balance, the position, visual weight, size, value, color, shape, and texture of a mark on the page must be considered and weighed against every other mark. It is almost impossible to list all the ways to achieve asymmetrical balance because every element and its position contribute to the overall balancing effect in a design solution.

Emphasis

How does the viewer glean information from a design? How does a design facilitate communication of information? The viewer—as receiver—depends upon the designer to direct his attention. This brings us to the importance of emphasis in design. **Emphasis** is the arrangement of visual elements, giving stress or importance to some visual elements, thereby allowing two actions: information to be easily gleaned and the graphic design to be easily received.

When you look at a well-designed poster, what do you look at first? You probably look at what the designer determined to be paramount. We call this point of emphasis the **focal point**— the part of a design that is most accentuated. The position, size, shape,

direction, hue, value, saturation, or texture of a component can make it a focal point. The focal point of the poster in Figure 3-14 is the white "c," and the words "new building." We are then led to all the other elements in the design because they have been arranged according to emphasis.

A primary focal point can be established along with supporting focal points, which we call **accents**. Accents are not as strongly emphasized as the main focal point. You first notice the title of the gift portfolio for Country Matters (Figure 3-15) because it is centered, framed, and lighter in value than the rest of the cover. The other typographic and decorative graphic elements— the subtitle, date, and decorative square in the upper left—are all accents.

It is important to remember that if you give emphasis to all elements in a design, you have given it to none of them. You will just end up with visual confusion. Establishing a **visual hierarchy**, which means arranging elements according to emphasis, is directly related to

Figure 3-13

Poster: *The Tale of the Allergist's Wife*
Design studio: SpotCo, New York, NY
Illustrator: Roz Chast
Designer: Mark Burdett

A theatre reviewer, Ronald Mangravite, opined that this play had the "brittle hilarity" of a *New Yorker* cartoon, which is probably why SpotCo enlisted *New Yorker* cartoonist Roz Chast. The center alignment of the typography brings our eye to the main character, a Manhattanite, who is cowering inside a huge shopping bag, sporting her interests and obsessions. This witty poster conveys the underlying humor in the main character's midlife crisis.

Figure 3-14

Poster: California College of Arts & Crafts, *New Building*
Design firm: Morla Design, San Francisco, CA
Art director: Jennifer Morla
Designers: Jennifer Morla and Petra Geiger
Client: California College of Arts & Crafts

The new San Francisco Architecture and Design building
for the California College of Arts & Crafts required
a recruitment announcement poster. The imagery of the
large bolt and energetic typography collide to symbolize
the process of creating the new campus. In addition, the
measuring rules and printers registration bar act as
a metaphor for the entirety of the design disciplines.

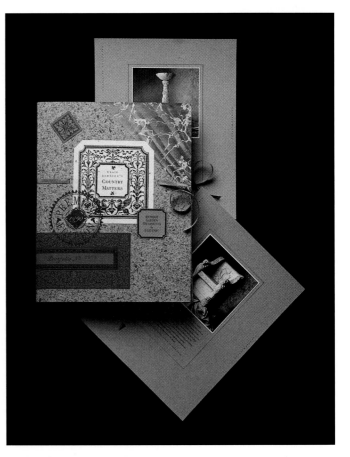

Figure 3-15

Catalog/Gift Portfolio
Design firm: Pentagram Design Inc., San Francisco, CA
Art director: Kit Hinrichs
Designer: Susan Tsuchiya
Photographer: Barry Robinson
Client: Country Matters

"Country Matters is a business that sources unique garden
ornaments from around the world for sale to U.S. clients.
They approached Pentagram for a catalog. The market
is so exclusive, however, that an ordinary catalog would
hardly have been appropriate. Instead, a 'gift portfolio'
was devised.

Each object was photographed and tipped into leaves
of recycled paper with descriptions written in the manner
of an art catalog and printed letterpress. The portfolios
were individually numbered and addressed to clients."

—Alison Merkley, project manager, Pentagram Design Inc.

establishing a point of focus. It goes beyond a focal point to establish a priority order of all the information in a work.

A. Where do you look first?
B. Where do you look second?
C. Where do you look third?

To establish a hierarchy, decide on the importance of the elements that are part of your design. Use factors such as position, size, value, color, and visual weight to make sure your audience sees these elements in the order of importance. Create a flow of information from the most important element to the least. On the annual report cover in Figure 3-16, first you notice the photograph. In fact, your eyes go directly to the hands within the photograph. Then you read "Cancer Care, Inc." and then you go to the last element on the cover.

Rhythm

In music, most people think of rhythm as the "beat"—a sense of movement from one chord to another, a flow, accent patterns, or stresses. In design also, you can think of rhythm as the beat; however, this beat is established by visual elements rather than by sound. **Rhythm** is a pattern that is created by repeating or varying elements, with consideration given to the space between them, and by establishing a sense of movement from one element to another.

The key to establishing rhythm in design is to understand the difference between repetition and variation. Repetition occurs when you repeat visual elements with some or total consistency, as on the CHA CHA poster (Figure 3-17). Several elements—the heads, the repeat of the word "CHA CHA"—create the rhythm along with the background colors and layers. Variation can be established by changing any number of elements, such as the color, size, shape, spacing, position, and visual weight of the elements in a design, as in the CD design shown in Figure 3-18.

Unity

When you flip through a magazine, do you ever wonder how the graphic designer was able to get all the type, photographs, illustrations, and

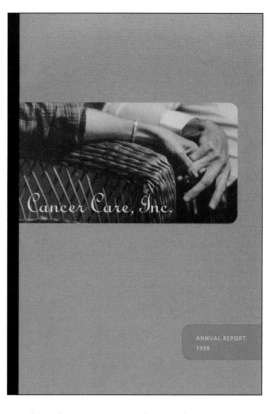

graphic elements to work together as a unit? There are many ways to achieve what we call **unity**, where the elements in a design look as though they belong together. A designer must know how to organize visual elements and establish a common bond among them.

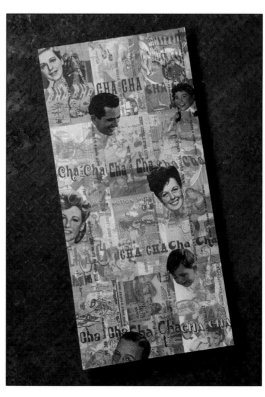

Figure 3-16
Annual report:
Cancer Care, Inc.
Design firm: Lieber Brewster Design, Inc.,
New York, NY
Client: Cancer Care, Inc.

"The special challenges we incurred included a limited budget allowing for three colors and saddle-stitch binding. Also, we were required to use Cancer Care's existing black-and-white photos showing people really touched by Cancer Care, rather than stock photos.

An unusual challenge occurred on press when the solid color on the cover would not print without streaking. Pressmen worked for two days adjusting the press to correct this problem as the creative director stood by. In the end, with the problem resolved, the annual report met the deadline and received compliments from the Cancer Care staff."

—Lieber Brewster Design, Inc.

Figure 3-17
Poster: CHA CHA Beauty Parlor and Haircut Lounge
Design firm: Planet Design Company, Madison, WI
Art director: Kevin Wade
Designer: Darci Bochen

"CHA CHA Beauty Parlor and Haircut Lounge is truly a one-of-a-kind hair salon. To help create a fresh and funky image, we developed this poster. With budget being an issue, we also printed a direct mail campaign on the back of the poster, which was then cut into twelve ready-to-send direct mail cards."

—Planet Design Company

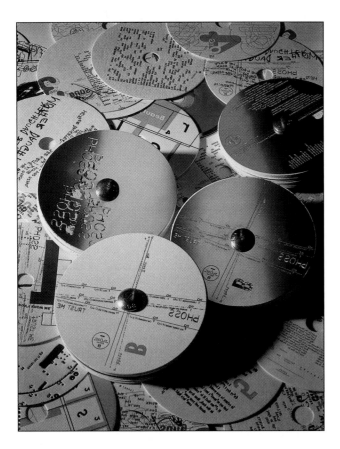

Figure 3-18
CD: Bhoss, *Trust Me*
Design firm: Jennifer
Sterling Design,
San Francisco, CA
Art director/Designer/
Illustrator: Jennifer Sterling
Copywriter: Deonne Kahler

Figure 3-19
Packaging: Bella Cucina
Design firm: Louise Fili Ltd.,
New York, NY
Art director/Designer:
Louise Fili

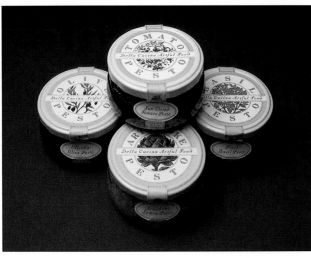

Unity is one of the primary goals of composition—establishing an integrated whole, rather than unrelated parts. The packaging design system created by Louise Fili has unity, as a system and as independent pieces (Figure 3-19). Each package design has unity on its own, through compositional movements—circular movements, in the typography and graphic elements—echoing one another. All the elements are used consistently on each package—typography, illustration, position, composition, and color.

One or more principles (or devices) may be employed to get the desired results for unity. Here are some of them.

Correspondence

When you repeat an element like color, direction, value, shape, or texture, or establish a style, like a linear style, you establish a visual connection or **correspondence** among the elements. To establish correspondence in the folder/poster in Figure 3-20, the designers used several related elements, type, lines, and a grid.

Continuity is related to correspondence. It is the handling of design elements—like line, shape, texture, and color—to create similarities of form. In other words, continuity is used to create family resemblance. For example, if you were designing stationery, you would want to handle the type, shapes, colors, and any graphic elements on the letterhead, envelope, and business card in a similar way to establish a family resemblance among the three pieces.

A certain level of variety can exist and still allow for continuity, as in the CD design in Figure 3-21, where there is both variety and continuity. All the elements are arranged on a central vertical axis on the cover page for Marko Lavrisha's promotional piece (Figure 3-22).

Grid

A **grid** is a guide—a modular compositional structure made up of verticals and horizontals that divide a format into columns and margins. It may be used for single page formats or multipage formats. A grid gives a design a unified look. (The grid is examined in depth in Chapter 5.)

Alignment

Visual connections can be made between and among elements, shapes, and objects when their edges or axes line up (are in **alignment**) with one another. The eye easily picks up these relationships and makes connections among the forms. All the type on the packaging system for Tesco is aligned flush left (Figure 3-23). Besides the type alignment, other design decisions

Figure 3-20
Poster
Design firm: Concrete Design Communications Inc., Toronto, Ontario
Designers: John Pylypczak and Diti Katona
Client: Area, Toronto, Ontario

"Manufactured by Wiesner Hager in Austria, this line of furniture was inspired by the Viennese Secession. The Canadian distributor, Area, needed a vehicle to promote the line. We responded with a two-sided poster that folded down into a 10" x 10" folder. Printed economically in one color, the poster uses quotes by artists and architects of the secession."

—Diti Katona, Concrete Design Communications Inc.

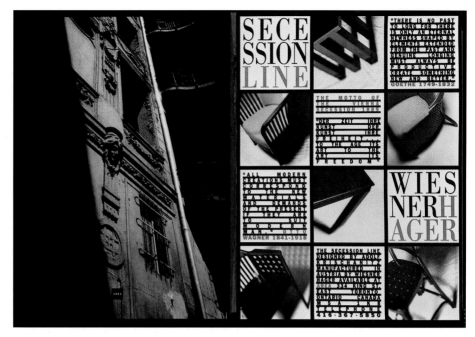

Figure 3-21
CD: Q101, *Ear.Candy.v3*
Design studio: Segura Inc., Chicago, IL
Designer: Carlos Segura
Client: Q101

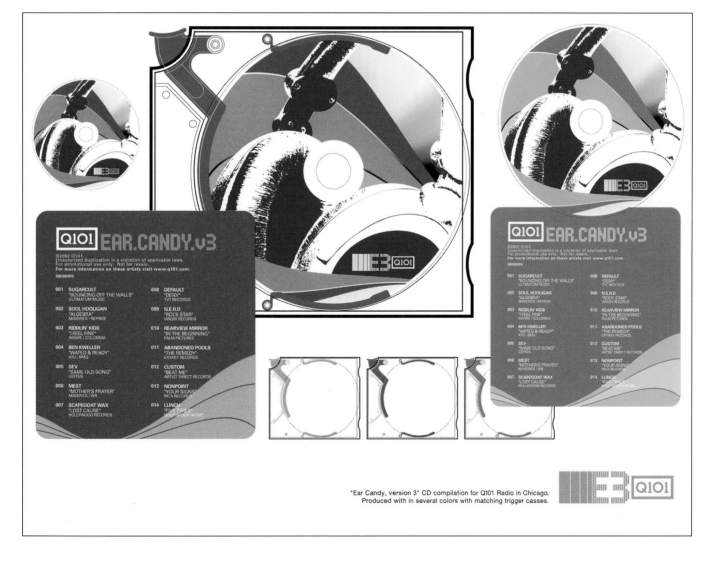

"Ear Candy, version 3" CD compilation for Q101 Radio in Chicago.
Produced with in several colors with matching trigger casses.

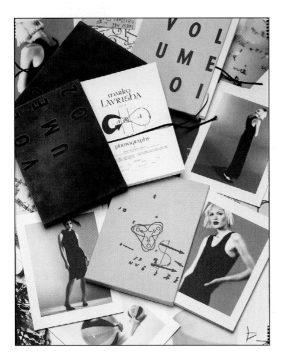

Figure 3-22
Promotional: Lavrisha/La Brecque
Design firm: Jennifer Sterling
Design, San Francisco, CA
Art director: Jennifer Sterling
Designers: Jennifer Sterling
and Amy Hayson
Illustrator: Jennifer Sterling
Photographer: Marko Lavrisha
Copywriter: Eric La Brecque
Client: Lavrisha/La Brecque

The other designs in this
promotional incorporate an
exciting variety of typographic
arrangements, including "Volume
01" and "Volume 02," where the
individual letters are aligned in
vertical rows.

Figure 3-23, top and bottom right
Identity/Packaging: Tesco Finest
Design studio: Pentagram Design Ltd.
Designer: John Rushworth (Partner)
Design Assistants: Kerrie Powell
and Chris Allen
Photographers: Roger Stowell
and James Murphy
Client: Tesco

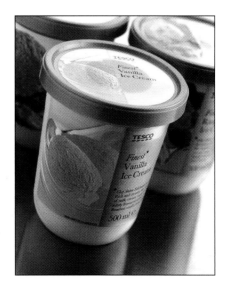

"The U.K.'s leading supermarket
retailer, Tesco, recently launched
a new sub-brand of prepared and
ready-made meals—Finest—with
packaging and identity designed by
Pentagram. The range was devised
to target a new market for the more
discerning customers who require food of
exceptional quality and want a restaurant
experience in the comfort of their own home.

It was important for Pentagram to design packaging that reflected an air of freshness and
quality, personified professional cooking, and positioned the new line above Tesco's current
range of Luxury products.

A two- and three-dimensional visual language was designed using simple geometric shapes
for the structure of the packs, to which clear, elegant graphics were applied.

The packs, predominately silver and black, have an understated quality which was created
by reducing the size of the pictures rather than using full-bleed images often seen on own
brand products. Each pack was divided geometrically, the pictures placed in the top left
corner taking up either an eighth, sixth, or quarter of the whole. The photography has an
editorial style that adds to the refined appearance of the packaging."

—Pentagram

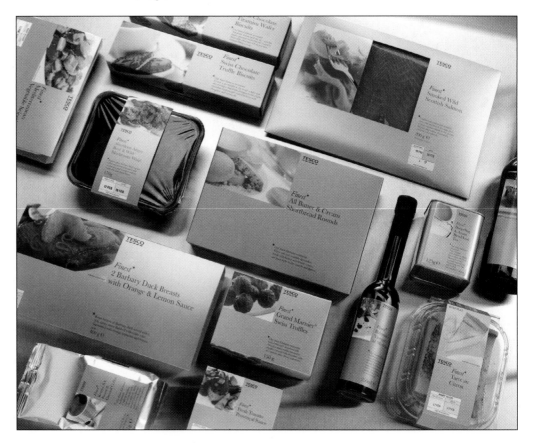

contribute to unity in this design solution—color, fonts, and position of photographs in relation to the flush-left alignment of type.

Flow

Elements should be arranged so that the audience is led from one element to another through the design. **Flow** is also called **movement** and is connected to the principle of rhythm. Rhythm, in part, is about a sense of movement from one element to another. In Jennifer Sterling's signage (Figure 3-24), the arrangement of type and visuals move your eyes from one element to another, across the elongated horizontal format and back again.

Manipulation of Graphic Space

As Nathan Gams, Academy of Design and Technology, McIntosh College, Dover, New Hampshire, pointed out: "A good graphic designer can take the same visual elements (type and images) of a poorly composed design and arrange them to make an effective design simply by manipulating the graphic space."

Positive and Negative Space

In a successful positive/negative relationship, the positive and negative space is interdependent. Considering all space as active forces you to consider the *whole* space. The arrangement of the figures of Godzilla and King Kong in the *Peace* poster (Figure 3-25) creates interesting and powerful negative shapes. The negative shapes are so powerful that they become positive—like the positive message of hope and survival communicated by the design concept.

Figure 3-24
Signage: American Institute of Graphic Arts (AIGA)
Design firm: Jennifer Sterling Design, San Francisco, CA
Art director/Designer: Jennifer Sterling
Client: American Institute of Graphic Arts (AIGA)

Figure 3-25
Poster: *Peace*—Godzilla and King Kong • Commemoration of the 40th Anniversary of Hiroshima
Design firm: Chermayeff & Geismar Inc., New York, NY
Designer: Steff Geissbuhler

"Godzilla is a modern folk hero and a symbol of Japanese superpower, called upon in times of crisis and invasion by other superpowers such as King Kong. Apparently, Godzilla emerged from the volcanic emptiness after a nuclear blast. Therefore, it is even more of a symbol relating to peace. King Kong was used as the American counterpart to Godzilla.

The centered red sun on a white background is another symbol of Japan (Japanese flag, etc.). The color palette of red, black, and white is classic, and typical in Japanese calligraphy, painting, and woodcuts. The red-to-white gradation in the background relates directly to contemporary airbrush techniques frequently used in Japanese design. Meaning of the poster: The friendship of Godzilla and King Kong makes them mightier than any other single beast. Friendship does not mean that one has to eliminate the other. It means coexistence with mutual respect and understanding. Nobody has to be the winner—nobody has to lose."

—Steff Geissbuhler, designer, Chermayeff & Geismar Inc.

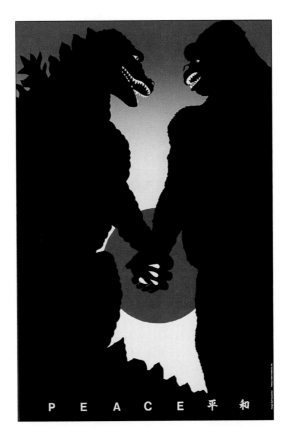

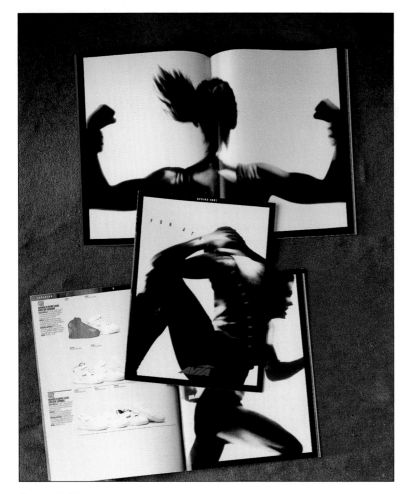

Figure 3-26
Catalog: *For Athletic Use Only*
Agency: Sandstrom Design, Portland, OR
Designer: Steven Sandstrom
Photographer: C. B. Harding
Client: Avia Group International,
Portland, OR

"Avia's advertising campaign used the slogan 'For Athletic Use Only.' The photographic style used in this catalog attempted to reflect the emotions and passion of that positioning line. We specifically avoided 'fashion' shots of attractive models using or wearing Avia athletic shoes and apparel. Through the use of hand-tinted black-and-white Polaroids, we attempted to capture the intensity of sports participation—giving viewers a chance to project themselves into the photos."

—Rich Braithwaite, president,
Sandstrom Design

Figure 3-27
Logo
Design firm: Chermayeff & Geismar Inc.,
New York, NY
Designer: Tom Geismar
Client: The National Aquarium, Baltimore, MD

"The National Aquarium in Baltimore is about fish and aquatic animals, but also about the waters they inhabit. The symbol combines images of fish and water in the figure/ground relationship."

—Tom Geismar, Chermayeff & Geismar Inc.

The cover of the catalog (Figure 3-26), published by the Avia Group presenting its footwear collection for athletes, makes dynamic use of positive and negative space. Notice the loose triangular shapes created within the figure in relation to the format. Both figure and ground—fish and water—are given great consideration in the logo design for the Baltimore Aquarium (Figure 3-27). Tension exists between the negative and positive space because the designer, Lanny Sommese, thought of the figures, objects, type, and background as active shapes in the ingenious poster in Figure 3-28.

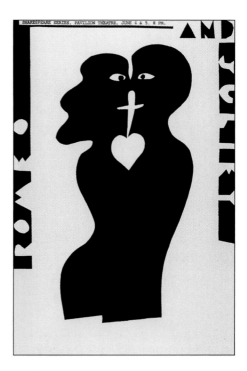

Figure 3-28
Poster: *Romeo & Juliet*
Design firm: Sommese Design, State College, PA
Art director/Designer/Illustrator: Lanny Sommese
Client: Penn State Theater

"The Theater at Penn State needed a poster for the play, quickly and cheaply. I cut image and headline type out with scissors (low-tech). The concept of the play lent itself to boy/girl with the negative areas between becoming heart and dagger. It also seemed appropriate. At the time, everyone seemed to be doing high-tech, computer-generated stuff. I decided to go low-tech. The simplicity of the image also made it very easy to silkscreen."

—Lanny Sommese

Illusion

In general, there are two possibilities when designing a two-dimensional surface: you can keep it flat, or you can create the illusion of three-dimensional space or spatial depth. The illusion of spatial depth can be shallow or deep, recessive or projected.

The size and scale of shapes or objects play an important role in creating the illusion of spatial depth. Used effectively, the size of one shape or object in relation to another—what we call **scale**—can make elements appear to move forward or backward on the page. Overlapping shapes or objects can also increase the illusion of spatial depth. When you overlap shapes, one shape appears to be in front of the other.

Volume, on a two-dimensional surface, can be defined as the illusion of a form with mass or weight (a shape with a back as well as a front). When you set out to do a design on a two-dimensional surface, like a board or a piece of paper, you begin with a blank, flat surface. That surface is called the **picture plane**. It is your point of departure; it is where you begin to create your design.

As soon as you make one mark on the surface of the page, you begin to play with the picture plane and possibly create the illusion of spatial depth. The **illusion of spatial depth** means the appearance of three-dimensional space, where some things appear closer to the viewer and some things appear farther away—just as in actual space.

Think of the common image of train tracks. If you are standing on train tracks, the tracks appear to converge in the distance. You know the tracks do not converge, but actually remain parallel. Perspective is a way of mimicking this effect. **Perspective** is based on the idea that diagonals moving toward a point on the horizon, called the vanishing point, will imitate the recession of space into the distance and create the illusion of spatial depth. Perspective is a schematic way of translating three-dimensional space onto a two-dimensional surface (Figure 3-29). A perspective drawing is used on the cover of the Chestnut Park brochure (Figure 3-30). Volumetric shapes, such as cubes, cones, and cylinders, can also create the illusion of spatial depth.

It is possible to create such impressive illusions that the viewer, at first sight, is in doubt as to whether the thing depicted is real or a representation. This effect is called **trompe l'oeil**. The use of shadows and overlapping shapes can create wonderful trompe l'oeil effects, as on the cover for *Design Quarterly 110*, and the book jacket design for *Graphic Design USA 12* (Figures 3-31 and 3-32). In both examples, you feel as though you might be able to pick elements off the surface because of the illusion.

Figure 3-29
Diagram: William Stanke

Figure 3-30
Brochure cover: Chestnut Park
Design firm: Teikna Graphic Design Inc., Toronto, Canada
Art director/Designer: Claudia Neri
Client: Chestnut Park

"We were asked to design a brochure for a luxury real estate company in the residential market, which would not sell any houses, but present the real estate company and its people. We used archival images from 1500-1600 Italian architectural drawings because they were both elegant and affordable. This was a low-budget project."

—Claudia Neri, Teikna Graphic Design Inc.

Figure 3-31
Cover: *Design Quarterly 110*, "Ivan Chermayeff: A Design Anatomy"
Design firm: Chermayeff & Geismar Inc., New York, NY
Designer: Ivan Chermayeff

"A collage of personal images, notes, type proofs, etc., used for the cover of a magazine special issue devoted to the work of Ivan Chermayeff."

—Tom Geismar, Chermayeff & Geismar Inc.

Figure 3-32
Book jacket: *Graphic Design USA 12*
Design firm: Muller + Company, Kansas City, MO
Art director/Designer: John Muller
Collage photographer: Michael Regnier
Client: AIGA

"When asked by AIGA to design the cover for their design annual, the goal was to create an interesting, powerful image. The collage image is actually a compilation of some famous AIGA medalists: Alvin Eisenman, Frank Zachary, Paul Davis, and Bea Feitler.

The photos supplied by AIGA were reprinted in toned colors, cut and torn apart, and reassembled (with Scotch tape, etc.). For example, Paul Davis's mole is right next to Bea Feitler's mouth, below Frank Zachary's nose, and flanked by Paul Davis's right eye, Bea's left eye, and Alvin Eisenman's hair; the neck and torso belong to John Muller, the designer."

—John Muller, president, Muller + Company

Creating the illusion of depth on a two-dimensional surface is something that fascinates many designers and their audiences. Look at the cover design by Paul Rand for *Direction* magazine (Figure 3-33). Rand uses the horizontal stripes as a back wall or backdrop behind the dancer. The stripes seem to hold the surface in a fixed position—they define the picture plane. Rand has created the illusion that the picture plane is no longer on the surface of the page, but has moved back behind the dancer. However, the picture plane does not seem to be too far away from us; the illusion of spatial depth seems shallow. Shallow space can have great impact. It immediately engages our attention; our eyes cannot wander off into deep space. We tend to think of writing or lettering as flat elements drawn on a flat surface. Seeing letterforms that

seem to have depth is a visual surprise, as in the Le Monde logo (Figure 3-34).

Remember, as a designer manipulating graphic space, you have many choices. You can maintain the flatness of the picture plane, or create the illusion of spatial depth. You can create a shallow or deep space, or create the illusion that forms are projecting forward. Understanding the illusion of spatial depth will enlarge your design vocabulary and enhance your ability to affect an audience.

The foundation of a solid graphic design education begins with the study of two-dimensional design—the formal elements, the principles of design, and the manipulation of graphic space. This study provides the basic perceptual and conceptual skills necessary to study typography, layout, and graphic design applications.

Summary

A visual communication professional must have a foundation in two-dimensional design and color. Learning to successfully manipulate the formal elements—line, shape, color, value, texture, and format—and apply the design principles of balance, emphasis, rhythm, and unity, as well as manipulate graphic space, is an imperative. These formal elements and principles underpin every visual solution. Without a complete understanding of these concepts, the designer creates primitively rather than with design intelligence.

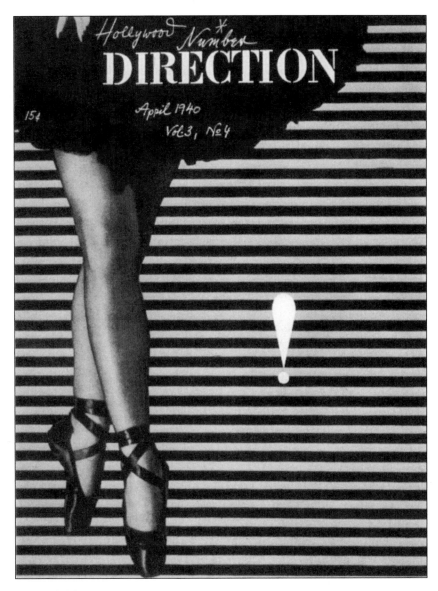

Figure 3-33
Magazine cover: *Direction,*
April 1940
Designer: Paul Rand

Figure 3-34
Logo: Le Monde
Design firm: Louise Fili Ltd.,
New York, NY
Art director/Designer:
Louise Fili

Color Design Basics

Equal to and perhaps surpassing the power of letterforms and the written word, color is a most powerful communication tool. Color can conjure intense emotions and create visual energy, or it can be mystical, musical, and exude a great sense of spiritual peacefulness. Color speaks on many levels.

Rose Gonnella

Rose Gonnella is an educator, artist, designer, and writer. She is Professor of Visual Communications and Chairperson of the Department of Design, Kean University of New Jersey. A practicing artist and designer, Gonnella has exhibited her drawings internationally. In addition, her published writing includes a co-authored set with Robin Landa and Denise M. Anderson, Creative Jolt, *and its companion,* Creative Jolt Inspirations, *and* Visual Workout: A Creativity Workbook. *Also, co-authored with Margaret Booker and Pat Butler:* Sea Captains' Houses and Rose-Covered Cottages: The Architectural Heritage of Nantucket Island.

Each word used in our verbal and written language is constrained to a single or several variants of meaning and function. Yet, the emotions, associations, ideas, thoughts, and feelings contained by a color are fluid and boundless. Individual colors are the rich and dynamic "words" of a visual language—a language that takes time, patience, and experience in which to develop fluency.

When you begin to "speak" with color, remember that designing is not subjective. There is a far more important basis for choosing color for a design than just your personal taste. In fact, your personal taste should play only a small part in your design. Knowledge of the emotional, intellectual, and physical properties of color and understanding how these attributes and properties can contribute to solving the objectives of a design problem should be the primary guide for your creative choices. You can be creative and objective when you become versed in the language of color. For this brief study, let's try to simplify the monumental task of objectively designing with color: how do

you pick a color for your design from the infinite possibilities?

Active, Passive, Hot, and Cold: Feeling the Colors

Don't be daunted. The process of learning always begins with the first step—an understanding of the fundamentals.

The pigment-based color wheel offers an excellent chart for a basic selection of color relationships. From an understanding of the basics, even the most complex and expressive designs can be created.

Each of the charted relationships on the color wheel can suggest an emotion, a feeling, and/or a physical state. The primary colors—from which all pigment-based hues are said to be mixed—seem to be innocent or wholesome due to their pureness. The secondaries are slightly more complex than the primaries, but still feel basic and simple. Analogous colors are harmonious because of their similarities, while complements that oppose each other on the color wheel feel tense. Red and accompanying analogous colors feel hot and

> *When you begin to "speak" with color, remember that designing is not subjective. There is a far more important basis for choosing color for a design than just your personal taste.*

loud at full saturation—their warmth seems to jump off the surface.

These warmer hues tend to create a very dynamic design. In contrast, blue and green hues feel cool and quiet and passive.

Expanding the physical properties of hue through saturation and value also affects the expressive character. Dark blues may be thought of as mysterious and brooding, or may simply suggest limitless spatial depth. Muted or low-saturation colors create a sense of stillness or sophistication. In pointed contrast, a muted color may also suggest something that is frayed and old. The meaning depends on the hue chosen and the degree of color saturation or value, as well as the association given to it by the viewer.

Each of the thousands of colors to choose from also carries a set of meanings and associations originating in many cultures. Individual colors may speak on several levels (emotional, intellectual, and physical), and each color may be interpreted in different ways by its viewers.

Imagine metallic bronze—flood your visual imagination with the color. Let yourself freely associate with it. Ask yourself these questions:

What associations do I have with the color (Olympic medals? Ancient Greek statues? Skin color? Ancient tools?)? How does metallic bronze physically feel (cold? warm?

hot?); what does the color express (mystery? richness? tradition? achievement?); what other physical properties does it possess (is it dull? bright? hard?)? Each color, selected from the thousands that exist, communicates an emotion and/or a state of being, and a physical feeling. Each color carries many associative meanings.

An Objective Pick

You may wonder how to control the communication of color when it can fluctuate in meaning and feeling so easily. The answer is: You can't. Instead of thinking that you can control color, you must remember that colors do not precisely define—they suggest.

Once you have developed a knowledge of the communicative power of the individual hues and hue relationships through reading, observation and practice, you will actually be able to suggest, with greater control, a complex range of emotions and ideas, and predict the reactions to your objective choices.

Do remember that color does not act alone; the many elements of your design (line, shape, type, pattern, space, format) must all work together with color to guide the viewer to the message you intended for a design solution. For a successful design solution, always pick your colors (and all the elements) objectively—using your base of knowledge, not your personal taste.

Each of the thousands of colors to choose from also carries a set of meanings and associations originating in many cultures. Individual color may speak on several levels (emotional, intellectual, and physical), and each color may be interpreted in different ways by its viewers.

It is important to be able to recognize and create shapes that have similar qualities so that your ability to discern shapes becomes more acute.

Exercise 3-1

Exploring lines

1. Divide a page into four units.
2. Draw a curving line from corner to corner in each square.
3. Draw different types of lines of varying direction and qualities in the divided areas.

Project 3-1

Creating illusion with lines—a warp

1. Using a black marker or the line tool in your computer's software, draw horizontal lines of varying thickness completely across the page.
2. Vary the distance between the lines.
3. Do several versions or thumbnails before going to the comp.

Note: *This project is well suited for the computer.*

Presentation

Create a comp on an 11″ x 14″ smooth board using black marker, or mount a computer-generated comp on an 11″ x 14″ board.

Comment: *Varying the distances between the lines and the thickness of the lines creates the illusion of swelling or warping on the surface of the page. The areas where the lines are light and close together may seem to recede, and the areas where lines are heavier and farther apart may seem to advance. Using line, you created an optical illusion.*

Exercise 3-2

Designing shapes

Design ten shapes that have similar qualities, for example, curving shapes or angular shapes.

Project 3-2

Shape

1. Draw four 5″ x 7″ rectangles, two in a horizontal format and two in a vertical format (or flip to a vertical format or direction).
2. Within each rectangle, design four shapes that have similar qualities, for example, four geometric shapes or four free-form shapes.
3. Arrange the shapes so that the viewer's eyes will move from one shape to the other with ease.
4. Produce several thumbnail sketches (or versions) and roughs before creating the comps.

Presentation

Present each of the four comps on an 8½″ x 11″ board.

Comment: *It is important to be able to recognize and create shapes that have similar qualities so that your ability to discern shapes becomes more acute. Composing the shapes introduces you to the process of designing elements on a page.*

Exercise 3-3

Use of color in graphic design

1. Find ten examples of color usage in graphic design applications, such as logos, labels, and packages.
2. Analyze the use of color in these examples in terms of appropriateness for the subject matter, the audience, and the feelings and ideas expressed or communicated.

Project 3-3

Color palette selection

1. Choose a brand or nonprofit organization that does not have a distinctive color palette associated with it.
2. Divide a 9″ square into nine equal sections.
3. Select one hue that you believe to be the main color within a color palette for this brand or group, and place the hue in the center section.
4. Select one other hue, and including values and intensities of each of the two hues, fill the remaining sections.
5. Make sure the color palette is appropriate for the brand or group.

Presentation

Present the finished project on an 11″ x 14″ board.

Comment: *It is essential for a designer to be able to select an appropriate color palette.*

Exercise 3-4

Low contrast and high contrast

Find two examples of graphic design solutions that use low contrast and two examples that use high contrast.

Project 3-4

Value scale

1. Look through magazines or stock images for photographs, and tear out or print out all the different grays you can find, as well as a black and a white value.
2. Create a ten-step scale of grays ranging from white to black.
3. Cut the grays into shapes.
4. Arrange the gray shapes on a page to create the effect of moving back into space.
5. Create another scale using grays created by typography.
6. Compare the gray scale of photographic fragments to the one of typographic grays.

Note: *This project also can be executed on the computer, in paint, or with colored paper.*

Presentation

Present the comp on an 11″ x 14″ board.

Comment: *If someone asked a group of people to think of the color blue, each person would probably think of a different blue; some would think of a blue with green in it, and some would think of a blue with red in it. Being able to make subtle distinctions among hues will enhance your ability to create successful color solutions.*

Being able to make subtle distinctions among hues will enhance your ability to create successful color solutions.

Exercise 3-5

Rubbings and blottings

1. Use tracing paper and pencils or crayons to make rubbings (also called frottages) of textured surfaces. For example, place tracing paper on the bark of a tree and pick up the texture by rubbing it with the side of a crayon.

2. Create blottings by dipping several objects with interesting textures into black paint or ink and blotting them on paper.

Note: *These textures can be simulated with computer software.*

Project 3-5

Creating visual textures

It is crucial to remember the format is a full participant in any design.

1. Draw an object, face, or landscape. Using a drawing instrument and technique—for example, stippling or cross-hatching—create shading. The shaded part of the drawing should have a texture.

2. To create a stippled effect, draw with dots.

3. To cross-hatch, draw a series of lines that move in the same direction, and then another series of lines in an opposing direction that cross over the others.

4. Produce at least ten visual textures before creating the finished comp.

Presentation

Present your comp on an 11″ x 14″ board.

Comment: *Graphic designers need to be aware of all the textures available to them. Paper has tactile texture. Inks and varnishes can create tactile textures. Visual textures, including indirect marks like rubbings and blottings, and direct marks like the ones in this project, should become part of any designer's vocabulary.*

Exercise 3-6

Rectangular formats

1. Draw rectangles of different sizes and shapes.

2. Draw a horizontal line, a vertical line, a diagonal line, and a curve in each rectangular format.

3. Analyze the relationship of each line to the different formats.

Project 3-6

Designing in different shape formats

1. You will need four different shape formats: a large circle; two extended rectangles (much longer in one dimension than the other), one vertical and one horizontal; and a standard 8½″ x 11″ size page.

2. In each one, arrange three shapes.

3. Consider how each shape looks and is arranged in relation to the others and to the format.

4. Produce at least five sketches for each of the four formats.

Note: *This project may be executed on the computer, with cut paper, or with markers.*

Presentation

Present each format on a separate 11″ x 14″ board.

Comment: *It is crucial to remember the format is a full participant in any design. Other components, like shapes, types, or photographs, are not the only ones to be considered. The format is more than a frame—it is an important formal element.*

Exercise 3-7

Creating a balanced design

1. Find a headline, a visual (photograph or illustration), text, type, and a photograph of a product from different advertisements.
2. Arrange them into a balanced design on an 8½″ x 11″ page.

Project 3-7

Destroying symmetry and retaining balance

1. Create a symmetrical design on a 10″ square format using solid black shapes.
2. Make a copy of it.
3. Cut the copy into 1″ horizontal strips.
4. Cut the strips in half vertically.
5. Rearrange the strips to create a balanced asymmetrical design.

Presentation

Present the finished comp on an 11″ x 14″ board.

> **Comment:** *Arranging a symmetrical design is not difficult. You divide the page in half with a vertical axis and place similar or identical shapes evenly on either side of the axis. Each side mirrors the other. Arranging a balanced asymmetrical design is a challenge because it is not a mirror image, and each element's position and visual weight must be decided and become crucial to the overall effect.*

Exercise 3-8

Creating a focal point

1. On a 10″ square format, draw ten arrows that all lead to one point or area on the page.
2. The arrows should be visually interesting; they may vary in quality and texture, and they may bend, curve, or intersect.
3. On an 8½″ x 11″ page, draw seven arrows that lead to a main focal point and three arrows that lead to a secondary focal point. Make sure the arrows are visually interesting; give them texture, tone, various line qualities, and vary the directions and lengths.

Project 3-8

Creating a visual hierarchy

1. Draw seven shapes of varying sizes.
2. Use color or texture on some of them; leave some in outline form.
3. Cut them out.
4. Decide which shapes should be seen first, second, third, and so on.
5. On an 8½″ x 11″ page, arrange them in hierarchical order.
6. Produce ten sketches and one rough before creating a comp.

Presentation

Present the comp on an 11″ x 14″ board.

> **Comment:** *Learning to arrange elements in order of their importance is critical to good graphic design. Visual hierarchy helps the audience glean information. You must direct your audience's attention in order to communicate a message effectively.*

Visual hierarchy helps the audience glean information. You must direct your audience's attention in order to communicate a message effectively.

Exercise 3-9

Creating rhythm

1. Using vertical lines and dots on a page, establish a steady rhythm.
2. Using vertical lines and dots on a page, establish a rhythm with variation.

Project 3-9

Rhythm

1. On an 8½″ x 11″ page, create a rhythm with great variation.
2. Use vertical, horizontal, and diagonal lines, dots, squares, and type.
3. Create ten sketches and one rough, before going to the comp stage.

Note: *This project can be executed on the computer, with markers, or with cut paper.*

Presentation

Present the comp on an 11″ x 14″ board.

> **Comment:** *Varying the type, direction, quality, and position of the lines, as well as the size, position, and visual weight of the dots, squares, and type will give your design rhythm.*

Unity is all encompassing. If the design is not unified—if it does not hold together—then not much else is going to work.

Exercise 3-10

Using alignment to achieve unity

1. Look through a magazine and find headline type, text type, and a visual (photograph or illustration).
2. Using the principle of alignment, align all the elements on a page.

Note: *Photographs can be scanned into a computer, and their size and shape can be altered.*

Project 3-10

Achieving unity

1. Choose a group of objects, like tools or chess pieces, and photocopy or draw them.
2. Cut them out.
3. Arrange them on a page with type (found type or hand lettered).
4. To achieve unity, use the principles of flow and correspondence. For example, repeat colors in the design to create visual relationships among the elements.
5. Create at least ten sketches and two roughs before going to the comp stage.

Note: *This project may be executed on the computer using a scanner.*

Presentation

Present the comp on an 11″ x 14″ board.

> **Comment:** *Unity is all encompassing. If the design is not unified—if it does not hold together—then not much else is going to work. You need to be aware of the total effect of your design. Sometimes it helps to take a break from your work and look at it a day or two later. When you come back to it, ask yourself if it looks as if all the elements belong together.*

Exercise 3-11

Positive and negative space

1. Paint a black shape on a board. Use water-based paint, such as poster paint or acrylics.
2. The shape should be big enough to touch the edges of the board in places. (The black shape is the positive space and leftover white area is the negative space.)
3. Paint a bold white X entirely across the black shape.
4. With white paint, paint the remaining white areas of the board so that they are connected to the X.
5. This should result in four pie-like shapes.
6. Now, it should be difficult to tell what is positive and what is negative. Do you see black shapes on a white board or white shapes on a black board?

Note: *This project may also be executed with cut black-and-white paper or on the computer.*

Project 3-11

Letterforms as positive and negative spaces

1. Using your initials, design the letters on an 8½″ x 11″ page so that both the positive and negative spaces are carefully considered.
2. The letters should touch all edges of the page.
3. The letters may be cropped or reversed.
4. Create at least ten thumbnail sketches and two roughs before going to the comp.

Note: *This project can be executed on the computer, with marker, or with cut paper.*

Presentation

Present the comp on an 11″ x 14″ board.

> **Comment:** *Letters are forms; they are composed of positive and negative spaces. The negative spaces they create when positioned next to one another are crucial to designing with type. The spaces between letters are important; they affect readability, legibility, and the memorableness of design.*

Exercise 3-12

The picture plane

1. Draw vertical and horizontal lines that oppose one another on an 8½″ x 11″ page.
2. Every line you draw must touch another line. Imagine your lines are like string and that you are tying a package.
3. Touch all edges of the page.

Note: *This exercise can be done with pencil, marker, black tape, or drawing software.*

Project 3-12

The illusion of spatial depth

1. With a light pencil, draw a 1″ grid on a 10″ square.
2. Using either a black marker or black tape, draw volumetric shapes such as cones, cubes, and pyramids.
3. Use the grid as a guide for the vertical, horizontal, and diagonal lines.
4. Fill the entire board.
5. Avoid creating flat shapes such as squares and triangles.
6. Produce at least two roughs before creating the comp.

Presentation

Present your comp on an 11″ x 14″ illustration board.

> **Comment:** *Project 3-12 is designed to develop an understanding of how to create the illusion of spatial depth on a two-dimensional surface. As soon as you draw one volumetric shape on a flat surface, you begin to create the illusion of spatial depth. If the shapes you create overlap or vary in size, the effect will be greater.*

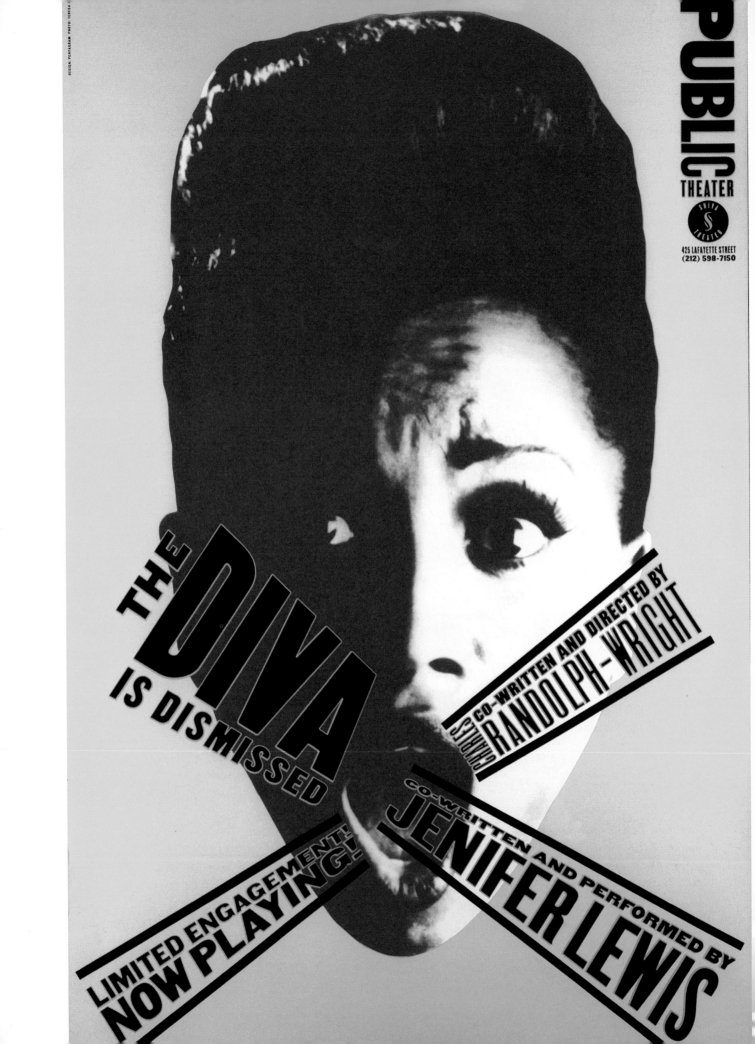

Chapter 4:
Typography

Letterforms: Form and Structure

The Principles of Design Applied to Typography

Designing with Type

Type and Visuals

◄ Poster: *The Diva Is Dismissed*
Design firm: Pentagram Design, New York, NY
Partner/Designer: Paula Scher
Designers: Ron Louie, Lisa Mazur, and Jane Mella
Photographer: Teresa Lizotte
Client: Public Theater, New York, NY

Objectives

Differentiate among calligraphy, lettering, and type

Gain knowledge of type definitions and nomenclature

Learn about type measurement, basic type specifications, and classifications of type

Identify the parts of letters

Pick up the basic principles of designing with type

Understand the interrelated visual factors involved in typographic design

Become familiar with the three types of spacing

Learn design considerations of form, direct and secondary meanings, and graphic impact

Consider the relationship of type and visuals

Use type creatively and expressively

Acquire tips on type from esteemed professionals

U p until recent times, letterforms were written by hand or text was set on a fixed format—a page—whether it was a poster, label, or newspaper. The digital age has presented new issues for graphic designers. Now, type is seen in windows, and on scrolling surfaces of pages that can seem quite endless (simply think of a federal government web site or a huge multinational corporate web site).

Typography is the design of letterforms and the arrangement of them in two-dimensional space (for print media) and in space and time (for digital media). For both print and digital media, visual communication professionals must consider the fundamental issues of form and structure, design, message and content, and expression.

Letterforms: Form and Structure

The **letterform** is the particular style and form of each individual letter of our alphabet. Each letter of an alphabet has unique characteristics that must be preserved to retain the legibility of the symbols as representing sounds of speech. Letterforms are used by designers in three primary forms:

• **Calligraphy:** drawn by hand, the strokes made with a drawing instrument, literally "beautiful writing" (Figure 4-1).

• **Lettering:** letters that are custom designed and executed by conventional drawing or by digital means (Figure 4-2).

• Type: letterforms produced by mechanical means. Digitally produced type is by far the most common means of using letterforms for visual communication.

Type is available in an ever-increasing number of styles for the designer's use simply by selecting a font size and style. Nearly every graphic design solution illustrated in this book is an example of digitally generated type.

Nomenclature

Today almost all type is produced digitally, but many of the terms we use in reference to type originated in the days when type was made of metal. A letterform was cast in relief on a three-dimensional piece of metal, which was then inked and printed.

When working with type, there are basic terms you must be familiar with.

• **Typeface:** the design of a single set of letterforms, numerals, and signs unified by consistent visual properties. These properties create the essential character, which remains recognizable even if the face is modified by design.

- **Type font**: a complete set of letterforms, numerals, and signs, in a particular face, size, and style, that is required for written communication (Figure 4-3).
- **Type family**: several font designs contributing a range of style variations based upon a single typeface design. Most type families include at least a light, medium, and bold weight, each with its own italic (Figure 4-4).
- **Type style**: modifications in a typeface that create design variety while retaining the essential visual character of the face. These include variations in weight (light, medium, bold), width (condensed, regular, extended), and angle (Roman or upright, and italic), as well as elaborations on the basic form (outline, shaded, decorated) (Figure 4-4).

Guidelines are imaginary lines used to define the horizontal alignment of letters (Figure 4-5). Here are some basic terms.

- **Ascender line**: defines the height of lowercase ascenders (often, but not always, the same as the capline).
- **Baseline**: defines the bottom of capital letters and of lowercase letters, excluding descenders.
- **Capline**: defines the height of capital letters.
- **Descender line**: defines the depth of lowercase descenders.
- **x-height**: the height of a lowercase letter, excluding ascenders and descenders.

A nomenclature exists that defines the individual parts of letterforms and how they are constructed (Figure 4-5). Here are some basic terms.

- **Apex**: the head of a pointed letter.
- **Arm**: a horizontal or diagonal stroke extending from a stem.
- **Ascender**: the part of lowercase letters (b, d, f, h, k, l, and t) that rises above the x-height.
- **Bowl**: a curved stroke that encloses a counter.
- **Character**: a letterform, number, punctuation mark, or any single unit in a font.
- **Counter**: space enclosed by the strokes of a letter.
- **Crossbar**: the horizontal stroke connecting two sides of a letterform, as in an "A."
- **Descender**: the part of lowercase letters (g, j, p, q, and y) that falls below the baseline.
- **Foot**: the bottom portion of a letter.
- **Hairline**: the thin stroke of a Roman letter.

Figure 4-1
Calligraphy
Design firm: Martin Holloway Graphic Design, Pittstown, NJ
Calligrapher: Martin Holloway

Figure 4-2
Custom lettering
Design firm: Martin Holloway Graphic Design, Pittstown, NJ
Lettering/Designer: Martin Holloway

THE TYPOGRAPHIC FONT

Capitals

ABCDEFGHIJKLMNOPQRSTUVWXYZ&

Lower Case

abcdefghijklmnopqrstuvwxyz

Old Style Figures

1234567890

Modern Figures (Lining, Ranging)

1234567890

Small Caps

ABCDEFGHIJKLMNOPQRSTUVWXYZ&

Ligatures

ffl ffi ff fl fi

Dipthongs

ÆŒæœ

Swash Characters

A M R r y

Accented and International Characters

ÅÁÀÂÄÑÇ åáàâäñçøß«» ¡¿

Punctuation

. . : , ; ! ? - – — " " ' ' () [] /

Monetary Symbols

$ ¢ £

Math Signs

+ − ÷ × = % °

Fractions

⅓ ¼ ½ ⅔ ¾

Reference Marks

→ SM TM Ⓟ ® © □ ■ • * † ‡ §

Superior (Superscript) and Inferior (Subscript) Figures

1234567890

1234567890

- Head: the top portion of a letter.
- Ligature: two or more letters linked together.
- **Lowercase:** the smaller set of letters; a name derived from the days of metal typesetting when these letters were stored in the lower case.
- **Serifs:** ending strokes of characters.
- Stem: the main upright stroke of a letter.
- Stroke: a straight or curved line forming a letter.
- Terminal: the end of a stroke not terminated with a serif.
- Thick/thin contrast or strokes: the thickness of the strokes varies in typefaces; that is, the amount of weight differs between thick and thin strokes.
- **Uppercase:** the larger set of letters or **capitals;** these letters were stored in the upper case.
- Vertex: the foot of a pointed letter.

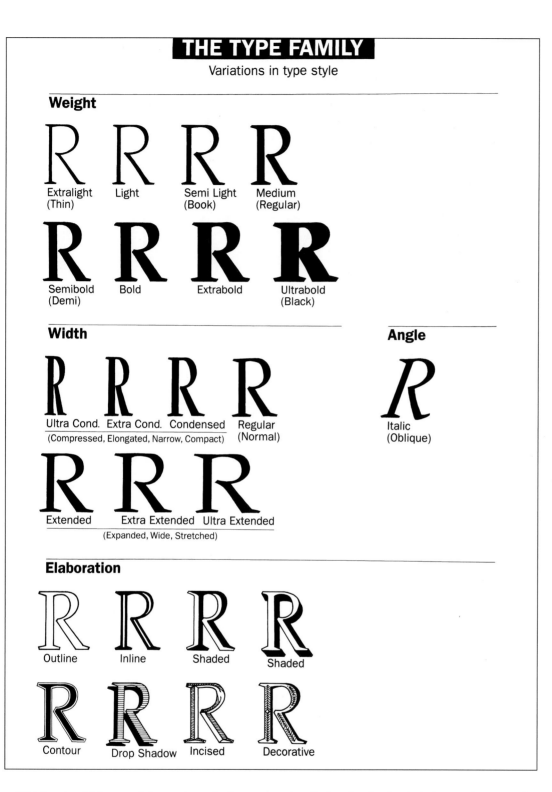

Figure 4-4
Chart: The Type Family
Chart by Martin Holloway
Design firm: Martin
Holloway Graphic Design,
Pittstown, NJ

• Weight: the thickness of the strokes of a letterform, determined by comparing the thickness of the strokes in relation to the height—for example, light, medium, and bold.

Typographic Measurement

The traditional system of typographic measurement utilizes two basic units: the point and the pica. Point size (body size), in metal type, is the height of the body (or slug) of lead the typeface is set upon; it's the height of the type. The height of type is measured in points, and the width of a line of type is measured in picas. Most type is available in sizes ranging from 5 points to 72 points. Type that is 14 points and less is used for setting text or body copy, and is

Figure 4-5
Chart: Letterform Terms
Chart by Martin Holloway
Design firm: Martin
Holloway Graphic Design,
Pittstown, NJ

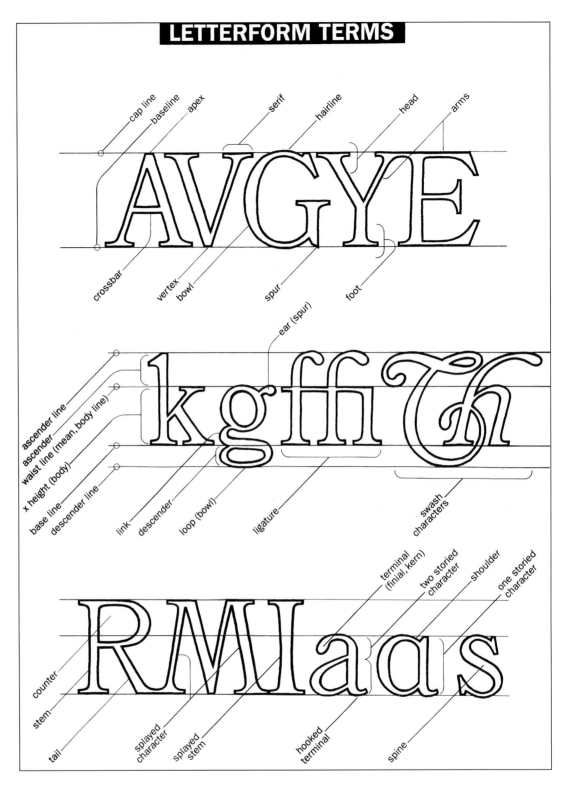

called **text type**. Sizes above 14 points are used for **display type**, such as titles, subtitles, headlines, and subheadlines (Figure 4-6). Line length, which is the horizontal length of a line of type, is measured in picas. Approximately 6 picas = one inch; 12 points = 1 pica; approximately 72 points = one inch.

Spatial Measurement

A designer must measure type as well as the spatial intervals between typographic elements. These intervals occur between letters, between words, and between two lines of type. The spatial interval between letters is called **letterspacing**. Adjusting the letterspacing is called

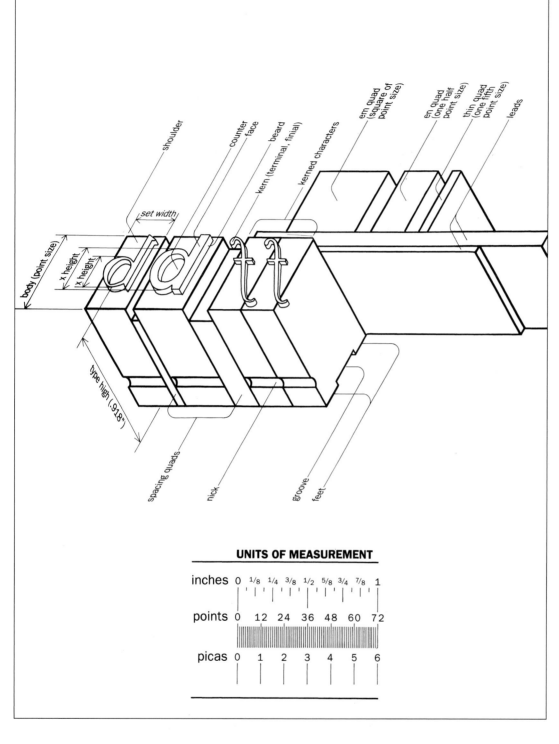

METAL TYPE TERMS

UNITS OF MEASUREMENT

Figure 4-6
Chart: Metal Type Terms
Chart by Martin Holloway
Design firm: Martin
Holloway Graphic Design,
Pittstown, NJ

kerning. The spatial interval between words is called **word spacing.** The spatial interval between two lines of type is called **line spacing,** traditionally called leading.

Leading, in metal type, is strips of lead of varying thickness (measured in points) used to increase the space between lines of type; it has come to mean line spacing: the distance between two lines of type, measured vertically from baseline to baseline.

In metal type, letterspacing and word spacing are produced by the insertion of quads—metal blocks shorter than the type height—between pieces of metal type. Both traditionally and

today, an "em" is used as a unit of measure. An em is the square of the point size of any type—a unit of type measurement based on the "M" character. One half of an em is called an "en." In digital typography, spacing is controlled by a computer using a unit system. A unit is a subdivision of the em, used in measuring and counting characters in photographic and digital typesetting systems.[1] The unit is a relative measurement determined by dividing the em into thin, equal, vertical measurements. When characters are digitally generated, each has a unit value including space on either side of the letter for the purpose of letterspacing, which can be adjusted by the designer.

Basic Type Specifications

When a designer wants to indicate the type size and the leading, the following form is used: 10/11 indicates a type size of 10 with one point leading; 8/11 indicates a type size of 8 with 3 points leading. The amount of leading you choose depends on several factors, such as the

Figure 4-7

Type size/Leading chart

Indication of type size and leading; the type size and the amount of leading you choose will enhance or detract from readability.

10/10 Gather material and inspiration from various sources and bring them together. Examine other cultures and draw inspiration from diverse styles, imagery, and compositional structures. Go to the movies, look at magazines, listen to comedians, read humorists' works, watch music videos, look at all graphic design, observe human behavior.

10/11 Gather material and inspiration from various sources and bring them together. Examine other cultures and draw inspiration from diverse styles, imagery, and compositional structures. Go to the movies, look at magazines, listen to comedians, read humorists' works, watch music videos, look at all graphic design, observe human behavior.

10/12 Gather material and inspiration from various sources and bring them together. Examine other cultures and draw inspiration from diverse styles, imagery, and compositional structures. Go to the movies, look at magazines, listen to comedians, read humorists' works, watch music videos, look at all graphic design, observe human behavior

type size, the x-height, the line length, and the length of the ascenders and descenders. When a designer does not want additional space between lines, type is set solid; that is, with no additional points between lines, such as 8/8 (Figure 4-7).

Classifications of Type

Although there are numerous typefaces available today, there are some major categories into which most fall (Figure 4-8).

Roman

The term Roman has two meanings in typography: 1) letterform designs having thick and thin strokes and serifs, which originated with the ancient Romans, and 2) letterforms that have vertical upright strokes, used to distinguish from oblique or italic designs, which slant to the right.

The subclassifications of Roman type are:
• Old Style: a style of Roman letter, most directly descended in form from chisel-edge drawn models, retaining many of these design characteristics. Characterized by angled and bracketed serifs, biased stress, less thick and thin contrast, some examples are Caslon, Garamond, Palatino, and Times Roman.
• Transitional: a style of Roman letter that exhibits design characteristics of both Modern and Old Style faces; for example, Baskerville, Century Schoolbook, and Cheltenham.
• Modern: a style of Roman letter whose form is determined by mechanical drawing tools rather than the chisel-edge pen. Characterized by extreme thick and thin contrast, vertical-horizontal stress, and straight, unbracketed serifs; for example, Bodoni, Caledonia, and Tiffany.
• Egyptian: a style of Roman letter characterized by heavy, slab-like serifs. Thin strokes are usually fairly heavy. It may have Modern or Old Style design qualities; also called square serif or slab serif. For example, Clarendon, Egyptian, and ITC Lubalin Graph.
• Italic: letterform design resembling handwriting and denotes angle/slant. Letters slant to the right and are not joined. Originally used as an independent design alternative to Roman, now used as a style variant of a typeface within a type family.

Figure 4-8
Chart: Classifications of
Type Chart by Martin
Holloway
Design firm: Martin
Holloway Graphic Design,
Pittstown, NJ

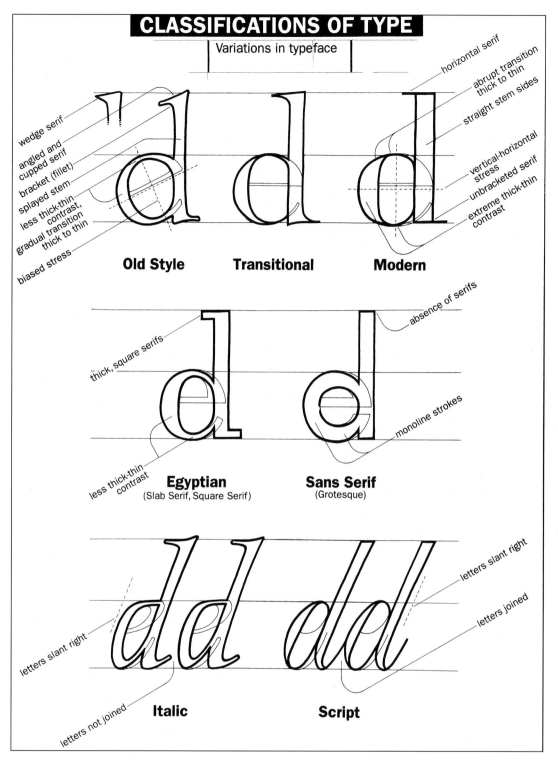

CLASSIFICATIONS OF TYPE

Variations in typeface

wedge serif
angled and cupped serif
bracket (fillet)
splayed stem
less thick-thin contrast,
gradual transition thick to thin
biased stress

horizontal serif
abrupt transition thick to thin
straight stem sides
vertical-horizontal stress
unbracketed serif
extreme thick-thin contrast

Old Style **Transitional** **Modern**

thick, square serifs

absence of serifs

monoline strokes

less thick-thin contrast

Egyptian
(Slab Serif, Square Serif)

Sans Serif
(Grotesque)

letters slant right
letters joined

letters slant right
letters not joined

Italic **Script**

Sans Serif

Sans serif letterforms are designed without serifs and usually having monoline stroke weights (no clearly discernable thick and thin variations); for example, Futura, Helvetica, and Univers. Some letterforms without serifs have thick and thin strokes, such as Optima, Souvenir Gothic, and Baker Signet.

Script

Script is a letterform design that most resembles handwriting. Letters usually slant to the right and are joined. Script types can emulate forms written with chisel-edge pen, flexible pen, pencil, or brush; for example, Brush Script, Shelley Allegro Script, and Snell Roundhand Script.

Suggestions

• Consider the format: print vs. digital and window vs. scrolled pages.
• Consider the context: where will the type be read and how closely will it be read?
• Design type in a visual hierarchy. People tend to read the biggest elements first; they tend to read heads or titles first, subheads or pull quotes second, then captions, and finally the text type.
• Type arrangement or alignment should enhance readability.
• Letterspacing, word spacing, and line spacing all factor into readability, communication, and expression. Never depend on automatic spacing—adjustments by eye are always necessary to enhance typography.
• Consider letterforms as pure forms; think about them as having positive/negative space relationships.
• Color should enhance the communication and expression, not hinder readability.
• Word spacing and line spacing establish a rhythm, a pace at which the viewer reads the message.
• Fonts should be appropriate for the message and audience.
• Typography should enhance the reader's experience.
• When mixing typefaces, think about appropriateness to the message, contrast, weights, visual hierarchy, and scale.
• Learn to use at least five classic faces; for example, Bodoni, Caslon, Futura, Univers, and Times Roman.
• Avoid novelty or decorative typefaces, which often look obviously contrived.

Many typefaces may not fit precisely into one of these historical classifications of type. In order to help you discern various features and make informed and appropriate choices, here are some common traits or characteristics to look for.
• Serifs: a collection of many different kinds, such as bracketed, hairline, oblique, pointed, round, square, straight, and unbracketed. It is a good idea to become familiar with their historical origins.
• Stress: the stress of the letterforms is the axis created by the thick/thin contrast; stress can be left-slanted, right-slanted, or vertical.
• Thick/thin contrast: the thickness of the strokes varies in typefaces, that is, the amount of weight differs between thick and thin strokes.
• Weight: the thickness of the strokes of a letterform, determined by comparing the thickness of the strokes in relation to the height; for example, light, medium, and bold.

The Principles of Design Applied to Typography

Fundamental organizational principles also apply to typographic design. When arranging typographic elements, you should consider emphasis, rhythm, alignment, unity, spacing, and the illusion of spatial depth to create illusion.

Emphasis

When typographic elements are arranged according to emphasis, most often there is a focal point. This is the element that is most prominent and most important to the communication of the message. Once you have decided which typographic element is most important, you must make decisions about all the others—what should be read first, second, third, and so on. Whether you are designing a book cover, a magazine layout with numerous columns, or a digital page, you must direct the reader's attention. Of course, as the ingenious cover designs by John Gall show, the arrangement, visuals, and color all are contributing factors to the visual hierarchy. When creating emphasis with typography, consider:
• position,
• rhythm,
• color contrast,
• size contrast,
• weights of the type, meaning the lightness or boldness of a typeface (weights usually are light, medium and bold),
• initial caps: a large letter usually used at the beginning of a column or paragraph, and
• Roman vs. italic: Roman type is upright as opposed to italic, which is slanted to the right.

Rhythm

You direct the reader from one typographic element to another by using visual hierarchy and rhythm (a pattern that is created by repeating or varying elements), by considering the space between elements, and by establishing a sense of movement from one element to another.

Some designers call it flow—some call it the beat. Whatever it is called, it is all about moving the reader's eyes from element to element so that they get all the necessary information and messages. Certainly, rhythm contributes to graphic impact.

Alignment

The style or arrangement of setting text type is called **type alignment**. (The term alignment here is used more specifically than its broader definition in Chapter 3.) The primary options are as follows:

• Flush left/ragged right: text that aligns on the left side and is uneven on the right side.

• Justified: text that aligns on both the left and right sides.

• Flush right/ragged left: text that aligns on the right side and is uneven on the left side.

• Centered: lines of type are centered on an imaginary central vertical axis.

• Asymmetrical: lines composed for asymmetrical balance—not conforming to a set, repetitive arrangement.

There are many ways to ensure that all the type is interrelated, integrated into a whole design, and not seen as unrelated elements.

Unity

To establish unity in a typographic design, there are a number of things to consider.

• Choose typefaces that complement each other visually. Use contrasting styles, faces, and weights, rather than faces that are similar. Typefaces with pronounced or exaggerated design characteristics seldom mix well. Avoid mixing two or more sans serif typefaces in a design.

• Establish harmonious size relationships.

• Determine how the size and choice of typefaces will work with the visuals.

• Create a cooperative action between type and visuals.

• Create tension between type and visuals. Establish color connections, harmonies, and complementary relationships.

• Establish correspondence.

• Use a grid.

• Establish alignment.

• Establish rhythm or a flow.

Old Style

BAMO hamburgers
BAMO hamburgers
Garamond, Palatino

Transitional

BAMO hamburgers
New Baskerville

Modern

BAMO hamburgers
Bodoni

Egyptian

BAMO hamburgers
BAMO hamburgers
Clarendon, Egyptian

Sans Serif

BAMO hamburgers
BAMO hamburgers
Futura, Helvetica

Italic

BAMO hamburgers
BAMO hamburgers
Bodoni, Futura

Script

BAMO hamburgers
Palace Script

Figure 4-9
Typeface Examples

Figure 4-10
Magazine spread: *IN*
magazine, Fall
Design firm: Frankfurt Balkind
Partners, New York, NY
Creative director: Kent Hunter
Designer: Riki Sethiadi
Photography:
Mark Jenkinson
Client: MCI Communications

"In this spread from a story
about telecommunications at
Humana Inc., a health care
corporation, the designers at
Frankfurt Balkind used the
icon of a cross in a classic
positive/negative layout
where the type became an
integral design element."

—Kent Hunter, executive
design director and principal,
Frankfurt Balkind Partners

Figure 4-11
Magazine spread: *Print*
magazine
Art director/Designer:
Steven Brower

"Art is a good way to break
up text and move it along;
here the street poster of
artist Shepard Fairey
divides a standard four-
column grid. The opening
page is shown as well."

—Steven Brower

• Use positive and negative shape relationships.
• Make type an integral player in the commu-
nication of meaning.

Unity is established in different ways in
both sides of the spread by Frankfurt
Balkind Partners (Figure 4-10); correspon-
dence and connection are established
through the repetition of a visual shape. The
heavier weight of the type on the left page
echoes the darker value of the right page.

Steven Brower creates unity by aligning the
subhead with the flush-left text type, and he
uses visuals to connect the entire spread and
opening page in Figure 4-11.

In the poster design by Tudhope Associates,
the type echoes the centered target-like visual;
correspondence is established (Figure 4-12).
Similarly, correspondence is established in the
way the type follows the form of the globe on
the packages for CE Software (Figure 4-13).

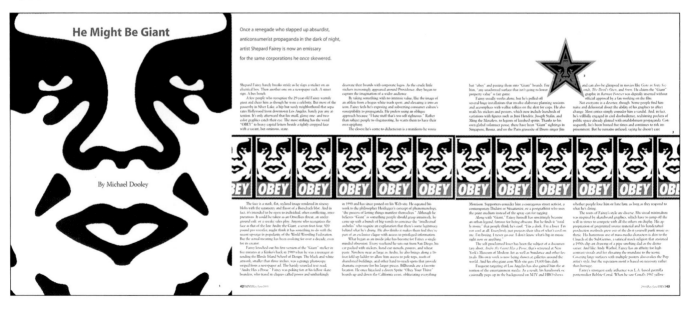

Spacing

The three types of spacing you have to control when designing with type are letterspacing, word spacing, and line spacing. Spacing should enhance legibility and reader comprehension, or, at the very least, enrich the reader's experience (unless, of course, your concept and approach calls for purposeful dissonance). If people have difficulty reading something, they probably will lose interest.

When a character is produced digitally, the software automatically advances in numbers of units before generating the next character. It is not a good idea to rely on automatic spacing when designing with type. The designer can control the letterspacing by adding or subtracting units between letters to improve the legibility.

Since computers calculate spatial intervals—units—according to type metrics (preset calculations for each font), designers should consider the type as form, adjusting letter, word, and line spacing for balance and visual relationships. For example, the computer may automatically set the same distance between an "H" and an "N" as it does between an "L" followed by an "A," yet the shapes between the letters in the second pair are quite different and can be moved closer together to enhance readability and cohesiveness.

You should always judge the letterspacing optically. In setting display type, it is feasible to adjust the spacing of individual characters since the number of words in headlines is limited. This fine-tuning of negative space is a hallmark of

Figure 4-12
Poster
Design firm: Tudhope Associates Inc., Toronto, Ontario, Canada
Designer: Peggy Rhodes
Writer: Kelvin Browne
Client: T-D Centre, Cadillac Fairview, Toronto, Ontario, Canada

"The objective was to create interest and add energy to the underground concourse. The design approach was 'less is more' to complement the simplicity of the Mies Van Der Rohe architecture."

—Ian C. Tudhope, principal, Tudhope Associates Inc.

typographic excellence. In text settings, since the space adjustment of individual letters is impractical, the designer selects the spacing mode (or tracking amount) for the computer to use.

Here are some general considerations to keep in mind.
• The size of the type in relation to the amount of spacing,
• The length of the lines in relation to the amount of spacing, and
• The spacing in relation to the characteristics of the typeface.

Spacing between words and lines of type should enhance the legibility, readability,

Figure 4-13
Package design
Design firm: Muller + Company, Kansas City, MO
Client: CE Software

Figure 4-14
Logo
Design firm: Muller +
Company, Kansas City, MO
Client: CE Software

Figure 4-15
Logo: Channel 39
Design firm: Sibley Peteet
Design, Dallas, TX
Client: KXTX Channel 39

"This mark was selected
from a group of about
thirty alternatives
presented. The mark's
interest lies in the
juxtaposition of a positive
three with the negative
shape of the nine, bleeding
the common shapes of the
two number forms."

—Don Sibley, principal,
Sibley Peteet Design

Positive and Negative Space

Understanding positive and negative space
is crucial to designing with type. The
spaces between letters, between words,
and between lines of type must be carefully
considered if you want your design to be
legible and memorable. Once you lose legi-
bility, you lose meaning.

Factors that enhance legibility are:
• Considered positive and negative
shape relationships
• Distinctiveness of individual letters
• Thoughtful letter, word, and line spacing
• Strong value contrast between letters
and background
• Word placement to encourage eye
movement in the correct reading sequence

and overall comprehension of the message.
Legibility refers to how easily the shapes of
letters can be distinguished (usually refers
to larger sizes), and readability refers to
how easily type is read (usually refers to the
text type).

Dynamic positive and negative space is created
in the logos for CE Software and Channel 39; the
"E" and "9" are formed by the negative space
(Figures 4-14 and 4-15).

Illusion of Spatial Depth

Using type, you can maintain the flat surface of
a page or you can create the illusion of spatial
depth. The weights, color, size, position, and
arrangement of type are all factors in the
creation of illusion. In all of the designs in
Figures 4-16 through 4-19, there are varying
degrees of the illusion of spatial depth. The letter
"C" appears to be closest to the viewer and
defines the picture plane in the spread in Figure
4-16. The overlapping letters and the word
"communication" define the other layers of
spatial illusion. Subtle elements—such as the red
line of type, the "drop out" line of type over the
photograph, and the photograph of the road—
create the illusion of spatial depth on the annual
report spread in Figure 4-17.

The overlapping of type of the spread from
French Fries gives the effect of several layers of
space (Figure 4-18). The variation in the range
of values enhances the illusion and adds atmos-
phere. Shira Shecter creates very exciting
illusions that grab any viewer's attention in the
promotional postcards shown in Figure 4-19.

Designing with Type

Perhaps the most difficult part of any graphic
design education is learning to design with type.
Maybe it is because we tend to be literal. We
concentrate on the literal meaning of words, and
give their form and their arrangement short
shrift. In order to design with type, you must
consider four main points:
• type as form
• type as a direct message—its primary meaning
• the secondary meaning (or connotation) of type
• the graphic impact of type

communication

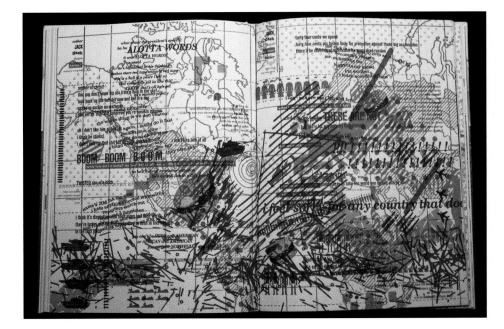

Figure 4-16
Annual report: "Communication"
Design firm: Leimer Cross Design
Corporation, Seattle, WA
Client: Expeditors International
of Washington, Inc.

"A global logistics company, Expeditors continues to distinguish itself from competitors by building a worldwide, proprietary logistics management network. In 1994, that principal EDI network was called exp.o—named by Leimer Cross Design. The message confirmed the many benefits customers could expect from exp.o and, by extension, the strong growth potential for investors. 'Communication' in real time, in the form Expeditors' customers specified, was the theme."

—Leimer Cross

Figure 4-17
Annual report: AARP
Design firm: AARP Creative Group,
Washington, D.C.
Designer: Melanie Alden-Roberts
Client: AARP

"We created an intimate look at people, rather than a list of AARP's accomplishments, which the reader wouldn't be able to relate to on a personal level. By using diverse images of boomers, midlifers, and older persons, we hope readers will see themselves in this report, or see someone like themselves who inspires them to become involved in their own communities."

—Melanie Alden-Roberts, designer,
AARP Creative Group

Figure 4-18
Spread: *French Fries*
Designer/Co-author: Warren Lehrer
Co-author: Dennis Bernstein
Client: Visual Studies Workshop

"The book called *French Fries* takes place inside the third largest burger chain in the Western Hemisphere. *French Fries* is a visual translation of a play written by Dennis Bernstein and me. It is a quick-service circus of culinary discourse, dream, memory, and twisted aspiration. In this double-page spread from *French Fries*, a political argument breaks out between patrons and the staff at Dream Queen. Overlay of works and images reveal the sonic and psychological cacophony of argument in the context of a fast-food joint."

—Warren Lehrer, Designer/Co-author

Figure 4-19
Promotional postcard
booklet
Design studio: Shira
Shecter Studio, Fresh
Graphic Design, Israel
Client: Tamooz

"With this promotional tool,
we aimed to present their
turnkey variety of creative
design and technology
services available to clients;
for example, historical
museums, visitor centers,
exhibitions, multimedia,
tech expertise, etc.
Each page within the
booklet was a perforated
postcard that could be
removed and used as
an actual postcard."

—Shira Shecter

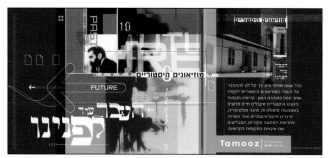

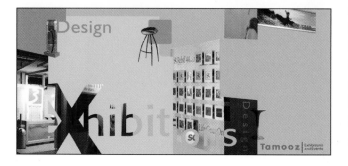

Form

Let's say you are visiting a foreign country and the national language uses a different alphabet than yours. You might be more inclined to view the characters of that alphabet as forms since you cannot read them. When we consider letterforms as positive and negative forms, we will be more aware of the visual interest they create. The stronger the positive and negative space relationships, the more dynamic and aesthetically pleasing the design.

Each letterform has distinguishing characteristics. Some letters are closed forms, like the "O" and "B," and some letters are open forms, like the "E" and "M." The same letterform can vary in form depending on the typeface, like this lowercase g in Times and this lowercase g in Helvetica. Have you ever noticed the variations of the form of the letter "O" in the different typefaces?

For example, the "O" in some typefaces is circular and in others it is oval (Figure 4-20). You may want to compare letterforms in a few classic typefaces, like Bodoni, Garamond, Century Old Style, Futura, Times Roman, and Univers. (In this case, classic means a typeface that has become a standard because of its beauty, grace, and effectiveness.) It is a good idea to be so familiar with at

least two classic typefaces that you know every curve and angle by heart.

Each letterform is made up of positive and negative forms. The strokes of the letterform are the positive forms (sometimes just called forms), and the spatial areas created and shaped by the letterform are the negative forms (or counterforms). The term **counterform** includes counters, the shapes defined within the forms, as well as the negative forms created *between* adjacent letterforms. Try to be as sensitive as possible to the forms of each letter and the counterforms between them. Remember that the negative forms are as important as the positive forms. In other words, the spacing between letters is a crucial aesthetic consideration. Line spacing also must be considered. You must have enough space for ascenders and descenders and consider the negative space between lines of type.

Direct Message

For various expressive purposes—whether whimsical or aesthetic—some designers utilize letterforms as purely decorative forms, ignoring their symbolic content. Most often, however, type is meant to be read. For the viewer to read the display or text type and get the direct message—the primary or denotative meaning—you must consider legibility and emphasis.

Legibility contributes to readability and is the quality that makes type easily comprehensible. Many things contribute to readability: letterspacing, word spacing, line spacing, line breaks, line length, typeface, type size, width, weight, capitals and lowercase letters, type alignment, italics, and color.

Let's examine some of these.

Just as letterspacing, word spacing, and line spacing (or leading) are crucial to the creation of interesting and harmonious positive and negative form relationships, they are also vital to readability.

Too much spacing may detract from readability; conversely, too little space may make reading difficult. As stated earlier, you must not trust automatic spacing—always make adjustments. Also, uneven letterspacing and word spacing may cause unwanted pauses or interruptions

that make something more difficult to read. You can test it by reading the words aloud to see if there are any unwanted pauses or spaces. Similarly, if the line length is too long or too short, it will detract from readability. When designing display or text type, always ask yourself, "Can I read it with ease?" There are many theories and rules of thumb about spacing, aesthetics, and readability. For example, some designers say that if you have open letterspacing, the word and line spacing should be open. Conversely, if you have tight letterspacing, the word and line spacing should be tight, as well.

Consistency is important. Of course, other factors come into play, such as the typeface, type size, and weight. Study books about designing with type in order to learn as many points of view as possible; the bibliography of these books may refer you to more books about type.

Obviously, when considering spacing, much depends upon the typeface(s) you are using and the type sizes, weights, and widths.

Some typefaces seem to lend themselves to more open spacing because of their form; some lend themselves to tight spacing. Study specimens of display and text type to get a "feel" or an "eye" for typefaces, weights, and widths.

Here are some things to consider.

• Typefaces that are too light or too heavy may be difficult to read, especially in smaller sizes.

• Typefaces with too much thick/thin contrast may be difficult to read if they are set very small—the thin strokes may seem to disappear.

• Condensed or expanded letters are more difficult to read because the forms of the letters change. You may, however, choose to use a condensed width, if, for example, you are designing a narrow column of type.

• Larger sizes require tighter spacing than smaller sizes. If the type is a display size, you will have to space it differently than a text size.

• In both display and text sizes, type set in all capitals is generally more difficult to read. A combination of capitals and lowercase letters provides maximum readability.

• In general, type that is flush left/ragged right is easiest to read. That does not mean you should not use any other type alignment. Base

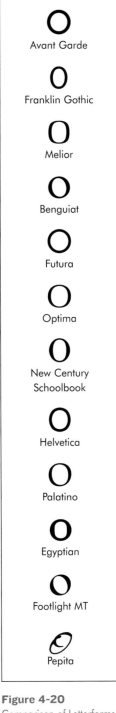

Figure 4-20
Comparison of Letterforms in Various Typefaces

Figure 4-21
Brochure: Network CPR
Design studio: Red Flannel
Creative director/Art
director: Bob Flanagan
Designer/Illustrator:
Michele Kalthoff
Client: Network CPR

your decision on several factors: the type size, the line length, the line spacing, the meaning, the audience, and the amount of type. Reading a short message in flush right/ragged left is not too difficult.

• Where you break the lines of type depends on two basic factors: aesthetics (appearance) and editorial meaning. Break lines in natural places to enhance meaning. Indentations and line spacing between paragraphs will also enhance legibility.

• Paragraphs that are too long are difficult to read. The use of initial capitals can also enhance readability.

• Remember: Italics are best used for emphasis, rather than for large blocks of text, which may be difficult to read.

• When the lines in a paragraph are too long or too short, they are hard to read. Approximately forty-five characters to a line is usually comfortable to read.

Color is also an important consideration. When a lot of text is involved, most designers choose black type on white or light backgrounds. The

more value contrast there is between the type and background, the greater the legibility. If the type and background colors are similar in value, the type will be difficult to read. Highly saturated colors may interfere with legibility, as well.

We use emphasis to determine the importance of information in a design. Viewers tend to read headings first, like titles or headlines, then sub-headings, and finally other typographic elements such as paragraph headings, pull quotes (quotes pulled from the text and enlarged in size), type in panels or feature boxes, captions, and last, the text or body copy. The designer must design the typography into a visual hierarchy, as exemplified in the corporate communication application shown in Figure 4-21.

For example, if you are designing a book cover, you will have to decide whether you want the viewer to read the book title first or the author's name first. If the author is well known, someone such as John Grisham, you may want the viewer to see the author's name first. Of course, you would want to emphasize Grisham because John is a common name—or give the first and last name equal emphasis—but you certainly would not emphasize John. In a more difficult layout, like a newspaper, you must use type size, weight, and width to control the order in which the viewer reads the information. We tend to read larger, darker elements first, and elements such as initial caps, paragraph indents, rules, and icons will aid in establishing emphasis. Contrasts in size and weight will lead the eye from one element to the next.

Here is a tip: When designing something with a lot of information, sort out the information on index cards or individual sheets of paper. Type or print out the heading on one card, the sub-heading on another card, the date of the event on another card, and so on. Stack the cards in order of importance. This will help you to establish tiers of information.

Secondary Meaning

Let's say you are designing the following sentence: "It looks like a storm is brewing." Which typeface would you choose to enhance the direct message? What size, weight, and

width? Would color enhance the meaning and if so, which colors? The direct message of the sentence is the primary meaning, the denotation. The way the type is designed suggests a secondary meaning, a connotation.

Each classification of typefaces has a different spirit or "personality," and the differences among the typefaces within each category give each typeface an individual spirit, as well. Typefaces that defy categorization—and there are many—have individual spirits. Sometimes it is easier to determine the spirit of a novelty typeface because it is more illustrative.

In addition to having personality, type has a "voice." Type can scream or whisper. As you will see later in this chapter, type can communicate the same way as the spoken word. Consider the typeface, size, scale, and position in the layout when determining the typography's voice.

Here is a standard example of secondary meaning. Most designers consider Old Style and Transitional typefaces more "conservative" or "serious" than Sans Serif faces. Perhaps it is because Old Style is based on Roman and fifteenth-century humanistic writing. Perhaps it is because Sans Serif typefaces are from the modern era and considered newer. The first Sans Serif typestyle appeared in the early nineteenth century, long after the initial Old Style typestyle appeared in the late fifteenth century. It is important to study the history and origins of typefaces so you can make informed decisions.

Every typographic element (weight, width, stress, thick/thin contrast, size) and design element (color, texture, value) contributes to the secondary meaning. Whether the type is heavy or light, Roman or italic, black or red, carries meaning beyond the direct message. For example, picture the words "heavily armored combat vehicle" in your mind's eye. Most people would probably think of heavy Sans Serif capitals. Using a light Script would suggest a meaning different from the direct message. If the designer did use a light Script, he or she would be suggesting an ironic meaning.

In order to become sensitive to the secondary meaning of typography, study the work of suc-cessful designers like the ones displayed in this text. Ask yourself why they chose the typefaces, weights, and widths they did to solve their design problems. Try to understand the relationship between the primary and secondary meanings in their works.

Graphic Impact

You are designing with type, and you have considered form, the direct message, and the secondary meaning. Now, how does it look? Yes, after all that, you also have to consider aesthetics—the underlying beauty of the typography. Today, we use the term "beauty" loosely. In reference to contemporary graphic design, and especially to typography, the terms "aesthetically pleasing" and "beauty" seem archaic. What is beautiful to one designer is ugly to another. Some contemporary designers believe typography must be legible, balanced, and harmonious, while randomness, obscured type, and disjointed forms appeal to other contemporary designers. So, graphic impact is a better term.

One way to determine the graphic impact of a typographic solution is to measure the "texture" or "color" of the solution. The terms texture and color have different meanings here. Some designers use these terms to refer to the tonal quality of type. The texture or color of typography is established by the spacing of letters, words, and lines, by the characteristics of the typeface, the pattern created by the letterforms, the contrast of Roman to italic, bold to light, and by the variations in typefaces, column widths, and alignment. Here is a tip: Stand back and squint at typography to get a sense of its "lightness or darkness," its tonal quality.

Another way to measure graphic impact is to determine the appropriateness of the style for the client, the message, and the audience. Which style is appropriate for a serious message? Are certain styles appropriate for certain types of clients? Would you design in the same style for both a young audience and a mature audience? The style you choose should be appropriate for the client, message, and audience. You would not design an ad for MTV the same way you

One way to determine the graphic impact of a typographic solution is to measure the "texture" or "color" of the solution.

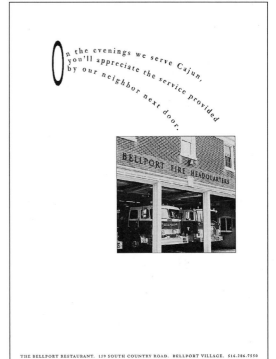

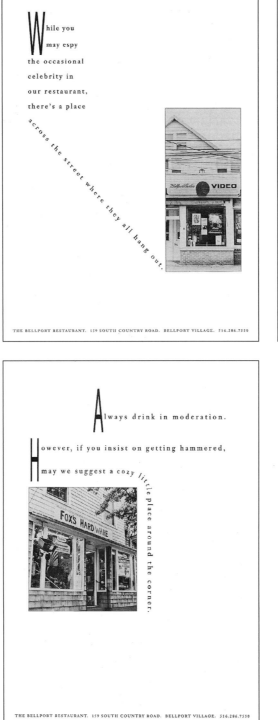

with other typefaces, and they usually do not lend themselves to legibility. They tend to take over a design and look contrived.

Years ago, most designers would have thought twice about using more than two typefaces in the same design solution. Some designers recommend using a type family to gain variations while retaining unity. Although many good designers still would not use more than two, others believe that using more can have great graphic impact. Try this experiment to become sensitive to mixing typefaces and using more than one typeface: Find an advertisement or any other design with a lot of type, both display and text. First, redesign the ad using only one typeface, one size, and one weight. Print out a copy and keep it as a control. Then change the heading to another typeface. Next, change the size of the heading and subheadings. Try various combinations. Experimenting with type is one of the best ways to learn about it.

Graphic design students usually take at least two courses in typography and then spend their careers trying to master designing with type. Entire books are devoted to type and to designing with type. Consider this chapter a starting point for further study.

would design an ad for a commercial bank; they are different clients with different needs and probably different audiences.

There are many novelty or decorative typefaces that design students seem to be attracted to but should avoid because they are difficult to design with; it is difficult to mix them

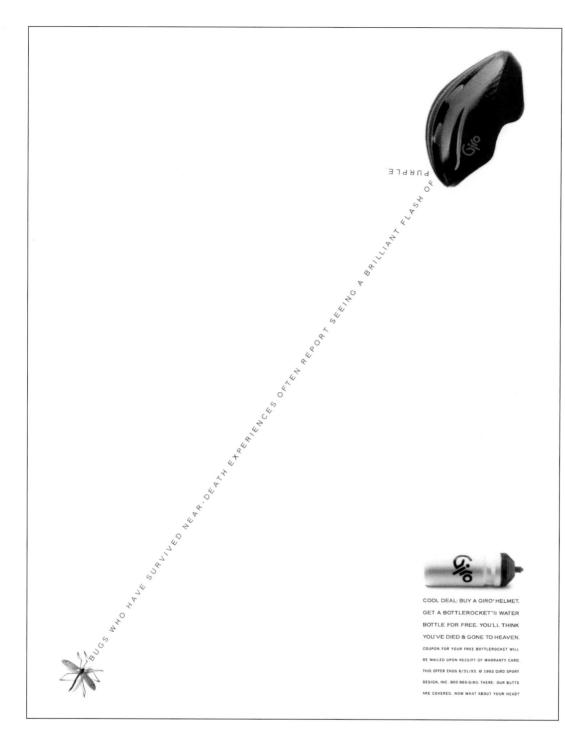

Type and Visuals

Type is usually designed with other visual elements, such as photographs, illustrations, graphs, and graphics (elemental visuals—both pictorial and abstract—such as rules, patterns, or textures). The relationship between type and visuals is crucial—it should be synergistic. When a cooperative action between type and visuals is created, the design becomes a cohesive unit. In the advertisements for The Bellport Restaurant and for Giro, type and visuals cooperate to communicate the ad messages (Figures 4-22 and 4-23).

The message to be communicated will help you determine which visuals and typefaces are appropriate.

Some things to think about when designing with type and visuals are:
- Consider the format in the design
- Establish a visual hierarchy between the type and visuals

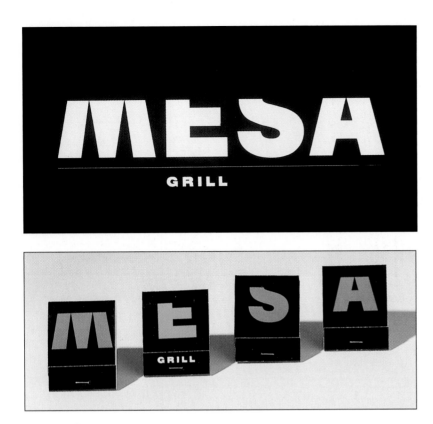

Figure 4-24
Logo: Mesa Grill
Design firm: Alexander
Isley Inc., Redding, CT
Client: Mesa Grill

Figure 4-25
Magazine spread:
"Chappaquiddick"
Design firm: Alexander
Isley Inc., Redding, CT
Client: Spy magazine

- Maintain balance
- Carefully consider the size relationship (scale) of the type to the visuals
- Determine the amount of type (both text and display) and the number of visuals
- Consider the spirit, tone, and meaning of the visuals in relation to the spirit, style, and historical meaning of the typeface(s)
- Consider how the type and visuals look together, whether they are complementary in form and style

Type and Expression

In addition to understanding the fundamentals of design and how they relate specifically to designing with type, it is essential to understand how type can be used creatively and expressively. The following design concepts use type in a structural way in order to express meaning. The design concept, the spacing, the positive and negative space, and the typeface all lend to the success of the two typographic design solutions by Alexander Isley Inc. The Mesa Grill logo is a play on the word "mesa" which means "flat-topped mountain" (Figure 4-24). In the Chappaquiddick spread from *Spy* magazine (Figure 4-25), to represent a tragic drowning, the words are shown sinking into water.

Used in conjunction with a visual, type is often the verbal part of the design message. However, type can also be the visual itself and can express the entire message. By designing the type to look cramped, Bonnie Caldwell expresses meaning through the typographic design (Figure 4-26). When a still medium like print can evoke the idea of sound, it is very exciting. Paula Scher designed the typography in the poster for the Public Theatre to create the illusion of sound (Figure 4-27).

Martin Holloway uses custom lettering and low contrast (created with a technical pen on graph paper) to express the rustic meaning of the words "Country Things" (Figure 4-28). In Jennifer Morla's "Environmental Awareness" poster for AIGA (Figure 4-29), Morla uses type as a vehicle to express the subtle shades of meaning that go beyond the written expression of the message. In the series of ads shown in Figure 4-30, the spacing and size relationships of the typography communicate the messages.

Summary

Typography is the design of letterforms and the arrangement of them in two-dimensional space (for print media) and in space and time (for digital media). For both print and digital media, visual communication professionals must consider some fundamental issues of form and structure, design, message/content, and expression. Learning to differentiate among letterforms and understanding

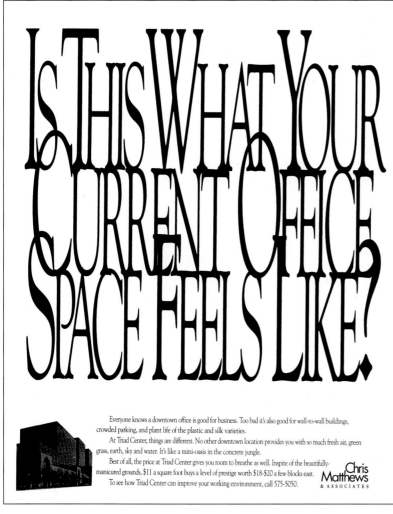

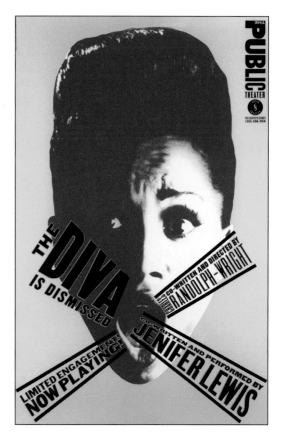

Figure 4-26
Ad
Agency: Williams &
Rockwood, Salt Lake City, UT
Creative director:
Scott Rockwood
Art director: Bonnie Caldwell
Writer: Chris Drysdale
Client: The Triad Center

"We wrote this ad in an
office the size of a shoe
box on 2nd South in Salt
Lake City. It went on to
win many awards. But
what pleased us most
was that the ad was
so effective. The Triad
Center reached 95
percent occupancy
in about a year. Just
working on the ad
had us convinced.
We moved to the Triad
Center six months later."

—Williams & Rockwood

Figure 4-28
Logo: "Country Things"
Design firm: Martin
Holloway Graphic Design,
Pittstown, NJ
Lettering/Designer:
Martin Holloway

Figure 4-27
Poster: *The Diva Is Dismissed*
Design firm: Pentagram Design, New York, NY
Partner/Designer: Paula Scher
Designers: Ron Louie, Lisa Mazur, and Jane Mella
Photographer: Teresa Lizotte
Client: Public Theater, New York, NY

"When Joseph Papp was producer at the Public Theater,
Paul Davis produced a memorable series of illustrated posters
which set the standard for theater promotion for nearly a
decade. In keeping with the expanded vision of new producer
George C. Wolfe, a new identity and promotional graphics
program have been developed to reflect street typography:
active, unconventional, and graffiti-like. These posters are
based on juxtapositions of photography and type.

'The Diva Is Dismissed' was Jennifer Lewis's one-woman show."

—Pentagram

Figure 4-29
Poster: "Environmental
Awareness," AIGA
Design firm: Morla Design,
San Francisco, CA
Art director: Jennifer Morla
Designers: Jennifer Morla
and Jeanette Arambu
Client: AIGA, San
Francisco, CA

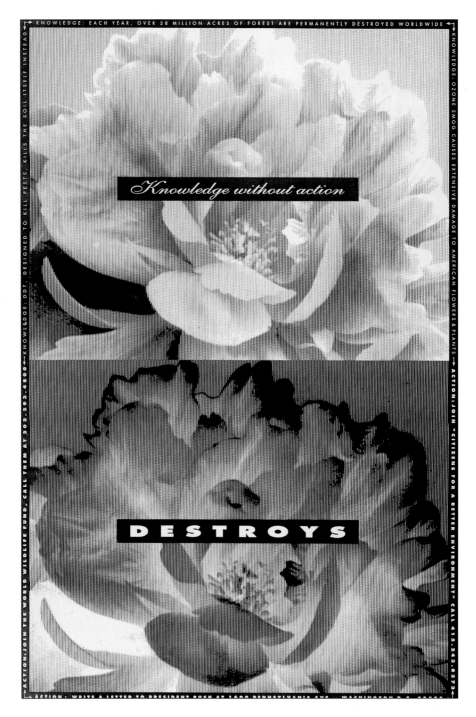

how letterforms are structured as well as generated, adds to one's realization that type demands a thorough study to be mastered.

When arranging typographic elements, you should consider emphasis, rhythm, alignment, unity, spacing, positive and negative space, and the illusion of spatial depth to create illusion.

Besides the importance of letter, word, and line spacing to readability and legibility, when designing with type, one must also consider form, direct and secondary meanings, and graphic impact. Considering the subtle, precise relationship of type and visuals in a design solution is crucial to creating visual messages with impact. In addition to understanding the fundamentals of design and how they relate specifically to designing with type, it is essential to understand how type can be used creatively and expressively.

Finally, acquiring type tips from esteemed professionals always speeds up the process of learning to design with type.

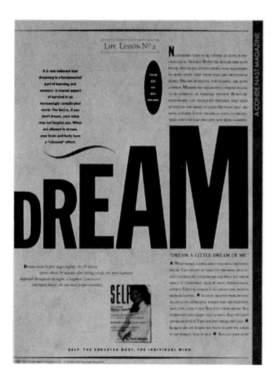

Figure 4-30
Trade ads: *Self* magazine
Design firm: The Valentine
Group, Inc., New York, NY
Art director/Designer:
Robert Valentine
Designers: Robert Valentine
and Tracy Brennan
Writers: Shari Sims and
Dean Weller, Courtesy of
Condé Nast Publications

Notes

[1] Rob Carter, Ben Day, and Philip B. Meggs, *Typographic Design: Form and Communication*, 3rd ed. (Hoboken, NJ: John Wiley & Sons, Inc., 2002), p. 293.

Tips from Designers

Alexander Isley, president
Alexander Isley Inc., Redding, CT

"Read the manuscript. It is surprising how easy it becomes to design when you understand what the writer's message is."

Thomas Courtenay Ema
Ema Design Inc., Denver, CO

On designing with type in general:

"For me, designing with type is one of the most important and pleasurable aspects of graphic design. If design were visual music and layout, composition, and grids were the structural elements of the music, then typographic elements would be the notes. With these notes, an accomplished musician can write beautiful music.

It is possible to create visual music that can express any emotion or communicate any ideas."

On designing with type and visuals:

"To fully express a visual communication message with type and image, the designer must pay particular attention to the relationship between those two elements. The most effective design solutions exhibit a unique connection between the type and the visual that communicates something more than either one alone. This connection can sometimes be made by letting the type reflect or contrast the form, composition, pattern, or color of the visual image.

Remember that the type and image are all individual pieces of a whole design that should not be thought of alone, but in terms of how they work together to create the overall design and visual communication message."

On designing with display type:

"One of the biggest traps that a student of typography can fall into when selecting and designing with type is giving in to the use of special display faces to communicate different ideas. If one truly understands the methods of creating good typography, wonderful design solutions can be created with a limited group of proper type families such as Garamond No. 3, Helvetica, Univers, Times Roman, and Bodoni.

If we use a musical analogy, it is like playing different instruments. Do not try to play a hundred different instruments; learn to play a few instruments well!"

Tom Geismar
Chermayeff & Geismar Inc., New York, NY

"Typography forms the basis of almost all our design work. It is the way we express ourselves. It is the cornerstone of our practice."

Martin Holloway
Professor of Visual Communications,
Department of Design, Kean University of
New Jersey

"There are at least two qualities that are always present in successful typographic design.

First is form: type should work in a purely formal manner. All visual elements, including letterforms, possess design properties such as line, texture, shape, and mass. These elements are configured into compositions—the arrangement of elements to achieve visual equilibrium.

Second is function: type should work as the visual counterpart of language. In spoken communication, factors such as syntax, inflection, and the emotional quality of the voice are inseparable from the message

content, in terms of the impact the spoken word has upon the listener. Similarly, the selection of typeface, style, and size—and their placement relative to other visual elements—is equally inseparable from the message content."

Mike Quon
Mike Quon Design Office, New York, NY
• "So often, people get involved in the nonreadability of things, ways to cover up words. Type is meant to be read. If we are not encouraging reading, we are missing one of the better ways to communicate."
• "Do it the way you want to—trust your first instinct—then do it several more ways. Then put them all in front of you and compare them. The more successful solution will stand out. Develop a rationale; be able to explain why one is better than another."
• "The rules about designing with type are being broken. You have to find your own style and vision—what feels right for you."
• "I like headlines, because people look something over in seconds."
• "There is a lot of entertainment value in what we do."
• "There is a blur between the lines of good typography and bad typography. It is hard to say what is good or bad because it is a value judgment. Design and beauty are in the eye of the beholder, but there are different styles that people like. There is no one way, however, to make it tasteful, simple, and not too hard to read."

"To fully express a visual communication message with type and image, the designer must pay particular attention to the relationship between those two elements. The most effective design solutions exhibit a unique connection between the type and the visual that communicates something more than either one alone."

—Thomas Courtenay Ema
Ema Design Inc., Denver, CO

"Typography forms the basis of almost all our design work. It is the way we express ourselves. It is the cornerstone of our practice."

—Tom Geismar
Chermayeff & Geismar Inc., New York, NY

Exercise 4-1

Design your name

1. Get a book of typefaces.
2. Write down two or three adjectives that describe your personality or spirit.
3. Find typefaces that express your personality or spirit.
4. Design your first and last names; your middle name is optional.
5. Give careful consideration to the positive and negative forms in between the letters and the spacing between the letters.

"You have to find your own style and vision—what feels right for you."

—Mike Quon
Mike Quon Design Office,
New York, NY

Project 4-1

Design a poster entitled "Taking a Stand"

Step I

a. Research the Civil Rights movement in the United States.
b. Write an objectives statement. Define the purpose and function of the poster, the audience, and the information to be communicated. On an index card, in one sentence, write the objective of this poster.
c. Find typefaces that express the spirit of the subject.

Step II

a. Design a poster for a public television program entitled "Taking a Stand." The program is a documentary on the Civil Rights movement in the United States.
b. The poster should include the title and television station or channel. Optional: include the date and time of broadcast.
c. Your solution should be typographic, with no visuals.
d. Produce at least twenty sketches.

Step III

a. Produce at least two roughs.
b. Use a vertical format.
c. Be sure to establish emphasis.
d. Carefully examine your spacing between letters, among words, and between lines of type.

Step IV

a. Create a comp.
b. The poster should be no larger than 18″x 24″.

Presentation

Present the comp either matted or mounted with a 2″ border all around.

Comment: *One of the greatest challenges facing a designer is to organize typographic elements into a visual hierarchy. Establishing a visual hierarchy is central to clear communication. The designer must order elements so the reader can comprehend the message.*

Exercise 4-2

Expressive typography

1. Look through a few magazines.
2. Find typefaces used in articles or advertisements that express the following: light-heartedness, seriousness, and humor.
3. Find typefaces that you think are classics, retro (reminiscent of an era gone by), and edgy.
4. Defend your choices.

Project 4-2

All type

Step I

a. Design a poster or invitation for a natural history exhibition or foreign film festival.
b. The design solution should be solely typographic with no visuals or visual accents.
c. Produce at least twenty sketches.

Step II

a. Produce at least two roughs.
b. Use a vertical format.
c. Carefully examine letterspacing, word spacing, and line spacing.

Step III

a. Create a comp.
b. The invitation should be 4″ x 6″; the poster should be no larger than 18″ x 24″.

Presentation

Present the comp either matted or mounted with a 2″ border all around.

Comment:

It is important to remember that type can be the visual! You do not need to rely on photographs or illustrations to grab the audience's attention.

GEEF *FIETSENDIEVEN* GEEN KANS!

Chapter 5:
Layout

◄ Poster: *Don't give bicycle thieves a chance!*
Agency: KesselsKramer, Amsterdam

Objectives

Discover the meaning of a layout

Learn the interconnected goals and functions of a layout

Grasp the need to fit visual elements into a limited space, have them function effectively, and be unified

Learn that successful layout facilitates communication

Comprehend fundamental principles governing the layout of a page: emphasis (focal point and visual hierarchy), unity, and balance

Recognize the importance of format in any layout

Use the grid as a layout device

Construct simple grids

Defining Layout

To solve any graphic design problem, a designer must conceive an idea and realize it visually. The designer must create, select, and organize visual elements in order to create effective communication. A **layout** is the arrangement of type and visuals on a printed or digital page, and concerns the organization and arrangement of type and visuals on two-dimensional surfaces to create effective visual communication.

Layout Goals

Layout entails several interrelated goals: to fit visual elements into a limited space, to facilitate communication—which means to arrange visual elements so that they are functional, unified, and easily accessible to the viewer—and to create visual impact. How do you design a successful layout? As always, you begin by asking yourself a few questions: Who are the viewers? Which design choices are appropriate for the audience? What is the purpose of the design? What information or message has to be communicated? Where will it be seen? Once you have answered these questions, you can begin to produce thumbnail sketches in order to consider various layouts.

There are innumerable ways to arrange visual elements on a page. Once you have considered your strategy and formulated a concept, there are some basic principles to keep in mind. They are emphasis (focal point and visual hierarchy), unity, and balance. Although they all have to be considered as you work, let's go through them one by one.

Emphasis

When you establish a focal point, create a main area of interest on the page. Choosing which element should be the focal point—whether it is type or a visual—should be based on several factors. The following are some to consider:

- Which element will communicate the primary message or information?
- Which element is most important?
- Which element would be the most engaging for the viewer?
- Which element will lead to enrichment of the viewer experience?

For example, it is most likely that either the main visual component or the main verbal message (type) would be the focal point. It is unlikely that a secondary or tertiary point of information, such as the time of an event or a ZIP code, would be the focal point.

A focal point can be established in a multitude of ways. A designer can isolate an element or arrange all the elements to lead to it. Here is a list of possible ways to establish a focal point using contrast.

- Make it brightest
- Make it a different color
- Make it in color if everything else is in black and white or vice versa
- Turn it in a different direction
- Make it a different value
- Position it differently
- Give it a texture or a different texture from the other elements
- Make it a different shape than the other elements
- Render it in focus and the other elements out of focus
- Reverse it
- Render it an opaque color and the other colors transparent
- Make it glossy and the other elements dull

With a strong, saturated color, the book title in Figure 5-1 attracts the audience's attention first. The color of the title, its position on the page, and the size of the type all contribute to establishing the title as the focal point of this book jacket design.

Even though the entire high-contrast, startling visual of the cover grabs your attention, the fuchsia circle containing the type is the focal point in Figure 5-2, due to its color and difference from the other visuals on the page.

Without a doubt, the most important design principle for a student to keep in mind is visual hierarchy, which means arranging elements according to emphasis. Establishing a visual hierarchy sets a priority order for all the information in the design. Usually, any graphic design piece has several visual components; you must decide which will take priority over the others. This is crucial. You must ask yourself: What should the viewer see first? Second? Third? And so on. The position of elements on the page,

Figure 5-1
Book jacket:
The Transparent Society
by David Brin
Design firm: Steven Brower Design, New York, NY
Designer: Steven Brower

"In contrast, I gave this jacket a high-tech ominous feel to convey the warning within, that Big Brother is here and technology has made it possible."

—Steven Brower

Figure 5-2
Brochure cover:
Grubman Animals
Design firm: Liska + Associates, Inc., Chicago, IL, and New York, NY
Art director: Steve Liska
Designers: Kim Fry and Andrea Wener
Photography:
Steve Grubman
Client: Grubman Photography

As part of their continued marketing efforts for this photography studio, Liska + Associates designed this brochure to demonstrate Grubman Photography's expertise at animal photography.

Figure 5-3
Airline seat pocket placards:
Virgin Atlantic Airways, "CEO Conduct
While on Board," "Unauthorized
Bedtime Nonsense," and
"Transatlantic Hair Regulations"
Executive creative director: Alex Bogusky
Creative directors: Bill Wright and
Andrew Keller
Art director: Paul Stechschulte
Copywriter: Franklin Tipton
Illustrator: Timmy Kucynda
Client: Virgin Atlantic Airways

Airline seat pocket placard:
Virgin Atlantic Airways, "Tension
Escape Routes"
Executive creative director: Alex Bogusky
Creative directors: Bill Wright and
Andrew Keller
Art director: Tony Calcao
Copywriter: Rob Strasberg
Illustrator: Timmy Kucynda
Client: Virgin Atlantic Airways

Imitating the look of flight information
cards, these witty pieces are unified by
treatment of the layout, consistent "look
and feel," and tone of voice of the copy
and concept.

Figure 5-3, continued
Web banner: Virgin Atlantic Airways, "Bounce"
Executive creative director: Alex Bogusky
Creative director: Andrew Keller
Interactive creative director: Jeff Benjamin
Copywriter: Franklin Tipton
Programming/Production: Barbarian Group
Client: Virgin Atlantic Airways

The visual elements within the banner work wonderfully in relation to the format/shape of the banner.

Web banner: Virgin Atlantic Airways, "Massage"
Executive creative director: Alex Bogusky
Creative director: Andrew Keller
Interactive creative director: Jeff Benjamin
Art director: Juan-Carlos Morales
Copywriter: Franklin Tipton
Client: Virgin Atlantic Airways

Both of these compositions utilize encapsulated shapes within the format to create a dynamic layout. Besides the success of the layout, asking the user to interact makes these banners a rich user experience.

the relationship of one element to another, and factors including size, value, color, and visual weight all must be considered.

Here are some general points to keep in mind when establishing visual hierarchy.

• Placement: both position on the page and relative position (each visual element in relation to the position of another) plays into establishing a visual hierarchy.

• Movement: the tendency to "read" visual elements in the direction we read our own language.

• Size: we tend to look at bigger things first and smaller things last.

• Color: we tend to be attracted to brighter colors, but also to look at the color that stands out, that is different from the surrounding colors.

• Visual weight: we tend to look at "heavier" elements first.

• Value: a gradation of values, moving from high contrast to low contrast, can establish a flow from one element to the next.

Sometimes designers have to arrange many elements on a page. Often, a client insists that a good deal of text and visuals be included, or a designer may choose to include multiple elements. In either case, the designer must be up to the challenge. In the ad campaign for Virgin Atlantic, the designer organizes a large amount of text and visuals, on the front and back of each piece, by grouping and encapsulating; the alignment of the visual elements and the responsiveness to the format add to visual hierarchy, as well (Figure 5-3). In advertising, some campaigns use the same template (compositional structure with designated positions for the elements) throughout a campaign, as in the placards for Virgin Atlantic.

Unity

In order for a layout to be effectual, it must hold together. It must seem organically integrated. There are many ways to achieve unity. Three of the most important means are correspondence, alignment, and flow.

When you repeat an element such as color, shape, texture, or a visual element, you may establish a visual connection or correspondence among the elements. The confluence of corresponding elements, along with design decisions, contributes to the "look and feel" (the general appearance and overall emotional expression) of an application.

Since visual connections can be made between and among elements, shapes, and objects when their edges or axes line up with one another, alignment contributes to establishing unity. Unity can be established by a color palette, the

Figure 5-4
Poster: The B'z
Design studio: Modern Dog
Design Co., Seattle, WA
Designer: Junichi Tsuneoka
Client: House of Blues
© Modern Dog Design Co.

Tsuneoka establishes
unity in this piece through
the color palette and
a related treatment
of each visual form.

treatment of the visual elements (correspondence in treatment), and establishing a visual flow from one element to another, as in the poster for The B'z (Figure 5-4). The viewer easily picks up these relationships and makes connections among the forms; elements are arranged so that the audience is led from one element to another through the design.

Balance

Balance is an equal distribution of weight in a layout. Establishing balance is crucial; the viewer will feel that something is "wrong" in the design if it is imbalanced. To balance a design, you must consider visual weight, position, and

arrangement. In the poster campaign for the Amsterdam City Council that reads "Don't give bike thieves a chance!" each visual element is balanced by the other. Consider the angle of the headline, encapsulated in a red band against the angle of the bicycle in each poster (Figure 5-5).

Try this little experiment. If you cover one of the oval portraits on the upper left side of the imaginative poster design in Figure 5-6, the right side becomes heavier. Each element in this poster design is dependent upon the other; each element was thoughtfully positioned. Similarly, using the spread in Figure 5-7, from a new edition of *Aesop's Fables* designed by Milton Glaser, cover the graphic element (artwork) in the lower right corner. You'll

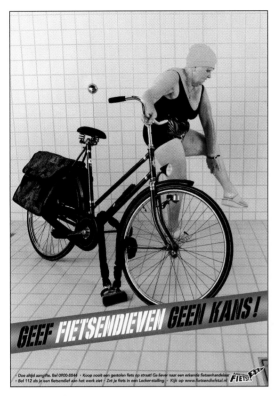

Figure 5-5
Posters: *Don't give bicycle thieves a chance!*
Agency: KesselsKramer, Amsterdam
Strategy: Matthijs de Jongh and Lineke van den Boezem
Art direction: Erik Kessels and Marieke Schooneman
Copywriter: Johan Kramer
Photography: Herman Poppelaars
Client: Amsterdam City Council

Every year, 100,000 bikes are stolen in Amsterdam. This campaign was intended to instruct people on how to prevent their bikes from being stolen. KesselsKramer chose an in-your-face approach that is "suitable for the Amsterdam public who are known for their direct and honest sense of humor. Taking your bike with you into the swimming pool, to the dentist, or to the museum—is that really what you want to do to prevent it from getting stolen?"

—KesselsKramer

notice that the layout is no longer balanced. This demonstrates just how important the arrangement of every element is to a successful layout.

Considering the Format

The term "format" has two related meanings: the actual thing or substrate you start out with—like a poster or brochure—and the limits of that substrate, such as the edges and overall shape of a poster. Never forget that the format is a primary player in any layout. All elements respond to the shape of the page. Each letter of the name "Fritz" touches the edges of the format in the poster design announcing Fritz Gottschalk's lecture at the Art Directors Club of Denver (Figure 5-8). The designer, Thomas C. Ema, creates dynamic positive and negative shape relationships between the typographic elements and the format. We start with the letter F and move clockwise, reading the name and the other information.

There are three very different examples of using the format as an active player in a design in Figures 5-9 through 5-11. The large, red negative shape has unique impact in the layout in Figure 5-9, and Sommese's whimsical figure/ground designs make all the space active in the poster in Figure 5-10. Using images of ancient currency, Liska + Associates designs powerful spreads that look much larger than their physical size (8″ x 5″) because of the layout, scale (size of visuals in relation to the size of the format), and resulting positive and negative spaces (Figure 5-11).

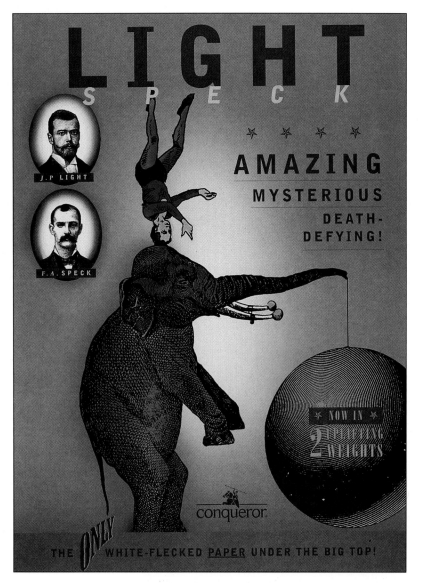

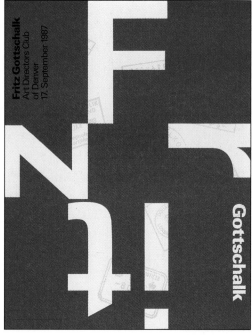

Figure 5-6
Poster: Conqueror LightSpeck
Design firm: Viva Dolan Communications and Design Inc.,
Toronto, Ontario, Canada
Designer/Illustrator: Frank Viva
Writer: Doug Dolan
Client: Conqueror Fine Papers

This poster was created to introduce Conqueror LightSpeck,
a new range of pale-flecked paper, to the North American
market. The chief design goal was to achieve a memorable
visual impact that would carry through in the accompanying
swatch book and other collateral, giving this unique product
a distinctive image while clearly positioning it as part of the
overall Conqueror range.

Figure 5-8
Poster: Fritz Gottschalk
Design firm: Ema Design Inc., Denver, CO
Art director/Designer: Thomas C. Ema
Client: Art Directors Club of Denver

Having studied with Gottschalk in 1984,
Ema arranged for his mentor to speak to the
Art Directors Club of Denver. Ema used
international passport stamps as the
announcement's random design elements—
and later learned that Gottschalk's topic was
his design of the new Swiss passport!

Figure 5-7
Book spread: *Aesop's Fables*, new edition of artwork created in 1947
Design firm: Milton Glaser, Inc., New York, NY
Artwork: John Hedjuk, architect
Publisher: Rizzoli International Publications, Inc.

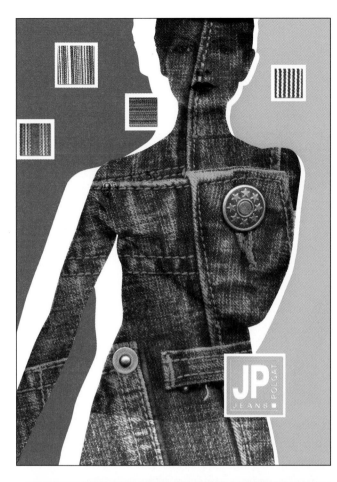

Figure 5-9

Corporate image: Polgat Jeans
Design studio: Shira Shecter Studio; Fresh Graphic Design, Israel
Client: Polgat Jeans

"Polgat Jeans is a leading fabric manufacturer in Israel. For this project, our aim was to take the fabric and infuse it with fashion as an integral part of our end vision. The brand character was built before displaying at a series of exhibitions in Europe. We tried to transform them into a dynamic, striking company—to make them stand out from the pack. An inspiring effect was created by covering the models with big patches of jeans. Contrast was enhanced by the use of shockingly bright red and yellow backgrounds."

—Shira Shecter

Figure 5-10

Poster: *Our Living World*
Design firm: Sommese Design, State College, PA
Art director/Designer/Illustrator: Lanny Sommese
Client: Penn State College of Agriculture

"The poster was sent to all of the high schools, middle schools, and elementary schools in Pennsylvania. The intent was to broaden awareness in the students concerning the interdependence of all the living things in Pennsylvania. All the imagery—insects, plants, and animals—are indigenous to the state. The Tree of Life aspect of the image with mother nature in the center seemed appropriate and essential to the use of the positive/negative. The stylistic approach, I felt, promoted the interdependence idea. Images were drawn or found and then pasted into the tree by hand. (Can you find them all?) The search was intended to appeal to the young audience."

—Lanny Sommese

Figure 5-11
Booklet: The AIGA
Salary Survey of
Graphic Designers
Design firm: Liska +
Associates, Inc., Chicago,
IL, and New York, NY
Art director: Steve Liska
Designer: Susanna Barrett
Photography:
Frederik Lieberath
Copywriters: Ric Grefe,
Roz Goldfarb, and
Jessica Goldfarb
Client: AIGA,
National Chapter

"The AIGA produced
a survey on standards
of compensation within
the graphic design field.
Liska + Associates
designed a booklet to
make this information
available to AIGA
members and nonmembers
interested in comparing
salary packages. The
design includes images
of currencies from other
cultures, reinforcing the
concept that compensation
is more than a dollar
amount and should be
considered a whole
package with a relative
value."

—Liska + Associates

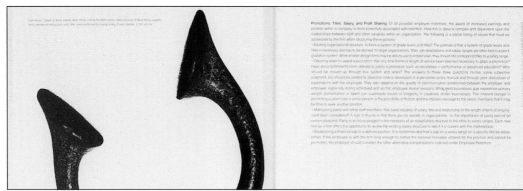

Once you feel comfortable with the fundamentals of graphic design, you can begin to lay out a single page, such as a poster or a print advertisement. Many graphic designers work on multipage designs, such as books, magazines, newspapers, brochures, web sites, and annual reports. When a designer needs to maintain emphasis, unity, and balance throughout a series of consecutive pages, the task becomes very difficult. For this reason, most designers use a grid.

The Grid

Open up a magazine. How many columns do you see? How are the visual elements organized? All the elements, display and text type, and visuals (illustrations, graphics and photographs) on the pages of a magazine, book, or newspaper are almost always organized on a grid. A grid is a guide—a modular, compositional structure made up of verticals and horizontals that divide a format into columns and margins. Margins are the spaces around the type and other design elements.

A grid's proportions and spaces provide the consistent visual appearance for a design; a grid underlies and structurally holds together all the visual elements. It is a way for a designer to establish unity for either a single page or multipage format. The assignment, strategy, concept, and budget help determine the number of pages in the piece. The size and shape of the paper is an important consideration in establishing a grid. There are many standard-size papers and traditional ways of dividing them into workable units.

There are many grid options. There are even and odd number grids, ranging from one to four and sometimes even six columns. A grid need not be ironclad. For the sake of drama or visual surprise, you can break from the grid occasionally. If you break the grid too often, however, the visually consistent structure it provides will be lost. How do you know which grid to use for a design? Consider your design concept, format, and the amount of information that needs to be designed. Each format has a different structure and presents different considerations. Often, magazines have several grid options that work together, as shown in the three sample grids used in *Print* magazine (Figures 5-12 through 5-14).

Looking at the designs for a brochure for Klein Bicycles (Figure 5-15) and a *Print* magazine spread (Figure 5-16), you can clearly see the column structures. Although the design concepts are very different, both designs are

Figure 5-12
One column grid:
Print magazine
Designer: Steven Brower

Figure 5-13
Two column grid:
Print magazine
Designer: Steven Brower

Figure 5-14
Four column grid:
Print magazine
Designer: Steven Brower

Sample grid designs. When
you have many elements to
organize—display type, text
type, and visuals—you
usually need to establish an
underlying structure that can
provide help in maintaining
clarity, legibility, balance,
and unity. This is especially
true when you are working
with a multipage format
where you need to establish
a flow or sense of visual
consistency from one page
to another.

Figure 5-15
Product catalog:
Klein Bicycles 2000
Design firm: Liska +
Associates Inc., Chicago,
IL, and New York, NY
Art director: Steve Liska
Designer: Mary Huffman
Photography:
Steve Grubman
Client: Klein Bicycles

"Liska + Associates
designed the Klein Bicycles
2000 product catalog, part
of their complete marketing
campaign, to build brand
confidence and increase
sales. We created a catalog
that functions as the
essential dealer tool for
selling bikes. It offers clear
illustrations of Klein's bike
lines, their specific features,
and the recommended uses.

We positioned the bikes
to appeal to the elite
consumer, expanding from
Klein's traditional market
base of professional racers,
while educating consumers
about the history and range
of the Klein brand."

—Liska + Associates

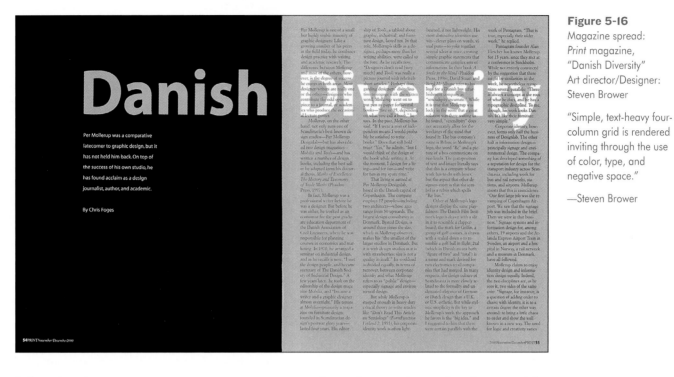

Figure 5-16
Magazine spread:
Print magazine,
"Danish Diversity"
Art director/Designer:
Steven Brower

"Simple, text-heavy four-
column grid is rendered
inviting through the use
of color, type, and
negative space."

—Steven Brower

balanced and consistent. Consistency is a very important element in multipage design; it provides flow from one page to the other. The design concepts and styles in these works are reflective of considerations toward the audience and the purpose of the design.

A four-column grid is used in the manual for American Express Travel Related Services (Figure 5-17). Although designer Ellen Shapiro uses four somewhat narrow columns, she establishes a strong horizontal emphasis that echoes the extended horizontal format of the manual.

Figure 5-17
Manual: American Express
Travel Related Services,
"Establishment Services
Communications
Guidelines"
Design firm: Shapiro
Design Associates Inc.,
New York, NY
Art director/Designer/
Writer: Ellen Shapiro
Agency responsible for
American Express Card
design elements: Ogilvy &
Mather, New York, NY
Client: American Express
Travel Related Services, Co.
Inc., New York, NY

Figure 5-18
Newspaper: *The Wall Street Journal*, second front page, new section design
Design firm: Shapiro Design Associates Inc., New York, NY
Art director: Ellen Shapiro
Publisher: Dow Jones & Co. Inc., New York, NY

Newspaper grids are particularly crucial since there is so much text, especially in a paper like *The Wall Street Journal*, where photographs are usually at a minimum. Shapiro's design was used for more than five years by *The Wall Street Journal* (Figure 5-18). A spread for the Time Warner annual report successfully balances and juxtaposes four strong and colorful visuals (Figure 5-19).

Some designers have such a strong sense of layout they can abandon a grid, as in the contents spread for *Emigre* magazine (Figure 5-20). The designer's only grid was the crop marks. A grid is not readily apparent in the imaginative spreads shown in Figure 5-21; it is obvious, however, that the layout has been carefully planned because correspondence and unity have been established. Similarly, the layouts by Shira Shecter for an image catalog are very thoughtfully composed to create engaging spatial illusions (Figure 5-22).

The spreads for the Worcester Art Museum—"where art celebrates life"—demonstrate how one can utilize a grid and have variety within the grid structure, yet maintain unity and flow (Figure 5-23). Notice

that both pages have images on the right page and text on the left page. Many novices don't think of the front and back of a CD cover as a unit, but the CD design in Figure 5-24 reminds us of just how cohesive a CD cover design can be. Nesnadny + Schwartz's design for the WorldCare Capabilities brochure teaches that a spread is more than two pages joined together (Figure 5-25); it reminds us that a spread is a unit that must be designed with flow and unity in mind. Figure 5-26 is a great example of how a grid operates over several pages.

Summary

To solve any graphic design problem, a designer must conceive an idea and realize it visually. The designer must create, select, and organize visual elements to create effective communication. A layout is the arrangement of type and visuals on a printed or digital page, and it concerns the organization and arrangement of type and visuals on two-dimensional surfaces to create effective visual communication. Layout includes several interrelated goals: to fit visual elements into a limited space; to facilitate communication—which means, to arrange visual elements so that they are functional, unified, and easily accessible to the viewer—and to create visual impact.

When designing a page (print or digital), there are basic principles to keep in mind: emphasis (focal point and visual hierarchy), unity, and balance. Remember, the format is a primary player in any layout; all elements respond to the shape of the page.

You can begin with the layout of a single page, such as a poster or a print advertisement. Many graphic designers work on multipage designs, such as books, magazines, newspapers, brochures, web sites, and annual reports. When a designer needs to maintain emphasis, unity, and balance throughout a series of consecutive pages, most will use a grid. A grid is a guide—a modular, compositional structure made up of verticals and horizontals that divide a format into columns and margins.

Figure 5-19
Annual report: Time Warner
Design firm: Frankfurt Gips Balkind, New York, NY
Creative directors: Aubrey Balkind and Kent Hunter
Designers: Kent Hunter and Ruth Diener
Photographers: Charles Purvis, Scott Morgan, and Lorraine
Day, and a still taken from a Time Warner video
Client: Time Warner, Inc.

"Photographic icons represent the four pieces of Time
Warner, the world's largest entertainment and information
company. A color palette and layout grid is established here
for the rest of the annual report. The spread is actually die
cut horizontally at the center grid, so readers can create
their own layout with the next two spreads."

—Kent Hunter, executive design director,
Frankfurt Gips Balkind

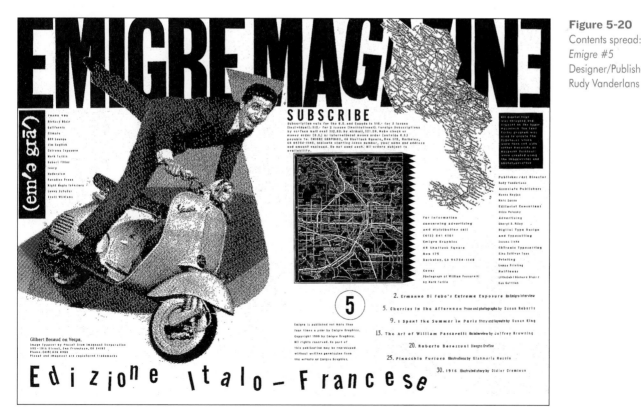

Figure 5-20
Contents spread:
Emigre #5
Designer/Publisher:
Rudy Vanderlans

Figure 5-21
Book divider spreads:
The Alternative Pick: Spirit
Design firm: Planet Design
Company, Madison, WI
Art director/Designer/
Illustrator: Kevin Wade

"Storm Music
Entertainment's *The
Alternative Pick* is the
standard 400-page source
book for the music and
entertainment industries,
speaking to progressive
photographers, design
firms, illustrators, and
directors. Planet crafted
the image and theme for
the 'Spirit' campaign.
Our assignment: design
and write the editorial
portion of the book, as well
as develop a direct mail
campaign, logos, calendar,
gift package, and other
ancillary items. The intent
was to create materials that
would catch the eye and
imagination of a design-
savvy entertainment
industry audience."

—Planet Design Company

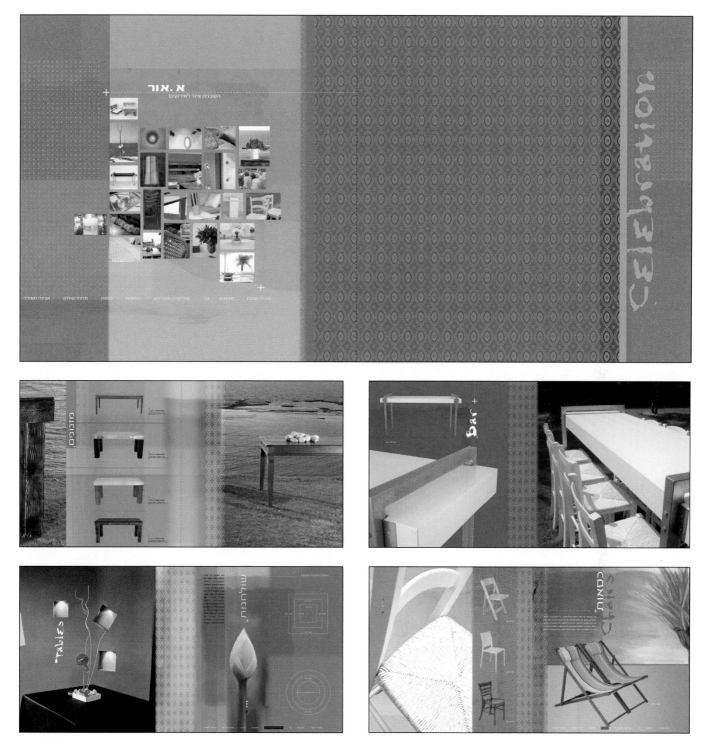

Figure 5-22
Catalog: A. Or Ltd.
Design studio: Shira Shecter Studio; Fresh Graphic Design, Israel
Client: A. Or Ltd.

"A. Or is an events equipment rental company offering all the necessary equipment for any type of event. With this catalog, we aimed, through the design, to create the image of the company by soft-selling its products. For the underlying theme of the catalog, we chose flowers that in their own right inspire unity for all kinds of events while offering a fresh, colorful approach. Instant atmosphere was created by photographing each of the products in nature-based surroundings."

—Shira Shecter

Figure 5-23

Brochure: Worcester Art Museum, "Where Art Celebrates Life" Centennial Campaign

Design firm: Nesnadny + Schwartz, Cleveland, OH, New York, NY, and Toronto, Canada

Art directors: Joyce Nesnadny and Mark Schwartz

Designers: Joyce Nesnadny, Mark Schwartz, and Brian Lavy

Artists: Various

Photographers: Various

Client: Worcester Art Museum

"Worcester Art Museum (WAM) embarked on a five-year campaign to raise $30 million, the largest fundraising effort in the museum's history. This brochure was created in response to the museum's need for a piece that articulates its story in a very compelling manner. The goal of this campaign was to increase investment income, thereby strengthening the museum's endowment, providing greater long-term financial stability, fueling current and new programs, improving upon its facility, and expanding community activities. Our quest was to produce a piece that reestablished the museum's commitment to the community and presented a vision that compels donors to step forward and join the Centennial Campaign."

—Nesnadny + Schwartz

Figure 5-24

CD cover: *Authentic Flavors*

Design studio: Segura Inc., Chicago, IL

Designer: Carlos Segura

Segura utilizes related visual elements (unity with variety) on the CD cover and the CD itself, as well as on promotional items such as T-shirts.

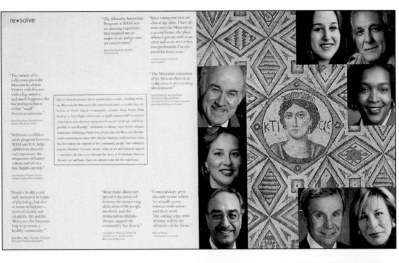

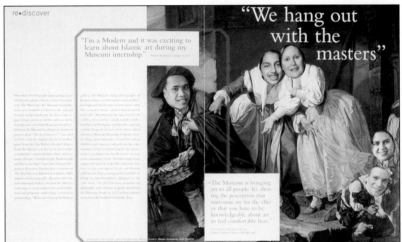

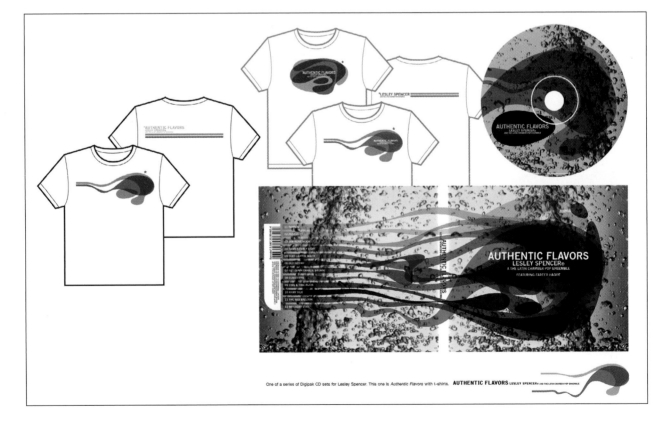

One of a series of Digipak CD sets for Lesley Spencer. This one is *Authentic Flavors* with t-shirts. AUTHENTIC FLAVORS LESLEY SPENCER® AND THE LATIN CHAMBER POP ENSEMBLE

Figure 5-25
Brochure: WorldCare Capabilities
Design firm: Nesnadny + Schwartz,
Cleveland, OH, New York, NY, and
Toronto, Canada
Art directors: Mark Schwartz, Joyce
Nesnadny, and Tim Lachina
Designers: Joyce Nesnadny and
Michelle Moehler
Photographers: Design Photography,
Inc. and stock
Client: WorldCare

"Our client, WorldCare, required
a brochure that would offer
a comprehensive, compelling
introduction and an overview of their
services. Using the latest technology,
WorldCare establishes a worldwide
connection between patients in need
and medical experts who can help
them. WorldCare wanted a 'branding'
piece to underscore the quality of the
institutional consortium, the tangible
humanitarian benefits, and the
leadership role that they seek to play.
This brochure describes all aspects
of WorldCare's business, from
telemedicine capabilities to clinical trial
services to the 'global HMO.' It includes
the company's mission statement, core
business, list of offices, and goals for
using telemedicine to overcome many
of the world's obstacles to providing
the best health care services."

—Nesnadny + Schwartz

Figures 5-26

Magazine spread: *Print*
Art director/Designer:
Steven Brower
Illustration: Ron Barrett
("Silent Partners"
spread)

"For this special
advertising issue of
Print, I devised a
method of utilizing a
two-column grid to its
maximum potential.
Creating a well with
the first half of the grid,
I then moved the type
and images around
and together so that
the section worked
cinematically as you
moved through it."

—Steven Brower

Steven Brower
Creative Director,
Print **magazine**

Figure 5A-1
Magazine spread:
Print magazine,
"Beyond the Fjords"
Art director/Designer:
Steven Brower

"I created a typographic
representation of a fjord for
an article on Norway's new
generation of designers,
utilizing a two-column grid."

Formation Architecture or How I Learned to Love the Grid

When I was about to begin the process of redesigning *Print* magazine, the question I was asked most often was whether I planned on doing away with the grid. "Without a doubt," I would answer, to knowing nods. Who needs structure when there is so much freedom to be had?

Of course, what they were really asking was "Will *Print* be as heavily structured as it had been in the past?" Indeed, starting in the early 1960s, *Print* followed a rigid modernist structure, with narrow justified columns of type and lots of white space. Originally designed by Herbert Bayer and then redesigned by Andrew Kner, the grid lasted for more than thirty years. So the answer to the question was, well, yes—and no.

While it was certainly my intention to make the pages of *Print* less reverent and more exciting to look at, the reality was that there needed to be an underpinning, a core at the center of the structure. Imagine walking through a city with no organization as to how the streets are laid out. Try keeping a lunch date. Or another way to view this is, would we want to enter a structure where the underlying girders were laid out with no plan in mind? Let's hope they have a good insurance policy.

Accordingly, whether freeform or conservative, all books, newspapers, and magazines have a grid. A grid is a collection of horizontal and vertical lines that define the space where the type and/or images are to be placed. This is the skeletal foundation of the

Unlike its Scandinavian neighbors, Norway has never shone too brightly in the graphic design firmament. A sparsely populated land of geographical extremes, it has struggled to establish and export an indigenous style. Yet since the 1990s, a new generation of designers has started to make a mark within Norway and even beyond. One of the reasons seems to be the opening up of geographical barriers via the Internet. Today, cyberspace not only allows Norwegian designers international visibility, but also encourages a much-cherished creative discussion with their European and American counterparts. Above all, Norway's currently buoyant economy means that designers are feeling more confident and optimistic than ever in promoting their own identity.

Norway achieved independence relatively recently, in 1905. Annexed by Denmark for 400 years, its official language was Danish, although the working class persisted in using Norwegian. During the early 20th century, discussions on national identity centered on which official language to adopt. While the moderate political faction opted for keeping the Danish language with the addition of Norwegian words, a radical faction wanted to create a new standard based on Norwegian dialects. As a result, Norwegians speak two languages: "Bokmal" (book language) and "Nynorsk" (new Norwegian). The necessity to differentiate itself visually, culturally, and linguistically from Denmark has always been a visceral issue.

Because of its history, Norway's cultural life often leaned toward nationalism. "This was due to the fight for independence and against Nazism in Germany," explains Jorunn Veiteberg, an art historian and author of several design books, including *The Norwegian Poster 1721–1998* (1998). "Fine artists were very active in defining the cultural national heritage, and were very anti-'internationalism.' Common people therefore mainly experienced cubism, art deco, functionalism, and surrealism through the posters and design made by commercial artists, or what would be later called graphic designers." Unlike fine artists, Norwegian graphic designers always kept an international outlook, Veiteberg adds. "I think this has to do with the nature of their job. It is urban, shaped by modern society, and always at the forefront of advanced technology."

Interestingly, many of the leading figures in the postwar development of Norwegian graphic design were foreigners, who brought outside influences with them. "The graphic designer Bruno Oldani, who started in Switzerland and came to Norway in 1958, has been extremely important," says Veiteberg. "Peter Haars, who came from Germany in 1962, has also had a seminal influence, especially in raising the quality of book cover design." In 1988, Haars became the first professor of graphic design at the Institute of Visual Communication, National College of Art and Design, Oslo.

But who are the movers and shakers today? According to Veiteberg, there is a large pool of Norwegian talent, including

Halvor Bodin, Kim Hiorthøy, Erik Johan Worsøe Eriksen, Tone Bergan, Liv Andreas Mesdøl, and Marius Watz, that has taken graphic design beyond the fjords while bringing a distinctly Norwegian flavor to the discipline.

Halvor Bodin, Kim Hiorthøy, and Marius Watz are part of a group that actively reflects upon Norwegian identity through their work. Although very different in style and training, the three designers collaborated in 1997 for the 17th issue of *Fuse*, the experimental typographic publication published by FSI and conceived and designed by Neville Brody. Under the tag "Function," the three designed two fonts: Where the Dog Is Buried and Shinjuku (www.katode.org/function/fuse). An accompanying statement referenced some of the national and international perceptions of their country: "Look at Norway: We are rich and we are proud. We have oil and we have mobile phones. We hunt whales. We invented the cheese slicer and the paper clip. We ate our dogs to reach the South Pole. We trust our government. We have social security. We have less discrimination of women than most other countries. We have government support of the arts. We are approaching the millennium in a state of gluttony."

The recent rise in Hiorthøy's international profile proves the exportability of a "Norwegian style." His September 2000 cover for the British magazine *Creative Review* and the inclusion of his record sleeves for Norwegian label Rune Grammofon in the books *Sampler 1* and *Sampler 2*, designed in collaboration with British design consultancy Intro, have made him something of a Nordic star. Educated in fine arts in Norway, 27-year-old Hiorthøy is an illustrator who works with type; he is also a music composer and filmmaker. Although he currently lives in Copenhagen, Denmark, he maintains strong ties with Norway, where most of his clients are based. Hiorthøy's recent projects include the illustrations for his second children's book, *Hundu Kjærdo*, a seven-inch record of his own music for label Smalltown Supersound, whose sleeve Hiorthøy designed himself, and a presence on the recently launched Web site thisisrealart.com, which showcases and sells limited editions of cult graphic designers' work.

"I have been prioritizing music work over clients' work in the past months," explains Hiorthøy of his eclectic approach. Work for Danish theater group Bidt and two recent exhibitions, one of his pencil drawings in Norway's capital, Oslo, and one at the Scandinavian Design Center in New York, round off what has been an extremely prolific period.

Yet despite his own success and increasing prominence, Hiorthøy is still forced to look overseas to find a wider design community in which new ideas can be shared. "There isn't an equivalent in Norway," says Hiorthøy of what he calls the "discussion about graphic design," in which British design groups such as Fuel and Tomato are seen to take part. "The crossover between design and art is not taken as seriously as it is in the U.K."

The field is still young in Norway, and many of those work-

Beyond the Fjords

Norway's new generation of graphic designers eagerly absorbs outside influences while simultaneously pursuing a national design identity.

By Sara Manuelli

NEW VISUAL ARTISTS REVIEW 2002

This issue marks the fifth anniversary of *PRINT*'s New Visual Artists Review, our annual showcase of 20 graphic artists under the age of 30. Over the past four years, we've been pleased to introduce young illustrators, designers, art directors, and photographers who were bringing fresh vision to the field. This year is no different: The New Visual Artists of 2002 are a diverse and accomplished lot, and they are pushing artistic and geographic boundaries.

The ways in which they are crossing artistic frontiers vary widely. Golan Levin and Casey Reas, both alumni of MIT's famed Media Lab, are exploring the possibilities of interactive design, creating applications with potential to revolutionize both technology and art. At the other end of the spectrum are artists like Lauren Redniss and Tifenn Python, whose materials often consist of no more than pencil and paper, but who use those traditional tools to capture life in surprising and ingenious ways. Others in this Review take their influences and interests and funnel them into their own original esthetic, with remarkable results. The illustrations of Nathan Fox, for instance, combine comics, Japanese woodprints, and a cinematic perspective, in a style that is as engaging as it often is outrageous.

Adventurous in their work, these artists are equally so in their lives. As with last year's artists, many of this group's members have an international outlook. Two—Daisuke Endo and David Heasty—spent their early years relocating around the globe with their army-employed fathers; others have roamed abroad for schooling or a change of scene. Illustrator Isabel Klett, who currently calls Barcelona home, has also lived in New York and Paris, all in the space of about five years.

Python and designer Christian Calabrò are among those raised in far-flung locales—Python in Tahiti and Calabro in Zurich; both came to New York to further their careers, and both find inspiration in location. Python's island origins still have an impact on her drawing, and Calabrò says that the mellowed brick-and-wood aura of his studio in Manhattan has shaped his own visual style.

Calabrò and Python are just two of this year's New Visual Artists who have made New York their home (some as recently as a year or two ago). Of course, for young creatives to head to the Big Apple is nothing new, and the formidable challenges the city poses are also well documented. But last September, those challenges were rendered trivial in light of the World Trade Center attack and its aftermath. Illustrators Joel Holland and Gina Triplett, friends who recently moved to Brooklyn from Baltimore, apparently discussed whether or not they should pull up stakes again. But Holland says that, in the end, the event actually helped him crystallize his motives for being in the city, and he decided to remain. Despite the downturn in the job market, he says, "In a way, the attack made me more determined than ever to stay here." Triplett concurs; though for a while after 9/11 she had difficulty being alone in her studio, she says she still loves New York and won't leave.

Nathan Fox, who moved to New York in 2000, has found himself facing a new type of obstacle since last September. "I've been censored," he says. "Art directors have told me not to do anything too gruesome; they say that they expect something happy." Fox, whose style is innately dark, finds requests of this kind curious, but says that, thankfully, it hasn't limited him too much, or kept him from getting work.

Indeed, while this past year has undoubtedly held difficulties, these young artists seem to have surmounted them with grace and aplomb. Their work reflects both their fortitude and their unflagging zest for life and art. And if the following pages tell us anything, it's that they'll be helping to shape their world—and the world of graphic design—for a long while to come. —*Caitlin Dover*

Figure 5A-2

Magazine spread: *Print* magazine, "NVA"
Art director/Designer: Steven Brower

"Sometimes special sections have their own requirements. This yearly feature of "New Visual Artists" (twenty artists under the age of 30 who are making their way in the field) breaks the standard grid of *Print*. Or does it?"

format: the margins of the page, the place for folios, and the width of the columns.

Today, grids are set in computer layout programs, and electronic templates are created. In the past, they were lines on paper, often preprinted in nonphoto reproducible blue, as a guide for the paste-up artist. How rigid or open a grid is has much to do with the content and personality of the publication. A news magazine may require more formality than a music magazine, and the weekly sections of a newspaper require less formality than the front page. However, with so many sections and so much information on each page in newspapers, the importance of the grid is paramount. Otherwise, you would be reinventing the wheel with every edition.

As is the case with *Print*, most publications have several grid variations. There can be one, two, or four columns on a page. That is to say, text can be placed in either two or four columns, although this is not always strictly adhered to. There are several important things to note: first line indentation may work for a wider two-column grid, but not for the single narrow column; the point size needs to be small enough to accommodate the more narrow measure so that there aren't too many single-word lines, rendering the text hard to read.

Folios often appear in the same spot from page to page, although it is up to the publication whether they must appear on every page and in the same position. A folio can simply be a page number, but it can also contain the issue date, and occasionally the title of the article or section. In books, the folio may be combined with a running head or running foot, which is generally the title of the book on the left page and the chapter title on the right, although this varies as well.

So do yourself a favor: embrace the grid—it is there to help. One day you will thank me.

Exercise 5-1

Designing with a simple grid

Part I

There are many systems for dividing up space; here is one way to begin experimenting with grids.

1. Take an 8½″ x 11″ page (paper or electronic) and place a margin around the entire format (think of it as a border). Decide on the number of inches for the margin; the margins can be adjusted to any size you find aesthetically pleasing and functional (a column width that is suitable to user-friendly reading). Now you are left with a central space or "live area" within which to place and arrange the design elements. That central space may be thought of as a single-column grid.

2. Now try another experiment. Take two pieces of an 8½″ x 11″ paper and place them next to each other to form a two-page spread (17″ x 11″). Create a single column on each page (using the method described above). Are the columns the same? Do they repeat one another? Or are they mirror images? Now divide the columns with horizontals.

3. Now try this. On an 8½″ x 11″ page, create a margin and divide the remaining area into two columns. Now divide the two columns into four. Divide them again into eight. Divide the columns with horizontals. Analyze the differences in appearance and function.

You have just created a few very simple grids.

Part II

1. Using the single-column and two-column grids you just created, design a layout.

2. Cut display text, subheads, text type, and some visuals out of a magazine, or use a computer and page layout program to import visuals.

3. Make a few photocopies of each element, reducing and enlarging a few. Also make several photocopies of your grids. Use a scanner and computer, if available.

4. Try different arrangements of the elements on the grids.

5. Remember to utilize the principles of emphasis, unity, and balance.

Project 5-1

Design two magazine spreads

Part I

Step I

a. Buy a music or entertainment magazine.

b. Analyze the grid system used in the magazine.

c. Choose an appropriate subject for your spread, for example, an article on a musician or celebrity.

d. Write a design brief. Define the purpose or function of the spread, the magazine's audience, and the information that needs to be communicated. On an index card, write a one-sentence statement about the article.

Step II

a. Design an opening spread (two facing pages) for an article in a music or entertainment magazine. An opening spread often puts emphasis on the name of the article and a main visual treatment to lure the reader, to catch the reader's attention.

b. Use the magazine's grid system for the spread.

c. Include the following elements: display text, visual(s), and some text type.

d. Produce ten sketches.

Step III

a. Produce two roughs.

b. Establish emphasis, unity, and balance.

Step IV

a. Refine the roughs. Create a comp.

b. The dimensions of the spread should be the same as those of the magazine you chose.

c. You may use black and white or full color.

Part II

Step I

a. Design a second spread for the same article spread (two facing pages); this spread will follow the opening spread. While an opening spread often captures the reader's attention, the following pages of an article offer more information (text and visuals) to the reader.

b. Use the magazine's grid system for the spread.

c. Include the following elements: subheads, small visual(s), a pull-quote (a quote pulled out of the text and given emphasis to both create visual interest and intrigue the reader), and text type.

d. Produce ten sketches.

Step II

a. Produce two roughs.

b. Establish emphasis, unity, and balance.

Step III

a. Refine the roughs. Create a comp.

b. The dimensions of the spread should be the same as those of the magazine you chose.

c. You may use black and white or full color.

Presentation

Reduce the spreads to half size and mount both spreads on a board with a 2″ border all around.

Comment: *If someone placed an open magazine in front of you, would you be able to identify the magazine by its design? There are some magazines that are so distinctive in design, a person can identify them by their format, layout, and typography alone. A spread is an extended rectangular format. Remember, you must establish unity across the entire format. A successful layout is functional, offers information in a hierarchical order, and both eases and enriches the reader's experience.*

Part 2:
Applications

Logos

Symbols

Pictograms

◀ Logo: Ilse
Agency: KesselsKramer, Amsterdam
Client: Ilse

Objectives

Learn the definition of a logo and the types of logos

Realize the logo is a keystone of a visual identity, which addresses the spirit of the brand, group, or social cause

Design logos with relevance to an audience in mind

Choose fonts appropriately and creatively

Understand the use of a logo in letterhead and stationery applications

Become acquainted with practical considerations of logo application

Learn historical periods and connotative meaning, as applied to choosing fonts for logo design

Become familiar with fundamental ways of depicting logos

Study the definition and potential meaning of a symbol

Recognize the various possible configurations of a symbol

Grasp how professionals utilize symbol nomenclature

Learn the definition and purpose of a pictogram and pictogram system

Communicate meaning through logo, symbol, and pictogram design

Convey information through pictograms

Design an elemental visual

Skillfully combine type and visuals into a coherent unit

Design logos, symbols, and pictograms

Logos

If you go shopping for athletic footwear, you need only glance at the logo to know a lot about the shoe—who manufactures it, the quality, the price range, and perhaps even which athletes endorse and wear the brand. Many brand names, such as Nike and Puma, are instantly recognizable. Not only does the logo serve as a label, it also conveys a message about the spirit and quality of the brand, one that is reinforced through marketing, other graphic design applications, advertising, and product performance.

A **logo** is a unique identifying symbol, also called a brandmark, mark, identifier, logotype, or trademark. A logo represents and embodies everything a brand or group signifies; it also provides immediate recognition. It is important to note that design nomenclature periodically changes; although brandmark is most current, logo is the most commonly accepted term among design professionals, clients, and the general audience.

Types of Logos

Logos can take various forms and combinations; they can be a wordmark, a lettermark, a symbol mark, or a combination mark.

- **Wordmark** (also called **logotype**): the name spelled out in unique typography or lettering (Figures 6-1 and 6-2).
- **Lettermark**: the logo is created using the initials of the brand name (Figures 6-3 through 6-5).
- **Symbol mark**: an abstract or nonrepresentational visual or a pictorial visual.
 - An abstract symbol mark is a representational visual with an *emphasis on the intrinsic form*, an *extraction* relating to a real object modified with an abstract emphasis (Figures 6-6 and 6-7).
 - A nonrepresentational or nonobjective symbol mark is a visual which is a nonpictorial visual that symbolizes the brand or social cause, one that does not relate to a person, place, activity, or identifiable object (Figures 6-8 through 6-10).
 - A pictorial symbol mark is a *representational* image that symbolizes the brand or social cause; it relates to an identifiable person, place, activity, or object (Figures 6-11 and 6-12).
- **Combination mark**: a combination of words and symbols (Figures 6-13 through 6-24).

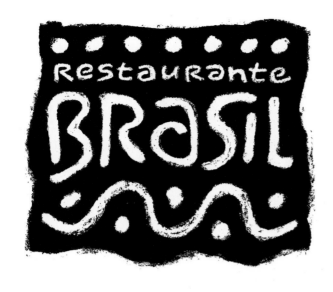

Figure 6-1
Logotype:
Restaurante Brasil
Design firm: Martin Holloway
Graphic Design, Pittstown, NJ
Designer: Martin Holloway
Client: Restaurante Brasil,
Martinsville, NJ

Figure 6-2
Logo: Monsoon Cafe
Design firm: Vrontikis Design Office, Los Angeles, CA
Creative director: Petrula Vrontikis
Designers: Christina Hsaio (logo) and Kim Sage
(poster and invitation)
Client: © Global-Dining, Inc.

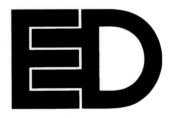

Martin Holloway uses unique hand lettering to create a wordmark for a Brazilian restaurant (Figure 6-1). His execution of the lettering adds visual texture to communicate the spirit and nature of the restaurant. Since logos are used in applications from letterheads to web sites to TV commercials, it's critical to understand how a logo will work in different applications, as in the example of how a wordmark for Monsoon Cafe is applied to a poster and an invitation (Figure 6-2).

For the *Electrical Digest* (Figure 6-3), Craig Bernhardt cleverly combined the initials of the brand name to denote an electrical plug in a socket. The initials of The National Network are

Figure 6-3
Logo: *Electrical Digest*
Design firm: Bernhardt
Fudyma Design Group,
New York, NY
Designer: Craig Bernhardt
Client: *Electrical Digest,*
New York, NY

"When I put the uppercase E and D next to one another and saw the negative spaces in the E as the prongs on an electrical plug—which the shape of the D resembled—the solution was obvious."

—Craig Bernhardt, Bernhardt Fudyma
Design Group

Figure 6-4
Logo: TNN
Design firm: Segura Inc.,
Chicago, IL
Client: The National
Network

All of these interesting
lettermark configurations
communicate the same
spirit for TNN.

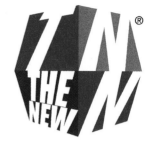

Figure 6-5
Logo: Nitro
Design firm: Firmenich,
Plainsboro, NJ
Art director/Designer:
Michael Sickinger

This is a logo for a
beverage concept.

Figure 6-6
Logo: Freehold Radiology
Design firm: Red Flannel,
Freehold, NJ
Creative director/Art
director/Designer: Jim
Redzinak
Illustrator: Jim Redzinak
Client: Freehold Radiology

Figure 6-7
Logo
Design firm: Firmenich,
Plainsboro, NJ
Art director/Designer:
Michael Sickinger

"The 'aroma band' is
a graphic representation
of 'aroma,' which
symbolizes the essence
of Firmenich's activities: the
creation and production of
flavors and fragrances.
It will be incorporated into
all media and collateral
to support the Firmenich
brand as a visual identity."

—Michael Sickinger

Figure 6-8
Logo: Lightflow
Design firm: Segura Inc.,
Chicago, IL

Figure 6-9
Logo: MetLife Financial
Corporation
Design firm: Red Flannel,
Freehold, NJ
Creative director/
Art director/Designer:
Jim Redzinak
Illustrator: Jim Redzinak
Client: MetLife

Figure 6-10
Logo
Design firm: Red Flannel,
Freehold, NJ
Creative director/
Art director/Designer:
Jim Redzinak
Illustrator: Jim Redzinak

This is a logo for a
construction company.

used in various lettermarks, created by Segura
Inc., to communicate the idea of a fully dimen-
sional television experience (Figure 6-4). To
communicate an edge, the lettermark for Nitro
expresses a high-tech look (Figure 6-5).

Radiating curves encircle a figure in the symbol
for Freehold Radiology (Figure 6-6). Abstracted
aroma is the corporate symbol for an internation-
al flavor and fragrance company (Figure 6-7).

Nonrepresentational visuals allow the viewer
some room for interpretation; they ask the
viewer to think, to conjure along with the
designer. In Figure 6-8, Carlos Segura designs
the symbol for Lightflow with typography and
as a standalone. Using black and white to create
dynamic patterns, Jim Redzinak, creates strong
marks with the illusion of movement (Figures 6-
9 and 6-10).

Figure 6-11
Logo: Ilse
Design agency:
KesselsKramer, Amsterdam
Client: Ilse

Pictorial symbols have a humanistic quality—people can immediately relate. Giving a Dutch online search engine a young girl's persona creates a very friendly face for a company (Figure 6-11). Traditionally, trees are used in literature and painting to symbolize growth and learning; here a tree is used to symbolize a college with an arboretum (Figure 6-12).

The following are some examples of combination marks (Figures 6-13 through 6-17).

The Learning Curve logo combines a nonrepresentational visual, representing a curve, with the name of the company (Figure 6-13). A pictogram is incorporated into the fitting and witty logo for Kozmo.com (Figure 6-14). Hornall Anderson Design Works' design concept is perfect for the client, the makers of a voice-recognition, conversational computing system, shown in Figure 6-15. The logo implies conversation; a conversation bubble replaces the "o." Combining type and visuals is a popular way of designing logos, as in the charming logo for children's clothing (Figure 6-16). Notice how well the type and illustration cooperate in terms of style and weights in the logo design for Jackrabbit (Figure 6-17).

Figure 6-12
Logo
Design firm: Red Flannel, Freehold, NJ
Art director: Jim Redzinak
Designer/Illustrator: Michele Kalthoff

Figure 6-13
Logo: Learning Curve
Design firm: Liska + Associates, Inc., Chicago, IL, and New York, NY
Art direction: Steve Liska
Designer: Holle Andersen
Client: Learning Curve International

Liska + Associates designed this logo as part of a complete identity program for Learning Curve International, an educational toy company.

Figure 6-14

Logo: Kozmo.com
Design firm: DiMassimo Brand Advertising,
New York, NY © Kozmo.com

The bright and energetic Kozmo.com logo
symbolizes fast delivery and user friendliness.

Figure 6-15

Logo/Stationery: Conversá
Design firm: Hornall Anderson Design Works, Seattle, WA
Art director: Jack Anderson
Designers: Jack Anderson, Kathy Saito, and Alan Copeland

The main objective was to develop a proprietary wordmark
for Conversá which incorporated a restylized saycon icon,
a speech-enabled icon. The marketing goal created a
compelling, proprietary identity that appropriately positions
the company, appeals to its audiences, and graphically
interprets and expresses its personality.

Because the client produces a voice-recognition,
conversational computing system, it was necessary to
emphasize a more futuristic look and feel throughout the
corporate branding program.

This design look was applied to a stationery program,
corporate capabilities brochure, and marketing folder.

Figure 6-16

Logo
Design firm: Rizco, Manasquan, NJ
Creative directors/Art directors: Keith Rizzi and Donald Burg
Designer: Keith Rizzi
Illustrator: Donald Burg
Client: Andrew & Company

Figure 6-17

Logo: Jackrabbit
Design firm: double entendre, Seattle, WA
Designers: Richard A. Smith and Daniel P. Smith

"We wanted to create a logo that implied gourmet food
that was good and that you could get quickly. The
clientele is mostly at lunchtime, when people don't have
a lot of time to spare."

—double entendre

The whimsical merge of a beer mug and a watch conveys a mirthful spirit (Figure 6-18). The positive and negative shapes comprising the "plunger" are so keenly designed that the plunger becomes an abstracted, dynamic shape (Figure 6-19). The Quaker Oats Company logo is one that many of us see every morning at breakfast. The pictorial part of this logo is an excellent example of high-contrast shapes used to create light and shadow yielding a memorable image (Figure 6-20). Creating a distinctive and memorable identifying mark is very important. A logo should become synonymous with the client, as the AMMI logo has (Figure 6-21). For a personal chef, abstracted aroma wafting into the air entices (Figure 6-22). Similar line qualities and form are shared by the letterform and pictorial symbol for PocketCard, where the symbol portion of the logo can stand on its own (Figure 6-23). Often, we think of a pictorial logo as an illustration; the logo for MR utilizes photography (Figure 6-24).

An identifying mark—a logo—communicates a great deal about a brand or group (social cause, company, or organization). When you create a logo, you are faced with the task of creating a design that will identify your client's product or business and distinguish it from the competition.

Therefore, a logo should be unique, memorable, and recognizable at a glance; it should become synonymous with the company, product, or service it represents. It also is important for a logo to be used in a consistent manner. For this reason, some designers develop extensive guidelines for logo use and reproduction.

Visual Identity

In today's competitive and worldwide marketplace, there are so many different brands in each product and service category, that it is important for each brand's logo to communicate a clear and consistent identity. Similarly, there are many social causes that require logos. Therefore, logos play a key role in the visual identity of a brand, social organization, or company. A **visual identity** is the visual and verbal articulation of a brand or group, including all pertinent design applications, such as the letterhead, business cards, and packaging, among many other possible applications. An example is the visual identity for Lluvia de ideas (Figure 6-25). (Also see Chapter 7 on Visual Identity and Branding.)

Every time a viewer sees a logo for a brand, group, or social cause, that viewer should be able to immediately recognize and identify the

Figure 6-18
Logo: Watch City Brewing Co.
Design firm: Pentagram Design Ltd.
Partner/Designer: Woody Pirtle
Art director: John Klotnia
Designer: Seung il Choi
Client: Frank McLaughlin

Watch City Brewing Co. is an upscale, 180-seat restaurant microbrewery located in the Boston suburb of Waltham, Massachusetts, or the so-called "Watch City," for its turn-of-the-century production of world-famous watches and clocks. The brewpub refers to the names of some of these watches in its beers and menu items.

The logo is an engraving of an old watch filled with beer. The time reads after five, when the workday ends and people stop watching the clock, relax, and have a beer. The logo appears on the brewpub's stationery, signage, glassware, menus, advertising, and promotional items.

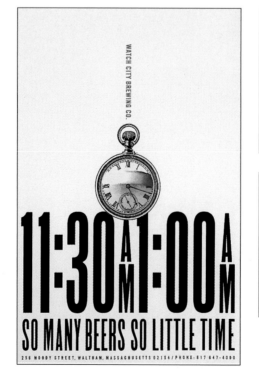

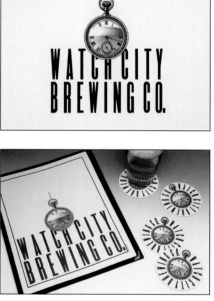

Figure 6-19
Logo: Plungees
Design firm: Segura Inc., Chicago, IL
Client: Plungees

Plungees is the world's first pretty plunger in a pretty box.

Figure 6-20
The Quaker Oats Company logo, used by permission of The Quaker Oats Company.

Figure 6-21
Logo: AMMI
Design firm: Alexander Isley Inc., Redding, CT
Client: American Museum of the Moving Image

"The client is the American Museum of the Moving Image, which is a very long name, so we came up with a shorter symbol for the museum. We did not want to use a cliché film symbol. We looked at more than one hundred eyes before we settled on the one we liked best."

—Alexander Isley, president, Alexander Isley Design

Figure 6-22
Corporate identity
Design firm: Rizco Design, Manasquan, NJ
Creative director/
Art director: Keith Rizzi
Designer/Illustrator:
Dawnmarie McDermid
Client: Lee Ann, Personal Chef

Figure 6-23
Logo
Design firm: Segura Inc., Chicago, IL
Client: PocketCard

Figure 6-24
Logo
Design firm: Ideograma, Mexico
Client: MR

Figure 6-25
Visual identity
Design firm: Ideograma,
Mexico
Client: Lluvia de ideas

Here is an example of
how parts of a logo can
be used separately and
also hold together in
a very memorable way.

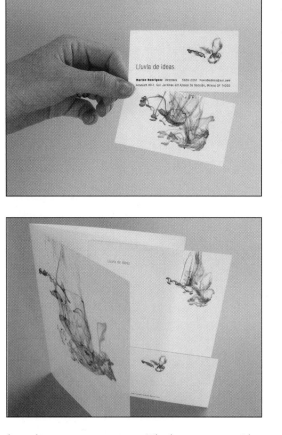

brand, company, or cause. The logo usage guidelines in a standards manual help to ensure recognition and, therefore, guard the logo's value. A logo carries enormous importance for a brand, social cause, or company; it is the keystone of any graphic design plan.

Graphic designers create standards and guidelines for the use of a logo on all applications. Consistent use guarantees immediate recognition in a cluttered commercial environment and ensures integrity of meaning. An **identity standards manual**, also called a **graphic standards manual**, sets up guidelines for how the logo is to be applied to numerous applications—from business cards to point-of-purchase materials to vehicles to web sites. Color, area of isolation (the ideal amount of space surrounding the logo), signatures, and placement are all part of the specifications. The standards manual is a set of guidelines for all future design and advertising applications. All designers and company employees who utilize the logo need to refer to the standards manual. Maintaining standards helps build equity in the logo.

A logo must be designed appropriately in terms of style (characteristic manner or appearance),

type, shapes, and symbols. For example, what might be appropriate for an insurance company might not be appropriate for an amusement park. A logo should express the spirit or personality of the product, service, or organization.

Since most logos are used for long periods, you need to create a logo that will stand up to the test of time in terms of style and trends. Of course, a logo should be aesthetically pleasing, have graphic impact, and be designed according to sound graphic principles. There are innumerable applications for a logo: packaging, stationery (letterhead, business cards, envelopes), signage, advertisements, clothing, posters, shopping bags, menus, forms, covers, and more. A logo needs to work for all applications.

Stationery and Letterhead

A staple of any visual identity is the stationery and letterhead. Most designers position information at the head, or top, of the page, which is why we call it letterhead. That kind of arrangement leaves ample room for correspondence. Some designers split the information and position some type at the foot, or bottom, of the page. Others break with tradition and position type, graphics, or illustrations in any number of ways—in a vertical direction at the left or right side, all over the page in light or ghosted values or colors, or around the perimeter of the page.

Any arrangement is fine, as long as it works. You can design anything you want, as long as it is a sound solution to a visual communication problem. The arrangement should leave a good amount of space for a message, and it should be appropriate for the client. Information should be accessible, and make use of a logical hierarchy; for example, the ZIP code should not be the first thing the viewer notices. The logo is usually the most prominent element on the letterhead; all other type and visuals should be arranged accordingly, from the most important to the least important. An element other than the logo can be the most prominent element in your design, as long as your solution is logical and stems from your strategy and concept.

The design—the arrangement of the elements, the creation of a visual hierarchy, the use of the

logo, and the selection of colors and typefaces—is usually consistent within the parts of the stationery and visual identity. Any design system, whether it is stationery or an extensive visual identity, should have continuity—that is, similarities in form. Some designers feel it is perfectly acceptable to have slight to moderate variations in color, type, or arrangements among the letterhead, envelopes, and business cards. It is possible to design a unified stationery system that incorporates variety.

Here are a few examples of the logo applied to letterhead. Hornall Anderson Design Works created a memorable logo and stationery system (Figure 6-26). Cleverly, an image is printed in the same color as the logo on the reverse side of the business card; the color helps to unify the design. The type on the stationery for the Vietnam Veterans' Widows Research Foundation appears to be a rubbing taken from a memorial, such as the Vietnam Veterans' Memorial in Washington, D.C. (Figure 6-27). By centering the title at the head of the page and aligning it with the type below, unity is established. The design firm of Richardson or Richardson came up with a

Figure 6-26
Stationery: Hammerquist & Halverson
Design firm: Hornall Anderson
Design Works Inc., Seattle, WA
Art director: Jack Anderson
Designer/Illustrator: Mike Calkins
Client: Hammerquist & Halverson

"The marketing objective behind the Hammerquist & Halverson stationery program was attributed to the redesign of the client's original logo and identity.

After years of enlisting the image of a bulldog standing before a target in their corporate identity, the advertising agency decided it was time to update their image.

Rather than eliminating the idea behind their original look, it was decided that the new logo would continue to retain these images. The logo, itself, was altered to reflect a dog's paw. Elements of the 'target' are employed in the design of the paw. The business cards alternate with full-bleed images of a bulldog and of a bull's-eye target printed on the backs."

—Hornall Anderson Design Works Inc.

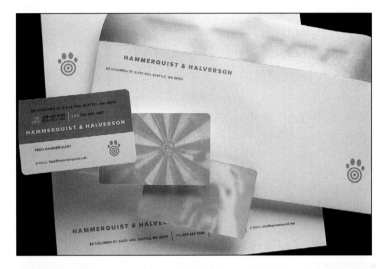

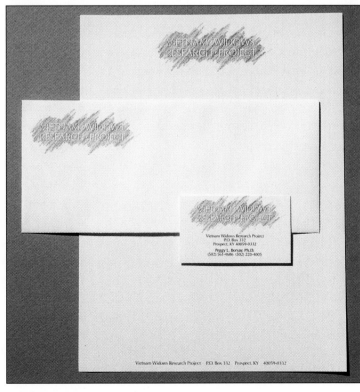

Figure 6-27
Stationery
Designer: Tommie Ratliff,
Crestwood, KY
Client: Vietnam Veterans'
Widows Research
Foundation, KY

"The project was one of those rare instances where, from the moment the idea comes to you, you know it is perfect. From that point, it is a matter of getting the piece produced the way you see it in your mind's eye. In this case, that included making a metal plate and doing dozens of pencil rubbings to have as a starting point for the artwork. I was able to achieve the effect I wanted, even though it was a one-color piece."

—Tommie Ratliff,
Crestwood, KY

Figure 6-28
Stationery
Design firm: Richardson or Richardson, Phoenix, AZ
Designers: Forrest Richardson and Rosemary Connelly
Client: J. W. Tumbles, San Diego, CA

"The client's trademark is a series of symbols, or glyphs, that may be tumbled to any position while still communicating the primary business— a children's gymnasium. The six different symbols combined with the various positions and six color options create an almost endless choice of looks for use on stationery and cards.

Each symbol is an actual label that is self-adhesive and is applied by the client at the time of use to the single color, preprinted stationery paper."

—Richardson or Richardson

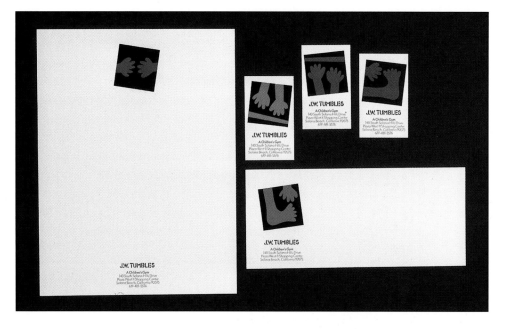

playful stationery solution for J. W. Tumbles, a chain of children's gymnasiums (Figure 6-28).

Designing stationery for one's self is particularly demanding. Even though you are the subject, you still have to follow the usual steps in formulating a strategy and concept. Since you are a designer or design student, people will look at your stationery as an example of your capabilities, as a piece in your portfolio. After all, if you design a great piece for yourself, you will probably come up with a great solution for someone else. Ideograma's witty design concept for their own identity reflects their design studio's capabilities and thinking; potential clients can get a sense of their work by looking

at their stationery (Figure 6-29). The stationery for Laughing Dog Creative uses overlapping type of varying weights to create the illusion of three-dimensional space and to conjure up sounds (Figure 6-30).

A logo is the central part of an identity system. Sometimes a logo can stand alone, apart from the stationery system or program. At other times, it is completely interwoven with the entire stationery system design. Jennifer Sterling's stationery system stands apart in that she combines elements, such as embossing, dates that require a hole-punch, linear elements with embossings, and a perforated bottom edge (Figure 6-31).

Suggestions

Although every rule in graphic design can be broken with a successful creative solution, there are some that a novice needs to keep in mind. A letterhead design should provide ample room for correspondence, and should not interrupt the correspondence. The design on the envelope should meet with postal regulations for the positioning of information. The design should work equally well on all pieces of the stationery. Your objectives are to:

- develop a unique, appropriate, and interesting concept
- create a design that is immediately identified with the sender
- coordinate the letterhead, envelope, and business card by establishing unity
- design and use legible typography
- clearly display the address, telephone and fax numbers, and e-mail and web site addresses
- express the spirit or personality of the company or client

Figure 6-29
Visual identity
Design firm: Ideograma,
Mexico
Client: Ideograma

"A green balloon that is transformed into different animals is a flexible and innovative concept that permits us to find ideal clients, to involve them in a creative adventure, and to communicate the philosophy of the business to them in each moment."

—Daniel Markus, Ideograma

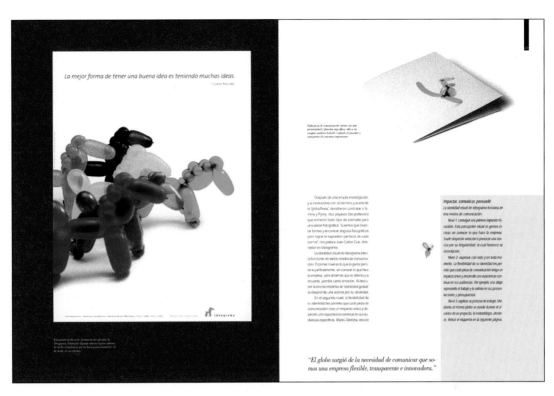

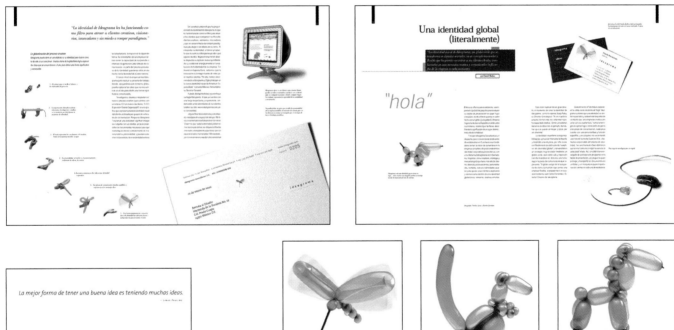

Figure 6-30
Stationery: Laughing
Dog, "Top Dog"
Design firm: Laughing Dog
Creative Inc., Chicago, IL
Creative director:
Frank E. E. Grubich
Designer: Joy Panos

"The primary objective
here was to exploit the
sounds in the phrase
'Bow Wow Tee Hee'."

—Frank E. E. Grubich,
Laughing Dog Creative Inc.

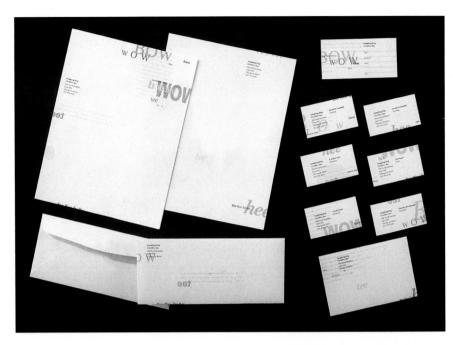

Figure 6-31
Stationery: Jennifer Sterling
Design Identity System
Design firm: Jennifer
Sterling Design,
San Francisco, CA
Art director/Designer:
Jennifer Sterling
Client: Sterling Design

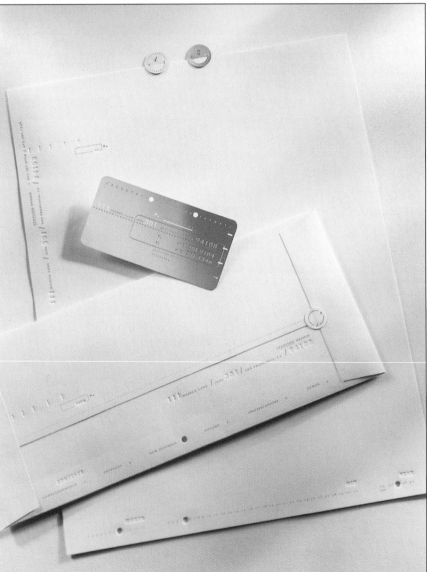

Practical Considerations

Choosing paper for your letterhead, envelope, and business card is part of a design solution. There are many paper companies and numerous qualities, styles, and colors of paper. The weight of the paper is very important because the letterhead and envelope must stand up to typewriters, computer printers, pens, and markers. Letterhead must be sturdy enough to withstand being folded. Business cards are usually inserted into wallets and therefore must be a heavier weight paper than the letterhead. When choosing paper, also think about texture, how the color of the paper will work with the color of the ink, and whether the shape will fit into a standard envelope. Most paper companies provide paper samples and have shows to promote their products. They also advertise in leading graphic design periodicals.

Papers and envelopes come in standard sizes; anything other than standard size is more expensive. A business card should be of a size and shape that fits into a wallet—usually the size of a credit card. If a card must be folded to fit it into a wallet, the design is being compromised (folded cards are an exception). A designer must also be aware of the printing processes available, including special technical processes such as die-cuts, varnishing, and embossing. Research the printing process by visiting a good printer.

Choosing a Font for a Logo

Very often, design students choose fonts, visuals, and graphic elements and forms without the full understanding that each and every font and visual element carries a heritage and connotative meaning. A novice often chooses a font on a purely personal basis; he likes the look or shape of the font. Choosing a font for a logo should be done with form and expression in mind, with knowledge of both the denotative meaning and the connotative meaning (heritage, voice, expressive meaning) of the font.

Historical Periods and Connotation

Studying the history of graphic design affords one an understanding of how style communicates a period and the spirit of an age—the zeitgeist. Without a knowledge of design history, one risks designing without understanding the provenance, heritage, and associated meanings, as well as how form communicates meaning. For example, the Art Nouveau letterforms carry meanings that are reminiscent of that time period. By using an Art Nouveau-period font for a logo, that logo design would share in the vested meaning of the Art Nouveau period. The following are styles and periods every designer should be able to visually recognize and grasp:

- Victorian
- Arts & Crafts Movement
- Art Nouveau
- Vienna Secession
- Cubist
- Futurist
- Dadaist
- Surrealist
- Poster Style (Plakastil)
- Art Deco
- Russian Supremacist & Constructivism
- De Stijl
- Bauhaus
- Functionalism
- The New Typography
- International Typographic Style
- New York School
- Pop
- Swiss School
- Deconstructionist

Look, Manner, and Connotation

Designers may choose a look, manner, tone, bearing, or any appearance to communicate a certain attitude. For example, utilizing a retro look reminiscent of the 1950s for a hair gel product might add a kitschy attitude to the brand. Or using a historical period font or hand lettering for an American Civil War Memorial

Museum should add to its authenticity, rather than seem clichéd.

Some types of looks are:
- Retro (for example, 1950s-style graphics)
- Historical
- Funky
- Primitive
- Childlike
- Classic
- Period
- High-tech
- Low-tech
- Hipster
- Futuristic

Depiction of the Logo

How you depict the shapes or forms in a logo can vary greatly; for example, geometric and spiral designs can look flat, or they could give the illusion of three-dimensional space. Just remember that every aspect of a logo communicates something about the brand it represents.

Professors Rose Gonnella and Martin Holloway, my esteemed colleagues at Kean University, have categorized forms—or fundamental ways of depicting shapes or forms—in order to make form-making easily comprehensible.
- Elemental form: Line or flat tone used to reduce an image or subject to stark simplicity.
- High contrast: Depiction of forms based on extreme contrast of light and shadow falling on a three-dimensional form.
- Linear: Line used as the main element to depict or describe the shape or form.
- Texture or pattern: Line or marks used to suggest form, light, texture, pattern, or tone using hatch, cross-hatch, cross-contour, dots, smudges, etc.

Texture can also conjure or depict the following looks of media or materials:
- Woodcut
- Metal engraving
- Raised metal
- Carving
- Carved ice
- Wood
- Fabric
- Animal skins
- Wire
- Distressed leather
- Handprint
- Clay impression
- Cut paper
- Torn paper
- Brush drawing

Shapes are flat, whether they are closed or open, linear or flat color. Logo shapes can be:
- Geometric
- Curving
- Silhouettes
- Closed
- Open

Forms imply illusion, the illusion of three-dimensional form or mass. Logo forms can be:
- Droplets
- Spirals
- Beveled
- Projected outwards or canted
- Appear animated
- Shadows
- Transparent
- Photographic fragments
- Coiled-like
- Cube-like

Logo Design Points

Interestingly, there do seem to be trends in logo design, where many logos have a similar look or form. At times, certain color palettes are "in." Nevertheless, it is important to avoid designing a logo to look like every other new or revitalized logo out there, no matter how tempting a trend might be. A good creative philosophy is to zig when others zag.

The main issues to keep in mind when designing a logo are concept, expression, and graphic design.
- Concept: Your logo design must be based on a design concept, which is the driving idea underpinning what you are depicting and how you are depicting it, whether it is for print or interactive media. Your concept must be based on the strategy for the brand and the spirit of the brand. For example, a lettermark that relates to children uti-

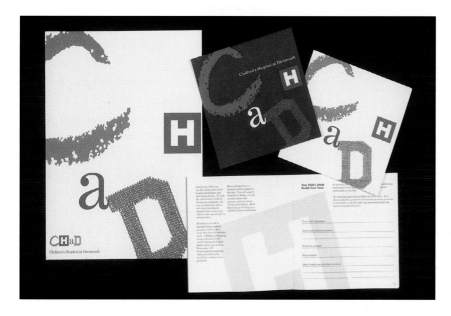

Figure 6-32
Graphic identity
Design firm: Harp and Company, Hanover, NH
Designers: Douglas G. Harp and
Linda E. Wagner
Client: Children's Hospital at Dartmouth, Dartmouth-
Hitchcock Medical Center, Lebanon, NH

"For the Children's Hospital at Dartmouth's identity, it was necessary to strike the proper balance between playfulness and dignity. It has to be appropriate for audiences ranging from young children to teenagers, and also for their parents. It is an identity that has to survive in the context of the parent medical center's existing identity, as well.

The 'C' is meant to capture the spirit of a child, but does not pretend to be drawn by one. Selecting the Dartmouth-Hitchcock Medical Center 'H' and the Dartmouth varsity letter sweater 'D' seemed to be the obvious choice for this playful solution. The lowercase Century Expanded 'a' plays no less vital a role, and helps to hold the other three forms together."

—Douglas G. Harp, president,
Harp and Company

Figure 6-33
Symbol: Peace

lizes four different typefaces to distinguish each initial (Figure 6-32) while trying to "strike the proper balance between playfulness and dignity," according to Douglas G. Harp of Harp and Company. You can see how the logo is used on the hospital's literature and how the design concept drives the entire design experience. Remember that the concept is the backbone for any logo design.

• Expression: A logo design must communicate meaning—clearly express a voice, communicate an essence, be engaging, be unique, and differentiate the brand, social cause, organization, or company in the mind of the viewer.

• Design: The visual design of the idea should hold together as a whole, stable unit.

Symbols

It is hard to think of anti-war protest posters without thinking of the nuclear disarmament symbol designed by Gerald Holton in 1956. This graphic, a circle with a few lines in it, stands for something as profound as the abstract idea of peace (Figure 6-33).

A **symbol** is an essential (uncomplicated) visual that represents something else—an idea, concept, or any other thing—by association. For a symbol to work, it needs to acquire a conventional significance; for example, an object such as a dove can be used to represent the concept of peace. A symbol can be a printed letter meant to represent a speech sound, or a symbol may be a nonpictorial visual such as an infinity symbol.

A symbol may be designed in any of the following configurations:

• Pictorial symbol: *representational* image of an object or objects

• Abstract symbol: an *emphasis on the intrinsic form* of a representational image, an extraction relating to a real object, but modified with an *abstract emphasis*

• Nonrepresentational symbol: a *nonobjective* or nonpictorial visual

• Typographic symbol: letter(s) or word(s)

Most often, a symbol is an essential visual—a simple or elemental visual, a visual graphically reduced to an essence so that it can be read quickly and easily. However, a symbol can be designed illustratively as well.

Nomenclature

Interestingly, many graphic designers use terms such as symbol, sign, symbol sign, pictogram, and pictograph interchangeably. Most would define a **sign** as a visual that indicates, represents, or denotes something—such as information, a place, or an object—or conveys an idea. Generally, most designers might agree that a symbol carries greater connotative and associative meaning than a sign. When it comes to symbols, people often have intense associations.

Just think of any religious symbol or political party symbol to understand a symbol's associative power and multilayered meaning. In contrast, the sign on a restroom door indicating gender merely signifies or denotes male or female; the sign does not carry any greater meaning than what it is representing. With all this in mind, some graphic designers include elemental visuals that represent a medical, scientific, or mathematical operation, element, quantity, quality, or relation as symbols. Symbols used in music, computer systems, language, and other disciplines also can be included. Those graphic designers who have studied design **semiotics**—the theory of signs and symbols that deal with their constructed function and meaning—often have more specific definitions of sign and symbol. Some designers and design educators find the study of semiotics to be a crucial complement to all other design theory.

Arrows, which are traditional symbols for direction, are used in different configurations as symbols for the Sun Microsystems Worldwide Operations program, a program of standards and guidelines providing a unified direction for Sun Microsystems' global operations (Figure 6-34). Each symbol, in combination with words, evokes imagery—a globe, torch,

Figure 6-34

Symbols: Sun Microsystems
Design firm: Gee + Chung Design, San Francisco, CA
Client: Sun Microsystems

"The symbols convey the chairman's belief in 'putting all the weight behind one arrow'."

—Earl Gee, principal, Gee + Chung Design

ESPIRITUALIDAD NATURISMO MEDICINA ALTERNATIVA AUTOAYUDA

ESOTERISMO VISUAL TRADICIONES DE ORIENTE CLÁSICOS

Figure 6-35
Logo/Symbols
Design studio:
Ideograma, Mexico
Client: Alamah

target, and building. Similarly, the symbols for Alamah are simple, yet mystical (Figure 6-35). George Tscherny has said that one of the directions he pursues in his work is "to extract the essence of a subject and present it simply and dramatically," which is what he does in his SUNPARK logo design solution (Figure 6-36).

Transforming messy strokes into a clean, straight arrow, designer Martin Holloway created a symbol of conflict resolution for a human relations conference. The symbol was used for several applications, including signage (Figure 6-37). Diana Ford designed the symbol for the Food Bank of Alaska (Figure 6-38). Many people think of bread as a food staple that is needed to sustain life; in combination with a heart—a symbol most understand to represent love—we get a new symbol about giving food to the needy.

"QuickTime allows for the integration of video, sound, text, and animation for computer multimedia. The imagery used is representative of all the facets of this platform," says Jennifer Morla, of the symbolic imagery on the promotional CD (Figure 6-39). With tongue-in-cheek humor, Sommese Design used symbols of good

and evil for their annual Halloween party invitation (Figure 6-40).

April Greiman's compelling design for the Sci-Arc web site (Figure 6-41) utilizes off-planet-looking icons to denote different menu items. The front cover of the TreeTop annual report illustrates four embossed icons used to represent each season and the missions during those times; the apple represents "Harvest," the branch represents the time to "Prune," the flower represents the time to "Protect," and the leaf represents the time to "Fertilize" (Figure 6-42).

Figure 6-36
Logo: SUNPARK
Design firm: George Tscherny, Inc., New York, NY
Client: SUNPARK

"SUNPARK is a company offering parking facilities, mostly adjacent to airports. Hence the 'P' in a red circle, which is the universal symbol for parking."

—George Tscherny

Figure 6-37
Symbol: "Human Relations on
New Jersey Campuses"
Design firm: Martin Holloway Graphic Design,
Pittstown, NJ
Designer: Martin Holloway
Client: New Jersey Department of Higher Education,
in cooperation with The National Conference of
Christians and Jews (New Jersey Region)

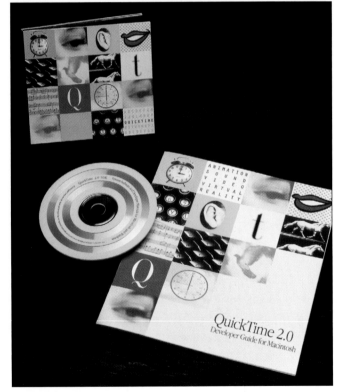

food bank of alaska

Figure 6-38
Symbol
Design firm: Northwest Strategies, Anchorage, AK
Designer: Diana Ford
Client: Food Bank of Alaska

"My first step in designing a logo is to make a list of words that correspond to
the title. Then I break down the title and make a separate list for each word.
Then I bring words from different lists together and see what kind of image
they create.

Usually it's very obvious when the right combination of words creates the
perfect image. The Food Bank of Alaska logo came together in about ten
minutes using this method.

I chose a very simple technique to illustrate the logo because I did not want to
overpower the concept, and I chose a common lowercase typeface in
keeping with the humility of the organization."

—Diana Ford, Northwest Strategies

Figure 6-39
Symbol: Apple QuickTime CD Digipak
Design firm: Morla Design, San Francisco, CA
Art director: Jennifer Morla
Designers: Jennifer Morla and Craig Bailey
Photography: Holly Stewart
Client: Apple Computer Inc.

The CD is distributed to software developers to promote the
use of QuickTime in their programs.

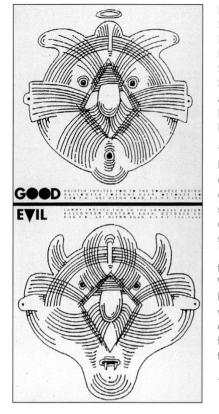

Figure 6-40
Symbols: "Good/Evil"
Party Invitation
Design firm and client:
Sommese Design,
State College, PA
Art director: Kristin Sommese
Designer/Illustrator:
Lanny Sommese

"My wife, Kristin, and I have an annual
Halloween party to which we invite our
clients, friends, etc. (Sommese Design is
our studio.) The idea was to create two
separate invitations—one for her (good)
and one for me (bad), which we could
send out individually or together. They are
18" square, so if someone wanted to cut
the masks out and wear them, they could.
We also used them together as a poster.
In her version, the O's are filled in (soft,
wonderful, good, etc.). In my version, the
angular letters are filled in and appear as
fangs (evil, vile, etc.). Actually in real life,
this is reversed (ha ha)."

—Lanny Sommese

Figure 6-41
Web site design: Sci-Arc
Design firm: April Greiman,
Los Angeles, CA

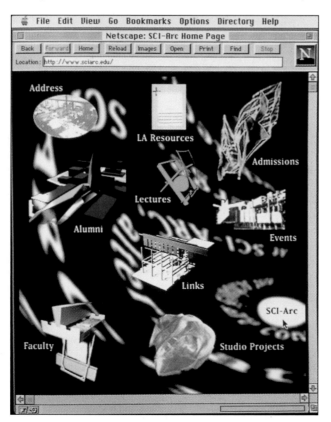

Figure 6-42
Annual report: TreeTop
Design firm: Hornall Anderson Design Works Inc., Seattle, WA
Art director: Katha Dalton
Designers: Katha Dalton and Jana Nishi
Illustrators: Jana Nishi and Denise Weir (icons)
Copywriter: Evelyn Rozner
Client: TreeTop

Unlike past TreeTop annual reports, this year's version focused
specifically on the product itself, more than only the financials.
The goal was to showcase the product—the apples and the
process of growing them.

The front cover illustrates four embossed icons used to represent
each season and the missions during those times: Harvest,
Prune, Protect, and Fertilize.

Pictograms

The graphic elemental visuals on restroom doors denoting gender are signs that communicate quickly. This type of sign is called a **pictogram** (or **pictograph**), which is a simple picture *denoting* an object, activity, place, or person. Although most pictograms are simple, like the ones on restrooms, some have more detail or are more illustrative. Whether the pictogram is elemental or illustrative, essential information should be communicated in a glance. There is much crossover among logos, symbols, and pictograms; sometimes the nomenclature is not as important as the function of the design.

Today, so much information must be universally understood, crossing language and cultural barriers. Pictograms serve this purpose wonderfully; they are purely visual, nonverbal communication. Way-finding signs and systems are used internationally. Usually these **way-finding systems** incorporate signs, pictograms, and symbols to assist and guide visitors and tourists to find what they are looking for in museums, airports, zoos, and city centers.

The primary objective of the Disability Access Symbols Project is for organizations to use these symbols to better serve their audiences with disabilities (Figure 6-43).

On the holiday greeting for Spalding Rehabilitation Hospital, you see graphic pictograms representing two people changing into one pictogram of a reindeer (Figure 6-44). The pictograms for Port Blakely planned community are illustrative and detailed; however, they communicate quickly, and share a common style and format (Figure 6-45). For Oquirrh Park Fitness, Dave Baker and Dave Malone used a linear style to create a series of activity symbols (Figure 6-46). Dots and triangular strokes used to connote movement make these symbols unique. Diamond shapes are used as an element of continuity in the store signage (pictograms) for The Safety Zone (Figure 6-47).

Graphic design matters. The TalkChart, designed at Kean University's Design Center, is an outstanding example of graphic design that benefits society (Figure 1-2); using pictograms and the alphabet, it enables people with aphasia to communicate.

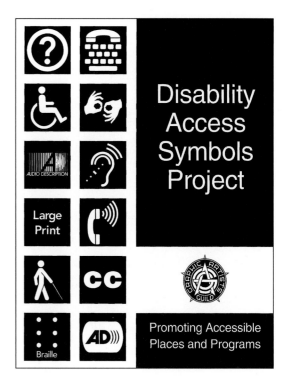

Figure 6-43

Symbols: Disability Access Symbols Project, courtesy of the Graphic Arts Guild Foundation, produced by the Graphic Artists Guild Foundation with the support and technical assistance of the National Endowment for the Arts, Office for Special Constituencies
Design firm: X2 Design, New York, NY

"The project was extremely challenging in terms of design because the client insisted on having organizations representing people with various disabilities review and comment on the proposed symbols. With the help of a disability consultant, we were able to reach consensus among all these groups and still achieve the primary objective—for organizations to use these symbols to better serve their audiences with disabilities.

Several existing symbols did not meet the standards we established and needed redesign. For example, the old symbol for Assistive Listening Systems focused on the disability (an ear with a diagonal bar through it). The new symbol focuses on the accommodation to the disability, i.e., a device that amplifies sound for people who have difficulty hearing. Other upgraded symbols include Sign Language Interpreted, Access (Other than Print or Braille) for Individuals Who Are Blind or Have Low Vision, and the International Symbol of Accessibility. A new symbol for Audio Description for TV, Video and Film was developed which, through design, proved less likely to degenerate when subjected to frequent photocopying."

—GAG Foundation

Figure 6-44
Holiday Card
Design firm: 601 Design,
Inc., Denver, CO
Art director:
Bruce Holdeman
Designers: Bruce
Holdeman and Ann Birkey
Client: Spalding
Rehabilitation Hospital,
Denver, CO

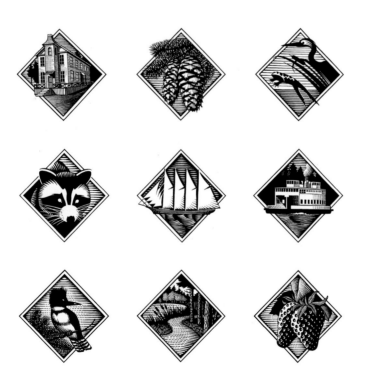

Figure 6-45
Pictograms
Design firm: The Rockey
Company, Seattle, WA
Client: Port Blakely
Mill Company

Figure 6-46
Symbols
Design firm: The Baker
Group, Salt Lake City, UT
Art director: Dave Baker
Designer: Dave Malone
Client: Oquirrh Park
Fitness Center

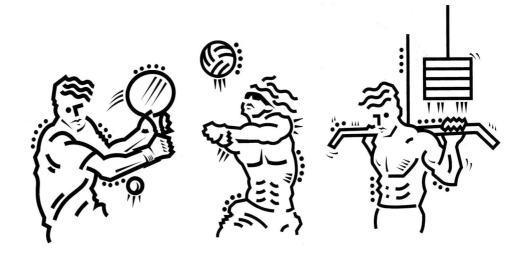

Figure 6-47
Signage
Design firm: Doublespace,
New York, NY
Client: The Safety Zone,
White Plains, NY

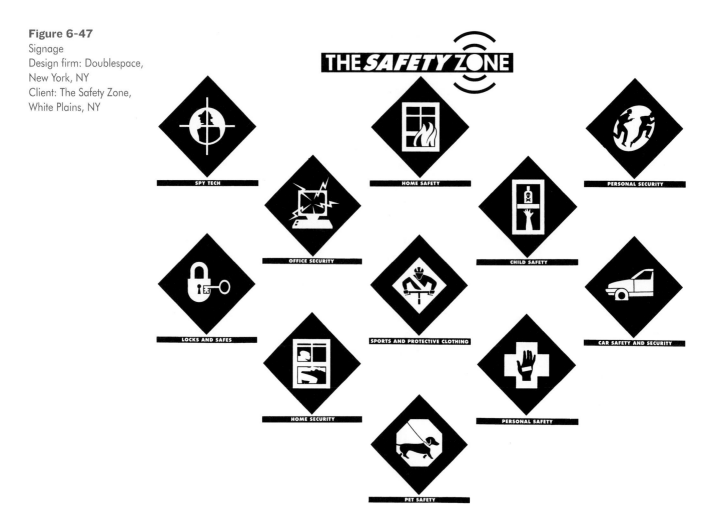

Designing a system requires a clear design concept and a consistent use of shapes, scale, and all the formal elements. The pictograms in a system must look as if they belong to the same family. At times, more than one designer in a design firm or studio will work to produce a system. It is imperative to establish a firm design concept, style, and vocabulary of shapes in order for the system to look like it was created by one hand and mind, as in the complete set of fifty passenger and pedestrian symbols developed by the American Institute of Graphic Arts (AIGA) (Timeline, page TL-12).

According to the AIGA: "This system of fifty symbol signs was designed for use at the crossroads of modern life: in airports and other transportation hubs and at large international events. Produced through collaboration between the AIGA and the U.S. Department of Transportation, they are an example of how public-minded designers can address a universal communication need.

Prior to this effort, numerous international, national, and local organizations had devised symbols to guide passengers and pedestrians through transportation facilities and other sites of international exchange. While effective individual symbols had been designed, there was no system of signs that communicated the required range of complex messages, addressed people of different ages and cultures, and were clearly legible at a distance.

A first set of thirty-four symbols was published in 1974, and received one of the first Presidential Design Awards; sixteen more symbols were added in 1979." (*www.aiga.org*)

Summary

A logo represents and embodies everything a brand or group signifies, providing immediate recognition. Logos can take the form of a wordmark, a lettermark, a symbol mark, or a combination mark. Therefore, a logo plays a key role in the visual identity of a brand, social organization, or company. A visual identity is the visual and verbal articulation of a brand or group, including all pertinent design applications. The logo usage guidelines in a standards manual help to ensure recognition and, therefore, guard the logo's value.

There are some fundamental ways of depicting shapes or forms. A logo must be designed in terms of style, type, shapes, and symbols to appropriately express the spirit or personality of the product, service, or organization. Learning historical periods and connotative meaning allows for greater expression when choosing fonts for logo design.

A symbol is an essential visual that represents something else—an idea, concept, or any another thing—by association. A symbol may be designed in a number of configurations.

Although nomenclature varies among design professionals and clients, most designers might agree that a symbol carries greater connotative and associative meaning than a sign.

A pictogram is a simple picture *denoting* an object, activity, place, or person; it is purely visual, nonverbal communication. Way-finding signs and systems are used internationally to assist and guide visitors and tourists to find what they are looking for in museums, airports, zoos, and city centers.

Start to Finish

Project: Logo design
Designer: Liz Kingslien,
Lizart Digital Design,
Chicago, IL
Client: Page's Day Spa
& Salon

1 After discussing the desired "look" that the client wanted, several thumbnail sketches were produced.

2 Artwork, such as this copyright-free pattern, was gathered from source materials.

3 Four sketches were worked up into black-and-white logos.

4 Color was applied to the chosen logo.

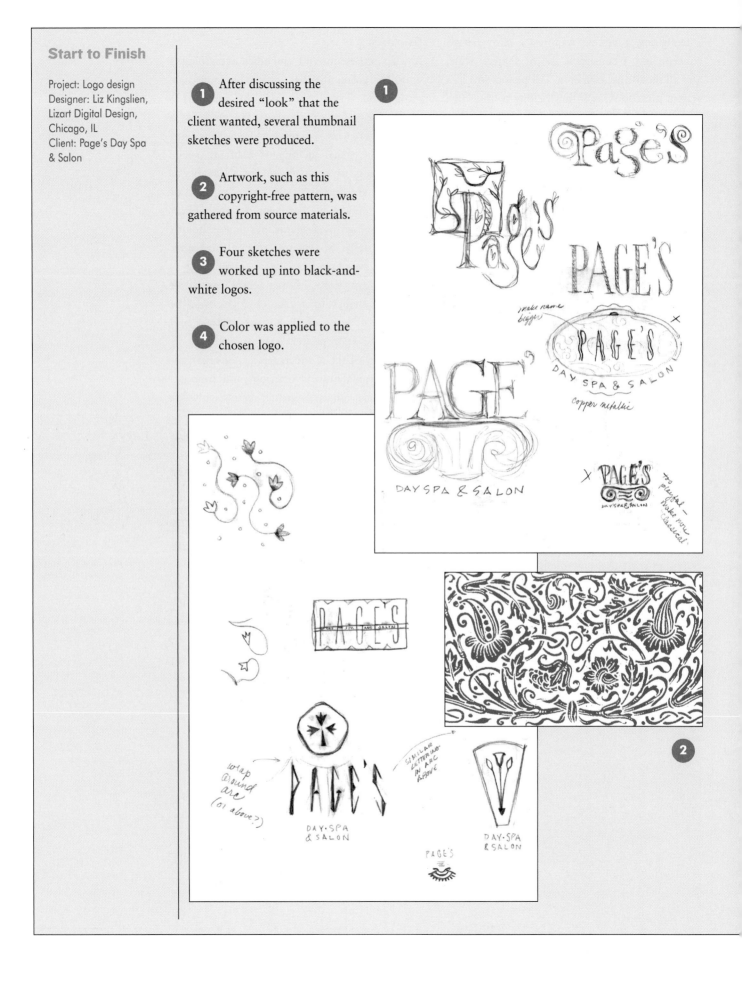

3

4

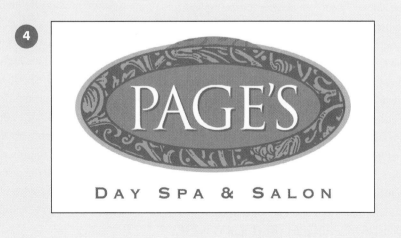

Exercise 6-1

Examples of logos

Find examples of logos that appear in the different configurations listed in this chapter. Maintain an ongoing collection. Keep a file or paste the logos into a book as source material.

Project 6-1

Logo design

Step I

a. Choose a company, product, service, or organization.

b. Research your client. Gather information on your subject. Find related visuals that you could use as references. Find examples of logos with the style or look you think is appropriate for your client.

c. Write an objectives statement. Define the purpose and function of the logo, the audience, the competition, the message that needs to be communicated, and what kind of personality should be conveyed. It helps to write two or three adjectives on an index card that describe and summarize the spirit or personality that your logo should communicate. Keep the index card in front of you while sketching.

Step II

a. Design a logo in any of the following configurations: logotype, initials, pictorial visual, abstract visual, or any combination of these. The logo should be self-contained. It should be able to "float" anywhere; for example, it should not be dependent upon being positioned in the corner of a page. There should be no bleeds—nothing running off the edge of a page. Note: If your final choice is an abstract or pictorial visual, you will have to choose type to work with it for the stationery.

b. Produce at least twenty different sketches before choosing a solution. At least four sketches should be devoted to each of the various configurations. In other words, you should make four sketches of initials, four sketches of an abstract visual, and so on. If a computer is not available, you may want to work on tracing paper so you can trace parts of one sketch and incorporate them into another (keep the sketches for future reference and for your portfolio sketchbook).

Step III

Refine the sketches into three roughs on 8½″ x 11″ paper.

Step IV

Create a comp using computer-generated type or hand lettering. The logo should be no larger than 5″ in any direction.

Presentation

The logo should be shown by itself in black and white on an 8½″ x 11″ board.

Optional: Design the logo on stationery: a letterhead, envelope, and business card. Present the stationery on an 11″ x 14″ board, held vertically. Mount the letterhead first. Overlap the envelope and business card.

Exercise 6-2

Building an image-making vocabulary—xerography

1. Go though a magazine or newspaper and find a few black-and-white photographs of people or objects.

2. Make copies of the photographs on a copier. If possible, adjust the lightness/darkness control on the copier to result in an image with extreme values or high contrast. Or use a scanner and computer, and either page layout or drawing software. Scan in a photograph and apply the high-contrast setting to the image.

3. Look at the Quaker Oats Company logo (Figure 6-20). This logo uses high-contrast shapes to depict shadows and forms.

4. With a black marker, draw over the copies to increase the value contrast. Your objective is to convert light and shadow into black and white.

5. Trace the high-contrast copies, picking up only the most essential black-and-white shapes to depict the image.

6. Choose your best drawing. Make a copy of it. Refine it. Present it as a comp on 8½" x 11" paper.

Exercise 6-3

Symbols

1. Write down three adjectives that describe your personality. Write down three adjectives that describe the personality of a celebrity.

2. Design an exclamation mark to express your personality.

3. Design an ampersand or question mark to express the personality of a celebrity.

4. Create twenty thumbnail sketches for each design.

5. Refine the sketches into two roughs for each.

6. Refine the roughs into comps. Present one comp for each problem on 8½" x 11" paper, held vertically. You may use color or black and white.

Project 6-2

Symbol design

Step I

a. You are going to design four symbols to represent the four seasons (spring, summer, fall, and winter), or four activities (hiking, biking, skiing, and boating) for use on a travel bureau located on the Internet.

b. On an index card, write down a simple, three- or four-word definition of each of the four you have chosen to represent.

Step II

a. All four symbols should be designed in circular, square, or rectangular formats.

b. Create twenty thumbnail sketches. Try designing within the different formats.

c. Explore different ways of developing shapes and images. Try geometric shapes, shapes created with torn paper, linear shapes, photographically derived images, the style of woodcuts, or posterized images.

d. The four symbols should share a common vocabulary of shapes, lines, or textures.

Step III

Refine the sketches and create three roughs on 8½" x 11" paper. Remember, all four symbols should share a common vocabulary.

Step IV

a. Refine the roughs and create a comp.

b. The circular or square formats should be 3" and the rectangular formats should be no larger than 3" in any direction.

Presentation

Present all four symbols on one 11" x 14" board, held vertically. The symbols all should be the same size and in black and white. When mounting, allow ½" of space between the symbols.

Alternate presentation: one symbol per board, 3" symbols on 8½" x 11" boards, held vertically.

Comments: *In order to graphically symbolize an idea, person, or thing, you must analyze it and reduce it to its most fundamental level. Although time and tradition play a great role in imbuing symbols with meaning, it is essential that a newly designed symbol be the result of a valid design concept. Project 6-2 is a good lesson in developing a vocabulary of similar forms. Experimenting with various ways of developing shapes and images will greatly increase your ability to think visually and to design.*

Exercise 6-4

Building an image-making vocabulary—printmaking

1. Go to the library or online and find information on and examples of printmaking: woodcuts, etching, drypoint, lithography, aquatint, and monotypes.
2. Choose three types of printmaking. Try imitating the printmaking media style with black markers on white paper; in other words, try to imitate the look of a woodcut without actually doing a woodcut.
3. Choose an image, such as a tree or a shoe.
4. Depict the image in all three styles.

Exercise 6-5

Building an image-making vocabulary—painting

1. Use fruit for reference.
2. Go to the library and find monographs on three modern painters; for example, Henri Matisse, Diego Rivera, Romare Bearden, or Georgia O'Keeffe.
3. With any kind of water-based black paint, imitate the style of one or two of the artists you choose, using the fruit as your subject matter.
4. When the paints are dry, make copies of them on a copier or scan them.
5. You may have to clean them up or make adjustments.
6. Present two finished illustrations on separate sheets of 8½″ x 11″ paper, held vertically.

Exercise 6-6

Pictogram design

1. Buy some vegetables for reference.
2. Using geometric forms, design pictograms for two vegetables.
3. Create twenty thumbnail sketches, ten for each.
4. Create two roughs for each pictogram.
5. Refine the roughs. Create one comp for each pictogram and present it in black and white on 8½″ x 11″ paper, held vertically.

Project 6-3

Designing pictograms for an airport

Step I

a. Choose an airport, for example, the Heathrow in London, or your local airport.
b. Research it. Find out what type of stores, format, and services the airport has.
c. Choose four subjects from among baggage claim, rest area, restaurants, information, gift shops, or anything you would find at an airport.

Step II

a. Design four pictograms for the airport. Do not use any type.
b. Produce twenty different sketches, at least five for each subject.
c. Explore different ways of developing shapes and images. Try free-form linear shapes, geometric shapes, high-contrast images, or woodcut-like images.
d. The pictograms should share a common vocabulary of shapes, lines, or textures; they all should be in the same style, for example, all geometric or all free-form.

Step III

Refine the sketches and create two roughs on 8½″ x 11″ paper, held vertically.

Step IV

a. Make changes. Create a comp.
b. The pictograms should be no larger than 3″ in any direction.

Note: *Creating pictograms is made easier with a scanner and computer. Scan in a photograph and trace the essential elements of the form. Remove the scanned photograph from the image, and you are left with an accurate tracing. You can then manipulate the image in any number of ways to make it work.*

Presentation

Present all four pictograms on one 11" x 14" board, held vertically. The pictograms all should be the same size and in black and white. When mounting, allow ½" of space between the pictograms.

Alternate presentation: one pictogram per 8½" x 11" board. Option: You may want to present a colored version, as well.

Comments: *The pictograms should be in the same style, having similar distinctive characteristics. There should be a consistent use of the formal elements: line, shape, and texture. They should be understood in an instant by the viewer. Project 6-3 promotes two important objectives: the ability to maintain a vocabulary of shapes and style, and the ability to communicate through simple visuals.*

Exercise 6-7

Stationery design

Design stationery for yourself.

Comments: *In one way this is an easy project. You do not have to do any research because you are your own client.*

On the other hand, it may be difficult to define or develop an image for yourself. If your design is conservative, potential clients may think your work is conservative. If it is very edgy, they may think all your work is edgy. More importantly, if it is not well designed—and well thought out—it will say a lot about you. Make sure you apply everything you have learned about design fundamentals and the components of a design solution. Do not underestimate the importance of this piece. You may eventually want to coordinate your resume with your stationery.

Project 6-4

Pictograms for travelers

Step I

a. Determine eleven places, necessities, or activities a traveler would want to know about; for example, a hospital, a gym, a restroom, a taxi stand, drinking water, place of worship, or a bank.

b. Determine a handy-sized rectangle that a traveler could keep with her passport or travel guide or in a pocket. Then draw a grid of six squares or rectangles on each side; if twelve pictograms won't fit, then determine how many pictograms could manageably fit your chosen size rectangular format.

Step II

a. Explore different techniques and ways to depict pictograms. Make sure the resulting visuals are easily understood, discernable.

b. Use shapes and forms consistently to ensure unity among the pictograms.

c. Produce five preliminary sketches to determine one style for the traveler's pictograms.

Step III

a. Design ten pictograms to denote those places, activities, necessities, or objects you have chosen.

b. Follow through to finish.

Presentation

Present six pictograms on the front and five pictograms on the back, with one space on the back available for emergency contact information.

Visual Identity

Brands and Branding

◄ Corporate identity: CompuSoluciones
Design studio: Ideograma, Mexico
Creative director: Juan-Carlos Fernandez
Designers: Marilu Dibildox, Daniel Markus,
and Ricardo Rios
Client: CompuSoluciones

Objectives

Define visual identity

List the most common applications comprising a visual identity

Comprehend the meaning of a visual identity program that coordinates every aspect of graphic design material

Learn when and why visual identities began to become an industry standard

Identify the objectives of a visual identity program

Learn how unity with variety creates visual interest across applications

Understand the purpose of a graphic standards manual

Design a visual identity

Realize the role of the logo as the foundation of a visual identity

Define brand, branding, and integrated brand experience

Understand the purpose of branding

> "Identity is the unique character of a group or brand—a combination of reputation, name, culture, manner, and values. Identity design represents these qualities and in doing so adds something to them. The identity designer has to become intricately involved in the group or brand in order to understand and thus influence its presented image."
>
> —www.Pentagram.com

Visual Identity

If we think of a logo as a unique *identifying* mark that characterizes a brand or group, then a visual identity extends that representation and characterization with an all-encompassing voice, with a unifying thread. A visual identity is the visual and verbal articulation of a brand or group, including all pertinent design applications, such as letterhead, business cards, and packaging, among many other possible applications. It may also include a tagline (or brandline) and advertising. A visual identity is also called a corporate identity or brand identity. A visual identity is a program that *integrates* every element of a company's graphic design including typography, color, imagery and its application to print, interactive and new media, environmental graphics, and any other conventional or unconventional media. It is a *master plan* that coordinates every aspect of graphic design material in order to attain and sustain an identifiable image and status in a multinational marketplace of brands and groups.

With a very carefully planned visual brand identity that is memorable, consistent, and distinctive, companies such as General Electric, Disney, 3M, Honda, and Federal Express have been able to maintain consumer loyalty and positive consumer perception. A consistent visual identity presents a memorable and stable public face.

The most common applications of any visual identity include the logo, letterhead, and other related business correspondence, as in the visual identity designed by Denise M. Anderson for Greg Leshé Photography (Figure 7-1). A visual identity consists of the following integrated components:

- brand name
- logo
- letterhead
- business cards
- packaging
- web site
- any other application pertinent to a particular brand

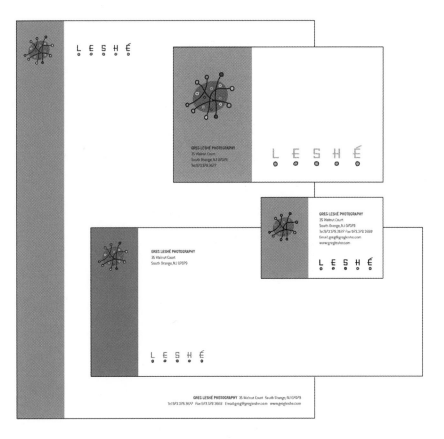

Figure 7-1
Visual identity:
Greg Leshé Photography
Design firm: DMA Inc.,
Jersey City, NJ
Design director:
Denise M. Anderson
Designers: Greg Leshé
and Denise M. Anderson
Client: Greg Leshé
Photography

All the applications carry
the same spirit of the logo.
The voice of the typography
is completely appropriate
for the client.

Background

The postwar period in the 1950s brought about a clear need for visual identities, especially for corporations. Applying the same logo to all materials was not enough to distinguish corporations or brands. Consistent identity programs for CBS Television, first created by William Golden and then by Lou Dorfsman; Olivetti Corporation's identity, created by Giovanni Pintori; and the CIBA visual identity, created by James K. Fogleman, made design history with comprehensive design distinction throughout all design applications.[1] Visual identities would become graphic design industry standards with designers such as those listed above, as well as many seminal designers and firms leading the way, including Paul Rand, Lester Beall, Otl Aicher, Saul Bass, Vignelli Associates, and Chermayeff & Geismar Associates.

Unity with Variety in a Visual Identity

Continuity must be established among the various designs in a visual identity. There must be a "family resemblance" among the designs. Of course, you can have a certain level of variety and still maintain visual unity. The identity and graphics system for the International Design Center of New York includes graphics, invitations, publications, advertising, and signage (Figure 7-2); Vignelli Associates used Bodoni type and a limited color palette emphasizing black and red.

Most designers prepare a graphic standards manual that guides the client in the use of the identity by detailing the use of the logo, colors, and other graphics and imagery. This may seem stringent and restrictive, but it demonstrates just how crucial a consistent identity is to the image and success of a group or brand. Richard Danne was design director of the visual identity for the National Aeronautics and Space Administration, Washington, D.C. (Figure 7-3). A comprehensive seventeen-page graphic standards manual was developed, designed, and written that included paint schemes for aircraft, the Space Shuttle, and other space vehicles, as well as graphic systems for all publications, signage, forms, and media.

When designing a visual identity, you must know your audience. Clearly, the visual identity developed for Levi's SilverTab jeans is aimed at a young audience (Figure 7-4). The poses of the

Figure 7-2
Identity and graphics program: IDCNY
Design firm: Vignelli Associates, New York, NY
Designers: Massimo Vignelli and Michael Bierut
Client: International Design Center of New York,
Long Island City, NY

"IDCNY, the International Design Center of New York,
is an international furniture merchandise mart in Long
Island City. The logo portrays elegance and strength
by the choice of two contrasting typefaces. The visual
identity includes graphic invitations, publications,
advertising, and signage. Based on three very basic
elements—Bodoni type with black and red colors—the
visual identity is nevertheless extremely articulated and
vibrant, and has achieved a very strong identity often
imitated by similar organizations."

—Vignelli Associates

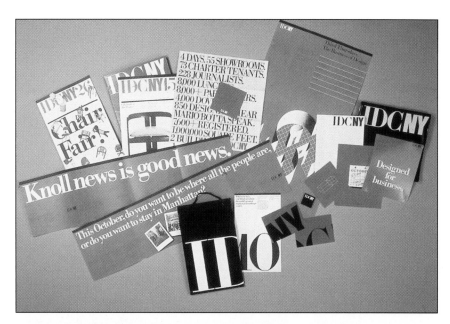

Figure 7-3
Graphic standards manual: NASA
Design firm: Danne & Blackburn Inc., New York, NY
Design director: Richard Danne
Client: National Aeronautics and Space
Administration, Washington, D.C.

Material supplied by Richard Danne & Associates, Inc.,
Eastham, MA

A United States government agency dedicated to
aeronautics research and space exploration, NASA
is headquartered in Washington, D.C., with ten
individual centers across the nation.

"The firm of Danne & Blackburn Inc. was
selected to develop and design a unified visual
communications program for the agency. The
acronym NASA was more recognizable than either
the full name or its previous symbol. Building on
this, the NASA logotype was developed. A system
was devised that incorporates the logotype and
sets standard configurations for the full agency
name and the various centers. This program was
honored with one of the first Presidential Awards
for Design Excellence."

—Richard Danne, Richard Danne & Associates

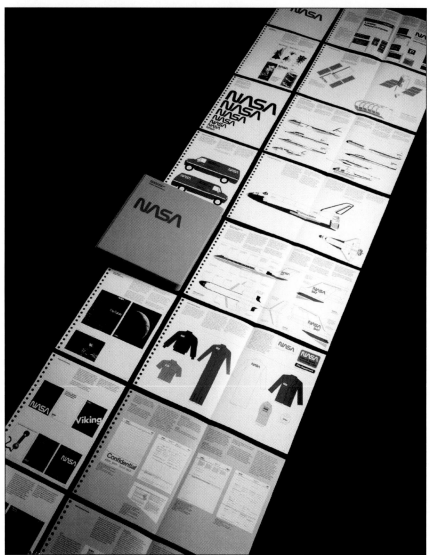

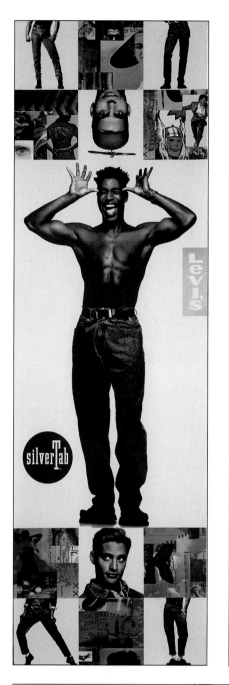

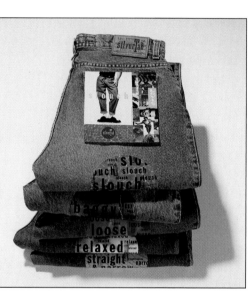

Figure 7-4
Graphic identity:
Levi's SilverTab
Design firm: Michael Mabry
Design, San Francisco, CA
Advertising agency:
Foote Cone & Belding
Client: Levi Strauss & Co.

Every visual element—
photographs, illustrations,
and typography—carries
the same look and feel.

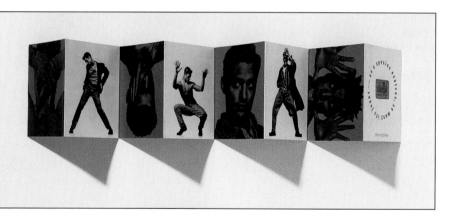

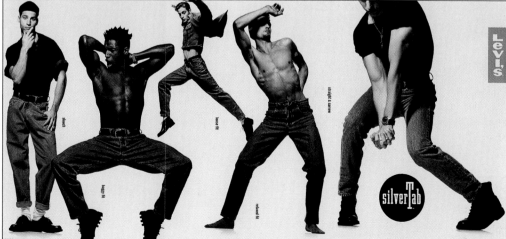

models and the use of patterns, collage, photomontage, and the contemporary typography all work together, contributing to the hip spirit of the visual system.

An identity can be designed for a new brand or group, or a designer may be required to refresh or invigorate an existing visual identity, retaining some of the most memorable elements, such as a color. An appropriate and distinguishing color palette is crucial to making a visual identity memorable. The corporate identity for Tamooz communicates a high level of quality (Figure 7-5). The designer Shira Shecter comments: "Their original orange color evolved into a more powerful, focused 'orange' with metallic light-blue and white as secondary colors."

Pentagram developed a new visual identity for the San Francisco Zoo; it was "part of an initiative to refresh the zoo's profile and redefine the visitor experience," according to Pentagram (Figure 7- 6). The new identity was launched to coincide with the opening of a wide range of new and improved facilities, such as the new Lipman Family Lemur Forest and a new main entrance experience.

Figure 7-5
Corporate identity: Tamooz
Design firm: Shira Shecter
Studio; Fresh Graphic
Design, Israel
Client: Tamooz

"Tamooz is a local exhibition and events design company. Here we aimed to evoke clean, sophisticated lines blended with creativity as part of their new corporate identity. Most of the Tamooz collateral includes the use of 3D folds, unusual paper weighting, circles, and rounded holes—the 'T' super icon always emerges prominently from the circles or holes."

—Shira Shecter

Suggestions

Creating a visual identity is an extensive design project; you will need a list of criteria to keep in mind. Your objectives are to:

- Coordinate all of a company's graphic design material
- Express the personality of the company
- Establish an image for the company
- Design appropriately for the brand or group
- Build in flexibility to work in a variety of applications and media
- Build in sustainability (longevity—think at least five years down the road)
- Ensure differentiation and identifiability for the brand or group

The elegance of the LS Collection of fine objects for the home is expressed through James Sebastian's minimalist use of type, choice of textured paper, exquisitely lighted photography, and, of course, layout (Figure 7-7).

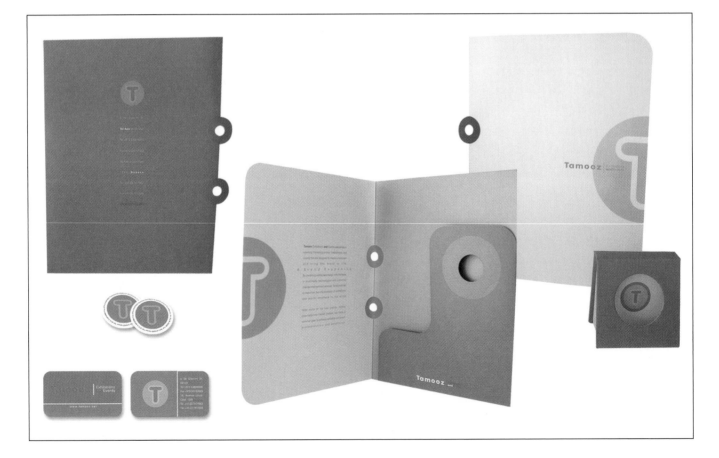

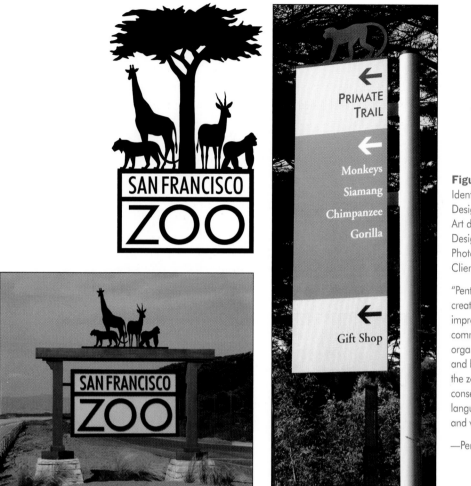

Figure 7-6
Identity: San Francisco Zoo
Design studio: Pentagram Design Ltd.
Art director/Creative director: Kit Hinrichs
Designer: Erik Schmitt
Photography: David Wakely
Client: San Francisco Zoo

"Pentagram partner Kit Hinrichs and his team created a visual identity that reflects the much improved visitor experience. The identity communicates the zoo's role as a community organization with a park, nature center, gardens, and bird sanctuary. The new identity also reflects the zoo's commitment to wildlife education and conservation, with a strong, accessible visual language and a color palette of natural, earthy, and vibrant hues."

—Pentagram Design Ltd.

Figure 7-7

Identity: LS Collection
Design firm: Designframe
Incorporated, New York, NY
Client: The LS Collection,
New York, NY

"The elements of the LS
Collection were created to
reflect the design and
personality of the store,
incorporating the corporate
mark and copper color."

—James A. Sebastian,
president, Designframe Inc.

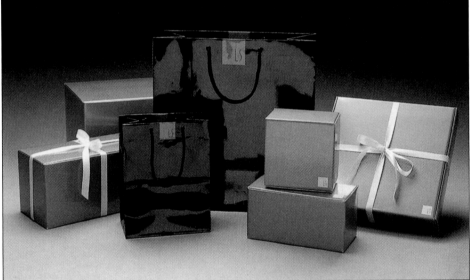

For the corporate identity created for the Hotel Hankyu (Figure 7-8), Pentagram Design developed a visual identity of six stylized flower symbols, a custom alphabet, a coordinating color scheme, and decorative motifs. The program expresses luxury by differentiating each item in the hotel with special detailing. Applications include signage, room folders, stationery, labels, menus, and amenity packages for male and female guests.

Mastandrea Design created the branding program and signage for the Loft store (Figure 7-9). Visual and color juxtapositions communicate a polished yet light spirit.

Pentagram's design solution for Muzak is comprehensive and memorable (Figure 7-10). Although a visual identity is an extensive program, the main application in a visual identity is the logo, as is apparent in the visual identity for Muzak. For CompuSoluciones, Ideograma created "the rings of the solutions," a symbol that represents the company's four areas of business, as well as the dexterity that its leadership has been required to maintain in Latin America during the last nine years (Figure 7-11).

The shapes and colors in the identity design for Öola, a chain of Swedish candy stores located in American shopping malls, projects a playful image (Figure 7-12). Without being

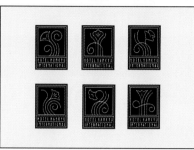

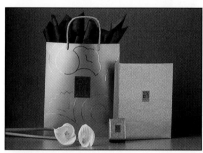

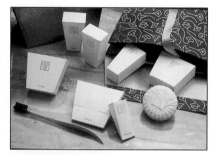

Figure 7-8

Identity and packaging: Hotel Hankyu International
Design firm: Pentagram Design Ltd.
Partner: Colin Forbes
Associate/Designer/Typographer: Michael Gericke
Designer: Donna Ching
Illustrator: McRay Magleby
Interior design: Intradesign, Los Angeles, CA
Client: Hotel Hankyu International
Produced with: OUN Design Corporation and Dentsu Inc.

"In a reversal of the usual procedure, the client commissioned the identity program before any other design project, and the graphic elements were used to guide development of the hotel's interior design and architecture. Pentagram New York coordinated the project with the client, consultants, and promotional advisers in Osaka, as well as the Los Angeles-based interior designers.

Hankyu specified a distinctive emblem that would communicate quality, internationalism, and the 'universal appeal of flowers.' The visual concept is a modern interpretation, drawing upon the glamour of steamer trunk labels from the Art Deco era. The program also expresses luxury by differentiating each item in the hotel with special detailing.

Applications include signage, room folders, stationery, labels, menus, and amenity packages for male and female guests."

—Sarah Haun, communications manager, Pentagram Design Ltd.

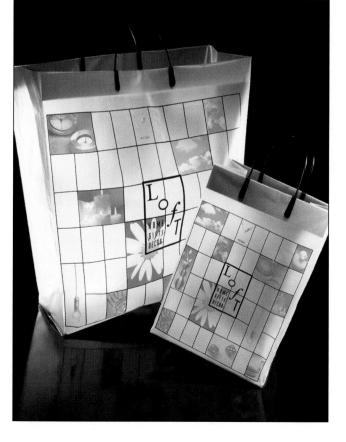

Figure 7-9

Branding: Loft
Design firm: Mastandrea Design, San Francisco, CA
Art director/Designer: MaryAnne Mastandrea

"Loft is a retail store offering innovative home furnishings targeted to the upscale consumer. The inspiration for Loft's brand identity came from the windows in our design studio. Our studio is in a 1920s loft building that features large windows sectioned into smaller panes of glass framed in black steel. By designing the Loft brand as a windowpane, I created a flexible system that can vary in size and use both product and conceptual images. The photos fit within and break out of the individual panes to add visual interest. This flexible approach keeps the brand fresh and conveys a sense of variety and style. Similarly, the shopping bags and business cards are printed on translucent plastic to simulate windowpanes."

—MaryAnne Mastandrea, Mastandrea Design

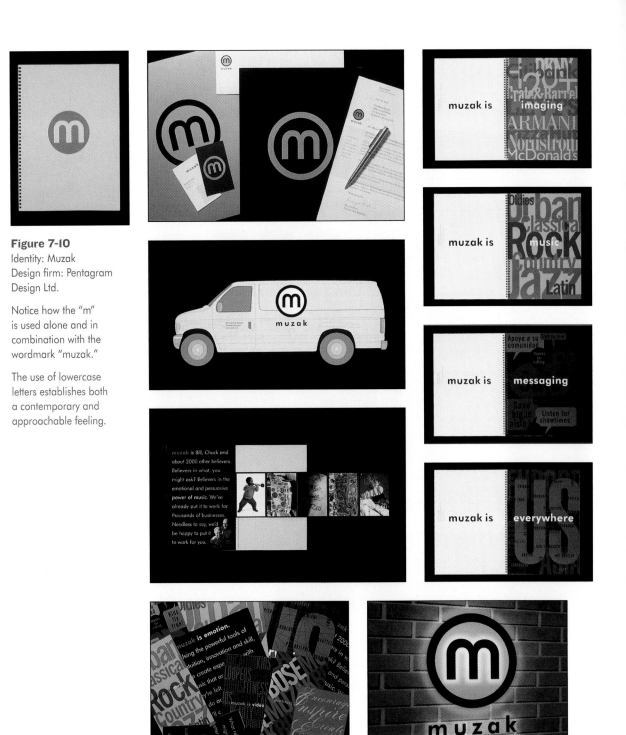

Figure 7-10
Identity: Muzak
Design firm: Pentagram
Design Ltd.

Notice how the "m" is used alone and in combination with the wordmark "muzak."

The use of lowercase letters establishes both a contemporary and approachable feeling.

illustrative, its colorful positive and negative shapes almost look edible—like candy.

Brands and Branding

A **brand** is the sum total of all functional (tangible) and emotional (intangible) assets that differentiate it among the competition.

Each brand has physical functionalities, features, or capabilities, which may or may not be unique to the product or service category.

Each brand also—due to its heritage, parent company, logo, visual brand identity advertising, and public perception—carries emotional assets. Emotional (as well as cultural) associations arise in response to the spirit of the brand identity, the emotional content or spirit of the advertising, and the communities and celebrities who adopt the brand as part of their lives.

Poorly conceived and designed branding can greatly diminish a brand's success. In a market-

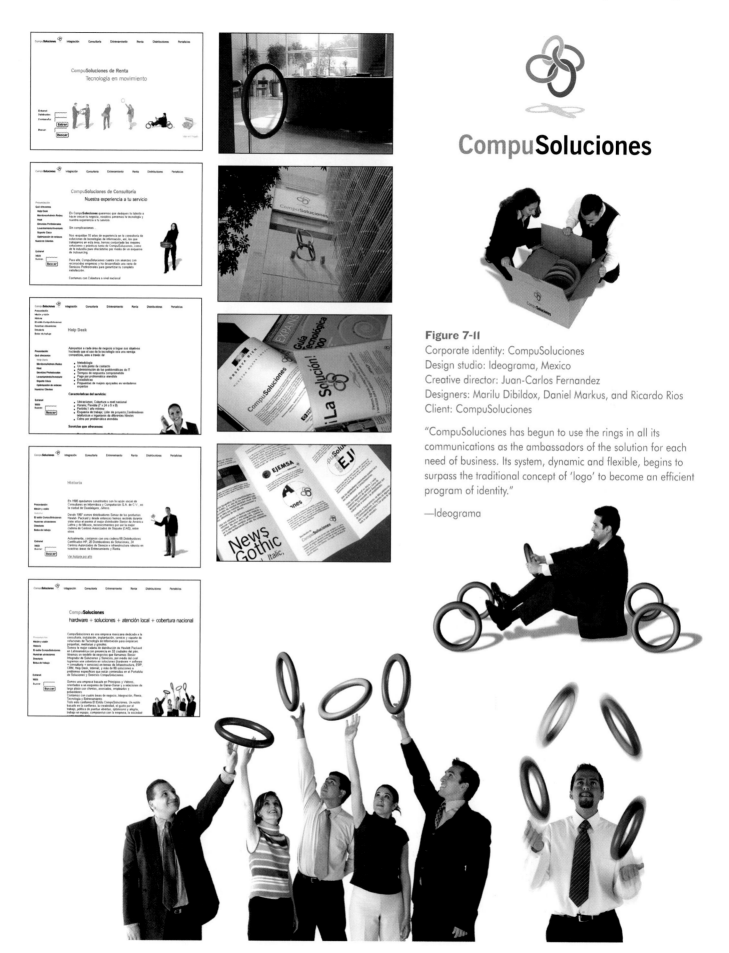

CompuSoluciones

Figure 7-11

Corporate identity: CompuSoluciones
Design studio: Ideograma, Mexico
Creative director: Juan-Carlos Fernandez
Designers: Marilu Dibildox, Daniel Markus, and Ricardo Rios
Client: CompuSoluciones

"CompuSoluciones has begun to use the rings in all its communications as the ambassadors of the solution for each need of business. Its system, dynamic and flexible, begins to surpass the traditional concept of 'logo' to become an efficient program of identity."

—Ideograma

Figure 7-12
Identity: Öola
Design firm: Pentagram
Design Ltd.
Partner/Designer:
Paula Scher
Client: Öola Corporation,
Boston, MA, Philadelphia,
PA, New York, NY, and
Washington, D.C.

"Öola is a chain of Swedish candy stores in American shopping malls. The company intended to enter the U.S. market under the name 'Sweetwave,' but when Paula Scher was commissioned to design their retail identity, she expressed a concern that the name would not be interesting enough to American consumers. Scher recommended playing up the company's European origins with a new name and a bright, clean graphic look.

The word 'öola' was invented and became the basis for the stores' entire visual identity. Öola was chosen for its Scandinavian sound, geometric letterforms, and the umlaut, which has become a central motif in graphic applications."

—Sarah Haun,
communications manager,
Pentagram Design Ltd.

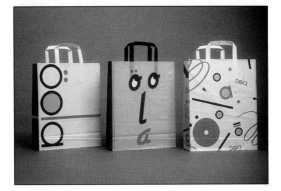

place that is overcrowded with goods and services, a relevant and engaging brand experience can make a brand well known. If you have any doubts about how important effective branding is, just think of the power of Sony or Coca-Cola.

When brands were first introduced, it was the brand name, logo, and packaging that established the brand identity. Today, we think of branding as a comprehensive, integrated process.

Branding is the entire development process of creating a brand, brand name, and brand identity, which might include other applications. Creating an integrated brand experience entails weaving a common thread or voice—seeming like one voice—across all of an individual's experience with a brand or group, and integrating the common language into all experiences with the brand. An integrated brand experience is the creation of a comprehensive, strategic, unified, integrated, and unique program for a brand, including every graphic design and advertising application for that brand, with an eye and mind toward how consumers and individuals experience the brand or group as each interacts with it.

Differentiation

Due to many convergent factors—greater mass production, competing companies manufacturing parity products and offering parity services, rise of disposable income, desire for sanitary packaging, and changes in the scope of corporations—logos, visual identities (identity design), brand names, distinctive packaging, and advertising have become crucial to a company's marketing message.

With such a huge glut of products and services (that have virtually become commodities), it is the brand name, visual identity, branding, and brand experience that serve to differentiate a brand or group. Certainly, Chiquita Brands International, Inc.—a leading international marketer, producer, and distributor of bananas sold under Chiquita—has distinctive branding (Figures 7-13 and 7-14).

In today's marketplace—where, in almost all cases, there is more supply than demand *and* several, or perhaps many, brands in each product or service category—it is vital to a company's marketing strategy to establish a comprehensive, distinctive branding program for their brand. Similarly, it is vital for any group to have a distinctive branding program.

Designers are also faced with the challenge of reinventing a brand, renaming a brand, and/or redesigning a brand logo and visual identity. For

example, Federal Express changed its name to FedEx to establish it as an international company. Esso was changed to Exxon, a more modern name with strong sounding "x's" to represent all of the parent company's new holdings. USAir was changed to US Airways to establish the brand as a global carrier because most people associate the word "air" with commuter airlines.

Landor Associates, Branding Consultants and Designers Worldwide, created the brand identity and environmental design for A.G. Ferrari (Figure 7-15). Warm earth colors appeal to our sense of taste, creating the feeling that the foods are delicious.

After defining the target audience, Liska + Associates worked with Revlon to develop a complete branding program for mop modern organic products, including all promotional materials. They established a visual language that defines the product as pure and simple. As a part of this language, the packaging parallels the clarity and neutrality of the line's vegetable-based contents (Figure 7-16).

Figure 7-13
Brand: Miss Chiquita Worldwide Personality
Design studio: SamataMason, West Dundee, IL
Art director: Greg Samata
Designers: Greg Samata, Jim Hardy, and Lynne Nagel
Illustrator: Paul Turnbaugh
Client: Chiquita

A brand icon that takes on a human persona gives the corporation a personal, and in this case, beautiful face.

Summary

A visual identity is the visual and verbal articulation of a brand or group, including all pertinent design applications, such as letterhead, business cards, and packaging, among many other possible applications. The most common applications of any visual identity include the logo, letterhead, and other related business correspondence. Continuity must be established among

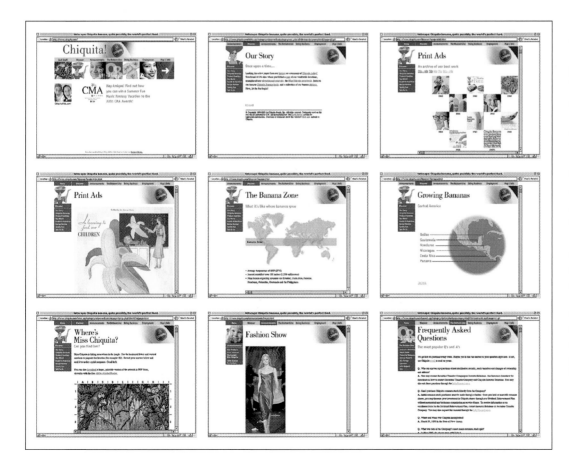

Figure 7-14
Corporate web site
Design studio: SamataMason, West Dundee, IL
Art director: Greg Samata
Designers: Greg Samata, Jim Hardy, and Lynne Nagel
Copywriter: Chiquita
Photography: Miscellaneous
Client: Chiquita

This web site incorporates the Miss Chiquita Worldwide Brand Personality icon, as well as the Chiquita wordmark, and the design delivers the same spirit as the identity. Note the sense of place established in this web site design, where unity with corresponding elements gives the user a sense of location from page to page.

Figure 7-15
Brand identity and environmental design:
A.G. Ferrari
Design firm: Landor Associates, Branding
Consultants and Designers Worldwide
Client: A.G. Ferrari

the various designs in a visual identity. There must be a "family resemblance" among the designs. Most designers prepare a graphic standards manual that guides the client in the use of the identity by detailing the use of the logo, colors, and other graphics and imagery.

Branding is the entire development process of creating a brand, brand name, and brand identity, which might include other applications. Creating an integrated brand experience entails weaving a common thread or voice, and integrating the common language into all experiences with the brand. An integrated brand experience is the creation of a comprehensive, strategic, unified, integrated, and creative program for a brand, including every graphic design and advertising application for that brand, with an eye and mind toward how consumers and individuals experience the brand or group as each interacts with it. With such a

huge glut of products and services (that have virtually become commodities), it is the brand name, visual identity, branding, and brand experience that serve to differentiate a brand or group. Designers are also faced with the challenge of reinventing a brand, renaming a brand, and/or redesigning a brand logo and visual identity.

Notes
[1] John McDonough and Karen Egolf, *The Advertising Age Encyclopedia of Advertising*, volume 2, p. 755.

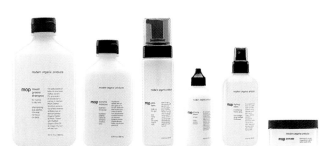

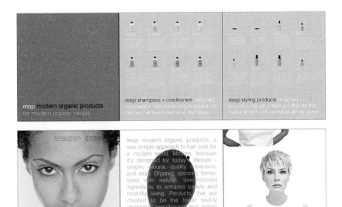

Figure 7-16

Image brochure: mop modern organic products
Design firm: Liska + Associates, Inc., Chicago, IL,
and New York, NY
Client: mop modern organic products

As part of its complete branding program for mop, Liska + Associates created a comprehensive brochure and product overview to define the brand and support the line. These materials instantly define the mop product line to encourage recognition among salon owners, stylists, and patrons. A minimal image style reduces the products to the most basic elements—their natural ingredients. The promotional materials feature models intended to appeal to a targeted range of consumers seeking products that are part of a healthy lifestyle. To accompany mop's marketing materials, Liska + Associates designed a dealer kit for product promotion. The kit functions as both a sales tool for product representatives and as a trial for salon owners interested in the mop line. Its packaging is designed to resemble an egg carton and is constructed of similar material, referring to the line's natural, vegetable-based origin. The self-contained package includes small sample bottles of the mop product line, along with a product brochure explaining the samples.

Start to Finish

Design studio: DMA,
Jersey City, NJ
Design director:
Denise M. Anderson
Designers: Kathryn
Schlesinger and Jenn Calle
Client: Lauren Rutten
Photography
www.laurenruttenphoto.com

1 Source photos

2 Thumbnails sketches

3 Sketches further developed in a drawing program

4 Proposed business card layouts using developed sketches

5 Final business card

DMA had to work with a theme preestablished by the client. Lauren Rutten—who specializes in "life events" photography, such as weddings, where she captures and records people's major life events on film—uses a wishing well as her symbol. Rutten also views the wishing well as a metaphor.

Since the wishing well theme was already utilized in Rutten's web site, DMA's design team also incorporated the theme in her identity.

Here is an inside look at one design studio's process of designing a business card, from start to finish.

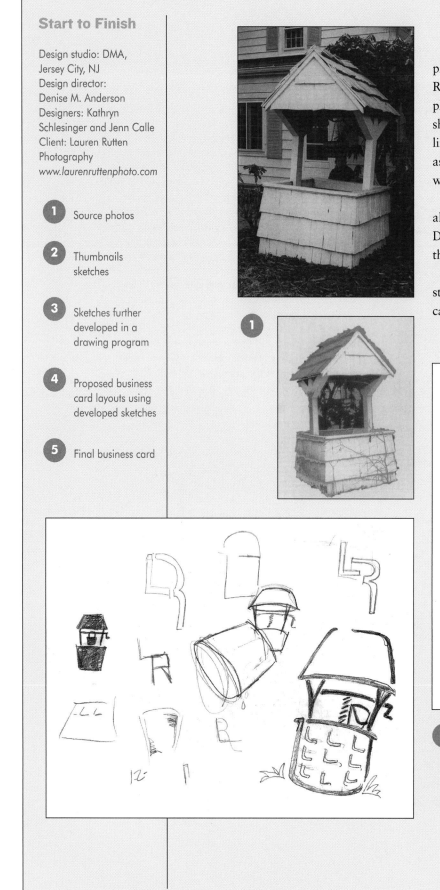

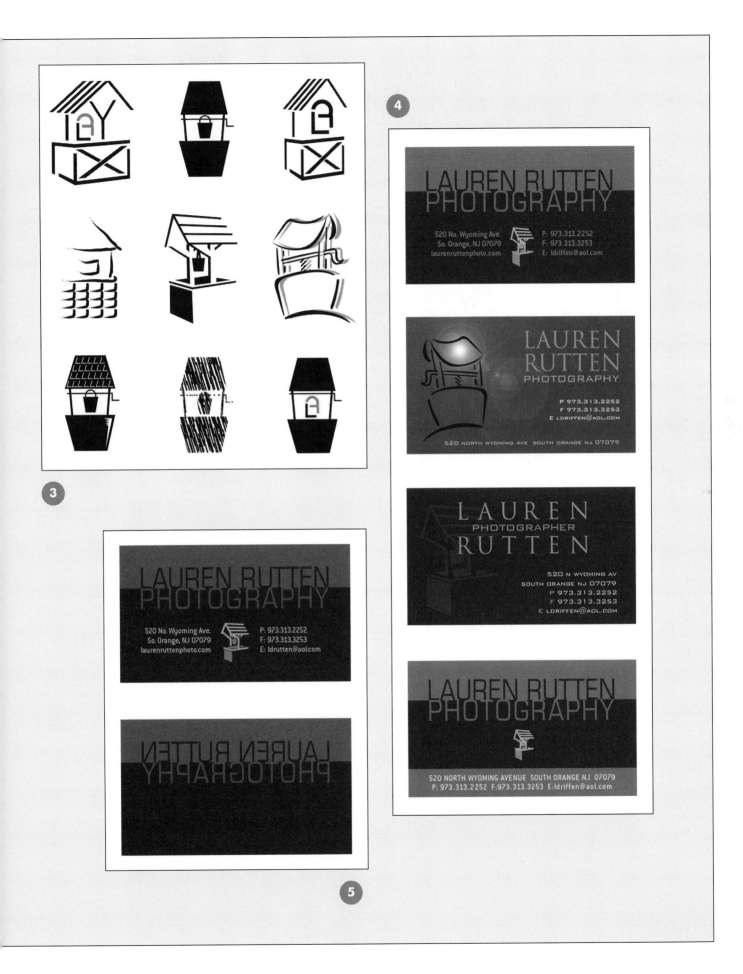

Exercise 7-1

Examining visual identities

Look through design award annuals to find several examples of award-winning visual identities.

Exercise 7-2

Inventing a company name

1. Choose a product or service and invent a brand name for it.
2. The name should be appropriate and communicate the brand's personality.
3. The name should be memorable.
4. The name could convey the brand's or group's functional benefit. Functional benefits are the practical or useful characteristics of a product or service that aid in distinguishing a brand from its competition, such as nutritional, economical, or convenient advantages.
5. The name should have a long life span.
6. If the company is international, the name should reflect its global status.
7. If the brand is international, the name should work for each country in which it is sold.

Tips
a. Think about using a metaphor.
b. Brainstorm all words and things related to the product or service. Categorize the brainstorming list.
c. Choose one in each category. Write three or four variations on each.

Project 7-1

Visual identity design: creative brief for a film festival

Here's a sample creative brief to use as the strategy for a visual identity design. (Feel free to change the type of festival and adjust the creative brief accordingly.)

Project: Neo-Noir Film Festival Brand Identity
Product: Neo-Noir Film Festival

1. What are we trying to accomplish?
 • Identify and inform
 • Raise awareness
 • Advertise festival
 • Create cohesive brand identity materials
2. Who are we trying to influence?
 • Men and women, 21-99
 • Film buffs
 • Film goers who enjoy festivals
3. What do they think now?
 • I appreciate neo-noir films; they're exciting and entertaining and nostalgic.
4. What do we want them to think?
 • Film festivals offer variety, even in one genre.
 • Film connoisseurs enjoy festival settings.
5. Why should they think this way?
 • Because this film festival will allow them to see their favorite films, as well as unseen neo-noir films.
 • Festivals have a lot to offer.
 • The brand identity is going to convey mystery, allure, and be provocative.

6. What are the most important executable guidelines?
- Color palette and "look"
- Two-color job

7. What is the brand/customer relationship?
- Entertainment time well spent

8. What is the tonality of the communication?
- Mysterious and cool

9. What is the most important thing we want our prospective customers to take away from our communication?
- This festival is for me!

Step I

a. Gather information. View some films in the genre you select for the film festival.

b. Read the creative brief. Supplement or change it as necessary.

Step II

a. Design a visual identity for a film, including the following applications: logo, poster, schedule, tickets, and passes.

b. Produce twenty sketches for each application. Use a two-color palette or black and white.

Step III

Refine the sketches and create two roughs for each design application.

Step IV

Refine the roughs and create one comp for each application.

Presentation

The logo, schedule, and tickets should be matted or mounted on one 11″ x 14″ board, and the poster on a separate 11″ x 14″ board.

Comments: *It's good practice to get used to using a design brief or creative brief. All pieces should have corresponding visual elements, and all should look as though they belong to the same nuclear family.*

Project 7-2

Branding for a pet supply store

This project calls for a comprehensive visual identity for a retail store—from its marketing strategy to its packaged goods. It demonstrates your ability to be consistent yet creative.

This is a difficult and involved assignment. It demonstrates to potential employers your ability to formulate a strategy and design concept and follow it through with a visual identity that includes several design applications. The experience and knowledge gained here can be applied to any identity. If your solution to this project is successful, it could be one of the most important pieces in your portfolio.

Designing a visual identity is a creative activity, but do not forget the bottom line. To identify, persuade, and inform—these are the goals of the graphic designer. If you can create a design that communicates to a mass audience and has graphic impact and is creative, you are designing effectively.

This is a multifaceted project. Once you have completed it, keep going. Create more applications, and then create another visual identity for a different type of brand or group.

Creating an integrated brand experience entails weaving a common thread or voice, and integrating the common language into all experiences with the brand.

Step I

a. Invent a name for a pet supply store. Try to be creative with the name—it does not need to have the word "pet" in it—for example, "Eat Your Biscuit" or "The Furry Zone." Decide on the type of pet supply store it will be (general, specialized, discount, family-run, part of a chain, or upscale). Decide what makes your store special, what sets it apart from the competition. Where would your store be located—online, in a mall, a strip mall, or a storefront on a neighborhood street?

b. Work on your strategy. Write an objectives statement (see Chapter 2).

c. Identify key descriptive words. On an index card, write one sentence about the store using two adjectives to describe it.

If you can create a design that communicates to a mass audience and has graphic impact and is creative, you are designing effectively.

Step II

a. Design a logo for the store (see Chapter 6 on logo design).

b. Be sure to use your objectives statement and your strategy.

c. Design stationery consisting of a letterhead, envelope, and business card. Include the store name, address, telephone and fax numbers, e-mail address, Web address, and manager's name (see Chapter 6 on stationery design).

d. Design in-store signage. Use visual elements consistently across applications—you are creating a visual identity for the store.

e. Design at least two signs; for example, one for food and one for toys.

Optional: Design at least one other promotional or informational item; for example, a web site, postcard, poster, T-shirt, calendar, mug, food chart, or pet care brochure.

f. Produce at least twenty sketches for each design application.

g. Use black and white or color.

Step III

Refine the sketches and create two roughs for each design problem, the logo, stationery, and signage.

Step IV

Refine the roughs and create one comp for each application.

Presentation

The stationery (letterhead, envelope, and business card) should be matted or mounted on one 11″ x 14″ board and the logo on a separate 11″ x 14″ board. The signs should be mounted on a separate 11″ x 14″ board.

Comments: *The foundation of a visual identity is the logo. Your logo should establish the store's image and express its personality; it should also be flexible enough to be used in a wide variety of applications, such as packaging and web sites. All the other pieces should be consistent with the visual elements and spirit of the logo; they should build the brand, be unique, and seem superior to the competition.*

SAVE
THE
HUMANS

◀ Poster: *Save the Humans*
Agency: Crispin Porter + Bogusky, Miami, FL
Executive creative director: Alex Bogusky
Art director: Mary Taylor
Copywriter: Ari Merkin
Photography: Stock

Objectives

Become acquainted with the history of posters

Know the purpose of a poster

Realize the dual nature of a poster as visual communication and art object

Appreciate how a viewer may identify with a poster as an expression of individuality

Be aware of how a poster must be considered in context

Consider designing a poster as an instant memorable communication

Understand the integration of concept with type and visuals in poster design

Value poster design as an interpretative medium

Design a poster

The Purpose of Posters

The purpose of any poster is to communicate a message. In order to do that, a poster must first grab a viewer's attention. A poster is noticed while the viewer is on the move—either driving, riding, or walking by—so it must be engaging enough to capture the viewer's attention amidst all the other visual clutter.

A **poster** is a two-dimensional, single-page format used to inform (display information, data, schedules, or offerings) and to persuade (promote people, causes, places, events, products, companies, services, groups, or organizations). Produced in multiples and (usually) widely circulated, posters are often seen in numerous locations around town by the same viewer. Ubiquity and multiple viewings address the many and also reinforce the message for a single viewer.

If a poster isn't well designed or is dull, it most certainly will be ignored when surrounded by other visual communication or an interesting environment. An appealing poster design can capture our attention and imagination, and perhaps provoke us like no other graphic design application. When words and visuals are effectively combined in a poster, it has the potential to communicate and become more than just a fleeting visual communication—it can become an object to return to, again and again, for contemplation, enjoyment, or provocation. It is fascinating that in this age of moving images and Flash graphics, a still form of visual communication—a poster—can hold our attention.

In public spaces, we see posters promoting musical events and films. Posters featuring attractive models and celebrities endorsing brands are hung in bus shelters and subway stations. Theatrical events, public service advertising, sporting events, rallies, protest causes, propaganda, wars, museum exhibits, brand advertising—all are subjects for posters.

A Little History

Before posters became a visual communication staple, broadsides were used to communicate ephemeral information—to make announcements and publicize news and events, as well as to promote merchandise. A **broadside**, or broadsheet, is a large sheet of paper, typically printed on one side. In Europe, after the invention of moveable type, broadsides were used to make announcements. Once printers began working in the American colonies around the mid- to late seventeenth century, broadsides had a role in colonial life.

Broadsides were relatively inexpensive to produce and served their purpose for local advertisers and information seekers. In both Europe and

America, there were advances in printing technology by the late nineteenth century; in France, color lithography was significantly advanced by Jules Cheret, allowing for great color and nuance in poster reproduction. By 1900, colorful posters would eclipse broadsides as visual communication that could attract viewers.[1]

Before the end of the nineteenth century, printers composed posters with mostly just text, sometimes embellishing the poster with decorative yet conventional graphic elements, such as borders or dingbats.

"With the development of color lithography, however, and with the upsurge of interest in the spare, strongly patterned, asymmetrical graphic designs found in Japanese prints, artists such as Cheret, Toulouse-Lautrec, and Bonnard began to experiment with posters, abandoning type and weaving together hand-lettering and evocative images. By the mid-1890s, the popularity of these new posters had become widespread; exhibitions were held, connoisseurs collected them, and their virtues were discussed in illustrated books and magazines."[2]

Posters as Art Objects

It is not unusual to walk through a public space, see a poster, and think, "I would love to hang that in my home." And people do. (In fact, some people find some of the posters they see in public so attractive that they steal them. In some cases, as soon as the posters were hung, they were stolen, therefore having to be continually replaced.) Whether a poster is a promotion for an art exhibit or a musical group, it is common to see a poster tacked on a wall or framed and hanging in homes and offices alongside paintings, photographs, and prints.

No other graphic design format has been so successful in capturing the attention and hearts of museum curators, art critics, social historians, and the public. Some people have extensive poster collections, collecting either a variety of posters or a series. French artist Henri de Toulouse-Lautrec embraced the poster; perhaps that is why fine artists have wholly accepted this graphic design application (Figure 8-1). The American, Japanese, Chinese, Cuban, Israeli,

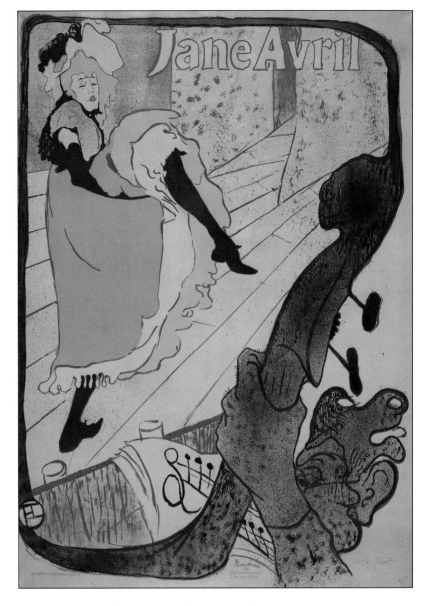

Russian, and European art and design communities (and governments) have embraced the poster; innumerable visual artists have designed them, such as Romare Bearden (American) (Figure 8-2), Ben Shahn (American), Eiko Ishioka (Japanese), Tadanori Yokoo (Japanese), Eduardo Munoz Bachs (Cuban), Dan Reisinger (Israeli), and Oskar Kokoschka (Austrian).

Posters as Expressions of Individuality

When someone chooses to hang a social protest poster or concert poster in his room, that individual, of course, believes in the cause or favors the musical artist. Yet, the association with the poster may be more significant; it may be emblematic, choosing a poster as an expression

Figure 8-1
Poster: Toulouse-Lautrec, *Henri de (1864-1901)*. *Jane Avril*, 1893 Collection: The Museum of Modern Art, New York, NY, Photo credit: SCALA/Art Resource, NY

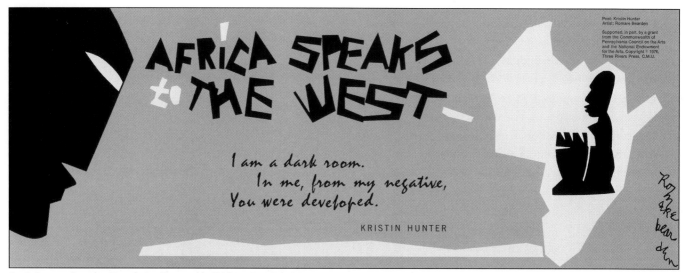

Figure 8-2
Poster: Bearden, Romare, *Africa Speaks to the West*, 1976
Offset lithograph on paperboard, 11 1/8" X 28"
Gift of Poetry on the Buses, © 1976 Three Rivers Press,
Carnegie Mellon University
Location: Smithsonian American Art Museum,
Washington, D.C., U.S.A.
Photo credit: Smithsonian American Art Museum,
Washington, D.C./Art Resource, NY

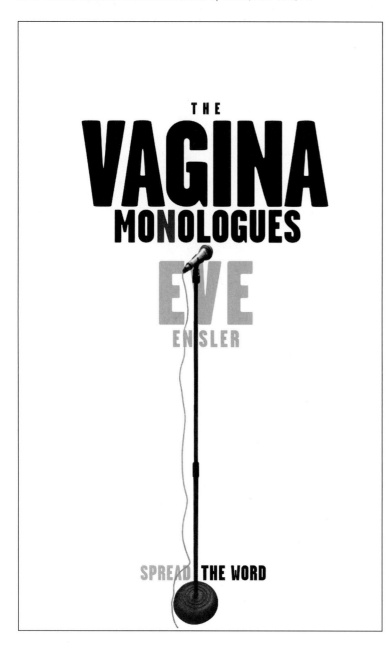

Figure 8-3
Poster: *The Vagina Monologues*
Design studio: SpotCo, New York, NY
Designer: Lia Chee

Ensler's provocative play is captured in this seemingly
modest yet brave and emblematic conceptual treatment of
type and visual. At second glance, an astute viewer might
note an evocative form that both captivates and surprises.

of one's individuality. The depiction of an individual in a poster, also, can communicate meaning about a subject, as does the poster for 50 Cent (see Timeline, page TL-21). Or we can identify with the message of a playwright or a social commentary communicated by the poster design, as well as the play (Figure 8-3).

Interestingly, we identify ourselves with brands as well as with individuals. Provocative posters, such as the one in Figure 8-4, surely find

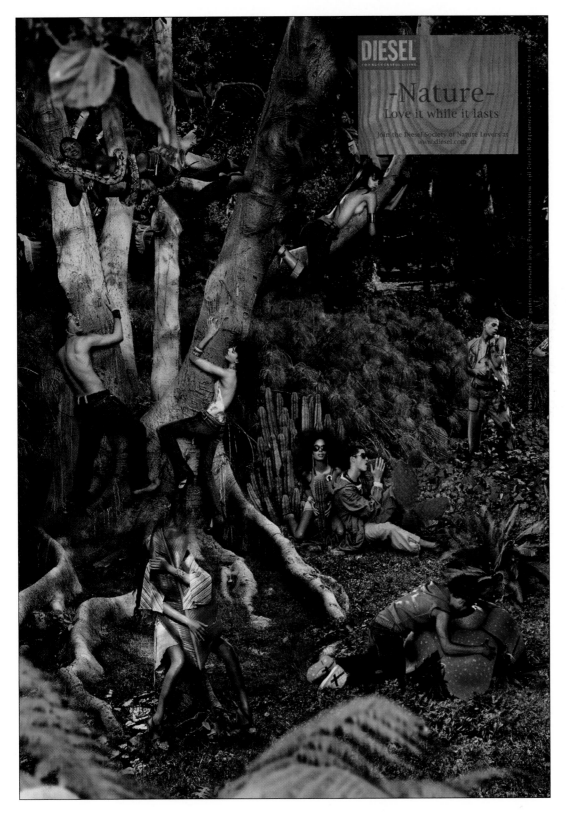

Figure 8-4

Poster: *Nature—Love It While It Lasts,* Diesel Spring/Summer 2004 Advertising Campaign
Agency: KesselsKramer, Amsterdam
Art director: Karen Heuter
Copywriter: Dave Bell
Photography: Henrik Halvarsson
Postproduction: Cabbe @Artista Studio
Client: Diesel SPA

"Kiss it. Lick it, even. Go on . . . it feels good, doesn't it? Feels . . . sexy. That's because you're not holding paper. You're holding a small piece of tree. A piece of nature (recycled, of course).

Nature is something we take for granted. The only time we ever seem to run into it is when we're buying food from the supermarket. Or watching the National Geographic channel on TV. We've started using nature for our own enjoyment and needs. In its new advertising campaign for Spring/Summer 2004, Diesel asks you to give something back to nature.

So if you think cows were made from meat . . . and trees were put on this earth to be carved into chairs . . . this campaign is for you. It's time to start loving nature while it lasts. And you can start licking this press release again."

—KesselsKramer

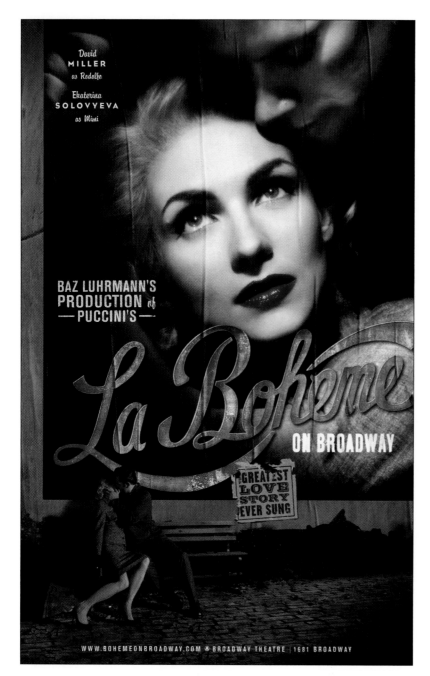

Figure 8-5
Poster: *La Boheme*
Design studio: SpotCo, New York, NY
Photographer: Douglas Kirkland
Designers: Vinny Sainato and Mary Littell

"This campaign features rich, romantic photography of the beautiful young performers, capturing director Baz Luhrmann's vision of *La Boheme* as 'the greatest love story ever sung.' The goal was to make the production of Puccini's classic opera as vibrant today as it was in 1896, and even more accessible to a wide audience."

—SpotCo

their way to people's walls. About this work, KesselsKramer comments: "So, in the campaign we see people getting down and dirty with plants, getting kinky with trees, hugging an egg until it starts to crack, and other very human and physical forms of love. However, does this way of showing their love for nature, ironically, do it more harm than good?

To execute the idea in a new way, for the first time ever, Diesel will show off the whole collection in one big picture—a huge, natural Garden of Eden-style paradise. This one big picture will form the basis for all communication. This season, the catalogue takes the form of one huge nature-loving poster. On the reverse of the poster is a statement to read out loud and become a member of the 'Diesel Society of Nature Lovers'."

The Challenge of Poster Design

Most posters are meant to be hung in public places and to be seen from a distance. Understanding the context for any graphic design is crucial. Where will it be seen? How close will the viewer be? How will an application be viewed? It is essential to remember that a poster must catch the attention of passersby. In today's competitive visual landscape, a poster also competes for attention with surrounding posters, outdoor boards, neon signs, and any other visual material. We only need to think of the myriad of posters in the city square near a theater district to realize just how much a poster must do to capture attention. The poster for *La Boheme* would stand out amidst any environment (Figure 8-5). This lush "poster within a poster" sets the stage (reset from 1840 to the bohemian Left Bank of Paris in 1957) and gives us a romantic glimpse; it communicates not only the romance, but includes us—the viewers—as an audience even before we get to the theater. Often, posters stand alone, as a single unit. Sometimes they are applied as barricade posters, used in multiples, as the series for the CCAC Institute (Figure 8-6). The entire Mission Mall was wallpapered with the fun and nostalgic posters by Muller + Company, to create a barricade effect (Figure 8-7).

Understanding the subject matter, ordering information so it can be easily gleaned, attracting

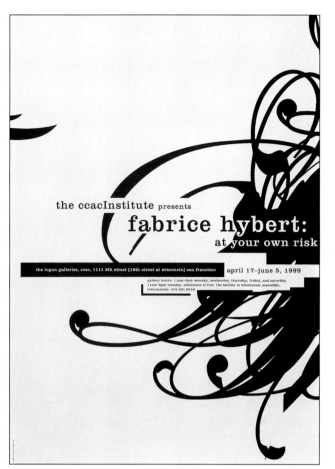

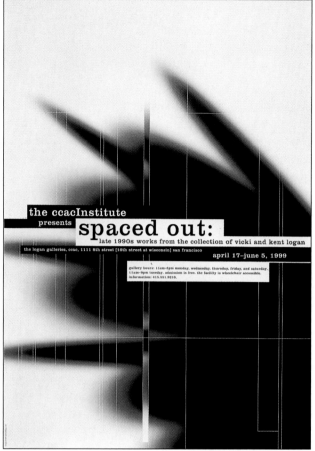

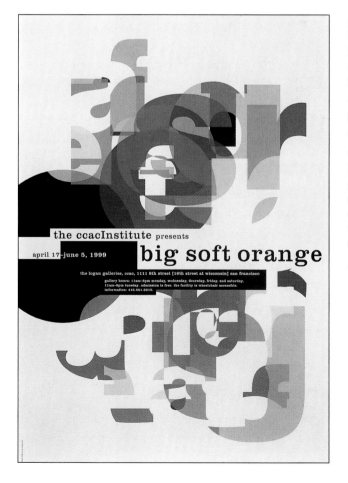

Figure 8-6

Posters: *Fabrice Hybert, Spaced Out,* and *Big Soft Orange*
Design firm: Morla Design, San Francisco, CA
Art director: Jennifer Morla
Client: California College of Arts & Crafts

"This series of exhibition announcements was designed for the CCAC Institute, one of San Francisco's newest experimental art venues.

Working with extreme budget constraints, each poster incorporates letters from the show's title to create dynamic graphics that give each show a unique visual voice. Applied as barricade posters, they create a dynamic presence when used in multiplicity. The experimental typographic vocabulary reflects the nature of the art shown and creates a recognizable identity for the CCAC Institute."

—Morla Design

Figure 8-7

Posters

Design firm: Muller +
Company, Kansas City, MO

Creative director/Designer:
John Muller

Writer: David Marks

Production art: Kent Mulkey

Client: Mission Mall,
Mission, KS

"A regional shopping mall
was going to open in two
weeks. The developer of
the mall called me and
said, 'We have 150,000
square feet of blank
storefront barricades and
it looks desolate in here!'
So, in order to get
something produced and
installed in two weeks and
respond to a limited budget
situation, I designed a
series of three-color silk-
screen posters. We printed
75 each of the posters on
cheap billboard paper
40" x 60" and simply
wallpapered the entire
mall. These posters quickly
became collector's items."

—John Muller

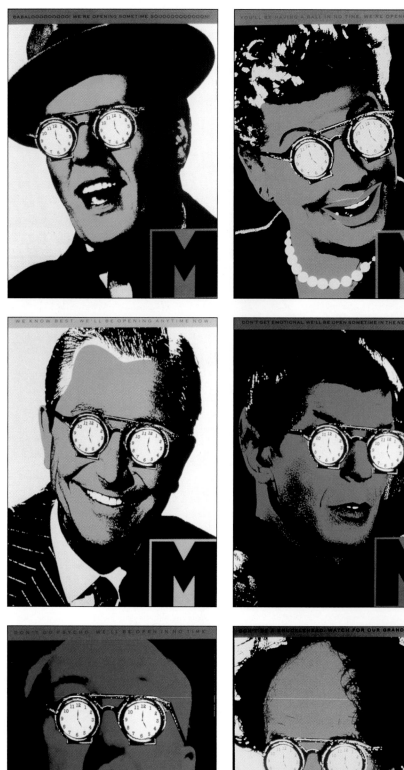
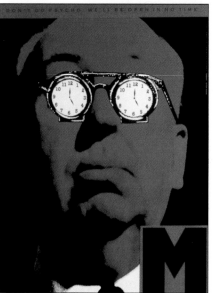
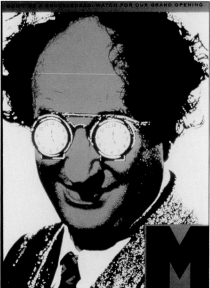

the audience's attention, and then keeping it long enough to communicate the information or message is essential to designing a successful poster. If you were designing a poster for a certain musical genre, you would probably want to reflect the musical style in the design, as in the poster for The Funk Brothers (Figure 8-8). Alexander Isley's vanguard poster is designed to reflect, as the designer says, the "exciting, engaging, and fun" nature of the Brooklyn Academy of Music's festival, "New Music America" (Figure 8-9). The smiling face, with words coming out of its mouth and words going into its ears to symbolize sound, is as smart as the concert series. Similarly, when Stefan Sagmeister designed the iconic poster for Lou Reed, he found inspiration and used it to create something very illuminating about the artist and lyrics (see Timeline, page TL-19).

Making emotional connections with the audience can make a poster memorable, as well as powerful. Certainly, a designer must understand the audience. Using humor on behalf of the Miami Rescue Mission, the Crispin Porter + Bogusky agency grabs our attention with visual surprises in their campaign (Figure 8-10).

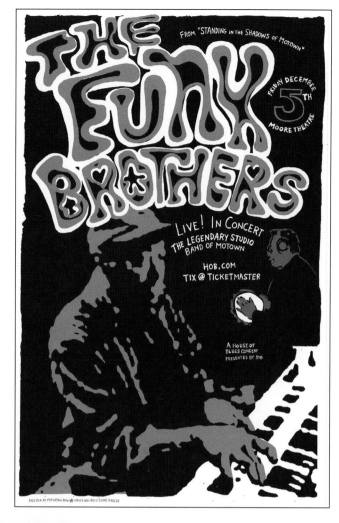

Figure 8-8
Poster: *The Funk Brothers*
Design studio: Modern Dog Design Co., Seattle, WA
Designer: Robynne Raye
Client: House of Blues
© Modern Dog Design Co.

"Robynne Raye routinely ignores the boundaries between illustration, design and typography."

—Modern Dog Design Co.

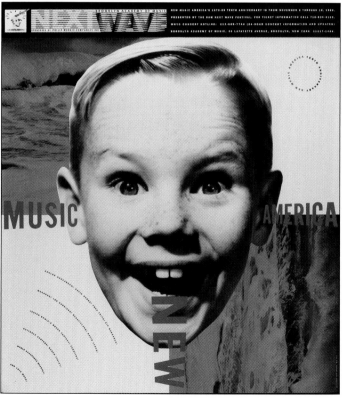

Figure 8-9
Poster: *New Music America*
Design firm: Alexander Isley Inc., Redding, CT
Art director: Alexander Isley
Designer: Alexander Knowlton
Client: Brooklyn Academy of Music, "New Music America" Festival

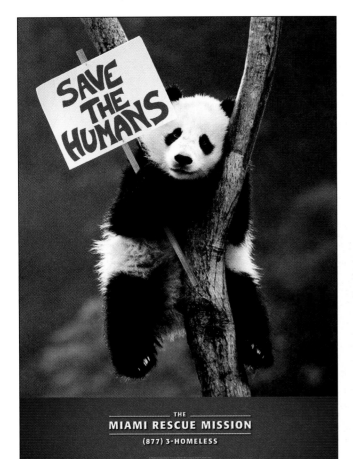

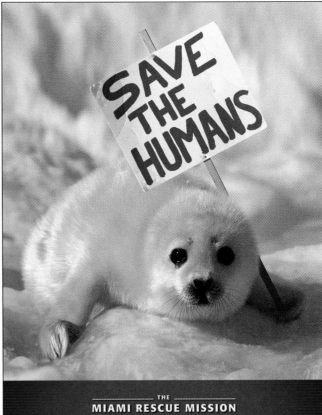

Figure 8-10
Posters: *Save the Humans*
Agency: Crispin Porter + Bogusky,
Miami, FL
Executive creative director: Alex Bogusky
Art director: Mary Taylor
Copywriter: Ari Merkin
Photography: Stock

With a reversal in roles, endangered
species ask us to save humans.

The typography is fully integrated with the
photographs in these memorable posters
that use humor to reach out and call us
to action.

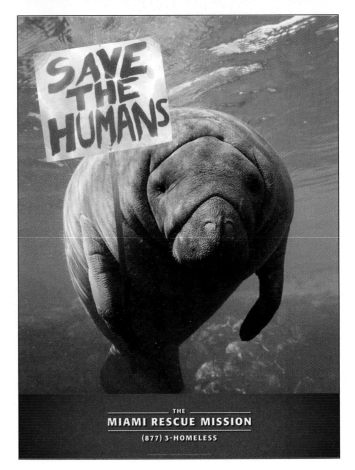

Integration of Concept with Visual Elements

Like all other graphic design, the success of a poster depends upon expressing the concept through the right combination of type and image. Type and image must complement each other, as they do in the poster for The Pretenders (Figure 8-11). Notice the visual hierarchy. You see the visual first, and then you read the words. The visual is thoughtfully designed in terms of scale—the size of the image in relation to the format yields a powerful effect. SpotCo's poster for *Freak* communicates a very different energy and message (Figure 8-12). All the visual elements in that poster—vibrating patterned background, cartoonish typography, graphic illustration,

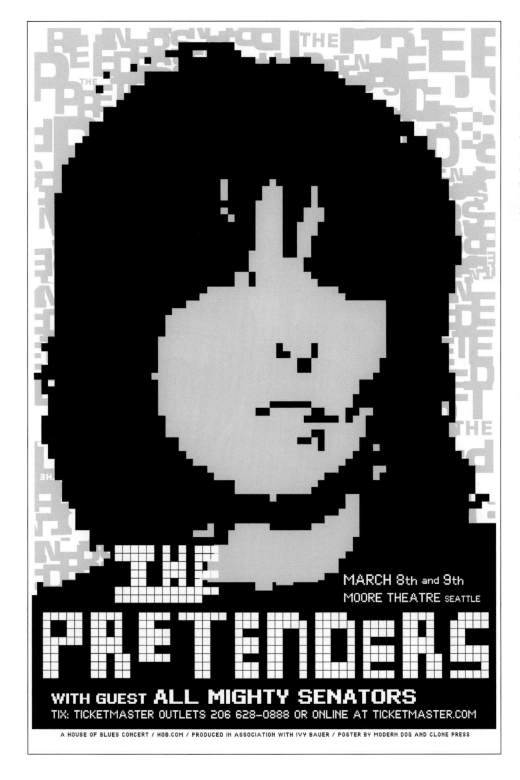

Figure 8-11
Poster: *The Pretenders*
Design studio: Modern Dog Design Co., Seattle, WA
Designer: Robynne Raye
Client: House of Blues
© Modern Dog Design Co.

The pixelated image of Chrissy Hynde corresponds with the treatment of the type to make an imaginative and unified visual statement.

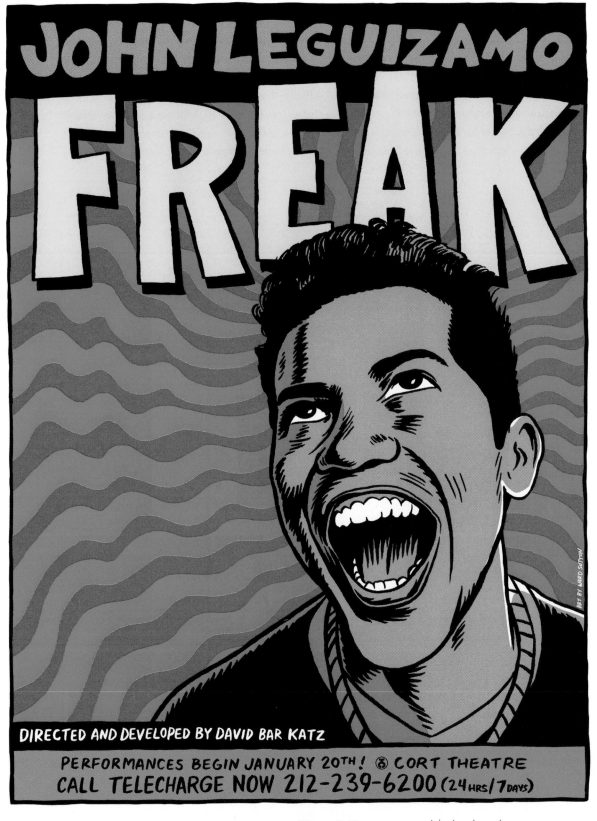

Figure 8-12
Poster: *Freak*
Design studio: SpotCo,
New York, NY
Designer: Kevin Brainard
Illustrator: Ward Sutton

John Leguizamo's
semiautobiographical one-man
performance features many
fascinating characters, and the
energy of the performer/writer
is communicated through the
poster design.

choice of image, and bright color palette—communicate Leguizamo's angst-ridden, tailored autobiographical journey.

Sometimes we can almost see the designer thinking, and in these cases, the design concept is very clear. The poster by designer Woody Pirtle is a hybrid of agriculture and architecture. Pirtle traveled from Pentagram's New York office to lecture on graphic design in Iowa. His announcement poster fuses an icon of the Midwest—corn—with an icon of Manhattan—the Chrysler Building (Figure 8-13). George Tscherny divides the poster into a grid and uses eight of the nine subdivisions to promote a new press capable of printing eight colors plus coating in one pass (Figure 8-14). Using a trompe l'oeil effect can yield both entertaining and dramatic results, as in the clever poster by Louise Fili (Figure 8-15).

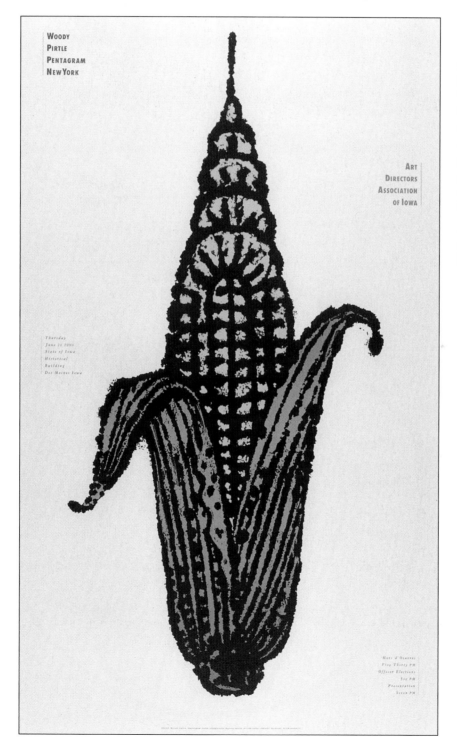

Figure 8-13
Poster: *Chrysler/Corn*
Design firm:
Pentagram Design Ltd.
Partner/Designer/Illustrator:
Woody Pirtle
Client: Art Directors
Association of Iowa

"This design was developed from a sketch Woody Pirtle made with a fountain pen on a napkin during a lecture trip to Iowa."

—Sarah Haun,
communications manager,
Pentagram Design Ltd.

Figure 8-14
Poster: *8 + 1*
Design firm:
George Tscherny, Inc.,
New York, NY
Designer/Illustrator:
George Tscherny
Client: Sandy Alexander, Inc.,
Clifton, NJ

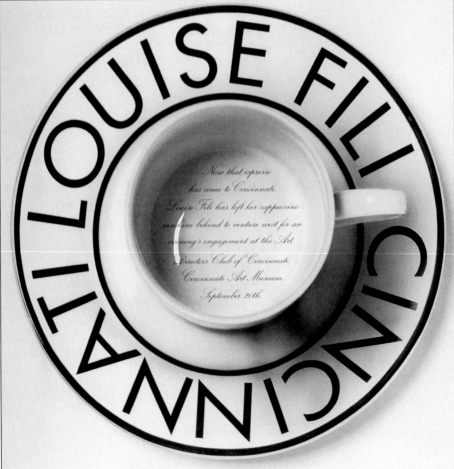

Figure 8-15
Poster: *Louise Fili,
Cincinnati*
Art director/Designer:
Louise Fili
Design firm: Louise Fili Ltd.,
New York, NY

Michele Kalthoff, Designer, Red Flannel, Freehold, NJ, and Dawnmarie McDermid, Designer, Rizco, Manasquan, NJ, wear many of the same hats: Kean University alumni, graphic designers for boutique firms in New Jersey, adjuncts at Kean University, and most importantly, 'sistas.' "We balance and complement each other in ways that allow us to be better together than we could ever be alone."

Working Design Tips from Michele Kalthoff and Dawnmarie McDermid

On working with clients:

• You can NEVER ask too many questions.
• Listen! Listen! Listen! Being a good listener and taking good notes will be incredibly helpful when it's time to design. If your client tells you he hates lemon yellow, steer clear of lemon yellow.
• Earn your client's confidence. Become as familiar with your client's business as you can. The more you know about their target audience, the better you can serve them. The more they see you know about them, the more they'll trust you. If your client believes in YOU, you'll have a better chance of your client following your lead and respecting your advice on design.

On budget:

One of the most difficult things for designers to swallow is the "B" word. That's right folks, we said it . . . budget! Here are a few things to consider in order to stay on budget:
• How technically innovative can the design solution be? Is there money in the budget for die cuts, foil stamping, or varnishes?
• Choose paper carefully. Cheap stock looks and performs like cheap stock. Money spent on good-quality paper is well spent.
• How will the book be bound? Saddle stitch, perfect bound, or can you go wild with custom binding?
• What is the print run (quantity printed)?
• What is your timetable on each deliverable? Rush charges will be incurred for anything needed quickly.
• Are mailing costs an issue? Most likely, they are. Get estimated mailing costs early in the project. This is where working backwards is a good idea. Get your size, binding technique, paper choices, and mailing information determined first. If mailing costs come in high and you have to change direction, at least you haven't invested too much time on one design.

• Good photography and illustrations enhance reader understanding and appreciation. Can you afford to hire someone to do this or will you need to purchase stock items?

On collaboration:

• Who are the people on your team? You know who your design firm's players are, but what you really need to know is who comprises the client's team.
• What is the desired involvement of the CEO? If the CEO isn't involved until the end, how much does she trust the management team to make decisions?
• Are decisions made by one person or a committee?
• Does the design team have a contact person?
• What are the experience levels of the photographer, writers, others?
• No one appreciates an unexpected turn of events. The more you know at the beginning of the project, the better you can estimate your time and involvement—and the smoother things will go.

Some final general advice:

• Always pay attention to detail!
• Pay attention to type, kerning, leading, and image choice. It all matters, no matter how small or insignificant you think it is.
• Use a dictionary and a thesaurus. Definitions are extremely helpful when thinking of ideas and expanding on them.
• Ideas will come to you at the strangest times; always jot them down. Never think you'll remember them. Chances are they'll leave your head as quickly as they came.
• We had a design professor who taught us "one trick per design is all you need." It's possibly the best design advice we've received through the years. In our opinion, simple is definitely better.
• Treat your work as if it were to be displayed in a museum. Hey, you never know.
• Good design is good business. If you can get your client to understand that, you've won half the battle.

Interpretation of Posters

Sagmeister takes a very familiar face and reinvents it in the poster for *The New York Times Magazine* (Figure 8-16). "Yes, that is Albert Einstein hidden in all those molecules," says Sagmeister of *Quantum Weirdness Symposium*. The School of Visual Arts asked several designers to interpret the phrase "Art is" Milton Glaser's interpretation is shown in Figure 8-17. All of the designers' posters were hung around New York City, in subways and at bus shelters.

Understanding scale can give a designer an edge in creating the illusion of spatial depth, creating surprise, and creating visual dynamics or variations. The classic poster, shown in Figure 8-18, by Herbert Matter is a good example of a designer using extreme differences in size to create a strange mood and a somewhat disjunctive space. Interpreting Matter's poster, in

Figure 8-16

Poster: *Quantum Weirdness Symposium*
Design firm: Sagmeister Inc., New York, NY
Creative director: Janet Froelich
Art directors: Stefan Sagmeister and Joel Cuyler
Designers: Stefan Sagmeister and Veronica Oh
Digital art: John Kahrs
Client: *The New York Times Magazine*

Figure 8-17
Poster: *Art is. . .*
Designer: Milton Glaser
Client: School of Visual
Arts, New York, NY

Could Glaser's
combination of words and
visuals be about the hidden
nature of art—how art is
not where you expect to
find it?

Figure 8-18
Poster: Matter, Herbert
(20th Century)
Pontresina Engadin, 1935
Collection: The Museum of
Modern Art, New York, NY,
Gift of the designer.
The Museum of Modern
Art, New York, NY, U.S.A.
Digital Image © The
Museum of Modern Art/
Licensed by SCALA/Art
Resource, NY

homage to him, Paula Scher sets up similar scale relationships, as shown in Figure 8-19.

When a designer has a very unusual design concept, imaginative things can happen (Figure 8-20). Steven Brower talks about his ideation process: "While researching my talk for the Kean University 'Thinking Creatively' conference, I began to think about what it truly means to be creative in what is essentially a collaborative field.

Figure 8-19

Poster: *Swatch Watch*
Design firm:
Pentagram Design Ltd.
Partner/Designer:
Paula Scher
Client: Swatch Watch USA

"In keeping with Swatch's irreverent, trendy marketing identity, Paula Scher designed a series of advertisements and posters parodying graphics from earlier design styles. Herbert Matter's poster from the 1930s was modified for one execution."

—Sarah Haun, communications manager, Pentagram Design Ltd.

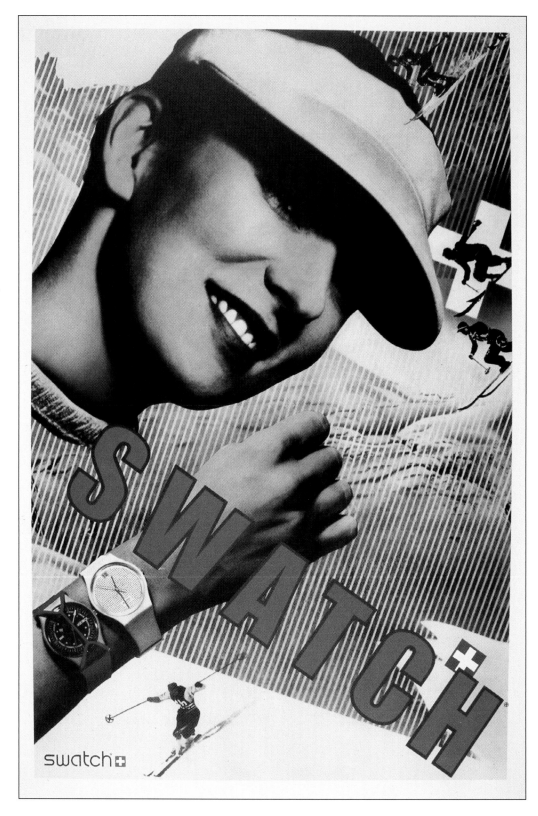

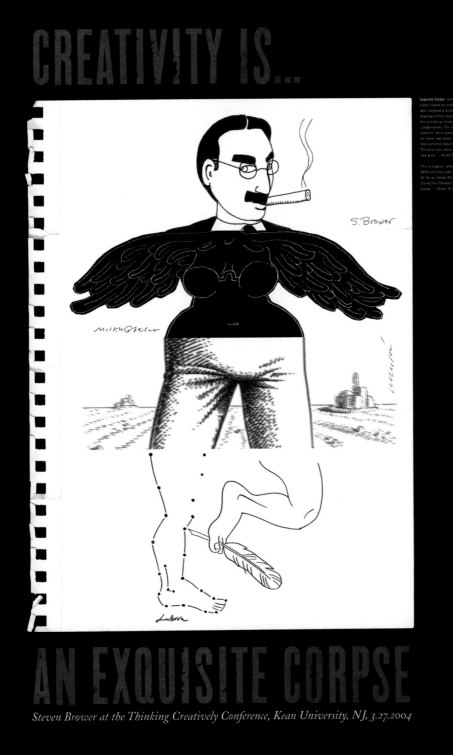

Figure 8-20
Poster: *Exquisite Corpse*
Art director/designer:
Steven Brower
Participants: Steven Brower,
Milton Glaser, Mirko Ilic,
and Luba Lukova
Clients: Art Directors Club
of New Jersey, and Kean
University Department
of Design

Steven Brower designed
this poster for the inaugural
creativity conference at
Kean University. Attendees
waited patiently in line
to have Brower and Luba
Lukova (one of the poster's
illustrators/participants)
autograph their posters,
which have now,
undoubtedly, become
prized objects of
contemplation.

I recalled a game I used to play with my father, wherein one person draws the beginning of a figure, folds the paper, and the next one continues the drawing without seeing what came before. When I invited Milton Glaser to participate, he informed me that the 'game' was actually an 'Exquisite Corpse,' invented by the Dadaists and Surrealists. I also asked Mirko Ilic and Luba Lukova to participate."

Summary

The purpose of any poster is to communicate a message. A poster is a two-dimensional, single-page format used to inform (display information, data, schedules, or offerings) and to persuade (promote people, causes, places, events, products, companies, services, groups, or organizations). Produced in multiples and widely circulated, posters are often seen in numerous locations around town by the same viewer.

Before posters became a visual communication staple, broadsides were used to communicate ephemeral information—to make announcements and publicize news and events, as well as to promote merchandise. By 1900, colorful posters won over viewers and artists, alike. Ever since then, the public has embraced posters as both visual communication and art objects worthy of display in their homes and offices.

Posters must be designed with the context in mind; a poster competes for attention with surrounding posters, outdoor boards, neon signs, and any other visual material. As memorable communication, posters have the potential of making emotional connections with the audience. To do that, a poster depends upon expressing the concept through the right combination of type and image. When a designer has an inspiring and targeted design concept, imaginative things can happen.

Notes

[1] Digital Scriptorium web site, *http://scriptorium.lib.duke.edu/eaa/broadsides.html*.

[2] J. Stewart Johnson, *The Modern American Poster* (New York: The National Museum of Modern Art, Kyoto, and The Museum of Modern Art, New York, 1983), p. 8.

Suggestions

A poster may be designed with just typography or with a combination of type and visuals. The visuals may be abstract, pictographic, symbolic, illustrative, graphic, photographic, or a collage or hybrid. Type may be designed within the visuals, or there may be a fusion of type and visuals. Anything goes, as long as it communicates and connects with the audience. Designing a poster is a challenge in terms of both design principles and message communication. Your objectives are to:

- Gain someone's attention
- Communicate a clear and easily understood message
- Fully integrate the concept with the visual elements
- Create a design that can be seen from a distance
- Include all pertinent information
- Establish a clear hierarchy of information
- Establish unity
- Design appropriately for the subject, audience, and context
- Make an emotional connection with the audience

Exercise 8-1

Poster design variations

Step I

Find a poster; analyze its design concept and execution.

Step II

a. Redesign it three different ways: first, using only type.

b. Redesign it so the visual is the dominant element and the type is secondary.

c. Redesign it so the type is the dominant element and the visual is secondary.

d. Produce about twenty sketches before going to the rough stage.

e. Create one rough for each design problem.

Project 8-1

Poster design for a social cause

Step I

a. Choose a social cause, such as helping the homeless. Gather information about it.

b. Find related visuals to use as references.

c. Write a design brief. Define the purpose and function of the poster, the audience, and the information to be communicated.

d. Design a poster to promote helping others.

Step II

a. Concentrate your conceptual thinking on finding a way to prompt people to think about the cause. You don't have to call them to a specific action, such as donating time or food. Simply get their attention and get them to think. For example, interpret the statement "Helping means . . ." or "Being hungry means . . ." or ask the viewer a question: "What would you do with an extra ten dollars?"

b. The poster should include the social cause's web address so that people can act.

c. Your solution should grab the attention of people walking by.

d. Produce at least twenty sketches.

Step III

a. Produce at least two roughs before going to the comp.

b. Be sure to establish visual hierarchy.

c. The poster can be in either a vertical or a horizontal format.

Optional: Design accompanying paperboard cut-out figures or objects.

Step IV

a. Refine the roughs. Create one comp.

b. The size, shape, and proportion should be dictated by your strategy, design concept, and where the poster will be seen (environment). The maximum size is 20″ x 26″.

c. Use two colors.

Presentation

Present the comp in one of two ways: mat on an illustration board with a 2″ border, or mount on an illustration board.

Comments: *The first objective of any poster is to get someone to notice it. Your objective here, primarily, revolves around learning to create concepts that can be translated into type and visuals with impact. A poster can provoke on behalf of a social cause, patriotism, or global concern or issue.*

Project 8-2

Poster design for a play

Step I

a. Choose a contemporary play. Read it. Research it.

b. Find related visuals you could use as references.

c. Write an objectives statement. Define the purpose and function of the poster, the audience, and the information to be communicated. On an index card, write down three adjectives that describe the spirit of the play, one sentence about the play's theme or plot, and images or visuals that relate to the play. Keep this card in front of you while sketching.

Step II

a. Design a poster to promote a play at your college or at a local theater. The poster should include the following copy: title, credits (author, producer, director, etc.), date, place, time, web address, and other contact information.

b. Your solution should include type and visuals. The key to developing your design concept may be a visual that is symbolic of the play's spirit, message, or mood. Visuals do not have to be photographs of the cast or scenes from the play.

c. Produce at least twenty sketches.

Step III

a. Produce at least two roughs before going to the comp.

b. Be sure to establish visual hierarchy.

c. The poster can be in either a vertical or a horizontal format.

Step IV

a. Refine the roughs. Create one comp.

b. The size, shape, and proportion should be dictated by your strategy, design concept, and where the poster will be seen (environment). The maximum size is 18″ x 24″.

c. Use four-color process colors.

Optional: Design a playbill.

Presentation

Same as Project 8-1.

Comments: *Since this poster is promoting a play, you must carefully select visuals and words that will interest people; you have to motivate them to see the play. Try to create a meaningful relationship between what is being said (the verbal) and what is being shown (the visual). This is a good opportunity to use imagery or visuals that are essential or provocative without being a literal translation of the subject. Your goal is to communicate a message to an audience.*

Create a meaningful relationship between what is being said (the verbal) and what is being shown (the visual).

Project 8-3

Poster series

Step I

a. Gather information about a series of events that happened on your campus or at a local library or community center.

b. Find visuals related to the events.

c. Write a design brief.

Step II

a. Design a series of posters for the campus or other events.

b. The posters should have a similar style, looking as if they belong to a series.

c. Produce at least twenty sketches for the series.

Step III

a. Refine the sketches, and produce one rough for each poster in the series.

b. Be sure to maintain visual hierarchy.

Step IV

a. Create a comp for each poster in the series.

b. There should be a minimum of three in the series.

c. Each poster should be no larger than 16″ x 20″. All the posters should be the same size.

d. You may use a maximum of two colors.

Presentation

The posters should be presented as tight comps in one of three ways:

1. Mat or mount on consecutive boards with a 2″ border.

2. Attach three boards that fold together, so that the board folds out to reveal three posters.

3. Reduce the posters and mount or mat on one board.

Comments: *Designing a poster series demonstrates your ability to develop a design concept and follow it through in several ways or versions. It also provides you with an opportunity to develop a "look" or style for a series. Though each poster should be able to stand on its own and send its own message, there should be a visual connection throughout the series; there should be continuity. You may want to design companion pieces for this poster series, such as an invitation to events or a promotional button.*

Though each poster should be able to stand on its own and send its own message, there should be a visual connection throughout the series; there should be continuity.

print

America's Graphic Design Magazine

$8.00 US • $11.25 Canada • Print July/August 2003 LVII:IV

◄ Magazine cover: *Print*
Art director/Designer: Steven Brower
Photographer: Gregory Crewdson

Objectives

Understand the purpose of book jacket and magazine cover design

Realize that cover design is both promotional and editorial design

Be aware of how a cover is seen in context

Appreciate the relationship a reader has with a cover

Consider how the combination of type and visuals communicates to the viewer

Learn a cover designer's basic options of driving the design solution

Consider the front, back, and spine of a book cover

Realize the need for consistency and unity in a cover series

Understand the function of a template when designing a series

Understand the use of a slipcase

The Purpose of Covers

Have you ever walked by a newsstand and stopped to look more closely because a magazine cover caught your eye? Or, when walking by a bookstore window display, have you ever been stopped in your tracks by the sight of a book cover design? That's part of the purpose of a cover.

At once, a cover must grab a reader's attention and, in visual shorthand, communicate the book's substance or "feel." Whether a reader views a reduced version of the cover online or in a catalog or sees it in its actual size displayed in a bookstore, a cover must grab the reader's attention and generate intrigue. At times, in a bookstore environment, it is the spine of the book that works to grab the reader's attention.

The design of a cover or book jacket may influence your decision to purchase a book or magazine. At the very least, it gives you a clue as to what is between the covers. Book jackets and covers are an interesting hybrid design application—they are both promotion and editorial design. A cover promotes the book or magazine; it acts to attract the reader. Covers are also editorial design problems since they must communicate the publication's content.

Every book and magazine is in competition. All are vying for the potential consumer's attention, though not every book or magazine is aimed at the same audience. All the rules about developing a strategy apply here; design with your audience and the marketplace in mind.

Design Considerations

A jacket or cover should give the reader a sense of what the book or magazine is about. You can think of it as a trailer or preview for a film, both informing and creating suspense or intrigue, as in the *Print* magazine cover in Figure 9-1. For example, if you are designing a book jacket for a murder mystery, you would want to convey a sense of the excitement, setting, time period, drama, and mystery in the book—but you would not want to give away too much information (especially not the ending). A book jacket or magazine cover must communicate its message quickly and clearly, and arouse interest. How much of the book do you reveal in the cover design? Which visual would capture the book's essence? Plot? Character? Storyline?

The cover is the reader's first experience with a book and an ongoing experience. After a reader's initial reaction to a cover in a bookstore, online, at a newsstand, or when a magazine arrives in the mail, once the reader starts reading, a new relationship develops. Often a reader will turn to and contemplate the cover. In a fashion similar to our experiences with CD covers, a reader develops a relationship with a book or magazine

cover—it becomes part of the entire reading experience.

Use of Type and Image

Like any other graphic design piece, a book jacket or magazine cover most often combines type and image. In the case of the front cover of a book, we usually see the title of the book and the author's name; sometimes, the price and series logo are included on the cover. Whether you design with type alone, type and photography, type and illustration, or type and graphics depends on your strategy, concept, and whether the book belongs to a series. If a book is part of a series, the series should be visually coordinated.

Type and image should complement one another. Consideration must be given to the combination of these elements—how well they work together to convey a message and the spirit of the book or magazine. When choosing type or visuals, it is crucial to make selections based on the concept, style, or image you wish to convey, and the appropriateness to the subject matter. There are many approaches to creating or selecting imagery. For example, Steven Brower, former creative director of *Print* magazine, spent a Sunday afternoon chasing down knickknacks for the cover of *Print's* European Design Annual 2000 (Figure 9-2).

As with almost all graphic design applications, the cover designer has a good number of options.

All Type

Sometimes budgets won't cover the cost of buying images; sometimes the best solution for the design concept is an all-type treatment. In those cases, typography used exclusively can have very pointed, compelling results. John Gall quite effectively solved the problem of including the names of all the authors included in an anthology by using an all-type solution (Figure 9-3).

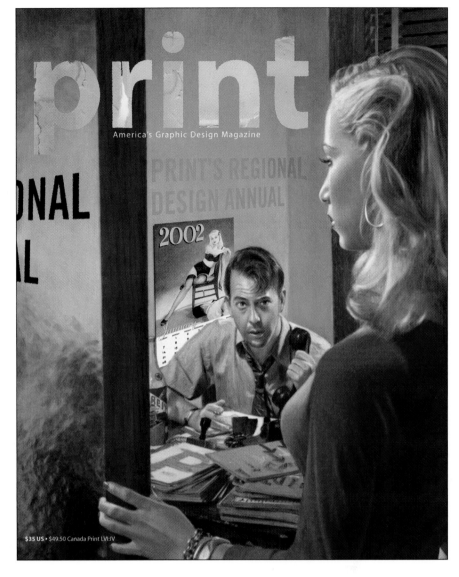

Figure 9-1

Magazine cover and sketch:
Print's Regional Design Annual 2002
Art director/Designer: Steven Brower
Photographer: Richard Fahey

A film noir effect lends suspense about which design solutions were chosen to be in this regional design annual. Also shown is Brower's original sketch for the cover design.

Figure 9-2
Magazine cover: *Print's* European
Design Annual 2000
Art director/Designer: Steven Brower
Photographer: Melissa Hayden
Hand lettering: Scott Menchin

Figure 9-3
Book cover: *The Anchor Book of
New American Short Stories*
Art director/Designer: John Gall
Publisher: Anchor Books

Type Plus Image

When type and image work cooperatively to communicate a publication's substance, there can be magical results. Many beginners choose or create interesting visuals only to "slap" type on the cover to accompany the visual. Make the visual and type work synergistically to maximize communication and effect nuance, as in the cover for *Advertising by Design*™ (Figure 9-4). Steven Brower's design for *Feynman's Lost Lecture* book jacket is a hybrid image of a photograph of Feynman combined with Brower's graphic drawn over the photograph; both the color of the typography and the font work cooperatively with the visual to communicate the subject (Figure 9-5).

Text-Driven Design

When the title of the book (title-driven) or the author's name (name-driven) is the predominant visual element, the viewer is expected to be attracted to the title's meaning or the author's reputation. For example, in Dr. John Chaffee's book *The Thinker's Way: 8 Steps to a Richer Life*, the designers focus on the title since it conveys substantive information to the viewer (Figure 9-6).

Image-Driven Design

There is no doubt that most viewers are attracted to interesting images. When a publication's cover is image-driven, it means that the image is the predominant visual element on the cover—the one doing the most work to attract

Figure 9-4
Book cover: *Advertising by Design*™ by Robin Landa
Creative director: Robin Landa
Designer: Adam C. Rogers
Photography: Getty Images
Publisher: John Wiley & Sons, Inc.

Here is an outstanding example of using a stock image and color to full advantage.

Figure 9-5
Book jacket: *Feynman's Lost Lecture* by David L. Goodstein and Judith R. Goodstein
Design firm: Steven Brower Design, New York, NY
Art director: Debra Morton-Hoyt
Designer: Steven Brower
Publisher: W. W. Norton

"I had a much better solution to this, with the title, subtitle, and author written on the blackboard, but the client selected this one where the lecture Feynman is giving comes to life."

—Steven Brower

Figure 9-6
Book cover: *The Thinker's Way: 8 Steps to a Richer Life* by John Chaffee, Ph.D.
Designers: Michael Ian Kaye and Amy Goldfarb
Publisher: Little, Brown and Company

The Thinker's Way offers eight steps to a richer life; the jacket design appropriately focuses on the title, and the visual treatment enhances the number eight.

the viewer. If you have any doubt about a visual's potential power, take a look at this book jacket by John Gall (Figure 9-7).

Certainly, budget might dictate which images are available to a designer. At times—for nonfiction book jackets or lead magazine cover stories—photographs or illustrations may be provided to the designer or may come from a feature in the magazine, as shown in Figure 9-8.

In other cases, when options are entirely open, it is up to the designer to find a visual that best communicates his design concept for the book or

Figure 9-7
Book cover: *South of the Border, West of the Sun* by Haruki Murakami
Art director/Designer: John Gall
Publisher: Vintage Books

Gall's mysterious visual juxtaposition—which makes the viewer look twice (or more)—reflects Haruki Murakami's psychological probe into obsession, unrequited love, and human frailties.

magazine. For the *Print* Regional Design Annual 2003 cover, Steven Brower decided to use six graphic patterns and color schemes to represent the six regions the United States is broken into within the annual (Figure 9-9). These same colors were used inside the issue to create tabs for each section, for accessibility. For *The Box Man* by Kobo Abe, designers John Gall and Ned Drew symbolize the existential abyss with the illusion of a three-dimensional space (Figure 9-10). They play with our senses by using a flat, black circle with an illusionistic linear cube and cutout hands, only to cover the space with a panel that displays the title, author, and other text. At times, a designer must coordinate several design pieces, as in the project *Children First*—a 100-page book and CD (Figure 9-11). If a book is designed and published on behalf of a social cause, the designer must also be concerned with eliciting a call to action on the part of the reader. "I could not crop or manipulate color in any of the images. This opened up more possibilities in experimenting with juxtaposition and scale to support the narrative," comments designer Petrula Vrontikis.

Figure 9-8
Magazine cover: *Print*
Art director/Designer: Steven Brower
Photographer: Gregory Crewdson

Photographer Gregory Crewdson,
who was featured inside the magazine,
became the subject of the cover as well.
This photo, heavily cropped, was
featured in full on the table of contents.

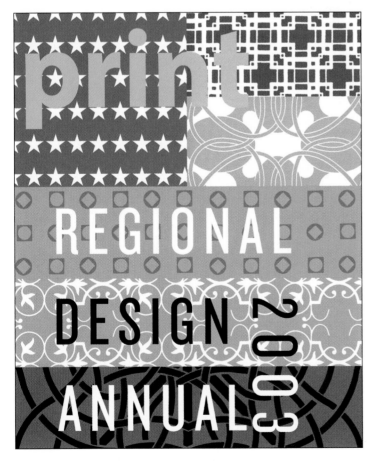

Figure 9-9
Magazine cover:
Print Regional Design Annual 2003
Art director/Designer: Steven Brower

"This is a good example
of form following function."

—Steven Brower

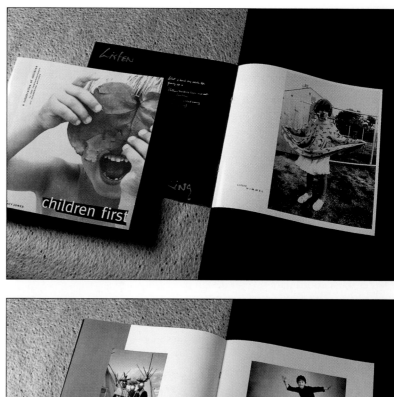

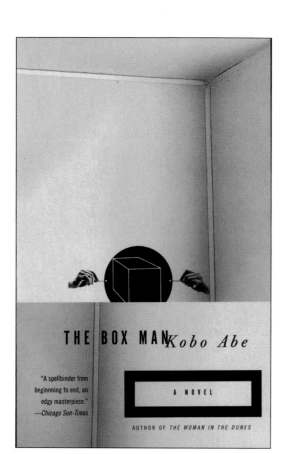

Figure 9-10
Book cover: *The Box Man* by Kobo Abe
Designers/Illustrators: John Gall and Ned Drew

A bizarre commentary on contemporary society, *The Box Man* concerns a man who relinquishes normal life to live in a "waterproof room," a cardboard box that he wears on his back.

Figure 9-11
Book and CD covers: *Children First*
Design firm: Vrontikis Design Office, Los Angeles, CA
Creative director/Designer: Petrula Vrontikis
Client: © Little, Brown and Company

"Children First is a book that contains images donated by the top fashion photographers, recordings of children-related music from top recording artists, and writings, all on the celebration of children.

The challenge was to emotionally sequence the images for maximum impact. All proceeds of the sale are donated to 'Homes for the Homeless,' an organization assisting homeless kids and families."

—Petrula Vrontikis

Oftentimes, books are published as paperbacks after the hardcover edition has had a run, and the paperback cover may be redesigned. The jacket design of the hardcover edition of *The Verificationist*, which utilizes a painterly-style picture, is markedly different from the paperback edition seen in Figure 9-12. To avoid repeating the hardcover's solution, John Gall thought of using a visual of pancakes, an idea the author rejected. Gall then went in a completely different direction from the original jacket design.

Images can be:

- Photography: custom or stock
- Illustration: custom or stock
- Graphics: custom or stock
- Hybrid imagery

Suggestions

When designing a book jacket or magazine cover, your objectives are to:

- Attract and intrigue readers
- Express the essence of the editorial content
- Be appropriate to the publication (in the case of a magazine) and be appropriate for the author and subject (in the case of a book)
- Design the spine for graphic impact and readability
- Consider placement of the publisher's logo, bar code, and any other specific visual element
- Treat the back cover and all panels as part of the "whole" design
- Consider the relationship to the cover, if you are designing the interior pages
- Check on standard sizes of books and magazines

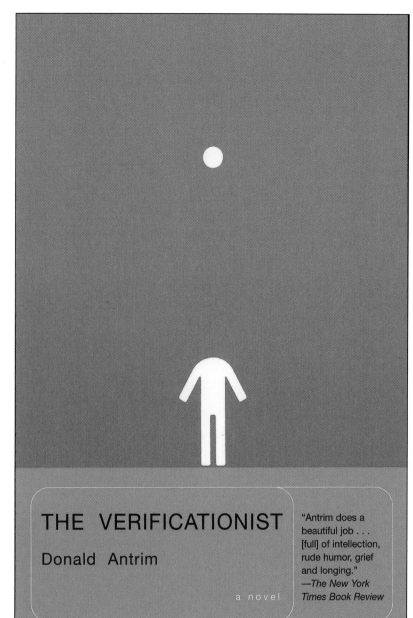

Figure 9-12
Book cover:
The Verificationist
by Donald Antrim
Art director/Designer:
John Gall
Publisher: Vintage Books

In this novel, a group of psychologists from the Krakower Institute meet at a pancake house, where discussion ensues. Due to a series of events, Tom, the main character, goes through an out-of-body experience that leaves him hovering over his colleagues. Gall's cover cleverly expresses Tom's out-of-body experience.

Figure 9-13
Book cover: *Typology*
by Steven Heller and
Louise Fili
Design firm: Louise Fili Ltd.,
New York, NY
Art director/Designer:
Louise Fili

Figure 9-14
Cover: *Belles Lettres*
Design firm: Louise Fili Ltd., New York, NY
Art director/Designer: Louise Fili

The work of many designers is uniquely identifiable, yet they are able to serve each design problem with a voice appropriate for that problem. Louise Fili's style is apparent when you look at her body of work, and yet, like any excellent designer, she is able to adapt her personal vision to communicate the spirit of each project. Compare the two book jackets by Fili (Figures 9-13 and 9-14); both have Fili's distinctive typography, yet the distinctiveness of each project's personality is maintained.

Front, Back, and Spine

Often, people think of a book jacket as just the front cover. The entire cover—including the spine, which is a key player in a bookstore environment—must be considered as a whole package. Shown are four intelligent and interesting examples of designs that address the book jacket, both front and back, as a continuous piece (Figures 9-15 through 9-18).

Designing for a Series

When designing for a series, you must establish a "look" for the series, so people will recognize the books as belonging together. A series should be identifiable as such. Among the covers or jackets, there should be visual similarities; for example, placement of the elements, type treatments, color, or use of visuals.

Templates

For a series, often a designer will create a **template**—a compositional structure with designated positions for the visual elements. The author's name, book title, and visuals are usually placed in the same position on each jacket or cover, or with only slight variations in position. A template unites each individual cover within a series so that the viewer can easily relate or identify each cover to another in the series. Without question, a template establishes unity among covers. Each cover is "twin" to the next. There needs to be some variation in order to make each cover unique to the author and/or title. Some templates include very little variation. Others allow for greater variation, creating the

Figure 9-15
Book cover: *JFK: The CIA, Vietnam And The Plot To Assassinate John F. Kennedy* by L. Fletcher Prouty
Design firm: Steven Brower Design, New York, NY
Art director/Designer: Steven Brower
Photography: Arnold Katz
Client: Birch Lane Press

"Three entrance wounds in the back and three exit wounds in the front, ripping through the American flag pretty much sum it up. Who done it?

Damned if I know."

—Steven Brower

Figure 9-16
Book cover: *Walkin' The Dog* by Walter Mosley
Publisher: Little, Brown and Company

Figure 9-17
Book cover: *Careless Love*
by Peter Guralnick
Publisher: Little, Brown
and Company

Figure 9-18
Book cover: *Assuming The
Risk: The Mavericks, The
Lawyers, And The Whistle-
Blowers Who Beat Big
Tobacco* by Michael Orey
Publisher: Little, Brown
and Company

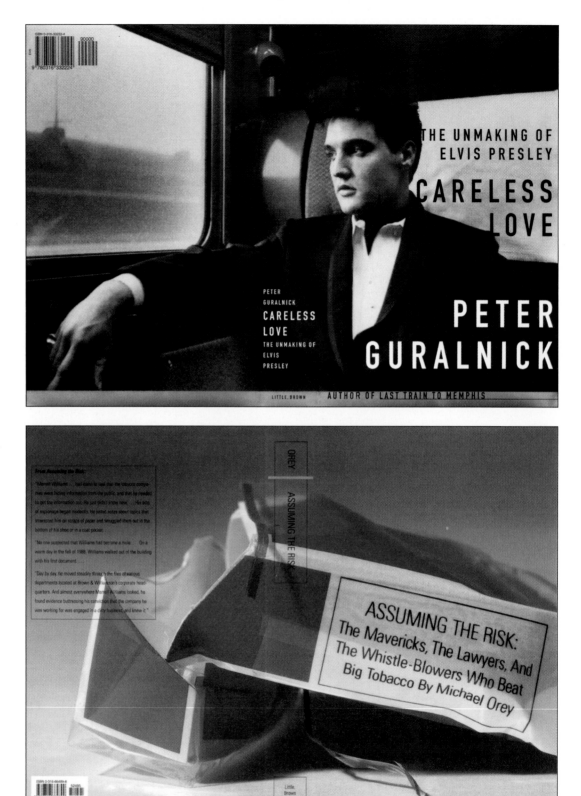

look of "cousins" among the covers; there is some family resemblance, but they are not identical to one another.

In addition to a template, a designer may also choose to keep the visual elements consistent from book cover to cover. For example, if one book has photographs, they all do. If one is a purely typographic solution, they all are, as in the designs by Jo Bonney (Figure 9-19). Some periodicals (magazine covers or special sections

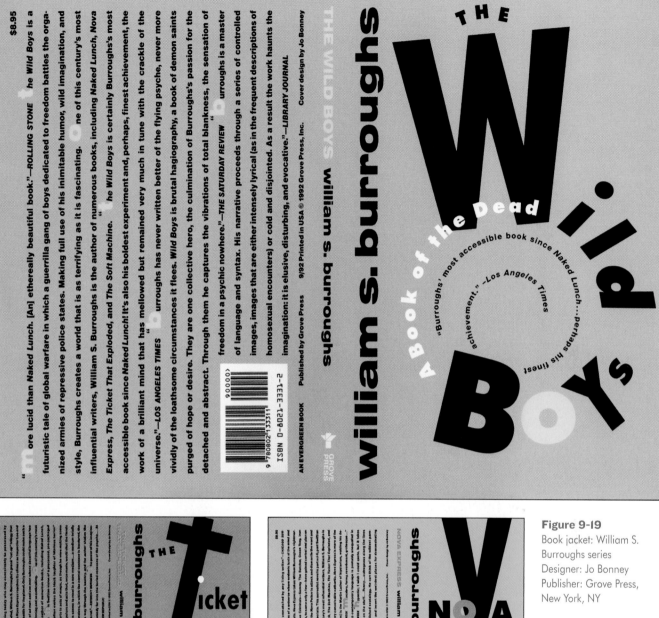

Figure 9-19
Book jacket: William S.
Burroughs series
Designer: Jo Bonney
Publisher: Grove Press,
New York, NY

in a newspaper) are known for utilizing illustrations and others for photographs. For example, *The New York Times Book Review* invariably features an illustration on the cover.

Rather than choose a firm with a history of designing textbooks, Houghton Mifflin selected Carbone Smolan Associates for their broad range of work and creative solutions.

The design program for "The Literature Experience" series (Figure 9-20) resulted in a series of highly acclaimed and unconventional children's textbooks for kindergarten through eighth grade.

In the Kahlil Gibran series, Steven Brower used an identical template; he also used the same Indian rug motif and one photograph of Kahlil

Figure 9-20
Book jackets:
"The Literature
Experience" series
Design firm:
Carbone Smolan
Associates, New York, NY
Designer: Leslie Smolan
Client: The Houghton
Mifflin Company

"The Houghton Mifflin
Company, long regarded
as the industry leader in
textbooks for reading, had
recently lost ground to one
of its prime competitors.
With 65 percent of its
revenue dependent upon
reading, a lot was at stake.
The company had a bold
idea: the key to success
was to reevaluate the role
of design in its books.

The books translate the
excitement of a bookstore
into each volume by
capturing the diversity and
spontaneity of individual
books. An array of
pageturning devices makes
the books playful, funny,
and interesting—quite
beyond the textbook norm.
After the books were in
production, we were
invited to design the
marketing materials and
kindergarten packaging.
The gamble seems to be
paying off—the program
is in use in all fifty states,
and sales represent 25
percent of the industry-wide
reading text market."

—Leslie Smolan, principal,
Carbone Smolan Associates

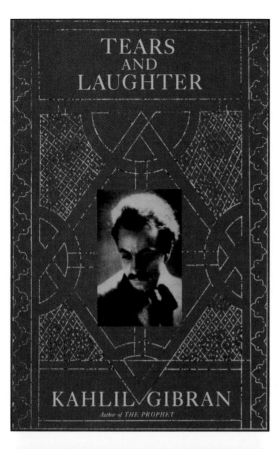

Figure 9-21
Book covers: series of
books by Kahlil Gibran
Design firm: Steven Brower
Design, New York, NY
Art director/Designer:
Steven Brower
Client: Citadel Press

"I used an Indian rug motif
to tie it all together."

—Steven Brower

Gibran to tie this series together (Figure 9-21); only the colors vary from cover to cover. Many designers are in favor of as much variety as possible within a series. In Figure 9-22, Brower establishes unity within the series, yet varies each cover so as to express the individuality of each book's content.

Slipcase Designs

Special binding techniques can be employed to make a book more special. Slipcases are used to turn a book into an esteemed object, usually reserved for art-book publishing (Figure 9-23), limited editions, or highly promoted projects. Various materials can be utilized, such as plastic, sealed plastic bubbles, and metal or screen-printed slipcases. Certainly, the book's content should inspire the slipcase or special binding solution.

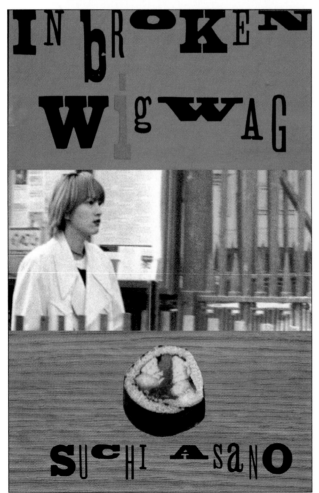

Figure 9-22

Book covers: *Power Game* by Perry Henzell,
Watching by John Fergus Ryan, and
In Broken WigWag by Suchi Asano
Design firm: Steven Brower Design, New York, NY
Art director/Designer: Steven Brower
Photographers: Barnaby Hall (*Power Game*),
Langdon Clay (*Watching*), and Astrid Myers
(*In Broken WigWag*)
Client: Fox Rock Books

"Three very different types of novels required
a loose format to hold them together. The
triptych approach worked as a strong enough
indicator that these worked together—and
independently."

—Steven Brower

Summary

A book jacket must grab a reader's attention and, in visual shorthand, communicate the book's substance or "feel."

Often, the design of a cover influences the viewer's decision to purchase a book or magazine. Book jackets and covers are both promotion and editorial design. A cover promotes a book or magazine, as well as communicating the publication's content. The cover is the reader's first experience with a book; once the reader starts reading, a new relationship develops.

Consideration must be given to the combination of type and visuals in conveying a message and the spirit of the book or magazine. When designing, the cover designer has many style options: all type, type plus image, text-driven, and image-driven. The entire cover—including the spine, which is a key player in a bookstore environment—must be considered.

When designing for a series, you must establish a "look" so that people will recognize the books as belonging together. Many designers create templates for series, where the author's name, book title, and visuals are usually placed in the same position on each jacket or cover, or with only slight variations in position.

Figure 9-23

Book cover: *Wave UFO* by Mariko Mori
Design studio: Sagmeister Inc., New York, NY
Art director: Stefan Sagmeister
Designer: Matthias Ernstberger
Photography: Richard Learoyd, Markus Tretter, Tom Powel, Red Saunders, and Rudolf Sagmeister
Illustrator: Marcus Della Torre
Client: Kunsthaus Bregenz/Public Art Fund

"Mariko Mori's *Wave UFO* book consists of a 200+-page publication hovering in a semitransparent slipcase. The entire book talks about one single piece of art, but a rather complex one: Three people can enter the Wave UFO, have electrode headsets attached to their foreheads, and experience a 3D animation that changes in sync to their individual brain waves."

—Sagmeister Inc.

Denise M. Anderson and Robin Landa brainstormed ideas and color palettes. After Anderson designed several covers, the comps were presented to Jim Gish, senior acquisitions editor, who helped direct the final cover design.

When designing a new edition for a popular, existing book, several factors must be kept in mind:

• Targeting the audience (current and future readers)

• Designing a cover that represents the content as an enthusiastic and intelligent approach to the book's topic

• Retaining some visual equity from the previous cover

• Making it clear to current readers that this edition has new subject content and illustrations through an updated cover look

• Differentiating the cover from the current competition

• Making the author's name easy to see and read

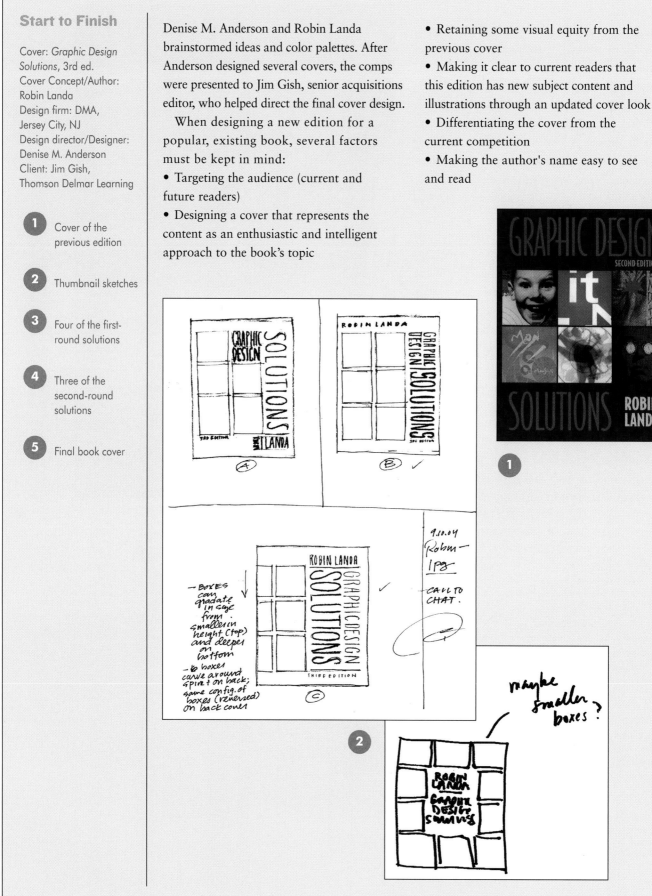

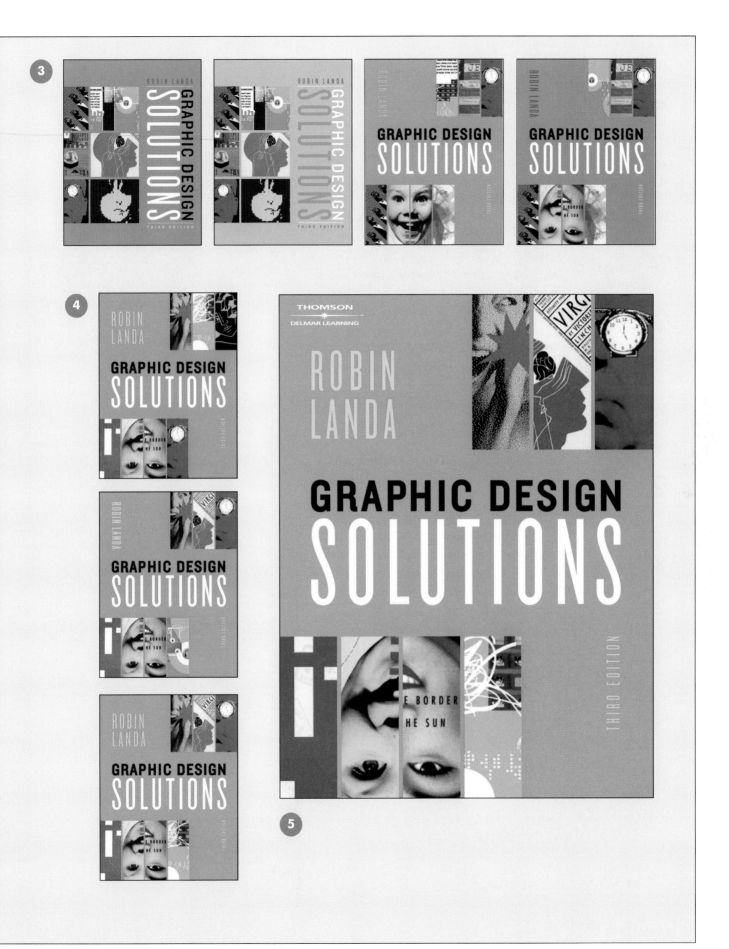

Exercise 9-1

Analyzing book jackets and magazine covers

Find five examples of book jackets or magazine covers that express the spirit or personality of their contents. Justify your choices.

Project 9-1

Magazine cover design

Step I

a. Choose a respected news magazine.

b. Gather information about a current news event, including one main article written by an esteemed journalist on this subject; this article will be the subject of the cover design.

c. Select or create visuals that relate to the story.

d. Write a design brief.

e. On an index card, summarize the story. Keep this card in front of you while sketching.

Step II

a. Design a magazine cover for the chosen magazine to reflect the lead article.

b. The cover's design should include the existing logo and any other information the magazine includes in its usual issues (the format of the chosen magazine must stay the same, and the logo must stay the same and be positioned in the way the magazine positions it).

c. Include the title of the article and/or journalist's name.

d. Your solution may be purely typographic or combine type and visuals. The visuals may be photographs, illustrations, graphics, or hybrid images. The selection, creation, and arrangement of type and visuals should create or set an appropriate tone.

e. Produce at least twenty sketches.

Reminder: Design with any or all tools that are appropriate—computer, pencils, markers—but do not lock yourself into using one tool for all projects.

Step III

Create two roughs for each cover.

Step IV

a. Refine the roughs. Create one comp for each cover.

b. You may use black and white or full color.

Presentation

The cover should be matted or mounted on an 11″ x 14″ board.

Comments: *The covers should reflect the approach of the magazine and the content of the article. It is important that the covers appeal to the appropriate reading audience. Remember: A wide variety of visuals may be used; you are by no means limited to using photographs.*

Project 9-2

Book jacket design series

Step I

a. Select three short-story writers. Read their works. Research them. Ask a literature professor about them.

b. Write an objectives statement. Define the purpose and function of the problem, the audience for the books, and the information to be communicated. On an index card, write adjectives that describe the work of each writer.

Step II

a. Name the series.

b. Design a logo for the short-story series. (See Chapter 6 on logo design.)

Step III

a. Design three book jackets—one for each writer in your series. Design front covers and spines.

b. The covers must be similar in style and yet express the individuality of each writer.

c. The logo must appear on each jacket in the same position.

d. Produce at least ten sketches for each jacket that could be expanded into a series format.

e. Your solution may be purely typographic, visually-driven, text-driven, or type plus visual(s).

f. Think about the various ways the series could be tied together:

 1. Through the use of similar visuals: illustrations, graphics, photographs, typography

 2. Through the use of a technique: woodcut, mezzotint, torn paper, xerography

Step IV

Refine the sketches. Create two sets of roughs for the series.

Remember: Book jackets or covers are very much like posters—they must attract the potential consumer. They should have initial impact. Your book jacket design must compete against other books sitting next to it on a shelf.

Step V

a. Refine the roughs and create one comp per book.

b. The covers should be 6″ x 9″, held vertically.

c. You may use black and white or full color.

Presentation

Each book jacket should be matted or mounted on a separate 11″ x 14″ board.

Comments: *The best way to begin is to read the books, in order to have a clear sense of your subject. Your designs must reflect the writer's works. It is crucial for a designer to learn to do research and to translate editorial content and ideas into graphic design. Like the poster series, each book jacket should be able to stand on its own, but also belong to the series. Any book in the series should be identifiable as such.*

There should be visual similarities among the books, for example, placement of the elements, type treatments, color, and use of visuals.

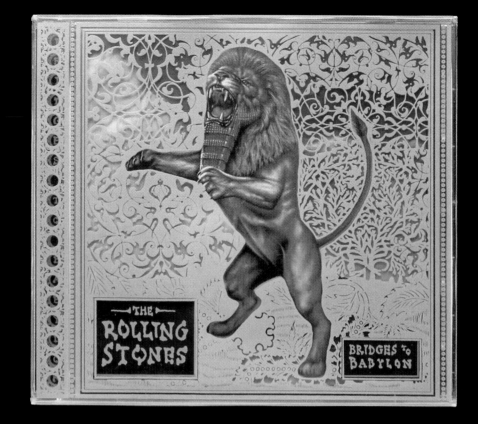
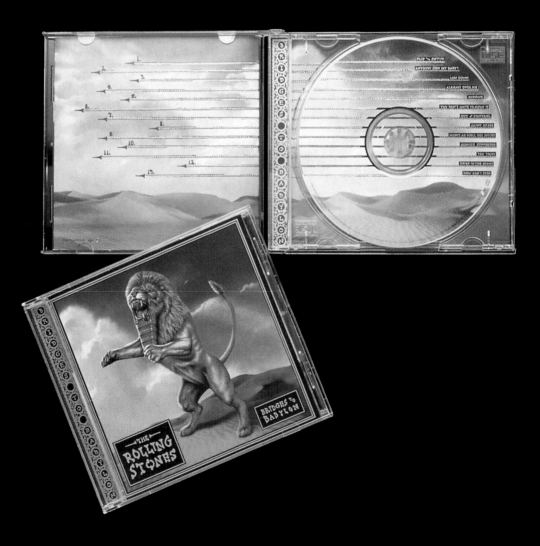

Packaging Design

Audio/Compact Disc Packaging

Shopping Bags

◄ CD packaging: Rolling Stones, *Bridges to Babylon*
Design firm: Sagmeister Inc., New York, NY
Art director: Stefan Sagmeister
Designers: Stefan Sagmeister and Hjalti Karlsson
Photography: Max Vadukul
Illustration: Kevin Murphy, Gerard Howland (Floating
Company), and Alan Ayers
Client: Promtone B.V.

Objectives

Understand the purpose of packaging design

Realize that there are form and function requirements

Be conscious of sustainable design issues

View packaging as part of a larger brand identity design

Understand how packaging design is a collaborative effort

Grasp the power of effective packaging design to influence the consumer

Learn that packaging must enclose, inform, and persuade

Study the different types of packaging

Be aware of how a consumer views most packaging in a store setting or on screen

Design packaging

Appreciate the special role of audio packaging to the listener/viewer

Consider integration of type and visuals to communicate a CD's feel

Design a CD cover

Recognize a shopping bag as a functional object, identity design, and a promotional design

Design a shopping bag

Packaging Design

Packaging design affects you more than you realize. If you walk into a store and see a package on display that is attractive, you might pick it up. Attractive packaging can seduce you into purchasing a brand, at least once. Well-designed packaging can make a parity product look exclusive, and conversely, poorly designed packaging can make a superior product look inferior. Poorly engineered packaging can infuriate the customer, just as well-engineered packaging can facilitate the use of a product and increase its brand loyalty.

Besides promoting a brand—while oftentimes being a pleasure to look at—packaging is also functional. Packaging encloses a product while at the same time allowing access to the product by means of a pour spout, a flap, a clasp, a drawstring, and many other such devices. **Packaging design** is a graphic design application which functions as packaging, but also attracts a consumer and presents information; it is a blend of two- and three-dimensional design, promotional design, information design, and practicality. Any packaging has several surfaces, and all sides must be considered in the design. Most packaging is displayed on shelves where we see the cumulative effect of several packages lined up next to one another. Online shopping may change how we react to packaging; however, once it is delivered to our homes, we interact with it.

Most often, packaging is just one part of a large, integrated marketing strategy and media planning, featuring a variety of applications and marketing initiatives, including promotions, new product launches, merchandising, and advertising. Just think of some giant brands, such as McDonald's, General Mills, and 3M, and how packaging is part of their entire branding program. Although packaging is part of brand identity design and promotional design, it is a specialized area of the graphic design profession—packaging designers must be knowledgeable about a range of construction and technical factors. Familiarity with and knowledge of materials and their qualities—such as glass, plastic, paperboard, paper, and metal—and with manufacturing, safety, display, recycling, regulatory management, and quality standards, as well as printing, is necessary. All visual communication professionals should make an earnest attempt to practice sustainable design—design that incorporates environmental matters, also called eco-design, green

design, or design for the environment. The greater use of materials in packaging design necessitates an investigation into how materials and processes impact on the environment, troubleshooting for potential hazards and wastefulness. As designers, we must consider the materials we use. Consider deeply how the materials affect (deplete, pollute, add unnecessary refuse) the environment. We can make choices to use environmentally friendlier materials and inks, and reduce packaging materials to essentials. The main areas of concern for a designer are:

• Materials: utilize recyclable materials, compostable organic materials, or continuously cycled minerals; and

• Pollution: manufacturing processes and materials that are nontoxic to air, water, and earth.

Packaging designers must work collaboratively with others, including chemical, mechanical, and packaging engineers. Designers may also work as part of a group to develop the basic shape of the package, materials, and structure.

Relevance and Emotional Connections

Many design experts believe that packaging is *the* make-or-break decision for a consumer reaching for a product on the shelf. It is estimated that about seventy-five percent of the decisions are made standing in front of the packaging in the store. What makes you notice any particular packaging sitting on a store shelf amidst numerous others? The design concept behind the packaging design must be relevant to the audience, in the same voice as the larger brand identity, and eye-catching.

The packaging design system for Barneys New York reflects the sophisticated image of the store (Figure 10-1). Using simple, legible uppercase letters, subtle colors, and a classic simplicity of design, an image of quality is conveyed.

"A palette of warm colors adds to the desirable shelf presence, tempting the shopper to take a package of the coffee home with him/her. The high quality of the packaging graphics, made up of the blend of color palette and illustrations, yields a product that is a popular gift, as well as a source of coffee for personal consumption," says Hornall Anderson Design Works of their packaging for Nordstrom Debut coffee (Figure 10-2).

For many types of packaging, there is mandatory information—such as nutritional information or ingredients—that must be included and considered when designing. An important part of packaging is providing the

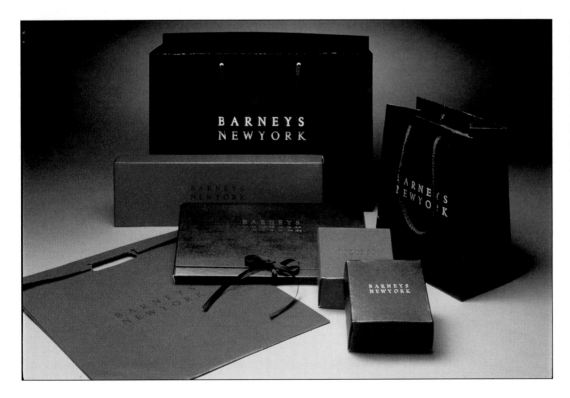

Figure 10-1
Packaging design:
Barneys New York
Design firm:
Donovan/Green,
New York, NY
Art director: Nancye Green
Designers: Julie Riefler
and Jenny Barry
Photographer: Amos Chan
Client: Barneys New York

Figure 10-2
Packaging: Nordstrom
Debut Coffee
Design firm: Hornall
Anderson Design Works,
Seattle, WA
Art director: Jack Anderson
Designers: Jack Anderson,
Debra Hampton, Margaret
Long, and Heidi Favour
Illustrator: Celia Johnson
Calligrapher: Geri Anderson
Copywriter: Nordstrom
Client: Nordstrom

Debut Coffee, a new
Nordstrom branded
product, was designed to
be sold throughout their
restaurants with Starbucks
Coffee Company as the
vendor. The packaging
was designed to portray the
cycle of a full day in which
to enjoy the coffee blends.
The packaging illustrations
depict a morning scene with
a croissant, the morning
paper, and the sun coming
up. As the package rotates,
the illustration changes to a
scene of a midday coffee
break. The scene continues
to evolve, turning into
evening, which includes
coffee by candlelight
beneath the crescent
of a moon overhead.

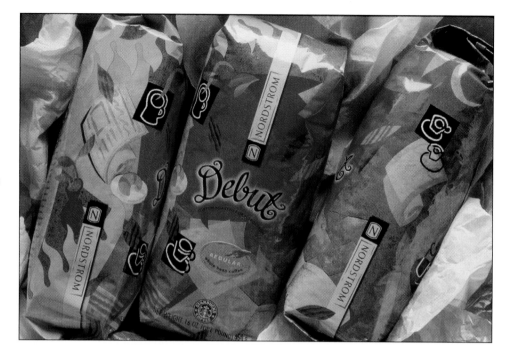

consumer with information, as in the packaging design for Ensemble (Figure 10-3). "A combination of uniquely photographed products, a bright green border, and package front text dotted with ingredient icons, all signal a new entry and a new idea in consumer packaged foods," says Landor Associates of its Ensemble packaging.

The type and illustrations work very well together in the label and package design for the client HAM I AM, which produces sauces for pork, beef, and fish dishes, as well as other food products (Figure 10-4). Color is an important design element. In the packaging of products like food, toiletries, and beverages, color often conjures up key associations.

Working with the strategy of "simple solutions with style," Landor Associates created the new brand name "Evercare," and developed unique proprietary packaging structures and a dynamic graphic design flexible enough to work across Helmac's extensive product offering (Figure 10-5). The result is a synergistic branding system, which clearly positions Helmac as the leader in its category.

Figure 10-3
Brand identity: Kellogg's Ensemble
Design firm: Landor Associates, Branding Consultants
and Designers Worldwide, San Francisco, CA
Creative director: Nicolas Aparicio
Design director: Christopher Lehmann
Designers: Christopher Lehmann, Julie Keenan,
and Brad Berberich
Photographer: Richard Jung, Kellogg Company
Project manager: Jennifer Richardson
Consultant: Greg Warren
Production: Susan Steiner
Client: The Kellogg Company

The Kellogg Company created a new and unique concept to bring to consumers a line of great-tasting foods to be eaten throughout the day, foods that contain a natural soluble fiber that actively works to lower cholesterol. This new proposition, named Ensemble, was presented in a packaging designed to look like a dictionary definition, as though the product concept is being literally defined for consumers.

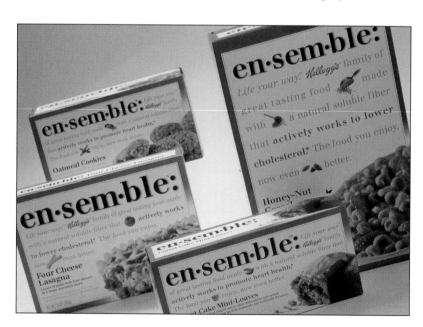

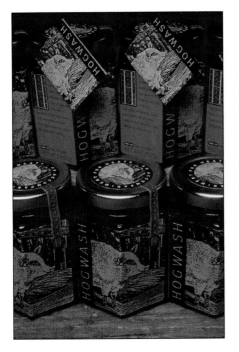

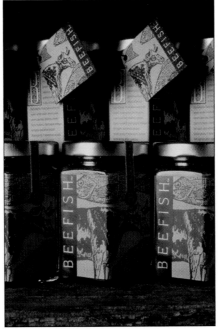

Figure 10-4
Package design
Design firm: SullivanPerkins, Dallas, TX
Art director: Ron Sullivan
Designers: Clark Richardson and Art Garcia
Illustrators: Art Garcia and Clark Richardson
Writer: Mark Perkins
Client: HAM I AM, Plano, TX

"Our client, HAM I AM, produces sauces for pork, beef, and fish dishes, as well as other food products. To keep with the upscale feeling and humor the client wanted, SullivanPerkins printed a kraft paper label with an old-looking engraving of a hog. The labels and seals were printed with PMS colors red, kraft brown, black, and gold on adhesive stock."

—SullivanPerkins

When asked, "How is your design a unique solution for your design objective?" slover [AND] company responded, "Typographic patterns incorporate the Saks Fifth Avenue name repeatedly. The black S5A icon is used consistently to signify that this is an exclusive Saks product. Coordinated color palettes crisscross and connect diversified food product categories at point of sale for the Gourmet Food Col-lection (Figure 10-6A), and coordinated color palettes in both product liquids and package design create strong allure at point of sale for the Spa Collection (Figure 10-6B)."

Unique Design Ideas

There are numerous software programs on the market today, each with a unique packaging design. The packaging for SmartWareII is intelligent and

Figure 10-5
Brand identity: Evercare
Design firm: Landor Associates,
Branding Consultants
and Designers Worldwide, San Francisco, CA
Creative director: Nicolas Aparicio
Design director: Carl Mazer
Designer: Anastasia Laksmi
Writer: Schuyler Brown
Photographer: Leigh Beisch
Client: Helmac Products Corporation

Helmac, a leader in the home and apparel care industry, decided to forge a bold position in the marketplace by making a unique fashion-forward packaging statement as innovative as their products. They challenged Landor Associates with this task.

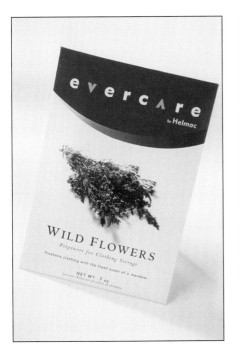

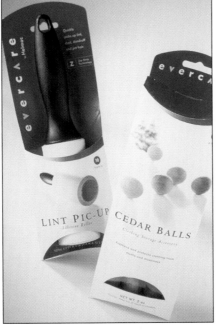

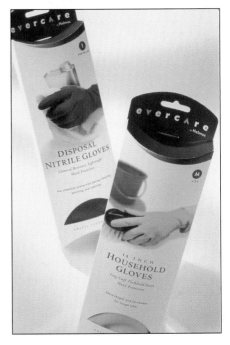

Figure IO-6A
Packaging design: Saks
Fifth Avenue Gourmet
Food Collection
Design firm: slover [AND]
company, New York, NY
Client: Saks Fifth
Avenue, New York, NY

Private label packaging
program created for Saks
Fifth Avenue's Gourmet
Food Collection.

Objective: To create a
strong Saks signature that
would also accommodate
an evolving product line.

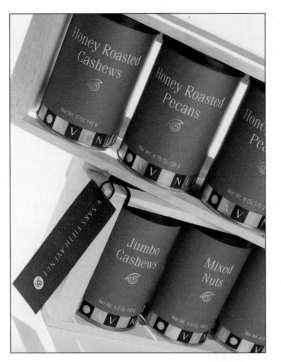

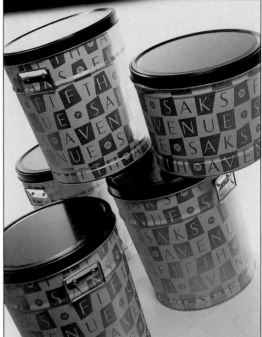

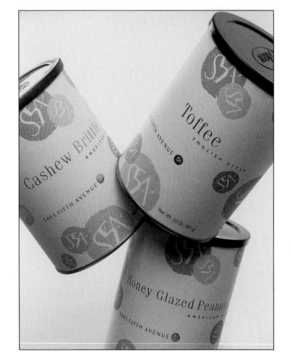

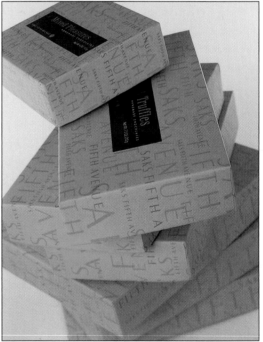

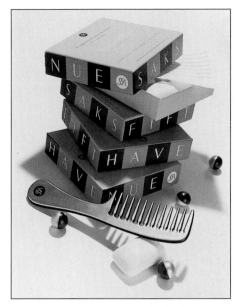

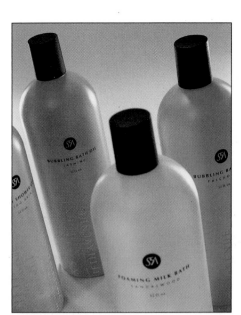

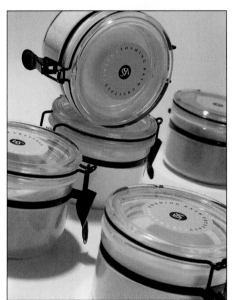

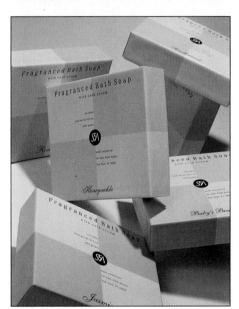

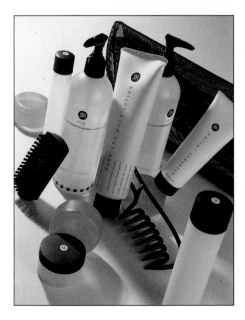

Figure 10-6B
Packaging design: Saks Fifth Avenue
Spa Collection
Design firm: slover [AND] company,
New York, NY
Client: Saks Fifth Avenue, New York, NY

Private label packaging program created
for Saks Fifth Avenue's Spa Collection.

Objective: To create a strong Saks
signature that would also accommodate
an evolving product line.

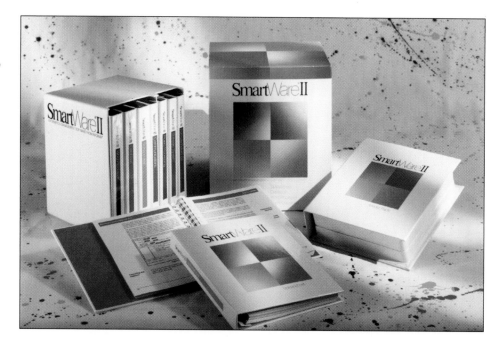

aesthetically pleasing; a colorful central square is the focal point of the design (Figure 10-7). The packaging design for Aspire is a good example of a unified composition (Figure 10-8). Correspondence is established through repeating curves in the logo (little figure), the small curved shape in the lower right, and the large patterned shape on the left. Notice how the logo is used in application on the packaging.

At times, packaging is created as a limited edition promotion. Unconventional thinking can break through to consumers in a new way that conventional design concepts cannot (Figure 10-9). Strawberryfrog comments about the 'Super Tiger Take-away': "To commemorate the death of the King of Kung Fu on July 20, 1973, Onitsuka Tiger (by Asics) are reissuing limited numbers of an old favorite: the yellow and black Tai-Chi shoe. As a mark of respect, thirty specially packaged pairs of shoes will initially be released, one for every year since Bruce Lee's death in 1973." Compare this to the whimsical design solution for the Taboo game (Figure 10-10), and you can see how a design solution must be appropriate for the product and client.

There are innumerable types of packaging. Here are several types of problems a designer might encounter: CD case (Figure 10-11), footwear boxes (Figure 10-12), toy packaging (Figure 10-13), and wine (Figure 10-14).

Figure 10-8
Packaging and visual
identity design:
ACER Aspire
Design firm: AERIAL,
San Francisco, CA
Client: ACER Aspire

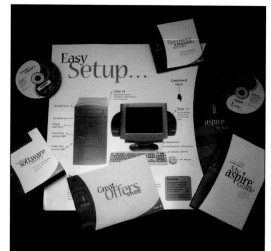

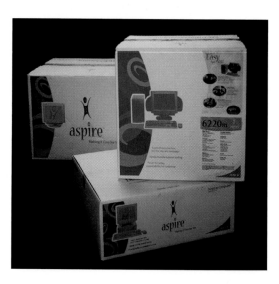

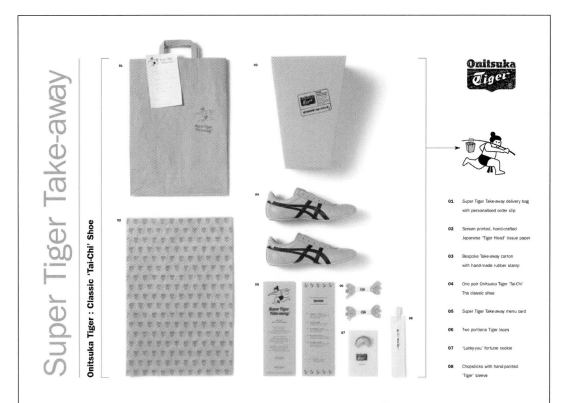

Super Tiger Take-away

Onitsuka Tiger : Classic 'Tai-Chi' Shoe

01 Super Tiger Take-away delivery bag with personalised order slip

02 Screen printed, hand-crafted Japanese 'Tiger Head' tissue paper

03 Bespoke Take-away carton with hand-made rubber stamp

04 One pair Onitsuka Tiger 'Tai-Chi' The classic shoe

05 Super Tiger Take-away menu card

06 Two portions Tiger laces

07 'Lucky-you' fortune cookie

08 Chopsticks with hand-painted 'Tiger' sleeve

Onitsuka Tiger : The Original Tai–Chi Shoe | To commemorate the death of the King of Kung Fu on 20th July 1973, Onitsuka Tiger* are re-issuing limited numbers of an old favourite, the yellow and black Tai-Chi shoe. | As a mark of respect, 30 specially packaged pairs will initially be released, one for every year since Bruce Lee's death in '73. | The 'Super Tiger Take-away' contains all the kickin' flavour and ingredients you need. Hand delivered as a Chinese take-away, the bespoke hand-crafted box reveals a pair of Tai-Chi's, deliciously wrapped in screen-printed Japanese tissue paper. Chopsticks with hand paint-ed sleeves, two portions of laces and a fortune cookie provide the tasty accompaniments to the classic shoe. | Worn by Bruce Lee during some of his most legendary films, this martial arts shoe is perfect for Jeet Kune Do, the freestyle fighting technique he pioneered. | For those unfortunate enough to miss out on this special edition, a further 250 pairs in their orig-inal Japanese boxes will be released in July. The shoes will only be available for limited period from select stores in Berlin, Paris, Amsterdam, London, Milan. | Onitsuka Tiger have delivered Japanese essential sporting heritage since 1949. The Tai-Chi shoe has been a favourite amongst professionals sportsmen for many years, and is internationally recognised as a top per-formance shoe by martial arts federations around the world.

*ONITSUKA TIGER by ASICS

Figure 10-9
Campaign: "Super Tiger Take-away" Product: Onitsuka Tiger's Classic "Tai-Chi" Shoe Design agency: Strawberryfrog, Amsterdam

"The 'Super Tiger Take-away' contains all the kickin' flavor and ingredients you need. Hand delivered as a Chinese take-away, the Bespoke Take-away carton reveals a pair of Tai-Chi shoes, deliciously wrapped in screen-printed Japanese tissue paper. Chopsticks with hand-painted sleeves, two sets of shoelaces, and a fortune cookie provide the tasty accompaniments to the classic shoe. Worn by Bruce Lee during some of his most legendary films, this martial arts shoe is perfect for Jeet Kune Do, the freestyle fighting technique he pioneered. For those unfortunate enough to miss out on this special edition, an additional 250 pairs in their original Japanese boxes will be released in July. The shoes will only be available for a limited period from select stores in Berlin, Paris, Amsterdam, London, and Milan. Onitsuka Tiger have delivered Japanese essential sporting heritage since 1949. The Tai-Chi shoe has been a favorite among professional sportsmen for many years, and is internationally recognized as a top-performance shoe by martial arts federations around the world."

—Strawberryfrog

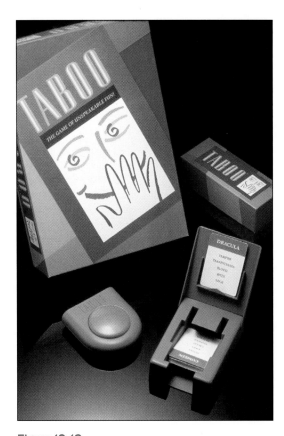

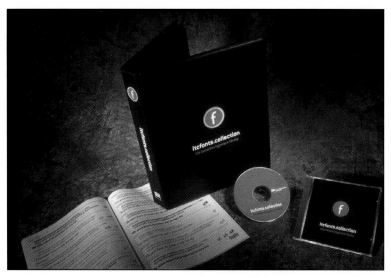

Figure 10-11
CD and kit packaging: itcfonts.collection
Design firm: DMA, Jersey City, NJ
Art director: Denise M. Anderson
Designers: Jenny Calderon and
Denise M. Anderson
Copywriter: Jennifer L. Bohanan
Client: International Typeface Corporation

"Being in the sometimes cluttered and colorful graphics industry, we went 180 degrees north and designed a minimal black, white, and red promotional identity for ITC. This 'CD kit' houses a bright red disc with all ITC available fonts and a printed catalog in a vinyl case. Our intention was to create a simple, powerful, and recognizable image."

—Denise M. Anderson

Figure 10-10
Packaging: Taboo game
Design firm: Sibley Peteet
Design, Dallas, TX
Designer/Illustrator:
Don Sibley
Client: Milton Bradley

The whimsical illustration and bright color blocks wrapping the box help portray the fun nature of the Taboo game. The simple, bold graphics are intended to grab attention on a crowded retail shelf.

Figure 10-12
Packaging and identity: Anne Klein
Design firm: Pentagram Design Ltd.
Partner/Designer: Paula Scher
Designer: Anke Stohlmann
Client: Anne Klein

The designers were commissioned to design a new identity for Anne Klein Co.'s rebuilt bridge lines. Previously known for sixteen years as Anne Klein II, these lines will now simply be known as Anne Klein. The identity is comprehensive and used throughout all of the company's graphics, advertising, packaging, and retail display.

Anne Klein II's presence in the upscale women's clothing market had receded following the company's discontinuation of its collection-level line. This designer collection had lost touch with Anne Klein's core consumer, and the bridge lines followed suit, resulting in a dilution of the company's identity.

The new identity elevates the brand through the use of a new logotype and reflective materials in packaging. The logotype is set in the bold, architectonic Trajan typeface, and displays a strong visual presence; it is an integral, structural part in each of the bridge line graphic identities, creating a cohesive and coordinated system that strengthens and refines the Anne Klein brand.

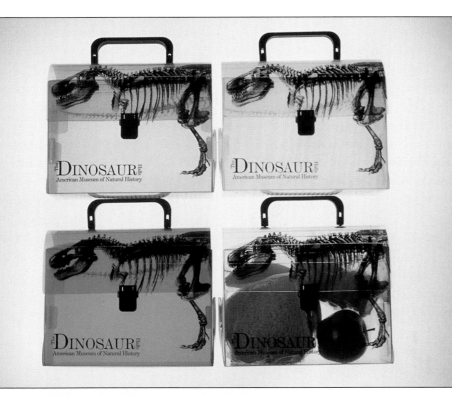

Figure 10-13
Packaging: American
Museum of Natural History,
Dino Store Merchandise
Design firm:
Pentagram Design Ltd.
Partner/Designer:
Paula Scher
Designers: Lisa Mazur
and Jane Mella
Client: American Museum
of Natural History

Pentagram has been
responsible for the New York
museum's comprehensive
graphic identity program,
including a new logotype,
printed materials,
promotions, merchandise,
and directional and
exhibition signage. The
reopening of the Dinosaur
Halls inspired a new line
of retail merchandise, which
has contributed to a surge
in profits for the institution.

Figure 10-14
Packaging: Chandon wine
Design firm: Landor Associates, Branding
Consultants and Designers Worldwide,
San Francisco, CA
Creative director: Nicolas Aparicio
Design director: Chris Lehmann
Designers: Chris Lehmann and John Kiil
Client: Chandon Estates

Chandon Estates, which produces sparkling
wine in five countries, did not convey the
unified message of a truly global company
in its packaging. A system was created that
established a consistent presentation of the
Chandon brand across all countries while
allowing for country, flavor, and price point
differentiation. It was also important that
the new brand expression convey an "edgy
elegance" that positions Chandon apart
from traditional champagne and sparkling
wine cues.

Packaging and Identity Systems

Often packaging design is part of a larger identity system including branding and marketing strategies, as shown in the extensive design solution for Burlington Industries' new "esenzia" product line (Figure 10-15). Hangtags are part of packaging, and in some cases, it is the only identification for a product; for example, the thoughtful design by DMA for Aris (Figure 10-16).

Audio/Compact Disc Packaging

For many people, listening to a CD at home involves contemplating the cover, reading the inside booklet and lyrics, and looking at the photographs (Figure 10-17). Like a poster, audio packaging takes on greater meaning. We may get pleasure from looking at a superbly designed shampoo bottle, but we study a CD cover! Looking at a CD cover becomes part of the listening experience. Also, audio packaging can draw in a new listener.

People feel very strongly about the music they enjoy and the recording artists they prefer. Audio packaging absolutely must reflect the recording artist's or group's sensibility—no equivocations. It must express the unique quality of the artist or group, while inviting the browser in a music shop to pick it up, consider it, and purchase it. And, each CD from a group must reflect the particular CD's theme or core, as in Segura Inc.'s solutions for

Figure 10-15

Identity system: Burlington Industries "esenzia"
Design firm: slover [AND] company, New York, NY
Client: Burlington Industries, New York

When America's largest mass manufacturer of fashion textiles wanted to embrace the luxury market, it needed a completely different product and selling approach. Slover [AND] company named the collection "esenzia" and developed selling tools and an environment that visually—and viscerally—reinforced the essential character of the collection. The result was a soft-selling approach that produced cold, hard sales in a flat-end market.

Touch kits—hand-sewn from textured papers and closed with a button and leather thong—were given to fashion editors and designers to reinforce the essential selling message.

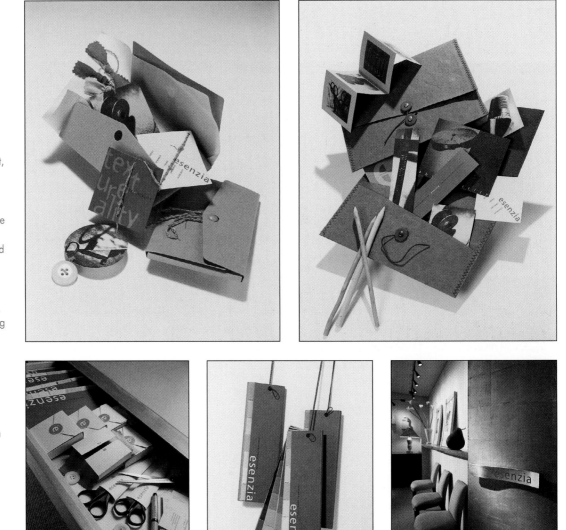

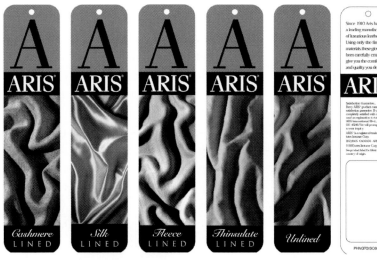

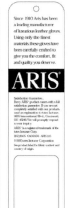

Figure 10-16

Hangtags: Aris women's leather gloves
Design firm: DMA, Jersey City, NJ
Art director: Denise M. Anderson
Designers: Laura Ferguson Menza and Denise M. Anderson
Photographer: Greg Leshé
Client: Aris Isotoner

The objective of this project was to create a system of hangtags that distinguished the linings of a new line of high-end women's leather and suede gloves.

Since the Aris name was being introduced without "Isotoner," a large letter "A" was designed in front of a neutral, fashionable purple/blue color. These elements created a cohesive look among all the tags and created brand identification. Photos were then shot, creating a "feel" of the inside lining. Each image was then colored with a complementary palette of duo and tritones.

Figure 10-17

CD packaging: Willie Nelson, *Teatro*
Design studio: Segura Inc., Chicago, IL

Segura creates a full experience—an environmental feel—for the viewer/listener in this CD design.

two different Spencer CDs (Figures 10-18 and 10-19). Notice the coordination of all visual parts—exterior of the CD case with the interior CD and printed inserts in the sets by Segura Inc.

Materials, Engineering, and the Design Concept

Special manufacturing techniques can help render an imaginative concept as reality, as shown in the CD packaging for the Rolling

Figure 10-18
CD packaging:
Spencer, *Best*
Design studio: Segura Inc.,
Chicago, IL

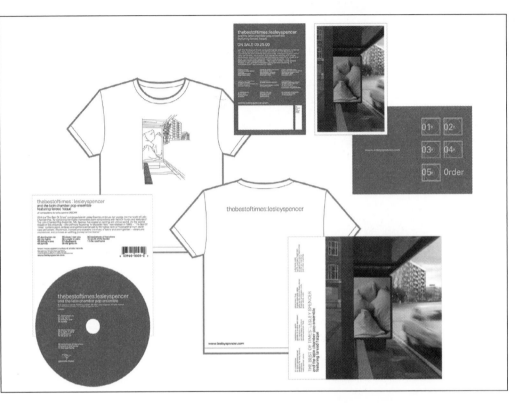

Figure 10-19
CD packaging:
Spencer, *Chamber*
Design studio: Segura Inc.,
Chicago, IL

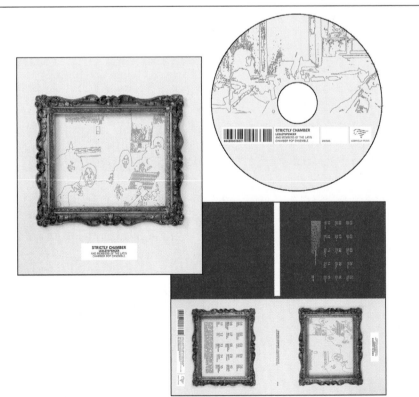

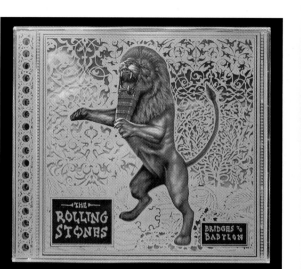

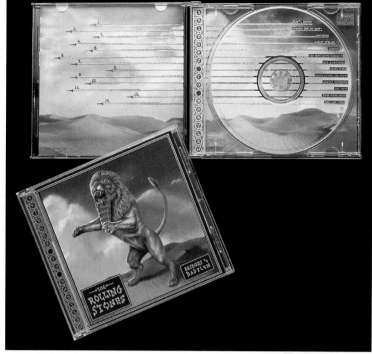

Stones (Figure 10-20), which is why it is important for packaging designers to work collaboratively with engineers and printers. And once again, Sagmeister expresses the nature of the recording group through his design concept, while utilizing materials to an optimum for Skeleton Key (Figure 10-21).

"This round-cornered *Feelings* CD packaging features happy, angry, sad, and content David Byrne dolls . . . The type was actually made as a model and then photographed," says Sagmeister. One of the art directors working on this CD (Figure 10-22) was the recording artist himself, David Byrne.

Figure 10-20
CD packaging: Rolling Stones, *Bridges to Babylon*
Design firm: Sagmeister Inc., New York, NY
Art director: Stefan Sagmeister
Designers: Stefan Sagmeister and Hjalti Karlsson
Photography: Max Vadukul
Illustration: Kevin Murphy, Gerard Howland (Floating Company), and Alan Ayers
Client: Promtone B.V.

"The *Bridges to Babylon* cover for the Rolling Stones CD features an Assyrian lion embedded into a specially manufactured filigree slipcase. The interior reveals a long strip of desert to fit the accompanying tour/ stage design."

—Stefan Sagmeister

Suggestions

Packaging that sits on a shelf is in visual competition with the products sitting all around it. It must be attractive, legible, and appropriate for its audience and marketplace. When shopping online, consumers view packaging on the computer screen, and its visual appeal must somehow remain effective in that setting. Some of the objectives in good packaging are:
• Make it functional
• Research materials and construction
• Consider using recycled materials, nontoxic materials and processes (nontoxic to air, earth, and water), and ecologically-minded design (also called sustainable design)
• Be aware that packaging is the integration of two- and three-dimensional design

• Consider all sides of a package in the design
• Design appropriately for the brand and for the audience
• It should work within a larger visual identity system (if applicable)
• Ensure legibility and clarity of information
• Differentiate from the competition
• Consider that it will be seen in multiples when on display
• Consider the appropriate color associations
• Coordinate color and design with other flavors or choices in a product line
• Identify the manufacturer, product name, contents, and weight, and provide any other pertinent information
• Realize that it may be seen on screen (reduced) for online shoppers

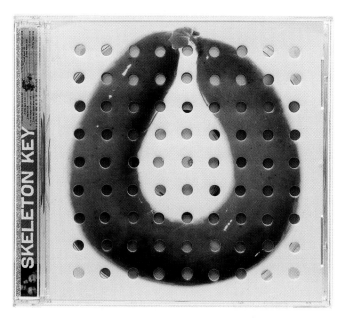

Figure 10-21

CD packaging: Skeleton Key, *Fantastic Spikes through Balloon*
Design studio: Sagmeister Inc., New York, NY
Art director: Stefan Sagmeister
Designers: Stefan Sagmeister and Hjalti Karlsson
Photography: Tom Schierlitz
Client: Capital Records

"True to the album title *Fantastic Spikes through Balloon*, we photographed all the balloon-like objects we could think of (sausage, fart cushion, blowfish, etc.), and punched a lot of holes through them. Simple.

Since the band did not want their audience to read the lyrics while listening to the music ('this is not a poetry affair'), the words to the songs are printed flipped so they are only readable when seen reflected in the mirror of the CD."

—Stefan Sagmeister

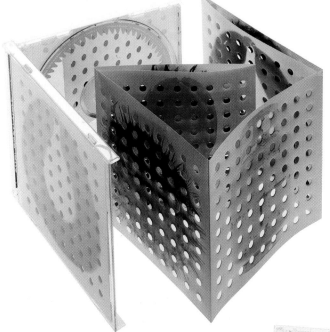

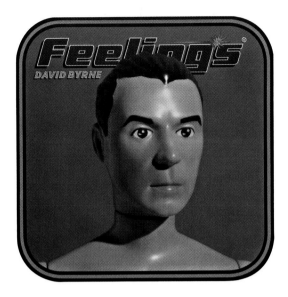

Figure 10-22

CD packaging: David Byrne, *Feelings*
Design studio: Sagmeister Inc.,
New York, NY
Art directors: Stefan Sagmeister
and David Byrne
Designers: Stefan Sagmeister
and Hjalti Karlsson
Photography: Tom Schierlitz
Models: Yuji Yoshimoto
Color advice: Anni Kuan
Client: Luaka Bop/Warner Brothers
Music Inc.

"The packaging includes a
sophisticated, color-coded 'David
Byrne Mood Computer' (printed
on and under the CD disc) that lets
you determine your current feelings."

—Stefan Sagmeister

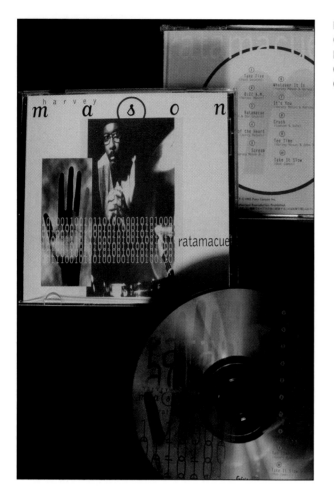

Figure 10-23
CD packaging: Harvey Mason, *Ratamacue*
Design firm: Vrontikis Design Office, Los Angeles, CA
Creative director/Designer: Petrula Vrontikis
Client: © Atlantic Recording Company

Figure 10-24
CD packaging: Pat Metheny Group,
Imaginary Day
Design firm: Sagmeister Inc., New York, NY
Art director: Stefan Sagmeister
Mechanicals: Mathias Kern
Designers: Stefan Sagmeister and
Hjalti Karlsson
Photography: Tom Schierlitz/Stock
Client: Warner Jazz

Figure 10-25
CD cover: Louis Armstrong, *Butter and Eggman*
Designer: Milton Glaser

Figure 10-26
CD packaging: David Byrne, *Rei Momo*
Design firm: Doublespace, New York, NY
Client: Warner Brothers Records, Burbank, CA

Integration of Type and Visuals

Engaging typography mixed with visuals communicates the style of Harvey Mason on the CD design shown in Figure 10-23. "All type on the *Imaginary Day* cover for the Pat Metheny Group has been replaced by code. The images connect to the songs and mood of the album and can be decoded by using the diagram printed onto the CD itself," says Stefan Sagmeister of his innovative design solution (Figure 10-24). Milton Glaser creates an expressive portrait of the great Louis Armstrong, fully integrating the form of the typography with the quality of the illustration (Figure 10-25). The strong color combinations and imagery on the cover of David Byrne's *Rei Momo* CD instantly grab one's attention; the spirit of the design is carried through on the disc, inside booklet, and back cover (Figure 10-26). The recurring circular motif, reds and greens, and visuals create unity throughout the CD package.

Shopping Bags

Most people will use a shopping bag more than once, especially people who are environmentally conscious. The more unique, sturdy, and attractive a bag, the more likely it is that consumers will use it over again. Think of a shopping bag as a portable store display.

There are standard sizes and weights for paper shopping bags, and although paper and plastic are used most often, other materials are suitable, such as cotton or burlap.

The main thing to remember is that, aside from being attractive, a shopping bag must function—it must hold things. Bags are often designed in several sizes; proportions should be considered in relation to function and aesthetics.

The choice of materials, the design of the bag shape, and what is on the bag all should be dictated by the design concept. Often, a shopping bag is part of a larger brand identity and is linked to other graphic design materials, such as boxes, packaging, signage, or displays. When this is the case, the designer must coordinate everything in terms of design concept, style, color palette, visuals, and type.

For Takashimaya, bags and boxes both were designed (Figure 10-27). The shopping bag for Strathmore's new paper grade, Renewal, is part of a promotional campaign to launch the new product (Figure 10-28). Designframe Incorporated created several pieces, including a book, *Seeing: Details*, and sample boxes, as other parts of the colorful promotional design solution. The SullivanPerkins design firm created the bold and contemporary shopping bag design for a mall, shown in Figure 10-29.

Figure 10-27

Packaging: Takashimaya Retail Program
Design firm: slover [AND] company, New York, NY
Client: Takashimaya, NY

Objective: To create a collection of bags and boxes that will reflect the store's East/West influence.

How is your design a unique solution for this objective?

"Slip-sleeve boxes with end-locking devices and symmetrical lids and shapes, unique triangular shopping bags and hand-combed silk tassels from recycled paper with long fiber all add up to unique lastability."

Are there any anecdotes that you think are appropriate to include about this project?

"The triangular-shaped shopping bag is reordered more than any other shape and has become a street status symbol."

—slover [AND] company

Suggestions
The logo or company name need not be the main visual on a bag; anything will work as long as it is a sound design concept. Here are some objectives for designing a shopping bag: • Design a bag that functions well • Consider all sides of the bag in the design • Coordinate it with any other graphic design material in the identity system • Express the brand's spirit • Think of it as a promotional display, kind of like a walking billboard • Make it so terrific that people will want to carry it around as a status symbol

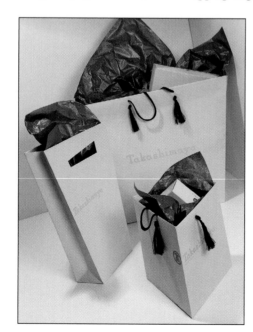

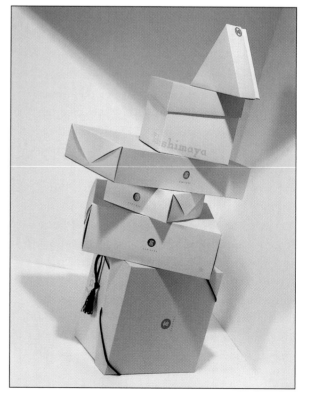

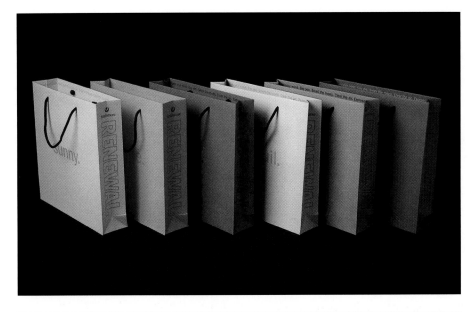

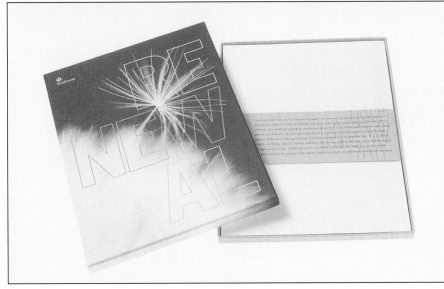

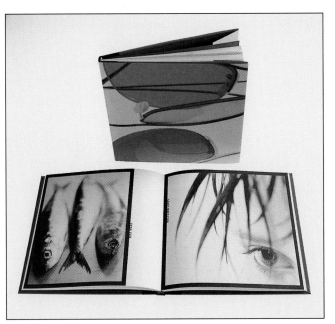

Figure 10-28
Packaging design: "Renewal" shopping bags, sample box, and *Seeing: Details* book.
Design firm: Designframe Incorporated, New York, NY
Client: Strathmore Papers

"The unexpected is often revealed in details—this is the premise of Strathmore's latest publication, *Seeing: Details*. It's the second in a series from Strathmore, examining the rich results that can be achieved by using traditional printing techniques and Strathmore's uncoated printing papers.

While the first book of the series, *Seeing: Doubletakes*, featured Strathmore 'Elements,' this second volume features a selection of Strathmore 'Renewal' stocks.

Seeing: Details is a collection of images from thirty of today's most prominent photographers. Accompanying text runs through the book and reminds the reader of the beauty and value of 'seeing the details.'

The discussion topic for *Seeing: Details* is the importance of a thoughtful and thorough color separation process."

—Designframe Incorporated

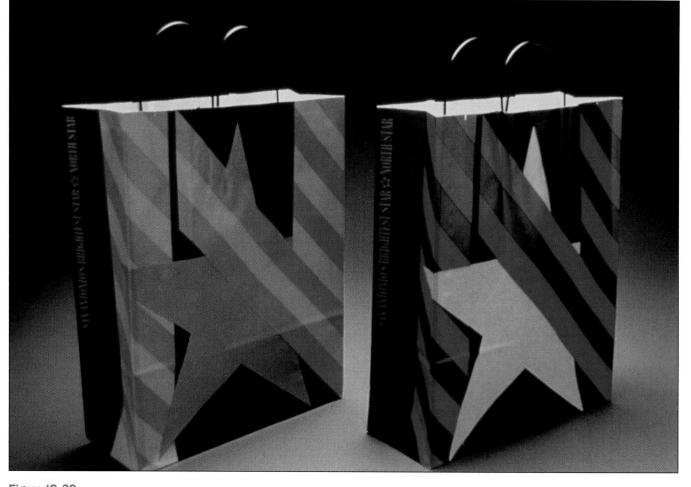

Figure IO-29
Shopping bag:
NorthStar Mall
Design firm:
SullivanPerkins, Dallas, TX
Art director: Ron Sullivan
Designer: Linda Helton
Client: The Rouse
Company, San Antonio, TX

"We have done shopping
bag designs and other
design and advertising for
this San Antonio shopping
center for some years. The
'N and Star' motif was
developed for a series of
shopping bags that were
so well liked, they replaced
the mall's logo and now
appear on letterhead and
other identity items."

—SullivanPerkins

Summary

Packaging design is a graphic design application which functions as packaging, but also attracts a consumer and presents information; it is a blend of two- and three-dimensional design, promotional design, information design, and practicality. Most packaging is displayed on shelves where we see the cumulative effect of several packages lined up next to one another. Online shopping may change how we react to packaging; however, once it is delivered to our homes, we interact with it. Often, well-designed packaging can be a pleasure to look at. Most often, packaging is one part of a large, integrated marketing strategy and media planning. Many design experts believe that packaging is *the* make-or-break decision for a consumer reaching for a product on the shelf.

Looking at a CD cover becomes part of the listening experience. Also, audio packaging can draw in a new listener. Special manufacturing techniques can help render an imaginative concept as reality in CD packaging.

Aside from being attractive, a shopping bag must function—it must hold things. It, too, is a hybrid application—usually part of a larger branding program—which functions, identifies, and promotes.

Exercise 10-1

Redesign of packaging

1. Choose a low-priced (not the top-of-the-line brand) packaged product, such as a box of pasta or a package of cookies.
2. Analyze the packaging design.
3. Redesign the packaging so it looks expensive or upscale.

Project 10-1

Create a packaging design for a gourmet snack food

Step I

a. Invent a brand of gourmet nuts or snacks (see Chapter 7, Exercise 7-2, on inventing a brand name).
b. Research similar products.
c. Find examples of gourmet food packaging.
d. Write a design brief.

Step II

a. Design a minimum of two packages for a line of gourmet snacks.
b. The packaging design should include the following information: logo, brand name, and flavor.
c. Design a logo (see Chapter 6 on logo design).
d. Your solutions may be type only or type and visuals.
e. Produce at least twenty sketches.

Step III

a. Produce at least two roughs for each package before creating a preliminary mock-up (a three-dimensional piece).
b. Create a preliminary mock-up of one package to see how it will look in three dimensions.

Optional: Design an individual snack packet.

Step IV

a. Create a finished mock-up for each packaging design.
b. The size of the packaging should be similar to the sizes of other products in its category.
c. You may use two colors or full-color.

Presentation

Create actual size mock-ups of the packaging.

Comments: *When you create packaging for a food or beverage, it must be visually appetizing. Your objective is to create an attractive, functional, and informational design. Since the products are of gourmet quality, the packaging should look upscale; aim at the target audience.*

Make sure the line of packaging has a similar style—like they belong to the same group and have similar distinctive characteristics. Consider how they will look next to one another on the shelf and next to the competition.

Exercise 10-2

Analyzing shopping bag design

1. Find five examples of shopping bags from specialty stores.
2. Analyze their designs and be aware of their materials; determine the designer's objectives and design concept.

Project 10-2

Design a packaging system for an online computer mail-order company

Step I

a. Invent an online computer mail-order company.

b. Research existing online computer mail-order companies.

c. Write a design brief.

Step II

Invent a name (it should have ".com" at the end of it). Design a logo for the company (see Chapter 6 on logo design).

Step III

a. Design the packaging system, including a shipping box, label, and product boxes (CPU, monitor, mouse, keyboard).

b. The packaging should include the logo.

c. Produce at least twenty sketches. You should have, at minimum, three distinct ideas.

Step IV

Create roughs and a preliminary mock-up.

Step V

a. Make necessary changes and go to a finished mock-up.

b. For your portfolio, have a good-quality photograph taken of this project.

Presentation

Photograph of mock-ups mounted on black board.

Comments: *Carefully consider your subject and audience. For example, packaging designed for a computer company should be markedly different from that of an online cosmetic company. Similarly, different types of computer companies might appeal to different audiences, and therefore would be designed differently—for example, Apple versus Dell.*

Project 10-3

Design a CD cover

Step I

a. Choose a recording artist or group.

b. Gather information. Research their music and audience.

c. Write a design brief.

Step II

a. Your solution may be type only or type and visuals, but may not include photographs of the recording artist or group on the cover.

b. Produce at least twenty sketches, including three different ideas.

Step III

a. Design a CD cover. Make sure it reflects not only the particular recording artist or group, but also the theme of the CD, as well.

b. Produce at least two roughs.

c. Create one preliminary mock-up to see how it will look.

Step IV

a. Create a final comp and insert it into a CD jewel case to see how it looks.

b. Use as many colors as you like.

Presentation

Present either in a jewel case or mounted on a black board.

Optional: Create a folding poster that is an insert with the CD.

Comments: *Project 10-3 is a favorite project for most students since music is important to many people. When designing, try to be objective (meeting the design brief's objectives) and also to draw upon personal passion for a recording artist or group.*

Project IO-4

Design a shopping bag and box for a food store or company

Step I

a. Find or invent a specialty take-out food or catering company. Invent a name.

b. Research the brand. Find out what makes them special or different.

c. Write a design brief.

Step II

a. Design a logo for the client (see Chapter 6 on logo design).

b. Your solution may be type only or type and visuals.

c. Produce at least twenty sketches, including three different ideas.

Step III

a. Design a shopping bag and box for the client.

b. Produce at least two roughs.

c. Create one preliminary mock-up to see how it will look.

Step IV

a. Create finished mock-ups of the bag and box.

b. Use as many colors as you like.

c. The maximum size for the bag is 16″ x 18″. The box should fit easily in the bag.

Presentation

Photograph of the mock-ups presented on black board.

Comments: *Whichever type of specialty company you choose, make sure the design concept is appropriate for the audience. You should try to avoid visual clichés; for example, type for a Chinese food store does not have to look like type from the Far East. Sometimes using unexpected type or visuals, or making a connection between unusual elements, makes something unique.*

Although most design solutions can be executed on the computer and printed on a laser printer, some projects require hand skills, for example, cutting, gluing, and building. It is important not to lose touch with hand skills.

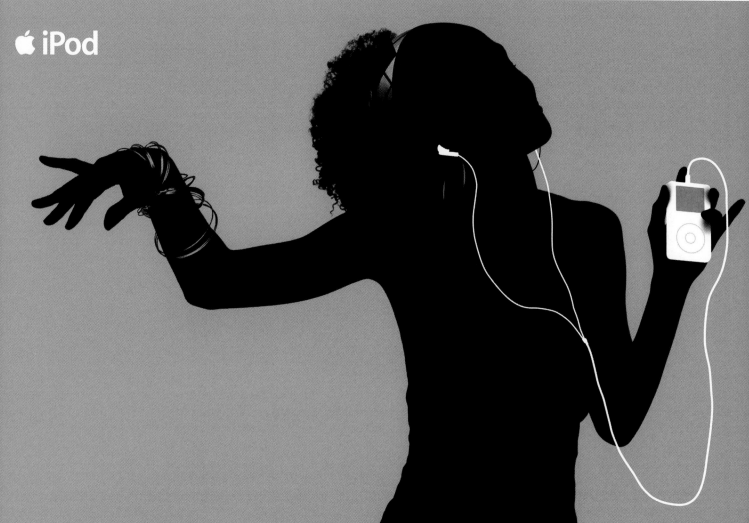

iPod

Welcome to the digital music revolution. 10,000 songs* in your pocket, including your favorites from the iTunes® Music Store. Mac® or PC.

◄ Ad: iPod
Agency: TBWA/Chiat/Day
Image: Courtesy of Apple Computer Inc.

Objectives

Grasp the purpose and value of advertising

Distinguish among different types of advertisements

Appreciate the purpose of a creative brief

Become aware of the role of the creative team

Identify the elements of an ad

Distinguish between copy-driven ads and visual-driven ads

Learn the four main components of an advertisement

Distinguish between a functional benefit and an emotional benefit

Be aware of visual/verbal synergy

Learn how to generate ideas for advertising

Understand the importance of a campaign structure

Learn some creative approaches to utilize during idea generation

Realize the strategy behind television commercials

Design a print advertisement

Create an advertising campaign

Create a storyboard

Explore creative approaches

Advertising matters. From public service to helping to drive the economy, creative advertising is an important contemporary visual communication vehicle. Advertising is part of daily life and inseparable from American popular culture. In many countries, advertising is the one common experience that is shared by a large, diverse group of people. It's the one pop culture vehicle we all come into contact with—from outdoor boards to banner ads to television commercials.

The Purpose and Value of Advertising

Advertising is used in a free market system to promote one brand or group over another. Advertising sells things. Whether it is used to launch a new brand or remind us to buy an established brand, advertising helps build the value of brands in people's minds. Advertising motivates us to act on behalf of a cause, helping to save lives and aid people in countless vital ways.

Most competing brands are **parity products** and services, meaning they are on a par, or equivalent in value. For example, even though many people prefer one shampoo to another, most shampoos in the same price category (or perhaps across price categories) are the same, and are an example of parity products. Therefore, when goods and services are on a par, an effective ad would successfully promote its brand, persuading you to buy a particular brand instead of the competition, for any number of reasons. The ad for a shampoo might convince you that your hair would be shinier or fuller or smell better or bounce more or be less frizzy or anything else that might appeal to a target audience.

Types of Ads

Advertising has become more ubiquitous than ever—including conventional and unconventional advertising—as advertisers try to find new ways to get their message through to viewers. Advertising differentiates brands, groups, and causes, and ultimately sells products and calls people to action. An **advertisement** (**ad**) is a specific message constructed to inform, persuade, promote, provoke, or motivate people on behalf of a brand or group. (In this book, "group" represents both commercial industry and social cause/nonprofit organizations.) An **advertising campaign** is a series of coordinated ads, in one or more media, that are based on a single, overarching strategy or theme, and each individual ad in the campaign can stand on its own.

Commercial Advertising

Commercial advertising promotes brands and commodities by informing consumers; it is also used to promote individuals, such as political candidates, and groups, including corporations and manufacturers. Commercial advertising messages can take the form of single advertisements, campaigns, or brand building in any traditional medium: television, radio, online, print, or direct response. They can also be found in unconventional media and formats. Integrated campaigns employ various media in a coordinated fashion.

Public Service Advertising

Public service advertising is advertising that serves the public interest. According to The Advertising Council, an American public service advertising organization, *(www.adcouncil.org)*: "The objectives of these ads are education and awareness of significant social issues, in an effort to change the public's attitudes and behaviors and stimulate positive social change."

Commonly referred to as PSAs, public service advertisements are created by various advertising agencies around the world for a great variety of social causes. In most countries, the media consider PSAs a service to the community, and therefore there is no charge by the media to run these advertisements on television, radio, or in print—although in order to have more control over the media and time placements, some nonprofit organizations and government agencies have begun to purchase advertising time and space, in addition to the donated time and space.

This PSA campaign for the Humane Society of Utah, with wit and charming photography, encourages people to adopt pets (Figure 11-1).

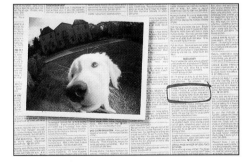

Figure 11-1

Public service ad
Agency: Publicis, Salt Lake City, UT
Art director: Steve Cardon
Writers: John Kinkead, Rebecca Bentley-Mila, and Bryan De Young
Photographer: Chip Simons
Client: Humane Society of Utah

Borrowing from the look and style of the "personals," these ads touch us emotionally.

Cause Advertising

Cause advertising, *sponsored by corporations,* is used to raise funds for nonprofit organizations and is run in paid media. Cause advertising is affiliated with a corporation and used in part to promote a corporation's public persona or brand, unlike public service advertising where there is no commercial affiliation.

Audience, Clients, and the Creative Team

Any individual or group who is on the receiving end of a commercial or public service message is the audience. A target audience is the specific group of people who are targeted for an adver-

tising or public service message, as a single ad or a campaign (as discussed earlier in Chapter 2).

Consumer ads are directed toward the general public; for example, the campaign for the Charlotte informational web site (Figure 11-2). Trade ads are directed toward specific professional or business groups. The ad for Hush Puppies Professionals shoes is aimed at nurses (Figure 11-3).

Types of clients include manufacturers, service firms, corporations, groups, resellers (retailers, wholesalers, distributors), government, social organizations, and charities. Advertising is a vehicle used to increase sales, influence voters, promote causes, obtain contributions, and so on.

Figure II-2
Newspaper ads: "Acupuncture," "Spark Plugs," and "Goat Meat"
Design firm: Planet Design Company, Madison, WI
Client: Charlotte.com

This newspaper campaign points out the benefit of the product (web site)—you can find anything you need on this site.

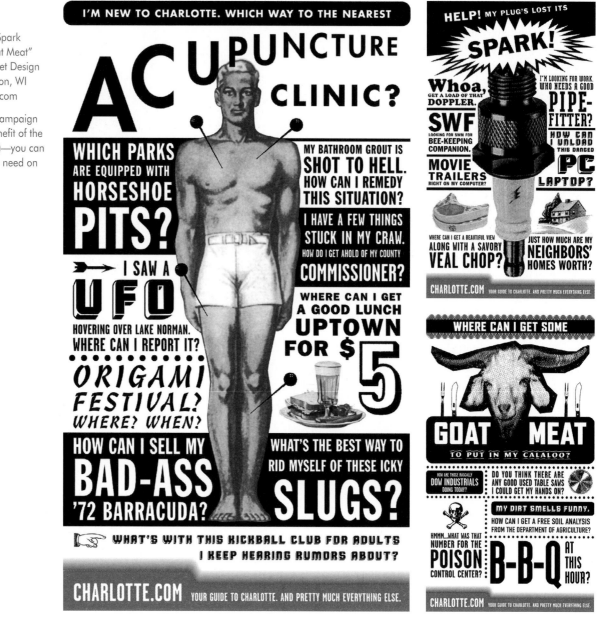

The Creative Team

In advertising, the traditional **creative team** includes an art director and a copywriter, but today more unconventional creative teams or brand teams can contain many players—from the client side and the agency side. Together they develop the idea behind an advertisement. After generating ideas, ultimately, the **art director** is responsible for the design decisions, and the **copywriter** is responsible for the writing. The creative team is usually supervised by a **creative director**, or associate creative director, who makes the ultimate decisions about the idea, creative approach, art direction, and copywriting before the work is presented to the client.

The Creative Brief

How do advertising professionals create fresh ads that will break through the clutter and entice

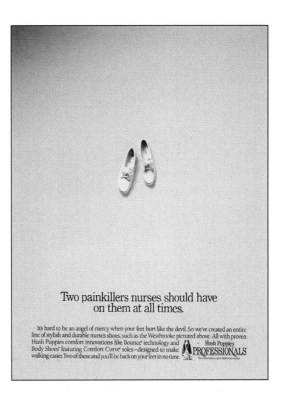

Two painkillers nurses should have on them at all times.

It's hard to be an angel of mercy when your feet hurt like the devil. So we've created an entire line of stylish and durable nurse's shoes, such as the Westbrooke pictured above. All with proven Hush Puppies comfort innovations like Bounce® technology and Body Shoes® featuring Comfort Curve® soles—designed to make walking easier. Two of these and you'll be back on your feet in no time. **PROFESSIONALS** · Hush Puppies · For information call 1-800-433-HUSH

Figure 11-3
Ad: Hush Puppies Professionals
Agency: Fallon McElligott, Minneapolis, MN
Creative director: Pat Burnham
Art director: Bob Barrie
Writer: Mike Gibbs
Photographer: Joe Lampi, Dublin Productions
Client: Hush Puppies Shoes/Wolverine

Types of Media

Conventional Media

- Broadcast

 Television
 - Major network
 - Independent station
 - Cable

 Radio
 - Network
 - Local

- Print

 Magazines

 Newspapers
 - National
 - Statewide
 - Local

 Direct Mail

Support Media

- Outdoor

 Billboards (outdoor boards)

 Transit

 Posters

New Media (interactive and online)

- Promotional web sites
- Social cause web sites
- Web films
- Web commercials
- Banner ads
- Online guerrilla or viral marketing
- Interactive broadcast entertainment programming
- Digital presentations

Unconventional Media

- Logos on sidewalks
- Wild postings (on scaffolding, temporary walls, etc.)
- Coffee cup sleeves
- Motion-activated ads projected on sidewalks
- Stickers
- Stampings (sidewalks, walls, surfaces)
- Doorknob hangers
- Wine corks
- Bathroom stalls

Premiums (giveaways)

- Calendars
- Logo clothing
- Novelties, such as pens, mugs

Miscellaneous

- Point-of-purchase displays
- Event sponsorship
- Exhibit sponsorship
- Site sponsorship
- Television sponsorship
- Product placement in television programs, music videos, films

the consumer, as creative director Tom McElligott says, ". . . get through to the consumer in ways they haven't been gotten to before"? They start with a creative brief.

Essentially, a **creative brief** is a strategic plan that both client and design studio or agency can agree upon and from which the creative team works as a strategic springboard. A thoughtful,

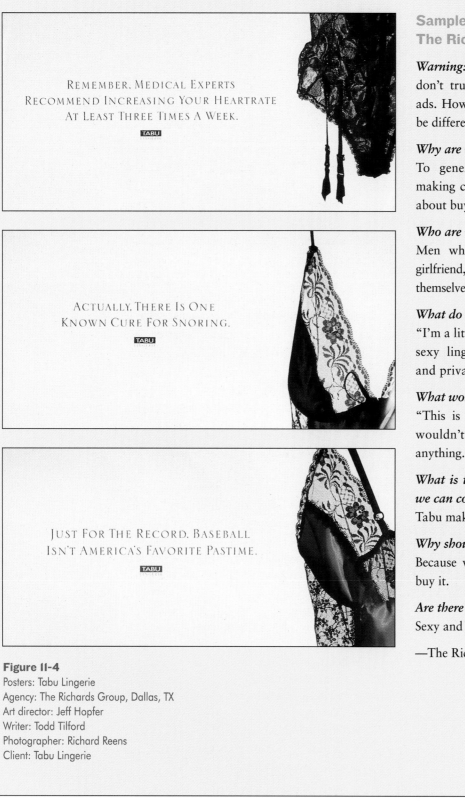

Figure II-4
Posters: Tabu Lingerie
Agency: The Richards Group, Dallas, TX
Art director: Jeff Hopfer
Writer: Todd Tilford
Photographer: Richard Reens
Client: Tabu Lingerie

Sample Creative Brief from The Richards Group, Dallas, TX

Warning: People don't like ads. People don't trust ads. People don't remember ads. How do we make sure this one will be different?

Why are we advertising?
To generate awareness for Tabu by making customers feel more comfortable about buying sexy lingerie.

Who are we talking to?
Men who buy lingerie for a wife or girlfriend, and women who buy lingerie for themselves (to please the men in their lives).

What do they currently think?
"I'm a little uncomfortable about buying sexy lingerie; lingerie is very intimate and private."

What would we like them to think?
"This is a friendly, uninhibited store. I wouldn't be embarrassed to ask for anything."

What is the single, most persuasive idea we can convey?
Tabu makes buying lingerie fun.

Why should they believe it?
Because we're honest about why people buy it.

Are there any creative guidelines?
Sexy and intelligent; not sexist and crude.

—The Richards Group

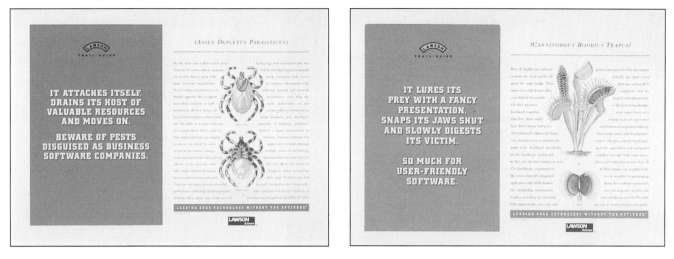

clear brief offers the creative team a solid point of departure and sets them on the right path for ideation. Research, information about the brand or group, and the budget all play into forming the strategy. Most often, a brief is written collaboratively between the client and ad agency.

Elements of an Ad

Most ads consist of the following elements: a visual, headline (or line), body copy, tagline, and sign-off. The **visual** is the image, which may be a photograph, an illustration, graphics, typography, or any other combination of visuals.

The **headline** is the main verbal message. It is called that because it typically resides at the top of the page, but it may reside anywhere on the page or screen. The **body copy** is the narrative text that further explains, supplements, and supports the main advertising concept and message. The **tagline**—also called a claim, endline, strap line, or slogan—conveys the brand benefit or spirit, and it generally acts as an umbrella theme or strategy for a campaign or a series of campaigns. A tagline helps complete the advertising communication; it helps round out the meaning. The strategy behind a campaign is usually revealed in the tagline. The **sign-off** includes the brand's or group's logo, a photograph or illustration of the brand, or both.

In the ads for Lawson Software (Figure 11-5), the headline appears on the left side of the ad, the visuals and text type are on the right side, and the tagline and sign-off are at the bottom right.

Figure 11-5
Ad: Lawson Software Healthcare II
Agency: Martin/Williams Inc., Minneapolis, MN
Art director: Jeff John
Copywriter: Cathy Ostlie
Photographer/Illustrator: Karel Havlicek

Copy-driven vs. Visual-driven

When the copy does the "heavy lifting" in an ad, the ad is considered to be copy-driven (Figure 11-6). That means the main message is primarily conveyed via the headline (verbal component). Conversely, when the visual or design of the ad conveys the message, the ad is visual-driven (Figure 11-7).

Figure 11-6
Ad: "Report Hate Crimes"
Agency: Firewerks >> Advertising + Design, Minneapolis, MN
Art director: Rebecca White
Copywriter: Ross Phernettor
Sponsored by: St. Paul Human Rights, Out Front Minnesota, FIREWERKS, and St. Paul Hate/Bias Network

Sometimes the line says it all and there is no need for a visual.

When aiming at a global audience where language translations might cause miscommunication, some feel the best route is no-copy advertising; that is advertising where the visual communicates the entire message, and there is no line of copy, except for perhaps a tagline.

Components of an Ad

Advertising is different from other graphic design. Advertising involves a high degree of persuasive intent. An ad must call people to action, stimulating sales or motivating behavior. The four main components involved with the creation of a print ad are strategy, idea, design, and copy.

The strategy is the master plan, a starting point to determine several key factors, such as the audience and brand positioning. A strategy is determined before the creative team goes to work on idea generation. It is usually outlined in the creative brief and utilized along with a briefing by the agency account manager (the liaison between the creative team and the client) or, in the case of a small agency, the client may brief the team. As creative director/copywriter John Lyons puts it, "A strategy is a carefully designed plot to murder the competition."

The idea is the creative solution to the advertising problem; it is a formulated thought that communicates a message and meaning, and thereby promotes action. The foundation of any successful ad is an idea or concept; it comes as a result of reflecting on the research, strategy, audience, advantages of the client's brand or social cause, intuition, feeling, and visualization.[1]

Functional vs. Emotional Benefits

What's in it for me? This is what a potential viewer wants to know. Will this brand make me happier, healthier, richer, more attractive, get me where I want to go, or make my life easier? Will I help someone if I give to this group or cause?

Functional benefits are the practical or useful characteristics of a product or service that aid in distinguishing a brand from its competition. For example, a bar of soap may have the advantage of extra moisturizer, or a credit card company may protect against identity theft. Whether the ad lets the viewer know about a special feature of a shoe (Figure 11-8) or learning "literacy" (Figure 11-9), a benefit can interest a viewer.

Emotional benefits are based on feelings and responses and are not based on any functional characteristic of a product or service. According to many, ads that promise greater self-esteem or pleasure or any emotional benefit may have a far greater impact than those that promise functional benefits. For example, hair coloring may improve self-esteem, or purchasing burglar alarms may alleviate fear. Humorous ads also offer an emotional benefit.

What an ad must do:
- Grab attention
- Communicate a message
- Serve as a call to action
- Respect the viewer and be ethical

The copy is the verbal part of the advertising message. It should express the idea while working cooperatively with the visual, as in the very humorous ad by Hunt Adkins (Figure 11-10). It should be clearly written in everyday language, and be consistent with the brand voice. The headline, body copy, and tagline should be unified in voice and style, and based on a common strategy and idea.

Figure 11-8
Poster: "Rollerblade
Grind Shoe"
Design firm: Planet Design
Company, Madison, WI

Design and Copy: Visual/Verbal Synergy

Together, the design and copy (the visual and verbal components) express the advertising idea in a synergistic visual/verbal relationship. Working cooperatively, the visual and verbal components should produce a greater effect than that of either part alone. Visual/verbal synergy is established in the classic ad for Volkswagen (Figure 11-11). The line and visual depend upon one another for the total ad message. Here is a way to test for visual/verbal synergy: Cover the visual and read the line. Do you get the meaning of the ad? Now reverse it; cover the line and look at the visual. Is the ad message communicated? Now look at the entire ad. The message should be clear because of the cooperative action of the visual and verbal components. When this type of synergistic action takes place, the communication becomes seamless.

Attention to the creative form, structure, and style of how all graphic elements and text are created, selected, and employed to communicate a message is the design of an ad.

Everything you have learned about the fundamentals of design should be used to create an ad design that expresses the idea, communicates a

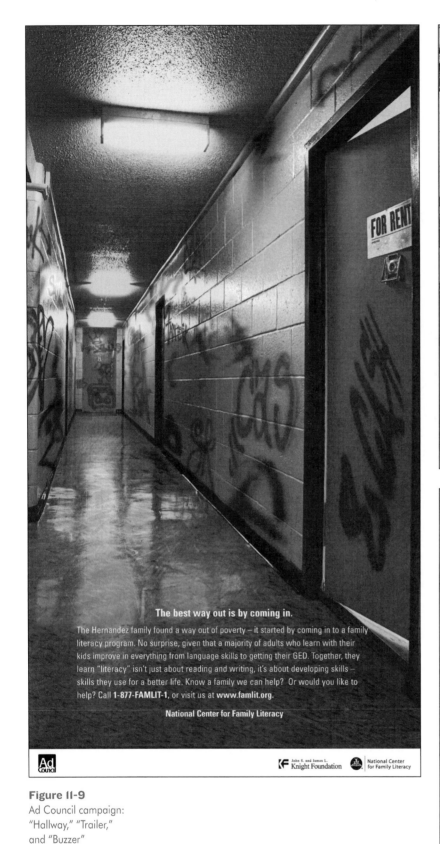

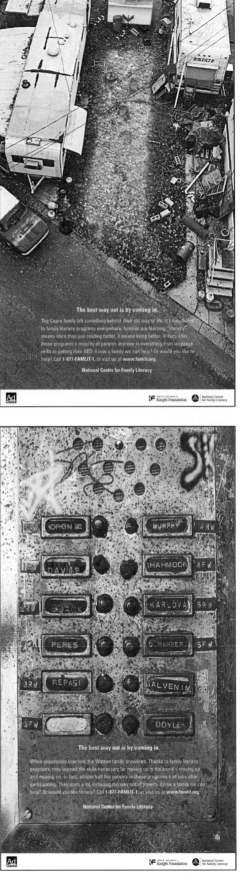

Figure 11-9
Ad Council campaign:
"Hallway," "Trailer,"
and "Buzzer"
Sponsoring organization:
National Center for
Family Literacy

message, complements the copy, attracts the viewer, has graphic impact, feels fresh, establishes a visual hierarchy, and is appropriate for the brand or group voice. When designing an ad, you must consider the main visual, layout (compositional form and structure), typography, sign-off, style, and presentation.

Developing Ad Ideas

In the advertising business, everyone talks about the elusive "big idea." The big idea is what will convince every consumer to buy, as well as *buy into* the brand you are advertising.[2] It's the mighty ad message that is engaging, memorable, unique, and has legs (meaning it can run for a long time, and has holding power). The big idea makes the viewer notice, remember, and act.

Figure 11-10
Ad campaign
Agency: Hunt Adkins
Art director: Mike Fetrow
Writer: Doug Adkins

The copy sounds authentic, like something one would say to a friend.

Figure 11-11
Ad: Volkswagen
Agency: BMP DDB, London, England
Art director: Mark Reddy
Writer: Tony Cox
Photographer: Andreas Heumann
Client: V.A.G. (United Kingdom) Limited

It's almost impossible for any creative director, art director, or copywriter to explain how ideas come to them. Sometimes ideas simply appear. Other times you work, think, write, sketch—and then an idea comes to you. Try the following points of departure for developing an idea.

Pun. A play on words can be funny. Years ago, the Chiat/Day agency created a winning print and television campaign for the NYNEX Yellow Pages, based on puns (Figure 11-12). On the heels of their campaign, everyone used puns for a while. For a pun to work, it has to be creative, otherwise it often sounds like prosaic humor.

Figure 11-12
Poster: NYNEX
Agency: Chiat/Day,
New York, NY
Creative director: Dick Sittig
Art director: Dave Cook
Writer: Dion Hughes
Client: NYNEX Yellow
Pages, Courtesy of NYNEX

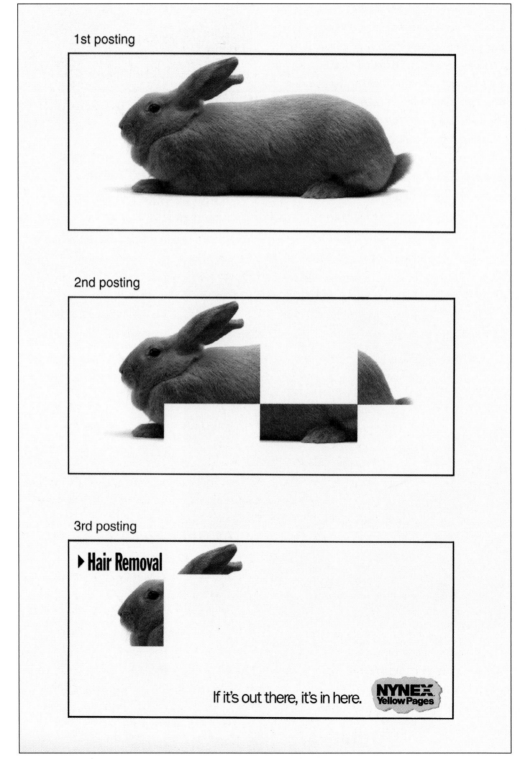

Visual analogy. A visual analogy is a comparison based on likeness or similarities. We assume that if two things are alike in one respect, they are alike in other or all respects. You can draw an analogy between pretzels and the human back, between a pleated lampshade and skirt, or between whitening a fence and teeth (Figures 11-13 through 11-15).

Visual metaphor. A visual metaphor uses a visual that ordinarily identifies one thing to identify another, thus making a meaningful comparison; for example, a rhinoceros to designate dry skin, or a Shar-Pei dog to designate a wrinkled human face.

Symbols and icons. In their ad, IBM declares its support for programs designed to strengthen women's skills in areas such as math and science by using colored baby booties to symbolize gender (Figure 11-16). Icons can represent a corporation or brand in a very friendly way (Figure 11-17).

Look at it this way. Your back is the center of your whole body.

That's why when your back gets all twisted up, you seem to hurt all over. If you have chronic back problems, give me a call at (213) 749-6438 and we'll arrange an appointment.

Chiropractic is a proven, altogether safe technique. Which is why many insurance plans now cover it.

I think that after you see me, you'll feel a lot better than you did before.

Orlando Pardo D.C.
DOCTOR OF CHIROPRACTIC

Figure 11-13
Ad: "Pretzel"
Agency:
Leonard Monahan Lubars
& Kelly, Providence, RI
Creative director:
David Lubars
Art director: Michael Kadin
Writer: David Lubars
Photographer: Paul Clancy
Client: Orlando Pardo, DC

Suggestions

There are no hard and fast rules in advertising because it is a creative business/field that often breaks rules to get through to people. However, the novice needs some useful guidelines.

Concept development

• Communicate one clear message per ad.
• Establish a functional or emotional benefit.
• Avoid clichéd visuals and copy.
• Inform. Tell the consumers something they did not know.
• The visual and line should not repeat one another.
• Be socially responsible—do not employ negative stereotypes.

Copy

• Make sure the copy works cooperatively with the visual.
• Write in plain, conversational language, not hype. Avoid sounding like a sales pitch.
• Break copy lines in logical places; line breaks should echo breaks in speech.
• Do not use the brand's or group's logo as the headline.
• Do not use headlines, taglines, or body copy from existing ads.
• Respect the viewer.
• Check spelling and grammar.
• The ad should be believable; it should not sound like an *empty* sales pitch.

Design

• Be original (avoid imitating the competition's ads).
• Find a compelling visual form for the brand or group.
• Establish a visual hierarchy.
• Experiment with page design; all your ads (in your portfolio) should not have the same layout.
• Adjust the letter and word spacing by eye.
• Type has a voice; use it appropriately.
• Establish unity with some variety in the layout of a campaign.
• Be aware that every denotative graphic element or word also carries connotation and conveys meaning.
• Style carries connotation.
• The design should grab the attention of someone who is leafing through a magazine or walking past a posted ad.

Figure II-14
Ad campaign:
"Lampshade"
Agency: Weiss, Stagliano +
Partners Inc., New York, NY
Creative directors: Marty
Weiss and Nat Whitten
Art director: Ellen Steinberg
Writers: David Statman,
Paula Dombrow, and
Ernest Lupinacci
Photographer: Guzman
Client: Apriori

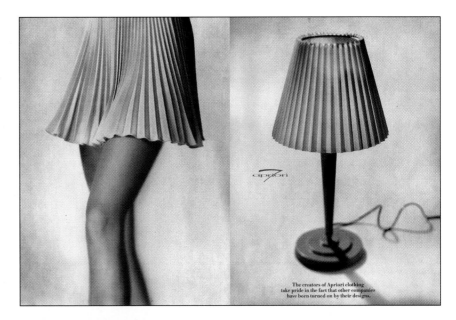

Figure II-15
Ad: "It's Whitening
Made Simple"
Agency: Martin/Williams
Inc., Minneapolis, MN
Product: 3M Zaris
Client: 3M Dental

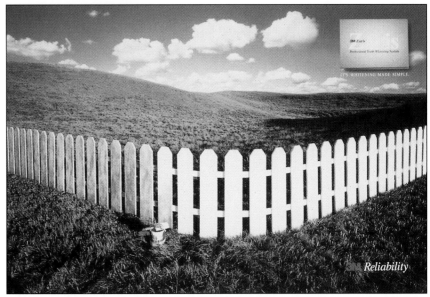

Figure II-16
Ad: "Guess which one will
grow up to be the engineer."
Advertising agency:
Dentsu Advertising
Creative director/Writer:
Bob Mitchell, Mitchell
Advertising, Millwood, NY
Art director: Seymon Ostilly
Courtesy of IBM Corporation

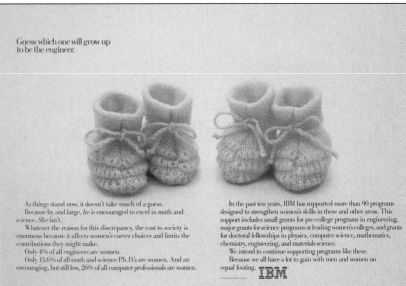

Life experience. If the consumer can relate to what you're saying, you're halfway home. "Yeah, that happens to me," should be the consumer's response. These ads behave as observational humorists, pointing out the humor in everyday life occurrences. We share familiar narratives in the witty ads for Cool Down (Figure 11-18).
The problem is the solution. Often, the answer to an ad problem is looking at the problem itself. In the late 1950s, Volkswagen wanted to sell a good deal more VW Beetles in America. The problem was that, compared to American cars, the Beetle was small

Figure 11-18
Ads: "Cool Down"
Agency: Arian, Lowe, Travis & Gusick Advertising, Chicago, IL
Creative director: Gary Gusick
Art director: Mike Fornwald
Writers: Gary Gusick and Mike Fornwald
Client: EverFresh Juice Co.

"We decided to target women for the Cool Down product. After all, 62 percent of all people who exercise three times a week

or more are female. We retained the services of Nicole Hollander, creator of the 'Silvia' nationally syndicated cartoon strip, to help with the executions. The ads are designed to poke gentle, gender fun on behalf of women and to demonstrate to women that Cool Down understands them. It worked."

—Daryl Travis, president, Arian, Lowe, Travis & Gusick Advertising

Figure 11-17
Ad: Hush Puppies
Agency: Fallon McElligott, Minneapolis, MN
Art director: Bob Barrie
Writer: Jarl Olsen
Photographer: Rick Dublin
Client: Hush Puppies Shoes/Wolverine

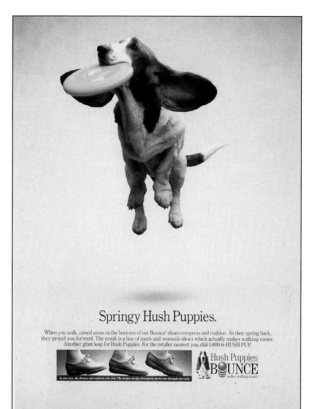

and strange looking. American consumers were used to big, streamlined cars. Doyle Dane Bernbach's (DDB) solution was to emphasize the characteristics that set VW apart from the competition; for example, the care put into manufacturing and inspection, which resulted in the now famous "Lemon" ad (Timeline page TL-9). Other VW ads from DDB touted: "Think small" and "It's ugly, but it gets you there."

Practical reasons to use the brand or change your behavior. It is very hard to dispute something that is proven or makes real sense. Prove that the consumer needs your brand through demonstration or explanation, as in the eye-catching campaign for MN Motorcycle Safety Center (Figure 11-19).

Comparison. A comparison between brands is usually boring and mean-spirited, like the old cola wars or the fast-food wars. However, comparisons to things other than the competition can be very seductive; for example, comparing the sensation of eating a York Peppermint Pattie candy to skiing or being under a refreshing waterfall, or contrasting rough and soft (Figure 11-20).

Exaggeration. Exaggeration is fun and can easily drive home a point. A classic example is the ad for Colombian coffee in which the pilot turns the plane around because they forgot the Colombian coffee. This brand is so good that . . . These high heels are so high that . . . A vacuum cleaner that is so powerful that . . . (Figure 11-21).

Endorsement. An ad may feature a celebrity to endorse the brand or group (Figure 11-22),

Figure 11-19

Ad campaign: "Tattoo remover," "There's nothing quite like the feel of the open road," and "The road won't protect you. You have to do it."
Agency: Martin/Williams Inc., Minneapolis, MN
Client: MN Motorcycle Safety Center

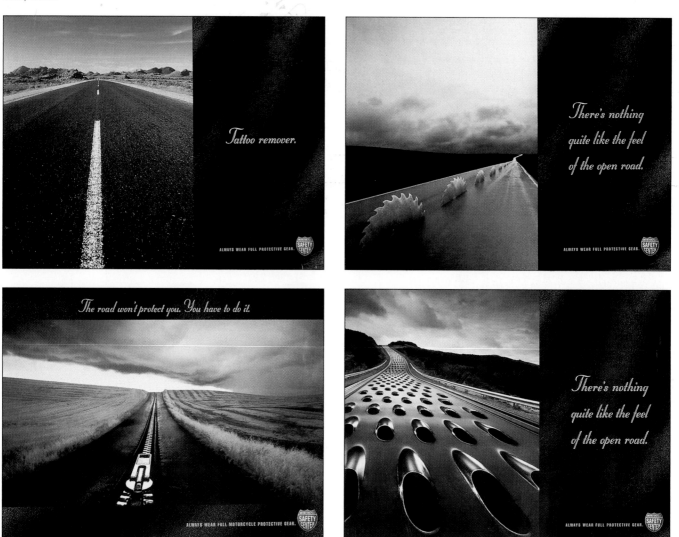

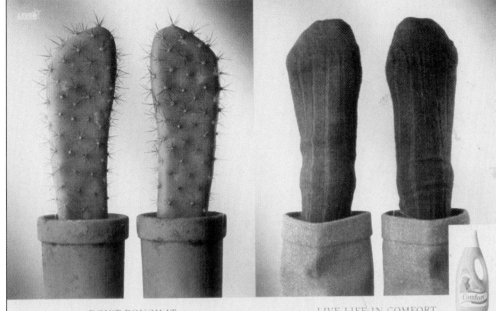

Figure 11-20
Ad: Comfort "Cactus"
Agency: Ogilvy & Mather
London Ltd.
Photographer: Peter Rauter
Client: Lever Bros. Ltd.

Contrasting socks to cacti
makes a point about using
Comfort fabric softener.

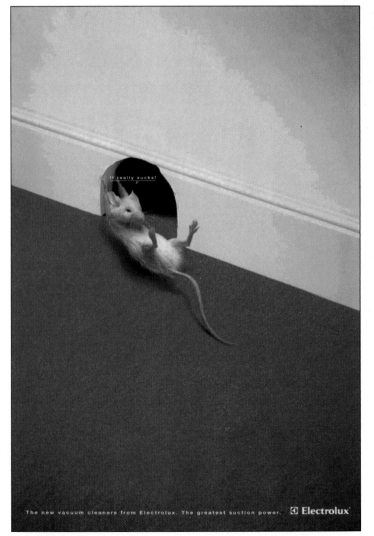

Figure 11-21
Ad: Electrolux Vacuum
Cleaner, "Mouse"
Agency: Delvico Bates,
Madrid, Spain
Creative directors: Pedro
Soler and Enrique Astuy
Art director:
David Fernandez
Copywriter:
Natalia Vaquero
Client: Electrolux
Vacuum Cleaner

Electrolux has the
greatest suction power,
as demonstrated by
a mouse being
sucked away.

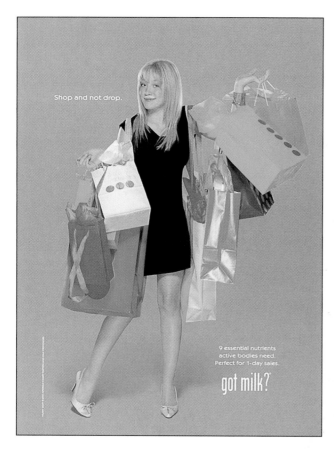

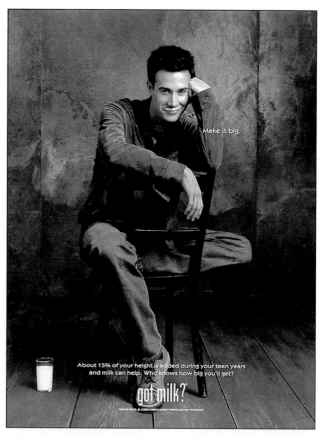

Figure 11-22
Ads: Hillary Duff, Freddie Prinze Jr., Williams Sisters, "Milk Mustache"
Agency: Lowe Worldwide, Inc.
Client: National Fluid Milk Processor Promotion Board

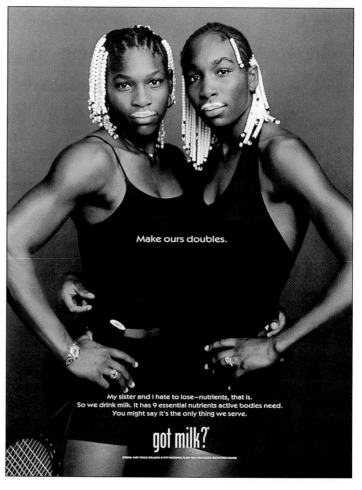

or it may feature an endorsement from an everyday person with whom the potential consumer can identify (Figure 11-23).

Lifestyle and attitude. Most advertising for fashion, alcoholic beverages, cigarettes, and jewelry is image advertising, in which a desirable lifestyle or spirit is created. The communication is intended to say: "If you use this product, you, too, will enjoy this lifestyle, belong to a certain community, be with fun people, look attractive, and be successful." Rollerblade is not just selling you their product; they are selling an attitude (Figure 11-24).

Irony. Since the advertising creative revolution of the 1960s, ad professionals have found value in winking at the consumer. There is no pretense, no hard sell. This underlying approach, which in my opinion has great integrity, is: "We know you know we're trying to sell you something, so let's just enjoy this transaction together." KesselsKramer takes what might be expected in advertising and doesn't give it to you. Instead, the agency plays with incongruity and absurdity, as in the ironic campaign for 55DSL (Figure 11-25). KesselsKramer comments: "Everyone needs a holiday, but in a world where concrete is replacing grass and mountains of rubbish are replacing real mountains, it's not so easy to find that special holiday destination. Welcome to Mount Trashmore, the world's first, most prestigious holiday resort built of rubbish— the perfect home away from home for urban clothing brand 55DSL. At Mount Trashmore, you can dip your toes in a lake of slime—see if it dissolves them. Or play mini-golf with the clubs you threw away last year. Or better still, admire the beautiful sunset over an ever-changing vista of trash, trash, and more trash."

Differentiation. Make a distinction for your brand or group by setting it

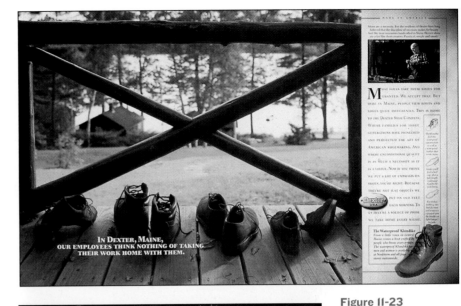

Figure 11-23
Ad: Dexter Shoes
Agency: Pagano Schenck & Kay Inc., Boston, MA
Creative director: Woody Kay
Art director: Hal Curtis
Copywriter: Steve Bautista
Photographer: Harry DeZitter
Client: Dexter USA

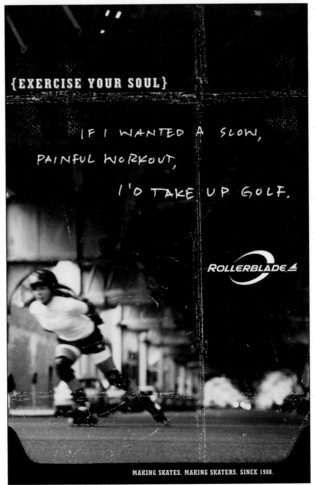

Figure 11-24
Poster
Design firm: Planet Design Company, Madison, WI
Client: Rollerblade

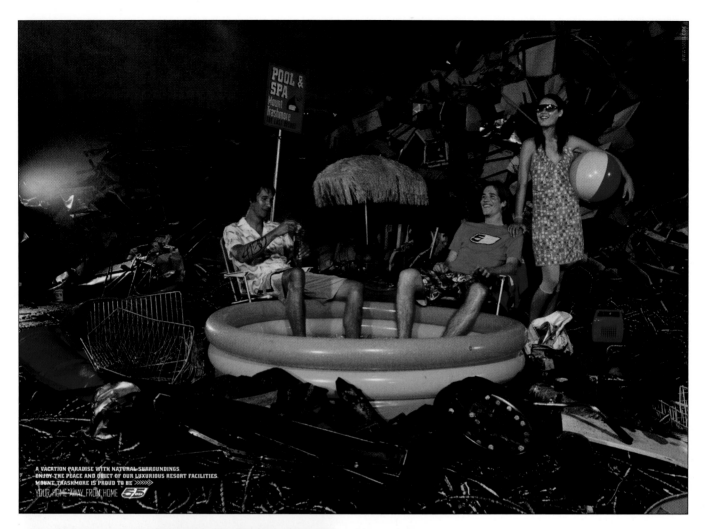

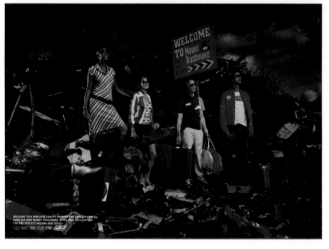

Figure II-25
Ads: "Mount Trashmore"
Agency: KesselsKramer, Amsterdam
Strategy: Chris Barrett
Creative director: Dave Bell
Art director: Krista Rozema
Copywriter: Tyler Whisnand
Photography: Bisse
Client: 55DSL; Cristina Clerici, Andrea Rosso, and Jean-Luc Battaglia

"For the last few seasons, 55DSL has been urging people to stay at home—outside is dangerous—and telling people of all the fantastic products and creatures that can make your domestic life bliss. This season 55DSL takes a tentative step outside of its front door, down the street, and on its first holiday to Mount Trashmore Resort. Mount Trashmore is a constantly changing resort—built out of trash. The visitors can experience a world of luxury, at the same time as visiting their own personal rubbish. In fact, it's a real home away from home.

The campaign consists of the 55DSL holidaymakers enjoying the fantastic facilities of this great resort and showcases the new collection whose theme is 'Take Away.' The pictures, taken by Swedish photographer Bisse, show Mount Trashmore in all its glory.

55DSL is an apparel brand that makes urbanwear to make you feel at home, any time any place.

Have a nice vacation."

—KesselsKramer

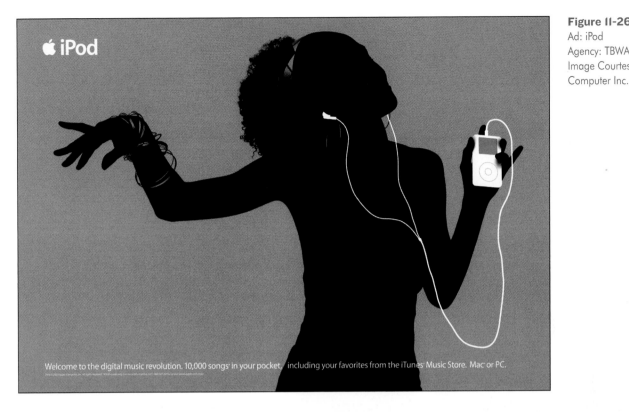

Figure 11-26
Ad: iPod
Agency: TBWA/Chiat/Day
Image Courtesy of Apple
Computer Inc.

apart from the competition; for example, print ads for Altoids peppermints, created by the Leo Burnett Agency, which positioned Altoids as extremely strong mints and created a distinctive retro "look and feel." The ad created by TBWA/Chiat/Day for the Apple iPod, a digital music player, grabs the viewer's attention and keeps the viewer's interest (Figure 11-26). Used both in print and on television, the dancing silhouetted images are in keeping with the entire Apple brand experience—and with Apple's cool image—absolutely differentiating Apple from the competition.

Humor. People enjoy being entertained, and entertaining humor disarms and endears. For example, Subservientchicken.com, a web site for Burger King created by Crispin Porter & Bogusky, received an enormous number of hits; people spent a good deal of time (about seven minutes on average) on the site because they found it entertaining.[3] Humorous ads—usually online ads or television ads—generate "water cooler buzz"; that is, when people find an ad funny, they tend to talk about it with coworkers. And that means that people are talking about your brand or group (Figures 11-27 through 11-29).

Figure 11-27
Ad: Varma/Cutty Sark Scots Whisky, "Altamira Cave"
Agency: Delvico Bates, Madrid, Spain
Creative directors: Pedro Soler and Enrique Astuy
Client: Varma/Cutty Sark Scots Whiskey

Cutty Sark is always distinguished from the crowd. Yellow signifies its persona.

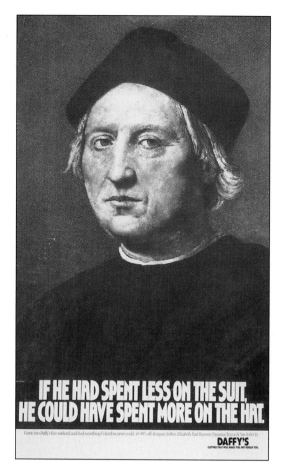

Figure 11-28
Ad
Agency: Follis DeVito Verdi, New York, NY
Creative directors: Sal DeVito, Rob Carducci, and Arri Aron
Client: Daffy's

"Objective: To do something fun and different
for an otherwise forgettable holiday."

—Julie Rosenberg, account executive, Folis DeVito Verdi

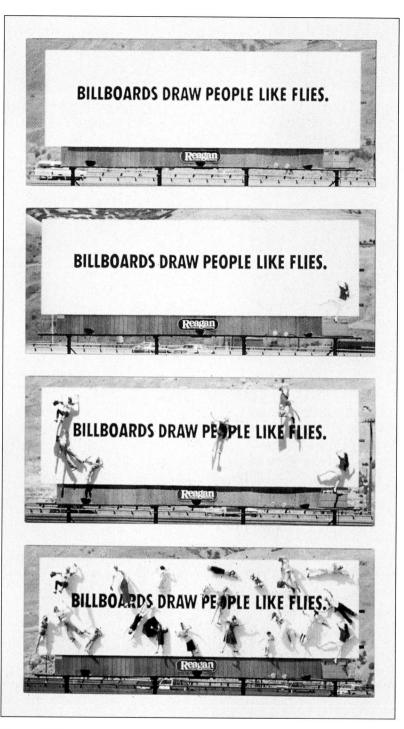

Figure 11-29
Outdoor board
Agency: Publicis, Salt Lake City, UT
Art director: Steve Cardon
Writer: Bryan DeYoung
Inspiration: If you stare at a blank billboard long enough,
it starts looking like fly paper. (At least it did to us.)

This billboard was posted in June. Over the course of seven
weeks, more and more mannequins were added each
weekend until the board was full. This billboard was
selected by the Outdoor Advertising Association of America
as one of the three best billboards of the year.

Poignancy. When an ad message touches people and affects them emotionally, evoking an emotional response, viewers are more likely to act. The campaign for the United Way is so well written it might move some people to tears (Figure 11-30). Compassion for animals certainly is provoked in the ad campaign shown in Figure 11-31. If an ad makes you feel something—anything—you are more likely to be persuaded by it. The best way to create ads that have emotional appeal is to think of the most human reactions to events or situations.

You get back from your honeymoon even more in love than the day you left. If that's possible.

He's your "husband" now. And you smile as you say the word silently in your head. So you make him his breakfast and you pour him his coffee, and you laughingly say that he shouldn't get used to this.

Then, as you share an amusing story from the morning paper, he looks at you and says, quite seriously, that his eggs are burned.

You laugh, which, to your surprise, angers him. And from out of nowhere, his fist flies toward your face. And the wedding band that you so lovingly placed on his finger just 2 weeks ago, slices your chin wide open.

It happens. Just like that.

There are more than 20,000 reports of domestic violence each year in St. Louis. You can help.
Please give to your United Way. It hits home.

Figure 11-30
Ad campaign: "It Hits Home"
Agency: DMB & B, St. Louis, MO
Creative director/Writer: Steve Fechtor
Art director: Vince Cook
Photographer: Scott Ferguson
Client: The United Way

"We tried to make the posters poignant. We felt the copy had to be read and dwelled on, so we dropped the visuals behind the words. The effect was dreamlike, as if the images were reminiscences in the mind of the person who had suffered. It must have worked, because more than one person choked up when they read it."

—Vince Cook, art director, DMB & B

Your father dies of a heart attack at the age of 54. You loved him. And you miss him. And you hate him for leaving you so suddenly.

But he's gone. So you grieve. And life goes on. Then one day you're doing the dishes, and there's something about the way the soap suds look that makes you sob uncontrollably.

And even when the sobbing stops, it never stops in your head. So the dishes go undone. And the grass goes unmowed. And the kids go uncared-for. And the dog never gets let out.

Because you're spending all of your time in your room. In your bed. In the dark.

It happens. Just like that.

There are more than 200,000 cases of severe depression in St. Louis. You can help.
Please give to your United Way. It hits home.

You're packing your bags, and you're loading the car, and you're moving out of your house. The kids try to help, but they're just in the way. And the baby is crying, and needs to be changed. And it looks like that last bag won't fit in the car. And all you can think of is, "What will we do with the goldfish?" Because you can't take it with you where you're going. Because you don't know where you're going. Because you once had a husband, who had a job, that paid the mortgage, and fed the kids. And now, you don't.

It happens. Just like that.

There are more than 8,000 homeless people in the St. Louis area. You can help.
Please give to your United Way. It hits home.

Figure II-3I
Posters: "Boycott Inhumane
Circuses"
Agency: Pagano Schenck
& Kay Inc., Boston, MA
Creative director:
Woody Kay
Art director: Kevin Daley
Copywriter: Tim Cawley
Illustration: Archival
Client: World Society for
the Protection of Animals

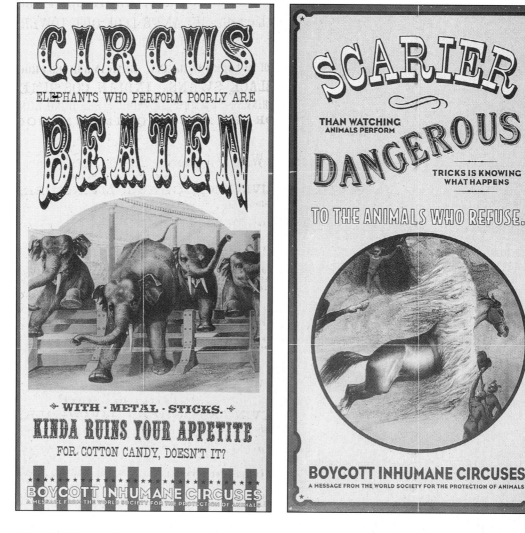

The Ad Campaign

A campaign is a series of ads that share a common strategy, concept, design, spirit, style, and tagline. A campaign serves to get the viewer's attention over a period of time and through a variety of media placements. Many believe that a viewer needs to hear and see ads many times in order to absorb the message and *buy into* the brand or answer the call to action on behalf of a cause.

Professional ad campaigns vary in the way they are structured. Some campaigns use the same template—a compositional structure with designated positions for the elements—throughout a campaign, as seen in Figure 11-5. The headline may vary and the visual will vary, but the template remains constant; for example, the famous original, long-running Absolut Vodka campaign where the bottle was centered and the headline positioned below it. Establishing variety while maintaining continuity within a campaign

is a necessity. It takes creative and critical thinking skills and a clear understanding of "stretching" a design idea to its fullest to make this happen.

Ironic wit is the earmark of KesselsKramer's work for The Hans Brinker Budget Hotel (Figure 11-32), where a template is used in the ads. With a tongue-in-cheek attitude, the creatives at Kessels-Kramer write: "Brinker Biology. Inspired by Professor Strachan's Hygiene Hypothesis, it came to the attention of the Hans Brinker Budget Hotel Amsterdam that for the first time, the 500-bed, budget hotel can now honestly offer one top-quality service: a bacteria-rich environment! The Hans Brinker Budget Hotel=Dirt Paradise. Here in the corridors, in the reception, in the toilets, the elevators and the bedrooms, countless little viruses and tiny dirty things live and breed by the minute. The Hans Brinker Budget Hotel Amsterdam is one of the perfect places for humans to come in contact with a wide variety of bacteria."

Figure II-32

Posters: *Improve Your Immune System*
Agency: KesselsKramer, Amsterdam
Creative directors: Keith Gray, Neil Aitken, Erik Kessels, and Tyler Whisnand
Client: The Hans Brinker Budget Hotel, Rob Penris

"As one option for human immune system upgrades, the Hans Brinker Budget Hotel is readily equipped to give a visitor a real workout. Simply visiting the Hans Brinker Budget Hotel Amsterdam a few times a year will improve your immune system. For this reason, the latest marketing and advertising initiative from the Hans Brinker Budget Hotel proudly showcases this unique selling proposition while making an effort to help everyone improve their immune systems."

—KesselsKramer

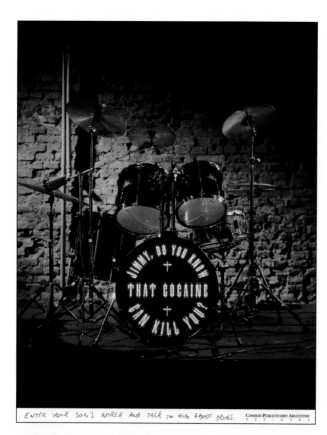

ENTER YOUR SON'S WORLD AND TALK TO HIM ABOUT DRUGS. Consejo Publicitario Argentino

ENTER YOUR SON'S WORLD AND TALK TO HIM ABOUT DRUGS. Consejo Publicitario Argentino

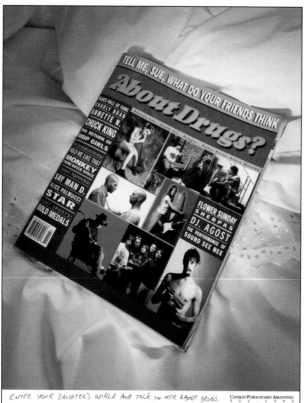

ENTER YOUR DAUGHTER'S WORLD AND TALK TO HER ABOUT DRUGS. Consejo Publicitario Argentino

Figure II-33
Ad campaign: Entre al mundo, "Drums," "Game,"
and "Magazine"
Agency: Verdino Bates Fernando Fernandez, Argentina
Creative director: Fernando Fernandez
Art director: Carlos Brana
Copywriter: Sebastian Alfie
Client: Consejo Publicitario Argentino

This campaign encourages parents to participate in their children's lives, in order to be candid about drug problems, by inventively embedding headlines into things used by young adults.

Other campaigns vary the composition throughout a campaign yet maintain unity. It is important to realize that you can have a good amount of variety in your designs, within a campaign, and still convey a similar spirit and establish a sense of unity throughout the campaign, as in those shown in Figures 11-33 and 11-34.

Creative Approaches
Creative approaches can yield exciting results. They are not suitable for every concept, brand, or group, even though they are very elastic.

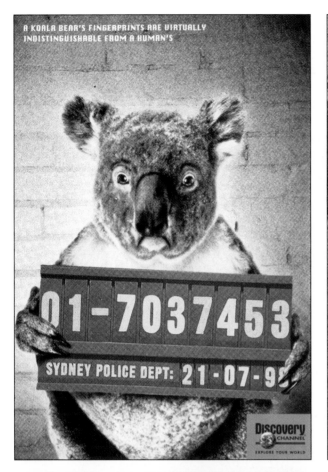

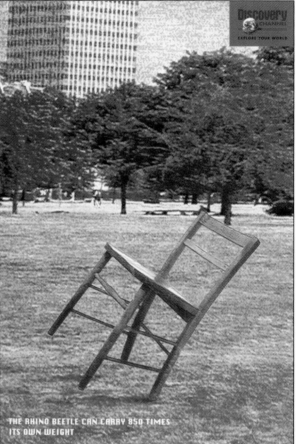

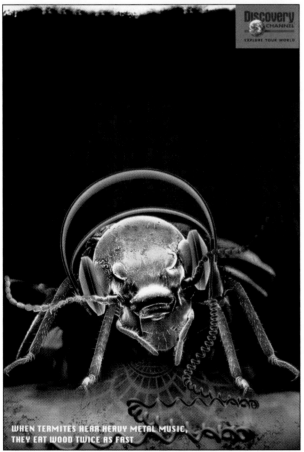

Figure 11-34
Ads: The Discovery Channel, "Koala," "Chair,"
and "Termite"
Agency: Bates Dorland, U.K.
Creative director: Chips Hardy
Art directors: Roy Antoine and Derek Hass
Copywriters: Des Barzley and Alan Lofthouse
Client: The Discovery Channel

Figure II-35
Ad
Agency: Fortis Fortis &
Associates, Chicago, IL
Client: Partnership for
a Drug-Free America

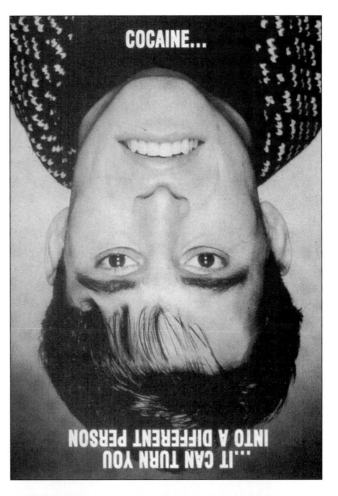

Figure II-36
Ad: "Flippers"
Agency: Marketforce,
Australia
Creative directors: Adam
Barker and Lori Canalini
Art director: Natlie Fryer
Copywriter:
Matthew Garbutt
Client: Garden City

A high-fashion store
has a promotion for
Mauritius, famous for
scuba and snorkeling.

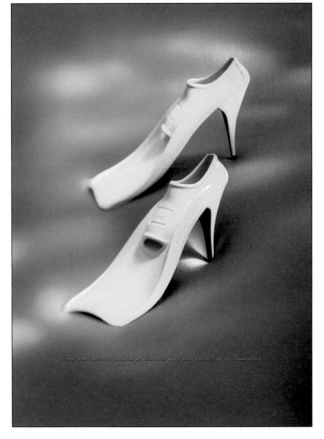

Figure II-37
Ad: New Zealand Cheese, "Roller"
Agency: The Bates Palace, New Zealand
Creative director: John McCabe
Art director: Lindsey Redding
Copywriter: Sion Scott-Wilson

This is a demonstration of the softness of New Zealand cheese.

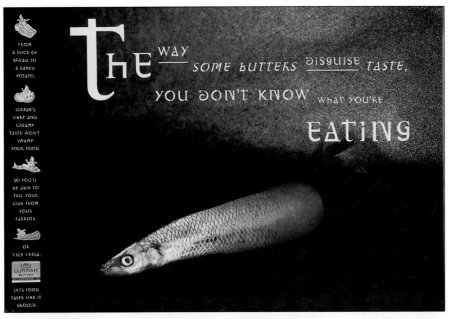

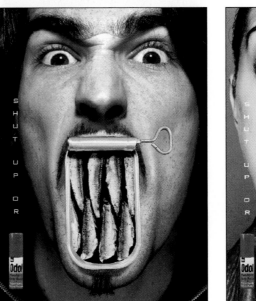

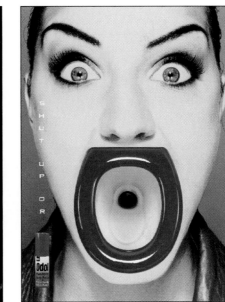

Reverse things and statements. Look at something in a mirror. Reverse a popular phrase. Turn a mouth upside down (Figure 11-35).

Merge things. Bring two different things, images, or objects together to make a new one. Merge a tennis ball and a croissant. Merge a fish and a carrot (Figures 11-36 through 11-39).

Use a strange point of view or angle. View something from an unusual or unexpected angle (Figure 11-40).

Compare things. This could be pastimes (Figure 11-41), or unlike objects, such as socks and cacti (Figure 11-20).

Visual surprise. Create a visual that will make viewers do a double-take, as demonstrated in the Lighthouse spread "Think Outside the Rectangle" (Figure 11-42).

Personify things. Give inanimate objects human qualities (Figure 11-43).

Figure II-40
Ad
Agency: Franklin Stoorza,
San Diego, CA
Art director: John Vitro
Writer: Bob Kerstetter
Illustrator: Mark Fredrickson
Client: Thermoscan

Thermoscan is a registered
trademark, and the
"Timmy" character is
a registered copyright of
The Gillette Company.

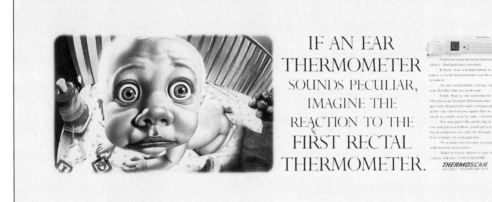

Figure II-41
Ad
Agency: Martin/Williams
Inc., Minneapolis
Client: Coleman © The
Coleman Company Inc.

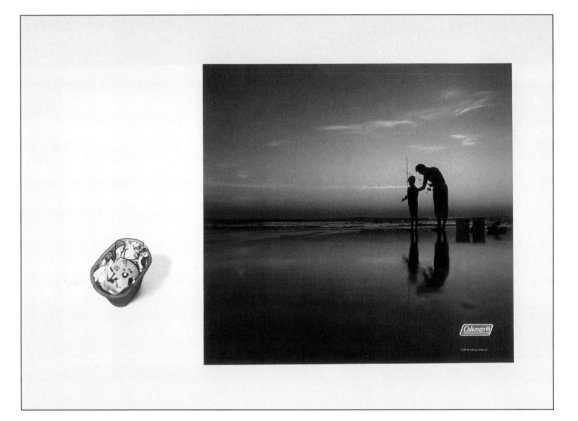

Figure 11-42
Ad: Lighthouse spread
"Think Outside the Rectangle"
Agency: Carmichael Lynch, Minneapolis, MN
Photography: Ripsaw
Client: Trex Company

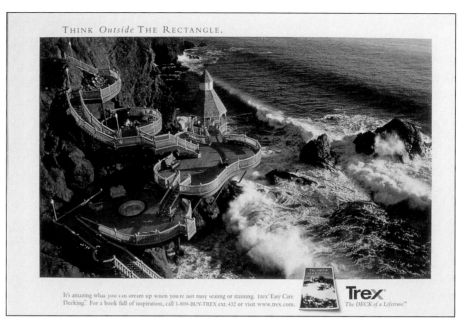

Figure 11-43
Ad campaign
Agency: Bartle Bogle Hegarty
(BBH), London, England
Client: Sony Walkman

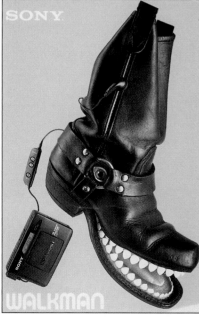

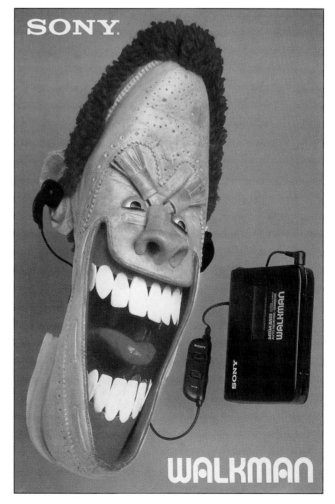

Television Commercials

Visualizing an ad for television begins with a storyboard. A **storyboard** illustrates and narrates the key frames of a television ad concept. The visuals are drawn inside small frames, in proportion to a television screen, and the action, sound or special effects, and dialogue are written underneath or next to each frame. Figure 11-44 shows an example of a storyboard for Pizza Hut.

Television has several advantages over print. Television commercials incorporate sound (including music, voice, and special effects) and motion (action, dance, demonstration, and visual effects). Only specific lengths of time (15 seconds, 30 seconds, or 60 seconds) are given to explain the message. Great TV ads are noticed, relevant, remembered, and compelling, like the funny one for the New York State Lottery (Figure 1-12).

Figure 11-44

Storyboard: The Pizza Head Show, "Super Steve to the Rescue"
Agency: Goodby, Silverstein & Partners, San Francisco, CA
Creative directors: Jeffrey Goodby and Rich Silverstein
Art director: Paul Renner
Writer: Erik Moe
Producer: Cindy Fluitt
Client: Pizza Hut

With print, you have approximately two seconds to grab the viewer's attention. When viewing television, a viewer may be attracted to a television commercial—also called a TV spot— and watch the entire ad, or may drift in and out. Thus, if the viewer stays in the room during the TV spot, there is an opportunity to regain his attention, if the viewer's attention has waned. That's where creative thinking comes in. If a TV spot is engaging, a viewer will watch. If it's pedestrian, it's most likely that a viewer will tune it out. For example, in one TV spot from KesselsKramer, at an airport, we see frogs discovered in someone's luggage (Figure 11-45). One frog jumps into another man's luggage and is brought home without the man's knowledge. When the frog jumps out, havoc ensues—things drop and break, revealing a rare painting. KesselsKramer states: ". . . this television advertisement calculates the chance of discovering a rare, Dutch 18th-century

Figure 11-45
Ads: REAAL Verzekeringen, "Frogs"
Agency: KesselsKramer, Amsterdam
Strategy: Edith Janson
Art director: Krista Rozema
Copywriter: Patrick van der Gronde
RTV producer: Jacqueline Kouwenberg
Production company for "Frogs": Stink
Director of "Frogs": James Brown
Client: Marcel Evertsen

"The new positioning for the insurance company, REAAL, comes down to the core element of the insurance industry: risk calculation. For every new case or customer, an insurer calculates the chance of an event occurring. With the knowledge of risk and the calculated percentage of chance, an insurance company develops insurance products for customers every day. Therefore, the central theme of REAAL's new campaign also uses the calculation of probability. This is the way insurers look at the world, after all, and it makes for compelling examples for showcasing REAAL's insurance products."

—KesselsKramer

Unity with Variety in an Ad Campaign

To maintain unity while still establishing variety, some elements must remain the same; for example, the color palette, fonts, manner, style, voice, and types of images. Here are some pointers:

• The visual and headline do not have to be in the same position in every ad.

• Set up a limited, yet flexible, color palette.

• Determine two or three elements that will remain constant while others can change.

• Choose two fonts or one extended font family, and vary the way you use them.

Figure II-46
Book: REAAL brand book
Agency: KesselsKramer, Amsterdam
Photography: Jacqueline Hassink
Strategy: Edith Janson
Art director: Krista Rozema
Copywriter: Patrick van der Gronde
Client: REAAL Insurances, Marcel Evertsen

"To make the new positioning of REAAL Insurances clear to REAAL employees, a new brand book was developed. In keeping with the new campaign and communications strategy, the REAAL brand book also makes its central theme the calculation of probability.

Photographer Jacqueline Hassink is internationally known for her photographic studies exploring several diverse company cultures. One previous series by Hassink, entitled 'Queen Bees,' included photographs taken of the dining room tables and conference tables of twelve top female CEOs, and in the series for the REAAL book, Hassink's photographs and subject matter have a compelling and interesting way of looking at identity. The pictures for the REAAL book were taken in three different REAAL Insurances offices, ranging from the post room to the manager's office. In this way, the book includes everybody at REAAL and strengthens the uniformity of REAAL's new brand direction. It also shows a different, and more human, side of people who, in the end, are REAAL."

—KesselsKramer

Ad Checklist
- Target the audience.
- Is your idea based on strategy?
- Be different from the competition.
- Make sure you can answer these questions from the viewer's standpoint: "What's the benefit?" and "What's in it for me?"
- Is the visual compelling? Is it fresh?
- Does it communicate?
- Does it call the viewer to action?

painting hidden behind an old print in an elderly person's house at .00000026%; and therefore REAAL offers pension insurance. The theme of the campaign anchors all the communication with the line: REAAL, Realists in Insurances." A new brand book was developed (complementing the TV spot), to make the new positioning of REAAL Insurances clear to REAAL employees (Figure 11-46).

"One great strength of the campaign is its flexibility and adaptability for all types of events and situations. This way, REAAL Insurances will not only be alert with their company policy, but also with their communication. Messages can be geared toward locations, moments, and the atmospheres in which people experience them. For example, at football stadiums a billboard reads: 'There is a chance of 0.000005% that in 2015 your son will sign a 1 million Euro contract with a club in the Series A. The Student loan insurance of REAAL. Realists in Insurances.'"

Summary

Advertising differentiates brands, groups, and causes, and ultimately sells brands and calls people to action. An advertisement (ad) is a specific message constructed to inform, persuade, promote, provoke, or motivate people on behalf of a brand or group. Any individual or group who is on the receiving end of a commercial or public service message is the audience. Commercial advertising promotes brands and commodities by informing consumers; it is also used to promote individuals and groups. Public service advertising is advertising that serves the public interest. Cause advertising, sponsored by corporations, is used to raise funds for nonprofit organizations and is run in paid media.

In advertising, the traditional creative team includes an art director and a copywriter. The team utilizes a creative brief—a strategic plan that both client and design studio or agency can agree upon and from which the creative team works as a strategic springboard.

Most ads consist of the following elements: a visual, headline, body copy, tagline, and sign-off, and they are either copy-driven or visual-driven. Usually, ads claim a functional or emotional benefit. The four main components involved with the creation of a print ad are strategy, idea, design, and copy. An advertising idea is the creative thinking that should drive the design. Combined, the design and copy (the visual and verbal components) express the advertising idea in a synergistic visual/verbal relationship. In this chapter, suggestions for idea generation were provided and creative approaches were explained to aid in concept development, as well.

An advertising campaign is a series of coordinated ads—in one or more media—that are based on a single, overarching strategy or theme, and each individual ad in the campaign can stand on its own. Professional ad campaigns vary in the way they are structured; some campaigns use the same template throughout a campaign. A good amount of variety can exist within a campaign, and still convey a similar spirit and maintain a sense of unity throughout the campaign.

Visualizing an ad for television begins with a storyboard. Television commercials incorporate sound (including music, voice, and special effects) and motion (action, dance, demonstration, and visual effects). Only specific lengths of time (15 seconds, 30 seconds, or 60 seconds) are given to explain the message.

Notes
[1] Robin Landa, *Advertising by Design*™ (Hoboken, NJ: John Wiley & Sons, Inc., 2004), p. 58.
[2] Stan Richards interview in *Advertising by Design*™, Robin Landa (Hoboken, NJ: John Wiley & Sons, Inc., 2004).
[3] Rob Walker, "Consumed: Poultry-Geist," *The New York Times*. 23 May 2004, late edition, sec. 6, p. 18, col. 1.

David Nehamkin

*Having artfully
insulted, demeaned,
and doubled-over
millions of people as
a writer of alternative
greeting cards at
American Greetings,
Dave Nehamkin
turned his sights on
advertising. Currently
an associate creative
director at* Publicis *in
Indianapolis, his
work has appeared
in* Communications
Arts, The Minneapolis
Show, *Graphis
Advertising Annual
Print Advertising
Annual, Archive—
and his guest
bathroom, where
tastefully framed
reprints bedeck
the walls.*

Those nasty rumors you're hearing are true: at some point in your career, you're likely to be teamed with a copywriter. Don't panic; this is actually good news, on several levels.

For one thing, such a teaming instantly boosts your neuron count by roughly 150 billion.

For another, those bonus brain cells are aligned on an axis complementary to yours, and can give your work added depth and impact. Better still, you have someone to blame when the idea doesn't sell. (If you're vigorously nodding your head after that last comment, go to the back of the class. Creative teams need to generate, polish—and defend— their work as One. Yin and yang. Electron and proton. Ham and swiss.)

The ideas that creative teams produce are like material possessions in a marriage: common property. They're intellectual offspring, with an equal number of thought chromosomes contributed by both partners. Since you want to be proud of your children, you need some ground rules for working with a copywriter.

You can find a library's-worth of superb books and articles on creative ideation— but first, know this: You are entering a *relationship*. Relationship skills, as much as talent, will determine the quality of the work you produce.

Develop an understanding of your partner as nuanced as the one you have of your target audience. Learn likes and dislikes. Work ethic. Quirks. Above all, assess the thickness of your partner's epidermis: how diplomatic or direct can you be when reacting to ideas? Of course, the only way to develop this rapport is to actually fill some blank pages with ideas. The first task (assuming your creative strategy is set) is to agree on a succinct goal. X piece will produce Y result through Z means. Sounds more like algebra than advertising, but this approach gives you workable borders. Unlimited possibilities are swell—until you're so far behind a deadline,

*The ideas that creative
teams produce are like
material possessions in a
marriage: common property.
They're intellectual offspring,
with an equal number of
thought chromosomes
contributed by both partners.
Since you want to be proud
of your children, you need
some ground rules for
working with a copywriter.*

the account team is chasing you through the halls with pitchforks and lit torches.

Next comes the down and dirty ideation process. A (very) partial list of effective techniques for getting started and producing work that stands out includes analogies, hyperbolae, altered perspectives, anachronisms, contextual inversions, parodies, stories, shock tactics, and visual solutions

(writers are surprisingly accepting of ads without words, as long as they get credit in awards shows). One of my favorite exercises is to produce competitive attack ads. Isolate the weaknesses of the product or service, and define its imitations. Then you can anticipate criticism, and turn liabilities into assets. This method is a great jump-starter for ideas.

I began this article by asserting the near inevitability of being teamed with a copywriter. But what if you remain a solo act, destined to work with the one brain you were issued? Simple. Just grow a second brain, a copywriter's brain. Follow basic rules (or don't; rule-breaking is allowed, even encouraged, if you can justify your actions). Write soon, and write often. Get the clichés, tropes, and flavor-of-the-moment constructions out of your system. Bear down on a clear benefit. Pretend that rather than being paid for creating an ad, you have to pay for every word you use.

Remember that cleverness is not the goal. Relevance is the goal. Imparting information is the goal. Evoking a feeling is the goal. Brevity is your default position, but if the job requires a long headline, and/or body copy, then revel in having the room to stretch (your skills, not the truth).

Read and reread your ad. Perform grammatical liposuction. Then ask yourself: will the target audience understand your ad? Relate to it? Remember it? In short, make sure that what you've written *sounds like one human being speaking to another, stating an objective or emotional truth in a clear, compelling way.* If it doesn't, put on your walking shoes, turn out the light, and we'll see you back at Square One.

Having a parallel brain to bear the enormous burden of making viewers notice and care about your client's message is one of the great blessings of working in advertising—even if that auxiliary idea generator happens to be your own.

> *Remember that cleverness is not the goal. Relevance is the goal. Imparting information is the goal. Evoking a feeling is the goal. Brevity is your default position, but if the job requires a long headline, and/or body copy, then revel in having the room to stretch (your skills, not the truth).*

Exercise II-I

Creative writing exercise— an autobiography

1. In essay form, write your autobiography (no more than one page). It may start at any point in your life. Establish an angle—emphasize one benefit of your life.
2. Condense the essence of the essay into one paragraph.
3. Write one line (not a title) that captures the essence of the autobiography.

Exercise II-2

A "how-to" essay

1. Write an essay about "How to lose someone at a party."
2. The opening line should hint at the purpose of the essay.
3. The middle of the essay should be the turning point for the reader—now he or she should know how to get rid of an annoying person at a party.
4. As you wrap it up, the essay should still hold your reader's attention.
5. The last line should be strong and almost carry the spirit of your message on its own.

Exercise II-3

A humorous story

1. Write about something funny that happened to you.
2. Write for five minutes without stopping. Do not worry about spelling or grammar.

Exercise II-4

A redo

1. Find a bad print ad.
2. Analyze the design concept (or lack of one).
3. Rethink it and redesign it.

Exercise II-5

Recognizing differences

1. Find ten different examples of layouts. Diagram the layouts.

2. Find five ads with examples of different types of visuals; for example, illustration, photography, cartoon, diagram, montage, typography, etc.

Exercise II-6

Analyzing ads

1. Find a few good ads on the Web, TV, and in print.
2. Identify the concept in each one; determine how the visual and copy express the concept.

Exercise II-7

Product research

1. Choose a product or service.
2. Research it.
3. Brainstorm strategies for selling it.

Exercise II-8

The creative team

1. Choose the role of an art director or copywriter. With a partner, create an ad for the client of your choice in a limited amount of time (for example, one hour).
2. Exchange the roles of art director and copywriter, and create another ad.

Presentations for all Ad Exercises

1. Most instructors do not mind when ads are presented as roughs. If you are interested in using ads in your portfolio, they should be presented as tight comprehensives—simulating finished, printed pieces as closely as possible. Photostats, color copies, and computer-generated type are recommended.
2. Your comp should be mounted on foam core without a border or on a black board with a 2″ border. The format of your ad, whether it is a single page or a spread, should be determined by your concept. Keep your thumbnail sketches in a ringless binder; most art directors like to see them as examples of your creative process.

Project 11-1

The search for a compelling visual

Step I

a. Choose a brand.

b. Gather information. Find out everything you can about the brand. Survey people; ask them what they think of it.

c. Determine the benefit of your client's product or service. For example, if your your client's product is cookies, is it sweetened with sugar or fruit juice? If it is sweetened with fruit juice, then the benefit for the consumer is that they will be eating a healthier cookie.

d. Write a creative brief.

e. Write a tagline.

Step II

a. Create one print ad.

b. Do not use the product, service, or logo as the main visual.

c. Brainstorm. Write down everything you can think of that is related to the brand. Think of analogies, metaphors, and similes.

d. Think of situations where the product or service might be used.

e. Create at least ten sketches.

Step III

a. Refine the best sketches and create two roughs.

b. You may show the product, service, or logo in the sign-off.

Remember: The main visual cannot be a photograph or illustration of the product or service.

Step IV

Create a comp.

Comments: *When the brand logo is the main visual in an ad, the viewers will be immediately alerted to the fact that they are being sold something. That kind of visual might as well read, "I'm an ad—do not bother to look at me." Learning not to depend upon the product as the visual is an important lesson to learn early. (Thanks, Bob Mitchell, for teaching this to me.)*

Project 11-2

Get wild

Step I

a. Choose a particular type of product, for example, OTC pain relief medication.

b. Gather information and research. Find out everything you can about this type of product. Now choose a brand.

c. Determine the audience.

d. Determine the benefit. Will this product/brand make the consumer more attractive, healthier, richer, or offer some other benefit?

e. Write a creative brief.

f. Write a tagline.

Step II

a. Create an ad; once again, do not use the product, service, or logo as the main visual.

b. This time you must use an unusual or odd visual, one that is uncommon or unexpected.

c. Produce ten sketches with at least three possible visuals.

Creative approach: If your product is a headache remedy, try thinking of visuals that symbolize headaches—like a monster—or try thinking of ludicrous headache remedies, such as using a guillotine.

Step III

a. Create a rough.

b. You may use a visual of the product or logo in the sign-off.

Step IV

Create a comp.

Comments: *So often we see ads that have rather commonplace visuals. An ad for tissues shows a tissue box. An ad for pain reliever shows someone with a headache—nothing interesting or unpredictable. However, if the visual is unusual, perhaps even completely unrelated to the product, then we might notice the ad. After all, you will not sell people anything unless you get their attention first.*

Project II-3

Public service announcement (PSA)

Step I

a. Choose a nonprofit organization or a charity.

b. Gather information about it.

c. Determine the benefit.

d. Write a creative brief.

e. Write a tagline.

Step II

a. Create a PSA.

b. Produce ten sketches.

Step III

Refine the sketches. Create two roughs.

Remember: Always establish a visual hierarchy.

Step IV

Create a comp.

Comments: *Here is an opportunity to create an emotional connection with the viewer. Go for the gut or heart. And avoid clichéd images and statements.*

Project II-4

Varying the layout

Take an ad that you have already created and compose it five very different ways.

Comments: *This assignment pushes you to think of alternative layout solutions. Most students are quite happy with their first layout and do not explore other possibilities.*

Project II-5

An ad campaign

Step I

a. Choose your best ad.

b. Determine whether you think the design concept can be expanded into a campaign. Can you think of two other ads that communicate a benefit? As stated earlier, a student campaign consists of three ads that share a common goal or strategy. The campaign shares a common spirit, style, claim, and usually, very similar layout.

c. Write a tagline for all three ads.

Step II

Produce twenty sketches for the campaign.

Remember: The layouts should have a similar template and look and feel.

Step III

Create two sets of roughs for the campaign.

Step IV

Create a comp for each ad in the campaign.

Comments: *A campaign demonstrates your ability to create a flexible idea and run with it. It also demonstrates your ability to be consistent with strategy, concept, design, writing, and style.*

Project II-6

**Creating a storyboard for
a television commercial**

Step I

a. Choose an inexpensive product.

b. Create a verbal presentation that will
convince an audience your product has
a benefit. Make sure it is entertaining.

c. Make sure your presentation does not sound
like a sales pitch. (You may want to
videotape the presentation.)

d. Use strong opening and closing lines.

Step II

a. Create a storyboard for your presentation
consisting of four to six frames.

b. The frames should illustrate the key actions
or visuals in the commercial.

c. The frames should be in proportion to the
size and shape of a TV screen.

d. Under each frame, describe the action seen
on the video and the audio being heard.

Step III

Create a rough.

Step IV

Create a comp.

Comments: *Preparing a verbal
presentation teaches you to use everyday,
informal language. You might be tempted
to write trite phrases such as "introducing
the most amazing . . ." or "take the taste
test . . ." but you would probably
realize they sound like sales pitches if you
say them aloud. Sound, movement, and
time are the advantages of television over
print. Make the most of demonstration,
music, sound effects, close-ups, cuts, and
every other wonderful thing television
offers. Television should be entertaining,
funny, dramatic, and bittersweet; think of
a TV ad as a mini-movie.*

*You may want to create a print ad and
a Web banner to coordinate with your
television commercial.*

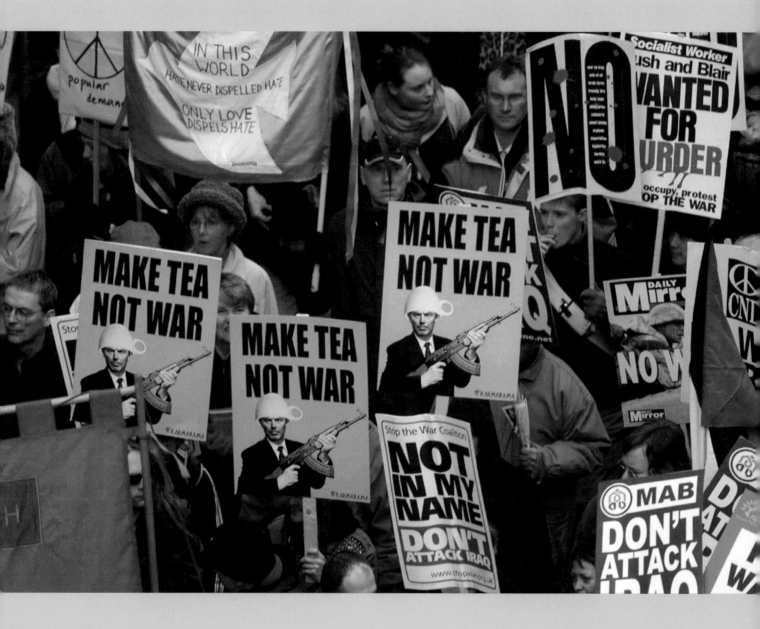

◀ "Make Tea Not War"
Agency: Diabolical Liberties, U.K.
Design agency: Karmarama, U.K.
Photographer: Paul Vicente
Credit: Images reproduced from "Your Space or Mine,"
published in the U.K. by ambient media agency
Diabolical Liberties, 2003.

Objectives

Learn about unconventional
advertising formats

Understand the reasons that
unconventional advertising
is being used today

Consider the pros and cons
of advertising

Become conscious of sponsorship
as advertising

Figure 12-1

Secretary

Agency: Diabolical Liberties, U.K.

Photographer: Mark Aikin

Client: Metro Tarten

Credit: Images reproduced from "Your Space or Mine,"
published in the U.K. by ambient media agency
Diabolical Liberties, 2003.

"No, not the fantastic person who makes life bearable
in the office, but the art house movie which received rave
reviews and critical acclaim when it opened in the U.K.
on May 6, 2003. This relatively low-budget, independent
movie required some clever niche marketing, so Metro
Tarten called in the services of Diabolical Liberties.

The campaign was launched with a cheeky teaser,
targeting the city gents of London's square mile in the
two weeks prior to the film's release, reasoning that
secretaries play a pivotal role in the district. In place
of the usual doom and gloom, posters advertising the
film popped up in select *Evening Standard* headline
frames throughout the city. Using the creative graphic
of some luscious long legs, Diabolical Liberties took the
campaign to the next stage with a second targeted hit,
leaving giant boards of freestanding legs in various
locations, including the bars close to media and
broadcasting opinion formers. The BBC, Channel 4,
Five, Virgin Radio, Soho, and Leicester Square were on
the list. They must have liked the boards, as many of
them were snapped up quickly, presumably for some
home entertainment. Finally, a very eye-catching poster
campaign, tailor-made to suit the creative graphic, rolled
out onto our 20 x 10-foot large-format sites in prominent
areas throughout central London."

—Diabolical Liberties

In spite of all the criticism of conventional advertising—TV spots, print ads, direct mail, outdoor boards, web banners—they are an identifiable species. They are what they are, and we know what they are. When conventional ads are commercial, we know they're trying to sell us something. When they are PSAs, we know they're trying to call us to action on behalf of a cause or for our own good.

Unconventional Advertising Formats

Because conventional advertising has become a recognizable, known entity, the creative minds in advertising have brought us unconventional advertising (also called guerrilla advertising, stealth marketing, ambient marketing, and nontraditional marketing), which is advertising that "ambushes" the viewer. It appears or is placed in unpaid media in the public environment—places and surfaces where advertising doesn't belong, such as on the sidewalk or at the bottom of golf holes. Unconventional advertising can take many forms, from free-standing posters on sidewalks (Figure 12-1) to street teams creating theatrical happenings to brand builders in the form of children's books (Figure 12-2). Instead of a traditional, nationwide billboard campaign, why not have giant cookies from outer space crash-landed onto prominent buildings in twenty cities simultaneously (Figure 12-3)? One could think of unconventional advertising as promotional design or public relations events or a mix of both. Certainly, effective unconventional solutions have been shown to successfully promote brands or groups in break-through ways.

Unconventional advertising is often utilized by public service advertising, perhaps advertising's greatest role in society (Figure 12-4).

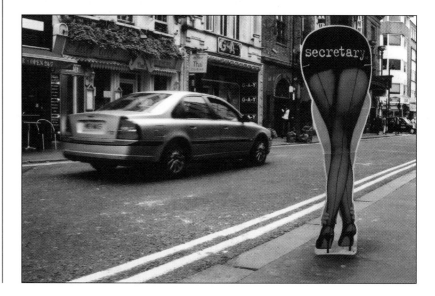

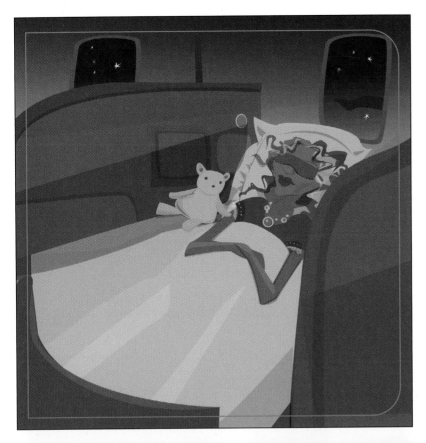

Figure 12-2
"Night-Night"
Agency: Crispin Porter + Bogusky, Miami, FL
Executive creative director: Alex Bogusky
Creative directors: Bill Wright and Andrew Keller
Senior art director: Dave Swartz
Copywriter: Mike Lear
Client: Virgin Atlantic Airways

These books were given to passengers on the flights when
the chairs were converted into suites to relax and sleep.

Figure 12-3
"Maryland Cookies Invasion"
Agency: Diabolical Liberties, U.K.
Photography: Diabolical Liberties, U.K.
Client: Maryland Cookies
Credit: Images reproduced from "Your Space or Mine," published in the U.K. by ambient media agency Diabolical Liberties, 2003.

"Instead of a traditional, nationwide billboard campaign, giant cookies from outer space crashlanded onto prominent buildings in twenty cities simultaneously. This was followed up by 'meteor shower' street displays consisting of two-foot-tall cookies landing in busy retail areas throughout the country over a period of three days.

A large-scale street media campaign was also executed simultaneously in all of the cities where activity was taking place. Locations included London Waterloo Bridge, Blackfriars Bridge, Old Street, Shepherds Bush Roundabout, Centrepoint, Olympia, and Tottenham Court Road."

—Diabolical Liberties

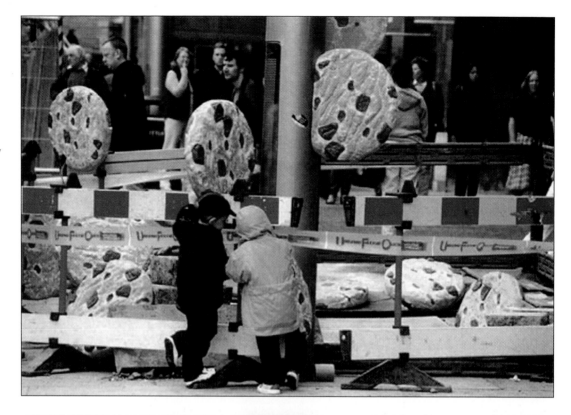

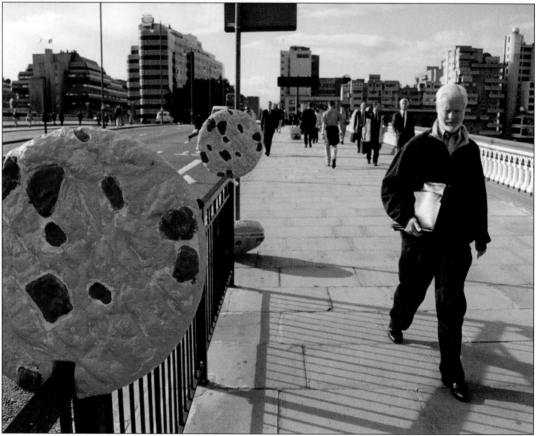

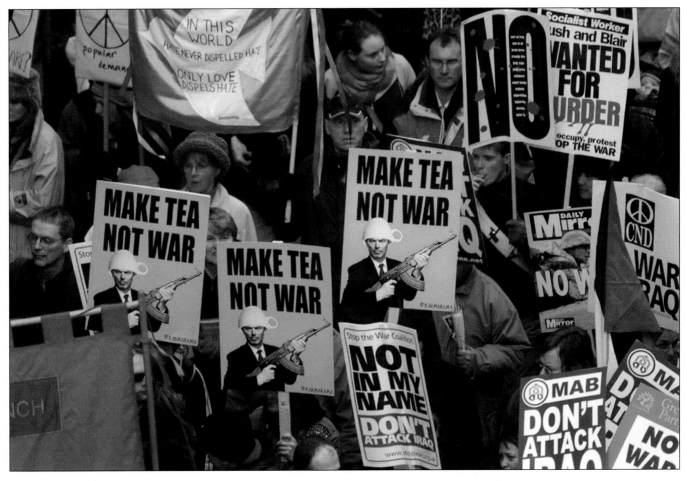

Figure 12-4
"Make Tea Not War"
Agency: Diabolical Liberties, U.K.
Design agency: Karmarama, U.K.
Photographer: Paul Vicente
Credit: Images reproduced from "Your Space or Mine,"
published in the U.K. by ambient media agency Diabolical
Liberties, 2003.

"Diabolical Liberties worked with design agency
Karmarama to implement and distribute the most
eye-catching peace message at the U.K.'s biggest ever
anti-war march. Over a million people marched through
central London, and this quickly became the day's defining
image. It now hangs in the Victoria & Albert Museum in
the propaganda section.

'Make Tea Not War' placards were the standout images in
the press from this huge story—dominating the front page
of *The Sunday Times*—while *The Independent on Sunday,*
News of the World, and *Sunday Mirror* all grabbed hold
of the peace-loving tea message within their coverage
(February 16, 2003).

The Guardian followed on Monday, February 17."

—Diabolical Liberties

Reasons for Unconventional Advertising

Our world is changing so quickly and in so many areas that the advertising industry has had to invent more ways to present their collective message; hence, the need for unconventional advertising. Let's look at some of the reasons that led to this proliferation of unconventional advertising.

Cynical Public

For the most part, unconventional advertising is used to grab the attention of a cynical public—those viewers who have grown to distrust or disbelieve conventional advertising—by appearing in unexpected places and ways (Figure 12-5).

Case Study

The Brief:

• Celebrate the reissue of Onitsuka Tigers Tokyo '64 Collection in the run-up to the Athens Olympic Games.

• Cut through the massive brand spends of Nike and Adidas, while maintaining the innovative spirit of the Tiger brand.

• Focus on authenticity instead of sports clichés.

The Solution:

• A limited edition mailer for instant glory!

• We broke through to trendsetters globally with an integrated campaign, pushing the only legal performance-enhancing drug at this year's Olympics.

Insight:

• Onitsuka Tiger swept the board in the '64 Olympics, winning 19 Gold medals for Japan.

• We recognized that something special was going on that year—so we captured it!

• Hero Breath—authentic breath, direct from the mouths of the Japanese 1964 Olympians, captured in commemorative cans.

• Hero Breath was sent out to influencers in major world cities. The shoe collection and film of the capture of the breath were featured on the accompanying web site: *www.tokyo64.com.*

The Results:

• Hero Breath has generated significant worldwide press, commentary, and buzz. Editorials alone in opinion-forming magazines range from Italian *Vogue* to *Sportswear International*, covering an estimated audience of 16 million readers.

• This tactically targeted campaign ensured that the Tokyo '64 collection completely sold out.

• The controversial can of "legal dope" has now become an eBay collectible.

"Hero Breath reflects our pioneering spirit and gives us presence in a very competitive market. We're delighted."

—Carsten Unbehaun, marketing director, Asics, Europe

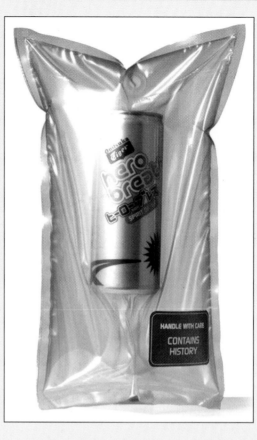

Figure 12-5
Creative brief and campaign: Strawberryfrog, "Hero Breath" Onitsuka Tiger running shoes by Asics, Tokyo '64 Collection.

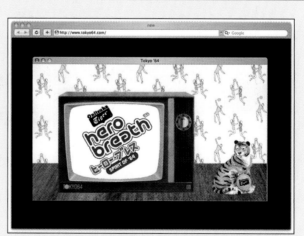

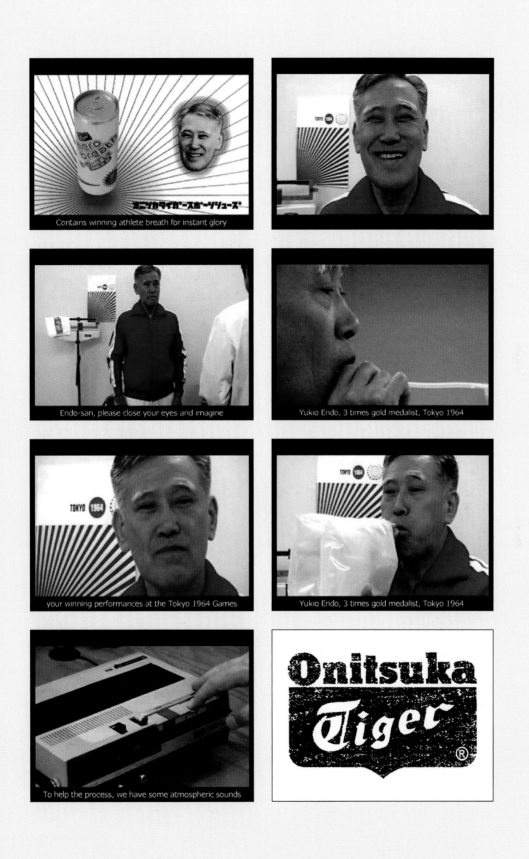

Technological Intervention

People are able to zap TV spots with their remote controls. And, recent digital video recorder technology allows high-speed Internet content to be delivered to the viewer's television, which means that viewers can download films *without* commercials to the hard drive of their video recorders. This greatly affects the amount of conventional advertising that is now actually seen on television.

Appeal of Small Budgets

Advertisers with small budgets find unconventional media appealing, especially when the cost of advertising on television or in large-circulation magazines may be prohibitive. With a successful unconventional ad campaign, free publicity—"buzz"—may be generated, as in the successful idea for Bluefly.com (Figure 12-6), which garnered an enormous amount of publicity when Renegade Marketing Group posed the question: "What's the best way to draw women to Bluefly.com in order to enter a contest to win this item, and in turn, check out their great holiday deals?"

Increased Viewer Participation

Conventional advertising is one-way communication—from advertiser to viewer—but some unconventional formats allow for more participation on the part of the viewer, requiring more interpretation or interaction. In these situations, the viewer may ask questions like "What is this experience?" or "Why is there writing on the sidewalk?"

One such example is shown in Figure 12-7, where the viewer is approached by four people in silver suits wearing space-age goggles. Put yourself in the viewer's place as you try on a pair of the goggles. "Suddenly a big-screen movie appears right in front of your face. This is so cool that you ask where you can get some goggles for yourself (you'd also like a silver bodysuit, but that's a question you can't bring yourself to ask)," comments Renegade Marketing Group of their street team for the Olympus Eye-Trek. For IKEA, to create buzz around the launch of the new interior-design concept "Go Cubic," Strawberryfrog developed "a street-level campaign, which would create intimate and personal experiences between the public and IKEA and the Go Cubic

Figure 12-6

"What would you do for a Birkin Bag?"
Agency: Renegade Marketing Group, New York, NY
Client: Bluefly.com

"Our strategy entailed hitting prime fashion avenues in New York, Los Angeles, and Miami with a camcorder and asking women the one million dollar (or at least between $5,000 and $50,000) question: 'What would you do for a Birkin Bag?'

Asking this question helped us gather plenty of heated responses—such as getting naked in front of our camera (!)—which we used to create a video news release that got picked up in over 200 markets.

After reaching over 20 million people via video and audio news releases, and 10,000 in person, 165,000 prospective customers registered on Bluefly.com. Bluefly was subsequently able to convert 10 percent of those registrants into customers, yielding over 16,000 new shoppers at a cost per acquisition of about $10, nearly half our original goal."

—Renegade Marketing Group

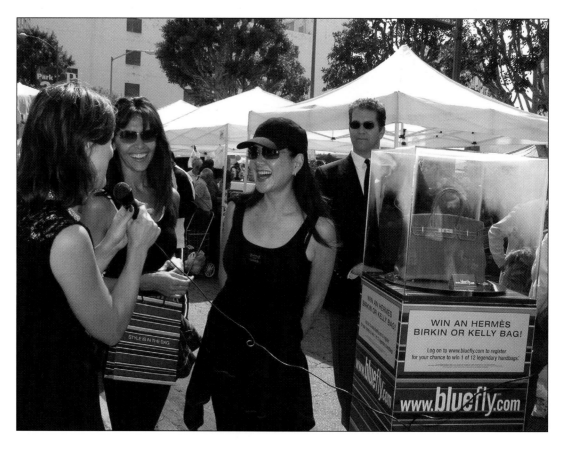

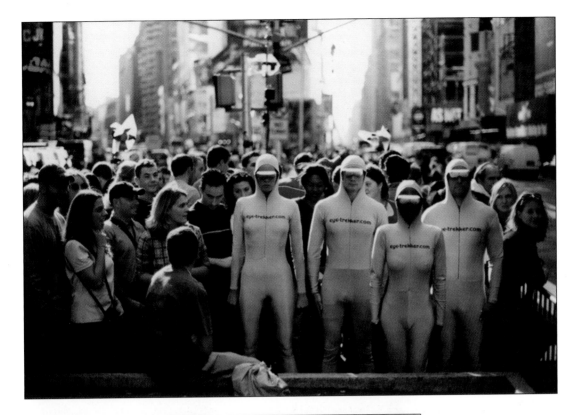

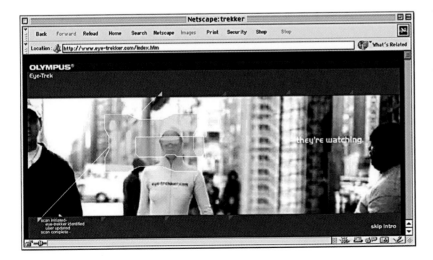

Figure 12-7
"Eye-Trekkers"
Agency: Renegade Marketing Group, New York, NY
Client: Olympus

"Renegade's objective was to generate interest and awareness in a year-old luxury item (Eye-Trek movie goggles you plug into a portable DVD player to get a virtual big-screen effect) that cannot truly be appreciated unless you experience it. And do it on a razor-thin budget. Tech-affluent people, age 30-plus, who love to have gadgets, and may not have heard about the Eye-Trek the first time around, were their target audience.

The Eye-Trek is most definitely a cool product, but without seeing it in action, it's tough to fully appreciate. So, realizing that the Eye-Trek is far more noticeable when attached to the face of someone in a silver suit rather than sitting in a glass case in an electronics store, we came up with a plan.

And the 'Eye-Trekkers' were born.

Dispatched to twelve cities, the Eye-Trekkers went where tech-affluent people congregate, providing live, hands-on demonstrations of the product. The goals were to drive traffic to the *www.eye-trekker.com* web site, and deliver maximum press exposure."

—Renegade Marketing Group

Figure 12-8
"Go Cubic"
Agency: Strawberryfrog,
Amsterdam
Client: IKEA, Netherlands

"Our aim was to build
excitement and demonstrate
in a fun and unexpected way
how people can 'maximize
their space at a minimal price.'

Eighteen living room
installations appeared over
night in twelve different IKEA
cities across the Netherlands.
Each installation was set in
8.5 square meters—the size
of an average parking space—
complete with a resident
eating breakfast, reading the
newspaper, and chatting to
passersby. All of the furniture
was free, and the public was
encouraged to 'steal' the
furniture and take it home
with them.

We deliberately chose colorful
furniture to increase visibility
and spread the buzz from the
street into the office and
people's homes."

—Strawberryfrog

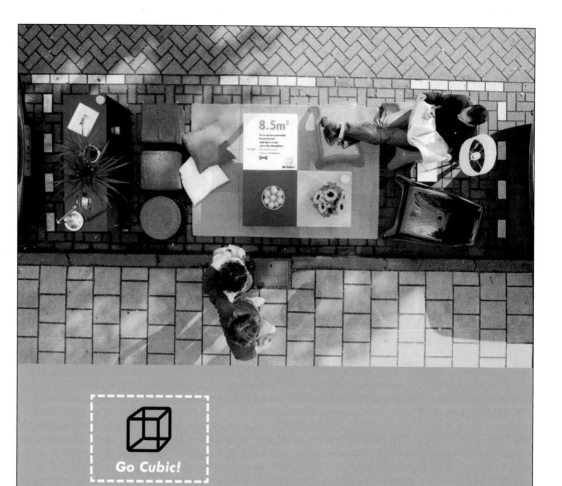

concept." (Figure 12-8) "A traditional advertising campaign can inform the public, but it takes a buzz campaign to generate excitement, intrigue, and positive perception, bringing IKEA to people on the streets," comments Strawberryfrog.

Pros and Cons of Advertising

Every year new kinds of advertising are added to those already in existence. The invention of digital recording devices that can skip television commercials has alarmed the advertising community into seeking other ways to advertise to cynical audiences. Unconventional advertising has added to what some culture critics call "ad creep." Since it hopes to catch the viewer in a relaxed state of mind and not expecting it, unconventional advertising may be considered more insidious. With that in mind, both advertising professionals and their clients must be cautious to not annoy the viewer and make advertising even more undesirable.

On the other side of the argument, people do seek out entertainment. Therefore, good web films, webisodes (web commercials), web sites, and street teams will attract viewers. The BMW films were a huge success. Jerry Seinfeld was actually interviewed on a talk show about the webisode he did for American Express. Web sites such as Burger King's subservientchicken.com get hundreds of hits from people looking for a little humor.

From the early days of television, brands have sponsored television programming. Today, there is a return to sponsorship (also called branded entertainment), even by theatre and sports, as well as product placement in television programs, films, and even novels. Novelist Fay Weldon was paid by Bulgari to be placed into one of her novels, and novelist Carole Matthews included Ford Fiestas in her work. New media will continue to present new opportunities; ambient advertising—unconventional advertising that is placed in an immediate environment other than the home—takes new forms daily, such as the one by Diabolical Liberties shown in Figure 12-9.

In all cases, if the public finds the unconventional advertising entertaining, they won't think of it as ad creep. If advertising is disrespectful and intrusive, we will all certainly complain.

List of Possible (Unconventional) Advertising Applications

- Pizza box cover
- Postcards
- Chalk drawings on sidewalk
- Car windshield visor
- Car mats
- Greeting cards
- Screensaver
- CD holder
- Instant Messenger screen backgrounds
- Tissue packets
- Music CD compilation
- Stickers
- Street teams
- Collectibles
- "Hand back" with car key from valet
- Coat check tags "get back"
- Odor eaters for bowling shoes
- Handles of supermarket carts
- Bottom of golf holes
- Dance club stamps (free samples when you leave the club, too)
- Popcorn box ads
- Mini-CDs that fit on soda cup tops
- Viral marketing
- Webisodes
- Web films

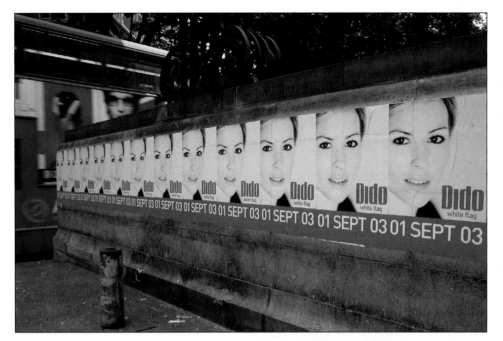

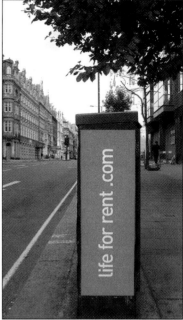

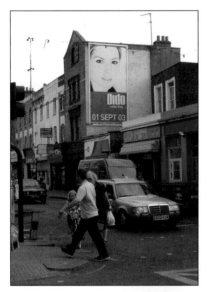

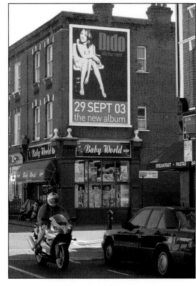

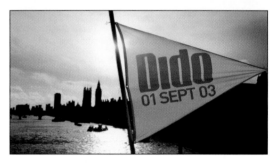

Figure 12-9

Dido: Life For Rent

Agency: Diabolical Liberties, U.K.

Photography: Diabolical Liberties, U.K.

Credit: Images reproduced from "Your Space or Mine," published in the U.K. by ambient media agency Diabolical Liberties, 2003.

"As dawn broke on the release day of Dido's first single from her new album *Life for Rent*, white flags were raised across major landmarks, dominating the London skyline from Primrose Hill to the Tate Modern. In other key regional cities, the occasion was similarly marked.

This was the culmination of the prelaunch buzz for the first single 'White Flag' and the precursor to a national mainstream billboard campaign declaring 'Life for Rent.'

Diabolical Liberties was the street media strategist behind the album launch in the U.K. Our music team devised a multilevel ambient media campaign that went through all stages of the marketing process, using a comprehensive selection of available street media formats throughout the entire campaign.

From tease, to stunt, to full reveal on our prime location billboards, Diabolical Liberties facilitated street-level hype in anticipation of the release. And the result? *Life for Rent* sold over 400,000 copies the first week in the U.K, making it one of the all-time fastest selling albums ever."

—Diabolical Liberties

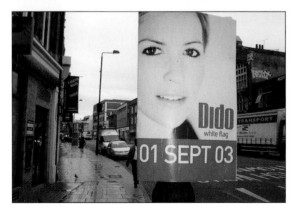

Summary

Unconventional advertising can take many forms, from free-standing posters on sidewalks to street teams creating theatrical happenings to brand builders in the form of children's books. One could think of unconventional advertising as promotional design or public relations or a mix of both. Certainly, effective unconventional solutions have been shown to successfully promote brands or groups in break-through ways.

A proliferation of unconventional advertising is being seen as a way to combat the increased cynicism of the public and the modern technological intervention being used against conventional ads. The small budgetary output has strong appeal, and some unconventional ad formats allow for more participation on the part of the viewer—and this is good.

If advertising is disrespectful and intrusive, we will all complain about ad creep. If the public finds the unconventional ads entertaining, then it will be effective.

Exercise 12-1

Recognizing possibilities

Find three different examples of unconventional advertising not shown in this book.

Presentation for all unconventional ads

1. Since most unconventional advertising depends upon where and how the audience will receive the message, it's important to simulate the experience in your comp. For example, if your solution involves a street team, then use a photo-editing program to produce, as accurately as possible, how the street team would look and where they would be seen. If your solution involves sidewalk chalk drawings, then render it as closely as possible to how the chalk drawing would appear on the sidewalk by using hand tools, photographing a chalk drawing that you create, or using a photo-editing program—simulating the finished, printed pieces as closely as possible.

2. When your solution involves the creation of a design object, such as a deck of cards, then create a comp or dummy of the deck. The deck can be mounted on a presentation board with a pocket or a recessed area. Or the deck can be photographed, and then the photograph can be mounted on a board.

3. Your comp should be mounted on foam core without a border or on a black board with a 2″ border. Keep your thumbnail sketches in a ringless binder; most art directors like to see them as examples of your creative process.

Project 12-1

Endear your brand

Step I

a. Choose a radio station.

b. Gather information. Find out everything you can about the radio station. Survey people—ask them what they think of it.

c. Determine the station's benefit and type of music or programming. For example, does the station offer special interest programming? Does it offer rarely heard music? Popular music?

d. Determine the audience.

e. Write a creative brief.

Step II

a. Design a deck of cards to promote the radio station.

b. Determine how listeners or potential listeners will receive the cards. For example, will the deck of cards be available if a listener goes to the web site or can they be obtained at a music store, at the point of purchase? Think of situations where the deck of cards might be distributed.

c. Brainstorm. Write down everything you can think of that is related to the radio station. Think of analogies, metaphors, and similes.

d. Think of possible uses for the deck of cards; for example, music trivia or playing cards with visuals that are also available as IM backgrounds online.

Step III

a. Refine your ideas in the form of sketches.

b. Choose the best sketches and create two roughs.

c. One side of the card should have text and the other side a visual.

d. Include the radio station logo and call number somewhere on a few of the cards.

Step IV

a. Design a box to hold the deck of cards.

b. Make sure the box design is related to the deck itself.

Step V

Create a comp of the cards and box.

> **Comments:** *When an unconventional application is something that an audience will find entertaining or useful, the brand will become endeared to the audience.*

Project 12-2

Get wild

Step I

a. Choose the same type of product and brand—for example, OTC pain relief medication—as you chose for Project 11-2 (in Chapter 11).

b. Utilize the same creative brief, amending it for an unconventional application.

Step II

a. Create an unconventional ad that relates to the ad concept you created for Project 11-2.

b. This time you must determine where and how the audience will receive the unconventional advertising message.

c. Produce ten sketches with at least three possible solutions.

Step III

Create a rough.

Step IV

Create a comp.

> **Comments:** *An unconventional application can support a traditional advertising campaign. Your goal here is to get the audience's attention in a respectful way.*

Project 12-3

Unconventional public service application

Step I

a. Choose a local food bank.

b. Gather information about it.

c. Write a creative brief.

Step II

a. Create an unconventional public service application to motivate people to donate food or money to the food bank.

b. See the list of possible (unconventional) advertising applications in this chapter for application ideas.

c. Determine how the audience would receive this unconventional ad.

d. Produce ten sketches.

Step III

Refine the sketches. Create two roughs.

Step IV

Create a comp.

> **Comments:** *Here is an opportunity to create an emotional connection with the viewer. Go for the gut or heart, but avoid clichéd images and statements.*

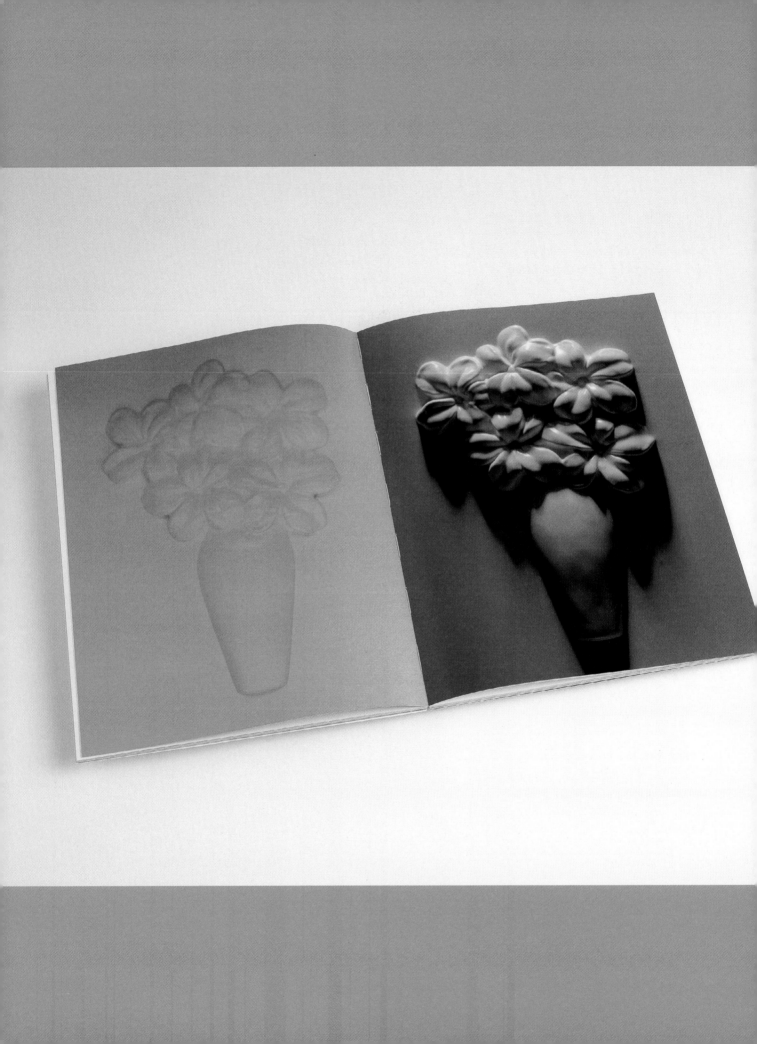

Purpose of an Annual Report

Components

Developing a Theme

Coordinating the Visual Elements

◀ Annual report: Zumtobel
Design studio: Sagmeister Inc., New York, NY
Art director: Stefan Sagmeister
Designers: Stefan Sagmeister and Matthias Ernstberger
Photography: Bela Borsodi
Client: Zumtobel AG

Objectives

Realize the purpose of an annual report

Identify the components that comprise an annual report design

Realize that an annual report is a hybrid visual communication tool

Understand that an annual report can be utilized in print, online, or both

Understand the role of a theme in annual report design

Organize multiple elements into one document

Comprehend the need for unity in a multipage corporate document

An annual report is a document of record, published yearly by a publicly held corporation, which contains information about the corporation's fiscal condition. Essentially, it is a required report to stockholders, and an important corporate document. This report—distributed to employees, stockholders, and potential stockholders—contains detailed information, such as the income statement, balance sheet, description of the corporation's operations, and general reports about management and operations. Given access to a corporation's information on the Internet, many investors, fund managers, securities analysts, and corporations still maintain that an annual report is the single most important document produced by a company.

Purpose of an Annual Report

Certainly, a web site and visual identity may carry more importance as visual communication tools; however, for a *single document*, an annual report still carries enormous credible weight in the minds of key players. Why? An annual report is not only a required corporate document, regulated in the United States by the SEC, it is also a marketing tool—a visual communication tool that conveys a corporate image. Some think of an annual report as a strategic positioning vehicle, as well. Since this document includes, very importantly, the discussion of financial results and the CEO's letter to investors, its message carries significant meaning to most of its target audience.

An annual report describes the state (health) of a company; it can be compared the United States President's "State of the Union" address, wherein the current state of affairs, as well as predictions and intentions for the future, are reported. Since the annual report is such an important single document, many people from a corporation contribute to its contents; for example, the CEO (chief executive officer), CFO (chief financial officer), controller, head of investor relations, marketing executive, COO (chief operational officer), corporate communications executive, and many others may contribute to a report's contents. Of course, none of these people design the report; they only contribute

content and strategy. One or more of these corporate executives—usually the corporate communications executive—works closely with a design firm to produce an annual report. The design team is responsible for:

- Generating the creative concept that drives the design
- Collaborating on or generating the theme of the annual report
- Facilitating agreement on the concept and theme
- Original photography and illustrations, making best use of available imagery, or choosing stock imagery
- Choosing and working with a printer
- Paper selection
- Guiding the production of the report
- Overseeing the onsite printing of the report
- Creating and producing the online report

Some designers specialize in the design of annual reports. "This field is specialized to the point that most clients want you to have experience in doing an annual report before they will ever trust you with one, which, of course, makes getting the experience rather difficult," says Denise M. Anderson, design director of DMA. Also, there are printers that specialize in high-end annual reports, since an annual report may require special techniques, binding, folding, and/or high-quality reproduction. Choosing a good printer is crucial; a winning design concept is hampered by poor printing. An annual report usually contains many pages, so the selection of paper is critical to how the printed piece will look. An informed printer or printer's representative can be a big help in choosing the right paper stock.

Components

Most annual reports are divided into two sections. The front of the report carries the editorial content, containing the most attractive marketing elements, such as photography or illustrations, the CEO's Letter to Shareholders, and thematic statements. The back of the report contains all the required statistics, what some call the "10K wrap." In fact, some may include the statistics as an insert on different paper, enclosed in a back pocket or stitched to the report.

Today, a corporate web site can host the required annual statistics (the "10K wrap"), leaving the printed annual report to be more of a corporate image tool, although still part of a required document. Some corporations post their entire annual report online—giving a visitor the ability to download an annual report in a PDF format—as well as publishing a print document. Depending upon the company, whether it is a Fortune 500 company, a recent Initial Public Offering (IPO), or a smaller corporation, the annual report may take more emphasis online than in print, or the parts may supplement each other. A Fortune 500 company can certainly afford to produce both superbly designed print and online annual reports.

Juggling many components—graphs, charts, lists, a large amount of text, product information, financial statistics, data, photographs, and graphic elements—is part of designing an annual report and demands the use of every design and problem-solving skill a designer possesses. Not only does one have to make a report, one also has to engage the public in reading what seems like dry information.

Leimer Cross solved that type of problem with an inventive technique-based concept as shown in Figure 13-1.

The importance of good compositional skills, and the ability to unify a large amount of information across a multipage document and make it accessible and relevant, cannot be underestimated. If the information is not easily accessible, the report fails, and shareholders would have good reason to be concerned. Annual report design is always a challenging layout problem. One must unify a multipage document, set up correspondence among all the information graphics and establish unity throughout the layout, while establishing correspondence among the visual elements, as illustrated in the annual report designed by Nesnadny + Schwartz (Figure 13-2). Red is used for the headlines, subheadlines, and introductory sentences, which establishes an

Figure 13-1

Annual report: Esterline Technologies
Design firm: Leimer Cross Design
Corporation, Seattle, WA

For this annual report, Leimer Cross
used the following unusual elements:

• A metal tag on the cover

• Colored close-up images (such as circuit
boards and cockpit switch light) on vinyl
inserts to make different important points
of information

• Inserts that lift to reveal graphs

Figure 13-2
Annual report: "Critical Research," The Cleveland Clinic Foundation
Design firm: Nesnadny + Schwartz, Cleveland, OH, New York, NY, and Toronto, Canada
Art directors: Tim Lachina and Brian Lavy
Designers: Brian Lavy and Tim Lachina
Writer: Steve Szilagyi, The Cleveland Clinic Foundation
Client: The Cleveland Clinic Foundation

In this annual report, unity is established by the clear use of a grid, correspondence in color palette, and the typographic design. On one spread, you can see how graphs are incorporated into the grid structure.

element of continuity. An unusual color palette in the statistical part of this annual report gives it a lively feeling. Besides great compositional skills and a pertinent design concept, a theme can help.

Developing a Theme

With the client or on his own, a designer usually chooses a theme as part of the development of a design concept for an annual report. A theme is "an implicit or recurrent idea; a motif." A chosen theme may relate to future growth, the people who make up the corporation, or any other related (or sometimes arbitrary, yet interesting) subject.

During the mid-twentieth century when corporations realized the importance of a corporate visual identity to the success of their businesses, they began to use the annual report as an opportunity to enhance their corporate identity and to "promote" their corporate message—the corporate ethos, drive, and main concerns. At times, a corporation's marketing message takes the form of a theme. For many companies, a theme is a way to make a statement, enhance a corporate image, highlight achievements or strong points, or explain major corporate actions. All visual elements—photography, illustration, graphs, and charts—should be visually related to the theme and corporate voice; the

Figure 13-3
Annual report: Heartport
Design firm: Cahan & Associates,
San Francisco, CA
Art director: Bill Cahan
Designer: Craig Bailey
Client: Heartport
© Cahan & Associates

"Heartport develops minimally
invasive cardiac surgery systems. Their
revolutionary procedure, Port-Access,
allows surgeons to perform many
procedures through small openings
between the ribs without cracking
open the chest of the patient. The
result is improved quality of life,
quicker recovery times, and much
less trauma than with conventional
open-chest surgery."

—Cahan & Associates

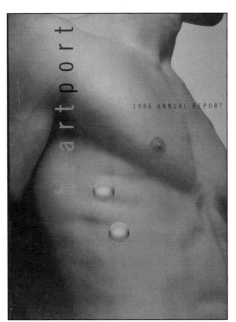

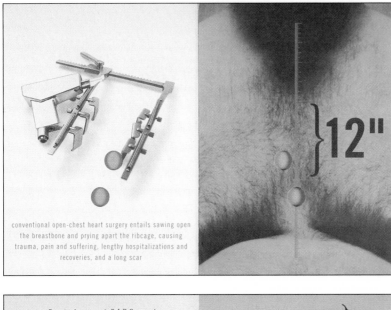

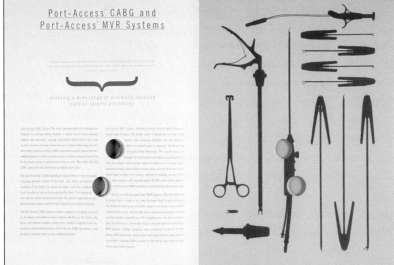

verbal tone of the copy also acts to create a corporate voice. The visual and verbal components must always be in sync.

Either the client or the design firm in collaboration with the client team can suggest a theme, which, for an annual report, must be seen as part of a larger corporate communication strategy. There are innumerable ways to generate a theme; the process is similar to generating a design concept. Some ideas that can be garnered from the strategy of the design brief are:

• Base it on the corporation's mission
• Base it on the corporation's charitable undertakings
• Base it on the CEO's letter, or any other research or information
• Use the corporation's accomplishments, activities, changes, or achievements of the past year as a springboard
• Use a brand icon, character, or product
• Use a general platform, such as family, giving, growth, advancement, development, or looking toward the future
• Use an intangible platform, such as responsibility, brotherhood, or fighting against tyranny
• Use a visual platform; for example visual juxtapositions, structure vs. fantasy, merges, or a high-tech look
• Use a reference, such as Cinco de Mayo, reason vs. passion, soccer, news, current events, or technology

Photographs and/or illustrations play a major role in the communication of the theme. Cahan & Associates' design, expressed both by theme and an appropriate technique-driven element (Figure 13-3), made a strong statement for Heartport. They commented, "Because the past year saw a critical mass of patients having this new minimally invasive procedure done, we created a small but many-paged book. The book is an examination of the return to normal life through personal photography and recovery stories told by the patients themselves." More than 800,000 people undergo conventional open-chest heart surgery each year, and Cahan & Associates utilized two holes in the report—a technique-driven visual element—to symbolize the fact that Heartport Port-Access Systems enable surgeons to perform a wide range

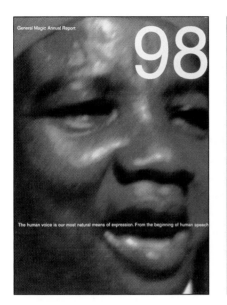

The human voice is our most natural means of expression. From the beginning of human speech

General Magic Annual Report

98

To Our Valued Shareholders: In 1998, General Magic entered an exciting new phase. In the second year after refocusing the company on creating and leading the market for voice-enabled services, we began to deliver concrete results. We launched our Portico™ virtual assistant service on schedule, set up distribution channels, and signed up subscribers. We also began trialing Portico with telecommunications carriers, and signed our first partnership agreement to bring voice-enabled services to the Internet. Also in 1998, we spun off our DataRover business and raised $44 million in capital. Both actions reflect our determination to put all our resources into successfully commercializing a new generation of voice-enabled services while developing the generation to come. All these services are based on foundation technologies that make General Magic a leader in voice-enabled services. These foundation technologies include our magicTalk™ voice user interface; the network operations center that hosts magicTalk applications; and our proprietary voice agent technology. Breakthrough with Portico One of the challenges we face in pioneering a new market is showing people something they can understand and get excited about. In 1998, we showed them Portico: a complete voice-enabled service that lets people access and act on their voice mail, email, calendar and address book as well as personalized company news and stock reports. Portico subscribers can do all this from any telephone, by talking with a virtual assistant using the same words and phrases they would use if they were talking to a human being: "get my email," "open my address book," and so on. Portico is a service that incorporates magicTalk and is hosted in our network operations center. Our initial target market for Portico is mobile professionals, who can readily benefit from the full range of Portico capabilities to simplify their busy lives on the road. We believe that Portico may be an equally good fit for individual entrepreneurs whose "corporate headquarters" is wherever they are at the moment. We are currently signing up Portico subscribers directly and through retail resellers of wireless services. At the same time, we are developing relationships that would enable us to host Portico for major telecommunications carriers, who would in turn offer the service to their subscribers. During 1998, a number of carriers launched internal trials of Portico. As I write, Qwest Communications International has advanced to a market trial and BellSouth Cellular Corp. is moving to initial deployment with subscribers. As important as Portico is in

Figure 13-4
Annual report: "Everyone has a voice"
Design firm: Cahan & Associates, San Francisco, CA
Art director: Bill Cahan
Designer: Bob Dinetz
Client: General Magic
© Cahan & Associates

"Though General Magic has interesting technology and product ideas, what seemed most compelling was the idea of your own voice being the next interface with the digital environment. People have been talking to their televisions, cars, and computers for years, and the human voice is the logical replacement from the graphical user interface (GUI). We made a case for voice as the most natural way to communicate throughout the world."

—Cahan & Associates

of heart operations through small incisions between the ribs. Also, note how color correspondence is established by using yellow on the right-side pages of the spreads.

For a company that leads the market in voice-enabled services, General Magic, Cahan & Associates used an accordion-fold format to link a wide variety of visual "voices" on one side of the report and display all the vital annual report information on the opposite side (Figure 13-4).

Coordinating the Visual Elements

Before attempting annual report design, you must be comfortable with the principles of design: balance, emphasis, rhythm, and, of course, unity. Finding a way to unify a multipage document is crucial. Using a flexible grid, selecting an interesting and clear numbering system, selecting a unified color palette, or choosing or designing corresponding graphic elements—these all contribute to unity. An alternative to a grid is a template—a compositional structure with designated positions for the visual elements, such as the title, page number, graphs, text, and other constant elements.

Unifying an annual report—with a measure of variety—is a formidable creative endeavor as this type of document contains informational graphic design applications such as charts, graphs, and data lists. Then, one must think of designing multiple applications within one unified document.

An annual report designer must consider the following major design decisions:

- Establishing a theme
- Relating all visual elements to the theme
- Coordinating a design concept and look for all *information* graphics related to the theme
- Setting up a color palette
- Designing a grid (and/or template) that can accommodate information graphics and text
- Determining the number and type of information graphics required
- Determining the type of visuals
- Selecting the font(s) or font family
- Determining print and online components

Nesnadny + Schwartz used cropped visuals and type to create a very graphic and contemporary look for the Progressive Corporation annual report (Figure 13-5). "Each year, Progressive commissions an artist or a group of artists to create a body of work for our annual report, which is inspired by a Progressive theme. This year, our inspiration was the American passion for car travel and the culture born from it. The artist is photographer Stephen Frailey. Stephen works by collaging found images to create new meaning from their juxtaposition. Frailey's work will become part of Progressive's growing collection of contemporary art," reported Peter Lewis of Progressive.

Each individual application contained within an annual report is a design problem in itself, yet each application must correspond to the other.

Figure 13-5
Annual report: "Be Progressive,"
The Progressive Corporation
Design firm: Nesadny + Schwartz,
Cleveland, OH, New York, NY,
and Toronto, Canada
Art directors: Mark Schwartz
and Joyce Nesnadny
Designers: Joyce Nesnadny
and Michelle Moehler
Artist: Stephen Frailey
Writer: Peter B. Lewis,
The Progressive Corporation
Client: The Progressive Corporation

The tree design is a federally
registered trademark owned by
Julius Samann, Ltd. and is used
here with permission.

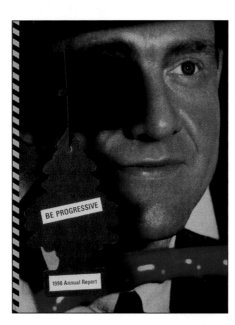

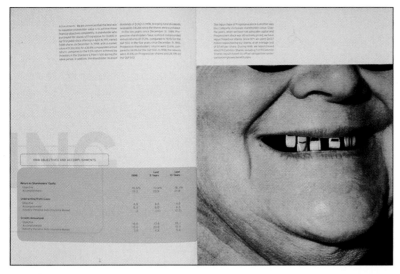

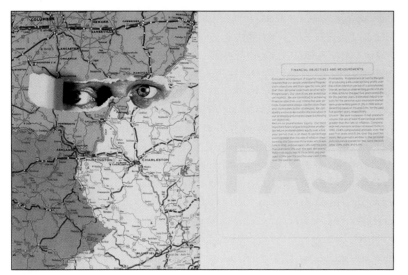

For example, one can design a table of contents that creates visual excitement and anticipation on the part of the reader (Figure 13-6). The stronger the underlying thinking, the stronger the overall effect of any annual report will be, as exemplified in the design shown in Figure 13-7, where all the visuals relate back to the concept and theme.

Suggestions

- Information gathering and research will enable you to design more effectively.
- Distill the information you've gathered into a workable concept.
- Start with a design concept (rather than a color palette or a favorite font).
- Every annual report must fulfill communication goals.
- Clearly organize all information for the reader.
- Make the financial information precise.
- Diagrams (charts and graphs) should be easily read and informative.
- Selection of photography or illustration should support the concept or theme.
- Generate interest in the company via the design concept and solution.
- Enable readability.
- Use the theme to highlight the company's achievements.
- All visual and verbal elements must comprise one larger, coherent message.
- Captions can support communication.
- Each company or organization has its own identity; make sure the annual report's look and feel is in step with the company's or group's established visual identity.
- Choose the printer and paper (cover stock and text stock) very, very carefully.

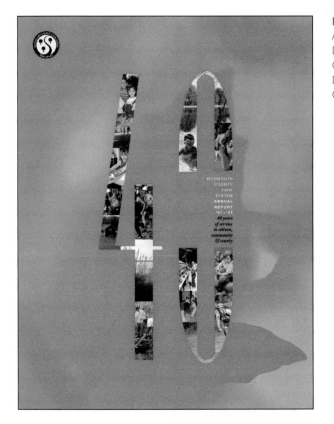

Figure 13-6
Annual report: Monmouth County Park System 2001
Design studio: Red Flannel, Freehold, NJ
Creative director/Art director: Jim Redzinak
Designer/Illustrator: Michele Kalthoff
Client: Monmouth County Park System

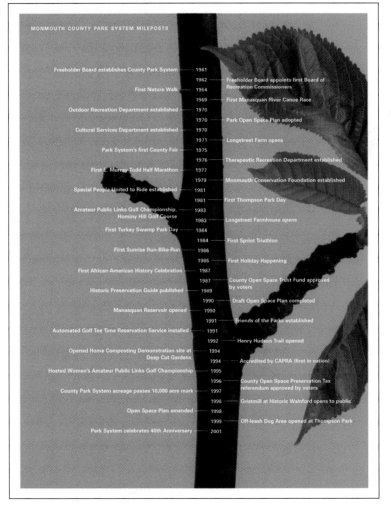

Figure 13-7
Annual report: Zumtobel
Design studio: Sagmeister
Inc., New York, NY
Art director:
Stefan Sagmeister
Designers:
Stefan Sagmeister and
Matthias Ernstberger
Photography: Bela Borsodi
Client: Zumtobel AG

"Zumtobel is a leading
European manufacturer
of lighting systems. The
cover of this annual report
features a heat-molded
relief sculpture of five
flowers in a vase,
symbolizing the five
subbrands under the
Zumtobel name. All images
on the inside of the annual
report are photographs of
this exact cover, shot under
different light conditions,
illustrating the incredible
power of changing light."

—Sagmeister Inc.

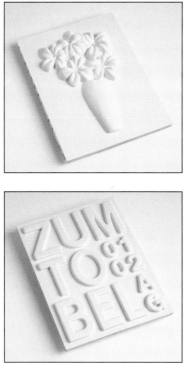

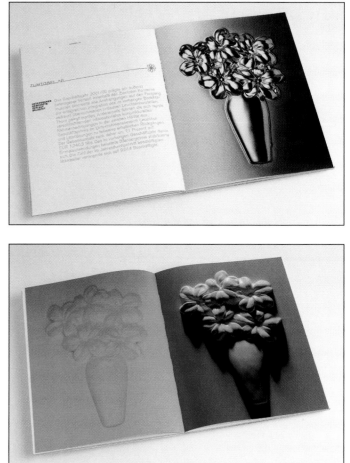

Summary

An annual report is a document of record, published yearly by a publicly held corporation, containing information about the corporation's fiscal condition.

Juggling many components—graphs, charts, lists, a large amount of text, product information, data, photographs, and graphic elements—is part of designing an annual report, and it utilizes just about every design and problem-solving skill that a designer possesses. Annual report design is always a challenging layout problem. One must unify a multipage document, set up correspondence among all the information and graphics and establish unity throughout the layout, while establishing correspondence among visual elements. Finding a way to unify a multipage document is crucial. Use a flexible grid, an interesting and clear numbering system, a unified color palette, and corresponding graphic elements—these will all contribute to unity. An alternative to a grid is a template.

A client or the designer can set a theme for an annual report as part of a larger corporate communications strategy. Each company or organization has its own identity; make sure the annual report is in sync with the company's or group's established identity.

Exercise 13-1

Becoming familiar with annual reports

Call or write to four corporations requesting copies of their annual reports.

Project 13-1

Annual report

Step I

a. Choose an existing corporation, or choose one of the following: a manufacturer of playground equipment, a nationally based visiting nurse service, or a web-based bookseller.

b. If you choose one of the three listed above, invent a name for the company.

c. Design a logo for the corporation, even if you've chosen an existing corporation.

Step II

a. Choose a theme for the annual report.

b. Collect visuals to support your theme.

Step III

Design a grid.

Step IV

Design a cover.

Step V

Design the following pages and spreads:

• letter to the shareholders from the CEO

• future growth page

• two theme-based spreads

• one page of statistical information, including a simple graph or chart

Presentation

Present your solution either on CD-ROM or create a dummy to be inserted into a mat board with a pocket.

Comments: *Make sure you have established correspondence among the visual elements, a consistent color palette, and unity with some variety throughout the pages.*

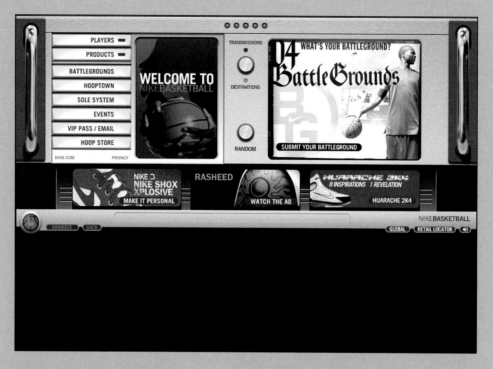

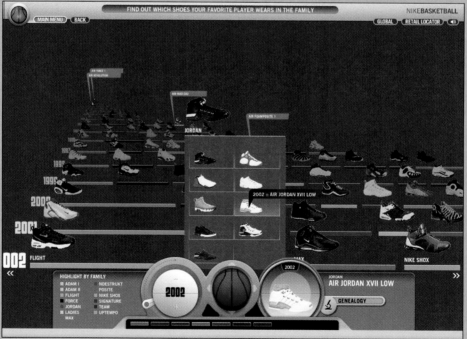

Web Design—the Big Picture

Web Site Development

Employing Basic Principles
of Design

Approach to Promotional Sites

◀ Web site: Nike Basketball, 2004
www.nike.com/nikebasketball/
Company: R/GA, New York, NY
Producer: Shawn Natko
Copywriter: Jason Marks
Art director: Nathan J. Iverson
Lead designers/Flash designers:
Andy Hsu and Joseph Cartman
Interaction designer: Richard Ting
Flash animator: David Morrow
Lead programmer: Chuck Genco
Programmer: Charles Duncan
Quality assurance: Tracey Carangelo
and August Yang

Objectives

Realize the function and purpose of a web site as an interactive experience

Identify different digital design applications

Appreciate web design as a collaborative effort

Specify types of online design solutions

List key parts in web site development

Understand the role of content, design concept, and information architecture

Become aware of navigation systems and links

Become familiar with the organization and basic design principles as applied to web design

Learn about approaches to promotional web sites

Understand the role of a grid and template in web design

Remember to keep the user's point of view in mind

W e have always been involved with and engaged by compelling graphic design—contemplating a CD cover while listening to the music, studying an interesting magazine cover, or laughing at a funny TV commercial. Web design, however, secures the viewer's involvement with a compelling and engaging interactive experience, provided the interactive experience is well designed. The viewer can become an active participant (user) by making choices: visiting the site, moving forward and backward through the site, entering information or comments, and generally interacting with content at various points. The user can search for and download information, purchase products, play games, enter contests, watch movies, animations, and videos, and—let's not forget—read information and fiction, obtain news, and take academic courses online.

Web Design—the Big Picture

Technology is evolving every day. Digital media presentations, applications, and uses for visual communication will change and significantly evolve over the next few years. Unlike designing for print media, it takes a team of experts to develop and execute web design applications, usually including a lead creative team (a creative director, art director, and designers) and information technology professionals, as well as producers, writers, animators, programmers, testers, the client, and perhaps even a cognitive psychologist or social anthropologist (who might provide insight into or predict visitor behavior). Designing for digital media is a collaborative effort that needs to meet industry standards, involves many different professions, and requires testing, maintenance, publicity, site seeding (where web sites are indexed into database search engines), and, most likely, updates or redesign. It is an ongoing, developmental process.

Web designers must work cooperatively with information technology (IT) professionals. These professionals must respect one another's expertise and contribution to the development of an operating online design applica-

tion; each must learn to respect the other's professional methods. They also must respect the user—making the web site's experience clear, useful, and frustration-free, alleviating any performance problems in the design and offering the user a media-rich experience. A collection of "pages" or files linked together and made available on the World Wide Web, web sites are authored and owned by companies, organizations, and individuals. The selection and coordination of available components to create the layout and structure of a web site requires a specialized knowledge base that spans a broad range of disciplines. Web design involves strategy, collaboration, creativity, planning, design, development, and implementation.

Compared with print, digital media is in its infancy; however, a good deal of it has become an integral part of our lives. Design applications that are digital or may be used in a digital format include:

- Web sites:
 - Public service/nonprofit
 - Product or service (brand) promotion
 - Institutional promotion
 - Self-promotion
 - News reference/education
 - Hybrid/experimental game/entertainment
 - Advertising
 - Transactive
 - Integrated branding campaigns
- Banner ads/floater ads
- Games and entertainment
- Instant Messaging backgrounds (ads as backgrounds for any digital application)
- Icons
- Animated logos
- Web films and videos
- Webisodes
- E-mail newsletters
- E-mail templates
- E-mail marketing
- Animations created with a software program such as Flash

 Digital formats that carry content include:
- Web sites, intranets, and extranets
- Interactive kiosks and installations
- CD-ROMs

- Interactive posters and digital signs
- Software interfaces for mobile digital devices such as cell phones and notepads

Although many of the elements and principles discussed in this chapter will apply to all the formats listed above, web and online design is our main focus.

Design agencies and studios that develop interactive (a word that has come to denote this specific area of visual communication) can solve a variety of graphic design problems for use by a brand or group. The most common solutions include:

- Launch of a web site
- Redesign of a web site
- Re-architect a web site
- Design and redesign of a global site with room for local marketing differences
- Design of an integrated campaign
- Animated presentations using software such as Flash

Web Site Development

As with solving any graphic design problem, there are various stages in the design and implementation process of a web site design. Besides the usual stages of creating proposals and creative briefs, the web design application process requires thorough prototyping, where a paper version of the site is created and tested for usability. The key steps in this part of the web site development process are:

1. Business proposal—a strategy statement to guide the goals and objectives of the web site

2. Creative brief, which outlines the creative strategy, audience, and concept

3. Establishment of exact content and information architecture (functional specifications)

4. Visual and creative specifications (color palette, typeface, grid, style of graphic interface [link buttons], style of photos and other imagery, placement)

5. Prototyping—paper is used to represent each web page to test usability. Focus group testing (performing a task using the paper prototype) enables online designers to refine the design. Often, very large sites are tested as "text only" sites on-screen without paper.

6. Visual design

7. Technical construction

A design concept is the driving idea—the backbone—of the planning for any interactive solution; it must be based on the content, strategy, and the established spirit of the brand or group. Related to design concept development is that of formulating a theme; some interactive designers, such as Hillman Curtis, often utilize a thematic approach.

The brand image, conveyed through concepts and visual design, should be consistent across all media in order to sustain a brand. Usually, there is a lead agency or studio that establishes the strategy/concept-base for a marketing effort or integrated campaign. There must be a consistent "look and feel." If there are print or offline graphic design applications for this same brand or group, then there should be online and offline campaign integration; one design should be informed by the other, and the entire branding program should be consistent. For example, a web site design for a retailer may want to reflect the same type of shopping experience that the visitor has in the actual store, or the design may duplicate online the layout and look of the store itself.

Content is the body of information that is available to visitors on a web site. It is the subject and substance of the text and graphics. Content can include general information, data, and entertainment; information that enhances knowledge and interest in the brand, institution, or social cause; downloadable or printable material; and interactive "goodies" such as contests, giveaway items, and games. Content should be well organized and easy to understand and access.

When providing content, good writing should always be a priority. Rules of writing apply to the Web and other new media, the same as to any print media. How well the headlines and copy or text is written will greatly affect communication. Good editing also applies; succinctness and clarity are main goals. Make the message clear; weave it into the theme and user experience.

Information architecture is the careful organization of the web site content into hierarchical (or sequential) order. For a user to be able to easily move through—or *navigate*—a web site, the content must be organized and structured in

a logical way, from general to specific. A clearly organized information architecture is crucial to giving the user a positive and frustration-free experience, especially for text-heavy web sites, such as editorial sites (online magazines and newspapers), archives, museums, and government sites. The information architecture is the designer's guide to the overall composition of the web site and hierarchy of individual graphic elements.

Navigation Systems

Once a simple, clear, and user-intuitive information architecture has been established, a designer creates a corresponding "push-button" system, or a graphic interface, for accessing the information. The visual design of information architecture is the **navigation system**. A consistent visual structure is equally critical to the ease of use of the web site and a frustration-free user experience. Often, a web site will have several levels of navigation, including:

• Portal navigation that leads to many other web sites

• Primary global or meta navigation within one web site

• Secondary or subnavigation (for second tier information)

• Single web page navigation

A well-designed web site will have a streamlined visual layout that provides an immediate sense of location at all times, one that offers consistent elements from page to page. Whether the web site is three screen-pages or a hundred screen-pages in size, a plan is necessary for leading the viewer through the site.

Links

All navigation systems consist of visual and digital "hot" **links** that connect one location on a web page to another location, which can be at the same web site or a different one. A link—also called a hyperlink—is the term used to indicate the text or visual area that a user selects by clicking the computer mouse directly over it.

The visual areas of links are referred to as tabs and buttons. Tabs are simply graphic interface metaphors based on the function of tabs on file

Compared with print, digital media is in its infancy; however, a good deal of it has become an integral part of our lives.

folders. Buttons can be in any shape (not just a disk shape). Both tabs and buttons are interactive links. The visitor must recognize that the graphic—the tab or button—is "clickable" and can be used to move to the next screen or offering. It is critical that tabs and buttons are clear, simple, and consistent in style, shape, and color so the visitor can recognize clickable links and move quickly and efficiently through the site. Color in particular is a strong visual "flag" that the visitor can immediately recognize. Our mind tends to see and register color before it does shape, therefore it is most important to use color clearly, effectively, and consistently. If red is chosen for a button on the home page or global navigation of the site, then that color red should be used exclusively for this purpose throughout the site and for no other nonclickable graphics or information.

A button is used to make selections; however, buttons do not necessarily have to look like little round disks. They can be graphic forms of any shape or they may be imagery that creates a visual metaphor. For example, in the web site designed by R/GA for Levi's 150th anniversary (Figure 14-1), the navigation imagery is a visual metaphor. R/GA chose "a stack of cards that echoes the Levi brand's iconic red Tab. Beginning in the 1850s and continuing to the present, each card correlates to a particular decade, and as the user zooms in on a decade, the card evolves into a richly textured mural or 'quilt' reflecting the spirit of the era . . . Within each decade there is a simple lateral navigation tool that allows users to travel across the decade murals and a 'rabbit hole' to drill-down into past decades within the same category," writes R/GA.

If the information architecture and navigation system graphics are well designed during the initial phase of web site development, any subsequent phases or developments in the design will be easily facilitated. A plan of how the pages will "flow" will ensure easy navigation and give a sense of where a visitor is—a sense of location/geography—anywhere throughout a web site. Some designers use a storyboard or flow chart technique to determine the flow of the site plan.

Elements of Design

Tools that aid in designing the site include grids, templates, and graphics. A grid is the central ordering system, a framework, used to create a uniform layout from page to page, while allowing for some variation. The grid splits the page into columns with defined widths, spacing, and margins, to establish positions for the standard elements on the page and alignment of

Figure 14-1
Web site: Levi's 150th anniversary, 2003
www.levistrauss.com
www.levi.com
Company: R/GA, New York, NY
Producer: Anja Ludwig
Lead art director: Kris Kiger
Art director: Winston Thomas
Designer/Flash designer: Patrick Kalyanapu
Designer: Ufoma Whiteru
Production artist: John James
Interaction designer: Lori Moffett
Backend developer/Tech lead/Interaction designer: John Jones
Flash programmer: Ted Warner
Programmer: Charoonkit Thahong
Technical consultant: Ed Bocchino
Quality assurance: Edwin Quan and Daniel LaPlaca

An immersive experience that pushes the boundaries of online design and reflects 150 years of Levi Strauss & Co.'s innovative spirit that started with the creation of the blue jean.

text and pictures. Often, there is more than one grid per online design to allow for the different types of content and applications.

The template is a master pattern, based on a grid and used to guide the placement of every element—text, headers, and graphics—in the web design; a template system is a group of templates related in visual design. By maintaining a visual grid, the visitor will have an easy time locating titles, information, and navigation graphics, thus enabling a smooth passage around the site. A template is created so that the design is consistent and content can be easily loaded. The graphics are the visuals or images, which include navigation tabs and buttons, photographs, illustrations, trademarks, graphic elements, and logos.

A **splash page** is the first screen the visitor sees; it serves as an introduction to a web site and usually features animation or an engaging visual. The splash page does not have navigation, and when the animation is over, the home page comes up.

The **home page** is the primary entrance to a web site that contains the central navigation system. A visitor can also sometimes enter via a link to a page other than the home page. The home screen is more than a title page—it gives the visitor a central navigation system and contact information, and establishes the "look and feel" of the site. If a visitor finds a home page engaging, he is more likely to be drawn further into the site. The home page can set the tone for the entire web site experience. The colors, graphics, textures, and spatial illusions set up an emotional level of expressiveness. If the home page displays moving graphics that twist, turn, and flip, the visitor will expect this playful activity throughout the site; a home page with clean, still imagery will cause visitors to expect this same simplicity everywhere else.

Employing Basic Principles of Design

Like any other graphic design solution, an online design necessitates knowledge of graphic design principles and idea generation. The design of a web site or other online experience should arise in response to the strategy, creative brief, concept, content, and usability, as well as to the entire branding or identity design. If the designer fully understands the content, then the graphic design solution becomes a natural outgrowth of that content. Ideally, the online graphic design solution is a function of usability, communication design, and the visual theme of the site, which amplifies the user's experience, best presents the content, and, for the user, promotes an emotional connection to the content.

Fundamental graphic design elements and principles apply to web design. Understanding how to use the formal elements of line, shape, color, value, texture, and the principles of balance, visual hierarchy, focal point, emphasis, rhythm, and unity (with an accent on correspondence) is a necessity. Web technology may be changing rapidly, but graphic design principles are constants.

Michael O'Keefe, information systems designer, BMW Group, implores, "Guide someone through a site, so it's not random, almost like a guided tour." It is best to establish a visual grid (a repetitive, modular compositional structure) to create an identity, help maintain order, create a sense of "geography and location," and make it easy for the visitor to quickly locate various options and information. With a strong layout or grid, the visitor will have a smooth passage through a formidable amount of information.

Layout Organization

As with any layout, there are several goals in a web design: fit elements into a limited space, arrange elements so that they are functional and accessible, and arrange elements engagingly. Before deciding on a grid or layout, here are some things to consider:

• *Audience.* The nature of the audience will help you determine how eccentric or conservative a web design you can create.

• *Amount of information.* If you need to post a great deal of information in a limited space, a grid is essential. A small amount of information allows you greater freedom to use visuals and play with a layout.

• *Purpose.* The purpose of the web site guides your design. An informational site may restrict you because it is primarily practical; the visitor is there to conduct research and to gain information quickly and clearly.

• *Message.* What message needs to be communicated? The tone or substance of your message may help you decide on the type of design.

• *Updates.* How often will it be updated, and who will update it? Almost always, the person loading the content is neither a designer nor an information technology professional; therefore, the template has to be clear and easy to use.

Visual Hierarchy

A visual hierarchy is as important on a web site as it is in print. You must direct the visitor's attention. Establishing a visual hierarchy allows the visitor to see, at a glance, informational or graphic elements (visuals or type) in the order of their importance.

Begin by choosing a focal point and go from there. Using the same factors you would in print—such as size, value, color, and visual weight—establish the flow of information from the broad message to the specific.

Unity

Unity refers to the level of consistency and correspondence throughout a site.

It's critical to make sure the entire site has a visual hierarchy of information and that each page is equally interesting and consistent in concept and visual look with the home page. Creating visual correspondence among the pages—unity throughout the entire work, rhythm from page to page, and a flow from page to page—is crucial. Providing a sense of location for the visitor is equally important. For instance, the home page link should be visually consistent (the same shape and in the same spot on every screen page) throughout the site. In addition, each screen should have a title in the same spot so the visitor knows exactly where to look to determine their "location" on the site. The visitor should never think, "Where am I?" without knowing where to look for the answer.

The problem of unity in a web site design is similar to establishing unity in a song; they are both experienced in "chunks" or sections. "There are many ways to create unity in music; one of the most prevalent might be generally called 'thematic processes,' for example, the repetition of some recognizable musical chunk, let's say a melody, in a slightly altered form at various points in the piece. Notice that such a strategy assumes that some aspect of the 'chunk' changes while something else stays the same," notes Professor Matthew Halper, of the music department at Kean University of New Jersey.

Color

A web page designer does have special considerations regarding color. When you design for print and see your design through production onsite at the printing facility, you have a good amount of control over the final color. Not so with web design. You can't control the color on the monitor of every web user, especially considering that Macintosh systems display color at a lighter value than non-Mac systems. Also, color palettes on web browsers are limited. It's best to view your design on all types of systems and browsers to ensure your color is balanced. Consult a technology-based manual on web color for limitations and cross-platform use, and functionality, which refers to how the site design works on all platforms, web browsers/versions, and modem/line speeds.

Style

The style of a web site can be as varied as that of a print ad. It can utilize photography or illustrations or a combination of both. It can be classic in composition or edgy. The tone may be irreverent, humorous, formal, conservative, or provocative. Certainly, the tone should work cooperatively with the style. Please keep in mind this advice from Landor Associates, Branding Consultants and Designers Worldwide: "Keep it clean and simple."

Some web designers use themes to establish a common thread throughout a site, to deliver the content as in a story. If you can identify a theme that best tells your group's or brand's story, that

Establishing a visual hierarchy allows the visitor to see, at a glance, informational or graphic elements (visuals or type) in the order of their importance.

theme can be used as a consistent design element (images, color palette, and typography) throughout to drive the flow of the design.

Approach to Promotional Sites

Advertising on a web site is no different from advertising in print or on television in this way: If it's not attractive, seductive, or interesting, no one is going to pay attention to it. In fact, at this point in time, web advertising has to be a little more seductive because it requires downloading time and more patience on the part of the visitor.

According to Giles Felton of *The New York Times* e-commerce section, a good site is one that has "stickiness," a marketing buzzword. "A sticky site is one that keeps users glued to it, either through sheer intrinsic niftiness or by piling layer upon layer of more-or-less related offerings, like stock quotes, weather updates, or interactive whiz-bangs like sports trivia quizzes," writes Felton.[1]

Companies and corporations—small, medium, and huge—develop web sites to sell or promote their products and services. To a brand or group, the Web offers an adaptable home base to inform or promote. Educational institutions have web sites (Figure 14-2); governmental agencies, health organizations, and nonprofit groups—for example, GoodCity (Figure 14-3)—utilize the Web to inform audiences, provide data, and allow research.

A rich user experience is where the web site actually performs or offers value, one where the visitor is not just passively looking through it, according to Michael O'Keefe. A shopping site offering rich media (audio, video, Flash animation), where one can transact with another entity and make selections such as Nike Lab, is a rich user experience (Figure 14-4). Brochure on demand is also a rich user experience.

For inspiration, researching well-designed, award-winning web sites is the best way to see

Figure 14-2
Web site: Tisch School of the Arts, New York University, 2003, *www.tisch.nyu.edu*
Design firm: R/GA, New York, NY
Creative director: Nick Law
Art director: Nick Law
Designers: Nina Schlechtriem, Brandon Malloy, Andy Hsu, Christian Kubek, Davie Eng, Garry Waller, Jerome Austria, and Maria Over
Interaction designers: Dixon Rohr, Dan Harvey, and Ryan Leffel
Producers: Lee Passavia and Adam Blumenthal
Production coordinator: Patrick Soria
Programming: Ed Bocchino and George Mathes
Copywriter: Cheryl Brown

The Tisch site serves as a main gateway to communicate its impeccable credentials in the fields of art and education to a broad group of users, including faculty, current students, and prospective students. R/GA created a flexible, user-centric site where information was organized in a fresh, intuitive way. A global navigation system ensures consistency across the site, while highlighting services that are relevant to many audiences. The site design maintains enough flexibility to allow each department the ability to create its own distinctive imagery, color, and content.

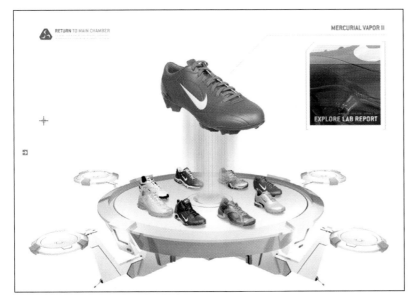

Figure 14-3

Web site: GoodCity

www.goodcitychicago.org

Design studio: SamataMason, West Dundee, IL

Art director: Greg Samata

Designer: Billie Knipfer

Copywriter: GoodCity

Photographer: Sandro

Client: GoodCity

"GoodCity is a nonprofit organization serving the Chicago area. They help to build better communities by empowering neighborhood, religious, business, and civic leaders to effectively address local needs. Through the support of GoodCity, many people are able to transform their visions into a reality."

—SamataMason

Figure 14-4

Web site: Nike Lab, Spring, 2004

www.nikelab.com

Design firm: R/GA, New York, NY

Producer: Jennifer Allen

Art director: Jerome Austria

Visual designers: Gui Borchert, Mikhail Gervits, and Hiroko Ishimura

Flash developers: Lucas Shuman and Veronique Brossier

Interaction design: Carlos Gomez de Llarena

Copywriting: Jason Marks

Quality assurance: August Yang

"NIKELAB.com is Nike's showcase of performance innovation—a completely interactive experience that lets customers learn about Nike's innovative products through cutting-edge graphics and original episodic content. The theme for Spring 2004 is Vapor Station. The concept is based on a futuristic Nike research center where the secrets of speed are studied and unlocked. Each chamber inside Vapor Station houses a facet of Nike's obsession with speed, from interactive product stories, to curated video compilations, to speed experiences created through collaborations with digital artists."

—R/GA

what is possible in designing navigation buttons. Almost all the visual communication trade magazines, such as *One Club Interactive, Print,* and *Communication Arts,* publish interactive annuals of award-winning new media design.

A designer can use all of his or her advertising know-how to promote a brand or group on the Web. The irreverent and fun site by Planet Design Company is aimed at a young audience (Figure 14-5), in contrast to the site aimed at an adult audience by Liska + Associates shown in Figure 14-6. An advertising agency's own web site has to set a tone for the agency (Figure 14-7).

Anyone who uses the Web on a regular basis has an opinion about banners. Certainly, all

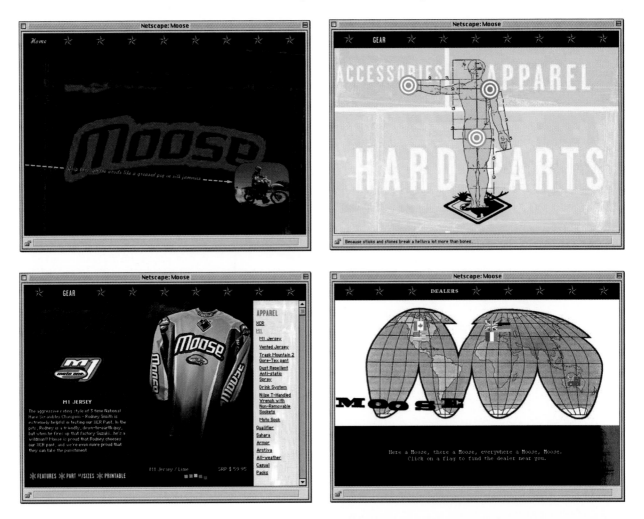

Figure 14-5
Web site: "Moose"
Design firm: Planet Design
Company, Madison, WI

Figure 14-6

Web site: Brininstool
+ Lynch
www.brininstool-lynch.com
Design firm: Liska +
Associates, Inc., Chicago,
IL, and New York, NY

Figure 14-7

Web site: kirshenbaum
bond + partners
www.kb.com
Ad agency: kirshenbaum
bond + partners,
New York, NY

would agree that a banner must grab interest in order to be effective (Figures 14-8 and 14-9).

Many people are looking online for information or to conduct research. They may be shopping or browsing, or simply looking for something interesting, something they are passionate about; for example, Nike Basketball offers ardent basketball fans fascinating information (Figure 14-10), and the Art Directors Club (ADC) web site offers a rotating gallery of stimulating visuals selected from the ADC archives of annual award winners (Figure 14-11).

Important Points

What are the most essential considerations for web design?

- Immediately engage the viewer
- Value the visitor's time
- Allow ease of access to content
- Offer or do something that traditional advertising media or graphic design can't
- Give a media-rich experience
- Get the visitor to interact

Figure 14-8

Boxer banner and landing pages: Sony Ad agency: kirshenbaum bond + partners, New York, NY

Figure 14-9

Slider banner and landing pages: Sony, Dating Game Ad agency: kirshenbaum bond + partners, New York, NY

Figure 14-10
Web site: Nike Basketball, 2004
www.nike.com/nikebasketball/
Company: R/GA, New York, NY
Producer: Shawn Natko
Copywriter: Jason Marks
Art director: Nathan J. Iverson
Lead designers/Flash designers:
Andy Hsu and Joseph Cartman
Interaction designer: Richard Ting
Flash animator: David Morrow
Lead programmer: Chuck Genco
Programmer: Charles Duncan
Quality assurance: Tracey Carangelo
and August Yang

"The site was created to deliver the most up-to-date information on basketball to an audience that treats basketball as a way of life. Sole System is a digital universe of Nike basketball shoes, an ever-evolving visual database of the last three decades of Nike hoop technology and Nike shoes."

—R/GA

Points to Consider

When designing an interactive experience, always keep the visitor's point of view in mind.
• Does it enable communication? Is it easy to navigate? Can I gather the information I need?
• Is it frustration-free?
• Is it relevant to me? Would I want to return? Does it create a worthwhile "dialogue" with me? Is the online experience worth my time?

• Am I getting something here I can't get elsewhere (a media-rich experience)?

People may be seeking information on a social issue or a charitable organization; they may also search for information that has nothing to do with a brand. Information should be easy to glean from a web site. Content should be easy to find, read, and print or download. It is acceptable to allow content to be "found" sometimes;

Figure 14-11
Web site: The Art Directors
Club (ADC), Spring 2004
www.adcglobal.org
Company: R/GA,
New York, NY
Producer:
Adam Blumenthal
Visual design: Natalie Lam
(Art director), Nick Law,
Christian Olson, and
Nina Schlechtriem
Interaction design: Mauro
Cavalletti and Racha Tarazi
Programming: John Jones,
Lisa Trujillo, and
Edwin Quan
Copywriting: Cheryl Brown

"The design of the new
ADC web site draws from
the rich content of the
83-year-old institution,
focusing attention on the
work seen and celebrated
by the ADC. The anchor
of the site is 'Inspiration,'
a rotating gallery of
stimulating visuals selected
from the ADC archives of
annual award winners.
The site also celebrates
ADC's Hall of Fame
laureates, Young Guns
competition winners,
promotes the range of
exhibitions and events
hosted by ADC, and
invites site visitors to
register online for ADC
membership. All sections
of the site feature work
across all media from
TV and radio to print
and interactive."

—R/GA

however, some content should be brought to the immediate attention of the visitor.

An online designer must juggle many important general objectives.

• Enable communication and create visual order, so that information can be gleaned and understood.

• Create visual impact and visual interest.

• Communicate strategy through execution.

• Provide an interesting, unique, and engaging emotional and/or intellectual experience.

• Communicate a positive and appropriate image.

• Provide a visual and interactive vehicle that will allow a relationship to form between brand or group and visitor.

A brand or group is represented by the site; if the design is well thought out, then the public perception of the brand or group may be positive. If the site design is cluttered, amateurish looking, or carries no visual impact or interest, then the brand or group may seem similarly unprofessional.

"Many interesting, innovative designs on the Web are not promotional sites. The future of the Web is about distribution of vast amounts of information. Therefore, the best web designers will be those who can grasp envisioning information most efficiently while still being visually engaging," asserts web designer, Professor Rose Gonnella, Kean University of New Jersey.

Clear design establishes a vision, a feeling, or an emotional level for a brand or group. It allows information to be gathered in an easy way and enhances communication on the most fundamental level.

Summary

Companies and corporations—small, medium, and huge—have web sites to sell or promote their products and services. To a brand or group, the Web offers an adaptable home base to inform or promote. Educational institutions have web sites; governmental agencies, health organizations, and nonprofit groups also utilize

the Web to inform audiences, provide data, and allow research.

It takes a team of experts to develop and execute web design applications, usually including a lead creative team and information technology professionals, as well as producers, writers, animators, programmers, testers, the client, and perhaps even a cognitive psychologist or social anthropologist. Designing for digital media is a collaborative effort that needs to meet industry standards, involves many different professions, and requires testing, maintenance, publicity, site seeding (where web sites are indexed into database search engines), and, most likely, updates or redesign. It is an ongoing, developmental process. The web design application process requires thorough prototyping, where a paper version of the site is created and tested for usability.

A well-designed web site will have a streamlined visual layout that provides an immediate sense of location at all times, one that offers consistent elements from page to page. Whether the web site is three screen-pages or a hundred screen-pages in size, a plan is necessary for leading the viewer through the site. Like any other graphic design solution, an online design necessitates knowledge of graphic design principles and idea generation. The design of a web site or other online experience should arise in response to the strategy, creative brief, concept, content, and usability, as well as to the entire branding or identity design. When designing an interactive experience, keep the user's point of view in mind.

Notes

[1] Giles Felton, "How to Talk Dot-Com Like a Webmaster," *The New York Times*, Wednesday, 22 September 1999, late edition, sec. G, p. 3, col. 3.

Nick Law
Creative Director
R/GA

Nick Law joined R/GA with a breadth of experience spanning many disciplines and continents. He has overseen creative executions at the most senior levels on print, advertising, branding, packaging, and interactive design projects, and is responsible for defining and delivering creative projects for design engagements, especially focusing on new business initiatives and R/GA marketing efforts. Prior to joining R/GA, Nick was creative director at FGI; a senior designer at Deifenbach Elkins (now FutureBrand) in New York; a senior designer for DMB&B (D'Arcy Masius Benton & Bowles) in London; and the founder and owner of Studio Dot, an Australian-based creative firm. Nick began his career at Pentagram in London. He has earned many international awards and been published in the United States, Australia, and Britain.

Designing for Interactive Mediums

There is a quaint belief among the design community that design is an international language. As anyone who is mystified by the Beijing Opera or thrash metal music can testify, it is a claim not even music can make. Design is many languages. With the disintegration of the mass market, these languages are multiplying to reach ever more specific audiences. Propelling this fragmentation is the Web—a channel that connects and atomizes the world simultaneously. For those of us in visual professions, the Web has become a dynamic, democratic, and idiosyncratic design bazaar.

Thanks to its ever-broadening band, the Web has also become a medium where film, music, art, culture, and commerce meet. It is the only channel where all the creative disciplines come together to entertain, inform, and transact—all at once, all the time, everywhere, and for everyone. Art directors, designers, typographers, photographers, animators, filmmakers, and information architects all contribute and collaborate. Embracing the breadth and depth of the interactive canvas is the first step to designing for the Web.

During the first years of the Internet, everything (including its impoverished aesthetic) was shaped by bold young techno fetishists.

It's easy to forget that this new interactive medium is so young. During the first years of the Internet, everything (including its impoverished aesthetic) was shaped by bold young techno fetishists. Only recently have well-rounded designers stepped forward to push pixels. For those trained in disciplines like advertising, identity, and print design, the hardest part of designing a web site is dealing with its additive process. For designers who

have been trained to subtract elements and distill meaning, this can be counterintuitive. While the success of an ad, logo, or billboard is judged by its ability to convey a simple powerful idea, the value of a web site is often based on its ability to provide multiple experiences—not only to attract, but also to remain attractive. In most cases, designing a web site is an ongoing process of bringing clarity and appeal to this depth and complexity.

Any medium can be hamstrung by trite design doctrines, but to impose such a thing on interactive is a tragic denial of its kaleidoscopic nature. That's not to say there aren't budding design principles and standards emerging from the chaos. Designing for the Web often requires using standard conventions such as left-hand navigation, search boxes, and underlined links. The trick is to do so without sacrificing a dramatic branded experience; slavish adherence to standards does not make a Nike site Nike.

Most of us in the graphic design profession are accustomed to dividing our colleagues into stylists and conceptualists. While these sensibilities are found in visual designers on the Web, there is an even more profound division between what we at R/GA call systematic designers and experiential designers.

A systematic designer's strength is in making information-rich web sites coherent. Using the classic design elements of color, shape, and composition, together with typographic and iconic systems, they create a sensible hierarchy of entry points into a page. They emphasize and enhance the information architect's functional intent. At a time when more and more people are using the Web as not only a source of information, but also of entertainment, there is a great need for experiential designers—designers who understand how to weave multiple narratives and bring drama to interaction.

Whatever your design aptitude, your willingness to collaborate is central to becoming a successful interactive designer. In the interactive medium—just as the name suggests—there are no solitary practitioners.

At a time when more and more people are using the Web as not only a source of information, but also of entertainment, there is a great need for experiential designers—designers who understand how to weave multiple narratives and bring drama to interaction.

Exercise 14-1

Becoming familiar with web sites

Visit and analyze the web sites of several major companies; also visit editorial, governmental, and nonprofit organization web sites, as well as the web sites of several advertising agencies and graphic design studios.

Project 14-1

Web site

Step I

a. Choose an existing corporation, or choose one of the following: an Internet auction house, an online magazine, or a state or city tourist board.

b. If you choose an Internet auction house or an online magazine, invent a name for the company or magazine.

c. Design a logo for the corporation, even if you've chosen an existing corporation.

Step II

a. Choose a theme for the web site.

b. Collect visuals to support your theme.

Step III

Design a home page.

Presentation

Present your project either on CD-ROM or mat on one 11″ x 14″ board with a 2″ border.

> **Comments:** *Remember, most visitors are impatient. The Web is still slow to load. It is best not to slow the loading time further with too many complicated graphics and tricks. Interactive design needs to be simple, clear, and visually engaging.*

Part III:
Careers

WHILE AT HER CORPORATE OFFICE IN JERSEY CITY, DESIGNER SHANA RUBIN-RIVERA RECEIVES A SURPRISING MESSAGE...

FIZZT! SECURE COMMUNICATIONS CHANNEL CODE 1701-ALPHA. FIZZT! TRANSMISSION COMMENCING:

SHANA! IT'S STEVE. WE HAVE A SITUATION. ADONJ COMMAND NEEDS US RIGHT AWAY. THE CALL FOR ENTRIES HAS BEEN ISSUED!

ELSEWHERE...

LOOKS LIKE YOUR PRESS RUN IS GOING TO HAVE TO WAIT.

THE ENTIRE TEAM NEEDS TO BE NOTIFIED... IMMEDIATELY!

STEVEN ALEXANDER KERN SENDS THE ORDER TO THE REST OF HIS TEAM.

AT THEIR STUDIO IN SOUTHERN JERSEY, KIM R. X. HAIKU AND CHRISTINE SICKINGER PICK UP THE COMMUNIQUÉ AND SPRING INTO ACTION.

DID YOU HEAR THAT, CHRIS? YOU KNOW WHAT WE HAVE TO DO! NOTHING CAN STAND IN THE WAY OF THE COMPETITION!

...AND NOTHING'S GOING TO! WE'VE GOTTA ASSEMBLE THE LEAGUE!

MASTER ILLUSTRATOR DORIAN KANE GETS THE CALL...

DORIAN, DO YOU COPY? WE'RE MEETING AT LOCATION 463-GREEN AT 18:30 HOURS.

MEANWHILE, ON HER AFTERNOON SHOOT AT THE SHORE, PHOTOGRAPHER VIVIAN MICHELE DAGUERRE MONITORS TEAM COMMUNICATIONS...

SO IT'S FINALLY HERE. IT IS ZE OPPORTUNITY FOR ALL OF US TO SHOW ZE WORLD WHAT WE'RE MADE OF. NOTHING CAN BE MORE IMPORTANT TO US.

COPY THAT. 18:30 HOURS. WE'LL BE READY.

...AND IN NEWARK, BRANDON S. LOVE AND LOIS BAKERSMITH GET IN CONTACT WITH THEIR TEAM LEADER...

WHAT'S YOUR SITREP, YOU TWO? DO YOU HAVE THE RENDEZVOUS COORDINATES?

--UMMF!-- UM, UH-HUH...

UM, THAT'S AN AFFIRMATIVE. COORDINATES RECEIVED, BOSS. PROCEEDING LOCATION 463-GREEN. E.T.A. TWENTY MINUTES.

SOON...

...AND THAT'S WHERE WE COME INTO THE PICTURE.

THIS COMPETITION WILL FEATURE THE BEST WORK IN THE ENTIRE STATE. IT'S UP TO US TO MAKE SURE IT GOES OFF WITHOUT A HITCH. I CAN'T STRESS ENOUGH HOW IMPORTANT THIS IS TO CREATIVES EVERYWHERE!

SO THE ORDERS FROM ADONJ COMMAND ARE THESE: SPREAD THE WORD ABOUT THE CALL FOR ENTRIES.

...AND THEN PROTECT THE ANNUAL AWARDS SHOW AT ALL COSTS!

Chapter 15:
The Portfolio and Job Search

A Generalized Graphic Design Portfolio

An Advertising Portfolio

Mini-Portfolios

Advice from Graphic Design Professors

The Career Search Process

The Interview Process

Student Solutions Showcase

◀ Call for Entries: Art Directors Club of New Jersey, 2004 Awards Show
Design/Concept: The Design Studio at Kean University
Art director: Steven Brower
Consultant: Christopher J. Navetta
Designers: Steven Brower, Christopher J. Navetta, Joana Cordoso, Erwing Corrales, Lori Dellano, Sylvia Miller, Patricia Rusinak, and Jason Washer
Copywriter: Christopher J. Navetta
Pencils: Ian Dorian
Inks: Ian Dorian, George Rodriguez, Ori S., and Christopher J. Navetta
Colors: Christopher J. Navetta
Client: Art Directors Club of New Jersey

Objectives

Understand the purpose of a portfolio

Compile a generalized graphic design or advertising portfolio

Prepare a résumé

Conduct a job search

Learn about the interview process

A **portfolio** is a body of work. It is used in the graphic design and advertising professions as the measure of one's professional ability. Whether you earned A's or B's in your design courses does not matter nearly as much as the work that ultimately goes into your portfolio.

There are several key components to a good portfolio:
- Twelve to twenty professionally executed pieces
- A résumé
- A professional-looking presentation
- A book of working sketches (optional)

A portfolio consists of anywhere from twelve to twenty pieces of exceptional work. Some of the pieces should be related, for example, a poster, brochure, and invitation for the same event. These pieces—which are called companion pieces—demonstrate your ability to formulate a design concept for several applications.

If you want to specialize in one area of graphic design, such as packaging or information design, the work in your portfolio should reflect that area of interest. If all areas of graphic design interest you, your portfolio should include a range of projects that reflect your ability to solve different types of design problems.

While a portfolio may contain as many as twenty pieces, fewer is better as long as they are excellent. If you do not grab a potential employer's attention with your first twelve pieces, the last few probably will not do the trick either. Do not put a piece in your portfolio unless it is good and well executed; you may be remembered by your weakest piece rather than by your best. Begin your portfolio with your best work and end it with your next-to-best work—or the other way around. Put a very strong piece in the middle (to maintain the interest of the person who is reviewing your work).

Design a résumé to send to potential employers or leave behind after an interview. It should be neat, legible, and well designed (after all, you are looking for a job as a designer). You may choose to have the résumé reflect your style or spirit. You also may want to create a self-promotional piece to leave with the interviewer—something that will demonstrate your abilities, illustrate your work, and highlight your creativity.

Your work should be presented in a neat, clean, consistent manner. There are three basic types of portfolio presentation cases: one has plastic sheets or pages to slide your work into, another is a clamshell box, and the last is an attaché-like case. If you choose the style with plastic pages, make sure the plastic is clean, not torn or scratched, and secure all work inside the plastic so that it does not move around. If you choose an attaché-like case or clamshell box, all the pieces should be mounted on boards of the same size and color (black doesn't show fingerprints), and they should fit easily

and neatly into the case. It is a good idea to have two complete portfolios; if you need to leave one at a studio or agency, you will still have one on hand for another job prospect.

Optionally, include a binder of the working sketches you made for the creative design solutions in your portfolio. Some employers like to see these sketches because they demonstrate your ability to work through a concept and generate more than one solution to a problem.

A Generalized Graphic Design Portfolio

Whether your work is in a case, a CD, or viewed on your web site, all work must be very good. Use the following sequence to set up your portfolio:

- Next-to-best piece first
- Third strongest ad in the middle
- Best piece last
- No weak solutions anywhere

Or:

- Best piece first
- Third strongest in the middle
- Next-to-best piece last
- No weak solutions anywhere

If it's not excellent, don't put it in. Start with a bang, end with a bang, and keep their interest in the middle. The point is to keep people's attention, any way you can do it.

The standard presentation cases most often used to hold mounted work are:

- Attaché-like presentation case

An attaché-like presentation case is a sturdy-wall constructed case with a flap cover and handle. It is excellent for matted work, laminations, or boards; many sellers will customize it to meet your specifications. These cases are usually available in a variety of sizes, materials, and colors, with the option of an embossed personalized logo.

- Clamshell boxes

A clamshell portfolio is a wood-wall constructed case, suited for boards or laminations. Assembled so that it opens for an easy display of your images, it is usually available in a wide range of sizes, materials, and colors.

The full-view clamshell is a variation of the standard clamshell portfolio, which features an opening on all sides, allowing for a dramatic display of all images. This container offers convenient removal of images, making for orderly presentations; it is usually available in a wide range of sizes, materials, and colors. The four-wall clamshell box with a flap is a constructed portfolio case that can contain a stack of boards or laminations and closes with a flap. Usually available either standard or custom, it is made in a wide variety of sizes and materials.

- Case and book combination

The case and book combo is a constructed case with a removable book, which allows you to include extra work; it's a multipurpose and practical presentation tool, usually available in a broad range of materials and colors, with the option of a personalized logo.

- Binders with sleeves

A ringless binder eliminates the bulkiness of rings and is a compact professional presentation book; usually available in black vinyl or leather, these compact and practical books contain *permanently sealed*, top-loading clear sheet protectors with black paper inserts. A ringless binder is a very practical choice for an extra portfolio, especially for an extra ad portfolio. The spiral bound book usually has a removable cartridge of twenty archival sheet protectors. Some have an inside pocket. A binder with rings containing acetate sleeves allows for removal of individual pages as they become damaged. This choice is the least professional-looking one, since the acetate usually damages easily and pieces can move around within the sleeves.

For presentation of digital work, your portfolio could be contained on a CD-ROM or shown online at your web site. If you put your work on a CD-ROM, make sure the case is designed well.

The following are the Kean University Department of Design recommended portfolio contents:

- Logos: five distinct designs mounted on a single board or contained in a handmade book
- Symbols and pictograms: a unified series for one program
- Visual identity, including an original logo
- Folded brochure (featuring the arrangement and choice of text type and subheads)
- Book jacket series

- Booklet, such as a CD insert
- Web site
- Packaging
- Annual report
- Promotional piece
- Editorial spreads for magazines, books, or newspapers
- Additional suggestions:
 - Labels (examples: wine bottles, jelly jars, carbonated beverages, fruit crates)
 - Poster series
 - Ad campaigns
 - Catalog
 - Branding
 - Maps and charts
 - Way-finding system
 - More of any of the above

Please note that it is advisable to use original logos for all pieces. In other words, when you create packaging, it should utilize an original logo rather than an existing one. You should present your materials either mounted on black board with a 2″ border or on a CD-ROM.

An Advertising Portfolio

A student's advertising portfolio (also called a book) should contain at least four excellent speculative ad campaigns and a few one-shot (single) advertisements. At the very least, you should include three excellent campaigns consisting of three ads each. Each ad in the campaign should be able to stand on its own, yet obviously belong to the campaign as a group, sharing a common strategy and related concepts.

A campaign demonstrates an ability to create a flexible strategy and related concepts, sustain it throughout a series, and run with it in a creative direction. Most advertising students can design one outstanding, one-shot ad. It's far more difficult to create a superb campaign!

Your ads should cover a variety of goods (hard and soft) and services, including nationally known brands. Avoid doing ads for tiny, local clients, like Joey's Barber Shop or Aunt Edna's Florist. Choose real products; don't do ads for widgets or other invented products or services. Avoid doing ads for products or services that currently have brilliant campaigns—it will probably cause a creative roadblock for you. Also, avoid product categories like perfume, liquor, cigarettes, and most vehicles; these products are very difficult to promote. Only include one public service ad, and only if it's great. Do include an outdoor board ad and unconventional advertising or integrated campaigns. An integrated campaign consists of work for different media, including print, digital, and unconventional.

Print ads will demonstrate your ability to conceptualize and think creatively. You don't need to include a storyboard or television commercial. Entry-level art directors do not usually create television commercials, but you should know how an ad would play out in different media.

Put your personality into your book—make it be your own vision. Have a fresh perspective on things. Don't mimic the ordinary. Have a variety of ads. Your ads should have different voices depending on the products you're advertising, such as humorous, tough, tongue-in-cheek, bittersweet, or serious. You should also vary the size of the ads; for example, full-page ads, some spreads, some half-page, and some third of a page (although some reviewers prefer to see *only* full-page ads or spreads).

Remember: One bad ad brings down the whole book.

Advertising Portfolio Contents Organization

The rule for organizing an advertising portfolio is the same as for graphic design: best ad campaign first and next-to-best ad campaign last or the other way around. Place a strong campaign in the middle. If you have a weak campaign, toss it and start again. Never include something that is weak in a portfolio; it will stand out, and you will be remembered for the weak link, rather than the strong!

Advertisements are usually mounted on foam core and placed in a clamshell box. Some students laminate their work; however, it's an unnecessary expense. An alternative is to mount the ads on black board with a 2″ border. You

can also use a ringless binder as your main portfolio, or put it all online or on a CD-ROM.

Always have at least two portfolios. If you leave one at an agency for review, you must have another one at the ready for another possible interview. You could also have your entire portfolio on CD-ROM.

Have many mini-portfolios that are copies of two or more campaigns bound together with a résumé. A mini-portfolio can be hard copies of your ads or on CD-ROM.

Depending on the nature of the ad agency—as it may be a full-service agency—you may need to include a few good graphic design pieces in your portfolio to demonstrate your design abilities. Some agencies require their creatives to know graphic design, as well as advertising.

General tips

- Be aware of the work that agencies are currently doing.
- Your ads should be illuminating, explaining something not already known.
- Your ads should change the way we think about a brand or group.
- Your ads should make us feel some emotion about a brand or group.
- Change the viewers' minds about a brand or cause.
- Get a reaction; make the viewer say, "Ah!" or "Oh!"
- Offer an insight into life.
- Try to entertain people with your ads.

Mini-Portfolios

Many advertising agencies and graphic design studios prefer to receive mini-portfolios (also called mini-books). A **mini-portfolio** is a bound collection of copies of your work, including anywhere from three to all the pieces in your portfolio. It can be to size or at a reduced size. An alternate mini-portfolio of your work could be a CD-ROM, contained in a designed jewel case or paperboard case, or a mini-portfolio containing three pieces and your web site address, where all your work can be viewed. If

the agency or studio likes the work in the mini-portfolio, you will get a chance to show all the work in your portfolio case. Some agencies and studios will return the mini-portfolios to you; most will not. If you want the mini-portfolio returned, it is advisable to include a self-addressed stamped envelope that is large enough to hold the mini-portfolio.

A mini-portfolio can be bound in a variety of ways. There are books that explain various bookbinding techniques, or you can take a course in bookbinding to find a suitable presentation—or you can have the book bound professionally. Most importantly, your mini-portfolio should be well crafted, neat, easy to view, and not too heavy to ensure low mailing costs.

Self-promotionals

In addition to sending a résumé to, or leaving a résumé with, a prospective employer, some students use self-promotionals (self-promos). Before the popularity of mailing out mini-portfolios, self-promos were used, which usually included a small version of your best work—a mini-portfolio—consisting of two to five pieces. This acted as a promotional about yourself. Since mini-portfolios function to display work, a self-promo is a creative, inventive piece that showcases your design skills and creativity—sort of a self-advertisement. Some students create elaborate self-promos, which can become too expensive and time consuming to make for every prospective employer. Professor Rose Gonnella, who teaches senior portfolio at Kean University of New Jersey, advises: "Self-promos should not be elaborate. A simple, clever message and design is best." Self-promos can be simple and inexpensive to produce, yet still be compelling and engaging.

A self-promo should always include your name and phone number. Like your portfolio, a self-promo represents you, your talent, intelligence, and abilities. Do not create anything that will be annoying to a prospective employer. For example, do not make something difficult to open or have glitter or confetti fall out all over someone. A self-promo must be well thought out and well crafted.

• If you want to write a different objective, keep it succinct.

• Start with your most recent position first (see examples).
• For entry-level candidates with little or no experience, it is necessary to list work experience (to demonstrate that you can hold a job), and any design-related experience, such as internships or freelance experience. For candidates with at least five years experience, be sure to include responsibilities, skills, and clients.
• Include job titles.
• Very briefly describe your responsibilities (what you do).
• Include a client list, when applicable.

• College and graduate school only. Include degree, date of degree, major, and honors, if any.
• Advanced course work, specialized training, workshops, and any academic awards.

• For entry-level candidates, listing special skills, especially computer and technical expertise, is crucial to securing a job. Include design skills, computer knowledge (hardware and software), and technical expertise.

• List all professional awards; this will demonstrate that your work has been recognized as outstanding. Simply list the year and award title.
• List ability to speak a second language. Advertising agencies or design studios with global clients may be especially interested in a bilingual candidate.

Sample résumé

Name
Street address
City, State, ZIP code
Phone number
E-mail address
Web address

OBJECTIVE Seeking a position as a (graphic designer) (junior art director).

EXPERIENCE

2005 – present The Design Studio at Kean University: Student Designer/Intern
Responsibilities include design concepts, execution and presentation of comprehensives, client contact, production preparation, on-press supervision, and monitoring and maintenance of computer lab. Projects include newsletters, posters, and brochures.

Clients include The Theater Department at Kean University, Morris County Park System, Liberty Hall Preservation, and The Office of the President at Kean University.

2004 Dunkin Donuts: Store Manager

Responsibilities included employee scheduling, customer relations, accounting, and quality control.

2002-2004 The United Way: Volunteer/Graphic Designer

Responsibilities included graphic design of fundraising materials, exhibit design for fundraising events, and community liaison.

2001-2002 Remark Studios: Production Intern

Responsibilities included execution and presentation of comprehensives, production preparation, and computer maintenance. Projects included assisting in the production of annual reports, newsletters, advertisements, and brochures.

2000-2001 Justin Advertising Agency: Student Assistant

Responsibilities included design concepts, execution and presentation of comprehensives, and client contact. Projects included print ads, direct mail, and electronic media ads.

Clients included The Chubb Group, Atlas Tires, and Barney's.

EDUCATION

2006 Kean University, Union, NJ. B.F.A.: Visual Communications/Graphic Design
[Any academic awards.]

2004 Brookdale Community College, Brookdale, NJ. A.A.: Graphic Design

May 2006 New Jersey Art Directors Workshops: Design Strategies

SPECIAL SKILLS

Design from concept to production

Macintosh and PC computers, using drawing, photo-editing, page layout, and web page layout software, and other skills

Copywriting

Photography

MISCELLANEOUS

2005 The One Club student advertising competition award

2005 First place in the Art Directors Club of New Jersey student portfolio competition

(FINAL LINE) Portfolio and references available upon request.

Advice from Graphic Design Professors

When I asked my esteemed colleagues to prepare a statement addressing the question, "What do you think makes a portfolio good?" they answered as a group, "Twelve great pieces." When asked again, they insisted, "Twelve great pieces." They are right; however, they finally offered more advice.

Portfolio: Your Talent in a Bottle by Alan Robbins

The problem most students have is assuming that the portfolio presents their work. It does not. That is not enough. It has to compress your work. It has to hold an essence, like a bottle of perfume.

Therefore, you cannot just mount your twelve best pieces and hope for the best. You have to deal with your portfolio as though it were your most important work to date. Make it capture the essence of your talent.

That means redoing pieces that are not up to snuff, combining pieces that look lonely, giving yourself new assignments that draw out your creativity, reshooting pieces that are out of focus, and refocusing in general. You are trying to make the portfolio explode with your individuality.

If there is something you can do that is not in the book, put it in. If some things are mediocre, you should fix them, change them, or junk them. Pretend that you are making the portfolio for a great-grandchild you will never meet, and this is all that will ever be known of your art. Let it stand by itself and charm, delight, or challenge.

If it does not compress your talent, then it is just a bag of stuff, easily forgotten.

Tips on the Most Important Things for a Portfolio by Martin Holloway

Consider the presentation a project in itself. The presentation should have:

- Consistent board color and size
- A logical sequence
- Immaculate and great craft—edges, backs, and corners

Cover the basics in your portfolio content: logos, folders, posters, covers, editorials, corporate visual identities, packaging, etc. Show your personal strengths and interests—your book should show *individuality*.

Show *several* ideas for a problem in rough form—ideas, ideas, ideas. Show that you can have more than one good idea for a problem.

Show sketching skills; this is especially important now in the computer age. Pencil and paper are for idea generation. Computers are for developing an idea, pushing it, and creating multiple variations.

Pay particular attention to type, especially now that you can show real type in comp form, generated by the computer (a real improvement). Think of type as the visual equivalent of the sound of a voice. Some messages should shout, some whisper, some be expressed with passion, some as a footnote. Sounds of the voice can add great richness and express layers of meaning about the same subject—type should do the same.

Make your résumé a design problem. Make it excellent typographically! Make it clear and easy to read, with good visual hierarchy.

Have more good pieces than you may use in one presentation so you can tailor the presentation to a particular interview. For example, have an extra ad campaign, packaging, or logo to accommodate a potential employer's business specialization.

Learn as much as you can about a potential employer's design clients so you can speak intelligently to them.

Do a special piece for a particularly important interview.

Make the presentation beautiful, but do not let it overwhelm the work.

Show a variety of mock-up techniques: thumbnails, full-size roughs, rough dummies, marker comps, and super comps (tight comps).

For conversation with prospective employers, be knowledgeable about the field, production, and designers. Be able to speak with interest and enthusiasm about your profession.

Never apologize for your work.

Always leave something behind after an interview—a résumé, at least, or a promotional piece—something with your work on it.

Learn to explain what you did and did not do for each piece; for a complex piece, elements on a page or surface may in themselves be impressive solutions to problems, such as maps, spot illustrations, or graphic devices. Do not assume a reviewer will know what you did (some people may use clip art, some may create the elements themselves). Learn to be concise in these explanations.

Know how much salary you want (or will settle for), instead of appearing befuddled by the question.

A Quality Portfolio by Rose Gonnella

A great portfolio displays a range of qualities—quality use of type, quality compositions, quality ideas, quality presentation, and quality organization. Now to understand quality, see the contents of Professor Landa's book. (I still hold to the twelve great pieces theory.)

The Career Search Process

Not all design or advertising careers are in design studios and advertising agencies. Many corporations, government agencies, publishing houses, and public institutions require the skills of a graphic designer or art director. Working in a design studio or advertising agency is a different type of work environment than working for a company or organization with an in-house design or advertising department. It's best to gather information and assess which work environment would best suit you. Also, most corporations require a college baccalaureate degree for entry-level positions.

Where are the careers?

- In-house design departments within:
 - Corporations
 - Public institutions
 - Pharmaceutical companies
 - Publishing companies (magazines, books, newspapers)
- Publication editorial departments
- Graphic design studios
- Advertising agencies
- Full-service agencies
- Branding firms
- Brand strategy firms
- Marketing firms
- Interactive agencies or studios

Information Gathering

Set short- and long-term goals for yourself, and then make a plan. Determine which studios specialize (or generalize) in the areas that interest you. Make a comprehensive hierarchical list. Compile your list of design studios or ad agencies from a variety of sources:

- Magazine award annuals featuring the best work of the year
- Award books
- Graphic design magazine web sites
- Design studio web sites
- The Source Book in your state
- Agency "Red Book" (Standard Directory of Advertising Agencies)
- *Adweek's* Agency Directory
- The *Yellow Pages*
- Art Directors Club membership listings
- American Institute of Graphic Arts (AIGA) membership directory

Make calls to studios and agencies. Get as much information as possible from the receptionist or Human Resources office. Ask if they have a portfolio drop-off day or review. Ask for the names of art directors and creative directors. Ask about studio size, clients, etc. Find out something about the studio or agency and include it in your cover letter. Put anything in the cover letter that makes you sound interesting.

Two weeks later, send a follow-up letter or postcard. Or call as a reminder: "May I see you for an information (or exploratory) interview?

For just ten minutes?" "Is there anyone else I may talk to? Is there anyone else you can send me to?" Get back to them to see if any positions have opened up. "I've done some new work; may I send it to you?" Send or fax résumés; many advertising agencies and design studios allow job seekers to e-mail their résumés or post their resumes directly onto their web sites.

Make calls to corporations' and public institutions' Human Resources offices to see if they have in-house creative/design departments; for example, Toys R Us, Johnson & Johnson, and UPS have in-house departments. Follow the same advice as above. Send résumés.

Check the credits listings in design magazines and newspapers for the art directors and creative directors. Send résumés.

Check the Classifieds and Magazines

Check the classified ads under graphic designer, designer, graphics, electronic media, web sites, publishing, editorial, advertising, and art director.

Read the business section of any newspaper and note companies that are expanding, hiring, changing management, etc.—these are the studios and agencies that might be hiring.

Also, look in an issue of *Adweek* or *Advertising Age* to see which agencies have new clients and therefore might need to hire new people or freelance people. Check ad columns in *Business Week, Forbes, Fortune,* and *The New York Times.* Check out *Ad Age's* Top 100 Agencies issue.

Check the professional design and advertising quarterly newspapers or magazines in your state.

Web Sites

Most graphic design studios, branding firms, advertising agencies, organizations, groups, and corporations have web sites. Many of these web sites list employment and/or internship opportunities. If you know the names of design studios and agencies, you can find their web sites via a search engine. If you don't know the names of the studios or agencies in your metropolitan area, you can also use a search engine to find lists. For example, type in "top graphic design firms in Cincinnati" or "top advertising agencies in Miami" to find the names and links to potential employers.

Employment Agencies

This is an extremely important resource. Employment agencies place a large range of entry-level and experienced creative professionals in graphic design, advertising, production, interactive, and trainee positions. Most have web sites where you can obtain more information about job listings and descriptions, salary guides, and contact information. There also are agencies that specialize in securing temporary employment for creative professionals.

Ideally, there should be no fee for the job applicant. Call the agency and ask for an appointment to review your portfolio. Check with your college or university professor or career placement center for employment agency names, or find listings by using Internet search engines.

Job categories include:

Advertising

- Junior art director (entry-level)
- Junior copywriter (entry-level)
- Art director (experience required)
- Copywriter (experience required)
- Associate creative director (experience required)
- Creative director (experience required)

Graphic design

- Graphic designer
- Production artist
- Interactive
- Web animator
- Web production artist
- Web site designer

Internships

One of the best ways to gain experience and entry into an agency or studio is through an internship. Some studios and agencies have internship programs; others will occasionally hire an intern.

- Ask your professor if your school offers internship credits.
- Call the top studios and agencies in your area and ask if they have internship programs. If they say no, ask if they ever have any interns, and if so, that you'd be interested.
- Treat applying for an internship like applying for a job; give it the same respect and attention.

- Have a résumé prepared. You may or may not need a portfolio.
- Some agencies pay interns; some do not.

Networking

Ask the design faculty at your college or university for leads. Also, the adjunct instructors are a good resource. Then tell *everyone* you know that you are looking for a design career. You never know when someone will say, "Oh, my sister-in-law is an art director; maybe she can help."

Stay in touch with your peers—one placement leads to others.

Pursue part-time, temporary, or freelance work. This road is a great way to get a feel for different avenues.

Join professional organizations. Most professional design and advertising organizations have student memberships at reduced rates. Go to portfolio reviews, meetings, lectures, and workshops at:

- Your state's Art Directors Club
- Your state's Advertising Club
- AIGA (American Institute of Graphic Artists)
- Society of Illustrators
- The One Club
- Type Club

The Interview Process

A successful interview has always hinged on the exchange between the job candidate and the employer. Now that many graphic design studios and advertising agencies can see a candidate's work in a mini-portfolio before an interview, the interview more truly serves the purpose of meeting the job candidate—the person—rather than evaluating the work.

Don't take an interview lightly. Be prepared. Know something about the company, especially the kind of work they do and who some of their clients are. Utilizing Internet search engines makes finding information about the company easier than ever before. If possible, try to get information about the person who will be conducting the interview. Be able to state the rationale for all your design projects. Prepare a list of smart questions.

Read up on the profession. Know what's going on in the visual communication industry. Be on top of the latest movements, hot designers, and classic master designers. Don't be afraid to have an opinion. And, of course, don't insult anyone's work.

- Be ready to honestly discuss your professional experience.
- Know what salary you are willing to take.
- Clearly advertise your unique capabilities and qualities, such as professional experience, internships, credentials, academic standing, and attractive personal qualities, like eagerness, being a self-starter, or being a quick learner.

Preparing Your Portfolio

Review all the contents of your portfolio to make sure everything is in order and neat. Tailor your portfolio to the company; for example, include more editorial pieces for an interview with a publishing company. Bring a copy of your résumé to leave with the interviewer and, perhaps, a self-promotional piece. Prepare a mini-portfolio to leave behind; that is, a résumé with several copies of your work neatly attached to it. It can be bound in a variety of ways, as long as it is neat and easy to handle and read, or it can even be put onto CD-ROM.

If possible, tailor your résumé to emphasize key accomplishments related to the job position. Your résumé should be clean, legible, and well designed. These characteristics are far more important than creating a "gimmicky" résumé.

Hang a name tag with your phone number on your portfolio, in case you have to leave it behind.

Make it clear that you were responsible for some or all of the work done on a piece. During an interview, it's important to clarify what part of a design project you did—whether you created the illustrations, took the photographs, or created the hand lettering.

At the Interview

The interview meeting is your first (and sometimes last) chance to make a good impression. With that in mind, be sure to be prepared: get enough sleep the night before, dress appropriately, be clean (including hair

and nails), and give yourself enough time to be prompt.

Be enthusiastic and energetic; the right attitude is extremely important.

Listen to the person conducting the interview. Make yourself seem indispensable. Sound like you have a well-rounded life; that is, you read, are up on current events, see films and plays, and participate in sports or social dance. Be prepared to do the low-end work if that's required. And always remember: A career in visual communication, whether it's advertising or graphic design, requires communication skills and that you work well with people.

Questions to Ask at the Interview:
- How is your studio or agency run?
- Do designers work alone or in teams?
- What software do you use?
- What are your current projects?
- What are the essentials necessary to succeed in this studio or agency?
- To whom would I report—an art director, creative director, or senior designer?

Tips for the Interview Process

On personality:
- Be flexible
- Find one point you want people to remember about you
- Respect people's time
- Be curious

Skills:
- Know as much new technology as possible
- Know how to read between the lines at an interview; for example, "Good luck," usually means they're not interested. "Are you available for a second interview," means they are interested.

During the interview:
- Get to an interview early
- If you're bilingual, say so
- Maintain a good energy level
- Listen
- Think
- Get people's names right
- Know about the studio or agency

Looking for the job:
- Be prepared to put in many hours "pounding the pavement" while searching for a job
- Send a personalized, typed "thank you" note after an interview

Choosing a job:
- Work with people you admire

- Only change agencies/jobs for the work, not for the money. Doing creative work is far more important, especially at the beginning of your career.

On the job:
- Demonstrate leadership capabilities
- Be a self-starter
- Learn to take criticism
- Make yourself indispensable
- Volunteer
- Listen
- Think
- Join the agency softball team
- Take advantage of a situation; for example, one of my former students got onto the elevator with the ad agency president. She offered him a piece of her candy and they started talking!
- Get people's names right
- Always make sure that you're more valuable than your salary
- Treat people respectfully
- Try to take criticism well and put it in perspective (most employers are going to be less patient with you than your teachers were)
- Be positive

In general:
- Read books written by advertising and design professionals
- Know what's current

Questions that Might be Asked of You:
- Are you willing to work as many hours as needed?
- What salary do your require?
- What do you think you can contribute to this agency or studio?
- Why do you want to work for us?
- Which software applications do you know?
- Are you interested in learning new software and technology?
- How quickly can you learn?
- Do you have any hobbies?

After the Interview:
- Send a thank-you letter.
- Ask the Human Resources officer for any positive or negative feedback.
- Assess your performance and portfolio.

Warning: Your portfolio is liable to be criticized by each interviewer. (It happens.) Don't start pulling your portfolio apart each time. If you rearrange or toss work after every criticism, you'll go crazy and destroy your portfolio. However, if more than one or two people don't like the same piece, consider tossing it. Keep in mind: a portfolio is an ongoing project. It should always be modified and improved.

On the Job
- Find a mentor.
- Stay if you're learning, even if the money isn't good.
- Leave if you're not learning. Find a place where you'll grow.

Summary

A portfolio is a body of work that is used in the graphic design and advertising professions as the measure of one's professional ability. It consists of anywhere from twelve to twenty pieces of a designer's most exceptional and representative work. Begin your portfolio with your best work and end it with your next-to-best work, or the other way around.

The portfolio should also contain a résumé that you can send to potential employers or leave behind after an interview, along with a mini-portfolio, if necessary. A mini-portfolio is a bound collection of copies of your work, including anywhere from three to all the pieces in your portfolio. It can also be shown on a CD-ROM or online at your web site.

Your résumé should be well designed and well written, and include all the essential information about you, your education, and your experience or skills.

Jobs for visual communication professionals are in graphic design studios and advertising agencies, as well as in corporations and organizations. Looking for an entry-level job takes effort, networking, and the right information. Check every possible resource. Try to obtain an internship before graduation. Attend portfolio reviews and join professional organizations in your city. Prepare well for an interview, and make the interviewer believe you are the best person for the job!

Student Solutions Showcase

Note that all solutions shown in the following section are student projects; that is, they were created as portfolio pieces and not for actual clients, except in those few cases where a client is specifically noted.* All student solutions for actual clients were created either during the student's senior year or in affiliation with Kean University's Design Studio, a non-profit design studio that serves as an academic course experience. Each student generated his or her own concept and design for each of these featured portfolio pieces except where noted.

Figure 15-1
Visual identity and standards manual:
Speculative
Designer: Adam C. Rogers
Client: Kean University of New Jersey

Design Solutions by Adam C. Rogers

Figures 15-1 through 15-10
www.arog.net
adam@arog.net

Figure 15-2
Visual identity: Bonehead, an upscale pet store
Designer: Adam C. Rogers

**For educational purposes, it is accepted practice to create advertising portfolio pieces for existing brands, as well as utilize stock photography, even though the portfolio pieces are speculative and not intended for use by actual clients. In order to comply with U.S. copyright and trademark laws, however, we are unable to include any student projects in this publication that incorporate existing brand names, brand logos, trademarks, and stock photography.*

Figure 15-3
Theater poster
Designer/Illustrator:
Adam C. Rogers

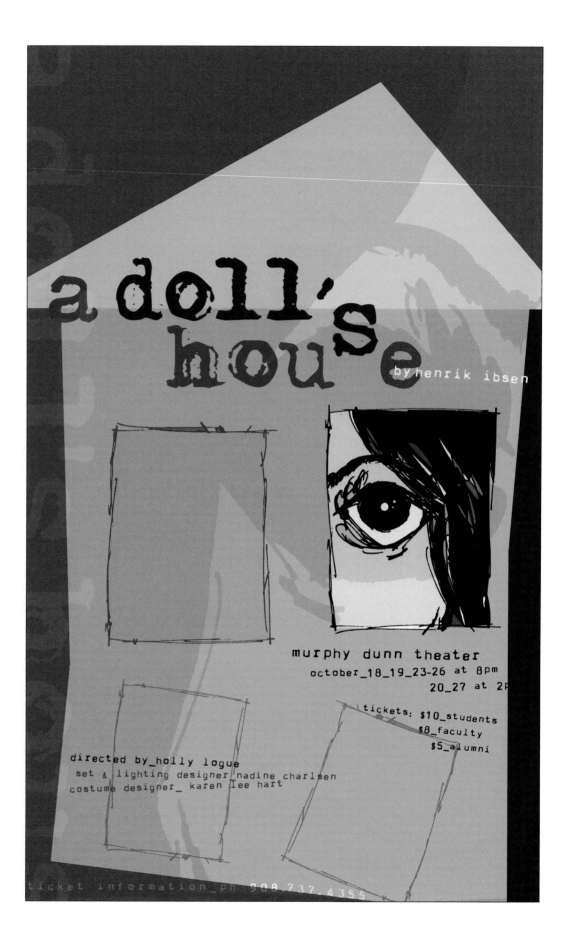

Figure 15-4
Visual identity: Zero,
a dance/music club
Designer: Adam C. Rogers

Figure 15-5
Logos: Speculative
Designer: Adam C. Rogers

Figure 15-6
Book cover: *Advertising by Design*™ by Robin Landa
Creative director: Robin Landa
Art director/Designer: Adam C. Rogers
Photography: Getty Images (royalty-free)
Client: John Wiley & Sons, Inc.

Figure I5-7
Book design: *You Might Get
in Trouble for . . .* by Adam C. Rogers
Designer/Illustrator: Adam C. Rogers

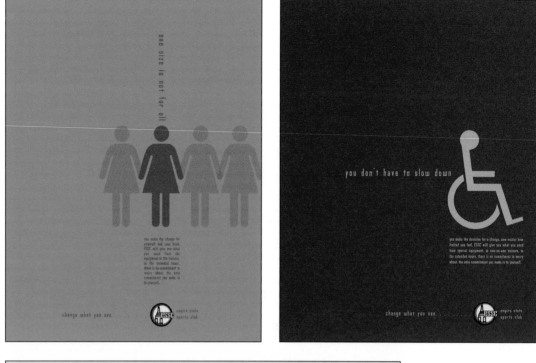

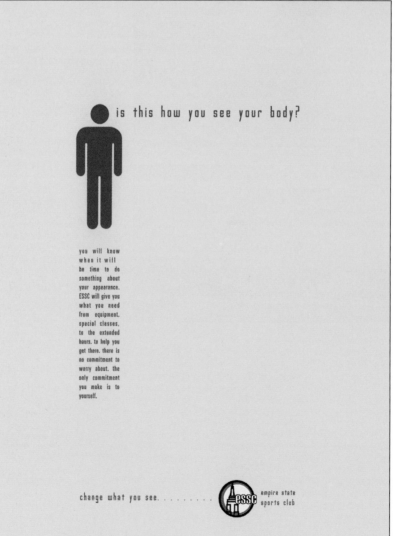

Figure 15-9
Print ad: Speculative
Product: pouch brand beverage
Art director/Copywriter:
Adam C. Rogers

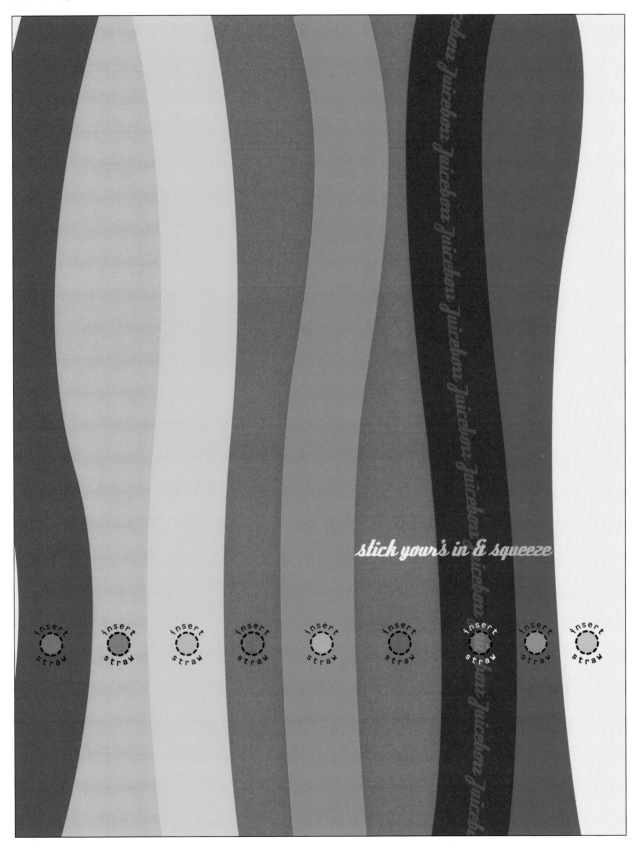

Figure 15-10

Interior book design: *Game Development Essentials* by Jeannie Novak

Art director: Adam C. Rogers

Client: Thomson Delmar Learning

How Did We Get Here?

A Brief History of Electronic Game Development in the U.S.

If you plan to become involved in the game development industry, it is important for you to learn about the industry's evolution. Did it begin with video arcades? Was there life before Pong? Has the industry always been successful? As you're reading this chapter, think about the first electronic game you ever played. Did you play it on a personal computer? On a home game console? At a video arcade? At a pizza parlor? What did you like about the game? After you finish this chapter, you will probably be surprised at the strange and unusual events that have occurred during the development of an industry that is still in its infancy today.

OBJECTIVES

+ What are the significant milestones in the history of electronic game development?

+ Who are the pioneers in game development, and how did they contribute to the industry?

+ How did the game industry evolve from coin-operated electromechanical and mainframe computer games of the '60s to today's console, personal computer, online, and mobile industries?

+ Why did different segments of the game industry experience "slumps" at different points in history?

+ Why did certain game companies, game systems, and game titles succeed during game development history--and why did some fail miserably?

CHAPTER

before the arcades

The first electronic games were not played at home or even at video arcades. Instead, research departments at universities, labs, military installations and defense contractors provided the backdrop for this industry. At military bases, electromechanical games were provided for the military to escape from the rigors of basic training. Meanwhile, a few bleary-eyed, overworked (but frequently bored) students, programmers, faculty and researchers in academic and government institutions turned their mainframe computers into game machines—relieving them of traditional duties such as performing complex mathematical calculations for research. These late-night hackers spawned what would become one of the most compelling forms of entertainment in history.

Two distinct segments of the electronic game industry developed in parallel, starting in the '50s. One of these segments begins in 1951 when Marty Bromley—who manages game rooms at military bases in Hawaii—buys electromechanical machines and launches SEGA (an abbreviation for SErvice GAmes). This segment of the industry grew into the coin-op video arcade industry, which experienced a boom in the 1970s. Home game versions of arcade favorites marked the beginning of what was to become the console game industry of today, while the video arcade business experienced what was to become a drastic slump from which it never recovered.

The other segment of the electronic game industry started with mainframe computer games developed by faculty and students at universities who either wanted to hone their programming skills or entertain each other during breaks from the long hours spent working on their dissertations. An adaptation of one of the early mainframe games, Spacewar!—developed by Steve Russell of the Massachusetts Institute of Technology (MIT)—became the first coin-op video arcade game in America. However, many of these games remained behind the walls of the ivory tower—as engineering and computer science students continued to have fun hacking and writing new programs. It was not until the advent of the personal computer revolution—complete with systems such as the Apple II and Commodore 64—that mainframe games were adapted for personal computers. The computer gaming industry was born.

01-01 Electronic games began in military bases and research departments at universities such as the Massachusetts Institute of Technology (MIT)

01-02

they're not all video games!

01-03 someone sitting at a personal computer

01-04 someone playing a console game

01-05 someone playing a game at a video arcade

Which of the above is definitely not a video game?

The home video game came out of the arcade business and gravitated toward the home console game business. Games played on personal computers have always been referred to as computer games --not video games. Rivalry between video game developers and computer game developers has existed since the beginning--and some of it has rubbed off on the players. Use the terms electronic games if you want to refer to both sides.

:::CHAPTER REVIEW QUESTIONS:::

1. What are the significant electronic game development companies that have been around since the beginning of the industry, and how did they get started?

2. Who are the individuals that have played a significant role in the evolution of the electronic game development industry, and what are their major contributions?

3. What are the key phases and major milestones in the history of electronic game development? How has convergence played a role in connecting these phases in today's industry?

4. Why have some game development companies succeed—while others have failed? How can you apply this knowledge to today's industry?

5. What electronic games helped to attract a larger audience to this industry? Why did they succeed in doing so?

6. What traditions in early game development are still in existence today? How are they appealing and useful to developers and players?

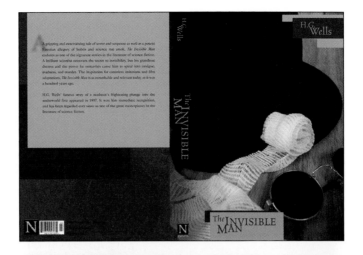

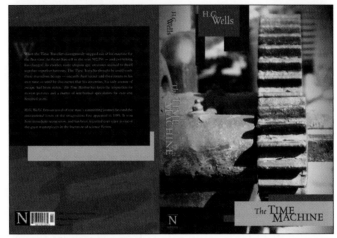

Design Solutions
by Christopher J. Navetta
Figures 15-11 through 15-19
www.christophernavetta.com
mightyfurcules@aol.com

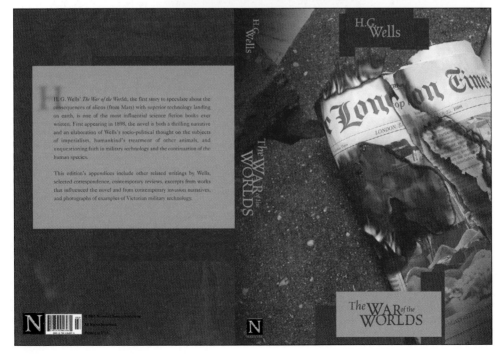

Figure 15-11
Book jacket series (front and back): Speculative
Designer/Photographer: Christopher J. Navetta

Figure 15-12
Book cover: *Designing
Brand Experiences*
by Robin Landa
Cover concept:
Robin Landa
Art direction/Typography:
Denise M. Anderson
Designers:
Christopher J. Navetta
and Laura F. Menza
Photographer:
Christopher J. Navetta
Client: Thomson
Delmar Learning

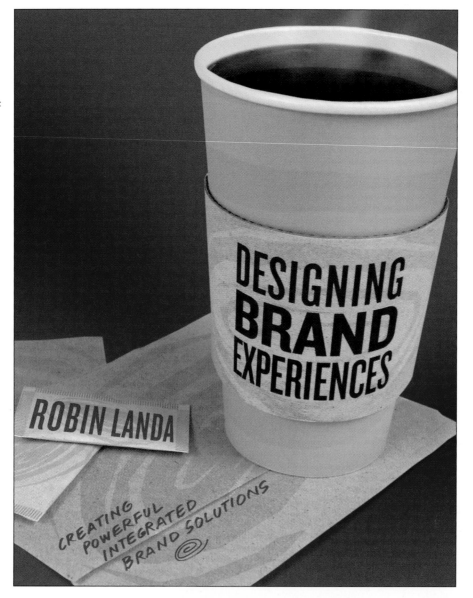

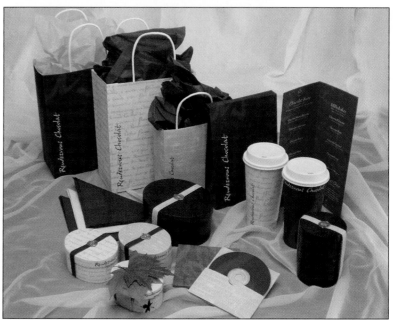

Figure 15-13
Visual identity : Speculative
Designer: Christopher J. Navetta

Figure 15-14

Call for Entries: Art Directors Club of New Jersey, 2004 Awards Show

Design/Concept: The Design Studio at Kean University

Art director: Steven Brower

Consultant: Christopher J. Navetta

Designers: Steven Brower, Christopher J. Navetta, Joana Cordoso, Erwing Corrales, Lori Dellano, Sylvia Miller, Patricia Rusinak, and Jason Washer

Copywriter: Christopher J. Navetta

Pencils: Ian Dorian

Inks: Ian Dorian, George Rodriguez, Ori S., and Christopher J. Navetta

Colors: Christopher J. Navetta

Client: Art Directors Club of New Jersey

**Figure 15-14,
continued**
Trading Cards:
Art Directors Club
of New Jersey, 2004
Awards Show
Design/Concept:
The Design Studio
at Kean University
Art director:
Steven Brower
Copywriter/Designer:
Christopher J. Navetta
Art: Christopher J.
Navetta, Ian Dorian,
Steven Brower,
Mark Romanoski,
Janna Brower, Ori S.,
Edwin Vazquez and
Guy Dorian
Client: Art Directors
Club of New Jersey

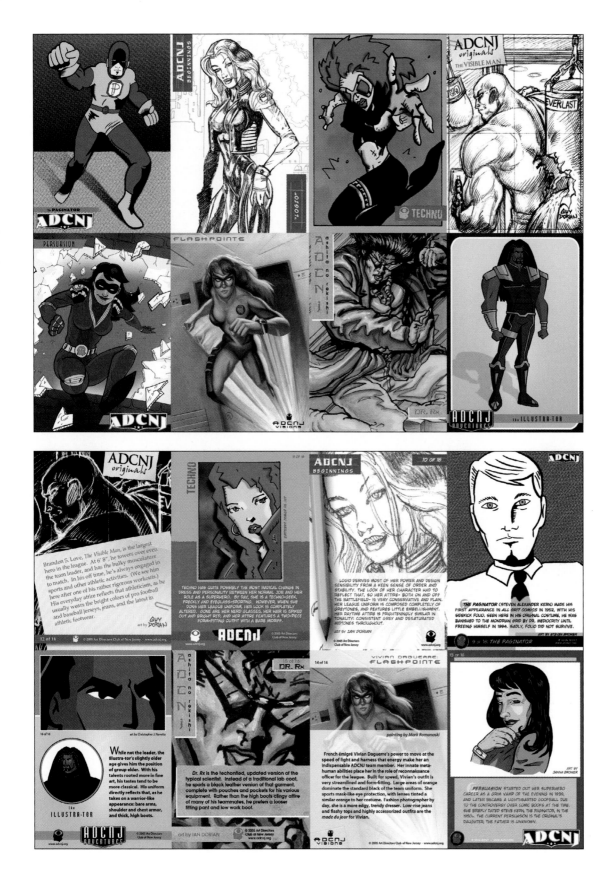

Figure 15-14, continued
Certificate of Excellence: Art Directors Club of New Jersey, 2004
Design/Concept: The Design Studio at Kean University
Art director: Steven Brower
Designer: Christopher J. Navetta
Pencils: Ian Dorian
Inks: Ori S.
Colors: Christopher J. Navetta
Client: Art Directors Club of New Jersey

Hangtag: Art Directors Club of New Jersey, 2004 Awards Show
Design/Concept: The Design Studio at Kean University
Art director: Steven Brower
Designer: Christopher J. Navetta
Client: Art Directors Club of New Jersey

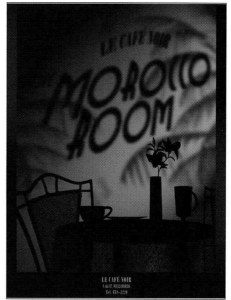

Figure 15-15
Ad campaign: Speculative
Art director/Copywriter/Illustrator:
Christopher J. Navetta

Figure 15-16
Book jacket: *The Art Student Survival Guide*
by Jeffrey K. Otto
Designer/Photographer: Christopher J. Navetta
Client: Thomson Delmar Learning

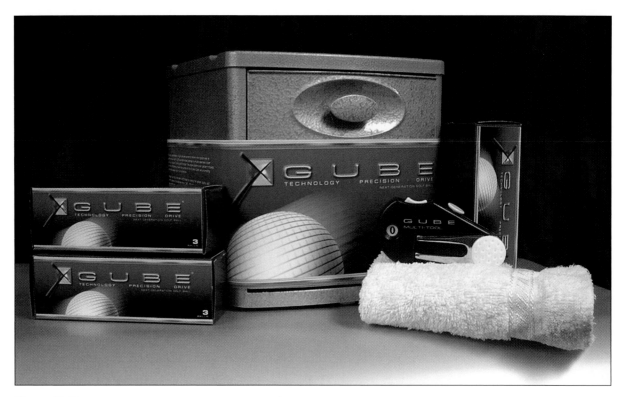

Figure 15-17
Visual identity/Packaging: Speculative
Product concept: Richard Palatini
Designer/Illustrator: Christopher J. Navetta

Figure 15-18
Self-promotional kit
Designer/Photographer:
Christopher J. Navetta

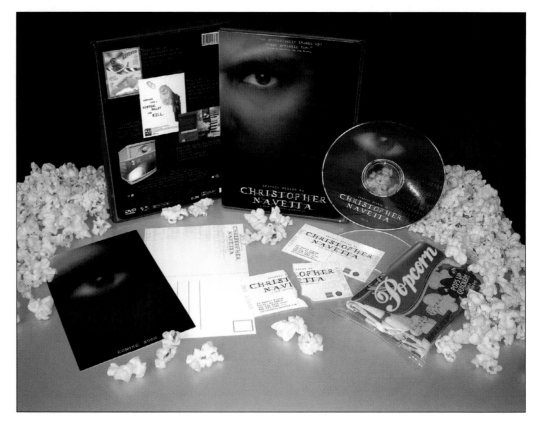

Figure 15-19
Handmade fantasy game and journal
Concept/Design/Fabrication: Christopher J. Navetta

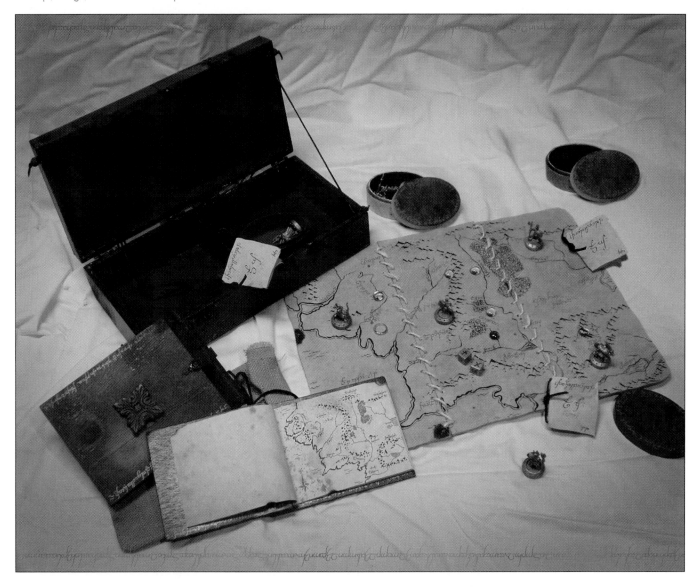

Design Solutions
by Sanghee Jeon
Figures 15-20 through 15-24
www.sangheejeon.com
sanghee@sangheejeon.com

Figure 15-20
Magazine cover: *Print* magazine
student cover competition entry
Designer: Sanghee Jeon
Photographer: Sanghee Jeon

Figure 15-21
Brand identity: Speculative
Designer: Sanghee Jeon

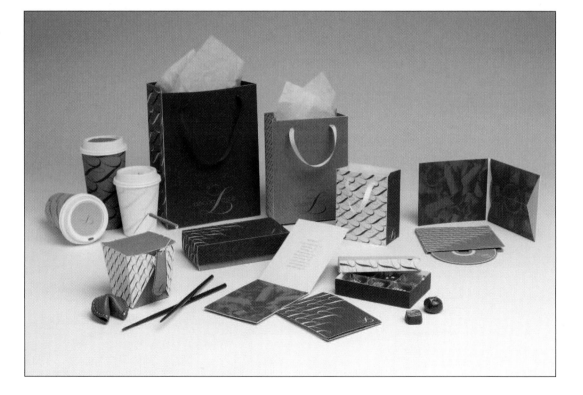

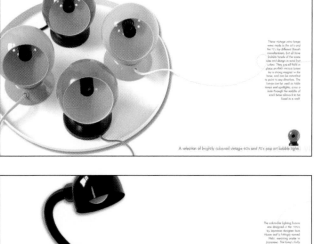

Figure 15-22
Brochure/Logo: Speculative
Designer: Sanghee Jeon

Product images and text © classic-modern.co.uk
2004. Reproduced with permission.

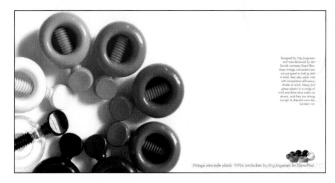

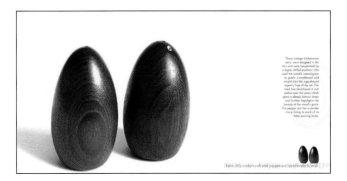

Figure 15-23
Logo: Mockingbird
Theater, a children's
theater company
Designer/Illustrator:
Sanghee Jeon

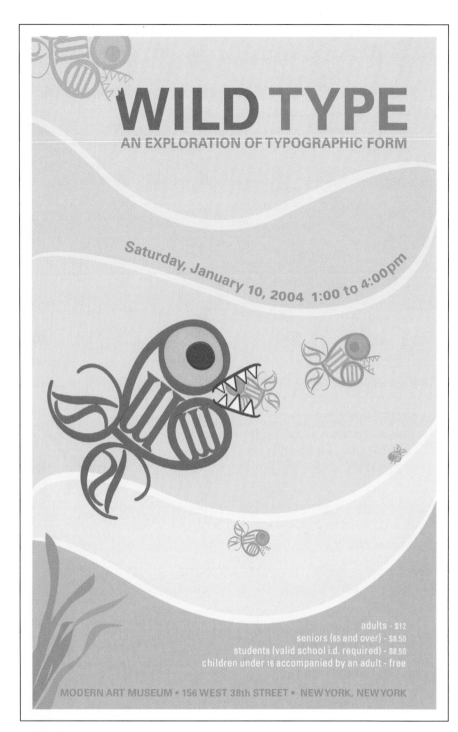

Figure 15-24
Poster: *Wild Type*,
Speculative
Designer/Illustrator:
Sanghee Jeon

Portfolio Projects:

Most of the projects offered in Chapters 5 through 14 are appropriate for inclusion in a portfolio, if well executed. Here are some additional projects to consider including in your portfolio.

Project 15-1

Hangtag designs

1. Design hangtags for a line of specialty goods made in different states, for example, western shirts made in Texas. The purpose of these tags is to promote goods made in America. The same project can be customized for any country.
2. Select five states, for example, "Made in Texas," or "Made in Idaho." Design the "Made in..." typography.
3. Select and design the typography of a quote to be placed on the back of the hangtag; for example, "Imagination is more important than knowledge. Albert Einstein." You may want to choose quotes from people famous in each state.

Presentation

CD-ROM or mounted on one mat board with a 2″ border.

Project 15-2

Book jacket series

1. Design a series of three book jackets for any of the following: Great Chinese writers, Great American poets, or Great South American writers.
2. Research three great writers in any of these categories.
3. Design an imprint for the series.
4. Design three book jackets that can stand alone, as well as look like they belong to a series.
5. Establish variety within the unity of the series.

Presentation

CD-ROM or reduce them to half size and mount on one mat board with a 2″ border.

Project 15-3

Logo

1. Design four related logos for a brand, for example, a specialty tea or a body and bath line.
2. Name the product.
3. Design four types of logos:
 - one in type only
 - one abstract visual logo
 - one pictorial logo
 - one that combines type and visual (abstract or pictorial)

Presentation

CD-ROM or mounted on one mat board with a 2″ border.

Project 15-4

Snowboards or skateboards

Design five theme-related visuals (abstract
or pictorial) for snowboards or skateboards.

Presentation

CD-ROM or mounted on one mat board
with a 2″ border.

Project 15-5

Brochure

1. Design a folded brochure for a physical
 therapy center or a sports medicine facility.
2. Create a logo for the physical therapy center
 or the sports medicine facility.
3. Find or create visuals.
4. Choose text type and subheads.
5. Design the brochure.

Presentation

CD-ROM or dummy slipped into a mat
board with a pocket.

Glossary

accents: supporting or secondary focal points.

advertisement (ad): a specific message constructed to inform, persuade, promote, provoke, or motivate people on behalf of a brand or group. (In this book, "group" represents both commercial industry and social cause/nonprofit organizations.)

advertising: the generation and creation of specific visual and verbal messages constructed to inform, persuade, promote, provoke, or motivate people on behalf of a brand or group.

advertising campaign: a series of coordinated ads, in one or more media, which are based on a single, overarching strategy or theme, and each individual ad in the campaign can stand on its own.

alignment: visual connections made between and among elements, shapes, and objects where their edges or axes line up with one another.

art director: the creative professional in an advertising agency responsible for ideation and the design decisions.

ascender: the part of lowercase letters (b, d, f, h, k, l, and t) that rises above the x-height.

asymmetry: the arrangement of dissimilar or unequal elements of equal weight on a page.

audience: any individual or group who is on the receiving end of a graphic design solution; the target audience is a specific targeted group of people.

balance: an equal distribution of weight.

baseline: defines the bottom of capital letters and of lowercase letters, excluding descenders.

body copy: the narrative text that further explains, supplements, and supports the main advertising concept and message.

brand: the sum total of all functional (tangible) and emotional (intangible) assets that differentiate it among the competition.

brand experience: entails developing an entire brand experience—a comprehensive, strategic, unified, integrated, and unique program for a brand, including every graphic design and advertising application for that brand, with an eye and mind toward how consumers and individuals experience the brand or group as each interacts with it.

branding: the entire development process of creating a brand, brand name, or brand identity.

broadside: a large sheet of paper, typically printed on one side, used to communicate information; also called broadsheet.

calligraphy: letters drawn by hand, the strokes made with a drawing instrument—literally "beautiful writing."

capitals: the larger set of letters, also called **uppercase.**

cause advertising: *sponsored by corporations,* is used to raise funds for nonprofit organizations and is run in paid media.

character: a letterform, number, punctuation mark, or any single unit in a font.

combination mark: a logo that is a combination of words and symbols.

commercial advertising: promotes brands and commodities by informing consumers; it is also used to promote individuals, such as political candidates, and groups, including corporations and manufacturers.

comp or **comprehensive:** a detailed representation of a design; comps usually look like a printed or finished piece.

content: the body of information that is available to visitors on a web site.

continuity: the handling of design elements, like line, shape, texture, and color, to create similarities of form; it is used to create family resemblance.

copywriter: the creative professional in an advertising agency responsible for ideation and writing.

correspondence: when an element, such as color, direction, value, shape or texture, is repeated and a visual connection or correspondence is established among the elements, or when style is utilized as a method of connecting visual elements, for example, a linear style.

counter: the space enclosed by the strokes of a letter.

counterform: the negative spatial area created by letterforms, including counters and the spaces between letterforms.

craftsmanship: the level of skill, proficiency, adeptness, and/or dexterity of the execution. It includes the use of papers, inks, varnishes, cutting and pasting, and also software programs.

creative brief: a strategic plan that both client and design studio or agency can agree upon and from which the creative team works as a strategic springboard.

creative director: the top-level creative professional in an advertising agency (or design studio) with the ultimate creative control over art direction and copy; usually the supervisor of the creative team who makes the ultimate decisions about the idea, creative approach, art direction, and copywriting before the work is presented to the client.

creative team: in an advertising agency, a conventional creative team includes an art director and a copywriter. Unconventional creative teams may include others, as well.

critique: an assessment or evaluation of work.

cropping: cutting an element so the entire element is not seen.

descender: the part of lowercase letters (g, j, p, q, and y) that falls below the baseline.

design brief: a written plan that delineates strategy, objectives, expectations, audience, brand or group perception, and may include budget and media.

design concept: the creative thinking underpinning the design solution. The concept is expressed through the integration and manipulation of visual and verbal elements.

display type: type usually used as headings, over 14 points in size.

editorial design: involves the design of editorial content; it is also called **publication design.**

emotional benefit: benefit based on feelings and responses, not on a functional characteristic of a product or service.

emphasis: the arrangement of visual elements, giving stress or importance to some visual elements, thereby allowing two actions: information to be easily gleaned and the graphic design to be easily received.

environmental design: solves problems about information or identity communication in constructed or natural environments, defining and marking interior and exterior commercial, cultural, residential, and natural environments.

execution: the fulfillment of the concept through physical processes that include the selection and manipulation of materials and/or software.

flow: elements arranged in a design so that the viewer's eyes are led from one element to another, through the design; also called movement.

focal point: the part of a design that is most emphasized.

formal elements: fundamental elements of two-dimensional design: line, shape, color, value, texture, and format.

format: whatever substrate you start out with in graphic design, such as a business card, book jacket, or poster.

functional benefit: the practical or useful characteristic of a product or service that aids in distinguishing a brand from its competition.

graphic design: can be thought of as a visual language that is used to convey a message to an

audience. A graphic design is a visual representation of an idea that relies on the creation, selection, and organization of visual elements to create an effective communication. A powerful graphic design can imbue a message with greater meaning through a compelling solution.

graphic design profession: an expert creative discipline that focuses on visual and verbal communication and meaning.

graphic design solution: can persuade, inform, identify, motivate, enhance, organize, brand, rouse, locate, engage, and carry or convey many levels of meaning.

graphic standards manual: sets up guidelines for how the logo (and/or visual identity) is to be applied to numerous applications, from business cards to point-of-purchase materials to vehicles to web sites; also called an **identity standards manual.**

grid: a guide—a modular compositional structure made up of verticals and horizontals that divide a format into columns and margins. It may be used for single-page formats or multipage formats.

headline: the main verbal message in an advertisement (although it literally refers to the main line of copy that appears at the head of the page); also called the line.

high contrast: a wide range of values.

home page: the primary entrance to a web site that contains the central navigation system.

hue: the name of a color; that is, red or green, blue or yellow.

identity design: the creation of a systematic visual and verbal program intended to establish a consistent visual appearance—a coordinated overarching identity—and spirit or image for a brand or group; also called corporate identity, brand identity, and corporate design.

identity standards manual: sets up guidelines for how the logo (and/or visual identity) is to be applied to numerous applications, from business cards to point-of-purchase materials to vehicles to web sites; also called a **graphic standards manual.**

illusion of spatial depth: the appearance of three-dimensional space on a two-dimensional surface.

information architecture: the careful organization of the web site content into hierarchical (or sequential) order.

information design: a highly specialized area of design that involves making large amounts of complex information clear and accessible to audiences of one to several hundred thousand.

kerning: adjustment of the letterspacing.

layout: the arrangement of type and visuals on a printed or digital page; it concerns the organization and arrangement of type and visuals on two-dimensional surfaces to create effective visual communication.

leading: in metal type, strips of lead of varying thickness (measured in points) used to increase the space between lines of type; also known as **line spacing.**

letterform: the particular style and form of each individual letter of an alphabet.

lettering: letters that are custom designed and executed by conventional drawing or by digital means.

lettermark: a logo created using the initials of the brand or group name.

letterspacing: the space between letters.

line: a mark made by a tool as it is drawn across a surface.

line direction: describes a line's relationship to the page.

line quality: refers to how a line is drawn.

line spacing or **leading:** the distance between two lines of type, measured vertically from baseline to baseline.

line type: (line attributes) refers to the way a line moves from its beginning to its end.

linear: a predominant use of lines to describe shapes, or when lines are used as a way to unify a design.

link: a connection from one location on a web page to another location, which can be at the same web site or a different one; also called hyperlink.

logo: a unique identifying symbol; it is also called a brandmark, mark, identifier, logotype, or trademark. A logo represents and embodies everything a brand or company signifies; it provides immediate recognition.

logotype: a logo that is an identifying mark where the name is spelled out in unique typography; also called **wordmark.**

low contrast: a narrow range of values.

lowercase: the smaller set of letters. The name is derived from the days of metal typesetting when these letters were stored in the lower case.

mini-portfolio: a bound collection of copies of work, including anywhere from three to all of the pieces in the portfolio. It can be to size or at a reduced size.

mock-up: a facsimile of a printed three-dimensional design piece; also called a dummy.

navigation system: the visual design of information architecture.

objectives statement: a clear, succinct description of design objectives, which summarizes the key messages that will be expressed in the design; for example, facts or information, desired personality or image, and position in the market.

packaging design: a graphic design application intended to function as packaging and to attract a consumer and present information; it is an amalgam of two- and three-dimensional design, promotional design, information design, and practicality.

parity products: products that are equivalent in value.

pattern: a repetitive arrangement of elements.

perspective: a schematic way of translating three-dimensional space onto the two-dimensional surface. This is based on the idea that diagonals moving toward a point on the horizon, called the vanishing point, will imitate the recession of space into the distance and create the **illusion of spatial depth.**

pictogram or **pictograph:** a simple picture *denoting* an object, activity, place, or person.

picture plane: the blank, flat surface of a page.

portfolio: a body of work used by the visual communication profession as the measure of one's professional ability.

poster: a two-dimensional, single-page format used to inform (display information, data, schedules, or offerings) and to persuade (promote people, causes, places, events, products, companies, services, groups, or organizations).

presentation: the manner in which comps are presented to a client or in a portfolio.

production: usually defined as preparing the electronic file, collecting all needed photographs and/or illustrations and having them scanned, and then proofreading (with or without the client) and working with the printer.

promotional design: design intended to introduce, sell or promote brands (products and services), ideas, or events and to introduce or promote groups and social causes. Promotional design and advertising overlap, at times, in definition and purpose. For example, one could consider a web site banner either promotional design or advertising.

public service advertising (PSA): advertising that serves the public interest.

publication design: involves the design of editorial content; it is also called **editorial design.**

rhythm: a pattern that is created by repeating or varying elements, with consideration to the space between them, and by establishing a sense of movement from one element to another.

roughs: sketches which are larger and more refined than thumbnail sketches and show the basic elements in a design.

sans serif: letterform design without serifs.

saturation: the brightness or dullness of a color; also called intensity and chroma.

scale: the size of one shape or thing in relation to another.

script: a letterform design that most resembles handwriting.

semiotics: the theory of signs and symbols that deals with their constructed function and meaning.

serifs: the ending strokes of characters.

shape: the general outline of something.

sign: a visual that indicates, represents, or denotes something—such as information, a place, or object—or conveys an idea.

sign-off: includes the brand's or group's logo, a photograph or illustration of the brand, or both.

splash page: the first screen the visitor sees; it serves as an introduction to a web site, and usually features animation or an engaging visual.

storyboard: illustrates and narrates key frames of the television advertising concept.

strategy: the master plan, a starting point to determine several key factors, such as the problem to solve, the objectives, the audience, and brand positioning.

style: the quality that makes something distinctive.

symbol: an essential (uncomplicated) visual that represents something else—an idea, concept, or another thing—by association.

symbol mark: a logo that is an abstract or nonrepresentational visual or a pictorial visual.

symmetry: the balanced arrangement of similar or identical elements so that they are evenly distributed on either side of an imaginary vertical axis, like a mirror image.

tactile texture: real texture that can be felt.

tagline: conveys the brand benefit or spirit, and it generally acts as an umbrella theme or strategy for a campaign or a series of campaigns; also called a claim, endline, strap line, or slogan.

template: compositional structure with designated positions for the elements used throughout a campaign, multipage design, or web site.

text type: set type used for text, usually in sizes ranging from 5 points to 14 points.

texture: the tactile quality of a surface or the representation of such a surface quality.

thumbnail sketches: preliminary, small, quick, unrefined drawings of ideas, in black and white or color.

trompe l'oeil: literally, "to fool the eye"; a visual effect on a two-dimensional surface where the viewer is in doubt as to whether the object depicted is real or a representation.

type alignment: the style or arrangement of setting text type; for example, flush left/ragged right.

type design and lettering: a highly specialized area of graphic design focusing on the creation and design of fonts, type treatments, and the drawing of letterforms by hand (as opposed to type generated on a computer).

type family: several font designs contributing a range of style variations based upon a single typeface design. Most type families include at least a light, medium, and bold weight, each with its own italic.

type font: a complete set of letterforms, numerals, and signs, in a particular face, size, and style, that is required for written communication. In metal type, every available size of this set of characters is a separate font of type.

type style: the modifications in a typeface that create design variety while retaining the essential visual character of the face. These include variations in weight (light, medium, bold), width (condensed, regular, extended), and angle (Roman or upright, and italic), as well as elaborations on the basic form (outline, shaded, decorated).

typeface: the design of a single set of letterforms, numerals, and signs unified by consistent visual properties. These properties create the essential character, which remains recognizable even if the face is modified by design.

typography: the design of letterforms and the arrangement of them in two-dimensional space (for print media) and in space and time (for digital media).

unconventional advertising: advertising that "ambushes" the viewer; often, it appears or is placed in unpaid media in the public environment—places and surfaces where advertising doesn't belong, such as the sidewalk or on wooden construction site walls; also called guerrilla advertising, stealth marketing, and nontraditional marketing.

unity: the level of consistency and correspondence throughout a design.

uppercase: the larger set of letters, also called **capitals**. The name is derived from the days of metal typesetting when these letters were stored in the upper case.

value: the range of lightness or darkness of a visual element or color; that is, a light red or a dark red.

value contrast: the relationship of one element (part or detail) to another, in respect to lightness and darkness.

viral marketing: the use of a self-perpetuation mechanism, such as a web site, to grow a user base in a manner similar to the spread of a virus; it also means a marketing phenomenon that facilitates and encourages people to pass along a marketing message.

visual: the image in a graphic design or ad, which may be a photograph, illustration, graphics, typography, or any combination thereof.

visual hierarchy: arranging elements according to emphasis.

visual identity: the visual and verbal articulation of a brand or group, including all pertinent design applications, such as letterhead, business cards, and packaging, among many other possible applications; also called brand identity and corporate identity.

visual texture: the illusion of texture or the impression of texture created with line, value, and/or color.

visual weight: the illusion of physical weight on a two-dimensional surface.

volume: on a two-dimensional surface, the illusion of a form with mass or weight.

way-finding system: visual system that incorporates signs, pictograms, and symbols to assist and guide visitors and tourists to find what they are looking for in museums, airports, zoos, and city centers.

webisode: in advertising, a short audio or video presentation on the Web, used to promote a brand or group, preview music, and present any type of information.

word spacing: the space between words.

wordmark: a logo that is the name spelled out in unique typography or lettering; also called **logotype**.

x-height: the height of a lowercase letter, excluding ascenders and descenders.

Selected Bibliography

Aitchison, Jim. *Cutting Edge Advertising.* Singapore: Prentice Hall, 1999.

Arnheim, Rudolf. *Art and Visual Perception.* Berkeley: University of California Press, 1974.

———. *The Power of the Center: A Study of Composition in the Visual Arts.* Berkeley: University of California Press, 1984.

Aynsley, Jeremy. *A Century of Graphic Design.* Hauppague, NY: Barron's Educational Series, Inc., 2001.

Barthel, Diane. *Putting on Appearances: Gender and Advertising.* Philadelphia: Temple University Press, 1988.

Beaumont, Michael. *Type: Design, Color, Character and Use.* Cincinnati, OH: North Light Books, 1987.

Berger, Warren. *Advertising Today.* New York: Phaidon Press Ltd., 2001.

Bond, Jonathan, and Richard Kirshenbaum. *Under the Radar.* New York: John Wiley & Sons, Inc., 1998.

Brady, Philip. *Using Type Right.* Cincinnati, OH: North Light Books, 1988.

Carter, David E. *Branding: The Power of Market Identity.* New York: Hearst Books International, 1999.

Carter, Rob. *American Typography Today.* New York: Van Nostrand Reinhold, 1989.

Carter, Rob; Ben Day; and Philip B. Meggs. *Typographic Design: Form and Communication.* 3rd ed. New York: Van Nostrand Reinhold, 2002.

Craig, James. *Basic Typography: A Design Manual.* New York: Watson-Guptill Publications, 1990.

———. *Designing With Type.* New York: Watson-Guptill Publications, 1992.

Curtis, Hillman. *MTIV: Process, Inspiration and Practice for the New Media Designer.* New York: New Riders Press, 2002.

Elam, Kimberly. *Expressive Typography: The Word As Image.* New York: Van Nostrand Reinhold, 1990.

Felton, Giles. "How to Talk Dot-Com Like a Webmaster." *The New York Times,* 22 September 1999, late edition, sec. G, p. 3, col. 3.

Fiell, Charlotte, and Peter Fiell. *Graphic Design for the 21st Century.* Germany: Taschen, 2003.

Friedman, Mildred, et al. *Graphic Design In America: A Visual Language History.* Minneapolis, MN: Walker Art Center, and New York: Harry N. Abrams, 1989.

Gill, Bob. *Forget All the Rules You Ever Learned About Graphic Design Including the Ones in this Book.* New York: Watson-Guptill Publications, 1981.

Glaser, Milton. *Milton Glaser: Graphic Design.* Woodstock, NY: Overlook Press, 1973.

Goldfarb, Roz. *Careers by Design: A Headhunter's Secrets for Success and Survival in Graphic Design.* New York: Allworth Press, 1997.

Gonnella, Rose; Denise M. Anderson; and Robin Landa. *Creative Jolt Inspirations.* Cincinnati, OH: North Light Books, 2000.

Goodrum, Charles, and Helen Dalrymple. *Advertising in America.* New York: Abrams, 1990.

Graphic Artists Guild *Handbook: Pricing & Ethical Guidelines.* New York: Graphic Artists Guild, 2004.

"Graphic Design and Advertising Timeline." *Communication Arts* 41, 1 (1999): 80-95.

Greiman, April. *Hybrid Technology: The Fusion of Technology and Graphic Design.* New York: Watson-Guptill Publications, 1990.

Haley, Allan. *Photo Typography.* New York: Scribner's Sons, 1980.

Hamilton, William L. "With the World Redesigned, What Role for Designers?" *The New York Times*, 25 October 2001, late edition, sec. F, p. 1, col. 2.

Hauffe, Thomas. *Design: An Illustrated Historical Overview.* New York: Barron's, 1996.

Heller, Steven. *Graphic Design: New York.* Rockport, MA: Allworth Press, 1993.

Heller, Steven, ed. *The Education of a Graphic Designer.* New York: Allworth Press, 1998.

Heller, Steven, and Gail Anderson. *Graphic Wit: The Art of Humor In Design.* New York: Watson-Guptill Publications, 1991.

Heller, Steven, and Seymour Chwast. *Graphic Style: from Victorian to Digital.* New York: Harry N. Abrams, 2001.

Heller, Steven, and Teresa Fernandes. *Becoming a Graphic Designer.* Hoboken, NJ: John Wiley & Sons, Inc., 1999.

Heller, Steven, and Elinor Pettit. *Graphic Design Timeline.* New York: Allworth Press, 2000.

Hinrichs, Kit. *Typewise.* Cincinnati, OH: North Light Books, 1990.

Hofmann, Armin. *Graphic Design Manual.* New York: Van Nostrand Reinhold, 1965.

Holland, D.K.; Michael Bierut; and William Drenttel. *Graphic Design: America.* New York: Rockport Publishers, Inc. and Allworth Press, 1993.

Hollis, Richard. *Graphic Design: A Concise History.* London: Thames & Hudson Ltd, 2001.

Hurlburt, Allen. *The Design Concept.* New York: Watson-Guptill Publications, 1981.

————. *The Grid.* New York: Van Nostrand Reinhold, 1978.

————. *Layout: The Design of the Printed Page.* New York: Watson-Guptill Publications, 1977.

Ives, Nat. Advertising: "Entertaining Web Sites Promote Products Subtly," *The New York Times*, 22 December 2004, late edition, sec. C, p. 2, col. 1.

Johnson, J. Stewart. *The Modern American Poster.* New York: The National Museum of Modern Art, Kyoto, and The Museum of Modern Art, New York, 1983.

Kanner, Bernice. *The 100 Best TV Commercials.* New York: Times Books, a division of Random House, 1999.

Labuz, Ronald. *Contemporary Graphic Design.* New York: Van Nostrand Reinhold, 1991.

Landa, Robin. *Advertising by Design™.* Hoboken, NJ: John Wiley & Sons, Inc., 2004.

————. *Designing Brand Experiences.* Clifton Park, NY: Thomson Delmar Learning, 2005.

————. *Thinking Creatively.* 2nd ed. Cincinnati, OH: North Light Books, 2000.

Landa, Robin, and Rose Gonnella. *Visual Workout: Creativity Workbook.* Albany: OnWord Press, Thomson Learning, 2000.

Landa, Robin; Denise M. Anderson; and Rose Gonnella. *Creative Jolt.* Cincinnati, OH: North Light Books, 2000.

Levenson, Bob. *Bill Bernbach's Book.* New York: Vintage Books, a division of Random House, 1987.

Livingston, Alan, and Isabella Livingston. *Graphic Design and Designers.* New York: Thames and Hudson, Inc., 1992.

Lyons, John. *Guts: Advertising from the Inside Out*. New York: AMACON, 1989.

Markoff, John. "New Service by TiVo Will Build Bridges From the Internet to the TV," *The New York Times*, 9 June 2004, late edition, sec. C, p. 1, col. 2.

Marquand, Ed. *Roughs, Comps, and Mock-ups*. New York: Art Direction Book Company, 1985.

McDermott, Catherine. *Design Museum Book of 20th Century Design*. Woodstock, NY: The Overlook Press, 1999.

McDonough, John, and Karen Egolf, eds. *The Advertising Age Encyclopedia of Advertising*. 3 vols. New York: Fitzroy Dearborn, 2003.

Meggs, Philip B. *A History of Graphic Design*. 3rd ed. Hoboken: John Wiley & Sons, Inc., 1998.

————. *Type and Image: The Language of Graphic Design*. New York: Van Nostrand Reinhold, 1989.

Minick, Scott, and Jiao Ping. *Chinese Graphic Design In The Twentieth Century*. New York: Van Nostrand Reinhold, 1990.

Myerson, Jeremy, and Graham Vickers. *Rewind: Forty Years of Design & Advertising*. London: Phaidon Press Ltd, 2002.

Ogilvy, David. *Confessions of an Advertising Man*. New York: Crown, 1985.

————. *Ogilvy on Advertising*. New York: Crown, 1983.

Paetro, Maxine. *How to Put Your Book Together and Get A Job in Advertising*. Chicago: The Copy Workshop, 1990.

Perfect, Christopher, and Jeremy Austen. *The Complete Typographer*. Englewood Cliffs, NJ: Prentice-Hall, 1992.

Remington, Roger, and Barbara J. Hodik. *Nine Pioneers in American Graphic Design*. Cambridge, MA: The MIT Press, 1989.

Ries, Al, and Jack Trout. *The 22 Immutable Laws of Marketing*. New York: HarperBusiness, 1993.

Rossol, Monona. *The Artist's Complete Health and Safety Guide*. New York: Allworth Press, 1990.

Rothenberg, Randall. "The Advertising Century." *www.adage.com/century/rothenberg.html*.

Scher, Paula. *The Graphic Design Portfolio*. New York: Watson-Guptill Publications, 1992.

————*Make It Bigger*. Princeton: Princeton Architectural Press, 2002.

Siegel, David. *Creating Killer Web Sites*. Indianapolis, IN: Hayden Books, 1996.

Snyder, Gertrude, and Alan Peckolick. *Herb Lubalin*. New York: American Showcase, 1985.

Spencer, Herbert, ed. *The Liberated Page*. San Francisco: Bedford Press, 1987.

Sullivan, Luke. *Hey Whipple, Squeeze This: A Guide To Creating Great Ads*. New York: John Wiley & Sons, Inc., 1998.

Swann, Alan. *Designed Right!* Cincinnati, OH: North Light Books, 1990.

Walker, Rob. "Consumed: Poultry-Geist," *The New York Times*. 23 May 2004, late edition, sec. 6, p. 18, col. 1.

Warlick, Mary, ed. *Advertising's Ten Best of the Decade 1980-1990*. New York: The One Club for Art and Copy, Inc., 1990.

Wilde, Richard. *Problems: Solutions*. New York: Van Nostrand Reinhold Company, 1986.

Wong, Wucius, and Benjamin Wong. *Visual Design on the Computer*. New York: Design Books, 1994.

Wrede, Stuart. *The Modern Poster*. Boston: Little, Brown and Company, 1988.

Online Sources

www.adage.com/century

www.adcouncil.org

www.admuseum.org

www.admuseum.org/museum/timeline/timeline.htm

www.adweek.com/adweek/creative/best_spots_01/02.jsp

www.aiga.org

www.emigre.com/ArticleFTF.php ("First Things First Manifesto 2000")

www.iabc.org

www.iloveny.com

www.lurzuersarchive.com

www.mullen.com

www.oneclub.com

www.rockefeller.edu/events/creativity/2003/program.php

www.saatchikevin.com/livingit/q&aindex.html

http://scriptorium.lib.duke.edu/eaa/broadsides.html

Video

Sell and Spin: A History of Advertising (A&E Home Video, 1999).

Subject Index

Agencies, Clients, Creative Professionals, and Studios Index